The Essential **Frank Lloyd Wright**

FRANK LLOYD WRIGHT FOUNDATION

The Essential **Frank Lloyd Wright**

Critical Writings on Architecture

Frank Lloyd Wright

EDITED BY

Bruce Brooks Pfeiffer

PRINCETON UNIVERSITY PRESS

PRINCETON AND OXFORD

Published by Princeton University Press, 41 William Street, Princeton, New Jersey 08540

In the United Kingdom:

Princeton University Press, 3 Market Place, Woodstock, Oxfordshire OX20 1SY

Library of Congress Cataloging-in-Publication Data

Wright, Frank Lloyd, 1867-1959.

 The essential Frank Lloyd Wright : critical writings on architecture / edited by Bruce Pfeiffer.

 p. cm.

 Includes index.

 ISBN 978-0-691-13318-8 (hardcover : alk. paper) 1. Architecture. I. Pfeiffer, Bruce Brooks.

II. Title.

 NA2560.W68 2008

 720—dc22 2007025251

British Library Cataloging-in-Publication Data is available

This book has been composed in Minion Pro with Meta display.

Printed on acid-free paper. ∞

press.princeton.edu

Printed in Canada

10 9 8 7 6 5 4 3 2 1

Contents

v

PART II

PART III

The Essential **Frank Lloyd Wright**

Down the long avenue of time, there have been few artists who have been able to express through the written word ideas about their art. Among them Frank Lloyd Wright stands at the pinnacle not only in his architectural work but also in his writings, the output of which was enormous. It is astonishing that in addition to all of the architectural work he found the time and energy to write so prodigiously.

From the very start of his career he was concerned with explaining his work and the principles underlying it. He wrote sixteen books and hundreds of articles and lectures over the seven decades of his career. The manuscript collection in the Frank Lloyd Wright Archives numbers over six hundred documents.

The most significant of all his writings deal, as one would expect, with architecture and all its aspects—from discussions of building materials themselves to the broader subject of urban and suburban planning. In 1894, one year after he opened his architectural practice, he lectured to various clubs and organizations in and around Chicago. He focused mainly on residential architecture in the early years of his practice, and noted his own refusal to accept the confusion of eclectic styles, many of European import that were rising throughout the Midwest where he lived and work. He urged his audiences to likewise abandon these clichés of the past and subscribe to an architecture more suited to its time and place.

It was his habit to write all of his first drafts by hand. Of the creation of his architectural designs he once remarked, "I never put anything down on paper until I have it pretty clean in mind. That is the habit of a life time, a long time. To see it definitely and correctly, imagine the thing completely, is no small feat." From the study of his first drafts that remain today, the same creative process is evident.[1] His thoughts, on whatever subject he chose to write about, were clear right from the start. As he continued to develop his architectural projects from conceptual sketches to final working drawings, he also worked on his texts from early draft through final manuscript ready for publication.

Of this enormous body of written work, the selection for this publication was made initially from the published material where he was trying to reach an audience beyond his clients. Wright's autobiography, first published in 1932 and then revised in 1943, is certainly among the most important writings. However, it has been reprinted recently and for that reason it has not been included in this book. With that exception, those that were chosen for inclusion are the most

[1] Frank Lloyd Wright to the Taliesin Fellowship, December 7, 1958.

1

critical to understanding the philosophy that drove his architectural mission, which he defined as: "The mission of an architect—of architecture—is to help people understand how to make life more beautiful, the world a better one for living in, and to give reason, rhyme, and meaning to life."[2]

The writings in this publication begin in 1901 with *The Art and Craft of the Machine* and end with *A Testament* in 1957, two years before his death. The former was an important lecture he delivered at Chicago's Hull House and so captured his thoughts that he revised it several times over his lifetime and even included part of it in his Princeton Lectures of 1930. *A Testament,* as its title implies, was his final word on his life and his principles of organic architecture.

From the beginning Wright exuded confidence, choosing the direction he wanted to take and from which he did not detour. That path continued in an uninterrupted line throughout a career that spanned close to three-quarters of a century, as these writings clearly demonstrate.

Wright read "The Art and Craft of the Machine" at Chicago's Hull House in March 1901. It was a reactionary and significant address given as it was at a time when the English Arts and Crafts movement was beginning to sweep across the nation. There is no doubt that Wright admired the hand-crafted work of designers such as Louis Comfort Tiffany, Charles Rennie Mackintosh, and Greene & Greene. He believed, however, that the work of these artists was not for the average American family, but rather for a more well-to-do clientele. To Wright's way of thinking, the role of the machine needed to be re-examined. He believed in the potential of the machine as a valuable tool in the hand of the creative artist, freeing him from laborious and expensive handiwork no longer relevant to twentieth-century machine technology. Geometrically patterned concrete block, stamped metal facia, and stamped copper panels are all examples of the machine at work rendering beautiful designs in materials readily available to architects. "The machine, by its wonderful cutting, shaping, smoothing and repetitive capacity, has made it possible to so use it without waste that the poor as well as the rich may enjoy today beautiful surface treatments of clean, strong forms that the branch veneers of Sheraton and Chippendale only hinted at, with dire extravagance, and which the Middle Ages utterly ignored."[3]

He also qualified what he meant by "simplicity" in an era—the Victorian—where simplicity was the last element to be found in art and architecture. He stressed that simplicity was not merely "a neutral of a negative quality." "Simplicity in art, rightly understood, is a synthetic, positive quality, in which we may see evidence of mind, breadth of scheme, wealth of detail, and withal a sense of completeness found in a tree or a flower. A work may have the delicacies of a rare orchid or the stanch fortitude of the oak, and still be simple. A thing to be simple needs only to be true to itself in organic sense."[4]

"In the Cause of Architecture," an article published in *The Architectural Record* in March 1908 and lavishly illustrated with photographs of his buildings, showed the public for the first time the scope of Wright's work with a detailed explanation of what it was, why it was, and how it came into being. This was during the so-called Prairie years and the article included several prairie style houses along with the Larkin Building and Unity Temple, buildings that would significantly influence the direction of modern architecture. The article ends with the prophetic statement: "As for the future—the work shall grow more tru-

[2] Frank Lloyd Wright talk at the University of California, April 27, 1957.

[3] Bruce Brooks Pfeiffer, ed. 1992. *Frank Lloyd Wright Collected Writings Volume 1* (New York: Rizzoli), p. 65; see p. [29] of this volume.

[4] Ibid., p. 64 [28].

ly simple; more expressive with fewer lines, fewer forms; more articulate with less labor; more plastic; more fluent, although more coherent; more organic."[5]

Ausgeführte Bauten und Entwürfe von Frank Lloyd Wright was a massive publication, a two-volume monograph, containing one hundred plates of drawings made specifically for this work. Published in Berlin by Ernst Wasmuth in 1910, it exerted a strong impact on the young architects of Germany and Holland. Lloyd, Wright's son who accompanied his father to Italy to prepare the plates for the monograph, explained the significance of the publication in a letter: "Soon after the work was published in Germany, we found they were using the folio and drawings in schools and universities for textbooks. There men like Gropius and Mies van der Rohe were students of my age, i.e. 19 and 20, and were greatly impressed and I heard later that Gropius' mother gave him one of the collections, he claimed he made it his Bible."[6]

In the introduction Wright opened with a glowing tribute to the Gothic and the early Renaissance artists and architects of Italy, no doubt a result of his living in Florence and neighboring Fiesole while preparing the Wasmuth plates.

> Of this joy in living, there is greater proof in Italy than elsewhere. Buildings, pictures, and sculptures seem to be born, like the flowers by the roadside, to sing themselves into being. Approached in the spirit of their conception, they inspire us with the very music of life.
>
> No really Italian building seems ill at ease in Italy. All are happily content with what ornament and color they carry, as naturally as the rocks and trees and garden slopes which are one with them.[7]

The introduction explained the drawings in a manner similar to the presentation in "In the Cause of Architecture" two years earlier. Here, though, he emphasized the role of an architect: "An architect, then, in this revived sense, is a man disciplined from within by a conception of the organic nature of his task, knowing his tools and his opportunity, working out his problems with what sense of beauty the gods gave him."[8]

The Japanese Print: An Interpretation, published in 1912, does not deal with architecture per se, however it is an important example of Wright's writings in light of the great debt he owed to the Japanese print—of which he was an avid collector. He wrote: "I have never confided to you the extent to which the Japanese print, as such, has inspired me. I never got over my first experience with it and I shall probably never recover. I hope I shan't. It was the great gospel of simplification that came over. The elimination of all that was insignificant . . ."[9]

His writing not only explained the beauty and quality of the Japanese print, but also of the very nature of the culture of Japan.

> The first prerequisite for the successful study of this strange art is to fix the fact in mind at the beginning that it is the sentiment of Nature alone which concerns the Japanese artist; the sentiment of Nature as beheld by him in those vital meanings which he alone seems to see and alone therefore endeavors to portray.
>
> The Japanese, by means of this process—to him by this habit of such study almost instinctive—casts a glamour over everything. He is a poet. Surely life in old Japan must have been a perpetual communion with the divine heart of Nature.[10]

[5] Ibid., pp. 100–1 [51].

[6] Letter of February 3, 1966, from Lloyd Wright to Linn Ann Cowles. Lloyd, along with draftsman Taylor Woolley, traveled to Italy to help Wright prepare the plates for the monograph.

[7] *Frank Lloyd Wright Collected Writings Volume 1,* pp. 103–4 [52].

[8] Ibid., p. 111 [62].

[9] Frank Lloyd Wright talk to the Taliesin Fellowship, June 20, 1954. FLLW Archives # 1014.101, p. 1.

[10] *Frank Lloyd Wright Collected Writings* Volume 1, p. 119 [68].

"Louis Henry Sullivan: His Work" is a tribute to the man Wright affectionately and reverently called "Lieber Meister" (Dear Master), written three months after Sullivan's death on April 14, 1924:

> Louis Sullivan's great value as an Artist-Architect—alive or dead—lies in his firm grasp of principle. He knew the truths of Architecture as I believe no one before him knew them. And profoundly he realized them.
>
> This illumination of his was the more remarkable a vision when all around him cultural mists hung low to obscure or blight every dawning hope of a finer beauty in the matter of this world. . . .
>
> The names, attributes, and passions of earth's creatures change, but—that creation changes never; his sane and passionate vision leaves testimony here on earth in fragments of his dreams—his work.[11]

Wright then proceeded to describe certain of Sullivan's works, pointing out that he was challenged by the obsession with classical architecture, which was the result of the World's Columbian Exposition in Chicago in 1893. In particular, as Wright reviewed Sullivan's buildings, he wrote of the Wainwright Building:

> When he brought in the board with the motive of the Wainwright Building outlined in profile and in scheme upon it and threw it down on my table, I was perfectly aware of what had happened. This was Louis Sullivan's greatest moment—his greatest effort. The "skyscraper" as a new thing beneath the sun, an entity with virtue, individuality and beauty all its own, was born. . . .
>
> The Wainwright Building cleared the way, and to this day remains the master key to the skyscraper as a matter of Architecture in the work of the world.[12]

"In the Cause of Architecture: The Third Dimension" was first published in the Dutch magazine *Wendingen* in 1925. *Wendingen* devoted seven issues to Wright's work, and then bound them together in a book. Along with texts by Wright, the other contributors included Lewis Mumford, H. P. Berlage, J.J.P. Oud, Robert Mallet-Stevens, Erich Mendelsohn, and Louis H. Sullivan. Wright's texts included reprints of "In the Cause of Architecture: First Paper" (March 1908), "In the Cause of Architecture: Second Paper" (May 1914), and as printed here, "In the Cause of Architecture: The Third Dimension." The final essay, by Wright, as requested by the editor H. Th. Wijdeveld, was "To My European Co-Workers."

The 1925 paper opens with a recounting of the negative reaction in 1901 to the reading of his essay, "The Art and Craft of the Machine." As stated earlier, in 1901 the Arts and Crafts Movement was exerting a strong influence on American designers and their clients. However, in protest of this trend, he explained, "In all the crafts, the nature of materials is emancipated by the Machine and the artist is freed from bondage to the old post-and-lintel form. . . . A modern building may reasonably be a plastic whole—an integral matter of three dimensions: a child of the imagination more free than of yore, owing nothing to 'orders' or 'styles.'"[13] He further clarified this term "plastic": "Plastic treatments are always out of the thing, never something put on it. The quality of the third dimension is found in this sense of depth that enters into the thing to develop

[11] Ibid., p. 197 [75].
[12] Ibid., p. 198 [76].
[13] Ibid., p. 210 [80–81].

into an expression of its nature. . . . In this architecture of the third dimension 'plastic' effects are usually produced from this sense of the within."[14] As a result, he wrote:

> . . . we may now, from the vision opened by the ideal of a plastic architecture, look down upon the limitations of the antique world with less respect and no regret. We have wings where they had only feet, usually in leaden shoes. We may soar in individual freedom of expression where they were wont to crawl—and we are the many where they were the few. A superior breadth and beauty in unity and variety is a universal possibility to us—if we master the Machine and are not, as now, mastered by it.[15]

The 1927–28 "In the Cause of Architecture" articles were commissioned by editor M. A. Mikkelson for *The Architectural Record*. He had long admired what Frank Lloyd Wright had built as well as written, and in 1926 he proposed that Wright write a series of fourteen essays, all under the general heading of "In the Cause of Architecture." Seven of these dealt with "The Meaning of Materials." Nothing of much significance had been written on "the nature of materials," least of all by an architect. Here were the tools, the very substance and backbone of an architect's work, and yet the subject remained unexamined. Wright's approach to materials began with steel, and continued with stone, wood, brick, glass, concrete, and sheet metal. His comments on these materials, as well as descriptions of their potential characteristics for architectural construction, are often eloquently poetic. "Materials! What a resource! With his 'materials'—the architect can do whatever masters have done with pigments or with sound—in shadings as subtle, with combinations as expressive—perhaps outlasting man himself. . . . These *materials* are human-riches. They are Nature-gifts to the sensibilities that are, again, gifts of Nature. . . . Each material has its own message and, to the creative artist, its own song."[16]

On steel:

> Now, ductile, tensile, dense to any degree, uniform and calculable to any standard, steel in a known quantity to be dealt with mathematically to a certainty to the last pound; a miracle of strength to be counted upon![17]

> Steel is most economical in tension; the steel strand is a marvel, let us say, as compared to anything the ancients knew, a miracle of strength for its weight and cost. We have found now how to combine it with a mass material, concrete, which has great strength in compression. The coefficient of expansion and contraction of both materials is the same in changes of temperature. . . .
>
> Here we have reinforced concrete, a new dispensation. A new medium for the new world of thought and feeling that seems ideal.[18]

On stone:

> The rock ledges of a stone quarry are a story and a longing to me. There is suggestion in the strata and character in the formations. I like to sit and feel it, as it is. Often I have thought, were great monumental buildings ever given me to build, I would go to the Grand Canyon in Arizona to ponder them.[19]

> The character of the wall surface will be determined also by the kind of stone, by the kind of mason, the kind of architect. Probably by the kind

[14] Ibid., p. 212 [87].

[15] Ibid., p. 214 [91].

[16] Ibid., p. 270 [121].

[17] Ibid., p. 234 [98].

[18] Ibid., p. 237 [99–100].

[19] Ibid., p. 237 [120].

of building. But, most of all, by the nature of the stone itself, if the work is good stonework. . . .

But most building stone—as Caen-stone, say—is a clear negative substance, like a sheet of soft beautiful paper, on which it is appropriate to cut images, by wasting away the surface to sink or raise traces of the imagination like a kind of human writing, carrying the ideology of the human race down the ages from the primitive to the decadent.[20]

On wood:

It is the most humanly intimate of all materials. Man loves his association with it, likes to feel it under his hand, sympathetic to his touch and to his eye. Wood is universally beautiful to Man. And yet, among higher civilizations, the Japanese understood it best. . . .

No Western peoples ever used wood with such understanding as the Japanese did in their construction—where wood always came up and came out as nobly beautiful.[21]

Wood can never be wrought by the machine as it was lovingly wrought by the hand into a violin, for instance, except as a lifeless imitation. But the beautiful properties of wood may be released by the Machine to the hand of the architect. His imagination must use it in true ways—worthy of its beauty.[22]

Of the kiln:

We have hitherto been speaking of "natural" materials. The natural material here is of earth itself. But to produce this material known as ceramics, another element, that of the artificer, has entered with Fire. . . .

What has man to show for the Brick? I should offer the brick buildings of Asia Minor—Persia.

What has he to show for his Tile? Wherever Persian or Mohammedan influence was supreme.

What has he to show for the Pot or Bowl? Chinese pottery.

What has he to show for his Vase? The Grecian urn.

To show for his Image? Those of Egypt, Greece, and China.[23]

Of glass:

Perhaps the greatest difference eventually between ancient and modern buildings will be due to our modern machine-made glass. Glass, in any wide utilitarian sense, is new.

Once a precious substance limited in quantity and size, glass and its making have grown so that a perfect clarity of any thickness, quality, or dimension is so cheap and desirable that our modern world is drifting toward structures of glass and steel.[24]

Of concrete:

Aesthetically it has neither song nor story. . . .

Concrete would be better named "conglomerate," as concrete is a noble word which this material fails to live up to. It is a mixture that has little quality in itself.

[20] Ibid., p. 272 [121].
[21] Ibid., p. 277 [126].
[22] Ibid., p. 283 [130].
[23] Ibid., p. 286 [131–32].
[24] Ibid., p. 291 [137].

If this material is to have either form, texture, or color in itself, each must artificially be given to it, by human imagination.[25]

Of sheet metal he wrote:

The machinery at work in the sheet-metal trades easily crimps, folds, trims, and stamps sheets of metal as an ingenious child might his sheets of paper.[26]

Copper is easily the king of this field, and what is true of copper will be true of the other metals in some degree, with certain special aptitudes and properties added or subtracted in the case of each.[27]

This series included additional articles such as "The Architect and the Machine"; "Standardization, the Soul of the Machine"; "Fabrication and Imagination"; and "The Logic of the Plan." These articles covered a wide range of topics never before explored by architects. They are as valuable today as they were when published and will continue to be so into the future.

If one had to choose just one of Wright's publications for posterity, it would be difficult to choose between his autobiography and *Modern Architecture, Being the Kahn Lectures,* six lectures delivered at Princeton University in May 1930. The lectures covered a wide range of topics: "Machinery, Materials, and Men" was followed by "Style in Industry." Wright then continues with a description of the early years of his own work in residential architecture with "The Passing of the Cornice" and "Cardboard House." He ends with a discussion of urban problems in "The Tyranny of the Skyscraper" and "The City." In these he projects his city planning vision, which four years later emerges as Broadacre City.

He opens the lectures with this:

An architecture for these United States will be born "modern," as were all the architectures of the peoples of all the world. Perhaps this is the deep-seated reason why the young man in architecture grieves his parents, academic and familiar, by yielding to the fascination of creation, instead of persisting as the creature of ancient circumstance. This, his rational surrender to instinct, is known, I believe, as "rebellion."

I am here to aid and comfort rebellion insofar as rebellion has this honorable instinct—even though purpose may not yet be clearly defined—nor any fruits, but only ists, isms, and istics be in sight. Certainly we may now see the dawning of a deeper insight than has for the past thirty years characterized so-called American architecture. In that length of time, American architecture has been neither American nor architecture. We have had instead merely a bad form of surface-decoration.

This "dawn" is the essential concern of this moment and the occasion for this series of "lectures." We, here at Princeton, are to guard this dawning insight and help to guide its courage, passion, and patience into channels where depth and flow is adequate, instead of allowing youthful adventure to ground in shallows all there beneath the surface in the offing, ready to hinder and betray native progress.[28]

The lectures were published the following year by Princeton University Press. They were published again in 1953 in *The Future of Architecture,* which

[25] Ibid., p. 300 [141–42].

[26] Ibid., p. 306 [146].

[27] Ibid., p. 305 [145].

[28] *Frank Lloyd Wright Collected Writings Volume 2,* p. 20 [159].

contained a selection of those of his writings that Wright himself believed to be of special significance.

In October of 1930 Wright delivered two lectures at the Art Institute of Chicago, which were published the next year as *Two Lectures on Architecture.* The first, "In the Realms of Ideas," was addressed to a more general audience than that for the Princeton lectures. In this lecture he presented the concept of the modern home, that had driven his practice some thirty years earlier:

> I had an idea that the planes parallel to earth in buildings identify themselves with the ground—make the building belong to the ground. . . . I had an idea that every house in that low region [the Midwest prairie] should begin *on* the ground—not *in* it, as they then began, with damp cellars. This idea put the house up on the "prairie basement" I devised, entirely above the ground. And an idea that the house should *look* as though it began there *at* the ground put a projecting base-course as a visible edge to this foundation, where as a platform it was seen as evident preparation for the building itself.
>
> An idea that shelter should be the essential look of any dwelling put the spreading roof with generously projecting eaves over the whole; I saw the building primarily not as a cave, but as shelter in the open.[29]

Continuing his fascination with the "nature of materials," he further elaborated on how he had learned to see all materials as they were—"each for itself and all for themselves"—in the modern house and to value the machine in creative endeavors: "Mankind is only now waking to visions of the machine as the true emancipator of the individual as individual."[30] He summed it up thus: "A new integrity then? Yes, integrity new to us in America—and yet so ancient! A new integrity alive and working with new means—greater means than ever worked before. A new integrity working for freedom—yours and mine and our children's freedom—in this realm, we have called, for the purpose of this hour together, 'the realm of ideas.'"[31]

While the first lecture was directed to an mixed audience of nonprofessionals, his second lecture, "To the Young Man in Architecture," as its title implies, was clearly directed to students:

> I am here to assure you that the circumference of architecture *is* changing with astonishing rapidity, but that its *center* remains unchanged. . . . The circumference is shifting because hunger for reality is not yet dead, and because human vision widens with science as human nature deepens with inner experience.
>
> The center of architecture remains unchanged because—though all unconfessed or ill-concealed—beauty is no less the true purpose of rational modern architectural endeavor than ever, just as beauty remains the essential characteristic of architecture itself.[32]

And he cautioned, "Young man in architecture—wherever you are and whatever your age, or whatever your job, we—the youth of America—should be the psychological shock-troops thrown into action against corruption of this supreme American ideal. It will be for youth, in this sense, to win the day for freedom in architecture."[33]

[29] Ibid., p. 86 [219].

[30] Ibid., p. 91 [224].

[31] Ibid., p. 91 [225].

[32] Ibid., pp. 91–92 [225].

[33] Ibid., p. 96 [230].

These two lectures, together with the six Princeton lectures, form a magnificent body of written work. One finds the substance of Wright's thoughts on many levels. They are remarkable testimony that his genius with words and thought matched his genius with brick, concrete, and glass.

The Disappearing City was published in 1932, the same year Wright's autobiography was published. It was revised in 1945 as *When Democracy Builds* and again as *The Living City* in 1958. However it is the 1932 text, *The Disappearing City*, that has been included here because of its proximity in time with the stock market crash in 1929 and the ensuing Great Depression. It was a time when American values made an enormous shift. The opulent era of the 1920s was gone forever. The nation faced lean years and then the promise of a growing economy. The American city experienced this same shock and then growth potential, but Wright believed the new shape of the city was developing in the wrong direction. *The Disappearing City* presented Wright's vision of what urban and suburban life in the United States could be, if not drowned by cheap commercialization and the grasping pursuit of profit and wealth at the expense of the American family.

> The value of this earth, as man's heritage, is pretty far gone from him now in the cities centralization has built. And centralization has over-built them all. . . .
>
> The properly citified citizen has become a broker dealing, chiefly, in human frailties or the ideas and inventions of others: a puller of levers, a presser of the buttons of a vicarious power, his by way of machine craft.
>
> A parasite of the spirit is here, a whirling dervish in a whirling vortex.
>
> Perpetual to and fro excites and robs the urban individual of meditation, imaginative reflection and projection once his as he lived and walked under clean sky among the growing greenery to which he was born companion.[34]

In describing the evils of the current city—the problem of rent contributing to poverty, inflated land values, salesmanship and selling by financing, collecting, threatening foreclosure or repossession—he pointed to the act of capitalistic centralization:

> Now, to maintain in due force and legal effect all these various white-collar armies deriving from the three artificial "economic" factors and keep all dove-tailing together smoothly, has inevitably exaggerated a simple natural human benefit. Government.[35]
>
> Meantime, what of the subject, or object or living man-unit upon whom, by his voluntary subordination this extraordinarily complicated economic superstructure, has been imposed, erected, and functions as government and "business"? What about the man himself?[36]

All of his concerns come together in a solution for the city of the future: "We are going to call this city for the individual the Broadacre City because it is based upon a minimum of an acre to the family."[37]

> The architectural features of the Broadacre City will arise naturally out of the nature and the character of the ground on which it stands and of which it is a component if not an organic feature.

[34] *Frank Lloyd Wright Collected Writings Volume 3*, p. 70 [235].

[35] Ibid., pp. 73–74 [238].

[36] Ibid., p. 74 [239].

[37] Ibid., p. 79 [242].

The individual architectural features themselves would naturally harmonize with the nature features. . . .

So, in the Broadacre City the entire American scene becomes an organic architectural expression of the nature of man himself and of his life here upon the earth.[38]

He listed the various individual components as he envisioned them incorporated into the Broadacre City: the highway and roadway systems, the farmer on his land, the employee on his acre, the office building, the new store or distributor of merchandise, the hotel, the hospital, the university, the community center, the theater, the church, the design center, the school, and the modern home: "Therefore it is time not to dream of the future but to realize that future as now and here. It is time to go to work with it, no longer foolishly trying to stand up against it for an eleventh hour retrenchment."[39]

Architecture and Modern Life was a book coauthored by Frank Lloyd Wright and Baker Brownell and published in 1937. While some of the chapters were cowritten, the chapters "Some Aspects of the Past and Present of Architecture" and "Some Aspects of the Future of Architecture" are solely by Wright. The former, a discussion of the historical structures of architecture is almost unrivaled in beauty of language and insight. (The latter, a discussion on the design and building of the Imperial Hotel in Tokyo, repeats much that can be found in his autobiography.) In the first he wrote:

Building upon the land is as natural to man as to other animals, birds or insects. In so far as he was more than an animal his buildings became what we call architecture.

In ancient times his limitations served to keep his buildings architecture. Splendid examples: Mayan, Egyptian, Greek, Byzantine, Persian, Gothic, Indian, Chinese, Japanese.

Looking back at these, what then is architecture?

It is man and more.

It is man in possession of his earth. It is the only true record of him where his possession of earth is concerned.

While he was true to earth his architecture was creative.[40]

Man takes a positive hand in creation whenever he puts a building upon the earth beneath the sun.[41]

. . . Perhaps architecture is man's most obvious realization of this persistent dream he calls immortality.[42]

Speaking of the various buildings built down the avenue of time, he wrote:

Let us now go nearer to the grand wreckage left by this tremendous energy poured forth by man in quest of his ideal, these various ruined cities and buildings built by the various races to survive the race. Let us go nearer to see how and why different races built the different buildings and what essential difference the buildings recorded.[43]

In all buildings that man has built out of earth and upon the earth, his spirit, the pattern of him, rose great or small. It lived in his buildings. It still shows there. But common to all these workmanlike endeavors in buildings

[38] Ibid., p. 93 [255-56].
[39] Ibid., p. 111 [274].
[40] Ibid., p. 222 [276].
[41] Ibid., p. 223 [277].
[42] Ibid., p. 226 [279].
[43] Ibid., p. 227 [280].

great or small, another spirit lived. Let us call this spirit, common to all buildings, the great spirit, architecture. . . . Any building is a by-product of eternal living force, a spiritual force taking form in time and place appropriate to man.[44]

The January 1938 issue of *The Architectural Forum* on Wright's work was a landmark publication. In 1937 the Johnson Building (formally the Administration Building for the S. C. Johnson & Son Company, Racine, Wisconsin) was still under construction and would not be complete until the spring of 1939. Nevertheless, it was clear that the structure would set a new standard for innovative American office design, and it piqued world interest. Both of the two prominent architectural magazines, *The Architectural Record* and *The Architectural Forum*, were anxious to publish it. *The Record* had historically been Wright's journal of choice, but the editorial direction had changed by 1937 and this new direction, favoring European modernism, did not please him. So, when *The Forum* approached him asking not only to publish the building, but that Wright compose the story, the architect chose to abandon his long allegiance to *The Record* in favor of their rival.

As Wright began making preparations for the publication, Howard Myers, the *Forum*'s editor, suggested that Fallingwater, the country home for Edgar J. Kaufmann, and the Herbert Jacobs and Paul Hanna houses should also be included in the issue with the intent of making it a monograph devoted to Wright's work. Other buildings and projects would be included, according to Wright's selection. He was given a free hand in the layout of the pages and the content of his own texts. Quotes from the writings of Henry David Thoreau and the poems of Walt Whitman were also incorporated into the design layout.

Many drawings were included and in his opening statement, Wright explains why: "I have always considered plans most essential in the presentation or consideration of any building. There is more beauty in a fine ground plan itself than in almost any of its consequences. So plot-plans and structural plans have been given due place in this issue as of first importance."[45]

The issue began with a long foldout plan of his home, Taliesin, along with accompanying photographs.

> . . . Taliesin is a natural building, in love with the ground, built of native limestone quarried nearby. Sand from the river below was the body of its plastered surfaces, plain wood slabs and marking strips of red cypress finish the edges, mark the ceilings, and make the doors and sash. . . .
>
> Perhaps this house should stand as a proper example of the sense of the ground in the category of sensitiveness mentioned in the foreword.
>
> It is also a good example of the use of materials and the play of space relations, the long stretches of low ceilings extending outside over and beyond the windows, related in direction to some feature of the landscape.[46]

Edgar Kaufmann's home Fallingwater was barely finished in time to be photographed for the issue. Although lacking interior furnishings, the exterior of the house was strikingly dramatic, and revealed Wright's first use of reinforced concrete in a residence: "For the first time in my practice, where residence work is concerned in recent years, reinforced concrete was actually needed to construct the cantilever system of this extension of the cliff beside a mountain

[44] Ibid., p. 231 [284].

[45] Ibid., p. 278 [292].

[46] Ibid., p. 278 [292–94].

stream, making living space over and above the stream upon several terraces upon which a man who loved the place sincerely, one who liked to listen to the waterfall, might well live."[47]

At the time that the *Forum* issue went to print, Wright's design for Herbert Johnson's country home Wingspread was under construction and was also included along with early construction photos, a plan, and perspective drawings.

> "Wingspread," the Herbert Johnson prairie house, now being built, is another experiment in the articulation which began with the Coonley House at Riverside, built 1909, wherein Living Room, Dining Room, Kitchen, Family sleeping rooms, Guest Rooms were each separate units grouped together and connected by corridor. . . .
>
> At the center of the four zones the spacious Living Room stands. A tall central chimneystack with five fireplaces divides this vertical space into spaces for the various domestic functions: Entrance Hall, Family Living Room, Library Living Room, and Dining Room. Extending from this lofty central room are four wings—three low and one with mezzanine. . . .
>
> This house, while resembling the Coonley House, is much more bold, masculine and direct in form and treatment—executed in more permanent materials.[48]

He also published the plan and perspective of the Arizona resort inn of 1927, San Marcos-in-the-Desert.

> Concrete block construction was on my mind at the time having just seen it through with Albert McArthur in the Arizona Biltmore. I used the surrounding giant growth, Sahuaro, as motive for the building . . . thus getting dotted lines throughout the construction. Here is another secret—the dotted line is outline in all desert creations. . . .
>
> . . . I have found that when a scheme develops beyond a normal pitch of excellence the hand of fate strikes it down. The Japanese made a superstition of the circumstance. Purposefully they leave some imperfection somewhere to appease the jealousy of the gods. I neglected the precaution. San Marcos was not built.
>
> In the vault at Taliesin is this completely developed set of plans, every block scheduled as to quantity and place. These plans are one of our prize possessions.[49]

The house for Dr. Paul Hanna of Stanford University had also recently been completed. The house still lacked furnishings and landscaping, but since the work introduced an innovative plan, using the hexagon as the basic unit, Wright and Myers elected to include it.

> . . . I am convinced that a cross-section of honeycomb has more fertility and flexibility where human movement is concerned than the square.
>
> . . . Glass? Yes, the modern house must use glass liberally. Otherwise this house is a simple wood house under a sheet of copper—thin as paper, enough material in the whole construction only to make it substantial. Not a pound to waste. It might be said of this building that it is a plywood house, plywood furnished.[50]

[47] Ibid., pp. 279–80 [300].
[48] Ibid., p. 282 [305–6].
[49] Ibid., p. 283 [308].
[50] Ibid., [308–9].

A substantial portion of text was devoted to the Herbert Jacobs house, which was the first constructed Usonian house. As Wright described it:

The house of moderate cost is not only America's major architectural problem but the problem most difficult for her major architects. As for me, I would rather solve it with satisfaction to myself and Usonia than build anything I can think of at the moment.[51]

I am certain that any approach to the new house needed by indigenous culture—why worry about the house wanted by provincial ignorance—is fundamentally different. That house must be a pattern for more simple and, at the same time, more gracious living: new, but suitable to living conditions as they might so well be in the country we live in today.[52]

These drawings represent a modest house that has no feeling at all for the "grand" except as the house extends itself parallel to the ground, companion to the horizon.
 . . . Withal, it seems a thing loving the ground with the new sense of space—light—and freedom to which our U.S.A. is entitled.[53]

The final building text was for the S. C. Johnson & Son Administration Building in Racine, Wisconsin. Still in construction in 1937–38, the building was illustrated with perspective drawings, plans, sections, and several construction photographs. Opening his text, Wright wrote:

Architectural interpretation of modern business at its best, this building is designed to be as inspiring a place to work in as any cathedral ever was in which to worship. . . . Main feature of construction is the simple repetition of hollow slender monolithic dendriform shafts or stems—stems standing on metal tips bedded at the floor level. The structure is light and plastic—reenforcing being mostly by steel mesh—welded. The structure is earthquake proof and fireproof, cold and sound proof. Weight, here by way of steel in tension, appears to float in light and air, the "column" taking on integral character as a plastic unit of a plastic building-construction instead of being a mere insert for support.[54]

Wright's comment about the building as an inspired place to work was a simple, meaningful, and humane statement. In the office building for the Larkin Company in 1903, photos of which accompanied this article, he was also concerned about the well-being of all who worked within the building. John Larkin, the client for the Larkin Building, and Herbert Johnson, the client for the Johnson building, shared this commitment—believing that a good, clean, well-lit, and harmonious workplace was an incentive to fine work; that respect for the place itself was an integral component of the daily work-life. The Larkin building was sadly demolished in 1950 in the guise of "progress." But the Johnson building goes on to this day to continually fulfill its role as originally conceived by its architect and carried to fruition by its client.

Wright concluded this monograph with: "We speak of genius as though it were the extrusion of some specialty or other. No, the quality is not there. Find genius and you will find a poet. What is a poet?"

In response to his own question, he turned to the words of Walt Whitman:

[51] Ibid., p. 284 [309].
[52] Ibid., p. 285 [310].
[53] Ibid., p. 287 [312].
[54] Ibid., [312–13].

If he is a poet he bestows on every object or quality its fit proportion—neither more nor less.
He is the arbiter of the diverse—the equalizer of his age and land.
He judges not as a judge judges, but as the sun falling round a helpless thing.

How America needs poets! God knows—she has enough profit takers, enough garage mechanics, enough journalists, enough teachers of only what has been taught, enough wage slaves. Without the poet—man of vision wherever he stands—the Soul of this people is a dead Soul. One must be insensible not to feel the chill creeping over ours. . . .

Having myself had the best and the worst of everything as preliminary to the ten years next to come, I hope none of those years will be wasted or thwarted where architecture, in what remains to us all of life, is concerned.[55]

The Natural House, a book about house construction, was inspired by a request from Wright's publisher, Ben Raeburn of Horizon Press, and evolved from Wright's responses to a series of questions his wife distributed to the Taliesin Fellowship as part of a traditional Sunday morning talk. However, he opened the book with passages from his autobiography that described his early residential work.

An idea [I had] (probably rooted deep in racial instinct) that *shelter* should be the essential look of any dwelling, put the low spreading roof, flat or hipped or low gabled, with generously projecting eaves over the whole. I began to see a building primarily not as a cave but as a broad shelter in the open, related to vista; vista without and vista within.[56]

Plasticity may be seen in the expressive flesh-covering of the skeleton as contrasted with the articulation of the skeleton itself.[57]

Proceeding, then, step by step from generals to particulars, plasticity as a large means in architecture began to grip me and to work its own will. Fascinated I would watch its sequences already in evidence: as in the Heurtley, Martin, Heath, Thomas, Coonley and dozens of other houses.

The old architecture, so far as its grammar went, for me began literally, to disappear.[58]

Digressing for a moment, there followed in his text a description of the deeper meaning of organic architecture:

If you will yet be patient for a little while—a scientist, Einstein, asked for three days to explain the far less pressing and practical matter of "Relativity"—we will take each of the five new resources in order, as with the five fingers of the hand. All are new integrities to be used if we will to make living easier and better today.

The first great integrity is a deeper, more intimate sense of reality in building than was ever pagan—that is to say, than was ever "Classic." More human than was any building ever realized in the Christian Middle Ages.[59]

The second of the five resources he listed as glass: "By means of glass, then, the first great integrity may find prime means of realization. Open reaches of

[55] Ibid., p. 290 [315].

[56] *Frank Lloyd Wright Collected Writings Volume 5*, p. 79 [320].

[57] Ibid., p. 92 [330].

[58] Ibid., p. 93 [331].

[59] Ibid., p. 94 [331–32].

the ground may enter as the building and the building interior may reach out to associate with these vistas of the ground."[60]

The third resource is somewhat more complicated to explain. He called it "the principle of continuity. . . . Steel is its prophet and master."[61] His explanation deals with the old concept of the post and beam.

> Of course this primitive post-and-beam construction will always be valid, but both support and supported may now by means of inserted and welded steel strands or especially woven filaments of steel and modern concrete castings be plaited and united as one physical body: ceilings and walls made one with floors and reinforcing each other by making them continue into one another. This Continuity is made possible by the tenuity of steel.[62]

> [The] potent fourth new resource—the Nature of Materials—gets at the common center of every material in relation to the work it is required to do. This means that the architect must again begin at the very beginning. Proceeding according to Nature now he must sensibly go through with whatever material may be at hand for this purpose according to the methods and sensibilities of a man in this age.[63]

> At last, is this fifth resource, so old yet now demanding fresh significance. We have arrived at integral ornament—the nature-pattern of actual construction.[64]

> What I am here calling integral ornament is founded upon the same organic simplicities as Beethoven's Fifth Symphony, that amazing revolution in tumult and splendor of sound built on four tones based upon a rhythm a child could play on the piano with one finger. Supreme imagination reared the four repeated tones, simple rhythms, into a great symphonic poem that is probably the noblest thought-built edifice in our world.[65]

At this point in his text, Wright finally arrived at "The Usonian House I." Here he included, in its entirety, his writings about the Herbert Jacobs house in Madison, Wisconsin, first published in the 1938 *Forum*. Since the *Critical Writings* includes *The Natural House*, it seemed prudent to include it exactly as Wright had written it.

Concluding the section on the Usonian I house, he wrote: "In designing the Usonian house, as I have said, I have always proportioned it to the human figure in point of scale; that is, to the scale of the human figure to occupy it. . . . The Usonian house, then, aims to be a *natural* performance, one that is integral to the site; integral to the environment; integral to the life of the inhabitants."[66]

A substantial section of the book contains the answers to the questions that he was asked in the Sunday morning talk to his apprentices. The responding remarks were edited and then grouped together under numerous headings. In the chapter entitled "The 'Usonian Automatic,'" he described a new system of construction that he was creating at the time this book was written. Realizing that the building system he first employed after the Depression in the Usonian houses was no longer cost-effective—labor costs had risen so—he then sought to create another system for the moderate-cost residence. He turned once more to the use of concrete block, as he had years earlier in California. But this time the blocks were substantially simpler.

[60] Ibid., [332].
[61] Ibid., p. 95 [333].
[62] Ibid., p. 96 [334].
[63] Ibid., p. 99 [336].
[64] Ibid., p. 100 [337].
[65] Ibid., p. 101 [338].
[66] Ibid., p. 112 [339–40].

. . . To build a low cost house you must eliminate, so far as possible, the use of skilled labor, now so expensive. The Usonian Automatic house therefore is built of shells made up of pre-cast concrete blocks about 1'o" × 2'o" or larger and so designed that, grooved as they are on the edges, they can be made and also set up with small steel horizontal and vertical reinforcing rods in the joints, by the owners themselves, each course being grouted (poured) as it is laid upon the one beneath; the rods meantime projecting above for the next course.[67]

"How the 'Usonian Automatic' Is Built" contained further instructions as to the method for building the house, the various types of blocks required, including the construction of the ceiling and roof, and installation of tract lighting systems, and furnishings. "Here then, within moderate means for the free man of our democracy, with some intelligence and by his own energy, comes a natural house designed in accordance with the principles of organic architecture."[68]

The following chapter, "Organic Architecture and the Orient," described his work on the Imperial Hotel in Tokyo. Why this digression from the central theme of the book remains enigmatic. His final chapter, "The Philosophy and the Deed," digresses even further, but contains an interesting "confession":

> Many people have wondered about an Oriental quality they see in my work. I suppose it is true that when we speak of organic architecture, we are speaking of something that is more Oriental than Western. The answer is: my work *is*, in that deeper philosophical sense, Oriental.[69]

> It cannot truthfully be said, however, that organic architecture was derived from the Orient. We have our own way of putting these elemental (so ancient) ideals into practical effect. . . . The idea of organic architecture that the reality of the building lies in the space within to be lived in, the feeling that we must not enclose ourselves in an envelope which is the building, is not alone Oriental. Democracy, proclaiming the integrity of the individual *per se*, had the feeling if not the words.[70]

Letters in the Frank Lloyd Wright Archives reveal that Wright was working on a manuscript entitled *A Testament* as early as 1955, although the work was not completed and published until two years later. Of all his books, it has the broadest scope of topics, ranging from his beliefs, ideas, and principles to a vivid account of his childhood years, the years with Adler and Sullivan, and the beginning of his own architectural practice. By the time the book was finished he was ninety years old, and its very title suggests a final accounting of his life and his work.

The book is divided into two sections. In Book One he reflects on his early years:

> Mother was a great teacher who loved teaching; Father a preacher who loved and taught music. He taught me to see a great symphony as a master's *edifice of sound*. Mother learned that Friedrich Froebel taught that children should not be allowed to draw from casual appearances of Nature until they had first mastered the basic forms lying hidden behind appearances. Cosmic, geometric elements were what should first be made visible to the child-mind.

[67] Ibid., p. 123 [360].
[68] Ibid., p. 124 [361].
[69] Ibid., p. 126 [362–63].
[70] Ibid., p. 127 [363].

. . . for several years I sat at the little kindergarten table-top ruled by lines about four inches apart each way making four-inch squares; and, among other things, played upon these "unit-lines" with the square (cube), the circle (sphere) and the triangle (tetrahedron or tripod)—these were smooth maple-wood blocks. Scarlet cardboard triangle (60°–30°) two inches on the short side, and one side white, were smooth triangular sections with which to come by pattern—design—by my own imagination. . . .

The virtue of all this lay in the awakening of the child-mind to rhythmic structure in Nature—giving the child a sense of innate cause-and-effect otherwise beyond child-comprehension. I soon became susceptible to constructive pattern *evolving in everything I saw*. I learned to "see" this way and when I did, I did not care to draw causal incidentals of Nature. I wanted to *design*.[71]

Let us look back. I remember how as a boy, primitive American architecture—Toltec, Aztec, Mayan, Inca—stirred my wonder, excited my wishful admiration. I wished I might someday have money enough to go to Mexico, Guatemala and Peru to join in excavating those long slumbering remains of lost cultures; mighty, primitive abstractions of man's nature—ancient arts of the Mayan, the Inca, the Toltec. . . . A grandeur arose in the scale of total building never since excelled, seldom equalled by man either in truth of plan or simple primitive integrity of form. Architecture intrinsic to Time, Place and Man.[72]

To cut ambiguity short: there never was exterior influence upon my work, either foreign or native, other than that of Lieber Meister, Dankmar Adler and John Roebling, Whitman and Emerson, and the great poets worldwide. My work is original not only in fact but in spiritual fiber. No practice by any European architect to this day has influenced mine in the least.

As for the Incas, the Mayas, even the Japanese—all were to me but splendid confirmation. . . .

As for inspiration from human nature, there were Laotze, Jesus, Dante, Beethoven, Bach, Vivaldi, Palestrina, Mozart. Shakespeare was in my pocket for the many years I rode the morning train to Chicago. I learned, too, from William Blake (all of his work I read), Goethe, Wordsworth, Dr. Johnson, Carlyle (*Sartor Resartus* at the age of fourteen), George Meredith, Victor Hugo, Voltaire, Rousseau, Cervantes, Nietzsche, Unamuno, Heraclitus, Aristotle, Aristophanes.[73]

After describing many of the elements and events that constituted his early life in architecture, he then proceeded to Book Two, "The New Architecture." In Part One he defined its principles:

At last we come to the analysis of the principles that became so solidly basic to my sense and practice of architecture. How do these principles, now beginning to be recognized as the centerline of American democracy, work?

Principle one: kinship of building to ground. This basic inevitability in organic architecture entails an entirely new sense of proportion. The human figure appeared to me, about 1893 or earlier, as the true *human* scale

[71] Ibid., p. 159 [368].

[72] Ibid., pp. 190–91 [398–99].

[73] Ibid., p. 211 [424–25].

of architecture. Buildings I myself then designed and built—Midwest—seemed, by means of this new scale, to belong to man and at the moment especially as he lived on rolling Western prairie.[74]

Principle two: decentralization. The time more for individual spaciousness was long past due. 1893. I saw urban decentralization as inevitable because a growing necessity, seeking more space everywhere, by whatever steps or stages it was obtainable. Space, short of breath, was suffocating in an airless situation, a shameful imposition upon free American life. . . .

To offset the senselessness of this inhuman act, I prepared the Broadacre City models at Taliesin in 1934.[75]

The third principle he somewhat awkwardly titled "Character is a Natural": "Appropriate 'character' is inevitable to all architecture if organic. . . . This means sane appropriation of imaginative design to specific human purposes, by the natural use of nature-materials or synthetics, and appropriate methods of construction."[76]

The fourth principle he identified as "Tenuity Plus Continuity": "Tenuity is simply a matter of tension (pull), something never before known in the architecture of this world. . . . Push it you might and it would stay together but pull on it and it would fall apart. With tensile strength of steel, this pull permits free use of the cantilever, a projectile and tensile at the same time, in building-design. The outstretched arm with its hand (with its drooping fingers for walls) is a cantilever. So is the branch of a tree.[77]

For the fifth principle, he wrote: "To sum up, organic architecture sees the third dimension never as weight or mere thickness but always as *depth*. Depth an element of space; the third (or thickness) dimension transformed to a *space* dimension."[78]

He elaborated further also on the concepts of space, form, shelter, materials, and style, as well as discussing the client and the concept of ownership. He concluded the first book of *A Testament* with this: "Meanwhile we continue to hope that the Comic Spirit in which we as a people do excel may survive long enough to salt and savor life among us long enough for our civilization to present us to the world as a culture, not merely as an amazing civilization."[79]

There followed a short section titled "Part Two: Humanity—The Light of the World":

Constantly I have referred to a more "humane" architecture, so I will try to explain what *humane* means to me, as an architect. Like organic architecture, the quality of humanity is *interior* to man. As the solar system is reckoned in terms of light-years, so may the inner light be what we are calling humanity. . . .

There is nothing higher in human consciousness than beams of this interior light. We call them beauty. . . . From the cradle to the grave his true being craves this reality to assure the continuation of life as Light thereafter.[80]

Although extremely short, Part Two of Book Two carries an intensely spiritual message. It seems fitting that the closing words of Wright's personal testa-

[74] Ibid., p. 214 [427].

[75] Ibid., p. 215 [427–28].

[76] Ibid., p. 216 [429].

[77] Ibid. [429].

[78] Ibid., p. 218 [430].

[79] Ibid., p. 224 [438].

[80] Ibid., pp. 224–25 [438].

ment portray him as an individual of devout convictions. We perceive him here as not just a creative architect but as a man of profound faith.

> There is no more precious element of immortality than mankind as thus humane. Heaven may be the symbol of this light of lights only insofar as heaven is thus a haven.
>
> Mankind has various names for this interior light, "the soul" for instance. To be truly *humane* is divinity in the only sense conceivable. There can be no such thing as absolute death or utter evil—all being from light in some form. In any last analysis there is no evil because shadow itself is of the light.[81]

As his writings clearly demonstrate from first to last, Frank Lloyd Wright's concern about architecture went beyond mere buildings set on the earth beneath the sun. Rather he perceived architecture as the frame of life, as the beneficent factor making life beautiful and meaningful. "Beautiful buildings are more than scientific. They are true organisms, spiritually conceived."[82]

Bruce Brooks Pfeiffer, Director of Archives
The Frank Lloyd Wright Foundation
Taliesin West
Scottsdale, Arizona
August 2006

[81] Ibid., p. 225 [438].
[82] Ibid., p. 172 [383].

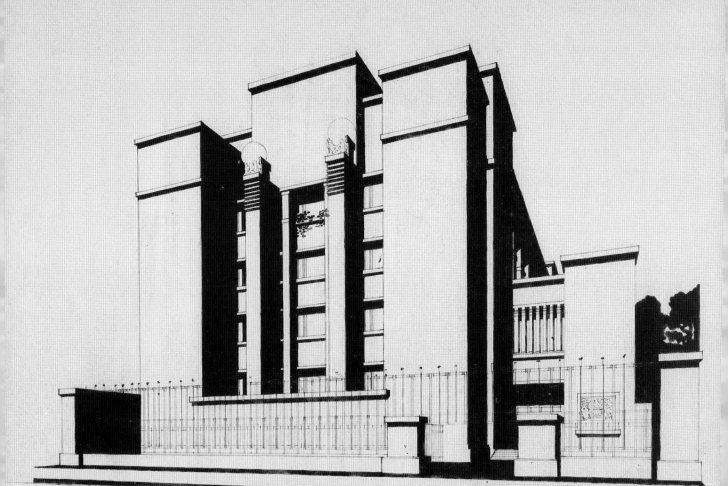
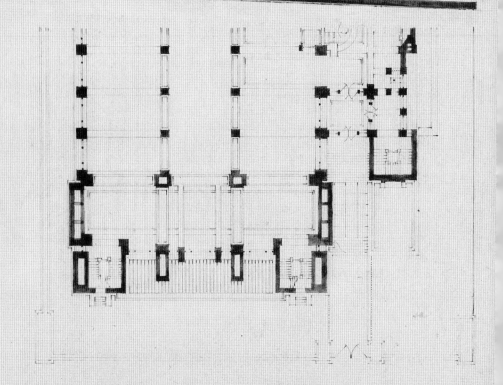

Larkin Company Administration Building,
Buffalo, New York. 1903
FLLW Fdn# 0403.003

The Art and Craft of the Machine

1901

As we work along our various ways, there takes shape within us, in some sort, an ideal—something we are to become—some work to be done. This, I think, is denied to very few, and we begin really to live only when the thrill of this ideality moves us in what we will to accomplish. In the years which have been devoted in my own life to working out in stubborn materials a feeling for the beautiful, in the vortex of distorted complex conditions, a hope has grown stronger with the experience of each year, amounting now to a gradually deepening conviction that in the machine lies the only future of art and craft—as I believe, a glorious future; that the machine is, in fact, the metamorphosis of ancient art and craft; that we are at last face to face with the machine—the modern Sphinx—whose riddle the artist must solve if he would that art live—for his nature holds the key. For one, I promise "whatever gods may be"[1] to lend such energy and purpose as I may possess to help make that meaning plain; to return again and again to the task whenever and wherever need be; for this plain duty is thus relentlessly marked out for the artist in this, the Machine Age, although there is involved an adjustment to cherished gods, perplexing and painful in the extreme the fire of many long-honored ideals shall go down to ashes to reappear, phoenix-like, with new purposes.

The great ethics of the machine are as yet, in the main, beyond the ken of the artist or student of sociology; but the artist mind may now approach the nature of this thing from experience, which has become the commonplace of his field, to suggest, in time, I hope, to prove, that the machine is capable of carrying to fruition high ideals in art—higher than the world has yet seen!

Disciples of William Morris cling to an opposite view. Yet William Morris himself deeply sensed the danger to art of the transforming force whose sign and symbol is the machine, and though of the new art we eagerly seek he sometimes despaired, he quickly renewed his hope.

He plainly foresaw that a blank in the fine arts would follow the inevitable abuse of new-found power and threw himself body and soul into the work of bridging it over by bringing into our lives afresh the beauty of art as she had been, that the new art to come might not have dropped too many stitches nor have unraveled what would still be useful to her.

That he had abundant faith in the new art his every essay will testify.

That he miscalculated the machine does not matter. He did sublime work for it when he pleaded so well for the process of elimination its abuse had made necessary, when he fought the innate vulgarity of theocratic impulse in art as opposed to democratic, and when he preached the gospel of simplicity.

All artists love and honor William Morris.

He did the best in his time for art and will live in history as the great socialist, together with Ruskin the great moralist: significant fact worth thinking about, that the two great reformers of modern times professed the artist.

The machine these reformers protested, because the sort of luxury which is born of greed had usurped it and made of it a terrible engine of enslavement, deluging the civilized world with a murderous ubiquity, which plainly enough was the damnation of their art and craft.

It had not then advanced to the point which now so plainly indicates that it will surely and swiftly, by

its own momentum, undo the mischief it has made, and the usurping vulgarians as well.

Nor was it so grown as to become apparent to William Morris, the grand democrat, that the machine was the great forerunner of Democracy.

The ground plan of this thing is now grown to the point where the artist must take it up no longer as a protest: genius must progressively dominate the work of the contrivance it has created; to lend a useful hand in building afresh the "Fairness of the Earth."

That the Machine has dealt Art in the grand old sense a death blow, none will deny.

The evidence is too substantial.

Art in the grand old sense—meaning Art in the sense of structural tradition, whose craft is fashioned upon the handicraft ideal, ancient or modern; an art wherein this form and that form as structural parts were laboriously joined in such a way as to beautifully emphasize the manner of the joining: the million and one ways of beautifully satisfying bare structural necessities, which have come down to us chiefly through the books as "Art."

For the purpose of suggesting hastily and therefore crudely wherein the machine has sapped the vitality of this art, let us assume Architecture in the old sense as a fitting representative of Traditional art and Printing as a fitting representation of the Machine.

What printing—the machine—has done for architecture—the fine art—will have been done in measure of time for all art immediately fashioned upon the early handicraft ideal.

With a masterful hand, Victor Hugo, a noble lover and a great student of architecture, traces her fall in *Notre-Dame*.

The prophecy of Frollo, that "the book will kill the edifice," I remember was to me as a boy one of the grandest sad things of the world.

After seeking the origin and tracing the growth of architecture in superb fashion, showing how in the Middle Ages all the intellectual forces of the people converged to one point—architecture—he shows how, in the life of that time, "whoever was born poet became an architect. All other arts simply obeyed and placed themselves under the discipline of architecture. They were the workmen of the great work. The architect, the poet, the master summed up in his person the sculpture that carved his façades, painting which illuminated his walls and windows, music which set his bells to pealing and breathed into his organs"—there was nothing which was not forced in order to make something of itself in that time, to come and frame itself in the edifice.

Thus, down to the time of Gutenberg, architecture is the principal writing—the universal writing of humanity.[2]

In the great granite books begun by the Orient, continued by Greek and Roman antiquity, the Middle Ages wrote the last page.

So to enunciate here only summarily a process, it would require volumes to develop; down to the fifteenth century the chief register of humanity is architecture.

In the fifteenth century everything changes.

Human thought discovers a mode of perpetuating itself, not only more resisting than architecture, but still more simple and easy.

Architecture is dethroned.

Gutenberg's letters of lead are about to supersede Orpheus' letters of stone.

The book is about to kill the edifice.

The invention of printing was the greatest event in history.

It was the first great machine, after the great city.

It is human thought stripping off one form and donning another.

Printed, thought is more imperishable than ever—it is volatile, indestructible.

As architecture it was solid; it is now alive; it passes from duration in point of time to immortality.

Cut the primitive bed of a river abruptly, with a canal hollowed out beneath its level, and the river will desert its bed.

See how architecture now withers away, how little by little it becomes lifeless and bare. How one feels the water sinking, the sap departing, the thought of the times and people withdrawing from it. The chill is almost imperceptible in the fifteenth century, the press is yet weak, and at most draws from architecture a superabundance of life, but with the beginning of the sixteenth century, the malady of architecture is visible. It becomes classic art in a miserable manner; from being indigenous, it becomes Greek and Roman; from being true and modern, it becomes pseudo-classic.

It is this decadence which we call the Renaissance.

It is the setting sun which we mistake for dawn.

It has now no power to hold the other arts; so they emancipate themselves, break the yoke of the architect, and take themselves off, each in its own direction.

One would liken it to an empire dismembered at the death of its Alexander, and whose provinces become kingdoms.

Sculpture becomes statuary, the image trade becomes painting, the canon becomes music. Hence Raphael, Angelo, and those splendors of the dazzling sixteenth century.

Nevertheless, when the sun of the Middle Ages is completely set, architecture grows dim, becomes more and more effaced. The printed book, the gnawing worm of the edifice, sucks and devours it. It is petty, it is poor, it is nothing.

Reduced to itself, abandoned by other arts because human thought is abandoning it, it summons bunglers in place of artists. It is miserably perishing.

Meanwhile, what becomes of printing?

All the life, leaving architecture, comes to it. In proportion as architecture ebbs and flows, printing swells and grows. That capital of forces which human thought had been expending in building is hereafter to be expended in books; and architecture, as it was, is dead, irretrievably slain by the printed book; slain because it endures for a shorter time; slain because human thought has found a more simple medium of expression, which costs less in human effort; because human thought has been rendered volatile and indestructible, reaching uniformly and irresistibly the four corners of the earth and for all.

Thenceforth, if architecture rise again, reconstruct, as Hugo prophesies she may begin to do in the latter days of the nineteenth century, she will no longer be mistress, she will be one of the arts, never again *the* art; and printing—the Machine—remains "the second Tower of Babel of the human race."

So the organic process, of which the majestic decline of Architecture is only one case in point, has steadily gone on down to the present time, and still goes on, weakening of the hold of the artist upon the people, drawing off from his rank poets and scientists until architecture is but a little, poor knowledge of archeology, and the average of art is reduced to the gasping poverty of imitative realism; until the whole letter of Tradition, the vast fabric of precedent, in the flesh, which has increasingly confused the art ideal while the machine has been growing to power, is a beautiful corpse from which the spirit has flown. The spirit that has flown is the spirit of the new art, but has failed the modern artist, for he has lost it for hundreds of years in his lust for the *letter*, the beautiful body of art made too available by the machine.

So the Artist craft wanes.

Craft that will not see that "human thought is stripping off one form and donning another," and artists are everywhere, whether catering to the leisure class of old England or ground beneath the heel of commercial abuse here in the great West, the unwilling symptoms of the inevitable, organic nature of the machine, they combat, the hell-smoke of the factories they scorn to understand.

And, invincible, triumphant, the machine goes on, gathering force and knitting the material necessities of mankind ever closer into a universal automatic fabric; the engine, the motor, and the battleship, the works of art of the century!

The Machine is Intellect mastering the drudgery of earth that the plastic art may live; that the margin of leisure and strength by which man's life upon the earth can be made beautiful, may immeasurably widen; its function ultimately to emancipate human expression!

It is a universal educator, surely raising the level of human intelligence, so carrying within itself the power to destroy, by its own momentum, the greed which in Morris' time and still in our own time turns it to a deadly engine of enslavement. The only comfort left the poor artist, sidetracked as he is, seemingly is a mean one; the thought that the very selfishness which man's early art idealized, now reduced to its lowest terms, is swiftly and surely destroying itself through the medium of the Machine.

The artist's present plight is a sad one, but may he truthfully say that society is less well off because Architecture, or even Art, as it was, is dead, and printing, or the Machine, lives?

Every age has done its work, produced its art with the best tools or contrivances it knew, the tools most successful in saving the most precious thing

in the world—human effort. Greece used the chattel slave as the essential tool of its art and civilization. This tool we have discarded, and we would refuse the return of Greek art upon the terms of its restoration, because we insist now upon a basis of Democracy.

Is it not more likely that the medium of artistic expression itself has broadened and changed until a new definition and new direction must be given the art-activity of the future, and that the Machine has finally made for the artist, whether he will yet own it or not, a splendid distinction between the Art of old and the Art to come? A distinction made by the tool which frees human labor, lengthens and broadens the life of the simplest man, thereby the basis of the Democracy upon which we insist.

To shed some light upon this distinction, let us take an instance in the field naturally ripened first by the machine—the commercial field.

The tall modern office building is the machine pure and simple.

We may here sense an advanced stage of a condition surely entering all art for all time; its already triumphant glare in the deadly struggle taking place here between the machine and the art of structural tradition reveals "art" torn and hung upon the steel frame of commerce, a forlorn head upon a pike, a solemn warning to architects and artists the world over.

We must walk blindfolded not to see that all that this magnificent resource of machine and material has brought us so far is a complete, broadcast degradation of every type and form sacred to the art of old; a pandemonium of tin masks, huddled deformities, and decayed methods; quarreling, lying, and cheating, with hands at each other's throats—or in each other's pockets; and none of the people who do these things, who pay for them or use them, know what they mean, feeling only—when they feel at all—that what is most truly like the past is the safest and therefore the best; as typical Marshall Field,[3] speaking of his new building, has frankly said: "A good copy is the best we can do."

A pitiful insult, art and craft!

With this mine of industrial wealth at our feet we have no power to use it except to the perversion of our natural resources? A confession of shame which the merciful ignorance of the yet material frame of things mistakes for glorious achievement.

We half believe in our artistic greatness ourselves when we toss up a pantheon to the god of money in a night or two, or pile up a mammoth aggregation of Roman monuments, sarcophagi, and Greek temples for a post office in a year or two—the patient retinue of the machine pitching in with terrible effectiveness to consummate this unhallowed ambition—this insult to ancient gods. The delicate, impressionable facilities of terra-cotta becoming imitative blocks and voussoirs of tool-marked stone, badgered into all manner of structural gymnastics, or else ignored in vain endeavor to be honest; and granite blocks, cut in the fashion of the followers of Phidias, cunningly arranged about the steel beams and shafts, to look "real"—leaning heavily upon an inner skeleton of steel for support from floor to floor, which strains beneath the "reality" and would fain, I think, lie down to die of shame.

The "masters"—ergo, the fashionable followers of Phidias—have been trying to make this wily skeleton of steel seem seventeen sorts of "architecture" at once, when all the world knows—except the "masters"—that it is not one of them.

See now, how an element—the vanguard of the new art—has entered here, which the structural-art equation cannot satisfy without downright lying and ignoble cheating.

This element is the structural necessity reduced to a skeleton, complete in itself without the craftsman's touch. At once the million and one little ways of satisfying this necessity beautifully, coming to us chiefly through the books as the traditional art of building, vanish away—become history.

The artist is emancipated to work his will with a rational freedom unknown to the laborious art of structural tradition—no longer tied to the meagre unit of brick arch and stone lintel, nor hampered by the grammatical phrase of their making—but he cannot use his freedom.

His tradition cannot think.

He will not think.

His scientific brother has put it to him before he is ready.

The modern tall office-building problem is one representative problem of the machine. The only rational solutions it has received in the world may be counted upon the fingers of one hand. The fact that a great portion of our "architects" and "artists" are shocked by them to the point of offense is as valid

an objection as that of a child refusing wholesome food because his stomach becomes dyspeptic from over-much unwholesome pastry—albeit he be the cook himself.

We may object to the mannerism of these buildings, but we take no exception to their manner nor hide from their evident truth.

The steel frame has been recognized as a legitimate basis for simple, sincere clothing of plastic material that idealizes its purpose without structural pretense.

This principle has at last been recognized in architecture, and though the masters refuse to accept it as architecture at all it is a glimmer in a darkened field—the first sane word that's been said in Art for the Machine.

The Art of old idealized a Structural Necessity—now rendered obsolete and unnatural by the Machine—and accomplished it through man's joy in the labor of his hands.

The new will weave for the necessities of mankind, which his Machine will have mastered, a robe of ideality no less truthful but more poetical, with a rational freedom made possible by the machine, beside which the art of old will be as the sweet plaintive wail of the pipe to the outpouring of full orchestra.

It will clothe Necessity with the living flesh of virile imagination, as the living flesh lends living grace to the hard and bony human skeleton.

The new will pass from the possession of kings and classes to the everyday lives of all—from duration in point of time to immortality.

This distinction is one to be felt now rather than clearly defined.

The definition is the poetry of this Machine Age, and will be written large in time; but the more we, as artists, examine into this premonition, the more we will find the utter helplessness of old forms to satisfy new conditions, and the crying need of the machine for plastic treatment—a pliant, sympathetic treatment of its needs that the body of structural precedent cannot yield.

To gain further suggestive evidence of this, let us turn to the Decorative Arts—the immense middle ground of all art now mortally sickened by the Machine—sickened that it may slough the art ideal of the constructural art for the plasticity of the new art—the Art of Democracy.

Here we find the most deadly perversion of all—the magnificent prowess of the machine bombarding the civilized world with the mangled corpses of strenuous horrors that once stood for cultivated luxury—standing now for a species of fatty degeneration simply vulgar.

Without regard to first principles or common decency, the whole letter of tradition—that is, ways of doing things rendered wholly obsolete and unnatural by the machine—is recklessly fed into its rapacious maw until you may buy reproductions for ninety-nine cents at "The Fair" that originally cost ages of toil and cultivation, worth now intrinsically nothing—that are harmful parasites befogging the sensibilities of our natures, belittling and falsifying any true perception of normal beauty the Creator may have seen fit to implant in us.

The idea of fitness to purpose, harmony between form, and use with regard to any of these things, is possessed by very few, and utilized by them as a protest chiefly—a protest against the machine!

As well blame Richard Croker[4] for the political iniquity of America.

As "Croker is the creature and not the creator" of political evil, so the machine is the creature and not the creator of this iniquity; and with this difference—that the machine has noble possibilities unwillingly forced to degradation in the name of the artistic; the machine, as far as its artistic capacity is concerned, is itself the crazed victim of the artist who works while he waits, and the artist who waits while he works.

There is a nice distinction between the two.

Neither class will unlock the secrets of the beauty of this time.

They are clinging sadly to the old order and would wheedle the giant frame of things back to its childhood or forward to its second childhood, while this Machine Age is suffering for the artist who accepts, works, and sings as he works, with the joy of the *here* and *now!*

We want the man who eagerly seeks and finds, or blames himself if he fails to find, the beauty of this time; who distinctly accepts as a singer and a prophet; for no man may work while he waits or wait as he works in the sense that William Morris' great work was legitimately done—in the sense that most art and craft of today is an echo; the time when such work was useful has gone.

Echoes are by nature decadent.

Artists who feel toward Modernity and the Machine now as William Morris and Ruskin were justified in feeling then, had best distinctly wait and work sociologically where great work may still be done by them. In the field of art activity they will do distinct harm. Already they have wrought much miserable mischief.

If the artist will only open his eyes he will see that the machine he dreads has made it possible to wipe out the mass of meaningless torture to which mankind, in the name of the artistic, has been more or less subjected since time began; for that matter, has made possible a cleanly strength, an ideality and a poetic fire that the art of the world has not yet seen; for the machine, the process now smooths away the necessity of petty structural deceits, soothes this wearisome struggle to make things seem what they are not, and can never be; satisfies the simple term of the modern art equation as the ball of clay in the sculptor's hand yields to his desire—comforting forever this realistic, brain-sick masquerade we are wont to suppose art.

William Morris pleaded well for simplicity as the basis of all the art. Let us understand the significance to art of that word—SIMPLICITY—for it is vital to the Art of the Machine.

We may find, in place of the genuine thing we have striven for, an affectation of the naive, which we should detest as we detest a full-grown woman with baby mannerisms.

English art is saturated with it, from the brand-new imitation of the old house that grew and rambled from period to period to the rain-tub standing beneath the eaves.

In fact, most simplicity following the doctrines of William Morris is a protest; as a protest, well enough, but the highest form of simplicity is not simple in the sense that the infant intelligence is simple—nor, for that matter, the side of a barn.

A natural revulsion of feeling leads us from the meaningless elaboration of today to lay too great stress on mere platitudes, quite as a clean sheet of paper is a relief after looking at a series of bad drawings—but simplicity is not merely a neutral or a negative quality.

Simplicity in art, rightly understood, is a synthetic, positive quality, in which we may see evidence of mind, breadth of scheme, wealth of detail,

and withal a sense of completeness found in a tree or a flower. A work may have the delicacies of a rare orchid or the stanch fortitude of the oak, and still be simple. A thing to be simple needs only to be true to itself in organic sense.

With this ideal of simplicity, let us glance hastily at a few instances of the machine and see how it has been forced by false ideals to do violence to this simplicity; how it has made possible the highest simplicity, rightly understood and so used. As perhaps wood is most available of all homely materials and therefore, naturally, the most abused—let us glance at wood.

Machinery has been invented for no other purpose than to imitate, as closely as possible, the wood carving of the early ideal—with the immediate result that no ninety-nine-cent piece of furniture is salable without some horrible botchwork meaning nothing unless it means that art and craft have combined to fix in the mind of the masses the old hand-carved chair as the *ne plus ultra* of the ideal.

The miserable, lumpy tribute to this perversion which Grand Rapids alone yields would mar the face of art beyond repair; to say nothing of the elaborate and fussy joinery of posts, spindles, jigsawed beams and braces, butted and strutted, to outdo the sentimentality of the already overwrought antique product.

Thus is the woodworking industry glutted, except in rarest instances. The whole sentiment of early craft degenerated to a sentimentality having no longer decent significance nor commercial integrity; in fact all that is fussy, maudlin, and animal, basing its existence chiefly on vanity and ignorance.

Now let us learn from the Machine.

It teaches us that the beauty of wood lies first in its qualities as wood; no treatment that did not bring out these qualities all the time could be plastic, and therefore not appropriate—so not beautiful, the Machine teaches us, if we have left it to the machine that certain simple forms and handling are suitable to bring out the beauty of wood and certain forms are not; that all wood carving is apt to be a forcing of the material, an insult to its finer possibilities as a material having in itself intrinsically artistic properties, of which its beautiful markings is one, its texture another, its color a third.

The machine, by its wonderful cutting, shaping, smoothing, and repetitive capacity, has made

it possible to so use it without waste that the poor as well as the rich may enjoy today beautiful surface treatments of clean, strong forms that the branch veneers of Sheraton and Chippendale only hinted at, with dire extravagance, and which the Middle Ages utterly ignored.

The machine has emancipated these beauties of nature in wood; made it possible to wipe out the mass of meaningless torture to which wood has been subjected since the world began, for it has been universally abused and maltreated by all peoples but the Japanese.

Rightly appreciated, is not this the very process of elimination for which Morris pleaded?

Not alone a protest, moreover, for the machine, considered only technically, if you please, has placed in artist hands the means of idealizing the true nature of wood harmoniously with man's spiritual and material needs, without waste, within reach of all.

And how fares the troop of old materials galvanized into new life by the Machine?

Our modern materials are these old materials in more plastic guise, rendered so by the Machine, itself creating the very quality needed in material to satisfy its own art equation.

We have seen in glancing at modern architecture how they fare at the hands of Art and Craft; divided and subdivided in orderly sequence with rank and file of obedient retainers awaiting the master's behest.

Steel and iron, plastic cement, and terra-cotta.

Who can sound the possibilities of this old material, burned clay, which the modern machine has rendered as sensitive to the creative brain as a dry plate to the lens—a marvelous simplifier? And this plastic covering material, cement, another simplifier, enabling the artist to clothe the structural frame with a simple, modestly beautiful robe where before he dragged in, as he does still drag, five different kinds of material to compose one little cottage, pettily arranging it in an aggregation supposed to be picturesque—as a matter of fact, millinery, to be warped and beaten by sun, wind, and rain into a variegated heap of trash.

There is the process of modern casting in metal—one of the perfected modern machines, capable of any form to which fluid will flow, to perpetuate the imagery of the most delicately poetic mind without let or hindrance—within reach of everyone, therefore insulted and outraged by the bungler forcing it to a degraded seat at his degenerate festival.

Multitudes of processes are expectantly awaiting the sympathetic interpretation of the mastermind; the galvano-plastic and its electrical brethren, a prolific horde, now cheap fakirs imitating real bronzes and all manner of the antique, secretly damning it in their vitals.

Electro-glazing, a machine shunned because too cleanly and delicate for the clumsy hand of the traditional designer, who depends upon the mass and blur of leading to conceal his lack of touch.

That delicate thing, the lithograph—the prince of a whole reproductive province of processes—see what this process becomes in the hands of a master like Whistler. He has sounded but one note in the gamut of its possibilities, but that product is intrinsically true to the process, and as delicate as the butterfly's wing. Yet the most this particular machine did for us, until then in the hands of Art and Craft, was to give us a cheap, imitative effect of painting.

So spins beyond our ability to follow tonight, a rough, feeble thread of the evidence at large to the effect that the machine has weakened the artist; all but destroyed his handmade art, if not its ideals, although he has made enough miserable mischief meanwhile.

These evident instances should serve to hint, at least to the thinking mind, that the Machine is a marvelous simplifier; the emancipator of the creative mind, and in time the regenerator of the creative conscience. We may see that this destructive process has begun and is taking place that art might awaken to that power of fully developed senses promised by dreams of its childhood, even though that power may not come the way it was pictured in those dreams.

Now, let us ask ourselves whether the fear of the higher artistic expression demanded by the Machine, so thoroughly grounded in the arts and crafts, is founded upon a finely guarded reticence, a recognition of inherent weakness or plain ignorance!

Let us, to be just, assume that it is equal parts of all three, and try to imagine an Arts and Crafts Society that may educate itself to prepare to make some good impression upon the Machine, the destroyer of their present ideals and tendencies, their salvation in disguise.

Such a society will, of course, be a society for mutual education.

Exhibitions will not be a feature of its programme for years, for there will be nothing to exhibit except the shortcomings of the society, and they will hardly prove either instructive or amusing at this stage of proceedings. This society must, from the very nature of the proposition, be made up of the people who are in the work—that is, the manufacturers—coming into touch with such of those who assume the practice of the fine arts as profess a fair sense of the obligation to the public such assumption carries with it, and sociological workers whose interest are ever closely allied with art, as their prophets Morris, Ruskin, and Tolstoy evince, and all those who have as personal graces and accomplishment perfected handicraft, whether fashion old or fashion new.

Without the interest and cooperation of the manufacturers, the society cannot begin to do its work, for this is the cornerstone of its organization.

All these elements should be brought together on a common ground of confessed ignorance, with a desire to be instructed, freely encouraging talk and opinions, and reaching out desperately for anyone who has special experience in any way connected to address them.

I suppose, first of all, the thing would resemble a debating society, or something even less dignified, until someone should suggest that it was time to quit talking and proceed to do something, which in this case would not mean giving an exhibition, but rather excursions to factories and a study of processes in place—that is, the machine in processes too numerous to mention, at the factories with the men who organize and direct them, but not in the spirit of the idea that these things are all gone wrong, looking for that in them which would most nearly approximate the handicraft ideal; not looking into them with even the thought of handicraft, and not particularly looking for craftsmen, but getting a scientific ground plan of the process in mind, if possible, with a view to its natural bent and possibilities.

Some processes and machines would naturally appeal to some, and some to others; there would undoubtedly be among us those who would find little joy in any of them.

This is, naturally, not child's play, but neither is the work expected of the modern artist.

I will venture to say, from personal observation and some experience, that not one artist in one hundred has taken pains to thus educate himself. I will go further and say what I believe to be true, that not one educational institution in America has as yet attempted to forge the connecting link between Science and Art by training the artist to his actual tools, or, by a process of nature-study that develops in him the power of independent thought, fitting him to use them properly.

Let us call these preliminaries then a process by which artists receive information nine-tenths of them lack concerning the tools they have to work with today—for tools today are processes and machines where they were once a hammer and a gouge.

The artist today is the leader of an orchestra, where he once was a star performer.

Once the manufacturers are convinced of due respect and appreciation on the part of the artist, they will welcome him and his counsel gladly and make any experiments having a grain of apparent sense in them.

They have little patience with a bothering about in endeavor to see what might be done to make their particular machine medieval and restore man's joy in the mere work of his hands—for this once lovely attribute is far behind.

This proceeding doubtless would be of far more educational value to the artist than to the manufacturer, at least for some time to come, for there would be a difficult adjustment to make on the part of the artist and an attitude to change. So many artists are chiefly "attitude" that some would undoubtedly disappear with the attitude.

But if out of twenty determined students a ray of light should come to one, to light up a single operation, it would have been worthwhile, for that would be fairly something; while joy in mere handicraft is like that of the man who played the piano for his own amusement—a pleasurable personal accomplishment without real relation to the grim condition confronting us.

Granting that a determined, dauntless body of artist material could be brought together with sufficient persistent enthusiasm to grapple with the Machine, would not someone be found who would provide the suitable experimental station (which is what the modern Arts and Crafts shop should be)—

an experimental station that would represent in miniature the elements of this great pulsating web of the machine, where each pregnant process or significant tool in printing, lithography, galvano-electro processes, wood and steel working machinery, muffles and kilns would have its place and where the best young scientific blood could mingle with the best and truest artistic inspiration, to sound the depths of these things, to accord them the patient, sympathetic treatment that is their due?

Surely a thing like this would be worthwhile—to alleviate the insensate numbness of the poor fellows out in the cold, hard shops, who know not why nor understand, whose dutiful obedience is chained to botch work and bungler's ambition; surely this would be a practical means to make their dutiful obedience give us something we can all understand, and that will be as normal to the best of this machine age as a ray of light to the healthy eye; a real help in adjusting the *Man* to a true sense of his importance as a factor in society, though he does tend a machine.

Teach him that that machine is his best friend—will have widened the margin of his leisure until enlightenment shall bring him a further sense of the magnificent ground plan of progress in which he too justly plays his significant part.

If the art of the Greek, produced at such cost of human life, was so noble and enduring, what limit dare we now imagine to an Art based upon an adequate life for the individual?

The machine is his!

In due time it will come to him!

Meanwhile, who shall count the slain?

From where are the trained nurses in this industrial hospital to come if not from the modern arts and crafts?

Shelley says a man cannot say—"I will compose poetry." "The greatest poet even cannot say it, for the mind in creation is as a fading coal which some invisible influence, like an inconstant wind awakens to transitory brightness; this power arises from within like the color of a flower which fades and changes as it is developed, and the conscious portions of our nature are unprophetic either of its approach or its departure"[5]; and yet in the arts and crafts the problem is presented as a more or less fixed quantity, highly involved, requiring a surer touch, a more highly disciplined artistic nature to organize it as a work of art.

The original impulses may reach as far inward as those of Shelley's poet, be quite as wayward a matter of pure sentiment, and yet after the thing is done, showing its rational qualities, are limited in completeness only by the capacity of whoever would show them or by the imperfection of the thing itself.

This does not mean that Art may be shown to be an exact Science.

"It is not pure reason, but it is always reasonable."

It is a matter of perceiving and portraying the harmony of organic tendencies; is originally intuitive because the artist nature is a prophetic gift that may sense these qualities afar.

To me, the artist is he who can truthfully idealize the common sense of these tendencies in his chosen way.

So I feel conception and composition to be simply the essence of refinement in organization, the original impulse of which may be registered by the artistic nature as unconsciously as the magnetic needle vibrates to the magnetic law, but which is, in synthesis or analysis, organically consistent, given the power to see it or not.

And I have come to believe that the world of Art, which we are so fond of calling the world outside of Science, is not so much outside as it is the very heart quality of this great material growth—as religion is its conscience.

A foolish heart and a small conscience.

A foolish heart, palpitating in alarm, mistaking the growing pains of its giant frame for approaching dissolution, whose sentimentality the lusty body of modern things has outgrown.

Upon this faith in Art as the organic heart quality of the scientific frame of things, I base a belief that we must look to the artist brain, of all brains, to grasp the significance to society of this thing we call the Machine, if that brain be not blinded, gagged, and bound by false tradition, the letter of precedent. For this thing we call Art is it not as prophetic as a primrose or an oak? Therefore, of the essence of this thing we call the Machine, which is no more or less than the principle of organic growth working irresistibly the Will of Life through the medium of Man.

Be gently lifted at nightfall to the top of a great downtown office building, and you may see how in

the image of material man, at once his glory and menace, is this thing we call a city.

There beneath, grown up in a night, is the monster leviathan, stretching acre upon acre into the far distance. High overhead hangs the stagnant pall of its fetid breath, reddened with the light from its myriad eyes endlessly everywhere blinking. Ten thousand acres of cellular tissue, layer upon layer, the city's flesh, outspreads enmeshed by intricate network of veins and arteries, radiating into the gloom, and there with muffled, persistent roar, pulses and circulates as the blood in your veins, the ceaseless beat of the activity to whose necessities it all conforms.

Like to the sanitation of the human body is the drawing off of poisonous waste from the system of this enormous creature; absorbed first by the infinitely ramifying, threadlike ducts gathering at their sensitive terminals matter destructive to its life, hurrying it to millions of small intestines, to be collected in turn by larger, flowing to the great sewer, on to the drainage canal, and finally to the ocean.

This ten thousand acres of fleshlike tissue is again knit and interknit with a nervous system marvelously complete, delicate filaments for hearing, knowing, almost feeling the pulse of its organism, acting upon the ligaments and tendons for motive impulse, in all flowing the impelling fluid of man's own life.

Its nerve ganglia!—the peerless Corliss tandems whirling their hundred ton fly-wheels, fed by gigantic rows of water-tube boilers burning oil, a solitary man slowly pacing backward and forward, regulating here and there the little feed valves controlling the deafening roar of the flaming gas, while beyond, the incessant clicking, dropping, waiting—lifting, waiting, shifting of the governor gear controlling these modern Goliaths seems a visible brain in intelligent action, registered infallibly in the enormous magnets, purring in the giant embrace of great induction coils, generating the vital current meeting with instant response in the rolling cars on elevated tracks ten miles away, where the glare of the Bessemer steel converter makes a conflagration of the clouds.

More quietly still, whispering down the long, low rooms of factory buildings buried in the gloom beyond, range on range of stanch, beautifully perfected automatons, murmur contentedly with oc-casional click-clack, that would have the American manufacturing industry of five years ago by the throat today manipulating steel as delicately as a mystical shuttle of the modern loom manipulates a silk thread in the shimmering pattern of a dainty gown.

And the heavy breathing, the murmuring, the clangor, and the roar!—how the voice of this monstrous thing, this greatest of machines, a great city, rises to proclaim the marvel of the units of its structure, the ghastly warning boom from the deep throats of vessels heavily seeking inlet to the waterway below, answered by the echoing clangor of the bridge bells growing nearer and more ominous as the vessel cuts momentarily the flow of the nearer artery, warning the current from the swinging bridge now closing on its stately passage, just in time to receive in a rush of steam, as a streak of light, the avalanche of blood and metal hurled across it and gone, roaring into the night on its glittering bands of steel, ever faithfully encircled by the slender magic lines tick-tapping its invincible protection.

Nearer, in the building ablaze with midnight activity, the wide white band streams into the marvel of the multiple press, receiving unerringly the indelible impression of the human hopes, joys, and fears throbbing in the pulse of this great activity, as infallibly as the gray matter of the human brain receives the impression of the senses, to come forth millions of neatly folded, perfected news sheets, teeming with vivid appeals to passions, good or evil; weaving a web of intercommunication so far-reaching that distance becomes as nothing, the thought of one man in one corner of the earth one day visible to the naked eye of all men the next; the doings of all the world reflected as in a glass, so marvelously sensitive this wide white band streaming endlessly from day to day becomes in the grasp of the multiple press.

If the pulse of activity in this great city, to which the tremor of the mammoth skeleton beneath our feet is but an awe-inspiring response, is thrilling, what of this prolific, silent obedience?

And the texture of the tissue of this great thing, this Forerunner of Democracy, the Machine, has been deposited particle by particle, in blind obedience to organic law, the law to which the great solar universe is but an obedient machine.

Thus is the thing into which the forces of Art are to breathe the thrill of ideality! A SOUL!

1. From *Invictus,* by Willian Ernst Henley.
2. From this paragraph, through the next twenty-three paragraphs Wright has paraphrased Victor Hugo's "The One Will Kill the Other" from *The Hunchback of Notre-Dame.*
3. Marshall Field (1834-1906), a Chicago merchant, commissioned both Henry Hobson Richardson and the firm of D.H. Burnham and Co. to design his stores. Richardson's wholesale store of 1885 is a building many critics consider to be one of the greatest of the nineteenth century. Field's comment, therefore, probably relates to the later Burnham building. Richardson's untimely death at the age of 48 in 1886 forced Field to choose a new architect.
4. Richard Croker (1841-1922) a New York politician of Irish birth, who rose to Tammany leadership in the mid-1880s.
5. Percy Bysshe Shelley, *A Defense of Poetry*, 1821.

In the Cause of Architecture

1908

Published
with 87
illustrations
in *The
Architectural
Record*,
March 1908

Radical though it be, the work here illustrated is dedicated to a cause conservative in the best sense of the word. At no point does it involve denial of the elemental law and order inherent in all great architecture; rather it is a declaration of love for the spirit of that law and order and a reverential recognition of the elements that made its ancient letter in its time vital and beautiful.

Primarily, Nature furnished the materials for architectural motifs out of which the architectural forms as we know them today have been developed, and, although our practice for centuries has been for the most part to turn from her, seeking inspiration in books and adhering slavishly to dead formulae, her wealth of suggestion is inexhaustible; her riches greater than any man's desire. I know with what suspicion the man is regarded who refers matters of fine art back to Nature. I know that it is usually an ill-advised return that is attempted, for Nature in external, obvious aspect is the usually accepted sense of the term and the nature that is reached. But given inherent vision there is no source so fertile, so suggestive, so helpful aesthetically for the architect as a comprehension of natural law. As Nature is never right for a picture so is she never right for the architect—that is, not ready-made. Nevertheless, she has a practical school beneath her more obvious forms in which a sense of proportion may be cultivated, when Vignola and Vitruvius fail as they must always fail. It is there that he may develop that sense of reality that translated to his own field in terms of his own work will lift him far above the realistic in his art; there he will be inspired by sentiment that will never degenerate to sentimentality and he will learn to draw with a surer hand the every-perplexing line between the curious and the beautiful.

A sense of the organic is indispensable to an architect; where can he develop it so surely as in this school? A knowledge of the relations of form and function lies at the root of his practice; where else can he find the pertinent object lessons Nature so readily furnishes? Where can he study the differentiations of form that go to determine character as he can study them in the trees? Where can that sense of inevitableness characteristic of a work of art be quickened as it may be by intercourse with nature in this sense?

Japanese art knows this school more intimately than that of any people. In common use in their language there are many words like the word *edaburi* which, translated as near as may be, means the formative arrangement of the branches of a tree. We have no such word in English, we are not yet sufficiently civilized to think in such terms, but the architect must not only learn to think in such terms but he must learn in this school to fashion his vocabulary for himself and furnish it in a comprehensive way with useful words as significant as this one.

For seven years it was my good fortune to be the understudy of a great teacher and a great architect, to my mind the greatest of his time—Mr. Louis H. Sullivan.

Principles are not invented, they are not evolved by one man or one age, but Mr. Sullivan's perception and practice of them amounted to a revelation at a time when they were commercially inexpedient and all but lost to sight in current practice. The fine-art sense of the profession was at that time practically dead; only glimmerings were perceptible in the work of Richardson and of Root.[1]

Adler and Sullivan had little time to design residences. The few that were unavoidable fell to my lot

outside of office hours. So largely, it remained for me to carry into the field of domestic architecture the battle they had begun in commercial building. During the early years of my own practice I found this lonesome work. Sympathizers of any kind were then few, and they were not found among the architects. I well remember how "the message" burned within me, how I longed for comradeship until I began to know the younger men and how welcome was Robert Spencer, and then Myron Hunt, and Dwight Perkins, Arthur Heun, George Dean, and Hugh Garden. Inspiring days they were, I am sure, for us all. Of late we have been too busy to see one another often, but the "New School of the Middle West"[2] is beginning to be talked about and perhaps some day it is to be. For why not the same "Life" and blood in architecture that is the essence of all true art?

In 1894, with this text from Carlyle at the top of the page—"The Ideal is within thyself, thy condition is but the stuff thou art to shape that same Ideal out of"—I formulated the following "propositions." I set them down here much as they were written then, although in the light of experience they might be stated more completely and succinctly.

I—Simplicity and Repose are qualities that measure the true value of any work of art.

But simplicity is not in itself an end nor is it a matter of the side of a barn but rather an entity with a graceful beauty in its integrity from which discord, and all that is meaningless, has been eliminated. A wildflower is truly simple. Therefore:

1. A building should contain as few rooms as will meet the conditions which give it rise and under which we live and which the architect should strive continually to simplify; then the ensemble of the rooms should be carefully considered that comfort and utility may go hand in hand with beauty. Beside the entry and necessary work rooms there need be but three rooms on the ground floor of any house, living room, dining room, and kitchen, with the possible addition of a "social office"; really there need be but one room, the living room, with requirements otherwise sequestered from it or screened within it by means of architectural contrivances.

2. Openings should occur as integral features of the structure and form, if possible, its natural ornamentation.

3. An excessive love of detail has ruined more fine things from the standpoint of fine art or fine living than any one human shortcoming—it is hopelessly vulgar. Too many houses, when they are not little stage settings or scene paintings, are mere notion stores, bazaars, or junk shops. Decoration is dangerous unless you understand it thoroughly and are satisfied that it means something good in the scheme as a whole, for the present you are usually better off without it. Merely that it "looks rich" is no justification for the use of ornament.

4. Appliances or fixtures as such are undesirable. Assimilate them together with all appurtenances into the design of the structure.

5. Pictures deface walls oftener than they decorate them. Pictures should be decorative and incorporated in the general scheme as decoration.

6. The most truly satisfactory apartments are those in which most or all of the furniture is built in as a part of the original scheme considering the whole as an integral unit.

II—There should be as many kinds (styles) of houses as there are kinds (styles) of people and as many differentiations as there are different individuals. A man who has individuality (and what man lacks it?) has a right to its expression in his own environment.

III—A building should appear to grow easily from its site and be shaped to harmonize with its surroundings if Nature is manifest there, and if not try to make it as quiet, substantial and organic as She would have been were the opportunity Hers.*

We of the Middle West are living on the prairie. The prairie has a beauty of its own, and we should recognize and accentuate this natural beauty, its quiet level. Hence, gently sloping roofs, low proportions, quiet skylines, suppressed heavyset chimneys and sheltering overhangs, low terraces and outreaching walls sequestering private gardens.

IV—Colors require the same conventionalizing process to make them fit to live with that natural forms do; so go to the woods and fields for color schemes. Use the soft, warm, optimistic tones of earths and autumn leaves in preference to the pessimistic blues, purples, or cold greens and grays of

*In this I had in mind the barren town lots devoid of tree or natural incident, townhouses and board walks only in evidence.

the ribbon counter; they are more wholesome and better adapted in most cases to good decoration.

V—Bring out the nature of the materials, let their nature intimately into your scheme. Strip the wood of varnish and let it alone—stain it. Develop the natural texture of the plastering and stain it. Reveal the nature of the wood, plaster, brick, or stone in your designs, they are all by nature friendly and beautiful. No treatment can be really a matter of fine art when these natural characteristics are, or their nature is, outraged or neglected.

VI—A house that has character stands a good chance of growing more valuable as it grows older while a house in the prevailing mode, whatever that mode may be, is soon out of fashion, stale, and unprofitable.

Buildings like people must first be sincere, must be true, and then withal as gracious and lovable as may be.

Above all, integrity. The machine is the normal tool of our civilization, give it work that it can do well—nothing is of greater importance. To do this will be to formulate new industrial ideals, sadly needed.

▦ These propositions are chiefly interesting because for some strange reason they were novel when formulated in the face of conditions hostile to them and because the ideals they phrase have been practically embodied in the buildings that were built to live up to them. The buildings of recent years have not only been true to them, but are in many cases a further development of the simple propositions so positively stated then.

Happily, these ideals are more commonplace now. Then the skylines of our domestic architecture were fantastic abortions, tortured by features that disrupted the distorted roof surfaces from which attenuated chimneys like lean fingers threatened the sky; the invariably tall interiors were cut up into box-like compartments, the more boxes the finer the house, and "Architecture" chiefly consisted in healing over the edges of the curious collection of holes that had to be cut in the walls for light and air and to permit the occupant to get in or out. These interiors were always slaughtered with the butt and slash of the old plinth and corner block trim, of dubious origin, and finally smothered with horrible millinery.

That individuality in a building was possible for each homemaker, or desirable, seemed at that time to rise to the dignity of an idea. Even cultured men and women care so little for the spiritual integrity of their environment; except in rare cases they are not touched, they simply do not care for the matter so long as their dwellings are fashionable or as good as those of their neighbors and keep them dry and warm. A structure has no more meaning to them aesthetically than has the stable to the horse. And this came to me in the early years as a definite discouragement. There are exceptions, and I found them chiefly among American men of business with unspoiled instincts and untainted ideals. A man of this type usually has the faculty of judging for himself. He has rather liked the "idea" and much of the encouragement this work receives comes straight from him because the "common sense" of the thing appeals to him. While the "cultured" are still content with their small châteaux, colonial wedding cakes, English affectations, or French millinery, he prefers a poor thing but his own. He errs on the side of character, at least, and when the test of time has tried his country's development architecturally, he will have contributed his quota, small enough in the final outcome though it be; he will be regarded as a true conservator.

In the hope that some day America may live her own life in her own buildings, in her own way, that is, that we may make the best of what we have for what it honestly is or may become, I have endeavored in this work to establish a harmonious relationship between ground plan and elevation of these buildings, considering the one as a solution and the other an expression of the conditions of a problem of which the whole is a project. I have tried to establish an organic integrity to begin with, forming the basis for the subsequent working out of a significant grammatical expression and making the whole, as nearly as I could, consistent.

What quality of style the buildings may possess is due to the artistry with which the conventionalization as a solution and an artistic expression of a specific problem within these limitations has been handled. The types are largely a matter of personal taste and may have much or little to do with the American architecture for which we hope.

From the beginning of my practice, the question uppermost in my mind has been not "what style?" but "what is style?" and it is my belief that the chief

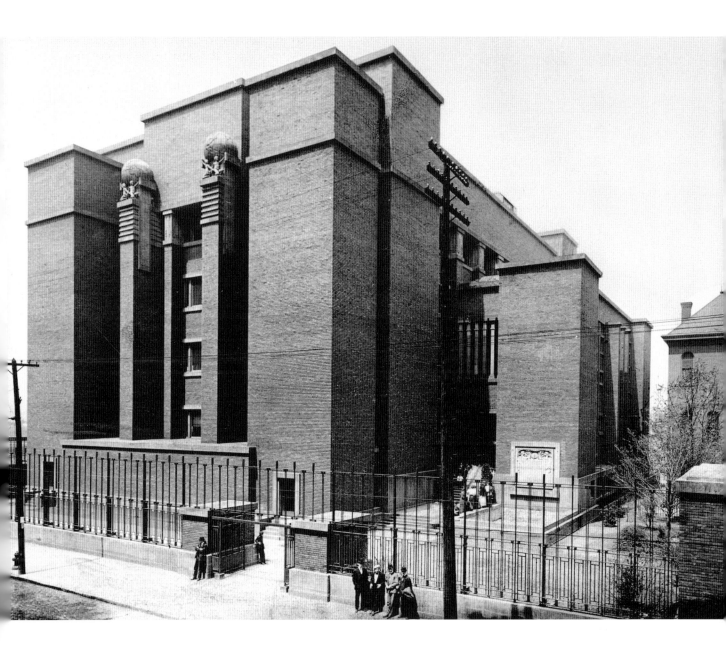

value of the work illustrated here will be found in the fact that if in the face of our present-day conditions any given type may be treated independently and imbued with the quality of style, then a truly noble architecture is a definite possibility, so soon as Americans really demand it of the architects of the rising generation.

I do not believe we will ever again have the uniformity of type which has characterized the so-called great "styles." Conditions have changed; our

Larkin Company Administration Building, Buffalo, New York. 1903
FLLW Fdn# 0403.0030

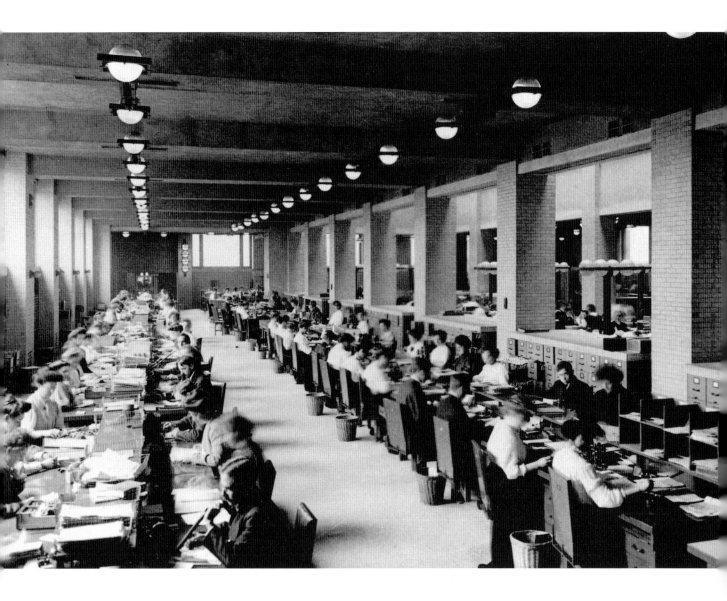

ideal is Democracy, the highest possible expression of the individual as a unit not inconsistent with a harmonious whole. The average of human intelligence rises steadily, and as the individual unit grows more and more to be trusted we will have an architecture with richer variety in unity than has ever arisen before; but the forms must be born out of our changed conditions, they must be *true* forms, otherwise the best that tradition has to offer is only an inglorious masquerade, devoid of vital significance or true spiritual value.

The trials of the early days were many and at this distance picturesque. Workmen seldom like to think, especially if there is financial risk entailed; at your peril do you disturb their established processes mental or technical. To do anything in an unusual, even if in a better and simpler way, is to complicate the situation at once. Simple things at that time in any industrial field were nowhere at hand. A piece of wood without a molding was an anomaly; a plain wooden slat instead of a turned baluster a joke, the omission of the merchantable "grille" a crime; plain fabrics for hangings or floor covering were nowhere to be found in stock.

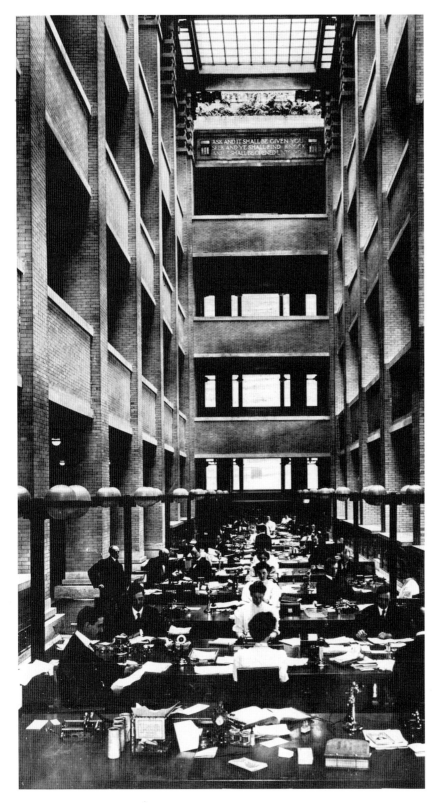

Larkin Company
Administration Building,
Buffalo, New York. 1903.
FLLW Fdn# 0403.0045
and FLLW Fdn# 0403.0046

To become the recognized enemy of the established industrial order was no light matter, for soon whenever a set of my drawings was presented to a Chicago mill-man for figures he would willingly enough unroll it, read the architect's name, shake his head, and return it with the remark that he was "not hunting for trouble"; sagacious owners and general contractors tried cutting out the name, but in vain, his perspicacity was ratlike, he had come to know "the look of the thing." So, in addition to the special preparation in any case necessary for every little matter of construction and finishing, special detail drawings were necessary merely to allow the things to be left off or not done and not only studied designs for every part had to be made but quantity surveys and schedules of millwork furnished the contractors beside. This, in a year or two, brought the architect face to face with the fact that the fee for his service "established" by the American Institute of Architects was intended for something stock and shop, for it would not even pay for the bare drawings necessary for conscientious work.

The relation of the architect to the economic and industrial movement of his time, in any fine-art sense, is still an affair so sadly out of joint that no one may easily reconcile it. All agree that something has gone wrong and except the architect be a plain factory magnate, who has reduced his art to a philosophy of old clothes and sells misfit or made over-ready-to-wear garments with commercial aplomb and social distinction, he cannot succeed on the present basis established by common practice. So, in addition to a situation already complicated for them, a necessarily increased fee stared in the face the clients who dared. But some did dare, as the illustrations prove.

The struggle then was and still is to make "good architecture," "good business." It is perhaps significant that in the beginning it was very difficult to secure a building loan on any terms upon one of these houses, now it is easy to secure a better loan than ordinary; but how far success has attended this ambition the owners of these buildings alone can testify. Their trials have been many, but each, I think, feels that he has as much house for his money as any of his neighbors, with something in the home intrinsically valuable besides, which will not be out of fashion in one lifetime and which contributes steadily to his dignity and his pleasure as an individual.

It would not be useful to dwell further upon difficulties encountered, for it is the common story of simple progression everywhere in any field; I merely wish to trace here the "motif" behind the types. A study of the illustrations will show that the buildings presented fall readily into three groups having a family resemblance; the low-pitched hip roofs, heaped together in pyramidal fashion or presenting quiet, unbroken skylines; the low roofs with simple pediments countering on long ridges; and those topped with a simple slab. Of the first type, the Winslow, Henderson, Willits, Thomas, Heurtley, Heath, Cheney, Martin, Little, Gridley, Millard, Tomek, Coonley, and Westcott houses, the Hillside Home School and the Pettit Memorial Chapel are typical. Of the second type, the Bradley, Hickox, Davenport and Dana houses are typical. Of the third, atelier for Richard Bock, Unity Church,[3] the concrete house of *The Ladies' Home Journal,* and other designs in process of execution. The Larkin Building is a simple, dignified utterance of a plain, utilitarian type, with sheer brick walls and simple stone copings. The studio is merely an early experiment in "articulation."

Photographs do not adequately present these subjects. A building has a presence, as has a person, that defies the photographer, and the color so necessary to the complete expression of the form is necessarily lacking; but it will be noticed that all the structures stand upon their foundations to the eye as well as physically. There is good, substantial preparation at the ground for all the buildings and it is the first grammatical expression of all the types. This preparation, or water table, is to these buildings, what the stylobate was to the ancient Greek temple. To gain it, it was necessary to reverse the established practice of setting the supports of the building to the outside of the wall and to set them to the inside, so as to leave the necessary support for the outer base. This was natural enough and good enough construction but many an owner was disturbed by private information from the practical contractor to the effect that he would have his whole house in the cellar if he submitted to it. This was at the time a marked innovation though the most natural thing in the world and to me, to this day, indispensable.

With this innovation established, one horizontal stripe of raw material, the foundation wall above ground, was eliminated and the complete grammar

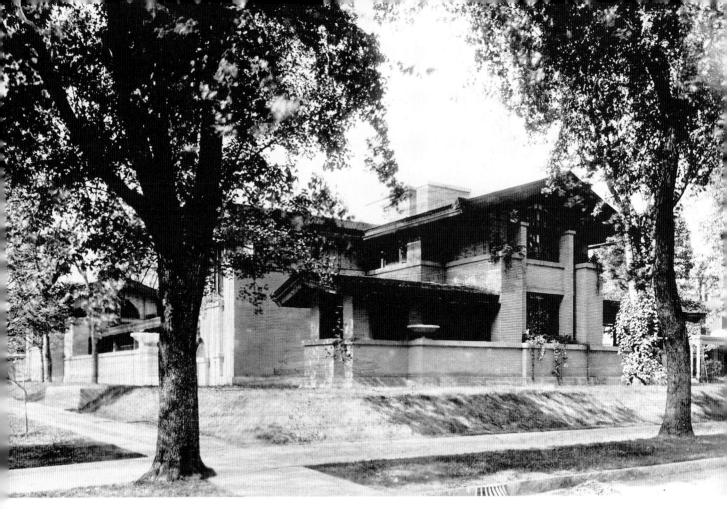

Susan Lawrence Dana House,
Springfield, Illinois. 1902.
FLLW Fdn# 9905.0008

Susan Lawrence Dana House,
Springfield, Illinois. 1902.
Breakfast Nook
FLLW Fdn# 9905.0025

of type one made possible. A simple, unbroken wall surface from foot to level of second story sill was thus secured, a change of material occuring at that point to form the simple frieze that characterizes the earlier buildings. Even this was frequently omitted, as in the Francis apartments[6] and many other buildings, and the wall was let alone from base to cornice or eaves.

"Dress reform houses" they were called, I remember, by the charitably disposed. What others called them will hardly bear repetition.

As the wall surfaces were thus simplified and emphasized the matter of fenestration became exceedingly difficult and more than ever important, and often I used to gloat over the beautiful buildings I could build if only it were unnecessary to cut holes in them; but the holes were managed at first frankly as in the Winslow house and later as elementary constituents of the structure grouped in rhythmical fashion, so that all the light and air and prospect the most rabid client could wish would not be too much from an artistic standpoint; and of this achievement I am proud. The groups are managed, too, whenever required, so that overhanging eaves do not shade them, although the walls are still protected from the weather. Soon the poetry-crushing characteristics of the guillotine window, which was then firmly rooted, became apparent, and single-handed I waged a determined battle for casements swinging out, although it was necessary to have special hardware made for them as there was none to be had this side of England. Clients would come ready to accept any innovation but "those swinging windows," and when told that they were in the nature of the proposition and that they must take them or leave the rest, they frequently employed "the other fellow" to give them something "near," with the "practical" windows dear to their hearts.

With the grammar so far established, came an expression pure and simple, even classic in atmosphere, using that much-abused word in its best sense; implying, that is, a certain sweet reasonableness of form and outline naturally dignified.

I have observed that Nature usually perfects her forms; the individuality of the attribute is seldom sacrificed; that is, deformed or mutilated by cooperative parts. She rarely says a thing and tries to take it back at the same time. She would not sanction the "classic" proceeding of, say, establishing an "order," a colonnade, then building walls between the columns of the order reducing them to pilasters, thereafter cutting holes in the wall and pasting on cornices with more pilasters around them, with the result that every form is outraged, the whole an abominable mutilation, as is most of the architecture of the Renaissance wherein style corrodes style and all the forms are stultified.

In laying out the ground plans for even the more insignificant of these buildings, a simple axial law and order and the ordered spacing upon a system of certain structural units definitely established for each structure, in accord with its scheme of practical construction and aesthetic proportion, is practiced as an expedient to simplify the technical difficulties of execution, and, although the symmetry may not be obvious, always the balance is usually maintained. The plans are as a rule much more articulate than is the school product of the Beaux Arts. The individuality of the various functions of the various features is more highly developed; all the forms are complete in themselves and frequently do duty at the same time from within and without as decorative attributes of the whole. This tendency to greater individuality of the parts emphasized by more and more complete articulation will be seen in the plans for Unity Church, the cottage for Elizabeth Stone at Glencoe, and the Avery Coonley house in process of construction at Riverside, Illinois. Moreover, these ground plans are merely the actual projection of a carefully considered whole. The "architecture" is not "thrown up" as an artistic exercise, a matter of elevation from a preconceived ground plan. The schemes are conceived in three dimensions as organic entities, let the picturesque perspective fall how it will. While a sense of the incidental perspectives the design will develop is always present, I have great faith that if the thing is rightly put together in true organic sense with proportions actually right the picturesque will take care of itself. No man ever built a building worthy the name of architecture who fashioned it in perspective sketch to his taste and then fudged the plan to suit. Such methods produce mere scene-painting. A perspective may be a proof but it is no nurture.

As to the mass values of the buildings the aesthetic principles outlined in proposition III will account in a measure for their character.

In the matter of decoration the tendency has

William Winslow House,
Riverside, Illinois. 1893.
FLLW Fdn# 9305.0002

been to indulge it less and less, in many cases merely providing certain architectural preparation for natural foliage or flowers, as it is managed in, say, the entrance to the Lawrence house at Springfield. This use of natural foliage and flowers for decoration is carried to quite an extent in all the designs and, although the buildings are complete without this effloresence, they may be said to blossom with the season. What architectural decoration the buildings carry is not only conventionalized to the point where it is quiet and stays as a sure foil for the nature forms from which it is derived and with which it must intimately associate, but it is always *of* the surface, never *on* it.

The windows usually are provided with characteristic straight-line patterns absolutely in the flat and usually severe. The nature of the glass is taken into account in these designs as is also the metal bar used in their construction, and most of them are treated as metal "grilles" with glass inserted forming a simple rhythmic arrangement of straight lines and squares made as cunning as possible so long as the result is quiet. The aim is that the designs shall make the best of the technical contrivances that produce them.

In the main the ornamentation is wrought in the warp and woof of the structure. It is constitutional in the best sense and is felt in the conception of the ground plan. To elucidate this element in composition would mean a long story and perhaps a tedious one, though to me it is the most fascinating phase of the work, involving the true poetry of conception.

The differentiation of a single, certain simple form characterizes the expression of one building. Quite a different form may serve for another, but from one basic idea all the formal elements of design are in each case derived and held well together in scale and character. The form chosen may flare outward, opening flower-like to the sky, as in the Thomas house; another, droop to accentuate artistically the weight of the masses; another be noncommittal or abruptly emphatic, or its grammar may be deduced from some plant form that has ap-

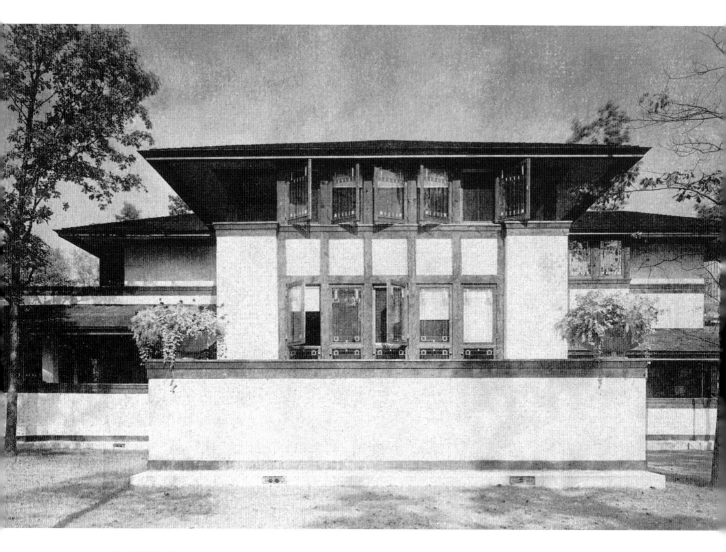

Ward Willits House,
Highland Park, Illinois. 1902.
FLLW Fdn# 0208.0006

Darwin D. Martin House,
Buffalo, New York. 1903.
FLLW Fdn# 0405.002

IN THE CAUSE OF ARCHITECTURE

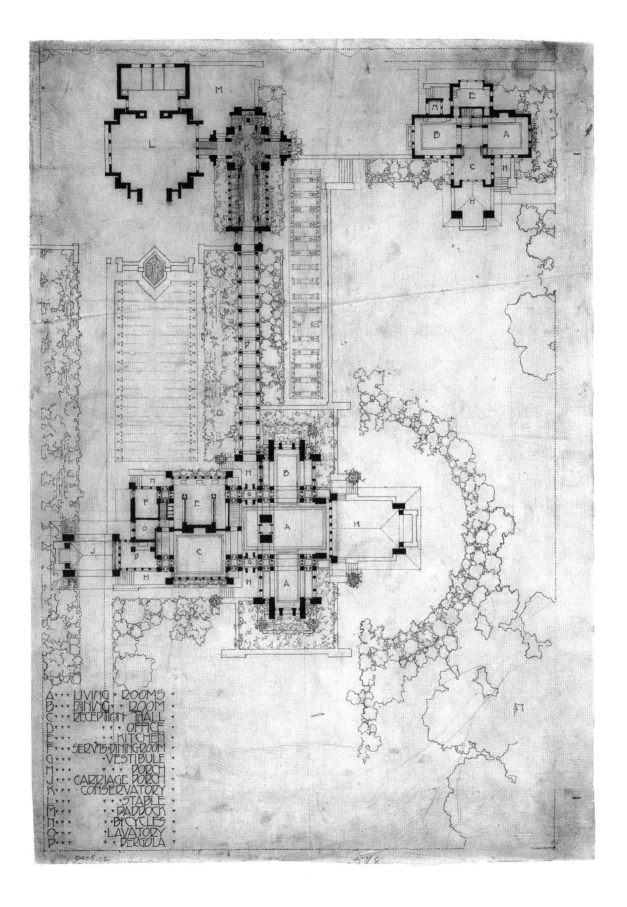

A···LIVING·ROOMS
B···DINING·ROOM
C···RECEPTION·HALL
D···OFFICE
E···KITCHEN
F···SERVTS·DINING·ROOM
G···VESTIBULE
H···PORCH
J···CARRIAGE·PORCH
K···CONSERVATORY
L···STABLE
M···PADDOCK
N···BICYCLES
O···LAVATORY
P···PERGOLA

pealed to me, as certain properties in line and form of the sumach were used in the Lawrence house at Springfield; but in every case the motif is adhered to throughout so that it is not too much to say that each building aesthetically is cut from one piece of goods and consistently hangs together with an integrity impossible otherwise.

In a fine-art sense, these designs have grown as natural plants grow, the individuality of each is integral and as complete as skill, time, strength, and circumstances would permit.

The method in itself does not of necessity produce a beautiful building, but it does provide a framework as a basis which has an organic integrity, susceptible to the architect's imagination and at once opening to him Nature's wealth of artistic suggestion, ensuring him a guiding principle within which he can never be wholly false, out of tune, or lacking in rational motif. The subtleties, the shifting blending harmonies, the cadences, the nuances are a matter of his own nature, his own susceptibilities and faculties.

But self-denial is imposed upon the architect to a far greater extent than upon any other member of the fine art family. The temptation to sweeten work, to make each detail in itself lovable and expressive is always great, but that the whole may be truly eloquent of its ultimate function restraint is imperative. To let individual elements arise and shine at the expense of final repose is, for the architect, a betrayal of trust for buildings are the background or framework for the human life within their walls and a foil for the nature efflorescence without. So architecture is the most complete of conventionalizations and of all the arts the most subjective except music.

Music may be for the architect ever and always a sympathetic friend whose counsels, precepts, and patterns even are available to him and from which he need not fear to draw. But the arts are today all cursed by literature; artists attempt to make literature even of music, usually of painting and sculpture and doubtless would of architecture also were the art not moribund; but whenever it is done the soul of the thing dies and we have not art but something far less for which the true artist can have neither affection nor respect.

Contrary to the usual supposition this manner of working out a theme is more flexible than any working out in a fixed, historic style can ever be, and the individuality of those concerned may receive more adequate treatment within legitimate limitations. This matter of individuality puzzles many; they suspect that the individuality of the owner and occupant of a building is sacrificed to that of the architect who imposes his own upon Jones, Brown, and Smith alike. An architect worthy of the name has an individuality, it is true; his work will and should reflect it, and his buildings will all bear a family resemblance one to another. The individuality of an owner is first manifest in his choice of his architect, the individual to whom he entrusts his characterization. He sympathizes with his work; its expression suits him, and this furnishes the common ground upon which client and architect may come together. Then, if the architect is what he ought to be, with his ready technique he conscientiously works for the client, idealizes his client's character and his client's tastes, and makes him feel that the building is his as it really is to such an extent that he can truly say that he would rather have his own house than any other he has ever seen. Is a portrait, say by Sargent, any less a revelation of the character of the subject because it bears his stamp and is easily recognized by anyone as a Sargent? Does one lose his individuality when it is interpreted sympathetically by one of his own race and time who can know him and his needs intimately and idealize them, or does he gain it only by having adopted or adapted to his condition a ready-made historic style which is the fruit of a seedtime other than his, whatever that style may be?

The present industrial condition is constantly studied in the practical application of these architectural ideals and the treatment simplified and arranged to fit modern processes and to utilize to the best advantage the work of the machine. The furniture takes the clean-cut, straight-line forms that the machine can render far better than would be possible by hand. Certain facilities, too, of the machine, which it would be interesting to enlarge upon, are taken advantage of and the nature of the materials is usually revealed in the process.

Nor is the atmosphere of the result in its completeness new and hard. In most of the interiors there will be found a quiet, a simple dignity that we imagine is only to be found in the "old" and it is due to the underlying organic harmony, to the each in all and the all in each throughout. This is the modern opportunity to make of a building, to-

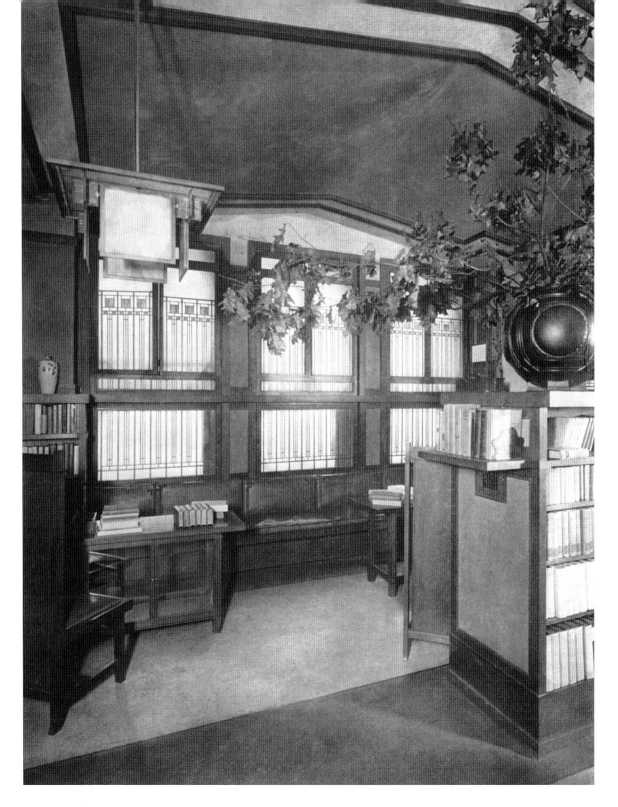

Browne's Bookstore,
Chicago, Illinois. 1907.
FLLW Fdn# 0802.0004

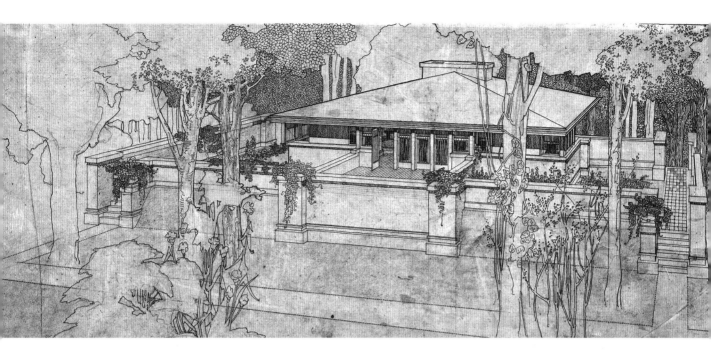

Edwin Cheney House,
Oak Park, Illinois. 1903
FLLW Fdn# 0401.017

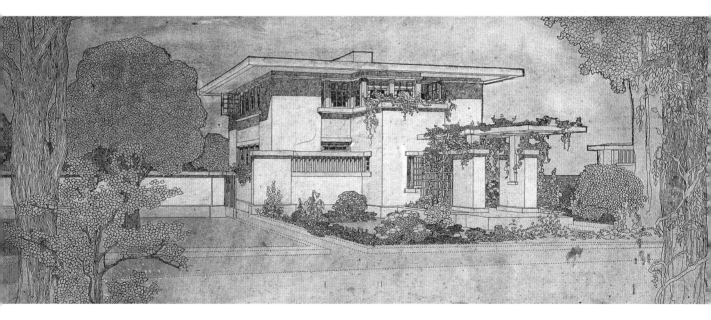

Ladies' Home Journal
Fireproof House. 1907. Project.
FLLW Fdn# 0614.007

gether with its equipment, appurtenances, and environment, an entity which shall constitute a complete work of art, and a work of art more valuable to society as a whole than has before existed because discordant conditions endured for centuries are smoothed away; everyday life here finds an expression germane to its daily existence; an idealization of the common need sure to be uplifting and helpful in the same sense that pure air to breathe is better than air poisoned with noxious gases.

An artist's limitations are his best friends. The machine is here to stay. It is the forerunner of the democracy that is our dearest hope. There is no more important work before the architect now than to use this normal tool of civilization to the best advantage instead of prostituting it as he has hitherto done in reproducing with murderous ubiquity forms born of other times and other conditions and which it can only serve to destroy.

▓ The exteriors of these structures will receive less ready recognition perhaps than the interiors, and because they are the result of a radically different conception as to what should constitute a building. We have formed a habit of mind concerning architecture to which the expression of most of these exteriors must be a shock, at first more or less disagreeable, and the more so as the habit of mind is more narrowly fixed by so-called classic training. Simplicity is not in itself an end; it is a means to an end. Our aesthetics are dyspeptic from incontinent indulgence in "Frenchite" pastry. We crave ornament for the sake of ornament; cover up our faults of design with ornamental sensualities that were a long time ago sensuous ornament. We will do well to distrust this unwholesome and unholy craving and look to the simple line; to the clean though living form and quiet color for a time, until the true significance of these things has dawned for us once more. The old structural forms which up to the present time, have spelled "architecture" are decayed. Their life went from them long ago and new conditions industrially, steel and concrete and terra-cotta in particular, are prophesying a more plastic art wherein as the flesh is to our bones so will the covering be to the structure, but more truly and beautifully expressive than ever. But that is a long story. This reticence in the matter of ornamentation is characteristic of these structures and for at least

two reasons: first, they are the expression of an idea that the ornamentation of a building should be constitutional, a matter of the nature of the structure beginning with the ground plan. In the buildings themselves, in the sense of the whole there is lacking neither richness nor incident but their qualities are secured not by applied decoration, they are found in the fashioning of the whole, in which color, too, plays as significant a part as it does in an old, Japanese woodblock print. Second: because as before stated, buildings perform their highest function in relation to human life within and the natural efflorescence without; and to develop and maintain the harmony of a true chord between them making of the building in this sense a sure foil for life, broad, simple surfaces and highly conventionalized forms are inevitable. These ideals take the buildings out of school and marry them to the ground; make them intimate expressions or revelations of the exteriors, individualize them regardless of preconceived notions of style. I have tried to make their grammar perfect in its way and to give their forms and proportions an integrity that will bear study, although few of them can be intelligently studied apart from their environment. So, what might be termed the democratic character of the exteriors is their first undefined offence—the lack, wholly, of what the professional critic would deem architecture; in fact, most of the critic's architecture has been left out.

There is always a synthetic basis for the features of the various structures, and consequently a constantly accumulating residue of formulas, which becomes more and more useful; but I do not pretend to say that the perception or conception of them was not at first intuitive, or that those that lie yet beyond will not be grasped in the same intuitive way; but, after all, architecture is a scientific art, and the thinking basis will ever be for the architect his surety, the final court in which his imagination sifts his feelings.

The few draughtsmen so far associated with this work have been taken into the draughting room, in every case almost wholly unformed, many of them with no particular previous training and patiently nursed for years in the atmosphere of the work itself, until saturated by intimate association, at an impressionable age, with its motifs and phases, they have become helpful. To develop the sympathetic grasp of detail that is necessary before this point is

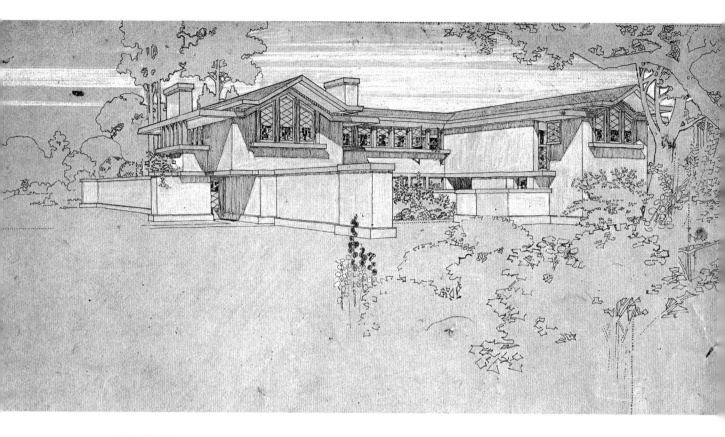

Walter Gerts House,
Glencoe, Illinois. 1906.
Project.
FLLW Fdn# 0615.004

reached has proved usually a matter of years, with little advantage on the side of the college-trained understudy. These young people have found their way to me through natural sympathy with the work and have become loyal assistants. The members, so far, all told here and elsewhere, of our little university of fourteen years standing are: Marion Mahony, a capable assistant for eleven years; William Drummond, seven years; Francis Byrne, five years; Isabel Roberts, five years; George Willis, four years; Walter Griffin, four years; Andrew Willatzen, three years; Harry Robinson, two years; Charles E. White, Jr., one year; Erwin Barglebaugh and Robert Hardin, each one year; Albert McArthur, entering.

Others have been attracted by what seemed to them to be the novelty of the work, staying only long enough to acquire a smattering of form, then departing to sell a superficial proficiency elsewhere. Still others shortly develop a mastery of the subject, discovering that it is all just as they would have done it, anyway, and, chafing at the unkind fate that forestalled them in its practice, resolve to blaze a trail for themselves without further loss of time. It is urged against the more loyal that they are sacrificing their individuality to that which has dominated this work; but it is too soon to impeach a single understudy on this basis, for, although they will inevitably repeat for years the methods, forms, and habit of thought, even the mannerisms of the present work, if there is virtue in the principles behind it that virtue will stay with them through the preliminary stages of their own practice until their own individualities truly develop independently. I have noticed that those who have made the most

IN THE CAUSE OF ARCHITECTURE

fuss about their "individuality" in early stages, those who took themselves most seriously in that regard, were inevitably those who had least.

Many elements of Mr. Sullivan's personality in his art—what might be called his mannerisms—naturally enough clung to my work in the early years and may be readily traced by the casual observer; but for me one real proof of the virtue inherent in this work will lie in the fact that some of the young men and women who have given themselves up to me so faithfully these past years will some day contribute rounded individualities of their own and forms of their own devising to the new school.

This year, I assign to each a project that has been carefully conceived in my own mind, which he accepts as a specific work. He follows its subsequent development through all its phases in drawing room and field, meeting with the client himself on occasion, gaining an all-round development impossible otherwise, and insuring an enthusiasm and a grasp of detail decidedly to the best interest of the client. These privileges in the hands of selfishly ambitious or overconfident assistants would soon wreck such a system; but I can say that among my own boys it has already proved a moderate success, with every prospect of being continued as a settled policy in future.

Nevertheless, I believe that only when one individual forms the concept of the various projects and also determines the character of every detail in the sum total, even to the size and shape of the pieces of glass in the windows, the arrangement and profile of the most insignificant of the architectural members, will that unity be secured which is the soul of the individual work of art. This means that fewer buildings should be entrusted to one architect. His output will of necessity be relatively small—small, that is, as compared to the volume of work turned out in any one of fifty "successful offices" in America. I believe there is no middle course worth considering in the light of the best future of American architecture. With no more propriety can an architect leave the details touching the form of his concept to assistants, no matter how sympathetic and capable they may be, than can a painter entrust the painting in of the details of his picture to a pupil; for an architect who would do individual work must have a technique well developed and peculiar to himself, which, if he is fertile, is still growing with his growth. To keep everything "in place" requires constant care and study in matters that the old-school practitioner would scorn to touch.

As for the future—the work shall grow more truly simple; more expressive with fewer lines, fewer forms; more articulate with less labor; more plastic; more fluent, although more coherent; more organic. It shall grow not only to fit more perfectly the methods and processes that are called upon to produce it, but shall further find whatever is lovely or of good repute in method or process, and idealize it with the cleanest, most virile stroke I can imagine. As understanding and appreciation of life matures and deepens, this work shall prophesy and idealize the character of the individual it is fashioned to serve more intimately, no matter how inexpensive the result must finally be. It shall become in its atmosphere as pure and elevating in its humble way as the trees and flowers are in their perfectly appointed way, for only so can architecture be worthy its high rank as a fine art, or the architect discharge the obligation he assumes to the public—imposed upon him by the nature of his own profession.

1. Architects Henry Hobson Richardson (1838–1886) and John Wellborn Root (1850–1891). Richardson, architect of the 1885 Marshall Field Wholesale Store in Chicago, was primarily known for his very individualistic—"Romanesque-like"—rock-faced masonry buildings on the East Coast. Root, who moved to Chicago in 1872 following the great fire, is best known for the tall office buildings he designed in partnership with Daniel Burnham during the 1880s.

2. H. Allen Brooks identifies "New School of the Middle West" as Wright's phrase and states that it first appears here, at least in print, in this essay of 1908. Thomas T. Tallmadge about the same time coined the phrase "the Chicago School," which included at least some of the same people Wright mentions here. By 1912 the term "Prairie Style" had also appeared. The definition of these "schools" or "styles" of architecture shifted over time and continues to be confusing (H. Allen Brooks, *The Prairie School.* New York: W.W. Norton & Co., 1972. pp. 10–11).

3. Actually Unity Temple in Oak Park, designed by Wright in 1904.

4. Francis Apartments. The Francis Apartments were built in Chicago in 1895 for the Terre Haute Trust Company of Indiana. They were demolished in 1971.

Ausgeführte Bauten und Entwürfe von Frank Lloyd Wright

1910

Published with 72 plates by Ernst Wasmuth, 1910

Since a previous article, written in an endeavor to state the nature of the faith and practice fashioning this work, I have had the privilege of studying the work of that splendid group of Florentine sculptors and painters and architects, and the sculptor-painters and painter-sculptors who were also architects: Giotto, Masaccio, Manna, Arnolfo, Pisano, Brunelleschi, Bramante, Sansovino, and Angelo.

No line was drawn between the arts in their epoch. Some of the sculpture is good painting; most of the painting is good sculpture; and in both lie the patterns of architecture. Where this confusion is not a blending of these arts, it is as amazing as it is unfortunate. To attempt to classify the works severely as pure painting, pure sculpture, or pure architecture would be quite impossible, if it were desirable for educational purposes. But be this as it may, what these men of Florence absorbed from their Greek, Byzantine, and Roman forebears, they bequeathed to Europe as the kernel of the Renaissance; and this, if we deduct the Gothic influence of the Middle Ages, has constituted the soul of the Academic fine arts on the Continent.

From these Italian flames were lighted myriads of French, German, and English lights that flourished, flickered feebly for a time, and soon smoldered in the sensuality and extravagance of later periods, until they were extinguished in banal architecture like the Rococo or in nondescript structures such as the Louvre.

This applies to those buildings which were more or less "professional" embodiments of a striving for the beautiful, those buildings which were "good school" performances, which sought consciously to be beautiful. Nevertheless, here as elsewhere, the true basis for any serious study of the art of architecture is in those indigenous structures, the more humble buildings everywhere, which are to architecture what folklore is to literature or folksongs are to music, and with which architects were seldom concerned. In the aggregate of these lie the traits that make them characteristically German, Italian, French, Dutch, English, or Spanish in nature, as the case may be. The traits of these structures are national, of the soil; and, though often slight, their virtue is intimately interrelated with environment and with the habits of life of the people. Their functions are truthfully conceived, and rendered directly with natural feeling. They are always instructive and often beautiful. So, underlying the ambitious and self-conscious blossoms of the human soul, the expressions of "Maryolatry," or adoration of divinity, or cringing to temporal power, there is the love of life which quietly and inevitably finds the right way, and in lovely color, gracious line, and harmonious arrangement imparts it untroubled by any burden—as little concerned with literature or indebted to it as the flower by the wayside that turns its petals upward to the sun is concerned with the farmer, who passes in the road, or is indebted to him for the geometry of its petals or the mathematics of its structure.

Of this joy in living, there is greater proof in Italy than elsewhere. Buildings, pictures, and sculpture seem to be born, like the flowers by the roadside, to sing themselves into being. Approached in the spirit of their conception, they inspire us with the very music of life.

No really Italian building seems ill at ease in Italy. All are happily content with what ornament and color they carry, as naturally as the rocks and trees and garden slopes which are one with them. Wher-

ever the cypress rises, like the touch of a magician's wand, it resolves all into a composition harmonious and complete.

The secret of this ineffable charm would be sought in vain in the rarefied air of scholasticism or pedantic fine art. It lies close to the earth. Like a handful of the moist sweet earth itself, it is so simple that, to modern minds trained in intellectual gymnastics, it would seem unrelated to great purposes. It is so close that almost universally it is overlooked.

Along the wayside some blossom, with unusually glowing color or prettiness of form, attracts us: held by it, we accept gratefully its perfect loveliness; but, seeking to discover the secret of its charm, we find the blossom, whose more obvious claim first arrests our attention, intimately related to the texture and shape of its foliage; we discover a strange sympathy between the form of the flower and the system upon which the leaves are arranged about the stalk. From this we are led to observe a characteristic habit of growth, and resultant nature of structure, having its first direction and form in the roots hidden in the warm earth, kept moist by the conservative covering of leaf mold. This structure proceeds from the general to the particular in a most inevitable way, arriving at the blossom to proclaim in its lines and form the nature of the structure that bore it. It is an organic thing. Law and order are the basis of its finished grace and beauty: its beauty is the expression of fundamental conditions in line, form, and color, true to them, and existing to fulfill them according to design.

We can in no wise [sic] prove beauty to be the result of these harmonious internal conditions. That which through the ages appeals to us as beautiful does not ignore in its fiber the elements of law and order. Nor does it take long to establish the fact that no lasting beauty ignores these elements ever present as conditions of its existence. It will appear, from study of the forms or styles which mankind has considered beautiful, that those which live longest are those which in greatest measure fulfill these conditions. That a thing grows is no concern of ours, because the quality of life is beyond us and we are not necessarily concerned with it. Beauty, in its essence, is for us as mysterious as life. All attempts to say what it is are as foolish as cutting out the head of a drum to find whence comes the sound. But we may study with profit these truths of form and structure, facts of form as related to function, material traits of line determining character, laws of structure inherent in all natural growth. We ourselves are only a product of natural law. These truths, therefore, are in harmony with the essence of our own being, and are perceived by us to be good. We instinctively feel the good, true, and beautiful to be essentially one in the last analysis. Within us there is a divine principle of growth to some end; accordingly we select as good whatever is in harmony with this law.

We reach for the light spiritually, as the plant does physically, if we are sound of heart and not sophisticated by our education.

When we perceive a thing to be beautiful, it is because we instinctively recognize the rightness of the thing. This means that we have revealed to us a glimpse of something essentially of the fiber of our own nature. The artist makes this revelation to us through his deeper insight. His power to visualize his conceptions being greater than our own, a flash of truth stimulates us, and we have a vision of harmonies not understood today, though perhaps to be tomorrow.

This being so, whence came corrupt styles like the Renaissance? From false education, from confusion of the curious with the beautiful. Confounding the sensations awakened by the beautiful with those evoked by things merely curious is a fatal tendency, which increases as civilization moves away from nature and founds conventions in ignorance or defiance of natural law.

The appreciation of beauty on the part of primitive peoples, Mongolian, Indian, Arab, Egyptian, Greek, and Goth, was unerring. Because of this, their work is coming home to us today in another and truer Renaissance, to open our eyes that we may cut away the dead wood and brush aside the accumulated rubbish of centuries of false education. This Renaissance means a return to simple conventions in harmony with nature. Primarily it is a simplifying process. Then, having learned the spiritual lesson that the East has power to teach the West, we may build upon this basis the more highly developed forms our more highly developed life will need.

Nature sought in this way can alone save us from

the hopeless confusion of ideas that has resulted in the view that beauty is a matter of caprice, that it is merely a freak of imagination—to one man divine, to another hideous, to another meaningless. We are familiar with the assertion, that, should a man put eleven stovepipe hats on top of the cornice of his building and find them beautiful, why then they are beautiful. Yes, perhaps to him; but the only possible conclusion is, that, like the eleven hats on the cornice, he is not beautiful, because beauty to him is utter violation of all the harmonies of any sequence or consequence of his own nature. To find inorganic things of no truth of relation beautiful is but to demonstrate the lack of beauty in oneself and one's unfitness for any office in administering the beautiful and to provide another example of the stultification that comes from the confusion of the curious with the beautiful.

Education seems to leave modern man less able than the savage to draw the line between these qualities.

▒ A knowledge of cause and effect in line, color, and form, as found in organic nature, furnishes guidelines within which an artist may sift materials, test motives, and direct aims, thus roughly blocking out, at least, the rational basis of his ideas and ideals. Great artists do this by instinct. The thing is felt or divined, by inspiration perhaps, as synthetic analysis of their works will show. The poetry which is prophecy is not a matter to be demonstrated. But what is of great value to the artist in research of this nature is knowledge of those facts of relation, those qualities of line, form, and color which are themselves a language of sentiment and characterize the pine as a pine as distinguished from those determining the willow as a willow; those characteristic traits which the Japanese seize graphically and unerringly reduce to simple geometry; the graphic soul of the thing, as seen in the geometrical analyses of Hokusai. Korin was the conscious master of the essential in whatever he rendered, and his work stands as a convincing revelation of the soul of the thing he portrayed. So it will be found with all great work—with the paintings of Velázquez and Frans Hals; with Gothic architecture—organic character in all.

By knowledge of nature in this sense alone are these guiding principles to be established. Ideals

gained within these limitations are never lost, and an artist may defy his "education." If he is really for nature in this sense, he may be "a rebel against his time and its laws, but never lawless."

The debased periods of the world's art are far removed from any conception of these principles. The Renaissance, Baroque, Rococo, the styles of the Louises are not developed from within. There is little or nothing organic in their nature; they are put on from without. The freedom from the yoke of authority which the Renaissance gave to men was seemingly a great gain; but it served only to bind them senselessly to tradition and to mar the art of the Middle Ages past repair. One cannot go into the beautiful edifices of this great period without hatred of the Renaissance growing in the soul. It proves itself a most wantonly destructive thing in its hideous perversity. In every land where the Gothic or Byzantine, or the Romanesque, that was close to Byzantine, grew, it was a soulless blight, a warning, a veritable damnation of the beautiful. What lovely things remain, it left to us in spite of its nature or when it was least itself. It was not a development; it was a disease.

This is why buildings growing in response to actual needs, fitted into the environment by people who knew no better than to fit them to it with native feeling—buildings that grew as folklore and folksong grew—are better worth study than highly self-conscious academic attempts at the beautiful; academic attempts which the nations seem to possess in common as a gift from Italy, after acknowledging her source of inspiration.

▒ All architecture worthy the name is a growth in accord with natural feeling and industrial means to serve actual needs. It cannot be put on from without. There is little beyond sympathy with the spirit creating it and an understanding of the ideals that shaped it that can legitimately be utilized. Any attempt to use forms borrowed from other times and conditions must end as the Renaissance ends, with total loss of inherent relation to the soul life of the people. It can give us only an extraneous thing in the hands of professors that means little more than a mask for circumstance or a mark of temporal power to those whose lives are burdened, not expressed, by it; the result is a terrible loss to life for which literature can never compensate. Buildings

will always remain the most valuable asset in a people's environment, the one most capable of cultural reaction. But until the people have the joy again in architecture as a living art that one sees recorded in buildings of all the truly great periods, so long will architecture remain a dead thing. It will not live again until we break away entirely from adherence to the false ideals of the Renaissance. In that whole movement art was reduced to the level of an expedient. What future has a people content with that? Only that of parasites, feeding on past greatness, and on the road to extinction by some barbarian race with ideals and hungering for their realization in noble concrete form.

In America we are more betrayed by this condition than the people of older countries, for we have no traditional forms except the accumulated ones of all peoples that do not without sacrifice fit new conditions, and there is in consequence no true reverence for tradition. As some sort of architecture is a necessity, American architects take their pick from the world's stock of "ready-made" architecture and are most successful when transplanting form for form, line for line, enlarging details by means of lantern slides from photographs of the originals.

This works well. The people are architecturally clothed and sheltered. The modern comforts are smuggled in cleverly, we must admit. But is this architecture? Is it thus tradition molded great styles? In this polyglot tangle of borrowed forms, is there a great spirit that will bring order out of chaos? Vitality, unity, and greatness out of emptiness and discord?

The ideals of the Renaissance will not, for the Renaissance was inorganic.

A conception of what constitutes an organic architecture will lead to better things once it is planted in the hearts and minds of men whose resource and skill, whose real power, are unquestioned and who are not obsessed by expedients and forms, the nature and origin of which they have not studied in relation to the spirit that produced them. The nature of these forms is not taught in any vital sense in any of the schools in which architects are trained.

A revival of the Gothic spirit is needed in the art and architecture of modern life; an interpretation of the best traditions we have in the world made with our own methods, not a stupid attempt to fasten their forms upon a life that has outgrown

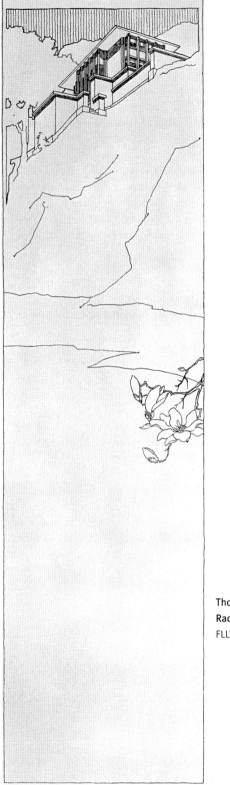

Thomas P. Hardy House, Racine, Wisconsin. 1905. FLLW Fdn# 0506.033

them. Reviving the Gothic spirit does not mean using the forms of Gothic architecture handed down from the Middle Ages. It necessarily means something quite different. The conditions and ideals that fixed the forms of the twelfth are not the conditions and ideals that can truthfully fix the forms of the twentieth century. The spirit that fixed those forms is the spirit that will fix the new forms. Classicists and schools will deny the new forms and find no "Gothic" in them. It will not much matter. They will be living, doing their work quietly and effectively, until the borrowed garments, cut over to fit by the academies, are cast off, having served only to hide the nakedness of a moment when art became detached, academic, alien to the lives of the people.

▓ America, more than any other nation, presents a new architectural proposition. Her ideal is democracy, and in democratic spirit her institutions are professedly conceived. This means that she places a life premium upon individuality—the highest possible development of the individual consistent with a harmonious whole—believing that a whole benefited by sacrifice of that quality in the individual rightly considered his "individuality" is undeveloped; believing that the whole, to be worthy as a whole, must consist of individual units, great and strong in themselves, not yoked from without in bondage, but united within, with the right to move in unity, each in its own sphere, yet preserving this right to the highest possible degree for all. This means greater individual life and more privacy in life—concerns which are peculiarly one's own. It means lives lived in greater independence and seclusion, with all toward which an English nobleman aspires, but with absolute unwillingness to pay the price in paternalism and patronage asked of him for the privilege. This dream of freedom, as voiced by the Declaration of Independence, is dear to the heart of every man who has caught the spirit of American institutions; therefore the ideal of every man American in feeling and spirit. Individuality is a national ideal. Where this degenerates into petty individualism, it is but a manifestation of weakness in the human nature, and not a fatal flaw in the ideal.

▓ In America each man has a peculiar, inalienable right to live in his own house in his own way. He is a pioneer in every right sense of the word. His home environment may face forward, may portray his character, tastes, and ideas, if he has any, and every man here has some somewhere about him.

This is a condition at which Englishmen or Europeans, facing toward traditional forms which they are in duty bound to preserve, may well stand aghast. An American is in duty bound to establish traditions in harmony with his ideals, his still unspoiled sites, his industrial opportunities, and industrially he is more completely committed to the machine than any living man. It has given him the things which mean mastery over an uncivilized land—comfort and resources.

His machine, the tool in which his opportunity lies, can only murder the traditional forms of other peoples and earlier times. He must find new forms, new industrial ideals, or stultify both opportunity and forms. But underneath forms in all ages were certain conditions which determined them. In them all was a human spirit in accord with which they came to be; and where the forms were true forms, they will be found to be organic forms—an outgrowth, in other words, of conditions of life and work they arose to express. They are beautiful and significant, studied in this relation. They are dead to us, borrowed as they stand.

I have called this feeling for the organic character of form and treatment the Gothic spirit, for it was more completely realized in the forms of that architecture, perhaps, than any other. At least the infinitely varied forms of that architecture are more obviously and literally organic than any other, and the spirit in which they were conceived and wrought was one of absolute integrity of means to ends. In this spirit America will find the forms best suited to her opportunities, her aims, and her life.

All the great styles, approached from within, are spiritual treasure houses to architects. Transplanted as forms, they are tombs of a life that has been lived.

▓ This ideal of individuality has already ruthlessly worked its way with the lifeless carcasses of the foreign forms it has hawked and flung about in reckless revel that in East, as well as West, amounts to positive riot.

Brown calls loudly for Renaissance, Smith for a French château, Jones for an English manor house, McCarthy for an Italian villa, Robinson for Hanseatic, and Hammerstein for Rococo, while the se-

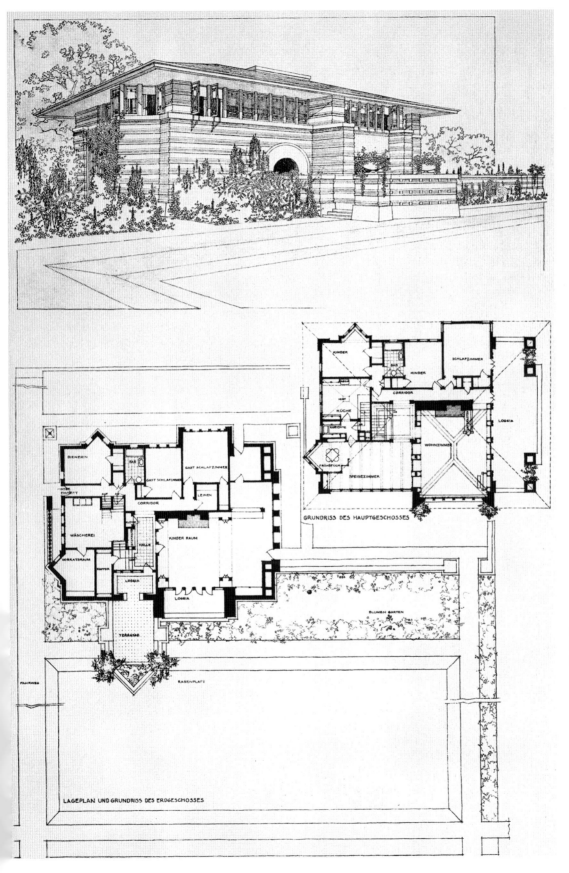

KINDER

SCHLAFZIMMER

BAD

KINDER

CORRIDOR

VEST

KÜCHE

ANRICHTE

LOGGIA

WOHNZIMMER

FRÜHSTÜCK

SPEISEZIMMER

GRUNDRISS DES HAUPTGESCHOSSES

DIENERIN

BAD

GAST SCHLAFZIMMER

GAST SCHLAFZIMMER

EINTRITT

LEINEN

AUF

CORRIDOR

KINDER RAUM

WÄSCHEREI

HALLE

VORRATSRAUM

RIFTER

LOGGIA

LOGGIA

TERRASSE

BLUMEN GARTEN

FAHRWEG

RASENPLATZ

LAGEPLAN UND GRUNDRISS DES ERDGESCHOSSES

Arthur Heurtley house,
Oak Park, Illinois. 1902.
FLLW Fdn# 0204.016

57

dately conservative families cling to "old colonial" wedding cakes with demurely conscious superiority. In all this is found the last word of the *inorganic.* The Renaissance ended in this—a thing absolutely removed from time, place, or people; borrowed finery put on hastily, with no more conception of its meaning or character than Titania had of the donkey she caressed. "All a matter of taste," like the hats on the cornice.

A reaction was inevitable.

It is of this reaction that I feel qualified to speak; for the work illustrated in this volume, with the exception of the work of Louis Sullivan, is the first consistent protest in bricks and mortar against this pitiful waste. It is a serious attempt to formulate some industrial and aesthetic ideals that in a quiet, rational way will help to make a lovely thing of an American's home environment, produced without abuse by his own tools and dedicated in spirit and letter to him.

The ideals of Ruskin and Morris and the teaching of the Beaux Arts have hitherto prevailed in America, steadily confusing, as well as in some respects revealing to us our opportunities. The American, too, of some Old World culture, disgusted by this state of affairs and having the beautiful harmony in the architecture of an English village, European rural community, or the grandiloquent planning of Paris in view has been easily persuaded that the best thing we could do was to adopt some style least foreign to us, stick to it, and plant it continually; a parasitic proceeding, and in any case futile. New York is a tribute to the Beaux Arts, so far as surface decoration goes, and underneath a tribute to the American engineer.

Other cities have followed her lead.

Our better-class residences are chiefly tributes to English architecture, cut open inside and embellished to suit; porches and "conveniences" added: the result in most cases a pitiful mongrel. Painfully conscious of their lack of traditions, our get-rich-quick citizens attempt to buy tradition ready-made and are dragged forward, facing backwards, in attitudes most absurd to those they would emulate, characteristic examples of conspicuous waste.

The point in all this is the fact that revival of the ideals of an organic architecture will have to contend with this rapidly increasing sweep of imported folly.

Even the American with some little culture, going contrary to his usual course in other matters, is becoming painfully aware of his inferiority in matters of dress and architecture and goes abroad for both, to be sure they are correct. Thus assured, he is no longer concerned and forgets both. That is more characteristic of the Eastern than the Western man. The real American spirit, capable of judging an issue for itself upon its merits, lies in the West and Middle West, where breadth of view, independent thought, and a tendency to take common sense into the realm of art, as in life, are more characteristic. It is alone in an atmosphere of this nature that the Gothic spirit in building can be revived. In this atmosphere, among clients of this type, I have lived and worked.

Taking common sense into the holy realm of art is a shocking thing and most unpopular in academic circles. It is a species of vulgarity; but some of these questions have become so perplexed, so encrusted by the savants and academies, with layer upon layer of "good school," that their very nature is hidden; approached with common sense, they become childishly simple.

I believe that every matter of artistic import which concerns a building may be put to the common sense of a businessman on the right side every time, and thus given a chance at it, he rarely gives a wrong decision. The difficulty found by this man with the Renaissance, when he tries to get inside—that is, if he does more than merely give the order to "go ahead"—arises from the fact that the thing has no organic basis to give; there is no good reason for doing anything any particular way rather than another way which can be grasped by him or anybody else; it is all largely a matter of taste. In an organic scheme there are excellent reasons why the thing is as it is, what it is there for, and where it is going. If not, it ought not to go, and as a general thing it doesn't. The people themselves are part and parcel and helpful in producing the organic thing. They can comprehend it and make it theirs, and it is thus the only form of art expression to be considered for a democracy, and I will go so far as to say, the truest of all forms.

So I submit that the buildings here illustrated have for the greatest part been conceived and worked in their conclusion in the Gothic spirit in

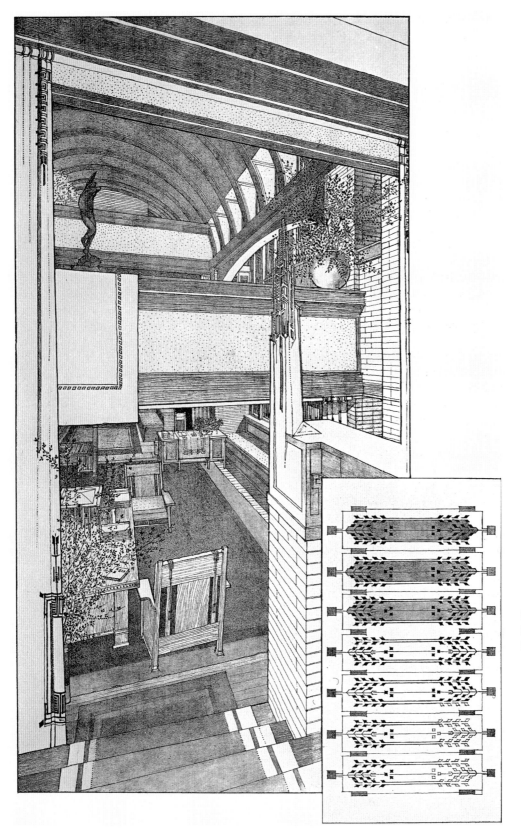

Susan Lawrence Dana House,
Springfield, Illinois. 1902.
FLLW Fdn# 9905.041

this respect as well as in respect to the tools that produced them, the methods of work behind them, and, finally, in their organic nature considered in themselves. These are limitations, unattractive limitations; but there is no project in the fine arts that is not a problem.

With this idea as a basis, comes another conception of what constitutes a building.

The question then arises as to what is style. The problem no longer remains a matter of working in a prescribed style with what variation it may bear without absurdity if the owner happens to be a restless individualist: so this question is not easily answered.

▦ What is style? Every flower has it; every animal has it; every individual worthy the name has it in some degree, no matter how much sandpaper may have done for him. It is a free product—a by-product, the result of an organic working out of a project in character and in one state of feeling.

A harmonious entity of whatever sort in its entirety cannot fail of style in the best sense.

In matters of art the individual feeling of the creative artist can but give the color of his own likes and dislikes, his own soul to the thing he shapes. He gives his individuality but will not prevent the building from being characteristic of those it was built to serve, because it necessarily is a solution of conditions they make, and it is made to serve their ends in their own way. In so far as these conditions are peculiar in themselves, or sympathy exists between the clients and the architect, the building will be their building. It will be theirs much more truly than though in ignorant selfhood they had stupidly sought to use means they had not conquered to an end imperfectly foreseen. The architect, then, is their means, their technique and interpreter; the building, an interpretation if he is a true architect in Gothic sense. If he is chiefly concerned in some marvelous result that shall stand as architecture in good form to his credit, the client be damned, why that is a misfortune which is only another species of the unwisdom of his client. This architect is a dangerous man, and there are lots of his kind outside, and some temptations to him inside, the ranks of the Gothic architects. But the man who loves the beautiful, with ideals of organic natures if all artist, is too keenly sensible of the nature of his client as a

fundamental condition in his problem to cast him off, although he may give him something to grow to, something in which he may be a little ill at ease at the outset.

In this lies temptation to abuses. Where ignorance of the nature of the thing exists or where there is a particular character or preference, it is to a certain extent the duty of an architect to give his client something dated ahead; for he is entrusted by his client with his interests in matters in which, more frequently than not, the client is ignorant. A commission therefore becomes a trust to the architect. Any architect is bound to educate his client to the extent of his true skill and capacity in what he as a professional adviser believes to be fundamentally right. In this there is plenty of leeway for abuse of the client; temptations to sacrifice him in the interest of personal idiosyncrasies, to work along lines instinctively his preference and therefore easy to him. But in any trust there is chance of failure. This educational relationship between client and architect is more or less to be expected and of value artistically for the reason that, while the architect is educating the client, the client is educating him. And a certain determining factor in this quality of style is this matter growing out of this relation of architect and client to the work in hand, as well as the more definite elements of construction. This quality of style is a subtle thing, and should remain so, and not to be defined in itself so much as to be regarded as a result of *artistic integrity*.

▦ Style, then, if the conditions are consistently and artistically cared for little by little will care for itself. As for working in a nominated style beyond a natural predilection for certain forms, it is unthinkable by the author of any true creative effort.

Given similar conditions, similar tools, similar people, I believe that architects will, with a proper regard for the organic nature of the thing produced, arrive at various results sufficiently harmonious with each other and with great individuality. One might swoop all the Gothic architecture of the world together in a single nation and mingle it with buildings treated horizontally as they were treated vertically or treated diagonally, buildings and towers with flat roofs, long, low buildings with square openings, mingled with tall buildings with pointed ones, in the bewildering variety of that marvelous

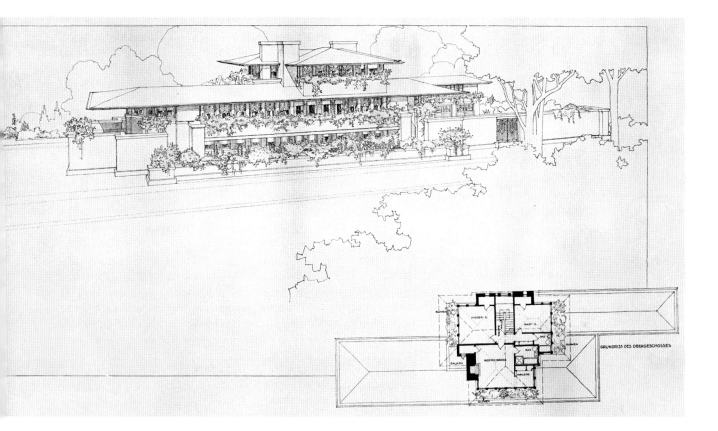

architectural manifestation, and harmony in the general ensemble inevitably result: the common chord in all being sufficient to bring them unconsciously into harmonious relation.

▦ It is this ideal of an organic working out with normal means to a consistent end that is the salvation of the architect entrusted with liberty. He is really more severely disciplined by this ideal than his brothers of the styles, and less likely to falsify his issue.

So to the schools looking askance at the mixed material entrusted to their charge, thinking to save the nation a terrible infliction of the wayward dreams of mere idiosyncrasies by teaching "the safe course of a good copy," we owe thanks for a conservative attitude, but censure for failure to give to material needed by the nation, constructive ideals that would from *within* discipline sufficiently, at the same time leaving a chance to work out a real thing in touch with reality with such souls as they have. In other words, they are to be blamed for not inculcating in students the conception of architecture

Frederick C. Robie House, Chicago, Illinois. 1908.
FLLW Fdn# 0908.034

as an organic expression of the nature of a problem, for not teaching them to look to this nature for the elements of its working out in accordance with principles found in natural organisms. Study of the great architecture of the world solely in regard to the spirit that found expression in the forms should go with this. But before all should come the study of the *nature* of materials, the *nature* of the tools and processes at command, and the *nature* of the thing they are to be called upon to do.

A training of this sort was accorded the great artists of Japan. Although it was not intellectually self-conscious, I have no doubt the apprenticeship of the Middle Ages wrought like results.

German and Austrian art schools are getting back to these ideas. Until the student is taught to approach the beautiful from within, there will be no great living buildings which in the aggregate show the spirit of true architecture.

▦ An architect, then, in this revived sense, is a man disciplined from within by a conception of the organic nature of his task, knowing his tools and his opportunity, working out his problems with what sense of beauty the gods gave him.

He, disciplined by the very nature of his undertakings, is the only safe man.

To work with him is to find him master of means to a certain end. He acquires a technique in the use of his tools and materials which may be as complete and in every sense as remarkable as a musician's mastery of the resources of his instrument. In no other spirit is this to be acquired in any vital sense, and without it—well—a good copy is the safest thing. If one cannot live an independent life, one may at least become a modest parasite.

▦ It is with the courage that a conviction of the truth of this point of view has given that the problems in this work have been attempted. In that spirit they have been worked out, with what degree of failure or success no one can know better than I. To be of value to the student they must be approached from within, and not from the viewpoint of the man looking largely at the matter from the depths of the Renaissance. Insofar as they are grasped as organic solutions of conditions they exist but to serve, with respect for the limitations imposed by our industrial conditions, and having in themselves a harmony of

idea in form and treatment that makes something fairly beautiful of them in relation to life, they will be helpful. Approached from the point of view that seeks characteristic beauty of form and feature as great as that of the Greeks, the Goths, or the Japanese, they will be disappointing; and I can only add it is a little too soon yet to look for such attainment. But the quality of style, in the indefinable sense that it is possessed by any organic thing, that they have. Repose and quiet attitudes they have. Unity of idea, resourceful adaptation of means, will not be found wanting, nor that simplicity of rendering which the machine makes not only imperative but opportune. Although complete, highly developed in detail, they are not.

Self-imposed limitations are in part responsible for this lack of intricate enrichment and partly the imperfectly developed resources of our industrial system. I believe, too, that much ornament in the old sense is not for us yet: we have lost its significance, and I do not believe in adding enrichment merely for the sake of enrichment. Unless it adds clearness to the enunciation of the theme, it is undesirable, for it is very little understood.

I wish to say, also, what is more to the point, that, in a structure conceived in the organic sense, the ornamentation is conceived in the very ground plan, and is of the very constitution of the structure. What ornamentation may be found added purely as such in this structure is thus a makeshift or a confession of weakness or failure.

Where the warp and woof of the fabric do not yield sufficient incident or variety, it is seldom patched on. Tenderness has often to be sacrificed to integrity.

It is fair to explain the point, also, which seems to be missed in studies of the work, that in the conception of these structures they are regarded as severe conventions whose chief office is a background or frame for the life within them and about them. They are considered as foils for the foliage and bloom which they are arranged to carry, as well as a distinct chord or contrast, in their severely conventionalized nature, to the profusion of trees and foliage with which their sites abound.

▦ So the forms and the supervisions and refinements of the forms are, perhaps, more elemental in character than has hitherto been the case in

highly developed architecture. To be lived with, the ornamental forms of one's environment should be designed to wear well, which means they must have absolute repose and make no especial claim upon attention; to be removed as far from realistic tendencies as a sense of reality can take them. Good colors, soft textures, living materials, the beauty of the materials revealed and utilized in the scheme, these are the means of decoration considered purely as such.

And it is quite impossible to consider the building one thing and its furnishings another, its setting and environment still another. In the spirit in which these buildings are conceived, these are all one thing, to be foreseen and provided for in the nature of the structure. They are all mere structural details of its character and completeness. Heating apparatus, lighting fixtures, the very chairs and tables, cabinets and musical instruments, where practicable, are of the building itself. Nothing of appliances or fixtures is admitted purely as such where circumstances permit the full development of the building scheme.

Floor coverings and hangings are as much a part of the house as the plaster on the walls or the tiles on the roof. This feature of development has given most trouble, and so far is the least satisfactory to myself, because of difficulties inherent in the completeness of conception and execution necessary. To make these elements sufficiently light and graceful and flexible features of an informal use of an abode requires much more time and thought and money than are usually forthcoming. But it is approached by some later structures more nearly, and in time it will be accomplished. It is still in a comparatively primitive stage of development; yet radiators have disappeared, lighting fixtures are incorporated, floor coverings and hangings are easily made to conform. But chairs and tables and informal articles of use are still at large in most cases, although designed in feeling with the building.

There are no decorations, nor is there place for them as such. The easel picture has no place on the walls. It is regarded as music might be, suited to a mood, and provided for in a recess of the wall if desired, where a door like the cover of a portfolio might be dropped and the particular thing desired studied for a time; left exposed for days, perhaps, to give place to another, or entirely put away by simply closing the wooden portfolio. Great pictures should have their gallery. Oratorio is not performed in a drawing room. The piano, where possible, should and does disappear in the structure, its keyboard, or open work, or tracery necessary for sound its only visible feature. The dining table and chairs are easily managed in the architecture of the building. So far this development has progressed.

Alternate extremes of heat and cold, of sun and storm, have also to be considered. The frost goes four feet into the ground in winter; the sun beats fiercely on the roof with almost tropical heat in summer: an umbrageous architecture is almost a necessity, both to shade the building from the sun and protect the walls from freezing and thawing moisture, the most rapidly destructive to buildings of all natural causes. The overhanging eaves, however, leave the house in winter without necessary sun, and this is overcome by the way in which the window groups in certain rooms and exposures are pushed out to the gutter line. The gently sloping roofs grateful to the prairie do not leave large air spaces above the rooms; and so the chimney has grown in dimensions and importance, and in hot weather ventilates at the high parts the circulating-air spaces beneath the roofs, fresh air entering beneath the eaves through openings easily closed in winter.

Conductor pipes, disfiguring down-spouts, particularly where eaves overhang, in this climate freeze and become useless in winter, or burst with results disastrous to the walls; so concrete rain basins are built in the ground beneath the angles of the eaves, and the water drops through open spouts into their concave surfaces, to be conducted to the cistern by underground drain tiles.

▦ Another modern opportunity is afforded by our effective system of hot-water heating. By this means, the forms of buildings may be more completely articulated, with light and air on several sides. By keeping the ceilings low, the walls may be opened with series of windows to the outer air, the flowers and trees, the prospects, and one may live as comfortably as formerly, less shut in. Many of the structures carry this principle of articulation of various arts to the point where each has its own individuality completely recognized in plan. The dining room and kitchen and sleeping rooms thus become in themselves small buildings and are grouped

together as a whole, as in the Coonley house. It is also possible to spread the buildings, which once in our climate of extremes were a compact box cut into compartments, into a more organic expression, making a house in a garden or in the country the delightful thing in relation to either or both that imagination would have it.

▦ The horizontal line is the line of domesticity.

The virtue of the horizontal line is respectfully invoked in these buildings. The inches in height gain tremendous force compared with any practicable spread upon the ground.

To Europeans these buildings on paper seem uninhabitable; but they derive height and air by quite other means and respect an ancient tradition, the only one here worthy of respect—the prairie.

In considering the forms and types of these structures, the fact that they are nearly buildings for the prairie should be borne in mind; the gently rolling or level prairies of the Middle West; the great levels where every detail of elevation becomes exaggerated; every tree a tower above the great calm plains of its flowered surfaces as they lie serene beneath a wonderful sweep of sky. The natural tendency of every ill-considered thing is to detach itself and stick out like a sore thumb in surroundings by nature perfectly quiet. All unnecessary heights have for that reason and for other reasons economic been eliminated, and more intimate relation with outdoor environment sought to compensate for loss of height.

▦ The differentiation of a single, certain, simple form characterizes the expression of one building. Quite a different form may serve for another; but from one basic idea all the formal elements of design are in each case derived and held together in scale and character. The form chosen may flare outward, opening flower-like to the sky, as in the Thomas house; another, droop to accentuate artistically the weight of the masses; another be noncommittal or abruptly emphatic, or its grammar may be deduced from some plant form that has appealed to me, as certain properties in line and form of the sumach were used in the Lawrence house at Springfield; but in every case the motif is adhered to throughout.[1]

In the buildings themselves, in the sense of the whole, there is lacking neither richness nor inci-
dent; but these qualities are secured not by applied decoration, they are found in the fashioning of the whole, in which color, too, plays as significant a part as it does in an old Japanese woodblock print.

These ideals take the buildings out of school and marry them to the ground; make them intimate expressions or revelations of the interiors; individualize them, regardless of preconceived notions of style. I have tried to make their grammar perfect in its way and to give their forms and proportions an integrity that will bear study, although few of them can be intelligently studied apart from their environment.

A study of the drawings will show that the buildings presented fall readily into three groups having a family resemblance; the low-pitched hip roofs, heaped together in pyramidal fashion, or presenting quiet, unbroken skylines; the low roofs with simple pediments countering on long ridges; and those topped with a simple slab. Of the first type, the Winslow, Henderson, Willits, Thomas, Heurtley, Heath, Cheney, Martin, Little, Gridley, Millard, Tomek, Coonley, and Westcott houses, the Hillside Home School, and the Pettit Memorial Chapel are typical. Of the second type, the Bradley, Hickox, Davenport, and Dana houses are typical. Of the third, atelier for Richard Bock, Unity Church, the concrete house of *The Ladies' Home Journal,* and other designs in process of execution. The Larkin Building is a simple, dignified utterance of a plain, utilitarian type, with sheer brick walls and simple stone copings. The studio is merely an early experiment in "articulation."

A type of structure especially suited to the prairie will be found in the Coonley, Thomas, Heurtley, Tomek, and Robie houses, which are virtually one-floor arrangements, raised at low-story height above the level of the ground. Sleeping rooms are added where necessary in another story.

There is no excavation for this type except for heating purposes. The ground floor provides all necessary room of this nature, and billiard rooms, or playrooms for the children. This plan raises the living rooms well off the ground, which is often damp, avoids the ordinary damp basement, which, if made a feature of the house, sets it so high above the surface, if it is to be made dry, that, in proportion to the ordinary building operation, it rises like a menace to the peace of the prairie.

It is of course necessary that mural decoration and sculpture in these structures should again take their places as architectural developments conceived to conform to their fabric.

▪ To thus make of a dwelling place a complete work of art, in itself as expressive and beautiful and more intimately related to life than anything of detached sculpture or painting, lending itself freely and suitably to the individual needs of the dwellers, a harmonious entity, fitting in color, pattern, and nature the utilities, and in itself really an expression of them in character—this is the modern American opportunity. Once founded, this will become a tradition, a vast step in advance of the day when a dwelling was an arrangement of separate rooms, mere chambers to contain aggregations of furniture, the utility comforts not present. An organic entity this, as contrasted with that aggregation: surely a higher ideal of unity, a higher and more intimate working out of the expression of one's life in one's environment. One thing instead of many things; a great thing instead of a collection of smaller ones.

▪ The drawings, by means of which these buildings are presented here, have been made expressly for this work from colored drawings, which were made from time to time as the projects were presented for solution. They merely aim to render the composition in outline and form and suggest the sentiment of the environment. They are in no sense attempts to treat the subject pictorially and in some cases fail to convey the idea of the actual building. A certain quality of familiar homelikeness is thus sacrificed in these presentments to a graceful decorative rendering of an idea of an arrangement suggesting, in the originals, a color scheme. Their debt to Japanese ideals, these renderings themselves sufficiently acknowledge.

1. Much of this paragraph and the following paragraphs were only slightly reworded from "In the Cause of Architecture" (1908). This close repetition of ideas was not uncommon for Wright.

The Japanese Print: An Interpretation

1912

Published
without
illustrations
by Ralph
Fletcher
Seymour,
1912

The unpretentious colored woodcut of Japan, a thing of significant graven lines on delicate paper which has kissed the color from carved and variously tinted wooden blocks, is helpful in the practice of the fine arts and may be construed with profit in other life concerns as great.

It is a lesson especially valuable to the West, because, in order to comprehend it at all, we must take a viewpoint unfamiliar to us as a people, and in particular to our artists—the purely aesthetic viewpoint. It is a safe means of inspiration for our artists because, while the methods are true methods, the resultant forms are utterly alien to such artistic tradition as we acknowledge and endeavor to make effective.

So, I will neglect the smattering of information as to artists and periods easily obtained from any one* of several available works on the subject and try to tell what these colored engravings are in themselves, and more particularly of their cultural use to us in awakening the artistic conscience or at least in making us feel the disgrace of not realizing the fact that we have none.

Go deep enough into your experience to find that beauty is in itself the finest kind of morality—ethical, purely—the essential fact, I mean, of all morals and manners—and you may personally feel in these aesthetic abstractions of the Japanese mind the innocent and vivid joy which, by reason of obviously established sentiment, is yours in the flowers of field or garden.

A flower is beautiful, we say—but why? Because in its geometry and its sensuous qualities it is an embodiment and significant expression of that precious something in ourselves which we instinctively know to be Life, "An eye looking out upon us from the great inner sea of beauty," a proof of the eternal harmony in the nature of a universe too vast and intimate and real for mere intellect to seize. Intuitively we grasp something of it when we affirm that "the flower is beautiful." And when we say, "It is beautiful," we mean that the quality in us which is our very life recognizes itself there or at least what is its very own: so there vibrates in us a sympathetic chord struck mystically by the flower. Now, as it is with the flower, so is it with any work of art and to greater degree: because a work of fine art is a blossom of the human soul, and so more humanly intimate. In it we find the lineaments of man's thought and the exciting traces of man's feeling—so to say, the very human touch, offered to us in terms of the same qualities that make us exclaim that the flower is beautiful; and it is this quality of absolute and essential beauty in the result of the artist's creative efforts that is the Life of the work of art, more truly than any literal import or adventitious significance it may possess. But it is the quick, immediate perception of this subjective quality, or rather, perhaps, the ability to perceive it instinctively in the work of art, that is lacking in us—as a people. Failing in this perception we are untouched by the true vitalizing power of art and remain outside the precincts of the temple, in a realm, literal, objective, realistic, therefore unreal. In art that which is really essential escapes us for lack of a "disciplined power to see."

The most important fact to realize in a study of this subject is that, with all its informal grace, Japanese art is a thoroughly structural art; funda-

Japanese Color Prints by Von Seidlit—the best book extant on the subject. *The Masters of Ukiyoe*, and *History of the Ukiyoe*, by Ernest Fenollosa. *Japanese Illustrations*, by Dr. William Anderson. *Japanese Illustrations* and *Japanese Woodcuts*, by E. S. Strange.

mentally so in any and every medium. It is always, whatever else it is or is not, structural. The realization of the primary importance of this element of "structure" is also at the very beginning of any real knowledge of design. And at the beginning of structure lies always and everywhere geometry. But, in this art, mathematics begins and ends here, as the mathematical begins and ends in music, however organically inherent here as there in the result.

But we have used the word structure, taking for granted that we agreed upon its meaning. The word structure is here used to designate an organic form, an organization in a very definite manner of parts or elements into a larger unity—a vital whole. So, in design, that element which we call its structure is primarily the pure form, an organization in a very definite manner of parts or elements into a larger unity—a vital whole. So, in design, that element which we call its structure is primarily the pure form, as arranged or fashioned and grouped to "build" the Idea; an idea which must always persuade us of its reasonableness. Geometry is the grammar, so to speak, of the form. It is its architectural principle. But there is a psychic correlation between the geometry of form and our associated ideas, which constitutes its symbolic value. There resides always a certain "spell-power" in any geometric form which seems more or less a mystery, and is, as we say, the soul of the thing. It would carry us far from our subject if we should endeavor to render an accurate, convincing account of the reason why certain geometric forms have come to symbolize for us and potently to suggest certain human ideas, moods, and sentiments—as for instance: the circle, infinity; the triangle, structural unity; the spire, aspiration; the spiral, organic progress; the square, integrity. It is nevertheless a fact that more or less clearly in the subtle differentiations of these elemental geometric forms, we do sense a certain psychic quality which we may call the "spell-power" of the form, and with which the artist freely plays, as much at home with it as the musician at his keyboard with his notes. A Japanese artist grasps form always by reaching underneath for its geometry. No matter how informal, vague, evanescent, the subject he is treating may seem to be, he recognizes and acknowledges geometry as its aesthetic skeleton; that is to say—not its structural skeleton alone, but by virtue of what we have termed the symbolic "spell-

power"—it is also the suggestive soul of his work. A Japanese artist's power of geometrical analysis seems little short of miraculous. An essential geometry he sees in everything, only, perhaps, to let it vanish in mystery for the beholder of his finished work. But even so, escaping as it does at first the critical eye, its influence is the more felt. By this grasp of geometric form and sense of its symbol-value, he has the secret of getting to the hidden core of reality. However fantastic his imaginative world may be, it competes with the actual and subdues it by superior loveliness and human meaning. The forms, for instance, in the pine tree (as of every natural object on earth), the geometry that underlies and constitutes the peculiar pine character of the tree—what Plato meant by the eternal idea—he knows familiarly. The unseen is to him visible. A circle and a straight line or two, rhythmically repeated, prescribe for him its essentials perfectly. He knows its textures and color qualities as thoroughly. Having these by heart, he is master of the pine and builds trees to suit his purpose and feeling, each as truly a pine and a pine only as the one from which he wrung the secret. So, from flying bird to breaking wave, from Fujiyama to a petal of the blossoming cherry afloat upon the stream, he is master, free to create at will. Nor are these forms to him mere specters or flimsy guesses—not fictitious semblances to which he can with impunity do violence. To him they are fundamental verities of structure, preexisting and surviving particular embodiments in his material world.

What is true of the pine tree, for and by itself, is no less true in the relation of the tree to its environment. The Japanese artist studies pine-tree nature not only in its import and bearing but lovingly understands it in its habitat and natural element as well—which, if the geometry be called the grammar, may by equal privilege of figurative speech be termed the syntax. To acquire this knowledge, he devotes himself to the tree, observes analytically yet sympathetically, then leaves it, and with his brush begins to feel for its attitude and intimate relations as he remembers them. He proceeds from visualized generals to definite particulars in this contemplative study, and as soon as he has recognized really the first elements constituting the skeleton of the structure, which you may see laid bare in the analysis by Hokusai, his progress in its grammar and syntax is rapid. The Japanese artist, by virtue of the

shades of his ancestors, is born a trained observer; but only after a long series of patient studies does he consider that he knows his subject. However, he has naturally the ready ability to seize upon essentials, which is the prime condition of the artist's creative insight. Were all pine trees, then, to vanish suddenly from the earth, he could, from this knowledge, furnish plan and specification for the varied portrayal of a true species—because what he has learned and mastered and made his own is the specific and distinguishing nature of the pine tree. Using this word "Nature" in the Japanese sense I do not of course mean that outward aspect which strikes the eye as a visual image of a scene or strikes the ground glass of a camera, but that inner harmony which penetrates the outward form or letter and is its determining character; that quality in the thing (to repeat what we have said before) that is its significance and its Life for us—what Plato called (with reason, we see, psychological if not metaphysical) the "eternal idea of the thing."

We may refer, then, to the nature of a "proposition" as we do to the nature of an animal, of a plant, of an atmosphere, or a building material. Nature, in this sense, is not to be studied much in books. They are little more than the by-product of other men's ideas of the thing, which in order to distill from it his own particular sense of its intrinsic poetry the artist must know at firsthand. This poetry he must find in the thing for himself, the poetry it holds in reserve for him and him alone, and find it by patient, sympathetic study. This brings us to the aesthetics of Japanese art.

Ideas exist for us alone by virtue of form. The form can never be detached from the idea; the means must be perfectly adapted to the end. So in this art the problem of form and style is an organic problem solved easily and finally. Always we find the one line, the one arrangement that will exactly serve. It is a facile art, incapable of adequate analysis, for it is the felicity of an intuitive state of mind and must, on the part of the student, be similarly recognized by intuition.

These simple colored engravings are a language whose purpose is absolute beauty, inspired by the Japanese need of that precise expression of the beautiful, which is to him reality immeasurably more than the natural objects from which he wrested the secret of their being. This expression of the beautiful is inevitable and there inheres in the result that inevitableness which we feel in all things lovely. This process of woodblock printing is but one modest medium by means of which he may express his sense of the universal nature of things, and which he justifies in his characteristic, highly expressive fashion.

So, these prints are designs, patterns, in themselves beautiful as such; and what other meanings they may have are merely incidental, interesting, or curious by-products.

Broadly stated then, the first and supreme principle of Japanese aesthetics consists in stringent simplification by elimination of the insignificant and a consequent emphasis of reality. The first prerequisite for the successful study of this strange art is to fix the fact in mind at the beginning that it is the sentiment of Nature alone which concerns the Japanese artist; the sentiment of Nature as beheld by him in those vital meanings which he alone seems to see and alone therefore endeavors to portray.

The Japanese, by means of this process—to him by this habit of study almost instinctive—casts a glamour over everything. He is a poet. Surely life in old Japan must have been a perpetual communion with the divine heart of Nature. For Nippon drew its racial inspiration from, and framed its civilization in accord with, a native perception of Nature-law. Nippon made its body of morals and customs a strict conventionalization of her nature forms and processes; and therefore as a whole her civilization became a true work of Art. No more valuable object lesson was ever afforded civilization than this instance of a people who have made of their land and the buildings upon it, of their gardens, their manners and garb, their utensils, adornments, and their very gods, a single consistent whole, inspired by a living sympathy with Nature as spontaneous as it was inevitable. To the smallest fraction of Japanese lives what was divorced from Nature was reclaimed by Art and so redeemed. And what was the rule thus established progressively in individual and social life, making of it in itself an art—a thing of strange and poignant beauty—dominated all popular art production also and furnished the criterion.

This process of elimination and of the insignificant we find to be the first and most important consideration for artists, after establishing the fundamental mathematics of structure. A Japanese may

tell you what he knows in a single drawing, but never will he attempt to tell you all he knows. He is quite content to lay stress upon a simple element, insignificant enough perhaps until he has handled it; then (as we find again and again in the works of Korin and his school) the very slight means employed touches the soul of the subject so surely and intimately that while less would have failed of the intended effect, more would have been profane. This process of simplification is in a sense a dramatization of the subject, just as all Japanese ceremonials are the common offices and functions of their daily life delicately dramatized in little. The tea ceremony is an instance. Nothing more than the most gracefully perfect way of making and serving a cup of tea! Yet, often a more elegant and impressive ceremonial than a modern religious service. To dramatize is always to conventionalize; to conventionalize is, in a sense, to simplify; and so these drawings are all conventional patterns subtly geometrical, imbued at the same time with symbolic value, this symbolism honestly built upon a mathematical basis, as the woof of the weave is built upon the warp. It has little in common with the literal. It is more akin to a delicate musical instrument that needs no dampers or loud pedals. Fleshly shade and materialistic shadow are unnecessary to it, for in itself it is no more than pure living sentiment.

Were we to contrast the spiritual grace of simple wildflowers, with the material richness of doubled varieties under cultivation, we would institute a suggestive comparison of this unpretentious art of the East with the more pretentious art of the West. Where the art of Japan is a poetic symbol, much of ours is attempted realism, that succeeds only in being rather pitifully literal. Where the one is delicately sensuous, the other is only too apt to be stupidly sensual.

This intuition of the Japanese artist for dramatizing his subject is no finer than his touch and tact are unerring. He knows materials and never falsifies them. He knows his tools and never abuses them. And this, too, just because he apprehends the secret of character at every chance contact with the actual. In the slight wash drawings of the kakemono, we find a more sheer and delicate manifestation of reserve than in this more popular, and in a sense therefore, more vulgar form of expression. Always latent, however, in the slightest and seemingly most infor-

mal designs, in the least of these works as through the greatest, the geometric structure effects a potent spell. No composition can we find not affected by it and that does not bear this psychic spell meanwhile, as if unconscious of its precious burden, its efficient causes enwoven and subtly hid between the lines of its geometric forms. As the poor saint was believed to bear his mystic nimbus, so each humble masterpiece asserts its magic of invisible perfection. Yet, this mystery is conclusively reduced by Japanese masters to its scientific elements, as exemplified by certain pages of textbooks by Hokusai, wherein the structural diagrams are clearly given and transformation to material objects shown progressively step by step.

This primitive graphic art, like all true art, has limitations firmly fixed; in this case more narrowly fixed than in any art we know. Strictly within these limitations, however, the fertility and resource of the Japanese mind produced a range of aesthetic inventions that runs the whole gamut of sentiment, besides reproducing with faithfulness the costumes, manners, and customs of a unique and remarkable civilization, constituting its most valuable real record—and without violating a single aesthetic tradition.

The faces in these drawings repel the novice and chill the student accustomed to less pure aesthetic abstractions; and the use of the human form in unrealistic fashion has often been explained on the ground of religious scruples. Nothing more than the aesthetic consideration involved is necessary to justify it. The faces in these drawings are "in place," harmonious with the rest, and one may actually satisfy himself on the subject by observing how the tendency toward realism in the faces portrayed by Kiyonaga[1] and Toyokuni[2] vulgarized results artistically, introducing as they did, this element—no doubt, for the same reason that actors sometimes play to the applauding gallery. The faces as found in the prints of the great period were the Japanese countenance dramatized, to use the term once more. They were masks, conventions, the visual image of the ethnic character of a people varied by each artist for himself. A close student may identify the work of any particular artist by merely ascertaining his particular variation, the print being otherwise totally concealed. And although an actor was portrayed in many different roles, the individ-

uality of the countenance, its character, was held throughout in the mask.

You may never fail to recognize Danjuro[3] in all the various drawings by Shunsho[4] and other artists that he inspired, and you may recognize others when you have made their acquaintance. But the means by which this was accomplished are so slight that the convention is scarcely disturbed, and no realism taints the result. A countenance drawn to please us would vulgarize the whole, for its realism would violate the aesthetic law of the structure. You find something like this typical face in the work of the Pre-Raphaelites, Burne-Jones, and Rossetti. These are often inanities as distressing as the more legitimate conventions of the Japanese are satisfying, because they were made in a more or less literal setting; the whole being inorganic and inconsistent. You will find something of this conventionalizing tendency employed more consistently and artistically in a Morris prose epic or verse tale, or in Spenser's *Faerie Queene*, where raging knightly battles and frightful episodes move quietly remote and sedate across the enchanted reader's field of mental vision, affecting him simply by their picturesque outlines and charm of color, as might an old arras.

The use of color, always in the flat—that is, without chiaroscuro—plays a wonderful but natural part in the production of this art and is responsible largely for its charm. It is a means grasped and understood as perfectly as the rhythm of form and line, and it is made in its way as significant. It affords a means of emphasizing and differentiating the forms themselves, at the same time that it is itself an element of the pattern. The blacks are always placed flat in the pattern, as pattern for its own sake—a design within a design. Comments are often made on the wonderfully successful use of masses of deep black, but the other colors at their command are used as successfully, according to the same method, to an identical, if less emphatic effect.

As we see the prints today, it must be confessed that time has imbued the color with added charm. Old vegetable dyes, saturating and qualified by the soft texture of wonderful silken paper, soften and change with the sunlight of the moist climate, much as the colors in oriental rugs. Blues become beautiful yellows; purples soft browns; *beni*, or bright red, fades to luminous pink; while a certain cool green together with the translucent grays and the brilliant red lead are unchangeable. The tenderness of tone found in fine prints is indescribable. This is in great part due to the action of time on the nature of the dye stuffs or pigments employed. When first printed, they were comparatively crude, and much of the credit formerly given by connoisseurs to the printer should be accredited to age. When first printed, also, there was a certain conventionalized symbolism in the use of color, which time confuses. The sky was then usually gray or blue, sometimes yellow; the water blue; grass green; garments polychromatic; woodwork red lead, pink, or yellow. Owing to the manner in which the color was brushed upon the block, few prints are exactly alike, and sometimes great liberty was taken with the color by the printer, most interesting differentiations of color occurring in different prints from the same block. In itself, the color element in the Japanese print is delight—an absolute felicity, unrivaled in charm by the larger means employed in more pretentious mediums. The prints afford a liberal education in color values, especially related to composition. A perfect color balance is rarely wanting in the final result, and although certain qualities in this result are in a sense adventitious, yet it should be strongly insisted, after all, that the foundation for the miracles of harmonious permutation was properly laid by the artist himself.

In this wedding of color and gracious form, we have finally what we call a good decoration. The ultimate value of a Japanese print will be measured by the extent to which it distills, or rather exhales, this precious quality called "decorative." We as a people do not quite understand what that means and are apt to use the term slightingly as compared with art, which has supposedly some other and greater mission. I—speaking for myself—do not know exactly what other mission it legitimately could have, but I am sure of this, at least—that the rhythmic play of parts, the poise and balance, the respect the forms pay to the surface treated, and the repose these qualities attain to and impart and which together constitute what we call good decoration, are really the very life of all true graphic art whatsoever. In the degree that the print possesses this quality, it is abidingly precious; this quality determines—constitutes, its intrinsic value.

As to the subject matter of the figure pieces, it is true that the stories they tell are mainly of the Yo-

shiwara,[5] or celebrate the lover and the geisha, but with an innocence incomprehensible to us; for Japan at that time—although the family was the unit of her civilization—had not made monopoly of the sex relation the shameless essence of this institution, and the Yoshiwara was the center of the literary and artistic life of the common people. Their fashions were set by the Yoshiwara. The geisha, whose place in Japanese society was the same as that of the Greek Hetaira, or her ancient Hindu equivalent, as for instance she appears in the Hindu comedy, the *"Little Clay Cart,"* was not less in her ideal perfection than Aspasia, beloved of Pericles. The geisha was perhaps the most exquisite product, scandalous as the fact may appear, of an exquisite civilization. She was in society the living Japanese work of art: thoroughly trained in music, literature, and the rarest and fairest amenities of life, she was herself the crowning amenity and poetic refinement of their life. This, all must recognize and comprehend; else we shall be tempted by false shames and Puritan prejudices to resent the theme of so many of the loveliest among the prints, and by a quite stupid dogmatism disallow our aesthetic delight in their charm. But we have very likely said enough of the print itself; let us pass on to consider what it has already done for us and what it may yet do. We have seen that this art exists—in itself a thing of beauty—inspired by need of expressing the common life in organic terms, having itself the same integrity, considered in its own nature, as the flower. Caught and bodied forth there by human touch is a measure of that inner harmony which we perceive as a proof of goodness and excellence.

It exists, a material means for us to a spiritual end, perhaps more essentially prophetic in function than it was to the people for whom it came into candid and gracious being. It has already spoken to us a message of aesthetic and ethical import. Indeed, its spirit has already entered and possessed the soul and craft of many men of our race and spoken again through them more intimately and convincingly than ever. That message we recognize in more familiar accents uttered by Whistler, Manet, Monet, the "Plein-air" school of France—Puvis de Chavannes, M. Boutet de Monvel—and through them it has further spread its civilizing, because its conventionalizing, simplifying, clarifying influence to the arts and crafts of the occident on both sides of the Atlantic.

Every dead wall in the land bears witness to the direct or indirect influence of this humble Japanese art of the people; for it has given us what we some time ago called "poster art." Because of it, in England Aubrey Beardsley and his kith lived and wrought. Modern France, the first to discover its charm, has fallen under its spell completely; French art and Parisian fashions feel its influence more from year to year. The German and Austrian Secessionist movement owes it a large debt of gratitude. Yet the influence of this art is still young. The German mind has only recently awakened to its significance and proceeds now with characteristic thoroughness to ends only half discerned. It has spread abroad the gospel of simplification as no other modern agency has preached it and has taught that organic integrity within the work of art itself is the fundamental law of beauty. Without it, work may be a meretricious mask with literal suggestion or sensual effect, not true art. That quality in the work which is "real" escapes and the would-be artist remains where he belongs—outside the sanctuary. The print has shown us that no more than a sandbank and the sea, or a foreground, a telegraph pole, and a weed in proper arrangement, may yield a higher message of love and beauty, a surer proof of life than the sentimentality of Raphael or Angelo's magnificent pictorial sculpture. Chaste and delicate, it has taught that healthy and wholesome sentiment has nothing in common with sentimentality, nor sensuous feeling with banal sensuality; that integrity of means to ends is in art indispensable to the poetry of so-called inspired results; and that the inspiring life of the work of art consists and inheres, has its very breath and creative being within the work itself; an integrity, in fine, as organic as anything that grows in the great out-of-doors.

Owing to its marked ethnic eccentricity, this art is a particularly safe means of cultivation for us, because the individual initiative of the artist is not paralyzed by forms which he can use as he finds them, ready-made. It may become most useful on this very account, as a corrector of the fatal tendency to imitation—be the antidote to the very poison it might administer to the weak and unwary—to that corrupting, stultifying, mechanical parasitism that besets and betrays so often to his ruin, in these days of hustle and drive, the eager and ambitious artist. For the architect, particularly, it is a quickening inspiration, without attendant perils, owing to

its essentially structural character and diverse materials and methods. To any and all artists it must offer great encouragement, because it is so striking a proof of the fact readily overlooked—that to the true artist his limitations are always, if but understood and rightly wooed, his most faithful and serviceable friends.

If, then, there is a culture we might acquire whereby the beautiful may be apprehended as such and help restore to us the fine instinctive perception of and worship for the beautiful, which should be our universal birthright instead of the distorted ideas, the materialistic perversions of which we are victims, we assuredly want to know what it is and just how it may be had. Nothing at this moment can be of greater importance to us educationally. For the laws of the beautiful are immutable as those of elementary physics. No work sifted by them and found wanting can be a work of art. The laws of the beautiful are like the laws of physics, not derived from external authority, nor have they regard to any ulterior utility. They preexist any perception of them; inhere, latent, and effective, in man's nature and his world. They are not made by any genius, they are perceived first by the great artist and then revealed to mankind in his works. All varieties of form, line, or color, all tendencies in any direction have, besides what value they may have acquired by virtue of the long cultural tradition recounting back to prehistoric man, a natural significance and inevitably express something. As these properties are combined, arranged, and harmonized, expression is gained and modified. Even a discord is in a sense an expression—an expression of the devil or of decay. But the expression we seek and need is that of harmony or of the good; known otherwise as the true, often spoken of as the beautiful, and personified as God. It is folly to say that if the ear can distinguish a harmonious combination of sounds, the eye cannot distinguish a harmonious combination of tones or shapes or lines. For in the degree that the ear is sensitive to sound—to the extent that it can appreciate the harmony of tones—in even a larger degree the eye will see and appreciate, if duly trained to attend them, the expression of harmonies in form, line, and color purely as such; and it is exactly harmonies of this kind, merely, which we find exemplified and exquisitely elucidated in Japanese prints.

Rhythmical and melodious combinations of tone otherwise only "noise" have portrayed the individualities of great souls to us—a Bach, Beethoven, or a Mozart; and while the practice of no musical rule of three could compass their art or sound the depths of their genius, there are definite laws of harmony and structure common to their art which are well known and systematically taught and imparted. So the mysterious impress of personality is revealed in certain qualities of this unpretentious art, as any even cursory observer must note, in the works of Harunobu,[6] Shunsho, Kiyonaga, Hokusai, and Hiroshige.

The principles underlying and in a sense governing the expression of personal feeling and the feeling of personality as expressed in these prints, or for the matter of that in any veritable work of art, have now been clearly formulated anew for many of us by assiduous study of their works. Questions of aesthetics may no longer be so readily referred to with flippancy, as mere negligible "matters of taste." Aside from their ethnic character—the fact that the individuality of these expressions may be but the color, so to say, of some Japanese artist's soul—such expressions do convey an ideal of the conditions they seek to satisfy, for the simple reason that the expression was the sought and wrought response to spiritual need, which nothing less or else could satisfy. Just as Beethoven at his keyboard imposed upon tone the character of his soul, so by these simple colored drawings a similar revelation is achieved by the Japanese artist through the medium of dye stuffs and graven lines applied to sensitive paper, putting together its elements of expression in accord with brain and heart, attaining to beauty as a result insofar as the artist was true to the limitations imposed upon him by the nature of the means he employed. He might merely characterize his subject and possess little more than the eye of the great craftsman; or he might idealize it according to the realizing insight of the great artist; but in either case to the degree that the colors and lines were true to material and means delightfully significant of the idea, the result would be a creative work of art.

Now, all the while, just as in any musical composition, a conventionalizing process would be going on. To imitate that natural modeling of the subject in shade and shadow—to render realistically its appearance and position—would require certain dexterity of hand and a mechanic's eye certainly. But

in the artist's mind there was a living conception at work—the idea: the revelation of the vision by means of the brush and dye stuffs and paper applied to engraved wooden blocks, with strict regard and devout respect for the limitations of materials, and active sympathy making all eloquent together; eloquent, however, in their own peculiar fashion as graven lines on sensitive paper, which has received color from the variously tinted blocks and wherein this process is frankly confessed—the confession itself becoming a delightful poetic circumstance. There results from all this a peculiar, exquisite language, not literature, telling a story regardless of the conditions of its structure. For a picture should be no imitation of anything, no pretended hole in the wall through which you glimpse a story about something or behold winter in summer or summer in winter. *Breaking Home Ties*, for instance, or any of its numerous kith and kin cannot be dignified as art. There are many degrees of kinship to *Breaking Home Ties* not so easy to detect, yet all of which bear the marks of vulgar pretense. The message of the Japanese print is to educate us spiritually for all time beyond such banality.

Not alone in the realm of the painter is the message being heeded, but also in that of the musician, the sculptor, and the architect.

In sculpture the antithesis of the lesson is found in the "Rogers Groups," literal replicas of incidents that as sculpture are only pitiful. Sculpture has three dimensions, possibilities of mass and silhouette, as well as definite limitations peculiar to itself. To disregard them is death to art. The Venus, the Victory,[7] classics living in our hearts today, and a long list of noble peers, are true sculpture. But the slavish making of literature has cursed both painter and sculptor. They have been tempted to make their work accomplish what literary art may achieve so much better—forcing their medium beyond its limits to its utter degradation. And this is as true of decorative art and in a sense true of architecture. General principles deduced from this popular art of the Japanese apply readily to these problems of right aesthetic conventionalization of natural things, revealing the potential poetry of nature as it may be required to make them live in the arts. This culture of the East therefore brings to us of the West invaluable aid in the process of our civilization. We marvel, with a tinge of envy, at the simple inevitableness with which the life-principle in so slight a thing as a willow wand will find fullness of expression as a willow tree—a glorious sort of completeness—with that absolute repose which is as of a destiny fulfilled. Inevitably the secret of the acorn is the glory of the oak. The fretted cone arises as the stately pine, finding the fullness of a destined life in untrammeled expression of its life-principle simply, naturally, and beautifully. Then we go to Nature that we may learn her secret, to find out that there has been laid upon us an artificiality that often conceals and blights our very selves, and in mere course of time and the false education of our mistaken efforts, deforms past recognition the life-principle originally implanted in us for our personal growth as men and our expressive function as artists.

We find and feel always in Nature herself from zero to infinity, an accord of form and function with life-principle that seems to halt only with our attempted domestication of the infinite. Society seems to lose or at least set aside some rare and precious quality in domesticating or civilizing—no—that is, in this conventionalizing process of ours which we choose to call civilization. Striving for freedom we gain friction and discord for our pains. The wisest savants and noblest poets have therefore gone direct to Nature for the secret. There they hoped against hope to find the solution of this maddening, perplexing problem; the right ordering of human life. But however much we may love oak or pine in a state of Nature their freedom is not for us. It belongs to us no longer, however much the afterglow of barbarism within us may yearn for it. Real civilization means for us a right conventionalizing of our original state of Nature. Just such conventionalizing as the true artist imposes on natural forms. The lawgiver and reformer of social customs must have, however, the artist soul, the artist eye, in directing this process, if the light of the race is not to go out. So, art is not alone the expression, but in turn must be the great conservator and transmitter of the finer sensibilities of a people. More still: it is to show those who may understand just where and how we shall bring coercion to bear upon the material of human conduct. So the indigenous art of a people is their only prophecy and their true artists, their school of anointed prophets and kings. It is so now more than ever before because we are further removed from Nature as an original source of inspiration. Our own art is the

only light by which this conventionalizing process we call "civilization" may eventually make its institutions harmonious with the fairest conditions of our individual and social life.

I wish I might use another word than "conventionalizing" to convey the notion of this magic of the artist mind, which is the constant haunting reference of this paper, because it is the perpetual insistent suggestion of this particular art we have discussed. Only an artist, or one with genuine artistic training, is likely, I fear, to realize precisely what the word means as it is used here. Let me illustrate once more. To know a thing, what we can really call knowing, a man must first love the thing, which means that he can sympathize vividly with it. Egypt thus knew the lotus and translated the flower to the dignified stone forms of her architecture. Such was the lotus conventionalized. Greece knew and idealized the acanthus in stone translations. Thus was the acanthus conventionalized. If Egypt or Greece had plucked the lotus as it grew and given us a mere imitation of it in stone, the stone forms would have died with the original. In translating, however, its very life-principle into terms of stone well adapted to grace a column capital, the Egyptian artist made it pass through a rarefying spiritual process, whereby its natural character was really intensified and revealed in terms of stone adapted to an architectural use. The lotus gained thus imperishable significance; for the life-principle in the flower is transmuted in terms of building stone to idealize a need. This is conventionalization. It is reality because it is poetry. As the Egyptian took the lotus, the Greek the acanthus, and the Japanese every natural thing on earth, and as we may adapt to our highest use in our own way a natural flower or thing—so civilization must take the natural man to fit him for his place in this great piece of architecture we call the social state. Today, as centuries ago, it is the prophetic artist eye that must reveal this natural state thus idealized, conventionalized harmoniously with the life-principle of all men. How otherwise shall culture be discerned? All the wisdom of science, the cunning of politics, and the prayers of religion can but stand and wait for the revelation—awaiting at the hands of the artist "conventionalization," that free expression of life-principle which shall make our social living beautiful because organically true. Behind all institutions or dogmatic schemes, whatever their worth may be, or their venerable antiquity, behind them all is something produced and preserved for its aesthetic worth; the song of the poet, some artist vision, the pattern seen in the mount.

Now speaking a language all the clearer because not native to us, beggared as we are by material riches, the humble artist of old Japan has become greatly significant as interpreter of the one thing that can make the concerns, the forms, of his everyday life—whether laws, customs, manners, costumes, utensils, or ceremonials—harmonious with the life-principle of his race—and so living native forms, humanly significant, humanly joy giving—an art, a religion, as in ever varied moods, in evanescent loveliness he has made Fujiyama—that image of man in the vast—the God of Nippon.

1. Torii Kiyonaga (1752–1815), prolific print designer perhaps best known for his tall, elegant women. The last major member of the Torii school, Kiyonaga was considered the great *ukiyo-e* master of the 1780s with tremendous influence through the end of the century, although he is believed to have given up printmaking about 1790.
2. Utagawa Toyokuni (1769–1825), an *ukiyo-e* painter and print designer whose most typical work depicted actors.
3. Ichikawa Danjuro, a famous Kabuki actor and the subject of numerous prints.
4. Katsukawa Shunsho (1726–1792) was one of the finest of the *ukiyo-e* actor print designers and a favorite of Wright's.
5. Pleasure was strictly controlled during the Tokugawa period (1603–1868), and the Yoshiwara was the licensed entertainment quarter of Edo, the "floating world" of the geisha and Kabuki theater.
6. Suzuki Harunobu (1724–1770) is known for his *nishiki-e*, brocade prints, of innocent youth. Although his prints were enormously popular until his death, the sweetness of his figures soon fell from favor and was replaced by the stately grace and elegance of Kiyonaga's courtesans.
7. The well-known *Winged Victory of Samothrace* was a favorite sculptural piece of Wright's. He had plaster casts of it made in reduced size and placed them in several of his early buildings.

Louis Henry Sullivan: His Work

Louis Sullivan's great value as an Artist-Architect—alive or dead—lies in his firm grasp of principle. He knew the truths of Architecture as I believe no one before him knew them. And profoundly he realized them.

This illumination of his was the more remarkable a vision when all around him cultural mists hung low to obscure or blight every dawning hope of a finer beauty in the matter of this world.

As "the name of God has fenced about all crime with holiness," so in the name of Architecture the "Classic" perpetually inserts skillful lies to hide ignorance or impotence and belie creation.

But the Master's was true creative activity—not deceived nor deceiving. He was a radical and so one knew, always, where to find him. His sense and thought and spirit were deep-rooted in that high quality of old and new which make them one and thereby he was apprised of the falsity of outward shows that duped his fellows and that dupe them still.

The names, attributes, and passions of earth's creatures change, but—that creation changes never; his sane and passionate vision leaves testimony here on earth in fragments of his dreams—his work.

His work! Who may gauge the worth of the work of such a man? Who shall say what his influence was, or is, or will be? Not I.

That his work was done at all was marvelous. That it could *be*, under the circumstances we call Democracy and that so mock his own fine sense of that much abused idea, was prophetic and for his country the greatest and most potent suggestion.

Here in this aspiring land of the impertinent, impermanent, and of commercial importunity, he never struck his colors. The buildings he has left us are the least of him—in the heart of him.

He was of infinite value to the country that wasted him, because it could not know him.

Work must be studied in relation to the time in which it presented its contrasts, insisted upon its virtues, and got itself into human view. Remember if you can the contemporaries of Louis Sullivan's first great work, the Chicago Auditorium. Those contemporaries were a lot of unregenerate sinners in the grammar of the insensate period of General Grant Gothic.

Imagine this noble calm of the auditorium exterior and the beautiful free room within, so beautifully conceived as a unit with its *plastic* ornamentation, the quiet of its deep cream and soft gold scheme of color, the imaginative *plastic* richness of this interior and compare both with the cut, butt, and slash of that period—the meaningless stiffness that sterilized the Chicago buildings for all their ambitious attitudes and grand gestures. They belonged to a world to which the sense of the word "*plastic*" had not been born. That the word itself could get itself understood in relation to architecture is doubtful—and then see what Louis Sullivan's creative activity from that time on meant to Architecture as an Art.

Back of that first great performance of his was a deepening knowledge, a tightening grasp on essentials. Much in the great effort got away from him; it wore him out; it was all at tremendous pressure, against fearful odds—but the Chicago Auditorium is good enough yet to be the most successful room for opera in the world. I think I have seen them all. His genius burst into full bloom with the impetus of the success and fame that great enterprise brought to him and to Adler. Dankmar Adler, his partner, was a fine critic. A master of the plan and of men.

1924

Published without illustrations in *The Architectural Record*, July 1924

His influence over Louis Sullivan at that time was great and good.

The Getty Tomb was a work that soon followed the Auditorium, as did the Wainwright Building[1] in St. Louis to greater purpose. The Getty Tomb in Graceland Cemetery was a piece of sculpture, a statue, an elegiac poem addressed to the sensibilities as such. It was Architecture in a detached and romantic phase, a beautiful burial casket, "in memoriam," but—a memorial to the architect whose work it was. His "type," the "form that was peculiarly his was never better expressed."

When he brought in the board with the motive of the Wainwright Building outlined in profile and in scheme upon it and threw it down on my table, I was perfectly aware of what had happened. This was Louis Sullivan's greatest moment—his greatest effort. The "skyscraper," as a new thing beneath the sun, an entity with virtue, individuality and beauty all its own, was born.

Until Louis Sullivan showed the way, the masses of the tall buildings were never a complete whole in themselves. They were ugly, harsh aggregates with no sense of unity, fighting tallness instead of accepting it. What unity those masses now have, that pile up toward New York and Chicago skies, is due to the Master-mind that first perceived one as a harmonious unit—its height triumphant.

The Wainwright Building cleared the way, and to this day remains the master key to the skyscraper as a matter of Architecture in the work of the world. The Wainwright and its group were Architecture living again as such in a new age—the Steel Age— *living in the work of the world!* The Practical therein achieving expression as Beauty. A true service rendered humanity in that here was proof of the oneness of Spirit and Matter, *when both are real*—a synthesis the world awaits as the service of the artist and a benediction it will receive when false ideas as to the nature and limitation of art and the functions of the artist disappear.

The Transportation Building[2] at the Columbian Exposition cost him most trouble of anything he ever did. He got the great doorway "straight away," but the rest hung fire. I had never seen him anxious before, but anxious he then was. How eventually successful this beautiful contribution to that fine collection of picture-buildings was, itself shows. But the Transportation Building was no solution to the work of the world as was the Wainwright Building. It was a "picture-building"—but one with rhyme and reason and, above all, individuality; a real picture, not a mere pose of the picturesque. It was not architecture in its highest sense, except as a great theme suggested, an idea of violent changes in scale exemplified, noble contrasts effected—meanwhile its excuse for existence being the enclosure of exhibition space devoted to transportation. It was no masterful solution of a practical problem. It was a holiday circumstance and superb entertainment, which is what it was intended to be. It was original, the fresh individual note of vitality at the Fair—inspiring, a thing created but—something in itself, for itself alone. Except that if here—where a mischief was done to architectural America from which it has never recovered, by the introduction of "the classic," so called, in the Fair buildings, as the "Ideal"—had that note of individual vitality as expressed in the Transportation Building been heeded for what it was worth, that mischief might largely have been averted. Only the Chicago Auditorium, the Transportation Building, the Getty Tomb, and the Wainwright Building are necessary to show the great reach of the creative activity that was Louis Sullivan's genius. The other buildings he did are blossoms more or less individual upon these stems. Some were grafted from one to the other of them, some were grown from them, but all are relatively inferior in point of that quality, which we finally associate with the primitive strength of the thing that got itself done regardless and "stark" to the Idea: sheer, significant, vital.

As to materials, the grasp of the Master's imagination gripped them all pretty much alike. As to relying upon them for beauties of their own, he had no need—no patience. They were stuff to bear the stamp of his imagination and bear it they did: cast iron, wrought iron, marble, plaster, concrete, wood. In this respect he did not live up to his principle. He was too rich in fancy to allow anything to come for its own sake between him and the goal of his desire. It would have been to him like naturalistic noises in the orchestra.

Where his work fell short, it fell short of his ideal. He could not build so well as he knew, nor so true to his thought as he was able to think—often. But sometimes he did better than either.

I see his individual quality in that feature of his

work that was his sensuous ornament—as I see the wondrous smile upon his face—a charm, a personal appealing charm. So very like and so very much his own. It will be cherished long, because no one has had the quality to produce out of himself such a gracious, beautiful response; so lovely a smile evoked by love of beauty. The capacity for love, ardent, true, poetic, was great in him as this alone would prove. His world in this was interior, esoteric, peculiar to himself. It is none the less precious for that. Do you prefer the Greek? Why not? Do you admire the Chinese? Why not, as a matter of course? Do you prefer the Romanesque? It is your privilege. Perhaps you respond to old Baroque? Your reactions to Gothic you find more satisfying? Doubtless. But do you realize that here is no body of culture evolving through centuries of time a "style," but an *individual* in the poetry-crushing environment of a cruel materialism, who in this, invoked the goddess that hitherto whole civilizations strove for centuries to win, and won her with this charming smile—the fruit of his own spirit.

Ah, that supreme, erotic, high adventure of the mind that was his ornament! Often I would see him, his back bent over his drawing board, intent upon what? I knew his symbolism—I caught his feelings as he worked. A Casanova on his rounds? Beside this sensuous master of adventure with tenuous, vibrant, plastic form, Casanova was a duffer; Gil Blas a torn chapeau; Bocaccio's imagination no higher than a stable boy's. Compared to this high quest, the Don's was as Sancho Panza's ass. The soul of Rabelais alone could have understood and would have called him brother. How often have I held his cloak and sword while he adventured in the realm within, to win his mistress; and while he wooed the mistress, I would woo the maid! Those days! And now, I say, this caress that was his own, should be his own, forever sacred to him and treasured high for its own sake—this rhythmic pulse of the wings of America's creative genius. Whoso has the temerity to undertake to imitate it will fail. Take his principle who will, none may do better—and try the wings that nature gave to you. Do not try to soar with his. Has the time come when every man may have that precious quality called style for his very own? Then where, I ask you, are the others? Eros is a fickle god and hard to please. Musing with blinded eyes, he has heard from earth the music of an immortal strain; henceforth, will take no less.

Genius the Master had—or rather it had him. It possessed him, he reveled in it, squandered it, and the lesser part of him was squandered by it. He lived! And compared to what came to him in life from his effort, the effort itself being a quality of it, the greatly successful careers were, I imagine, relatively lifeless.

Yes, genius he had in the most unequivocal sense—true genius—there is no other kind—the effect of which is not seen in his own time, nor can it ever be seen. Human affairs are of themselves plastic in spite of names and man's ill-advised endeavors to make them static to his will. As a pebble cast into the ocean sets up reactions lost in distance and time, so one man's genius goes on infinitely forever, because it is always an expression of *principle*. And therefore, in no way does it ever run counter to another's genius. The Master's genius is perhaps itself a reaction, the initial force of which we can not—need not—see.

Of one thing we may be sure—the intuitions of such a nature, the work to which he put his hand, no less than the suggestion he himself was to kindred or aspiring natures, is worth more to the future in all conservative or progressive sense than all the work of all the schools, just as example is more valuable than precept.

Is it not true that *individuality* is the supreme entertainment of life? Surely it is the quality most precious in it and most worthy of conservation; veritably the visible hand of the Creator! Here, in Louis Sullivan was an example as clear and convincing as any, anywhere at any time, under conditions as unpromising to fulfillment as ever existed.

Is it not probable that the social solidarity that produced the great "styles" exists no longer in the same sense and that never more will such a manifestation appear, especially in a nation composed of nationalities like ours? But, as free opportunity offers, when America awakens spiritually or is awakened by spirit, individuality will come to flower in almost as many styles as there are individuals capable of style. And there will arise more and more men who are capable of it. Until we have a wealth of vital expression. We will then only need order in the aggregate—an "order" which will be established eventually by the nature of the individual intelli-

gence capable of style—*itself* perceiving the necessity for it and making it therefore a veritable condition of every such individual expression. The nature capable of style is more capable than any other of the appropriate conduct of that power, when and wherever need be.

Is not that a more desirable and logical conclusion to draw from the principle upon which this country was founded than that of the dead level of a mongrelized version of the "Classic," a renaissance of Renaissance should be allowed to characterize the mongrel as mongrel—and nothing more?

H. H. Richardson, great emotionalist in architecture that he was, elected to work in the "style" Romanesque. The Master dug deeper and made style for himself out of the same stuff the Romanesque was made from and the Gothic too. With all these examples before us of "styles," surely man may penetrate to the heart of *Style* and unveiling its secret be master of his own. And as a master of this type was Louis Sullivan—esoteric though his synthetic style may be. The leadership of Stanford White was esoteric, his mind that of a connoisseur. His gift was selective, and we owe, to him and his kind the architectural army of "good taste" that smothers the practical in applied expedients—an army whose beauty-worship is content with the beauty of the painted lady, the henna, paste, and rouge, or the more earnest kind, the avid antiquarian, or the far too credulous historian. What does it matter if Tradition's followers fail to see that Louis Sullivan's loyalty to tradition was wholly complete and utterly profound? His loyalty was greater than theirs, as the Spirit transcends the Letter. What lives in New York architecture is little enough and in spite of its grammar and far beyond the style-mongering it receives in the atelier. It is the force of circumstance piling itself inexorably by mere mass into the sky—the darkening canyons that are paths leading into darkness, or to Death! It seems incredible now, but such unity as those tall masses may have is due to the mastermind, that first conceived and contributed one as a unit. The Wainwright Building cleared the way for them—and to this day remains the master key to the skyscraper as Architecture the world over. Why is it so difficult for standardization to receive to a greater degree the illumination from within that would mean Life instead of Death? Why is the vision of such a mastermind lost in the competitive confusion of so-called ideas and jostling ambitions? Why is the matter, except for him, still all from the outside—culture nowhere sane nor safe except as the imitation or the innocuous is safe—which it never is or was. Look backward toward Rome!

Yes the great Master's contribution as to form may die with him. No great matter. This Way-shower needs no piles of perishable granite, no sightly shapes to secure his immortality or make good his fame. It is his fortune that in the hearts of his fellows his gift was real. The boon to us of his journey on this earth in the span of life allotted to him, is beyond all question, all calculation. His work was the work of a man for men—for sincere humanity. The look of the thing he did may or may not appeal to the imagination trained to regard certain rhythms, spacings, forms, and figures as architecture. Many faults may be laid to him but they are the rough hewn edges of the real thing. And what he did even more than the way he did it will always repay painstaking study if it is free study. It can only vex and puzzle the pedantic mind and end in its hostility—the hostility that never more than entertained and amused him although eventually it did destroy his usefulness. That hostility of the provincial mind is found on the farm, in the small town on Main Street, on Fifth Avenue, in the Seats of the Mighty, in the Church, in New York, and in Hollywood. Wherever that type of mind is found it will accept no radical, because anything radical is the death of the provincial. Instinctively the provincial mentality feels this, and fears it, and therefore hates. And Louis Sullivan was a radical in the same sense that the Ideal Man was the consummate radical of human history.

Not long ago—weary—he said to me in a despondent moment that it would be far more difficult now to do the radical work he did—more difficult to get accepted than when he worked. The dead level of mediocrity had risen to the point where herd-psychology had accepted as normal the "good form" of the school and stopped thinking. The inevitable drift had set in. But no, it is not so! The torch flung to the Master hand from the depths of antiquity, from the heart of the world, and held faithfully and firmly alight and aloft for thirty years at least by him, shall not go out. It has never yet since time began for man, gone out. Willing hands have already caught the divine sparks and little running fires are

lighted on the hills and glimmer in the dark; some flickering and feeble; some with more smoke than fire; some guttering in candle grease; but some—clear, candescent flame—that shall rise high and higher until the darkness the tired, wayworn Master saw—that specter looming as the horror of his country's shade—will fade in true illumination. Hope too long deferred will make the strongest hearts foreboding. For the consummate radical, the Kingdom on Earth was "at hand" nineteen hundred years ago. It is a little nearer now. This laborer in the same vineyard with a similar hope to the same purpose has gone, his hope still high. The sire of an immortal strain has gone unterrified into the gulf, which we call Death. A great chief among men's spirits, he has been made one with Nature—and now he is a presence to be felt and known in darkness and in light, spreading a vital and benign influence wherever quick dreams spring from youthful minds or careworn, toil-stained comrades to his thought may need—"that Light whose smile kindles the universe: That Beauty in which all things work and move."

"He lives, he wakes, 'tis Death is dead—not he." Not he, who in a world that chains and fetters humankind was Life's green tree. A benediction, he that will outlive the Curse—live down the Lie.

1. The Getty Tomb was built in 1890; the Wainwright Building in 1890–1891.
2. The Transportation Building was built in 1891–1893.

In the Cause of Architecture: The Third Dimension

1925

Published with
13 illustrations
in *Wendingen*,
1925

Twenty-seven years ago a Society of Arts and Crafts was projected at Hull House in Chicago. The usual artist disciples of Morris and Ruskin, devoted to making things by hand, and a professorial element from the university were assembled. Jane Addams, the founder of Hull House, had invited me to be present and toward the end of the enthusiastic meeting asked me to contribute to the discussion. I had then been practicing Architecture for some years and I knew what I had to say would be unwelcome— so begged leave to present my project in writing at the next meeting. I prepared the "Art and Craft of the Machine," which I then delivered, advocating the patient study of the Machine at work as the first duty of the modern artist. I had invited to be present at the meeting sheet-metal workers, terra-cotta manufactures, tile and marble workers, iron workers, wood workers, who were actually turning out the work that was architectural Chicago, therefore the architectural heart of America. The thesis I presented, simply stated, was—that the old ideals that had well served the handicraft of old were now prostituted to the machine—which could only abuse and wreck them, that the world needed a new ideal recognizing the nature and capability of the machine as a tool and one that would give it work to do that it could do well—before any integrity could characterize our Art. I named many things which I had found the machines then in use in the trades could already do better than it had ever been possible to do them by hand—instancing the emancipation from the old structural necessities that the machine, as an artist's tool, had already brought about. Finally, I proposed that the society be formed to intimately study the Machine's possibilities as a tool in the hand of the artist, to bring it into the ser-

vice of the Beautiful—instead of serving as then and now—to destroy it.

Several brilliant disciples of Ruskin and Morris from the University of Chicago swept my propositions aside in a mood of sentimental eloquence—I was voted down and out by the enthusiastic disciples of Ruskin and Morris (whose sacred memory, it seems, I had profaned) and the Society was formed upon the same old basis of pounding one's fingers making useless things, that had been the basis of countless other "Art Societies" that had come to nothing in the end. So, together with my small band of modern industrials, I withdrew.

The Society as it was formed was a two-dimension affair that might foster Art as a pleasant amateur accomplishment, a superficial matter. It had rejected the third dimension—the integral element—on suspicion.

The Machine as an artist's tool—as a means to a great end in Art—did not exist for Ruskin and Morris, nor for the academic thought of that day.

Nor did the disciples of Ruskin and Morris, nor the architects and artists present at that much later date, see it then. They do not see it yet and that is, very largely, what is the matter with Artist[s] and with the Art, that is also craft, today.

The old structural necessity in Architecture is dead. The Machine has taken it upon itself and the *"raison d'être"* of the forms that were Architecture has therefore been taken away from them.

As the skeleton of the human figure is clothed with tissue in plastic sense to give us the human form, so the Machine has made possible expressive effects as plastic in the whole—as is the human figure as an idea of form.

In all the crafts, the nature of materials is eman-

cipated by the Machine and the artist is freed from bondage to the old post-and-lintel form, the pilaster and architrave are senseless, and Architecture in superimposed layers is now an "imposition" in every sense.

A modern building may reasonably be a plastic whole—an integral matter of three dimensions: a child of the imagination more free than of yore, owing nothing to "orders" or "styles."

Long ago both "orders" and "styles" became empty rituals—they were never Architecture—they were merely forms cast upon the shores of time by the Spirit of Architecture in passing. Architecture is the living spirit of building truly and beautifully.

So the ground for a new life of Architecture of the third dimension—an integral Architecture—is furrowed thus by the Machine and still fallow awaits the seed of common sense to germinate and grow in it, great true forms—a vital living Architecture.

But like all simple things—too common to be interesting, too hard work to be attractive, the mastery of the Machine is still to come; and a harsh ugliness, in relentless cruelty, obscures the common good.

The principle of the Machine is the very principle of Civilization itself now focused in mechanical forms. Servants of brass and steel and mechanical systems construct Civilization's very form today!

We have, whether we like it or not, here introduced an element into human life that is mastering the drudgery of the world, widening the margin of human leisure. If dominated by human greed it is an engine of enslavement—if mastered by the artist it is an emancipator of human possibilities in creating the Beautiful.

Yet the Machine is forced to mutilate and destroy old ideals instead of serving new ones suited to its nature—and because artists are become mere fashionable accidents or social indiscretions instead of masters, civilization is forced to masquerade in forms of "Art" false a century ago; the architectural "Renaissance" a sun still setting—mistaken still for sunrise.

To face simple truth seems too fearful a thing for those now claiming the title and place of the "artist." The simpletons hug their fond prejudices and predilections in foolish attempts to make them by book or hook or crook into queer little fashionable lies or gorgeous shams, so satisfied with results that any sane and sensible treatment of a project accord-

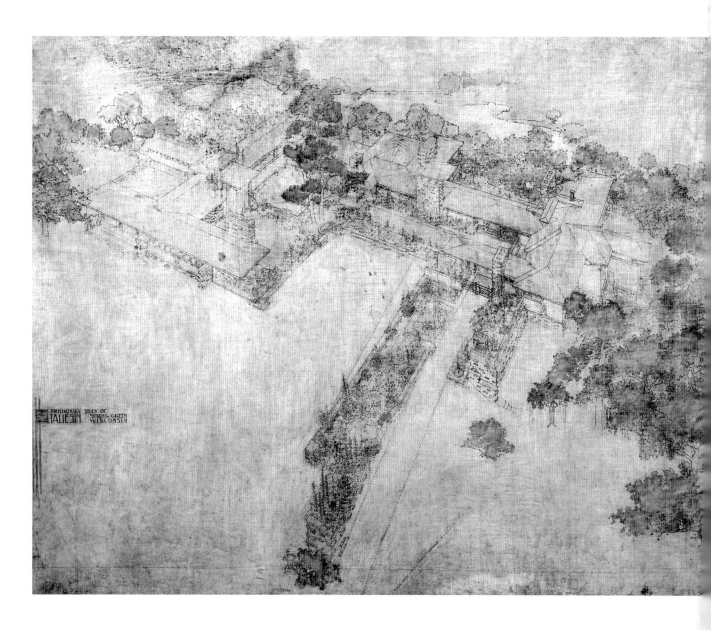

Frank Lloyd Wright House,
Taliesin II,
Spring Green, Wisconsin. 1914.
FLLW Fdn# 1403.022

ing to its nature is laughed at by and large; dubbed a freak and shown the door. Architecture in the hands of "Architects" has become a meaningless imitation of the less important aspect of the real thing: a mean form of bad surface decoration. It is Engineering that now builds.

Until the spirit of this modern Engineering finds expression as integral decoration, which is the third dimension coming into play, Architecture does not live at all.

The tools that produce work—(and by tools industrial systems and elements are also meant)—are now asked to do work to which they are wholly

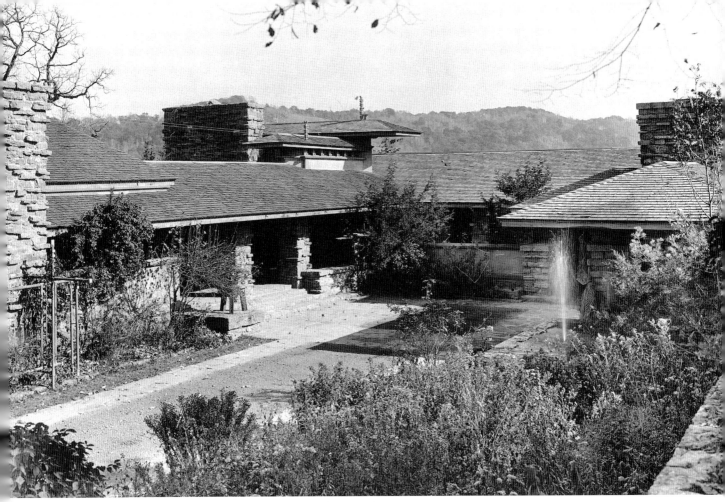

Frank Lloyd Wright House,
Taliesin II,
Spring Green, Wisconsin. 1914.
FLLW Fdn# 1403.0028

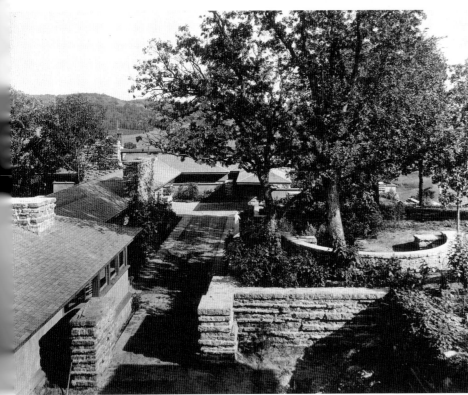

Frank Lloyd Wright House
and Studio, Taliesin I,
Spring Green, Wisconsin. 1911.
FLLW Fdn# 1104.0010

unsuited—"Styles" of work that were originated by hand when stone was piled on stone, and ornament was skillfully wrought upon it with clever human fingers: forms that were produced by a sensate power. Much as we may love the qualities of beauty then natural to such use and wont—we must go forward to the larger unity, the plastic sense of the "altogether" that must now be knowledge where then it was but instinct. The haphazard and picturesque must give way to ordered beauty emancipated from human fingers; living solely by human imagination controlling, directing great coordinations of insensate power into a sentient whole. Standardization and repetition realized and beautified as a service rendered by the Machine and not as a curse upon the civilization that is irretrievably committed to it.

I am not sure that the artist in this modern sense will be much like the picturesque personality of yore—in love with himself. Perhaps the quality in this modern will take off the curls and flapping hat of that love and show himself as sterner stuff in a most unpopular guise. Nor will he be a "business man." The reward of exploitation he will not have. His task will be otherwise and elsewhere—in the shops—in the factories, with the industrial elements of his age—as William Morris tried to be with them and for them; not with face turned backward to the Medieval world, as his was, but forward to a new one—yet unseen.

In that new world, all the resources that have accumulated to Man's credit as the Beautiful will only be useful in the Spirit in which they were created and as they stood when they were original and true forms. The Renaissance in Architecture was always false except that the admixture of ideals and races necessarily confused origins and so stultified them. And finally there is seen in America the logical conclusion of the ideal of "re-hash" underlying the European Renaissance, a mongrel admixture of all the styles of all the world. Here in the United States may be seen the final Usonian degradation[1] of that ideal—ripening by means of the Machine for destruction by the Machine. The very facility with which the "old orders of Beauty" are now become ubiquitous hastens the end. Academic thought and educational practices in America, seemingly, do not realize that the greatest of modern opportunities is being laid waste for the lack of that inner experience which is revelation in the Soul of the Artist-mind;

that sense of the third dimension as an essential factor to direct and shape the vital energy of these vast resources with integral forms if they are ever to have any spiritual significance at all—if America is ever to really live.

And I know that America is a state of mind not confined to this continent—but awakening over the whole civilized world.

America by virtue of her youth and opportunity is logical leader—were she not swamped by European backwash—sunk in the "get culture quick" endeavor of a thoughtless, too-well-to-do new country like this—buying its culture ready-made, wearing it like so much fashionable clothing, never troubled by incongruity or ever seeking inner significance.

A questionable bargain in the Antique, this culture—knocked down to the highest bidder, for cash.

Through this self-satisfied, upstart masquerade—with its smart attitude and smug sensibilities—this facetious parasite, skeptical of all save Fashion, this custom-monger whose very "life," as it sees it, would be taken by Truth—the new ideal must little by little work its way upward.

Among every hundred thousand opportunities, in the commercial sense, sacrificed to Fashion and Sham—we may hope for one, sincerely groping for reality, one willing to run the gauntlet of ridicule in a great cause; one to risk the next "job" in single-minded devotion to the one in hand—or for that matter all that might come after—for the precious sense of devotion to the freedom of Truth in creative work.

All that the new order signifies will not yet be found perfectly demonstrated in any one building. Each of the more sentient efforts will have a suggestion of it—a rare one may prophecy certain qualities to come in attributes already manifest—the seed time is now but the harvest shall not be yet.

First, we shall see a process of simplification—a rejection of the old meaningless forms—an erasure of the laborious mess of detail now striving, sweating for "effect." We will have a clean line, a flat surface, a simply defined mass—to begin with. What a rubbish heap will be behind this effort when it is got well under way!

Again to life will be called a sense of materials used for their own sake: their properties of line, form, and color revealed in treatments that aim to

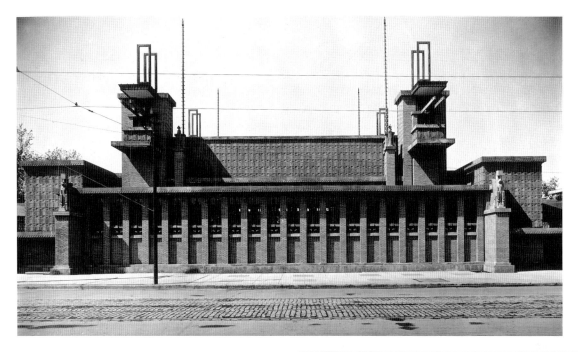

bring them out in designs that employ their beauty as a fair means, truthful in a consistent whole. Columns, lintels, voussoirs, pilaster, architrave, capital, and cornices—the whole grammar of the Art of building fashioned when the handicraft that imposed layer on layer in the old structural sense made it a fine thing—now false—inutile: the spirit of the old gone forward—made free.

Form, in the new plastic sense, is now infinitely more elastic. The third dimension enters with the "plastic" ideal as the very condition of its existence. Realism, as the outside aspect, is inutile. The abstraction that is the "within" is now reached.

Steel framing contributes a skeleton to be clothed with living flesh; reinforced concrete contributes the splay and cantilever and the continuous slab. These are several of the new elements in building which afford boundless new expressions in Architecture, as free, compared with post and lintel, as a winged bird compared to a tortoise, or an aeroplane compared with a truck.

The plastic order brings a sense of a larger unity in the whole—and fewer parts—monoliths where once we were content with patched and petty aggregates; soaring heights and sweeping breadths of line and mass uninterrupted by niggling handicraft units, as the laboriously made aggregation in two dimensions gives way to the unity born of conditions—plastic now—the third dimension essential to its reality.

Midway Gardens,
Chicago, Illinois. 1913.
FLLW Fdn# 1401.0028
and FLLW Fdn# 1401.0011

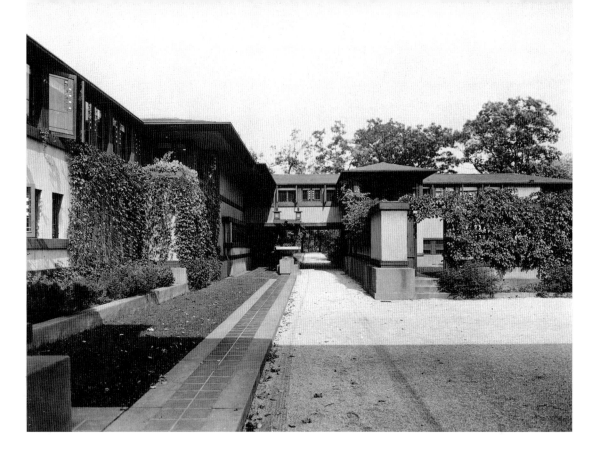

Avery Coonley House,
Riverside, Illinois. 1907.
FLLW Fdn# 0803.0013

The Larkin Building, like all the work I have done, is an essay in the third dimension, a conservative recognition of the element of the Machine in modern life. In it the old order has been rejected that the Principle of Architecture may live anew. The building expresses the interior as a single great form.

Unity Temple asserts again the quality and value of the third dimension in asserting the form within to be the essential to find expression. The reinforced concrete slab as a new architectural expression, is here used for its own sake as "Architecture." This building is a cast monolith. A transition building it is, wherein the character of the wooden forms or boxes, necessary at this time in casting concrete construction, are made a virtue of the whole in "style": that process of construction made a conscious aesthetic feature of the whole. Its "style" is due to the way it was "made." A sense of the third dimension in the use of the "box" and the "slab"— and a sense of the room within as the thing to be expressed in arranging them are what made Unity Temple; instead of the two-dimension-sense of the traditional block mass sculptured into architectural form from without.

The Coonley house at Riverside is of a type employing simple individual units, adapted each to its separate purpose, finally grouped together in a harmonious whole—simple materials revealed in its construction. The style of the Coonley home is due to this simple use of materials with a sense of the human figure in scale, the prairie as an influence and a sense of the horizontal line as the line of domesticity: this home and all its relatives grows as a part of its site. It grows from it and is incorporated with it, not planted on it. And this sense of the indigenous thing, a matter of the third dimension, is a first condition of any successful treatment, of any problem, in the modern sense—as it was the secret of success in all great old work wherever it may be found, subconscious then. But it must be used consciously now as a well-defined principle. Any building should arise from its site as an expressive feature

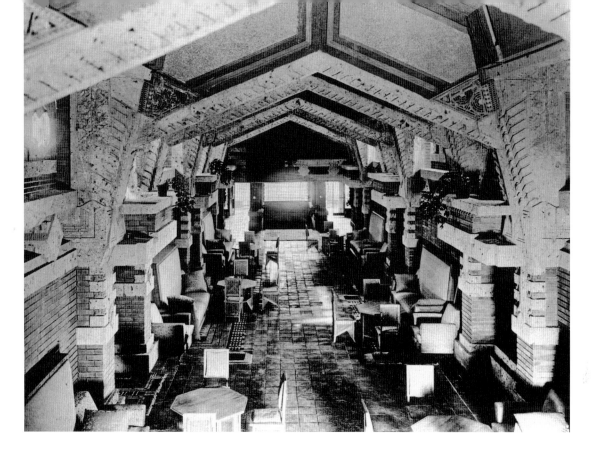

Imperial Hotel scheme #2,
Tokyo, Japan. 1917–22.
FLLW Fdn# 1509.0101

of that site and not appear to have descended upon it—or seem to be a "deciduous" feature of it. This "third dimension" element in architecture made more concrete when the work of Art is regarded as a plastic thing modeled as a fluid flowing whole, as contrasted with the idea of superimposition or aggregation or composition in the old structural sense, which was largely a two-dimension affair. No longer may we speak of "composition."

Plastic treatments are always out of the thing, never something put on it. The quality of the third dimension is found in this sense of depth that enters into the thing to develop it into an expression of its nature.

In this architecture of the third dimension "plastic" effects are usually produced from this sense of the within. The process of expression is development proceeding from generals to particulars. The process never begins with a particular preconceived detail or silhouette to secure which the whole is subsequently built up. In such two-dimensional mental processes the sense of third dimension is wholly absent, and not a natural thing but an applied thing is the inevitable result.

All the buildings I have built—large and small—are fabricated upon a unit system—as the pile of a rug is stitched into the warp. Thus each structure is an ordered fabric; rhythm and consistent scale of parts and economy of construction are greatly facilitated by this simple expedient: a mechanical one, absorbed in a final result to which it has given more consistent texture, a more tenuous quality as a whole.

I have wanted to build industrial buildings in America but unfortunately, though trained as an engineer and in commercial building, I have become known as an artist-Architect, the term "artist" being one of reproach in my country and therefore, for the moment shunned in the commercial field.

While I should have preferred to be employed in this field at home, I have been, for five years, constructing in a foreign country a romantic epic build-

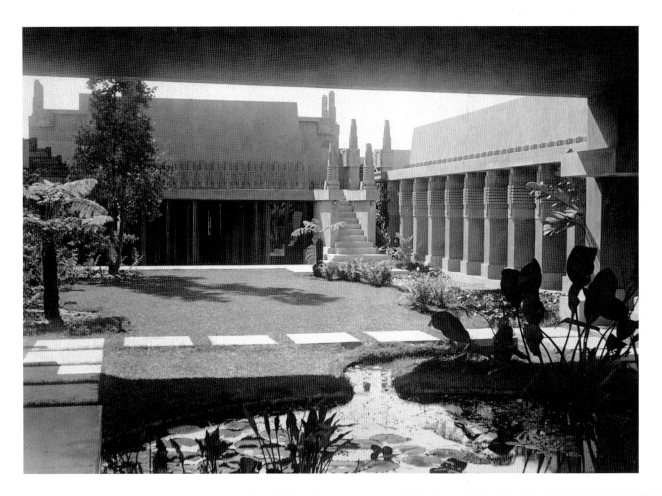

Aline Barnsdall "Hollyhock House,"
Los Angeles, California. 1920.
FLLW Fdn# 1705.0090
and FLLW Fdn# 1705.0015

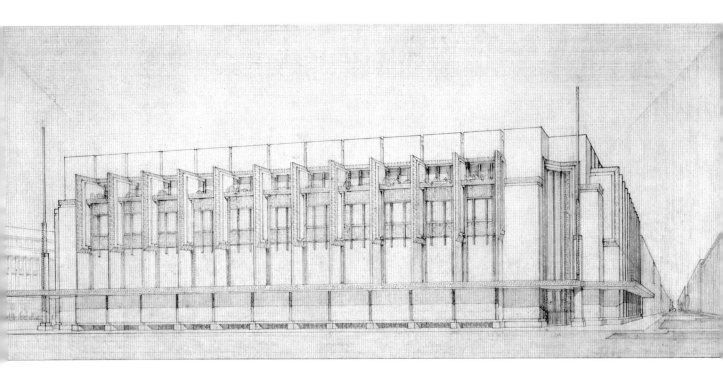

Merchandizing Building,
Department Store,
Los Angeles, California. 1922.
Project.
FLLW Fdn# 2203.007

ing, an architect's tribute to a unique nation he has much loved. This structure is not a Japanese building—nor an American building in Tokio. It is simply a free interpretation of the oriental spirit, once more employing the old handicraft system and materials to create a rugged, vital, monolithic building that would help Japan to create the necessary new forms for the new life that is her choice and inevitable to her now. I felt it desirable to do this without outraging all the noble Traditions which made that civilization a remarkable and precious thing in its own time.

But as a concession to the new spirit, the lava in this building and the brick are not used as structural materials. They are used as plastic covering "forms" cast in with the whole structure in decorative masses for their own sake. Where post and lintel construction is resembled it is a mere coincidence of not importance enough to be avoided.

The Olive Hill work in Los Angeles is a new type in California, a land of romance—a land that, as yet has no characteristic building material and no type of building except one carried there by Spanish missionaries in early days, a version of the Italian church and convent—now foolishly regarded as an architectural "Tradition." I feel in the silhouette of the Olive Hill house a sense of the romance of the region when seen associated with its background and in the type as a whole a thing adaptable to California conditions. This type may be made from the gravel of decayed granite of the hills easily obtained there and mixed with cement and cast in molds or forms to make a fairly solid mass either used as blocks to compose a "unit-slab" system or monolithic in construction. This is the beginning of a constructive effort to produce a type that would fully utilize standardization and the repetition of easily manhandled units. One of the essential values of the service rendered by the Machine, as elements in an architecture modeled by the "third dimension" is this standardizing of a convenient unit for structural purposes: I am still engaged in this effort.

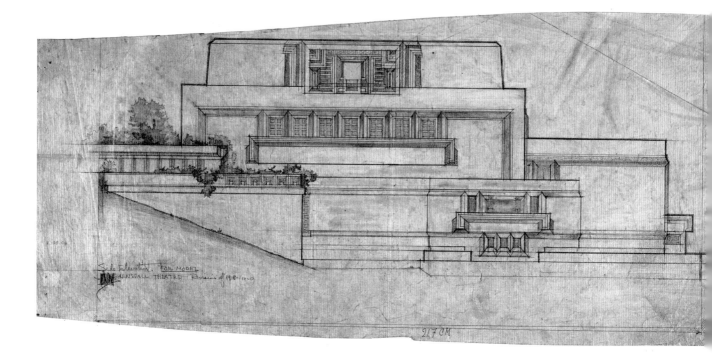

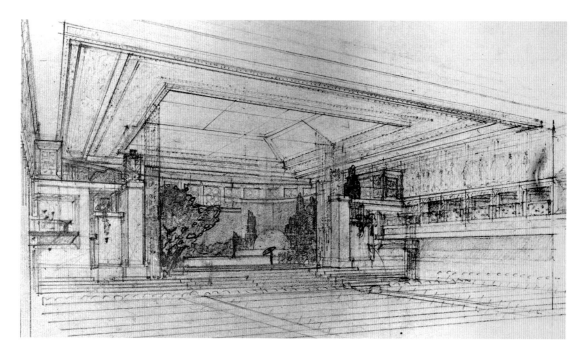

Olive Hill Theater Complex for Aline Barnsdall,
Los Angles, California. 1915. Project.
FLLW Fdn# 2005.006 and FLLW Fdn # 2005.064

It is a mistaken notion that the legitimate use of the Machine precludes ornamentation. The contrary is the case. Pattern—the impress of the imagination, is more vital than it ever was in the use of any other system or "tool" in any other age. But before we can find the significant expressions that give poetry and endless variety to this new architecture in any integral sense, we shall first have protested the old "ornamentation" by reverting to clean forms expressive as such in themselves. Little by little, the use of significant virile pattern will creep in to differentiate, explain, and qualify as a property of the third dimension as poetry. And the materials and structural enclosures will ever be increasing thereby in significance and what we call beauty. Imagination will vivify the background and expression of modern life, as truly and more universally and richly than was ever before seen in the world—even in the aesthetic background of the Moors or the Chinese.

The sneer of "factory aesthetics" goes by its mark.

It is the Imagination that is now challenged, not the Memory.

When the industrial buildings of a country are natural buildings and vital expressions of the conditions underlying their existence—the domestic architecture of that country will be likewise true; a natural, indigenous expression of modern life in its broader aspects and finer opportunities. This natural expression must be conditioned upon service rendered by the Machine—the Machine bringing man the fruits, that in olden times belonged only to the mastering few—to belong now to the many. In this we see the Machine as the forerunner of Democracy.

But then the Machine will not be, as now, engaged in impartially distributing meretricious finery of a bygone age, senselessly, from avenue to alley, but as that "finery" was once really fine, so again fullness and richness of life fitted to purpose in infinite poetic variety shall come to us.

Beauty may come abide with us in more intimate spirit than ever graced and enriched the lives of the masterful-few in the ancient "Glory that was Greece" or the "Grandeur that was Rome," if we master the Machine in this integral sense. It is time we realized that Grecian buildings have been universally overrated as Architecture: they are full of lies, pretence, and stupidity. And Roman architecture, but for the nobility of the structural arch, a thing now dead—was a wholly debased version of the better Greek elements that preceded it. Both civilizations have been saddled upon us as the very ideal so long that our capacity to think for ourselves is atrophied. Yet, we may now, from the vision opened by the ideal of a plastic architecture, look down upon the limitations of this antique world with less respect and no regret. We have wings where they had only feet, usually in leaden shoes. We may soar in individual freedom of expression where they were wont to crawl—and we are the many where they were the few. A superior breath and beauty in unity and variety is a universal possibility to us—if we master the Machine and are not, as now, mastered by it.

In the modern Machine we have built up a monster image of ourselves that will eventually destroy us unless we conquer it—and turn it from its work of enslavement to its proper and ordained work of emancipation. Then, in its proper place—the margin of human leisure immeasurably widened—the plastic in Art become a free-flowing channel for imaginative creative effort, we will have a background for life that is integral—a setting incomparably more organic and expressively beautiful as a whole than has ever been known before in the world—and more than that, an expression in itself of the best ideals, the purest sentiment for the beauty of Truth in all forms of life—ever yet realized by Man.

1. The first known written reference by Wright to the term *Usonia*. The term, meaning the United States and its culture, is further defined in "In the Cause of Architecture: The Architect and the Machine," p. 227 [93].

In the Cause of Architecture I: The Architect and the Machine

1927

Published without illustrations in *The Architectural Record*, May 1927

The Machine is the architect's tool—whether he likes it or not. Unless he masters it, the Machine has mastered him.

The Machine? What is the machine?

It is a factor Man has created out of his brain, in his own image—to do highly specialized work, mechanically, automatically, tirelessly, and cheaper than human beings could do it. Sometimes better.

Perfected machines are startlingly like the mechanism of ourselves—anyone may make the analogy. Take any complete mechanistic system and compare it with the human process. It is new in the world, not as a principle but as a means. New but already triumphant.

Its success has deprived Man of his old ideals because those ideals were related to the personal functions of hands and arms and legs and feet.

For feet, we have wheels; for hands; intricate substitutes; for motive power, mechanized things of brass and steel working like limited hearts and brains.

For vital energy, explosives or expansives. A world of contrivance absorbs the inventive energy of the modern brain to a great extent and is gradually mastering the drudgery of the world.

The Machine is an engine of emancipation or enslavement, according to the human direction and control given it, for it is unable to control itself.

There is no initiative will in machinery. The man is still behind the monster he has created. The monster is helpless but for him—

I have said monster—why not savior?

Because the Machine is no better than the mind that drives it or puts it to work and stops it.

Greed may do with it what it did with slaves in "the glory that was Greece and the grandeur that was Rome"—only do it multiplied infinitely. Greed in human nature may now come near to enslaving all humanity by means of the Machine—so fast and far has progress gone with it.

This will be evident to anyone who stops to study the modern mechanistic Moloch and takes time to view it in its larger aspects.

Well—what of it! In all ages Man has endured the impositions of power, has been enslaved, exploited, and murdered by millions—by the initiative wills back of arms and legs, feet and hands!

But there is now this difference—the difference between a bow and arrow and gunpowder. A man with a machine may murder or enslave millions, whereas it used to take at least thousands to murder millions. And the man behind the machine has nothing on his conscience. He merely liberates an impersonal force.

What is true of the machine as a murderer is just as true of it as a servant.

Which shall it be? It is for the creative artist to decide—For no one else. The matter is sociological and scientific only in its minor aspects. It is primarily a matter of using the machine to conserve life, not destroy it. To enable human beings to have life more abundantly. The use of the machine can not conserve life in any true sense unless the mind that controls it understands life and its needs, as *life*—and understands the machine well enough to give it the work to do, that it can do well and uses it to that end.

Every age and period has had its technique. The technique of the age or period was always a matter of its industrial system and tools, or the systems and tools were a matter of its technique. It doesn't matter which. And this is just as true today.

This age has its own peculiar—and, unfortunately, unqualified technique. The system has changed. The Machine is our normal tool.

America (or let us say Usonia—meaning the United States—because Canada and Brazil are America too)—Usonia is committed to the Machine and is Machine-made to a terrifying degree. Now what has the mind behind and in control of the Machine done with it to justify its existence, so far? What work suited to its nature has been given it to do? What in the way of technique has been developed by its use that we can say really serves or conserves Life in our country outside mere acceleration of movement?

Quantity production?—Yes. We have ten for one of everything that earlier ages or periods had. And it is worth so far as the quality of life in it goes, less than one-tenth of one similar thing in those earlier days.

Outside graceless utility, creative life as reflected in "things" is dead. We are living in the past, irreverently mutilating it in attempting to modify it—creating nothing—except ten for one. Taking the soul of the thing in the process and trying to be content with the carcass or shell or husk—or whatever it may be, that we have.

All Man-made things are worthy of life. They may live to the degree that they not only served utilitarian ends, in the life they served but expressed the nature of that service in the form they took as things. That was the beauty in them and the one proof of the quality of life in those who used them. To do this, love entered into the making of them. Only the joy of that love that gives life to the making of things proves or disproves the quality of the civilization that produced them.

See all the records of all the great civilizations that have risen and fallen in course of Time and you may see this evidence of love as joy in the making of their things. Creative artists—that is workmen in love with what they were making, for love of it—made them live. And they remain living after the human beings whose love of life and their understanding of it was reflected in them, are thousands of years dead. We study them longingly and admire them lovingly and might learn from them—the secret of their beauty.

Do we?

What do we do with this sacred inheritance? We feed it remorselessly into the maw of the Machine to get a hundred or a thousand for one as well as it can do it—a matter of ubiquity and ignorance—lacking all feeling, and call it progress.

Our "technique" may therefore be said to consist in reproduction, imitation, ubiquity. A form of prostitution other ages were saved from, partly because it was foolish to imitate by hand the work of another hand. The hand was not content. The machine is quite content. So are the millions who now have as imitations bearing no intimate relation to their human understanding, things that were once the very physiognomy of the hearts and minds—say the souls of those whose love of life they reflected.

We love life, we Usonians as much as any people. Is it that we are now willing to take it in quantity too—regardless of inferior quality and take all as something canned—long ago?

One may live on canned food quite well—But can a nation live a canned life in all but the rudimentary animal expressions of that life? Indefinitely?

Canned Poetry, Canned Music, Canned Architecture, Canned Recreation. All canned by the Machine.

I doubt it, although I see it going on around me. It has its limits.

We must have the technique to put our love of life, in our own way, into the things of our life, using for our tool the Machine, to our own best advantage—or we will have nothing living in it at all—soon.

How to do it?

Well! How does anyone master tools? By learning the nature of them and, by practice, finding out what and how they do, what they do best—for one thing.

Let architects first do that with the Machine. Architects are or must be masters of the industrial means of their era. They are, or must be—interpreters of the love of life in their era.

They must learn to give it expression in the background for that life—little by little, or betray their office. Either that or their power as normal high priests of civilization in a Democracy will never take its place where it is so badly needed. To be a mason, plasterer, carpenter, sculptor, or painter won't help architects much—now.

They may be passing from any integral relation to life as their architecture, a bad form of surface

decoration superficially applied to engineering or buildings would seem to indicate and their function go to something other and else. An embarrassment of riches, in the antique, a deadly facility of the moment, a polyglot people—the necessity of "ready-made" architecture to clothe the nakedness of steel frames decently or fashionably, the poisonous taste of the period; these alibis have conspired with architects to land us where we all are at the mercy of the Machine. Architects point with pride to what has happened. I can not—I see in it nothing great—at least nothing noble. It is as sorry a waste as riches ever knew. We have every reason to feel ashamed of what we have to show for our *"selves"* in any analysis that goes below the skin.

A kind of skin disease is what most architecture is now as we may view it today. At least it never is organic. It has no integrity except as a "composition." And modern artists, except architects, ceased to speak of "composition" long ago.

Fortunately, however, there is a growing conviction that architecture is something not in two dimensions—but with a third and that third dimension in a spiritual sense may be interpreted as the integral quality in the thing or that quality that makes it integral.

The quality of *life* in man-made "things" is as it is in trees and plants and animals, and the secret of character in them which is again "style" is the same. It is a materialization of spirit.

To put it baldly—Architecture shirks the machine to lie to itself about itself and in itself, and we have Architecture for Architecture's sake. A sen-

timental absurdity. Such "Architecture" being the buildings that were built when men were workmen—and materials and tools were otherwise—instead of recognizing Architecture as a great living Spirit behind all that—a living spirit that left those forms as noble records of a seed time and harvest other than ours, thrown up on the shores of Time, in passing. A Spirit living still only to be denied and belied by us by this academic assertion of ours that they are that spirit. Why make so foolish an assertion? I have asked the question in many forms of many architects, in many places, and always had to answer myself. For there is no philosophy back of the assertion other than a denial or a betrayal—that will hold together. Instead there is a doctrine of Expediency fit only for social opportunists and speculative builders or "schools." There is no other sense in it.

The Machine does not complain—it goes on eating it all up and crying continually for more.

Where is more coming from? We have already passed through nearly every discovered "period" several times forward and gone backward again, to please the "taste" of a shallow present.

It would seem, now, time to take the matter seriously as an organic matter and study its vitals—in a sensible way.

Why not find out what *Nature* is in this matter. And be guided by principles rather than Expedients? It is the young man in architecture who will do this. It is too late for most successful practitioners of today to recover from their success. These essays are addressed to that young man.

In the Cause of Architecture II: Standardization, the Soul of the Machine

John Ruskin and William Morris turned away from the machine and all it represented in modern art and craft. They saw the deadly threat it was to all they loved as such—and eventually turned again to fight it, to the death—their death. They are memories now. Pleasant ones. They did not succeed in delaying destruction nor in constructing anything. They did, however, remind us of what we were losing by using the machine or, as they might have said, letting the machine use us.

Repetition carried beyond a certain point has always taken the life of anything addressed to the living spirit.

Monotony kills.

Human feeling loves the vigor of spontaneity, freshness, and the charm of the unexpected. In other words, it loves life and dreads death.

The Machine Ruskin and Morris believed to be the enemy of all life. It was and is so still, but only because the artist has shirked it as a tool while he damned it; until now he has been damned by it.

Standardization as a principle is at work in all things with greater activity than ever before.

It is the most basic element in civilization. To a degree it is civilization itself.

An oriental rug, lustrous, rich with color and light, gleaming with all the brilliant pattern opulent oriental imagination conceived, has a very definite basis of standardization in warp and woof. In the methodical stitches regularly taken with strands of woolen yarn, upon that regular basis of cotton strings, stretched tight, lies the primitive principle of standardization. Serving the imagination full well.

Standardization here serves the spirit well—its mechanics disappear in the glowing fabric of the mind—the poetic feeling of the artist-weaver with love of beauty in his soul.

Standardization should have the same place in the fabric we are weaving which we call civilization—as it has in that more simple fabrication of the carpet. And the creative artist-mind must put it into the larger more comprehensive fabric.

How?

Not so simple.

This principle of standardization has now as its tool or body—the Machine. An ideal tool compared to which all that has gone before is as nothing.

Probably Gutenberg's invention of movable types was the first great advent of the machine in any sweeping form.

The blessing of that invention is obvious as is the curse that came with it.

The body of the book became volatile, almost infinite—and mind failed to keep up with it. Trash inundated the civilized world and streams of printed pages became wrapping paper to fill packing cases, light fires, and blow unheeded about the gutters of the world.

A deluge. And yet the book lives. There are a thousand writers for one in earlier eras and mostly worth one-thousandth part as much. "Shifting type" was the principle of standardization at work. The machine is the "press," that we have today serving it. What happened here in printing has happened to nearly everything in our lives. Happened or is happening or soon to happen with similar but more disastrous results, quantity at expense of quality—with always the blessing that comes from it, making available to the poor and needy a cheap or debased form of what was once rare and precious. I am speaking of fine art from the architect's standpoint.

1927

Published without illustrations in *The Architectural Record,* June 1927

So we see in the Machine the forerunner and ideal agent of Usonian Democracy such as it is. A Democracy sentimental and unsound, but that is another and longer story.

We see in this old force a new agency hard to control. A force once released into the world—never to be stopped until everything in it once precious and valuable for its own sake in its intimate relation to former good or great life has been fed to the dogs, or swine, speaking bitterly. But meantime raising the opportunities for "having things" the world over with a chance of turning the dogs, or swine, into more human beings.

And, honestly let it be said, of putting all human beings perhaps at the mercy of swine and dogs.

This is where the creative artist steps in: to bring new life of the mind to this potent agency: new understanding that will make living more joyous and genuine by abolishing the makeshift, showing up imitation for the base thing it is—saving us from this inglorious rampage and rapine upon antiquity. There is no artist conscience, it seems, in all this. The artist is like a hungry orphan turned loose in a bakeshop. The creative artist is not in it.

That ancient honor of the race, creative art, can not be dead. It needs only awakening. No wonder it lies all but moribund floating in the "deluge" at the mercy of the current of ubiquity, rushing toward—well, let us hope, toward the great peace of the great ocean.

This principle of standardization then, is no detriment to art or artist. It has always existed. And like any principle has its uses and its abuses.

How foolish therefore to take a prevalent abuse of any thing for the thing itself?

An artist is sentient. He is never fooled by brains or science or economics. He knows by feeling—say instinct—right or living, from wrong or dead.

He may not, however, have the technique to make his "knowing" effective and so remain inarticulate. But it is his duty to know, for his technique is what makes him serviceable to his fellows as artist. Acquiring the technique of the Machine as the tool of standardization, mastering the nature of both, is the only thing now that will make him the living force necessary to salvage the flotsam and jetsam of the "deluge," or, let it all go and begin over again.

Begin another era: the modern era of the machine with all it implies, economically making life more joyous and abundant as a matter of quality—as well as quantity.

Standardization apprehended as a principle of order has the danger of monotony in application.

Standardization can be murderer or beneficent factor as the life in the thing standardized is kept by imagination or destroyed by the lack of it.

By the "life" in the thing, I mean the *integrity* of the thing (we are talking of the things of art and craft) in the sense of the third dimension—as I have already tried to explain it.

The "life" in the thing is that quality of it or in it which makes it perfectly *natural*—of course that means organic. And that simply means true to what made it, as it was made, and for what it was made. That would be the *body* of the "thing." A matter of good sense.

New opportunities have come, not to hand but to the mind.

This may not seem specific. But it is a point of view necessary to the understanding of the experiences which follow. For in that spirit the experiments were made and the results judged as good or bad that will appear as I write.

The first study of importance in this connection is, of course, the nature of *materials*.

It is impossible to do anything intelligently to or with something you know nothing about. To know intimately the nature of wood, paper, glass, sheet metal, terra-cotta, cement, steel, cast iron, wrought iron, concrete, is essential to knowing how to use the tools available to make use of those materials, sensibly or artfully.

So let us glance at these more staple materials. We will find certain properties in all that standardization will serve well; and other properties, too, that standardization carried too far, will kill.

The principle of standardization, applied, may be said to be a matter of knowing by a *study* of the nature of whatever we apply it to—when to quit.

Let us begin with a short study of wood.

What is wood?

A workable, fibrous material got from trees in almost any length, certain breadths and thicknesses, now standardized. They may be had in almost any color or texture, as trees are growing, in great variety all over the world. Different woods vary in characteristics, made known by use in all ages. To it man has had recourse for nearly every need. He has made of

it a part, of entirely, in one form or another, nearly everything he uses. It may be polished or painted or stained to bring out its grain which is the great characteristic of its beauty. It may be sawed or cut to bring this beauty to the surface in various ways. It was once laborious to hand-saw and cut and smooth it. Machines now do all that better. Machines cut veneers so cheaply and so thin and so wide they may be applied like wallpaper to broad surfaces. Machines cut rotary veneers from the curling surface of the log in any width, unwinding the surface with a cut of the grain unknown before. Really, this property of wood has been liberated and made available in beautiful sheets, so beautiful in surface that it is folly to mold it and join it and panel it painfully any more as before.

It may be used in broad, simple, plastic ways now even more cheaply than in laborious joinery with its tendency to go to pieces because it was all in pieces.

Much more could be said. Here is enough to indicate new possibilities of design in machined wood.

Inlaid lines are characteristic too—slender inlaid decorative purflings or battens in between wide, plain, broad, etc., etc.

Plastic treatment, now you see, instead of *constructed* ones or "structuralities."

There are infinite possibilities here. And in making wood into furniture, clean straight line effects, as delicate as may be, are characteristic of the machine. A limitation that makes the nature of wood very beautiful as it appears within these limitations of form.

Wood carving usually did violence to the nature of wood. It tended to mutilate and destroy it.

The machine can inlay, fret, and bring up the beauty of wood in plastic treatments more true to the nature of the wood. Why not then, forget ancient models that are especially made to suit freedom of the hand? The nature of wood was overwrought and lost in three out of five of such models anyway. But here the beauty that is wood lives above standardization, if the architect sees it and uses it in this new "plastic" sense.

Let us take glass.

Glass was once a delightful substance in itself. It is now chiefly a perfect "clarity" or nothing very delightful.

Such clearness in polished glass as we have is new in the world. We may have great polished surfaces for reflections, leaving openings as though nothing closed them—limpid surfaces playing the same part in all interiors that water plays in the landscape. We have lost a substance but found a freedom infinitely precious to the designer of buildings. This is the mechanical plate glass of the machine. New opportunities here. Imagine a few.

There is electro glazing to introduce the element of pattern into the clear glass in delicate straight lines in bewildering delicacy and variety.

The mind must enter now to take the place of what, in the antique, was adorable as a natural quality of the glass itself. The scene has shifted, but we are still better off, in glass.

We can make colored glass for the painter to use as pigment in his hand, but it is now a lesser interest. We have limpid surfaces, true reflections, and unobstructed vision due to the machine.

And there is steel, a new thing under the sun. And the most significant material of this age. The one that has done most harm to the established order—or Pseudo-Classic.

In the Cause of Architecture III: Steel

1927

Published
without
illustrations
in *The
Architectural
Record,*
August 1927

Steel is the epic of this age.

Steel has entered our lives as a "material" to take upon itself the physical burden of our civilization.

This is the Age of Steel. And our "culture" has received it as ancient Roman culture received the great gift of the masonry arch. For centuries the Romans pasted the trabeated Greek forms of their "culture" on the arch in front as architecture, while the arch did the work behind.

Finally the noble virtue of the arch overcame the sham culture of the period and came forth and lived as a great and beautiful contribution to mankind.

Steel is still smothered in aesthetic gloom, insulted, denied, and doomed by us as was the masonry arch by the Romans. Inherent virtue will triumph here, too, in the course of time. So much wasted time!

This stupendous material—what has it not done for Man?

What may it not yet do for him with its derivatives and associates as the glare of the converters continues to mount into the sky, day and night.

Now, ductile, tensile, dense to any degree, uniform and calculable to any standard, steel is a known quantity to be dealt with mathematically to a certainty to the last pound; a miracle of strength to be counted upon!

Mathematics in the flesh—at work for man!

A mere plastic material, thin and yet an ultimate rigidity, rolled hot or rolled cold to any desired section of any strength unlimited in quantity; or, continuously night and day, drawn into thin strands of enormous strength and length as wire—enough to wind the world into a steel-covered ball; or, rolled in any thickness into sheets like paper, cut by the shears into any size.

A rigidity condensed in any shape conceivable, to be as easily bored, punched, planed, cut, and polished, too, as wood once was. More easily and cheaply curved or bent or twisted or woven to any extent and the parts fastened together. A material that in the processes already devised not only takes any shape the human brain can reduce to a diagram but can go on producing it until the earth is covered with it—and there is no escape from it. No, none!

For it is cheap.

Cheaper in its strength and adaptability than anything man ever knew before—thousands of times over.

But it has it in its nature to change its volume with changes of temperature.

It has a fatal weakness.

Slowly it disintegrates in air and moisture and has an active enemy in electrolysis. It is recovering from this weakness. It is only fair to say that it may become, soon, immune. Then, what?

Meanwhile, owing to its nature it may be plated with other metals or protected by coverings of various sorts or combined with them. In itself it has little beauty, neither grain, nor texture of surface. It has no more "quality" in this sense than mud. Not so much as sand. It is a creature wholly dependent upon imaginative influences for "life" in any aesthetic sense at the hand of a creator.

So is terra-cotta. So is concrete, although both these friable materials have certain internal possibilities of texture and color.

So also relatives of steel have beautiful permanent surfaces—bronze, brass, silver, gold, aluminum, copper, tin, and zinc and others. It would be interesting to write about them all.

But the weaknesses of steel are not fatal to beau-

tiful use, nor is the lack of individuality in texture other than an opportunity for the imagination.

Yet, how or where is steel evident in our life as a thing of beauty in itself? In tools? Yes, in knives and saws and skates: in hardware. In engines, in the rails of the railroad, in the locomotive, the submarine, the torpedo boat, the aeroplane. In bridges? Yes, but only where the engineer was inspired and allowed his stresses and strains to come and go clean in the members, innocent of any desire or intent on his part to "ornament" them. Used honestly by engineers, steel has something of the beauty of mathematics.

Remember, however, that music is but sublimated mathematics. And the engineer is no more capable of giving steel structure the life of "beauty" it should have than a professor of mathematics is capable of a symphony in music.

The principles of construction which find in steel a medium that will serve with safety and economically in various designs as a support for enormous loads to span wide spaces, or supporting enormous loads to enormous height, are, as long as they are really kept scientific and clean, showing as such, the best work we have to show.

And it is much.

But it is not the architect who can show it.

When the architect has dealt with it what has he done? The skyscraper and lied about it. The modern Cathedral, lifeless, dummy, supported from within to appear "lifelike" without. Anything you wish to name as architecture will be likewise.

Anything you may name as engineering where architects cooperated will be similar, probably.

An exception here and there is now manifest, already late. This era is fast and furious in movement. But all movement is not progress. Architecture has not progressed with steel. "Architecture" has all but died of it while architects were singing their favorite hymns and popular Christmas carols to the medieval antique.

Incredible folly! "Tower" Buildings, East River bridges, St. John the Divine's, States' Capitols, and all. How all of them mock integrity! Wherein lies the artist grasp of the "masters" who design such structures?

Had Bach or Beethoven made music the mathematics of which would be like the principles of construction in such edifices, what would such music

sound like? Pandemonium, requiring hideous grimaces and falsities of tone and absurdities of concatenation with no rhythm, obvious or occult, outrage to the mind. Inconceivable!

For the principles of construction now find in steel because it is a strictly calculable material of miraculous strength, ideal expression as the sinews and bones of structure.

The architect has been satisfied to leave the mathematical sinews and bones unbeautiful, although serviceable as such, and content to hang garments over them rented from some costumers or not even that—pawed from the scrap heap of antiquity.

It is superstition or plain ignorance to believe these sinews and bones incapable of beauty as such—if such, to be clothed with a flesh that will be living on them, *an expression of them!*

Is it reasonable too to go further and say "sinews and bones?" Yes, but not as in the human frame, but as a new world of form in themselves capable of being beautiful in a new sense, so devised in construction that flesh is unnecessary.

Why should not the structural principle be expressed artistically as well as scientifically for its own sake in this ideal material? Expressed with a knowledge of rhythm and synthesis of form that a master musician would bring to his mathematics? Can we not imagine a building to be serviceably beautiful and beautifully serviceable as it is naturally made—in steel? Glass is all that is needed really after we have honestly insured the life of the steel.

And, added to this immense possibility, here enters a vital modern probability:

Steel is most economical in tension; the steel strand is a marvel, let us say, as compared with anything the ancients knew, a miracle of strength for its weight and cost. We have found now how to combine it with a mass material, concrete, which has great strength in compression. The coefficient of expansion and contraction of both materials is the same in changes of temperature. The more bulky material protects the slighter material from its enemy, disintegration. The heavier material, or protector, strangely grows stronger as it grows older. Permanent "flesh" if we care to so regard it.

A valuable partnership in materials in any case more congenial to the architect than steel alone for he can do more richly with flesh and sinews than

he can with sinews and bones, perhaps. Certainly, if regarded as such by him.

Here we have reinforced concrete, a new dispensation. A new medium for the new world of thought and feeling that seems ideal: a new world that must follow freedom from the imprisonment in the abstract in which tradition binds us. Democracy means liberation from those abstractions and therefore life, more abundantly in the concrete. This is not intended as a pun. It happens to be so literally, for concrete combined with steel strands will probably become the physical body of the modern, civilized world. Here again and especially has the machine liberated the creative architect.

And he prefers his bonds!

The old structural limitation that took form as masonry, lintels and arches, "natural" posts and beams, is all gone. There is in their place a science of mathematics applied to materials of marvelous new properties and strength, here to the architect's hand instead—"mathematics materialized at work for man."

What are we, as architects, going to do with it? For as yet, we have done nothing with it on principle. We have merely "made shift." Architects have avoided an open break with the powers that be, on the ground of impotence, only by psalm singing and caroling in the name of tradition. But, enough.

Here in addition to the possibility of steel alone, is a perfect wedding of two plastic materials. A wondrous freedom! Freedom worthy of ideal democracy. Astounding! That upon so simple a means such a vast consequence to human life depends. But so it does. And just so simple has the initiation of far-reaching changes brought by evolution always been.

The limitation of the human imagination is all that ties the hands of the modern architect except the poison in his veins fostered by "good taste" for dead forms.

His imagination now must devise the new cross sections for the machine more suitable for use in harmoniously framing steel. Rivets have interesting effects as well as facts. Steel plates have possibilities combined with posts and beams. And now there is electric welding to make the work more simple and integral. Posts may become beautiful, beams too. The principle of the "gusset" has a life of its own, still. Strangely, here is plastic material delivered by the Machine in any rigid structural form to be fastened together as members in a structural design.

The design may emphasize the plastic as structural or the structural as plastic. What that means in detail is a liberal education in itself. It must be had by the young architect. He will have to go to work at it himself.

And again, easier to comprehend are the new forms brought to hand by reinforced concrete.

First among them is the slab—next the cantilever—then the splay.

To be able to make waterproof, weatherproof slabs of almost any size or continuity is a great simplification. A great means to a great end. To be able to make these slabs so they may be supported beneath as a waiter supports his tray on the fingers of his upraised arm, leads to another marvelous release, a new freedom.

This is the economic structural principle of the cantilever. A new stability as well as a new economy. The most romantic of all structural possibilities is here.

And last, there is the splay or sloping wall, used as a slide from wall into projections or from floors into walls or used in connection with the cantilever slab. It may be used as an expression of form in itself for protection or light. For economy it may be useful as support in both cases and enhance the plastic effect of the whole.

There is nothing in architecture ready-made to meet these sweeping new "freedoms."

What a release is here! The machine brought it in the ubiquitous ductile steel strand with its miraculous strength and the fortunate wedding of that strength with poured concrete.

What a circumstance!

Here, "young men in architecture," is your palette. The "foyer" of your new world.

Let us of the former generation see you at work on it, in it for all you are worth.

And here again, the password is the word "plastic." "Structuralities" as such must be forgotten. If you will take paper and fold it and bend it, or cardboard sheets and cut them and fit and arrange them into models for buildings, you will see the sense of the new structure in its primitive aspect. And then after this superficial external view, get inside and make the whole line as one plastic entity—however the slabs tend to separate or fall to themselves.

And never lose sight of the fact that all in this new world is no longer in two dimensions. That was the old world.

We are capable of a world now in three dimensions; the third, as I have said before, interpreted as a spiritual matter that makes all integral—"at one."

How life may be blessed by the release this simple development of its viewpoint will bring to mankind.

Paintings and sculpture for use to enrich and enhance the work, still live. They now live a detached life as things apart, for and by themselves. It is a pity, for they can never thrive in that separate life.

Unfortunately, there is a conviction in certain quarters—if it amounts to a "conviction"—chiefly European—that ornamentation is untrue to the Machine in this, the Machine Age. That the use of ornamentation is a romanticism and therefore inappropriate.

The contrary is the case.

But it is true that ornamentation in the old sense as an "applied" thing, as something added to the thing superficially, however cleverly adapted or "composed" is dead to this new world.

Ornamentation in the plastic sense is as characteristic of the thing we call the Machine as ornamentation in the old sense was a characteristic feature of "The Renaissance"; more so, because it is the imagination living in the process and so woven into the life of the thing. A matter of the "constitution" of the thing. The trace of human imagination as the poetic language of line and color must now live *in* the thing so far as it is natural to it. And that is very far.

In the Cause of Architecture IV: Fabrication and Imagination

1927

Published
without
illustrations
in *The
Architectural
Record*,
October 1927

Time was when the hand wrought. Time is here when the *process* fabricates instead.

Why make the fabrication a lie or allow it to become one when we try to make it "beautiful"? Any such lie is an abuse of Imagination.

All Man has above the brute, worth having, is his because of Imagination. Imagination made the Gods—all of them he knows—it is the Divine in him and differentiates him from a mere reasoning animal into a God himself. A creative being is a God. There will never be too many Gods.

Reason and Will have been exalted by Philosophy and Science. Let us now do homage to Imagination.

We have suspected it and punished it and feared it long enough.

Imagination is so intimately related to sentient perception—we can not separate the two. Nor need do so.

Let us call Creative-Imagination the Man-light in Mankind to distinguish it from intellectual brilliance. It is strongest in the creative-artist. A sentient quality. To a degree all developed individuals have this quality, and to the extent that it takes concrete form in the human fabrications necessary or desirable to human life, it makes the fabrication live as a reflection of that Life any true Man loves as such—Spirit materialized.

The Machine is an obedient, tireless fabricator of a nonsentient product. A shaper and drawer of steel, a weaver of fabrics—"casting" forms continually in every material solvent by fire or water.

So the study of the process is as important as the study of the Machine. It is another phase of the Machine and in the method of the process too lies the opportunity for the artist. Unless he understands it what can he do with it—to qualify its product—from within? To modify it externally is not enough. He has been on the surface, as intimately related to its nature as a decalcomania on a tin box cover is to the Nature of the thing going on inside. He has been a decorative label when he has been at all.

Let us, then, get inside.

We will find all the magic of ancient times magnified—Aladdin with his wonderful lamp had a poor thing relatively in that cave of his. Aladdin's lamp was a symbol merely for Imagination. Let us take this lamp inside, in the Architect's world.

Where begin? With mechanistic processes like weaving? printing? stamping? Or with casting? Or with plastic, chemicalized materials like concrete, plastering, steel making, glass making, paper making, ceramics?

One must serve for all. Then let us take one that is both a chemical-process and casting—concrete.

Concrete is a plastic material but sets so slowly as yet that molds or so-called "forms" are used to give it *shape.* It must be held, until it hardens sufficiently, to hold the shape desired.

Ordinarily in itself it has no texture unless the mold leaves it on the surface. It is, however, possible to use fine colored-gravel or crushed-marble or granite in the mixture so the superficial-cement (retarded in setting by some substance like soap applied to the interior surfaces of the "forms") may be easily washed away, leaving the hard gleaming aggregate exposed in almost any color or texture.

All composite materials like concrete have possibilities of bringing out the nature of the mixture in some kind of surface treatment, and the materials may be variously composed in the substances,

mixed to secure these effects of texture and color desired in the finished product.

But, mainly, concrete is still a mass material taking form from molds, erroneously called "forms."

The materials of which the molds themselves are made, will, therefore, modify the shape the concrete naturally takes, if indeed it does not wholly determine it.

Unity Temple at Oak Park was entirely cast in wooden boxes, ornamentation and all. The ornament was formed in the mass by taking blocks of wood of various shapes and sizes, combining them with strips of wood, and, where wanted, tacking them in position to the inside faces of the boxes.

The ornament partakes therefore of the nature of the whole, belongs to it. So the block and box is characteristic of the forms of this temple. The simple cubical masses are in themselves great concrete blocks.

The design makes a feature of this limitation as to form as they are grouped to express the great room within.

Here is a building, a monolith in mono-material, textured as described above, left complete as it came from the molds—permanent architecture.

The whole is a great casting articulated in sections according to the masses of concrete that could safely be made to withstand changes of temperature in a severe climate.

It is a good record of this primitive period in the development of concrete building when it was necessary to pour the material into boxes to "set it" into shape.

It is a "natural" building therefore, in a transition-period of the development of the use of concrete.

I say a period of transition because concrete is essentially a plastic material, sometime to be used as such; used as a plastic material by plastering upon cores or upon steel fabrications. The resultant form may then take the shapes characteristic of drifted snow or sand or the smooth conformation of animals perhaps—as they become finished buildings.

But at the present time there comes a less cumbersome and a cheaper because less wasteful method than the molds on a large scale that built Unity Temple. It was necessary then to build a rough building complete in wood as a "mold" into which the temple could be cast.

Now, in this easier more plastic method, standardization enters as the *unit-system.*

A unit-mass of concrete, size and shape determined by the work intended to be done and what weight a man can reasonably be expected to lift and set in a wall, is fixed upon. This in order to avoid the expensive larger molds—say, the slab block we make 16″ × 16″ × 2½″ thick.

Mechanical steel or aluminum molds are made in which to precast the whole building in a small "unit" of that size. Grooves are provided in the edges of the slab-blocks so a lacing of continuous steel rods may be laid in the vertical and horizontal joints of the block slabs for tensile strength. The grooves are as large as possible so they may be poured full of concrete after each course of blocks is set up, girding and locking the whole into one firm slab. Here ultimately we will have another monolith *fabricated* instead of *poured* into special wooden molds. The molds in this case are metal, good for many buildings, and take the impress of any detail in any scheme of pattern or texture imagination conceives. The whole building "precast" in a mold a man can lift.

Here the making of the structural-unit and the process of fabrication become complete synchronized standardizations. A building for the first time in the world may be lightly fabricated, complete, of mono-material—literally woven into a pattern or design as was the oriental rug earlier referred to in "Standardization": fabrication as infinite in color, texture, and variety as in that rug. A certain simple technique larger in organization but no more complex in execution than that of the rug-weaving, *builds* the building. The diagrams and unit molds are less *simple*. They have much study put on them, and organization becomes more than ever important.

When Machine-Standardizing enters, all must be accurate, precise, organized.

The Machine product can stand no slovenly administration for it can make good no mistakes.

The limitations of both process and material are here very severe, but when these are understood and accepted we may "weave" an architecture at will—unlimited in quality and quantity except by the limitation of imagination.

Several mechanical molds may be thrown into a Ford and taken where gravel and sand abound. Ce-

ment is all else needed, except a few tons of ¼″ commercial steel bars, to complete a beautiful building. This—and an organization of workmen trained to do one thing well.

The ground is soon covered with slab blocks, the block-stuff curing in moisture. After that, it is all a matter of reading the architect's diagrams, which is what his plans now become. They are not tediously figured with haphazard dimensions any longer. They are laid out by counting blocks, corner blocks, and halfblocks; so many blocks wide, so many high, and showing where specific blocks go is like counting stitches in the "woof" and threads in the "warp." Building is a matter of taking slab-block stitches on a steel warp.

So, a livable building may be made of mono-material in one operation!

There is an outer shell and an inner shell separated by a complete air space.

The inner walls, floors, and ceilings which this inner shell becomes are the same as the outside walls, and fabricated in the same way at the same time.

Windows? Made in the shop, standardized to work with the slab-block units. Made of sheet metal finished complete and set in the walls as the work proceeds.

Piping? Cut to the standard unit-length in the shop and set into the hollow spaces. Plastering? None. Carpenter work? None. Masonry? None. "Form" work? None. Painting? None. Decorations? All integral, cast into the structure as designed with all the play of imagery known to Persian or Moor.

The process of elimination which *standardization* becomes has left only essentials. Here is a process that makes of the mechanics of concrete building a mono-material and mono-method affair instead of the usual complex quarreling aggregation of processes and materials: *builds* a building permanent and safe, dry and cool in summer, dry and warm in winter. Standardization here effects economy of effort and material to the extreme, but brings with it a perfect freedom for the imagination of the designer who now has infinite variety as a possibility in ultimate effects after mastering a simple technique.

I give here only one instance of many possibilities in this one material.

What precisely has happened?

Well, one consistent economical imperishable whole instead of the usual confusion of complexities to be reduced to a heap of trash by time.

A quiet orderly simplicity and all the benefits to human beings that come with it.

A simple, cheap material everywhere available, the common stuff of the community—here made rare and exquisite by the Imagination.

Imagination conceives the "fabric" of the whole. The "unit" is absorbed as agreeable texture in the pattern of the whole. Here, too, is certainty of results as well as minimum of costs assured to the human being by free use of the Machine, in perfect control. The whole now in human scale and thoroughly humane. Here is true technique. The technique of a principle *at work*; at work in every minor operation with this material—concrete. Here the material is affected by a process suited to the result desired to such an extent that Architecture may live in our life again in our Machine Age as a free agent of Imagination.

Copper, glass—all materials are subject to similar treatment on similar terms according to their entirely different natures.

The forms and processes will change as the material changes—but the principle will not. In the case of each different material treated the expression of the whole would become something quite different with new beauty. So comes a true variety in unity in this, the Machine Age.

Coition at last. The third dimension triumphant.

The sickening monotony achieved by a two-dimensional world in its attempts to be "different" mercifully ended, perhaps forever.

True variety now becomes a *natural consequence;* a *natural* thing. We can live again and more abundantly than ever before. Differently, yet the same.

Such harmony as we know in the Gothic of "Le Moyen Age" is again ours—but infinitely expanded and related to the individual Imagination, intimately, and therefore to the human being as a unit of scale.

Is Machine-Standardization a hindrance? No, a release.

Boundless possibility, and with that comes increase of responsibility. Here, in the hand of the creative-artist, in *fabrication* in this sense, lies the whole expression, character and style, the *quality,* let us say, in any spiritual sense, of modern life.

The integrity of it all as an *expression* is now a matter of the creative-artist's Imagination *at work*.

Where is he? And if *he* is, may he be trusted with such power? Yes, if he has the Gift. If he is "God" in the sense that "man-light" lives in him in his work.

But should he fall short of that, if he is faithful, looking to principle for guidance, he is sufficiently disciplined by the honest technique of fabrication to be sure to produce steady quiet work.

Inspiration cannot be expected in any total fabric of civilization. It may only be expected to inspire the whole and lay bare the *sense of the thing* for others.

The whole is safe when discovered principle is allowed to work! Going *with* Nature in the use of Imagination may seem little different from going against Nature—but how different the destination and the reward!

It has been said that "Art is Art precisely in that it is not Nature," but in *"obiter dicta"* of that kind the Nature referred to is nature in its limited sense of material appearances as they lie about us and lie to us.

Nature as I have used the word must be apprehended as the life-principle constructing and making appearances what they are, for what they are, and in what they are. Nature inheres in all as *reality*. Appearances take form and character in infinite variety to our vision because of the natural inner working of this Nature-principle.

The slightest change in a minor feature of that "Nature" will work astounding changes of expression.

When the word Nature is understood and accepted in this sense, there is no longer any question of originality. It is natural to be "original" for we are at the fountainhead of all forms whatsoever.

The man who has divined the character of the ingrown sense-of-the-pine, say, can make other pine trees true to the species as any that may continually recur in the woods; make pine-tree forms just as true to the species as we see it and as we accept it as any growing out-of-doors rooted in the ground.

But, principles are not formulas. Formulas may be deduced from principles, of course. But we must never forget that even in the things of the moment principles live and formulas are dead. A yardstick is a formula—Mathematics the principle. So, beware of formulas, they are dangerous. They become inhibitions of principle rather than expressions of them in nonsentient hands.

This principle understood and put to work, what would happen to our world? What would our world be like if the Nature-principle were allowed to work in the hands of creative imagination and the *formulae* kept where it belongs?

*Note: the chemicalization of concrete or cement is too well-known to need any attention here.

In the Cause of Architecture V: The New World

1927

Published
without
illustrations
in *The
Architectural
Record,*
October 1927

The new world? A dangerous title.

But for a sense of humor in this old one there would be no new one. Length and breadth—with just enough thickness to hold them together for commercial purposes we have had in the old world and all *that* implies in Art and Philosophy.

The new world begins to be when the little "thickness" we have had in the old one becomes *depth* and our sense of depth becomes that sense of the thing, or the quality in it that makes it *integral*—gives it integrity as such. With this "quality" the new world develops naturally in three dimensions out of the one which had but two.

The abstractions and aesthetic lies of a canned pictorial-culture crumble and fade away, worn out and useless.

"Institutions" founded upon those abstractions to serve that culture, crumble. And Architecture now belonging to, and refreshing as the forests or prairies or hills, the human spirit is free to blossom in structure as organic as that of plants and trees. Buildings, too, are children of Earth and Sun.

Naturally we have no more Gothic Cathedrals for the busy gainful-occupations. No more Roman or Greek Sarcophagi for the sacred Banking business. No more French châteaux for Fire-Engine houses. No more Louis XIV or Louis XV or Louis XVI or any Louis at all, for anything at all!

The Classics? A fond professorial dream.

The Periods? Inferior desecration.

Picture-Postcard Homes? Museum relics affording much amusement.

The Skyscraper—vertical groove of the landlord? Laid down flatwise. A trap that was sprung.

Churches? We fail to recognize them.

Public buildings? No longer monuments.

Monuments? Abolished as profane.

Industrial buildings? Still recognizable for they were allowed to be themselves in the old world.

Commercial buildings, industrial, or official? Shimmering, iridescent cages of steel and copper and glass in which the principle of standardization becomes exquisite in all variety.

Homes? Growing from their site in native materials, no more "deciduous" than the native rock ledges of the hills, or the fir trees rooted in the ground, all taking on the character of the individual in perpetual bewildering variety.

The City? Gone to the surrounding country.

The landlord's exploitation of the herd instinct seems to be exploded. That instinct is recognized as servile and is well in hand—but not in the landlord's hand.

A touchstone now by way of the human mind lies in reach of human fingers everywhere to enable the human being to distinguish and accept the quick and reject the dead!

It would seem after all, that this "new world" is simply a matter of being one's *self.*

Beech trees are welcome and allowed to be beech trees because they are beeches. Birches because they are birches. Elms are not oaks and no one would prefer them if they were, or get excited about making them so if they could.

Nor are evergreens Christmas trees.

Materials everywhere are most valuable for what they are—in themselves—no one wants to change their nature or try to make them like something else.

Men likewise—for the same reason: a reason everywhere working in everything.

So this new world is no longer a matter of seeming but of *being.*

Where then are we?

We are in a corner of the twentieth century emerging into the twenty-first—and the first Democracy of *being* not seeming.

The highest form of Aristocracy be it said the world has ever seen is this Democracy, for it is based upon the qualities that make the man a man.

We know, now, the tragedy of a civilization lying to itself. We see the futility of expecting in hope, that a culture willing to deceive itself could or would know how to be sincere with others—or allow them happiness or know happiness itself.

What an inglorious rubbish heap lies back there in the gloom of that duodimensional era! In that "Period" of superficial length and breadth with just enough "thickness" to make them hang together—for commercial purposes!

The "Period" of Fashion and Sham in which the "Picture" was the "cause" and not the consequence.

And the rubbish heap gradually grew back there, useless, as the great simplicity of an Idea that was in itself an integrity rose to smite the Sham for what it was and proclaim, in fact, the Freedom we then professed.

SHAM and its brood—inbred by the ideals of "the classic" and its authority in education—fostered that duodimensional world beyond its ability to perform; educated it far and away beyond its capacity for life.

Character is Fate and invariably meets it. That Old World was ripe for the rubbish heap and went to its destruction by the grinding of universal principles, grinding slow, nor yet so exceedingly fine. For the awful simplicity of the Nazarene saw this "new world" at hand more than two thousand years ago. And here we are, two centuries later, only beginning to see it for ourselves.

Beginning to see it prepared by this simple enrichment of our selves in this *sense* of the "within" for our outlook. Beginning to understand and realize that the "Kingdom on Earth as it is in Heaven" of which He spoke was a Kingdom wherein each man was a King because Kingdom and King consisted of that quality of integrity of which, for lack of a better term, I have tritely spoken as the third dimension. That all of the Beyond is within, is a truism.

And just so simple, although at the time less obvious, is the initiation of all great evolutionary changes whatsoever.

But this simple first principle of being that is now at work for some strange reason came late and last.

Why?

We who have walked the Earth in eager search for the clear wine of Principle, tortured and denied or instead offered polluted water to quench an honest thirst, would like to know—why?

Were the Greeks poison? For us—yes. The Romans? More so.

Back there in the two-dimensional era we lived bewildered in a Roman-world—Romantic!

Not for nothing were we Romantic and did we speak a composite language corrupted from the Romance languages.

The honest Celt or Gaul or Teuton was corrupted by the Graeco-Roman corruption of the finer ancient culture of the Hellenes.

The Anglo-Saxon sanctified and recorrupted the corruption, and polished sophistries, imprisoning abstractions, became recipes for good life in the name of the Good, the True, and the Beautiful.

Hypocrisy for all cultivated men became as necessary as breathing and as "natural."

In order to be Beautiful—it became imperative to *lie*!

In order to *be* it became necessary to *seem*.

Art was a divorce from Nature.

"Nature" became the world of appearances round about us in our industrial life and all aspects of other individuals in relation to those appearances.

In the "Democracy" of the nineteenth century we witnessed the triumph of the insignificant as the fruit of the lie. A triumph by no means insignificant.

Some few unpopular individuals inhibited the "classic" in their education in that era, being afraid of it—seeing what it did to those who yielded to it, how it embalmed them in respectability and enshrined them in impotence. Seeing how it cut them off from Life and led them by the intellect into a falsified sense of living.

The precious quality in Man—Imagination—was shown the enticing objects man had made and shown them as so many "objectives." Therefore Imagination was offered patterns to the eye, not truths to the mind; offered abstractions to the Spirit not realities to the Soul. This was "Education."

To turn away from all that meant then, owing to the supreme psychology of the herd, well—what it has meant.

Since one need no longer turn from reality to be respectable, all sacrifices in former worlds are made a privilege, something to have enjoyed.

For the scene has shifted. The burden—there is no burden like artificiality—has lifted.

Art having been "*artificiality*" for centuries has come through its terrible trial, hard put to it by the Machine—which stripped it to the bone and lives.

It is living now because the Artifex survived the Artificer.

The Man has survived the Mime.

Be comforted—my young architect!

The "pictorial" still lives, for what it is, extended in this our new Usonian world, but as "consequence" not as "cause."

All we were given of love for the picturesque in gesture, form, color, or sound—gifts to the five senses—is realized. Appearances are expanded into a synthesis of the five senses—we may call it a sixth if we please—and all become manifest materialization of Spirit.

Appearances are now a great assurance. A splendid enrichment of Life. The Pictorial is merely an incident not an aim, nothing in itself or for itself or by itself; no longer an *end* sought for its own sake.

The picturesque? Therefore it is a by-product inevitably beautiful in all circumstances, from any and every point of view.

What wrought this miracle?

NATURE gradually apprehended as the principle of Life—the life-giving principle in making things with the mind, reacting in turn upon the makers.

Earth-dwellers that we are, we are become now sentient to the truth that living on Earth *is* a materialization of Spirit instead of trying to make our dwelling here a spiritualization of matter. Simplicity of Sense now honorably takes the lead.

To be good Gods of Earth *here* is all the significance we have here. A God is a God on Earth as in Heaven. And there will never be too many Gods.

Just as a great master knows no masterpiece, and there are no "favorite" trees, nor color, nor flowers; no "greatest" master; so Gods are Gods, and all are GOD.

Be specific? I hear you—Young Man in Architecture.

Shall I too paint pictures for you to show to you this new world?

Show you "pictures" that I might make?

Would you not rather make them for yourself?

Because any picture I could make would not serve you well.

A specific "picture" might betray you. You might take it for the thing itself—and so miss its merely symbolic value, for it could have no other value.

This new world so far as it lives as such is conditioned upon your seeing it for yourself—out of your own love and understanding. It is that kind of world.

As another man sees it, it might entertain you. Why should you be "entertained?"

His specific picture, the better it might be the more it might forestall or bind you. You have had enough of that.

For yourself, by yourself, within yourself, then, visualize it and add your own faithful building to it, and you cannot fail.

We are punished for discipleship—and, as disciples, we punish the thing we love.

Who, then, can teach? Not I.

It too is a gift.

Already I have dared enough. Try to see—in work.

Idealism and Idealist are the same failure as Realism and Realistic. Both the same failure as Romance and Romantic.

Life is. We are.

Therefore we will loyally love, honestly work and enthusiastically seek, in all things—the one thing of Value—Life.

It is not found in pictorial shallows.

In the Cause of Architecture I: The Logic of the Plan

Plan! There is something elemental in the word itself. A pregnant plan has logic—is the logic of the building squarely stated. Unless it is the plan for a foolish fair.

A good plan is the beginning and the end, because every good plan is organic. That means that its development in all directions is inherent—inevitable.

Scientifically, artistically to foresee all is "to plan." There is more beauty in a fine ground plan than in almost any of its ultimate consequences.

In itself it will have the rhythms, masses, and proportions of a good decoration if it is the organic plan for an organic building with individual style—consistent with materials.

All is there seen—purpose, materials, method, character, style. The plan? The prophetic soul of the building—a building that can live only because of the prophecy that is the plan. But it is a map, a chart, a mere diagram, a mathematical projection before the fact, and, as we all have occasion to know, accessory to infinite crimes.

To judge the architect one need only look at his ground plan. He is master then and there, or never. Were all elevations of the genuine buildings of the world lost and the ground plans saved, each building would construct itself again. Because before the plan is a plan it is a concept in some creative mind. It is, after all, only a purposeful record of that dream, which saw the destined building living in its appointed place. A dream—but precise and practical, the record to be read by the like-minded.

The original plan may be thrown away as the work proceeds—probably most of those for the most wonderful buildings in the world were, because the concept grows and matures during real-ization, if the mastermind is continually with the work. But that plan had first to be made. Ultimately it should be corrected and recorded.

But to throw the plans away is a luxury ill-afforded by the organizations of our modern method. It has ruined owners and architects and enriched numberless contractors. Therefore, conceive the building in the imagination, not on paper but in the mind, thoroughly—before touching paper. Let it live there—gradually taking more definite form before committing it to the draughting board. When the thing lives for you—start to plan it with tools—not before. To draw during conception or "sketch," as we say, experimenting with practical adjustments to scale, is well enough if the concept is clear enough to be firmly held. It is best to cultivate the imagination to construct and complete the building before working upon it with T square and triangle. Working on it with triangle and T square should modify or extend or intensify or test the conception—complete the harmonious adjustment of its parts. But if the original concept is lost as the drawing proceeds, throw all away and begin afresh. To throw away a concept entirely to make way for a fresh one—that is a faculty of the mind not easily cultivated. Few have that capacity. It is perhaps a gift—but may be attained by practice. What I am trying to express is that the plan must start as a truly creative matter and mature as such. All is won or lost before anything more tangible begins.

The several factors most important in making the plans—after general purpose scheme or "project" are:

2nd—Materials
3rd—Building methods
4th—Scale

1928

Published with 6 illustrations in *The Architectural Record*, January 1928

5th—Articulation

6th—Expression or Style

In the matter of scale, the human being is the logical norm because buildings are to be humanly inhabited and should be related to human proportions not only comfortably but agreeably. Human beings should look as well in the building or of it as flowers do.

People should belong to the building just as it should belong to them. This scale or unit-of-size of the various parts varies with the specific purpose of the building and the materials used to build it. The only sure way to hold all to scale is to adopt a unit-system, unit-lines crossing the paper both ways, spaced as predetermined, say 4'-0" on centers—or 2'-8" or whatever seems to yield the proper scale for the proposed purpose. Divisions in spacing are thus brought into a certain texture in the result; ordered scale in detail is sure to follow.

A certain *standardization* is established here at the beginning, like the warp in the oriental rug. It has other and economic values in construction. I have found this valuable in practice even in small houses. Experience is needed to fix upon the proper size of the unit for any particular building. Trained imagination is necessary to differentiate or syncopate or emphasize, to weave or play upon it consistently.

Scale is really proportion. Who can teach proportion? Without a sense of proportion, no one should attempt to build. This gift of sense must be the diploma Nature gave to the architect.

Let the architect cling, always, to the normal human figure for his scale and he cannot go so far wrong as Michelangelo did in St. Peter's in Rome. St. Peter's is invariably disappointing as a great building, for not until the eye deliberately catches a human figure for purpose of comparison does one realize that the building is vast. All the details are likewise huge and the sense of grandeur it might have had if the great masses were qualified by details kept to human scale—this effect of grandeur—is lost in the degradation of the human figure. A strange error for a sculptor to make.

The safest practice in proportion is not to attempt to allow for "perspective," stilting domes as he did, changing pitches of roofs as many do, and modifying natural lines and masses to meet certain views from certain vantage points as the Greeks are said to have done, but to make the constitution of the thing right in itself. Let the incidental perspectives fall when and how they will. Trust Nature to give proper values to a proper whole. The modifications she may make are better than any other. There is something radically wrong with a scheme that requires distortion to appear correct.

In the matter of materials. These also affect scale. The logical material under the circumstances is the most natural material for the purpose. It is usually the most beautiful—and it is obvious that sticks will not space the same as stones nor allow the same proportions as steel. Nor will the spacing adjustable to these be natural to made-blocks or to slabs or to a plastic modeling of form.

Sticks of wood will have their own natural volume and spacing determined by standards of use and manufacture and the nature of both.

A wood plan is slender: light in texture, narrower spacing.

A stone or brick plan is heavy: black in masses, wider in spacing.

Combination of materials: lightness combined with massiveness.

A cast-block building: such massing as is felt to be adequate to the sense of block and box and slab; more freedom in spacing.

The purely or physically plastic structure: center line of thin webbing with a flesh-covering on either side; unit-system may be abandoned.

Then there are the double-wall constructions requiring great skill in spacing so that the interior shell will work simply with the outer shell. And there are as many others as there are combinations of all these.

But the more simple the materials used—the more the building tends toward a mono-material building—the more nearly will "perfect style" reward an organic plan and ease of execution economize results. The more logical will the whole become.

A wood plan is seen in the plan for the Coonley house at Riverside and in the plan for "D101 house."

A cast-block and slab building: the plan for Unity Temple at Oak Park.

Brick plans: the plan for the D. D. Martin residence in Buffalo, and the Ullman house in Oak Park, Illinois.

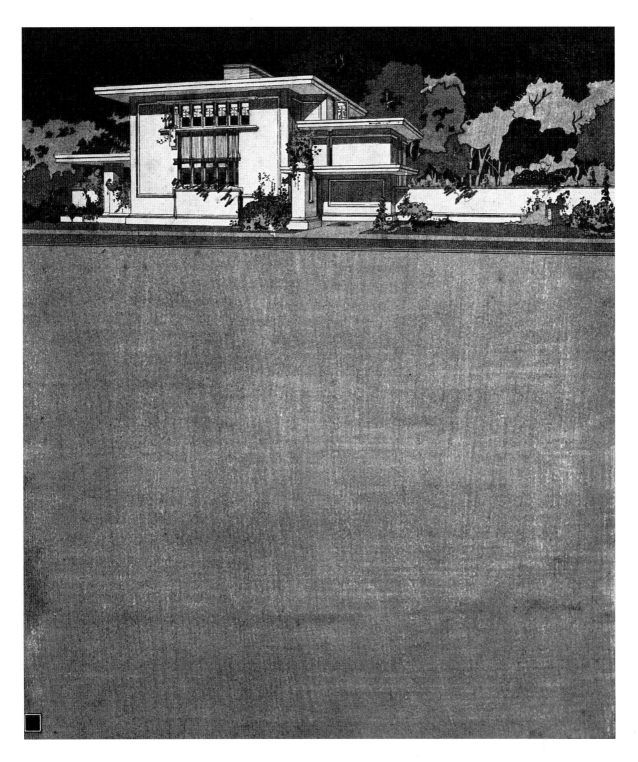

American System-Built Houses, 1915.
Model D-101.
FLLW Fdn# 1506.130

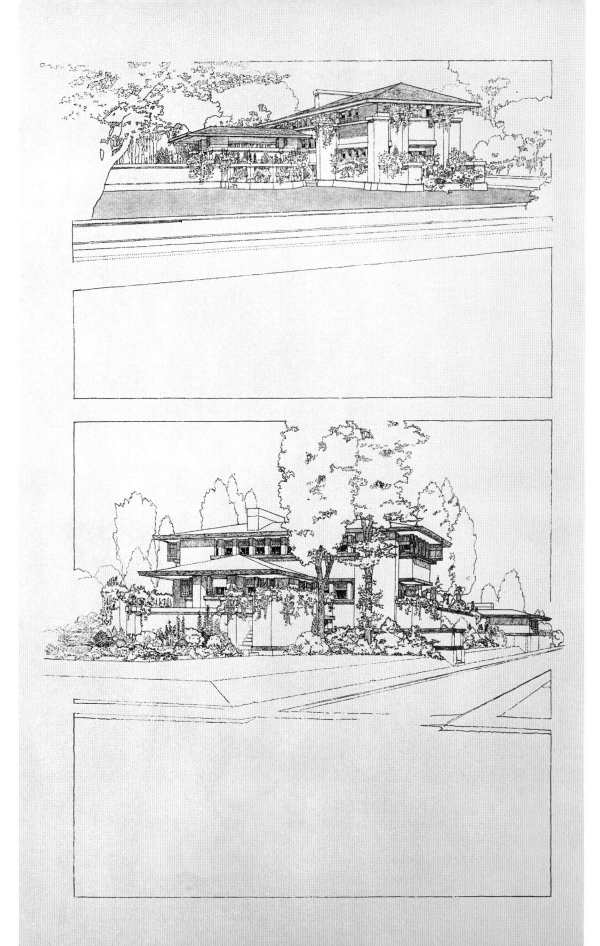

A steel-and-glass plan for a skyscraper, concrete supports and floor slabs: this plan will be used later in this series to illustrate another article.

The purely "plastic" structure may be seen in the "Einstein Tower" by Mendelsohn and buildings by European Modernists.

A double-wall construction, in this case of precast blocks, is seen in the Ennis house at Hollywood.

A thin concrete slab-structure: the merchandise building in Los Angeles.

In the matter of building methods. These methods too are meantime shaping the plan. In the Coonley house—the 4'-0" unit works with 16" centers as established in carpenter practice for the length of laths, the economical spacing of studs and nailing-bearings, standard lumber lengths.

In Unity Temple—the only limit was the mass of concrete that could withstand the violent changes of climate and remain related to human scale and easy construction. The box and blocks, however, determine the shape of every feature and every detail of the features, as it was all cast in "boxes."

So a unit suitable for timber construction was adopted as the false-work in which its cast was made of lumber. Multiples of 16", syncopated, was the scale adopted.

In the Martin house, brick was used. Brick lends itself to articulation in plan and is an easy material to use architecturally. Bricks naturally make corners and the corners are easily used for play of light and shade. The Martin house is an organized brick-pier building. It is when assembling groups of piers in rhythmical relation to the whole that brick comes out best according to its nature. A 7'-9" unit reduced by minor mullions to 3'-9", was used, in the horizontal only. There are other views of brick as legitimate as this one, to be used according to the individual "taste" of

H.J. Ullman House,
Oak Park, Illinois. 1904.
Project.
FLLW Fdn# 0411.009
and FLLW Fdn# 0411.010

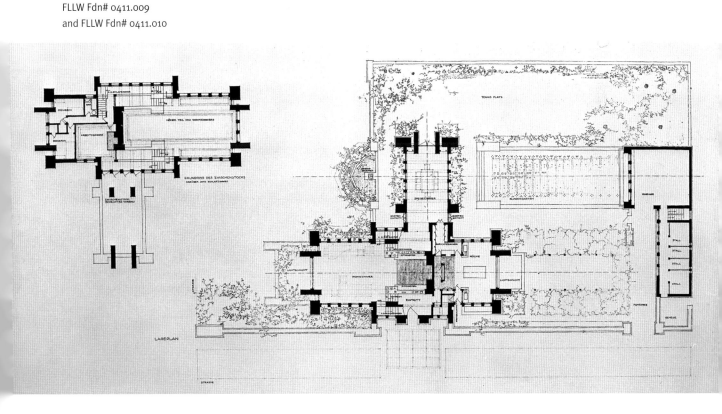

the designer. The broken masses of textured walls, for instance.

In the steel-and-glass building there are no walls. The method yields best to suspended screens, shop-fabricated. A mechanized fabric enters here to give the form and style that is Architecture. The structural supports and floor-slabs in this case happen to be concrete. They could be protected steel as well. Planned on a 4'-0" unit, emphasis on alternate verticals. No emphasis on horizontals.

In the precast-block building, the method of building wholly determines the form and style. This is a mono-material structure planned on multiples of 16 inches square, both horizontal and vertical. No emphasis.

The slab-building is an expression of another method. Cast-slabs, set sidewise and lengthwise, and flatwise, making everything, as may be seen in the result planned on multiples of 7'-0".

Concerning articulation. The Ennis house will serve to illustrate the principle which, once grasped, is simple.

In the building, each separate portion of the building devoted to a special purpose asserts itself as an individual factor in the whole.

The dining room associated with terraces is one mass. The living room with bedroom attached, another mass standing at the center on a terrace of its own—the dominating feature of the group.

Mr. Ennis's bedroom, semidetached and used as a study or office, is another and terminal mass.

At the rear is the kitchen unit, a subordinate mass. All are connected by a gallery passing along the group at the rear. Finally the terrace wall ends in a detached mass to the rear of the lot—the garage and chauffeur's quarters.

A little study will show how each separate room makes its own characteristic contribution to the whole mass.

The completed whole crowns the end of a high ridge in Hollywood and is a precast slab-block building woven together with steel.

These articulations are as obvious in the plan as in the perspective. The Coonley house is similarly articulate.

Articulate buildings of this type have their parallel in the music of Bach particularly, but in any of the true form-masters in music.

It may be readily seen that in this particular direction lies infinite variety in expression. The sense of it is fundamental in any architectural release.

In the matter of expression and style.

As a matter of logic in the plan, it is easy to see there can be none except as the result of scale, materials, and building method. But with all that properly set, there is the important human equation at work in every move that is made. The architect weaves into it all his sense of the whole. He articulates—emphasizes what he loves.

No matter how technically faithful his logic may have been to his scale and materials and method—over and above all that, living in the atmosphere created by the orchestration of those matters, hovers the indefinable quality of style. Style emanating from the form, as seen by the man himself. And while it speaks to you of all those important matters, it leaves you imbued by dignity, grace, repose, gaiety, strength, severity, delicacy, and of rhythmical order, in a musical sense, as the master wills—just as music does. Usually you hear music as you work. But not necessarily.

So every true building is of the quality of some man's soul, his sense of harmony and "fitness," which is another kind of harmony—more or less manifest in the fallible human process.

And his building will nobly stand, belonging to its site—breathing this message to the spirit quite naturally, so long as his work was well done or the course of human events does not inundate or human ignorance willfully destroy his building.

In the Cause of Architecture II: What "Styles" Mean to the Architect

In what is now to arise from the plan as conceived and held in the mind of the architect, the matter of style may be considered as of elemental importance.

In the logic of the plan what we call "standardization" is seen to be a fundamental principle at work in architecture. All things in Nature exhibit this tendency to crystallize—to form and then conform, as we may easily see. There is a fluid, elastic period of becoming, as in the plan, when possibilities are infinite. New effects may, then, originate from the idea or principle that conceives. Once form is achieved, that possibility is dead so far as it is a creative flux.

Styles in architecture are part and parcel of this standardization. During the process of formation, exciting, fruitful. So soon as accomplished—a prison house for the creative soul and mind.

"Styles" once accomplished soon become yardsticks for the blind, crutches for the lame, the recourse of the impotent.

As humanity develops there will be less recourse to the "styles" and more style—for the development of humanity is a matter of greater creative power for the individual—more of that quality in each that was once painfully achieved by the whole. A richer variety in unity is, therefore, a rational hope.

So this very useful tendency in the nature of the human mind, to standardize, is something to guard against as thought and feeling are about to take "form"—something of which to beware—something to be watched. For, overnight, it may "set" the form past redemption and the creative matter be found dead. Standardization is, then, a mere tool, though indispensable, to be used only to a certain extent in all other than purely commercial matters.

Used to the extent that it leaves the spirit free to destroy it at will—on suspicion, maybe—to the extent only that it does not become *a* style—or an inflexible rule—is it desirable to the architect.

It is desirable to him only to the extent that it is capable of new forms and remains the servant of those forms. Standardization should be allowed to work but never to master the process that yields the form.

In the logic of the plan we see the mechanics that are standardization, this dangerous tendency to crystallize into styles, at work and attempting to dispose of the whole matter. But if we are artists, no one can see it in the results of our use of it, which will be living and "personal," nevertheless.

There is a dictum abroad that "Great Art" is impersonal.

The Universal speaks by way of the Personal in our lives. And the more interesting as such the deliverer is, the more precious to us will that message from the Universal be. For we can only understand the message in terms of ourselves. Impersonal matter is no matter at all—in Art. This is not to say that the manner is more than the matter of the message—only to say that the man is the matter of the message, after all is said and done. This is dangerous truth for weak-headed egotists in architecture who may be in love with their own reflections as in a mirror.

But why take the abuse of the thing for the thing itself and condemn it to exalt the mediocre and fix the commonplace?

All truth of any consequence whatsoever, is dangerous and in the hands of the impotent—damned. Are we, therefore, to cling to "safe lies?" There is a soiled fringe hanging to every manful effort to realize anything in this world—even a square meal.

1928

Published with 3 illustrations in *The Architectural Record*, February 1928

The Universal will take care of itself.

Let us tune up with it, and it will sing through us, because of us, the song man desires most to hear. And that song is Man.

The question is now, how to achieve *style*, how to conserve that quality and profit to the fullest extent by standardization, the soul of the machine, in the work that is "Man." We have seen how standardization, as a method, serves as guide in the architect's plan, serves as a kind of warp on which to weave the woof of his building. So far, it is safe and may be used to any extent as a method, while the "idea" lives. But the process has been at work in everything to our hand that we are to use with which to build. We can overcome that, even profit by it, as we shall see. The difficulty is that it has been at work upon the man for whom we are to build. He is already more or less mechanized in this the Machine Age. To a considerable extent he is the victim of the thing we have been discussing—the victim, I say, because his ideas are committed to standards which he now willfully standardizes and institutionalizes until there is very little fresh life left in him. To do so is now his habit and, he is coming to think, his virtue.

Here is the real difficulty and a serious one.

What fresh life the architect may have is regarded with distrust by him, suspected and perhaps condemned on suspicion, merely, by this habituate who standardizes for a living—now, and must defend himself in it. The plan-factory grew to meet his wants. Colleges cling to the "classic" to gratify him. His "means" are all tied up in various results of the process. He is bound hand and foot, economically, to his institutions and blindfolded by his "self-interest." He is the slave of the Expedient—and he calls it the Practical! He believes it.

What may be done with him?

Whatever was properly done would be to "undo" him, and that can't be done with his consent. He cannot be buried because it is a kind of living death he knows. But there are yet living among him those not so far gone. It is a matter of history that the few who are open to life have made it eventually what it is for the many. History repeats itself, as ever. The minority report is always right—John Bright pointed to history to prove it.[1]

What we must work with is that minority—however small. It is enough hope, for it is all the hope there ever was in all the world, since time began, and we believe in Progress.

These slaves to the Expedient are all beholden to certain ideas of certain individuals. They tend to accept, ready-made, from those individuals their views of matters like style and, although style is a simple matter, enough nonsense has been talked about it by architects and artists. So "Fashion" rules with inexorable hand. The simple unlettered American man of business, as yet untrained by "looted" culture, is most likely, in all this, to have fresh vision. And, albeit a little vulgar, there, in him, and in the minority of which we have just spoken, is the only hope for the architectural future of which we are going to speak.

The value of style as against standardized "styles" is what I shall try to make clear and, to illustrate, have chosen from my own work certain examples to show that it is a quality not depending at all upon "styles," but a quality inherent in every organic growth—as such. Not a self-conscious product at all. A natural one. I maintain that if this quality of style may be had in these things of mine, it may be had to any extent by Usonia, did her sons put into practice certain principles which are at work in these examples as they were once at work when the antique was "now." This may be done with no danger of forming a style—except among those whose characters and spiritual attainments are such that they would have to have recourse to one anyway.

The exhibition will become complete in the course of this series. The immediate burden of this paper is properly to evaluate this useful element of standardization with which the architect works for life, as in the "logic of the plan," and show how it may disastrously triumph over life as in the "styles" in this matter that confronts him now.

This antagonistic triumph is achieved as the consequence of man's tendency to fall in love with his tools, of which his intellect is one, and he soon mistakes the means for the end. This has happened most conspicuously in the architectural Renaissance. The "re-birth" of architecture. Unless a matter went wrong and died too soon there could be no occasion for "re-birth." But according to architects, architecture has been in this matter of getting itself continually re-born for several centuries until one might believe it was never properly born, and now thoroughly dead from repeated "re-birth." As a

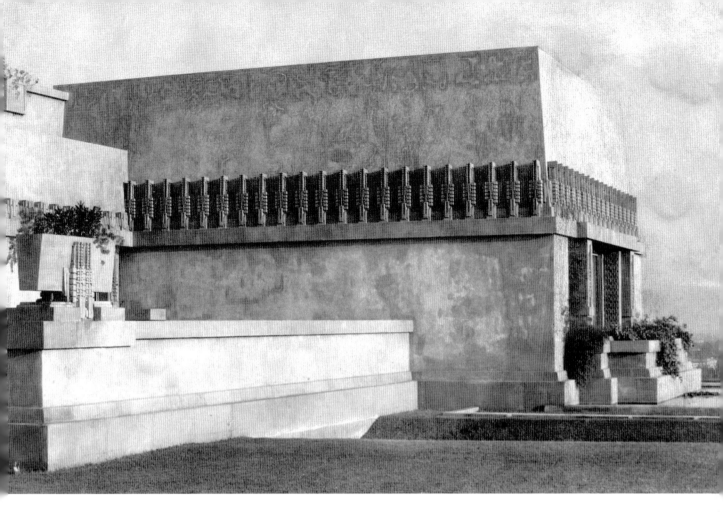

Aline Barnsdall "Hollyhock House,"
Los Angeles, California. 1920.
FLLW Fdn# 1705.0012

matter of fact, architecture never needed to be born again—the architects who thought so did need to be; but never were.

A few examples may serve to show "architecture" a corpse, like sticking a pin into some member of a cadaver. Such architectural members for instance as the cornice—pilasters and architraves, the façade, and a whole brain-load of other instances of the moribund.

But architecture has consisted of these things. And architecture before that had the misfortune to be a nonutilitarian affair—it was a matter of decorating construction or sculpturing, from the outside, a mass of building material. At its worst it became a mere matter of constructing decoration. This concept of architecture was peculiarly

Greek. And the Greek concept became the architectural religion of the modern world and became so, strangely enough, just when Christianity became its spiritual conviction. The architectural concept was barbaric, unspiritual—superficial. That did not matter. Architecture was "re-born" in Florence on that basis and never got anywhere below the surface afterward, owing to many inherent inconsistencies with interior life as life within, lived on. I am talking of "Academic" architecture.

Of the three instances we have chosen, the cornice would be enough to show—for as it was, the other two were, and so were all besides. We are now attacking the standard that became standardized.

It was a standard that, to the eye, had grace and charm but to the mind had, never, organic integ-

rity. It was "exterior" as thought, however exquisite the refinement and refreshing the play of light and shadow, or enticing the form—or seductive the nuances of shade. It could live only on the surface and thrive as a "cult." It was aristocratic as such. Sometimes an applied, studied elegance, it was often a studious refinement. But it had no interior vitality to inform new conditions and develop new forms for fresh life. The cornice, a constructed thing, constructed as a form for its own sake, became fixed as the characteristic architectural expression of this culture. The cornice was a gesture—a fine gesture, but an empty one. What original significance the cornice had was soon lost. It had come by way of the eaves of a projecting and visible roof. It stayed for "the look of the thing" centuries after its use and purpose had gone. It was said to be "a thing of beauty." It became the last word in the "language" of approved form, regardless of interior significance. And it hangs today in the eye of the sun, as dubious an excrescence as ever made shift. It has said the last word for "exterior" architecture. For the cornice has all but disappeared, and with it disappears a horde of artificialities no nearer truth.

Another concept of building enters in this coming era.

The building is no longer a block of building material dealt with, artistically, from the outside. The room within is the great fact about the building— *the room* to be expressed in the exterior as *space enclosed*. This sense of the *room* within, held as the great *motif* for enclosure, is the advanced thought of the era in architecture, and is now searching for exterior expression.

This is another conception of architecture entirely. It is probably new under the sun.

Here we have a compelling organic significance instead of seductive imposition of elegance.

Architecture so born needs no "re-birth." It will work out its own destiny at all times, in all places, under all conditions—naturally.

It will not fail of style.

This concept is a minority report in this democratic era. But it is the natural one for that era, because it is consistent with the nature of the highest spiritual and ethical ideal of democracy.

To make clear to the young architect this "interior" initiative, which is now his, is necessary to any comprehension on his part of the opportunity that is now to his hand in what may rise from his plan.

Once this interior viewpoint is grasped, his own nature will gather force from the idea and, with experience, become truly potent as a creative factor in modern life concerns.

"What significance?" This should be the question through which everything in the way of "form" should be sifted in imagination before it is accepted or rejected in his work.

Contrived elegancies the weary world has obediently borne and worn and regretfully cast aside in plenty, with undefined but inextinguishable hope.

But expressions of human life, rooted in that life, to grow and beneficently expand in human thought, compelled by our principle as great trees grow in their soil and expand in the air according to their interior principle, beguiled by the sun—that is what the world needs and what democracy must have. This is the very meaning of democracy, if it is ever to have any meaning.

The word "democracy" is used far from any such interior significance as yet. But once born into the soul and mind of American youth, this sense of architecture will grow fast and become strong as only law is strong, however weak man-made laws may ever be and pusillanimous his "enforcements."

To show this ideal at work in concrete form it is unnecessary to arouse animosity or give pain by illustrations of the falsity of the old conception, or, to be fairer, let us say the superficial character of that concept.

If we show the principle at work in certain new buildings—and it may be seen there, clearly—we will have no occasion to molest tradition or dissect the forms that are now sacred. We may leave all decently in their shrouds where architects, urged by the idea of "re-birth" have, for centuries past, wantonly refused to leave them.

Beyond what has been said of architectural members we will not go. We will go forward and then whoever will, according to his disposition, at his leisure, may look backward.

Apropos of "style"—let us take—say—Unity Temple.

Style I have said was a quality of the form that character takes, and it becomes necessary to explain what character means.

Any consistent expression of an organic entity,

as such; any animal, tree or plant has "character" we may observe. In varying degree, this character may appeal to us as beautiful. It may even be what we call "ugly" and possess the *character* which is the secret of *style*.

Character is one of our strong words. It is loosely applied to any manifestation of force. Properly, it is used to signify "individual significance."

To be insignificant is to have no "character." Observe that we may use the word "character" for "style" and the word "style" for "character" with no great inconsistency. The words are not interchangeable, but applicable to either case. Character is the result of some inward force taking consistent outward shape taking *form* consistent with its nature. The *exterior* any initial life-force naturally takes, reveals "character."

Character then is the significant expression of organic-entity. Yes, but—

That sounds complicated—let's try again—

Character, like style, is the quality of "being" one's self or itself. That—too—but again incomplete.

Character is the result of nature-expression of the soul or life-principle of anything "organic" whatsoever—to the degree that the idea or life-impulse achieves consistent form to our senses—to that degree will "character" be evident.

Character then is not only fate—

As a final definition we may say that *"character" appears to be nature's "art."*

We may observe it in the smooth, dark green watermelon, its swelling alchemy of pink flesh maturing in the sun, its multitude of black seeds, as we see its polished oval lifted above the surrounding tracery of gray-green vines—or in the garter snake darting its forked tongue from among the fretted leaves. How similar may be the markings, the "decoration" of both!

What, then, if all style must have character and all character has style—is the difference between character and style? Well—the difference is the difference between Truth and Beauty—both are forms of the same thing and inseparable from each other in any final analysis as the light ray is inseparable from its source. But we may enjoy the light, ignorant of its source, and speak of it—for that purpose we have the word style. Or we may look to the source, ignoring its consequences. To speak of that we have the word character.

Style is a consequence of character.

The serpent has "style." Bees as well as butterflies. So has the scarab that tumbles its ball of cow-manure in the hot sun of the dusty road. The white crane, the horse, the rat, every flower, any tree—even human beings, when they are natural—have it, because they are genuine. They have *character*. Buildings often have it when they too are genuine, not posing as "architecture." The rear of the New York Public Library has something of this quality of style, while the front has only "styles." The Woolworth Building would have had it to a degree but for professional Gothic prejudices and predilection. The Suspension Bridge from New York to Brooklyn has it. Some aeroplanes have it and some steamships: by no means all of them. Many grain elevators, steel plants, engines have it, and occasionally an automobile. The Wainwright Building of Saint Louis by Adler and Sullivan, as a tall building, had it. There are many tall buildings, now, that are stylish to some degree but all more or less marred by "styles." Unity Temple, for a shameless instance, has style without prejudice or predilection. How did it get it? First by directly acknowledging the *nature* of the problem presented and expressing it with a sense of appropriate shape and proportion in terms of the *character* of the materials and the process of work that was to make the building. It does this consciously and sensibly, all in its own way, simply because there never is any other way.

Let us follow this building through the thought that built it, from the beginning when Dr. Johonnot, the Universalist pastor, called and said he had always admired the little white church with a steeple as seen in the "East" and wanted something like that—follow its evolution to final *form*.

1. John Bright (1811–1889), English orator and statesman.

In the Cause of Architecture III: The Meaning of Materials—Stone

1928

Published with
4 illustrations
in *The
Architectural
Record*,
April 1928

The country between Madison and Janesville, Wisconsin, is the old bed of an ancient glacier drift. Vast, busy gravel pits abound there, exposing heaps of yellow aggregate, once, and everywhere else, sleeping beneath the green fields. Great heaps, clean and golden, are always waiting there in the sun. And I never pass without emotion—without a vision of the long dust-whitened stretches of the cement mills grinding to impalpable fineness the magic-powder that would "set" it all to shape and wish, both, endlessly subject to my will.

Nor do I come to a lumberyard with its city-like, gradated masses of fresh shingles, boards and timbers, without taking a deep breath of its fragrance— seeing the forest that was laid low in it and the processes that cut and shaped it to the architect's scale of feet and inches—coveting it, *all*.

The rock ledges of a stone quarry are a story and a longing to me. There is suggestion in the strata and character in the formations. I like to sit and feel it, as it is. Often I have thought, were great monumental buildings ever given me to build, I would go to the Grand Canyon of Arizona to ponder them.

When, in early years, I looked south from the massive stone tower in the Auditorium Building where I was pencil in the hand of a master—the red glare of the Bessemer steel converters to the south of Chicago thrilled me as the pages of the *Arabian Nights* used to do—with a sense of terror and romance.

And the smothered incandescence of the kiln! In fabulous heat baking mineral and chemical treasure on mere clay—to issue in all the hues of the rainbow, all the shapes of Imagination and never yield to time—subject only to the violence or carelessness of man. These great ovens would cast a spell upon me as I listened to the subdued roar within them.

The potter's thumb and finger deftly pressing the soft mass whirling on his wheel, as it yielded to his touch; the bulbous glass at the end of slender pipe as the breath of the glassblower and his deft turning, decided its shape—fascinated me. Something was being born.

Colors[1]—in paste or crayon—or pencils—always a thrill! To this day I love to hold a handful of many-colored pencils and open my hand to see them lying loose upon my palm, in the light.

Mere accidental colored chalkmarks on the sunlit sidewalk, perhaps, will make me pause and "something" in me hark back to "something" half remembered, half felt, as though an unseen door had opened and distant music had—for an instant, come trembling through to my senses.

And in the sense of earth—deep-buried treasure there—without end. Mineral matter and metal-stores folded away in the veins of gleaming quartz— gold and silver, lead and copper, and tawny iron ore—to yield themselves up to roaring furnaces and flow to the hands of the architect—all to become pawns in the play of the human mind.

And jewels! The gleam of mineral colors and flashing facets of crystals. Gems to be sought and set—to forever play with light to man's delight—in neverending beams of purest green or red or blue or yellow—and all that lives between. Light!—living in the mathematics of form to match with the mathematics of sound.

Crystals are proof of nature's architectural principle.

All this I see as the architect's garden—his palette I called it—to humble the figure.

Materials! What a resource!

With his "materials"—the architect can do whatever masters have done with pigments or with sound—in shadings as subtle, with combinations as expressive—perhaps outlasting man himself.

Stone, wood, pottery, glass, pigments and aggregates, metals, gems—cast in the industrious maw of mill, kiln, and machine to be worked to the architect's will by human-skill-in-labor. All this to his hand, as the pencil in it makes the marks that disposes of it as he dreams and wills. If he wills well—in use and beauty sympathetic to the creation of which he is creature. If he wills ill, in ugliness and waste as creature-insult to creation.

These *materials* are human-riches.

They are Nature-gifts to the sensibilities that are, again, gifts of Nature.

By means of these gifts, the story and the song of *man* will be *wrought* as, once upon papyrus, and now, on paper it is written.

Each material has its own message and, to the creative artist, its own song.

Listening, he may learn to make two sing together in the service of man or separately as he may choose. A trio? Perhaps.

It is easier to use them solo or in duet than manifold.

The solo is more easily mastered than the orchestral score.

Therefore, it is well to work with a limited palette and more imagination, than it is to work with less imagination and more palette.

So—work wherever possible in mono-material, except where the use of sympathetic extra-materials may add the necessary grace or graceful necessity desirable—or unavoidable.

Each material *speaks a language* of its own just as line and color speak—or perhaps because they do speak.

Each has a story.

In most Architectures of the world, stone has suffered imitation of the stick. Even in the oldest cultures like Chinese civilization, great constructions of stone imitate wood posts and beams in joinery—imitate literally great wood towering of poles and posts, beams, richly carved to imitate the carvings of the wooden ones that preceded them and could not endure. Undoubtedly the stick came first in architecture—came long before the stone. The ideas of forms that became associated with ideas of the beautiful in this use of wood took the more enduring material ignorant of its nature and foolishly enslaved it to the idea of the ornamented stick.

Stone is the oldest of architectural materials on record, as to form, except as the stone itself embodies earlier wood forms. So from Stonehenge to Maya masonry—the rude architecture of the Druid-Bards of whom Taliesin was one, down the ages to the intensely implicated and complicated tracery of the Goths—where stone-building may be said to have expired—stone comes first.

The Story of Stone

Stone, as a building material, as human hands begin upon it—stonecraft—becomes a shapely block.

The block is necessarily true to square and level, so that one block may securely rest upon another block and great weight be carried to greater height.

We refer to such masses, so made, as masonry.

The stone may show a natural face in the wall, or a face characteristic of the tool used to shape it—or be flatly smoothed. Sometimes honed or polished.

The walls take on the character of the surface left by the mason's use of his tools.

The character of the wall surface will be determined also by the kind of stone, by the kind of mason, the kind of architect. Probably by the kind of building. But, most of all, by the nature of the stone itself, if the work is good stonework.

Stone has every texture, every color, and—as in marble—also exquisite line combined with both—intensified clear down the scale until we arrive at what we call "precious" stone—and then on to jewels.

But most building stone—as Caen-stone, say—is a clear negative substance, like a sheet of soft beautiful paper, on which it is appropriate to cut images, by wasting away the surfaces to sink or raise traces of the imagination like a kind of human writing, carrying the ideology of the human race down the ages from the primitive to the decadent.

Other stone is hard and glittering; hard to cut. By rubbing away at it with other stones, the surface may be made to yield a brilliant surface, finally polished until its inner nature may be seen as though looked into, as in a glass—transparent.

Most marble is of this character. And granite. The very nature of the material itself becomes its own decoration.

To carve or break its surface, then, is a pity—if no crime.

Stones themselves have special picturesque "qualities" and were much cherished for their "qualities" in China and Japan. Perhaps these Orientals love stones for their own sake more than any other people. They seem to see in them the universe—at least the earth-creation, in little—and they study them with real pleasure and true appreciation.

The Byzantine mosaics of colored stone are a cherishing of these qualities, too. These mosaics on a large scale gave beautiful stone results—fine stonework—good masonry.

But stone is a solid material, heavy, durable, and most grateful for masses. A "massive" material, we say, so most appropriate and effective in simple architectural masses, the nobler the better.

The Mayas used stone most sympathetically with its nature and the character of their environment. Their decoration was mostly *stone-built*. And when they carved it the effect resembled naturally enriched stone surfaces such as are often seen in the landscape.

The Egyptians used stone—as the Chinese used stones—with real love and understanding.

The Greeks abused stone shamefully—did not understand its nature at all except as something to be painted or gilded out of existence. Before they painted it, they fluted and rolled and molded it as though it were wood—or degraded it far lower.

Polished sophistication is not at home with stone.

The Roman architects had no feeling about stone whatever. Their engineers did have—but there were few large stones.

They cut these prizes into wooden cornices to please the architects, and invented the arch to get along with small stones for construction.

The Goths made most of stone. But stone became for the Gothic imagination a mere negative material which they employed supremely well in a structural sense.

Stonecraft rose highest in the Gothic era.

But they, then, set to work and carved the beautiful construction elaborately and constructed carving in the spirit of the construction to an extent never before seen in the world. No arris was left without its molding. It was as though stone blossomed into a thing of the human-spirit. As though a wave of creative-impulse had seized stone and, mutable as the sea, it had heaved and swelled and broken into lines of surging, peaks of foam—human-symbols, images of organic life caught and held in its cosmic urge—a splendid song!

The song of *stone*?

No—because stone was used as a negative material neither limitations respected nor stone nature interpreted. In wood the result was pretty much the same as in iron or in plaster, in the hands of the Goths.

But as a building material it was *scientifically* used. And such stone was usually chosen as had little to say for itself and so not outraged much by such cutting to the shapes of organic life—as it was subjected to, by them.

We may say the stone was not outraged—but neither was it allowed to sing its own song—to be *itself*. Always nearer that, by them, than anywhere else since archaic times.

But it was not the *stone* that inspired the Cathedrals of the Middle Ages nor invited them. It limited them.

Had it not been so—what would they have been like? Was Gothic architecture because of stone or regardless of it?

But that is going far afield for subtle matter and casting the shadow of doubt upon one of the most beautiful spectacles of the triumph of the human spirit over matter.

A greater triumph will be man's when he triumphs through the nature of matter over the superstition that separates him from its spirit.

And that is where he is now in his industrial world as he faces stone, as an architect. As he sees stone in the story recorded by the buildings on the earth—there is not so much to help him now.

To "imitate" would be easy but no man's way.

His present tool, the Machine, can clumsily imitate but without joy or creative impulse behind it when imitation is its menial office. As a mass-material he can now handle stone better and cheaper than ever before, if he allows it to be itself—if he lets it alone for what it is.

Or if—sympathetically—he brings out its nature in his use of it. The Chinese did this in the way they

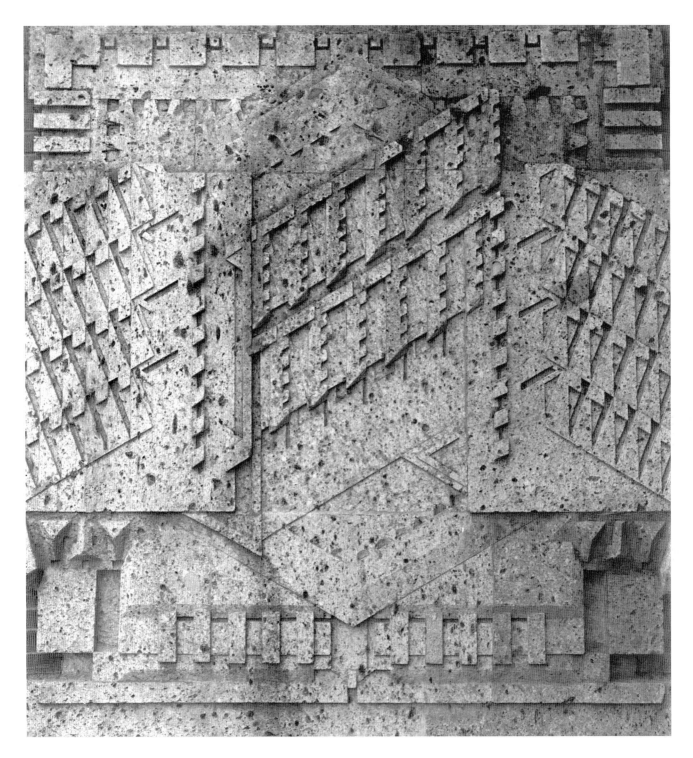

Imperial Hotel scheme #2,
Tokyo, Japan. 1917–22.
FLLW Fdn# 1509.0057

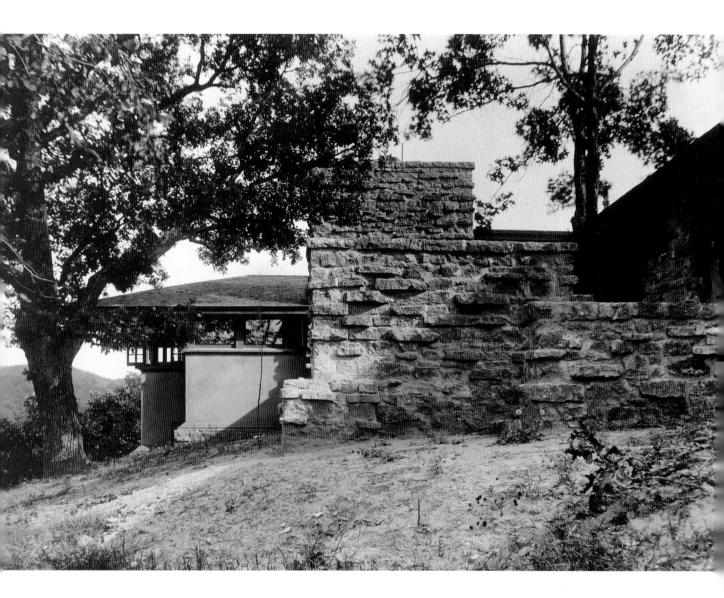

Frank Lloyd Wright House
and Studio, Taliesin I,
Spring Green, Wisconsin. 1911.
FLLW Fdn#1104.0004

cherished and developed the natural beauties of jade—lapis lazuli—crystal—malachite and cornelian, quartz—and other great stones as well.

Man has done this with his machine when he has sawed the blocks of marble and, opening them into thin slabs, spread them, edge to edge, upon walls as facings revealing and accenting its own pattern and color.

He has done this when he planes it and lays it up in a straight-line mass for its own sake, with the texture characteristic of his tools.

He has done this when he takes the strata of the quarry and lays it in like strata, natural edges out—in his walls. He has done this when he makes mosaic of stones and lays them in simple, stone-patterns in color, for whole buildings—stone brocade.

He does this, when, inspired by the hardness and brilliance of the granite, his Machine can now render so well, he makes his ultimate form as simple and clearly hard in mass and noble in outline when finished.

He may even introduce alternate and contrasting materials qualifying broad masses harmonious with stone qualities in horizontal bands or rich masses. Whenever, in his designs, he allows the natural beauty of the stone, as stone, to speak its own material-language, he has justified his machine as an artist's tool. And the nobility of his work will compensate for the loss of the imitations of organic-forms-of-life in the material itself—an imitation that used to be architecture.

Interpretation is still his.

So it will be seen again, as always, that if he now works *with* stone in this sense, using the new power which the machine has given him over it, he will gain a spiritual integrity and physical health to compensate him for the losses of the storyful beauties of that period, since passed, when a building, so far as its *architecture* was concerned, was a block of ornamentally sculptured stone.

It would take a volume to fully illustrate the story that is here written—a mere sketch in bare outline.

In each of the materials we have named there is treasure enough to make Aladdin's cave a mean symbol of an architect's riches, were each architect confined to only *one*.

Aladdin's lamp was a symbol for Imagination.

With this lamp the architect may explore the riches of the deep caves where treasure is waiting for him. And, through him, the human race waits too; for the key that unlocks the man-made door is hanging at his belt—still—though rusty with disuse and the lock itself now stiff with rust and lack of proper oiling.

Let him take his microscope and see the principle that "builds," in nature, at work in stone. Geometry the principle, busy with materials—producing marvels of beauty to inspire him. Read the grammar of the Earth in a particle of stone! Stone is the frame on which his Earth is modeled, and wherever it crops out—there the architect may sit and learn.

As he takes the trail across the great Western Deserts—he may see his buildings—rising in simplicity and majesty from their floors of gleaming sand—where organic life is still struggling for a bare existence: see them still, as the Egyptians saw and were taught by those they knew.

For in the stony bonework of the Earth, the principles that shaped stone as it lies, or as it rises and remains to be sculptured by winds and tide—there sleep forms and styles enough for all the ages, for all of Man.

1. The next seven paragraphs of the original manuscript for the essay on stone as a building material were deleted from the publication of the April 1928 issue of *The Architectural Record*. Observations such as "Light—living in the mathematics of form to match with the mathematics of sound. Crystals are proof of nature's architectural principle" proclaim Wright's deep reverence for nature, including the minerals of the earth and precious stones.

In the Cause of Architecture IV: The Meaning of Materials—Wood

1928

Published with 5 illustrations in *The Architectural Record*, May 1928

From the fantastic totem of the Alaskan—erected for its own sake as a great sculptured pole, seen in its primitive colors far above the snows—to the resilient bow of the American Indian, and from the enormous solid polished tree trunks upholding the famous great temple-roofs of Japan to the delicate spreading veneers of rare, exotic woods on the surfaces of continental furniture, wood is allowed to be wood.

It is the most humanly intimate of all materials. Man loves his association with it, likes to feel it under his hand, sympathetic to his touch and to his eye. Wood is universally beautiful to Man. And yet, among higher civilizations, the Japanese understood it best.

They have never outraged wood in their art or in their craft. Japan's primitive religion, "Shinto," with its "be clean" ideal, found in wood ideal material and gave it ideal use in that masterpiece of architecture, the Japanese dwelling as well as in all that pertained to living in it.

In that architecture may be seen what a sensitive material, let alone for its own sake, can do for human sensibilities.

Whether pole, beam, plank, board, slat, or rod, the Japanese architect got the forms and treatments of his architecture out of tree-nature, wood-wise, and heightened the natural beauty of the material by cunning peculiar to himself.

The possibilities of the properties of wood came out richly as he rubbed into it the natural oil of the palm of his hand, ground out the soft parts of the grain to leave the hard fiber standing—an "erosion" like that of the plain where flowing water washes away the sand from the ribs of stone.

No Western peoples ever used wood with such understanding as the Japanese did in their construction—where wood always came up and came out as nobly beautiful.

And when we see the bamboo rod in their hands—seeing a whole industrial world interpreting it into articles of use and art that ask only to be *bamboo*—we reverence the scientific art that makes wood *theirs*.

The simple Japanese dwelling with its fences and utensils is the *revelation* of wood.

Nowhere else may wood be so profitably studied for its natural possibilities as a major architectural material.

Material here fell into artistic hands—a religious sentiment protecting it, in all reverence for simplicity.

Sometimes in the oak-beamed and paneled rooms of Old England, when "carpentry" was restrained, oak was allowed to be something similar as is seen in oak-timbering of the Middle Ages. In the veneering of later periods the beauty of wood came out—but the carpenter-forms of the work invariably did violence to the nature of wood. The "cabinetmaker" had his way with it.

Woodwork soon became what we learned to call carpentry; more or less a makeshift. Paneling was its sum and substance where the pilaster would not stick nor the cornice hang.

All wooden joinery of the periods, soon or late, fell to pieces, and interruption by too many ingenious "members" frittered away wood-nature in confusion or in contortions of an ingenious but false or inferior "taste."

Outside primitive architectures, sympathetic use of wood in beautiful construction would be found far north or far south—among the Norsemen, or among the South Sea Islanders.

Because of wood we have—the carpenter.

The carpenter loved wood in feeble ways—but he loved his tools with strength and determination. He loved his tools more. Good wood is willing to do what its designer never meant it to do—another of its lovable qualities—but therefore it is soon prostitute to human ingenuity in the makeshift of the carpenter. Wood, therefore, has more human outrage done upon it than Man has done, even upon himself.

It has suffered more—far more than any of the materials in our category.

Where and when it is cheap and, so, becomes too familiar as it nearly always does in a new country, it soon falls into contempt. Man's longing for novelty tries to make it something else. To the degree that the carpenter-artist has succeeded in doing this—one might think—is he the artist-carpenter.

In his search for novelty, wood in his hands has been joined and glued, braced and screwed, boxed and nailed, turned and tortured, scroll sawed, beaded, fluted, suitably furbelowed, and flounced at the carpenter's party—enough to please even him. By the aid of "modern" machines the carpenter-artist got it into Eastlake composites of trim and furniture, into Usonian jigger porches and corner-towers eventuating into candle-snuffer domes or what would you have; got it all over Queen Anne houses outside and inside—the triumph of his industrious ingenuity—until carpentry and millwork became synonymous with butchery and botchwork.

Queen Anne! What murder!

And even now—especially now—in the passing procession of the "periods" I never see orderly piles of freshly cut and dried timber disappearing into the mills to be gored, and ground, and torn, and hacked into millwork without a sense of utter weariness in the face of the overwhelming outrage of something precious just because it is by nature so kind, beneficent, and lovely.

Man has glorified the Tree in the use he made of the Stick—but that he did long before the Louis or the Renaissance got by way of Colonial and Eastlake—or was it Westlake—to Queen Anne; and then by way of the triumphant Machine to General Grant-Gothic and the depths of degradation that soon came in the cut-and-butt of the fluted "trim," with turned corner-block and molded plinth-block.

This latter was the fashion in woodwork when I found the uses of wood I shall describe.

Machinery in that era was well under way and ploughed and tore and whirled and gouged in the name of Art and Architecture.

And all this was so effectually and busily done that the devastation began to be felt in the "boundless" Usonian forests. Conservative lumbermen took alarm and made the native supply go a little further by shrinking all the standard timber sizes first one-eighth of an inch both ways—then a little further on one-eighth inch more both ways—now still a little further—until a stud is become a bed slat, a board kin to a curling veneer.

All standardized sticks great and small are shrinking by a changing standard to meet the deadly facility which the Machine has given to man's appetite for useless *things*.

Usonian forests show all too plainly terrible destruction and—bitter thought—nothing of genuine beauty has Usonia to show for it.

The darkness of death is descending on wood by way of unenlightened architecture.

The life of the tree has been taken in vain as the stick, the substance of the shapely stick, to become imitation-à-la-mode; the precious efflorescent patterns of wood, to be painted out of sight; its silken textures vulgarized by varnish in the mis-shapen monstrosities of a monstrous "taste."

The noble forest has become an ignominious scrap heap in the name of Culture.

The Machine, then—was it—that placed this curse on so beautiful a gift to man? So friendly a material—this brother to the man—laid thus low in murder.

No.

Unless the sword in the hand of the swordsman murdered the man whose heart it ran through.

The Machine is only a tool. Before all, the man is responsible for its use.

His ignorance became devastation because his tool in callous hands became a weapon effective beyond any efficiency such hands had known before, or any sensibilities he ever had. His performance with his Machine outran not only his imagination which, long since, it vanquished, but the endurance of his own sensibilities as human.

No. Blame the base appetite the Machine released upon the forest, for its devastation. Blame the lack of imaginative insight for the scrap heap we have now to show for the lost trees of a continent—a scrap heap instead of a noble architecture.

What should we have had to show were it otherwise? Vain speculation. What may we have to show for what is left—if base appetite becomes enlightened desire and imagination awakes and sees.

Well—we may have the nobility of the *material* if nothing else.

We may have simple timber construction, at least overhead, as a scientific art, free of affectation. The wood let alone as wood or as richly ornamented by hand in color or carving.

We may have satin-boarded wainscots—polished board above polished board, the joints interlocked by beaded insertion, so that shrinkage is allowed and the joint ornaments the whole in harmony with its nature, individualizing each board. We may have plaster-covered walls banded into significant color surfaces by plain wood strips, thick or thin, or cubical insertion, wide or narrow in surface.

We may have ceilings rib-banded in rhythmical arrangements of line to give the charm of timbering without the waste.

We may use flat wood-strips with silken surfaces contrasting as ribbons might be contrasted with stuffs, to show what we meant in arranging our surfaces, marking them by bands of sympathetic flatwood.

We may use a plastic system of varying widths, weights of finely marked wood rib-bands to articulate the new plastic effects in construction never dreamed of before. The flat-strip came so easily into our hands, by way of the machine, to give us—the "backband" that follows all outlines even in an ordinary dwelling, by the mile, for a few cents per foot.

We may compound composite-slabs of refuse lumber glued together under high pressure and press into the glue, facings of purest flowered wood veneer on both sides—making slabs of any thickness or width or length, slabs to be cut into doors, great and small, tops thin or thick—preserving the same flower of the grain over entire series or groups of doors as a unit.

We may miter the flowered slabs across the grain at the edges of the breaks to turn the flowering grain around corners or down the sides and thus gain another plastic effect from the continuity of the flowering.

We may economically split a precious log into thin, wide veneers and, suitably "backed," lay each to each, opening one sheet to lay it edge to edge with the sheet beneath it, like the leaves of a book so the pattern of the one becomes another greater pattern when doubled by the next.

We may cross-veneer the edges of top-surfaces so that the grain of the top carries the flower unbroken down over the ends as it does on the sides.

There is the flat fillet (it happens to be true to wood) to "talk" with—if one must "explain."

We may use the plain-spindle alternating with the thin flat-slat or square or round ones in definite rhythms of light and shade—allowing the natural color and marking of the wood to enrich and soften the surface made by them as a whole. With this we may bring in the accent block.

We have the edgewise and flatwise-strip or cubical stick and accent-block to "ingeniously" combine into screens for light filters or for furniture.

These treatments all allow wood to be wood at its best and the machine can do them all surpassingly better than they could be done by hand—a thousand times cheaper.

Thanks to the machine we may now use great slabs compounded under heat and pressure, where rotary-cut veneers unrolled from a log in sheets ten feet long and as wide as the circumference of the log will yield, in thicknesses of one-thirty-second of an inch, wood wallpaper. And we may lay these sheets, against various compounds, on ceilings—with any manipulation of the efflorescence, now exaggerated by the rotary cut, but still true to wood, and do this to any extent.

The finer properties of wood have been emancipated by the machine.

Observe that, naturally, all these are *plastic* effects. That is, used for the sake of the surfaces and lines of their "wood quality" in contrast to other materials. Carving has a small place in the grammar of these effects, except as an "insert."

There is always the limiting frame or border, constricting surfaces—the most obvious of all uses to which wood is put. And there is always a use of the solid wood stick to be made into honest furniture. There is the wooden frame to be overstuffed for deep comfort—wood showing only at extremities. In light stick-furniture wood combines well with plaited rattan or raffia.

In other words the beauty of wood as silken-texture or satin-surfaces upon which nature has marked the lines of its character in exquisite draw-

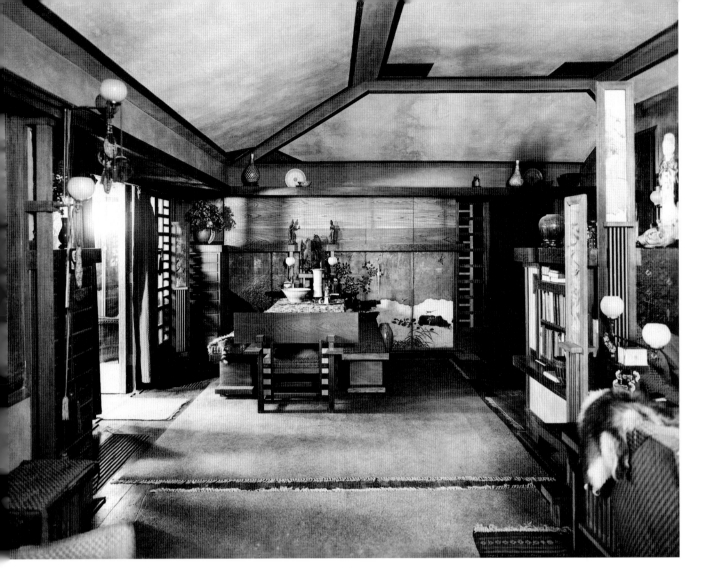

ing and color qualifying flat-surfaces and rib-bands of infinite delicacy, in all variety—because we work *with* the machine, understanding wood, is more liberally ours.

Another opportunity is wood-inlay. There is the chequered turning of the grain to crossgrain in the same wood.

There are the patterns of inlay in contrasting woods.

There are the cunningly cut, denticulated or machined strips to be inlaid between boards or used as edging flat surfaces of veneer: the denticulations to be picked out by polychrome in transparent bright stains, perhaps.

There is the whole gamut of transparent color stains from brilliant red, green, yellow, and blue, to

Frank Lloyd Wright House,
Taliesin II,
Spring Green, Wisconsin. 1914.
FLLW Fdn# 1403.0038

all hues in between, to aid and intensify or differentiate these uses of wood.

And for exterior work there are characteristic board-and-batten effects—horizontal, vertical, diagonal or checkered, got out of planks or boards with surfaces rough from the saw to be color-stained or allowed to weather.

There are roofs boarded lengthwise of the slope, likewise inlaid between the joints but with properly devised ornamental copper flashing to come up over the edges and the ends.

There are brilliantly decorative treatments of poles, free-standing as the Alaskan totem stood, or in rows, horizontal or vertical. Palisaded walls.

There are combinations of the slender pole and square-stick and the spindle-rod, alternating with the slat or the board in endless rhythmic variety.

All these undressed-wood, plastic treatments, are much the same as for inside work, allowing wood to be wood but coarser in scale with an eye to weathering in the joinery.

And finally after we have exhausted the board and machined inlaid-batten, and the spread of the figure of the wood-flowering over flat surfaces, and the combinations of the following back-band and the varying rib-band—the spindle-stick, the flat-slab and the rod, the marking-strip and the accent-block, the ornamental-pole—rectangular timbering ornamentally planked, the undressed, interlocking boards on walls and roof slopes—then—

We have combinations of all these. A variety sufficient to intrigue the liveliest imagination for as long as life lasts—without once missing the old curvatures and imaging of organic-forms; the morbid twists and curious turns, the contortions imposed on wood in the name of the "Styles" *mostly* using wood as a make-shift—or, if not, as something other than wood.

A most proper use of wood, now that we must economize, are these treatments using marking-bands or plastic-ribbons, defining, explaining, indicating, dividing, and relating plaster surfaces. It is economy in the material, while keeping the feeling of its beauty. Architectural articulation is assisted and sometimes had alone by means of the dividing lines of wood.

In these plastic treatments—using wood gently banded or in the flat allowing its grain and silken surface even in the spindle screens to assert itself and wood-quality to enter into effect of the whole, we have found the Machine a willing means to a simple end. But for the Machine this free plastic use of wood either in rib-bands or extended flowered surfaces would be difficult, uncharacteristic, and prohibitive in cost.

Moreover this is true conservation of wood because in these effects it is used only for its qualities as a beautiful material. The tree need no longer be lost.

In these papers we are not speaking of "building" as a makeshift, but of building as the Art of Architecture. And while all building, as things are, cannot be Architecture but must make shift—Architecture should hold forth such natural ways and means for the true use of good materials that, from any standpoint of economical realization of the best the material can give to structure, Architecture would put mere building to shame. Stupid waste characterizes most of the efforts of mere builders, always—even, or especially, when building for profit.

Wood grows more precious as our country grows older. To save it from destruction by the man with the machine it is only necessary to use the Machine to emancipate its qualities, in simple ways such as I have indicated, and satisfy the man.

There is no waste of material whatever in such uses, either in cutting up the tree or adapting the cutting to the work done when it is of the character described. The Machine easily divides, subdivides, sands, and polishes the manifold surfaces which any single good stick may be made to yield by good machine methods.

Wood can never be wrought by the machine as it was lovingly wrought by hand into a violin for instance, except as a lifeless imitation. But the beautiful properties of wood may be released by the Machine to the hand of the architect. His imagination must use it in true ways—worthy of its beauty. His *plastic* effects will refresh the life of wood, as well as the human-spirit that lost it—as inspiration—long since.

In the Cause of Architecture V: The Meaning of Materials—the Kiln

I see Tang glazes and Sung soft-clay figures from Chinese tombs in my studio as I write—a few of the noble Tang glazed horses that show Greek influence—and Han pottery. Some fragments of the Racca blue-glazed pots and the colored tiles of the Persians in Asia Minor—"the cradle of the race"—Egyptian vessels and scarabs.

It appears from a glance the oven is as old as civilization at least—which is old enough for us.

Our interest is not archaeological but architectural and begins with a lump of peculiarly pliable clay in the hand of the man who wants to make something useful and at the same time beautiful out of it—at the time when he knows he can bake it hard enough to make it serviceable. Then it all begins to grow rapidly in the experimental search for different clays. The grinding of minerals, to make paste for a flux to pour over the vessels to make them impervious and beautiful—and the legion of earnest chemical experiments that followed. The research of devoted craftsmen for several hundred centuries have laid up treasure and all but lost it but for a specimen or two—times without number.

The remains are a fascinating record of man's creative endeavor on his earth. A record that tells more of him probably than any other—for in it we find not only pottery and building but painting, sculpture, and script intimately related to the life of all the peoples who have inhabited the earth since cave dwellers built their fires.

All the materials we know, seem at one time or another in a state of flux. Fire is father-creator to them all—below ground. Light is mother-creator to all that rise in air out of the ground. Back to Fire again goes that which Fire made to be fused with man's creative power into another creation—that of his use and beauty.

Anything permanent as a constructive material comes into man's hands by way of Fire, as he has slowly learned to approach in "degrees" the heat in which his globe of earth was formed—and courage to set what he has himself made, again at its beneficent mercy. He knows much. But Fire knows more and has constant surprises for him.

He will never exhaust them all—nor need to.

He has the Brick.

He has the Tile.

He has the Pot and Bowl.

He has the Vase.

He has the Image.

He may color them all—forever so far as he knows—with the hues of nature and qualify each according to any or all the sensibilities he has—taught by the qualities he loves in the work of Nature all about him.

We have hitherto been speaking of "natural" materials. The natural material here is of earth itself. But to produce this material known as ceramics, another element, that of the artificer, has entered with Fire.

This product should therefore be nearer man's desire—molded, as it is, by himself. His creation is seen in it. What he has sensed of the story of his creation, he has put into it.

He sees as he is and this record will tell us what he sees, how he sees—as he sees it.

He has seen nothing, he is not himself. He is the imaginative geometrical tracery of the Persian and Moor and the noblest brick buildings man has ever erected. He is the noble sculpture and pottery of the

1928

Published with 4 illustrations in *The Architectural Record*, June 1928

Han dynasty in China, as well as the Satsuma and Nabeshima of Japan. His is the story painted on the pots and bowls of Greece no less than the flowered plaques of Byzantium or upon the utensils of the Indian cliff dweller.

His sense of form he took from those forms already made as his natural environment. In his striving for excellence in quality he was taught what to love by stone, leaf, and mold and flower—the book of "trees," the mosses and mists and the mosaics of foliage in the sun. Especially in China where his sense of Nature was profound did he learn from them. When he was at his best, he interpreted what he saw.

When he was inferior, he imitated it.

But always, superior or inferior, he was its reflection in his ceramics as in a mirror.

And in spirit looking away from himself, his eyes fixed on Gods as God or God as Gods—fashioning and firing and building as he himself was burning, all the while, better than he *knew*.

What has man to show for the Brick? I should offer the brick buildings of Asia Minor—Persia.

What he has to show for his Tile? Wherever Persian or Mohammedan influence was supreme.

What he has to show for the Pot and Bowl? Chinese pottery.

What he has to show for his Vase? The Grecian urn.

To show for his Image? Those of Egypt, Greece, and China.

The modern contribution to ceramics as building material is "terra-cotta." A poor name for an important material—but so it is named. I suppose "earthenware" seemed inadequate or not specific.

And it is the greatest opportunity for the creative artist of all the materials he may choose. It is, of course, burned clay in any color or glaze for entire buildings—pottery buildings! Earthenware on a great scale.

Modern terra-cotta has known but one creative master—only one—Louis H. Sullivan.

He is dead. His work in terra-cotta will live long after him. His was the temperament and the imagination that naturally found in this impressionable material the ideal medium for his genius. Terra-cotta lives only as it takes the impression of human imagination. It is a material for the modeler. It is in the architect's hand what wax is in the sculptor's hand.

After the material takes shape, the surface treatments are all a matter of taste. They are limitless in quality and style.

And the chief business of terra-cotta has been to imitate stone. It would imitate anything else as readily—with gratitude—it seems. It is the misfortune of anything impressionable to be called upon to give imitations. Mimicry is all too human. To imitate is the natural tendency of men. Not man.

But Louis H. Sullivan's exuberant, sensuous nature and brilliant imagination took terra-cotta—and it lived. It no longer asked permission of the Styles. It was *itself* because it was Louis H. Sullivan. In it this master created a grammar of ornament all his own. And notwithstanding certain realistic tendencies, an original style of ornamentation out of the man, astonishing in range, never lacking virility.

Into the living intricacy of his loving modulations of surface, "background"—the curse of all stupid ornament—ceased to exist. None might see where terra-cotta left off and ornamentation came to life. A fragment of Sullivanian terra-cotta—were we at some remote period of time to be excavated—would be found with a thrill. It would mean that a man lived among us at a dead time in Art.

The Sullivanian motif was efflorescent, ex-volute, supported by tracery of geometric motives—bringing up the clay in forms so delicate and varied and lively that no parallel in these respects exists.

We may see, for once, how completely a negative material can be appropriately brought to life by the creative artist. It is reassuring.

Is there in architectural history another man who out of himself not only created an exuberant type of beautiful architectural relief but furnished it forth, always consistent in style, in amazing variety that could not have ended but with his death? Even toward the last of his life, enfeebled, disillusioned, but indomitable, he drew with all his old-time freshness of touch a series of beautiful designs that show no falling off in power whatever—even in spontaneity.

His ornamentation was the breath of his life. Clay came into his hand, that both might live on forever.

Because, now that we know what terra-cotta can be, and how it can be, we shall never be satisfied to see it degraded to imitation again—nor satisfied to see it imitating him.

Taught by him, we should learn how to use it.

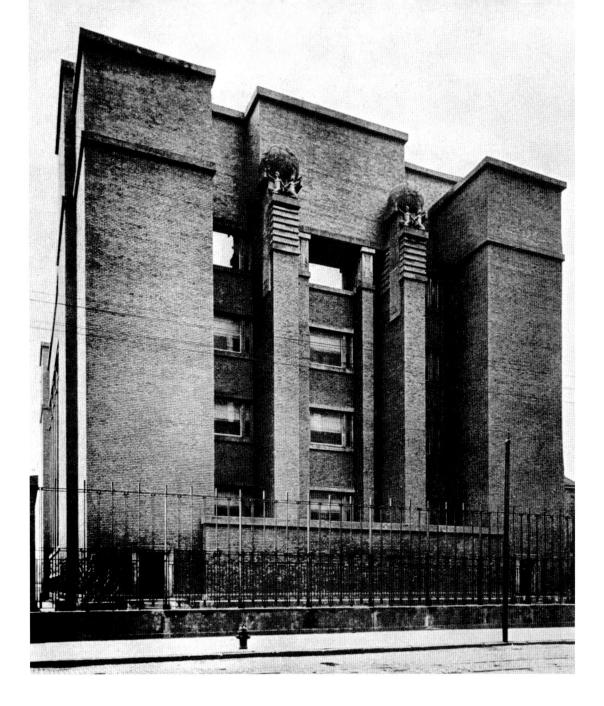

If not so well as he, at least on principle for its own sake as he did. His sense of Architecture found a fullness of expression in the plastic clay. Few architects ever find any such expression in any medium whatsoever.

Terra-cotta should revere him as its God, sing his praises but, better than that, be true to his teaching, which would mean more to him than psalms in his praise and his statue in the hills.

Larkin Company Administration Building, Buffalo, New York. 1903.
FLLW Fdn# 0403.0060

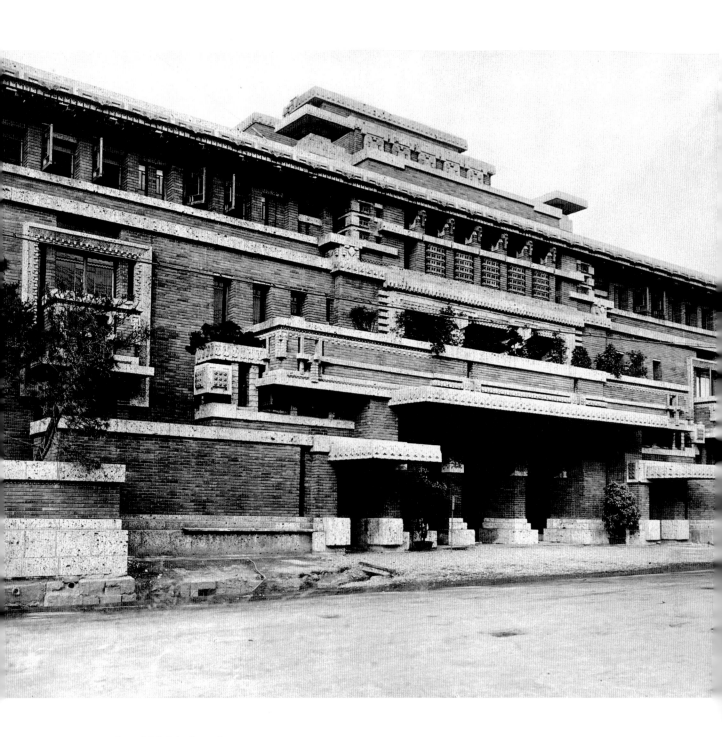

Imperial Hotel scheme #2,
Tokyo, Japan. 1917–22.
FLLW Fdn# 1509.0092

In the terra-cotta or pottery of earthenware building we may have today the sum and substance of all the kiln ever gave to architecture.

Modern methods have made the complete terra-cotta building, inside and outside, as definite a possibility as was the Han vessel in its time or the Greek vase. But—who would look upon it in its present state after Sullivan left it, as a work of Art?

It cannot live either on its own texture or color—to any great extent. And as for its design? It is a mendicant feeding on crumbs from the table of the styles.

Why? Is it because Sullivan is dead? Did this most valuable of modern achievements in "material" die with him, as it never really lived until he came?

No. Materials never die. This material is only asleep, waiting for some master to waken it to life.

Here, young man in Architecture, is a golden opportunity quite boundless so far as imagination goes. Rescue the royal beggar from penury and slavery.

Where is the pottery building beautiful in form and texture and color—as such?

Why are there not thousands cleaning themselves in the rain, warming themselves in the sun—growing richer with age instead of dingy and sad and old? Why do they look cheap and soon stale?

Just because there are no good pottery designs for good pottery buildings—so how can the pottery be good with no more inspiration than that?

A neglected minion of the Machine!

By way of terra-cotta we have here arrived at the matter of Ornament. Because terra-cotta chiefly lives by virtue of the human imagination in ornamentation.

As we intend to discuss ornament by itself on its merits later, let us say now that true ornament is of the thing, never on it. The Material develops into its own ornamentation by will of the master. He does not impose forms upon it. He develops it into forms from the within which is characteristic of its nature if he is "the master."

We may see this in Sullivanian terra-cotta. The only limit to Sullivan's treatment was the degree to which the substance of the pliable clay would stay up between the thumb and finger and come through the fire. Background disappeared but surface was preserved. There was no sense of background, as such, anywhere. All was of the surface, out of the material. So no sense of ornament as *applied* to terra-cotta, because terra-cotta became ornament and ornamented itself.

Terra-cotta was this master's natural medium because his sense of beautiful form was the subtle fluctuation of flowering surface, songlike, as found in organic plant-life—the music of the crystal is seen as a minor accompaniment only.

The tones of the main theme are those of organic efflorescence—*growth* as it is performed by plant species. This idea of growth was the theme—invariably—which he glorified.

He created a "species" himself—and kept on creating others.

This procedure of Growth intrigued his imagination—inspired him. "Organic" was his God-word, as he traced Form to Function.

When, I suggested, as I once did, that quite as likely the function might be traced to the form, he disposed of the heresy—by putting it on a par with the old debating school argument as to which came first, the Hen or the Egg. His interpretation was to him the Song-of-Creation and he never tired of singing it. As it was visible to him in the growth of the plant he saw it in all—as indeed it may be.

Think of this when you see his synthetic motifs in his sentient terra-cotta.

And realize that there are ways of making a pottery building, the joints of the material becoming unit-lines in the pattern of the whole—which he, the pioneer, touches upon but was called away before realization or called away *to* realization—who knows?—and imagine the glorious marvel of beauty it might be.

I remember going to Palermo some years ago to see the mosaics of Monreale.

I had just got into the Cathedral-square and lifted my eyes to that great work when to the left I saw—or did I see it—for some moments I thought I dreamed—there against the sky—no not against it, of it, literally of the sky was a great dome of pure Racca blue.

I forgot the Cathedral for quite some time in the wonderful blue dome so simple in form—a heavenly thing. I have never recovered from it. And that effect was "Ceramic." Why not Terra-Cotta? The old qualities in color; firing can not be dead!

To illustrate a simple use of brick I refer for noble examples to Ispahan, Sārí, Vera-min, Āmol, Samarkand, Bokhara, and, of course, tile and pottery as well. Unfortunately I have little brickwork to my credit. I have chosen a few examples that show the walls solidified by emphasis of the horizontal joint, and examples showing the brick-pier and mass as I feel it to be natural in brick construction today. Brick is the material we in Usonia know and love best. We probably have brought brick-making to a pitch of perfection never existing in the world before at any time. And we use it, on the whole very well. Not only is the range inexhaustible in texture and color and shape, but the material itself is admirable in quality.

Together with it go all those baked-clay, vitreous, hollow bricks and hollow tiles which are probably the most useful of all materials in building in our climate.

Usonian tiles and mosaics do not reach the quality of ancient or even contemporary materials of this nature. There is enough good material, however, to warrant a more general use which would inevitably cause it to grow better—and our day needs this development.

The nature of the mosaic either of stone, glass, or ceramics is a truly architectural medium—useful in this era of the Machine and lending itself to plastic treatment with no insult to its nature. I should like to see whole buildings clothed in this medium.

Our pottery is imitative. We have had Teco, Rookwood, and other types—all deserving experiments with something of originality in most of them. But none proceeding on principle to develop style, but of the nature and character of the process.

The "vessel" does not inspire us, it seems, as it did earlier people. Perhaps because we know no such need of it as they knew. I have chosen some natural "vessels" to show the help nature generously offers in the matter, to mention only one humble resource.

The Usonian Image, likewise the Vase, is tentative when not openly imitative. We seem to have little or nothing to say in the clay figure or pottery vase as concrete expression of the ideal of beauty that is our own. No sense of form has developed among us that can be called creative—adapted to that material. And it may never come. The life that flowed into this channel in ancient times apparently now goes somewhere else.

A few natural forms found in the Champlain clays seem interesting to me in this connection.

Again our subject remains in barest outline—for to go adequately into this most human and important feature of all Man's endeavor to be and to remain beautiful, the "kiln" would exhaust interesting volumes.

In the Cause of Architecture VI: The Meaning of Materials—Glass

Perhaps the greatest difference eventually between ancient and modern buildings will be due to our modern machine-made glass. Glass, in any wide utilitarian sense, is new.

Once a precious substance limited in quantity and size, glass and its making have grown so that a perfect clarity of any thickness, quality, or dimension is so cheap and desirable that our modern world is drifting toward structures of glass and steel. Had the ancients been able to enclose interior space with the facility we enjoy because of glass, I suppose the history of architecture would have been radically different, although it is surprising how little this material has yet modified our sense of architecture beyond the show windows the shopkeeper demands and gets.

How that show window plagued the architect at first and still teases the classicist! It has probably done more to show the classicist up as ridiculous than any other single factor.

The demand for visibility makes walls and even posts an intrusion to be got rid of at any cost. Architecture gave up the first story but started bravely above the glass at the second, nothing daunted and nothing changed. The building apparently stood in midair. Glass did it.

Crystal plates have generally taken the place of fundamental wall and piers in almost all commercial buildings; and glass, the curse of the classic, as an opportunity for the use of delicate construction of sheet metal and steel, is a tempting material not yet much explored. As glass has become clearer and clearer and cheaper and cheaper from age to age, about all that has been done with it architecturally is to fill the same opening that opaque glass screened before, with a perfect visibility now, except for the use to which the shop-man demands that it be put. The shop! That is where glass has almost come into its own. We have yet to give glass proper architectural recognition.

What is this magic material, there but not seen if you are looking through it? You may look at it, too, as a brilliance, catching reflections and giving back limpid light.

But it is what it is today because it may be seen through perfectly while it is an impenetrable stop for air currents, when due allowance is made for its fragility. When violence is done to it, it may be shattered, but a precious feature of the material is that it does not disintegrate.

I suppose as a material we may regard it as crystal—thin sheets of air in air to keep air out or keep it in. And with this sense of it, we can think of uses to which it might be put as various and beautiful as the frost designs upon the pane of glass itself.

Glass has been servile in architecture beyond the painting done with it in cathedral windows. It has been a utilitarian affair except when used for candelabra, chandeliers, or knobs—excepting only the mirror.

The sense of glass as the crystal has not yet to any extent entered into the poetry of architecture. It is too new, for one thing. For another thing, tradition did not leave any orders concerning it. It is strictly modern. Therefore, let us try to understand what it is. The machine has given to architects, in glass, a new material with which to work. Were glass eliminated now from buildings, it would be, so far as our buildings have gone, only like putting our eyes out. We could not see out or see into the building. We have gone so far as to make it the eyes of the building. Why not now combine it with steel, the spider's

1928

Published with 5 illustrations in *The Architectural Record,* July 1928

web, spin the building frame as an integument for crystal clearness—the crystal held by the steel as the diamond is held in its setting of gold—and make it the building itself?

All the diversity of color and texture available in any material is not only available but imperishable in glass. So far as deterioration or decay is concerned, it is possible now to preserve the metal setting for an indefinite period. And it is the life of this setting alone that would determine the life of the building. It is time to give attention to that setting.

Shadows have been the brushwork of the architect when he modeled his architectural forms. Let him work, now, with light diffused, light refracted, light reflected—use light for its own sake—shadows aside. The prism has always delighted and fascinated man. The Machine gives him his opportunity in glass. The machine can do any kind of glass—thick, thin, colored, textured to order—and cheap. A new experience is awaiting him.

Then why are modern cities still sodden imitations of medieval strongholds? Black or white slabs of thick glass have already gone far as substitutes for marble slabs. They could easily go farther for their own sake, in walls of buildings. Glass tiles, too, are not uncommon. Nor are glass mosaics an unusual sight.

All these uses together would form an incomparable palette for an architect. The difficulty is, architects are bound by traditional ideas of what a building must look like or be like. And when they undertake to use new materials, it is only to make them conform to those preconceived ideas.

Every new material means a new form, a new use if used according to its nature. The free mind of the natural architect would use them so, were the unnatural inhibition of that freedom not imposed upon all by a false propriety due to the timidity of ignorance.

The Persian, the Egyptian, and the Moor had most insight concerning the mathematics of the principle at work in the crystal. The Persian and the Moor were most abstract; the Egyptian was most human.

All knew more of the secrets of glass than we do—we who may revel in it unrestrained by economic considerations of any kind, and who understand it not at all, except as a mirror.

As a mirror, the vanity and elegance of the French brought glass into architectural use. Their brilliant salons, glittering with cut-glass pendants and floral forms blown in clear and colored glass, were something in themselves new in architecture. The very limitation of the size of the sheet available gave a feature in the joint that adds rather than detracts from the charm of the whole effect of their work.

But now the walls might disappear, the ceilings, too, and—yes—the floors as well. A mirror floor? Why not? In certain cases. Nicely calculated effects of this sort might amplify and transform a cabinet into a realm, a room into bewildering vistas and avenues: a single unit into unlimited areas of color, pattern, and form.

The Mirror is seen in Nature in the surfaces of lakes, in the hollows of the mountains, and in the pools deep in shadow from the trees; in winding ribbons of the rivers that catch and give back the flying birds, clouds, and blue sky. A dreary thing to have that element leave the landscape. It may be as refreshing and as beautifying in architecture, if *architecturally* used. To use it so is not easy, for the tendency toward the tawdry is ever present in any use of the mirror.

But to extend the vista, complete the form, multiply a unit where repetition would be a pleasure, lend illusion and brilliance in connection with light effects—all these are good uses to which the architect may put the mirror. As a matter of fact he never uses plate glass in his windows or indoors inside his buildings that he does not employ the same element in his architecture that the limpid pool presents in the landscape—susceptible to reflections. And this opportunity is new. It is a subtle beauty of both exterior and interior, as may be readily seen in the effect of the exterior if a poor quality of cylinder glass be substituted for polished plate glass. Perhaps no one other change in the materials in which any building is made could so materially demoralize the effect of the whole as this substitution.

In the openings of my buildings, the glass plays the effect the jewel plays in the category of materials. The element of pattern is made more cheaply and beautifully effective when introduced into the glass of the windows than in the use of any other medium that architecture has to offer. The metal divisions become a metal screen of any pattern—heavy or light, plated in any metal, even gold or silver—the glass a subordinate, rhythmical accent of

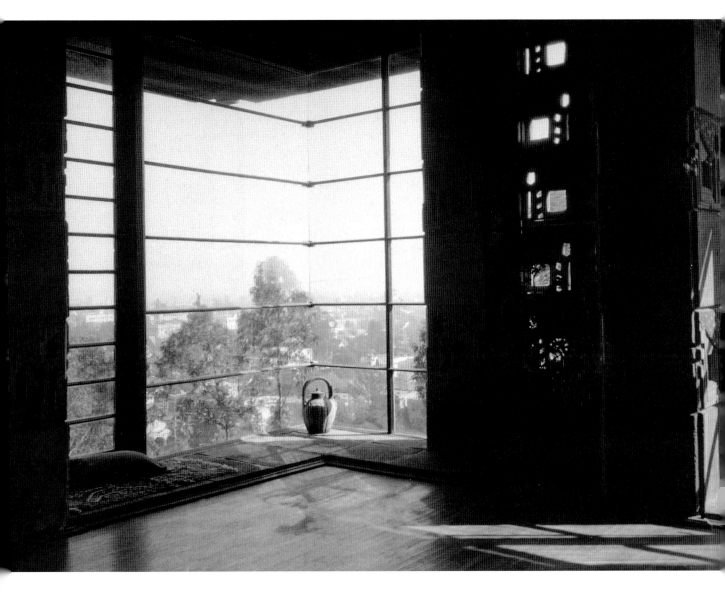

any emotional significance whatever, or vice-versa. The pattern may be calculated with reference to the scale of the interior and the scheme of decoration given by, or kept by, the motif of the glass pattern.

I have used opalescent, opaque, white, and gold in the geometrical groups of spots fixed in the clear glass. I have used, preferably, clear primary colors, like the German flashed glass, to get decorative effects; believing the clear emphasis of the primitive color interferes less with the function of the window and adds a higher architectural note to the effect of *light* itself. The kindersymphony in the windows in

Samuel Freeman House,
Los Angeles, California. 1923.
FLLW Fdn# 2402.0011

139

the Coonley playhouse is a case in point. The sumac windows in the Dana dining room another. This resource may be seen in most of my work, varied to suit conditions. This is a resource commonly employed in our buildings but usually overdone or insufficiently conventionalized. Nothing is more annoying to me than any tendency toward realism of form in window glass, to get mixed up with the view outside. A window pattern should stay severely "put." The magnificent window painting and plating of the windows of the religious edifice is quite another matter. There the window becomes primarily a gorgeous painting—painting with *light* itself— enough light being diffused to flood the interior dimly. This is an art in itself that reached its height in the Middle Ages. Probably no greater wealth of pictorial color effect considered as pure decoration exists in the world than in the great rose windows and pointed arches of the Cathedral.

But, the glass and bronze building is the most engaging of possibilities in modern architecture. Imagine a city iridescent by day, luminous by night, imperishable! Buildings—shimmering fabrics—woven of rich glass—glass all clear or part opaque and part clear—patterned in color or stamped to form the metal tracery that is to hold all together to be, in itself, a thing of delicate beauty consistent with slender steel construction—expressing the nature of that construction in the mathematics of structure, which are the mathematics of music as well. Such a city would clean itself in the rain, would know no fire alarms—nor any glooms. To any extent the light could be lighting seems to come more easily and reduced within the rooms by screens, a blind, or insertion of opaque glass. The heating problem would be no greater than with the rattling windows of the imitation masonry structure, because the fabric now would be mechanically perfect—the product of the machine shop instead of the makeshift of the field.

I dream of such a city, have worked enough on such a building to see definitely its desirability and its practicability.

Beauty always comes to and by means of a perfect practicability in architecture. That does not mean that the practicability may not find idealization in realization. On the contrary. Because that is precisely what architecture does and is when it is really architecture. Architecture finds idealization in realization or the reverse if you like.

Then, too, there is the lighting fixture—made a part of the building. No longer an appliance nor even an appurtenance, but really architecture.

This is a new field. I touched it early in my work and can see limitless possibilities of beauty in this one feature of the use of glass. Fortunately this field has been more developed than any other. The sense of integral lighting seems to come more easily and naturally because there was no precedent to impede progress. And it is now with the lighting feature, so will it soon be a disgrace to an architect to have left anything of a physical nature whatsoever, in his building unassimilated in his design as a whole.

Integral lighting began with this ideal in mind in my work thirty-one years ago, as may be seen in the playroom ceiling and in the dining room ceiling of my former house in Oak Park. Also, in the ceiling of my studio library in that building. Perhaps it might be said to have begun earlier than that in the Auditorium by Adler and Sullivan where the electric lights became features of the plaster ornamentation. The lights were not incorporated, but they were provided for in the decoration as accents of that decoration.

Glass and light—two forms of the same thing!

Modern architecture is beckoned to a better reckoning by this most precious of the architect's new material. As yet, little has been done with it but the possibilities are large.

This great gift of glass is of the machine—for today mechanical processes are as much the Machine as any other of its factors.

In the Cause of Architecture VII: The Meaning of Materials — Concrete

1928

Published with 4 illustrations in *The Architectural Record,* August 1928

I am writing this on the Phoenix plain of Arizona. The ruddy granite mountain-heaps, grown "old," are decomposing and sliding down layer upon layer to further compose the soil of the plain. Granite in various stages of decay, sand, silt, and gravel make the floor of the world here.

Buildings could grow right up out of the "ground" were this "soil," before it is too far "rotted," cemented in proper proportions and beaten into flasks or boxes—a few steel strands dropped in for reinforcement.

Cement may be, here as elsewhere, the secret stamina of the physical body of our new world.

And steel has given to cement (this invaluable ancient medium) new life, new purposes, and possibilities, for when the coefficient of expansion and contraction was found to be the same in concrete and steel, a new world was opened to the Architect. The Machine in giving him steel-strands gave concrete the right-of-way.

Yet three-fourths of the dwellings here are of wood and brick brought from great distances and worked up into patterns originated, east, thirty years ago. The "houses" are quite as indigenous as a cocked hat and almost as deciduous; one-half the cost of the whole—freight.

The Indian did better in the adobe dwelling he got from Mexico and built in the foothills. Even the few newer concrete buildings imitate irrelevant "styles"—although more relevant Mexico is coming north at the moment, to the rescue, in little ways. So funny, they will be architectural comedy ten years later.

It is only natural that the Architect, at first, should do as he has always done—reproduce badly in the new material the forms of the old Architecture or whatever he had instead, which were probably, themselves reproductions, as false.

Let us frankly admit that these human processes of thought move more by habit and indirection than by intellectual necessity and attach to the established order with tenacity worthy of a nobler thing.

The Architect, by profession, is a conservative of conservatives. His "profession" is first to perceive and conform and last to change this order.

Yet gradually the law of gravitation has its way, even with the profession: natural tendency in even so humble a thing as a building material will gradually but eventually force the architect's hand and overcome even his "profession."

Then after it has had its way, will come its sway, so that when a newer material condition enters into life, it, in turn, will have just as hard a time of it, until "the nature of the thing," by gravity, conquers "professional resistance" once more: a resistance compounded of ignorance, animal fear, and self-interest.

The literature of concrete, as a conglomerate, now fills libraries. Its physical properties are fairly well understood.

Aesthetically it has neither song nor story.

Nor is it easy to see in this conglomerate a high aesthetic property, because in itself it is amalgam, aggregate, compound. And cement, the binding medium, is characterless in itself. The net result is, usually, an artificial stone at best, or a petrified sand heap at worst.

Concrete would be better named "conglomerate," as concrete is a noble word which this material fails to live up to. It is a mixture that has little quality in itself.

If this material is to have either form, texture, or color in itself, each must artificially be given to it, by human imagination.

Thus it is one of the insensate brute materials that is used to imitate others.

"Concrete"—so called—must submit to the "artistic" at the hands of any parlor-architect or interior desecrator and, consequently seldom have life of its own worthy a substance so obedient and useful.

As a material it is its misfortune to project as wooden beams, travel molded as cornices. Yet it will faithfully hang as a slab, stand delicately perforated like a Persian faience screen or lie low and heavily in mass upon the ground. Again, unluckily, it will stand up and take the form (and texture too) of wooden posts and planks. It is supine, and sets as the fool, whose matrix receives it, wills.

When, and as, he has made up his mind to his "*taste*" it will set into whatever shape may be, and will then go to work with steel strands for sinews and do mighty things. When aged it becomes so stubborn that it would cost more to remove the structure often, than the ground upon which it stands might be worth.

Surely, here, to the creative mind, is temptation. Temptation to rescue so honest a material from degradation. Because here in a conglomerate named "concrete" we find a plastic material, that as yet has found no medium of expression that will allow it to take plastic form. So far as it is now used it might be tallow, cast iron, or plaster, poured into molds and at the mercy of their shape.

Therefore its form is a matter of this process of casting rather than a matter of anything at all derived from its own nature. Because it is thus, universally, at the mercy of demoralizing extraneous influences, it is difficult to say what is "concrete" form and what is not.

But certain truths regarding the material are clear enough. First, it is a mass-material; second, an impressionable one as to surface; third, it is a material which may be continuous or monolithic within certain very wide limits; fourth, it is a material that may be chemicalized, colored, or rendered impervi-

ous to water: it may be dyed or textured in the stuff; fifth, it is a willing material while fresh, fragile when still young, stubborn when old, lacking always in tensile strength.

What then should be the Aesthetic of Concrete?

Is it Stone? Yes and No.

Is it Plaster? Yes and No.

Is it Brick or Tile? Yes and No.

Is it Cast Iron? Yes and No.

Poor Concrete! Still looking for its own at the hands of Man.

Perhaps the term "concrete" popularly meaning conglomerate, in this connection, denotes it the mongrel, servile as such, destined to no more than the place of obedient servant in the rank of materials.

Terra-cotta, the fanciful, however, though less artificial, is not much more fortunate in character and makeup. The two materials have much in common. Terra-cotta having the great advantage of standing up to be modeled and becoming indestructible, colorful, and glazed when fired, a comparatively expensive process.

The chief difference between stone and concrete lies in the binding medium which, in the case of stone, is of the stone itself—a chemical affinity.

In the case of concrete it is a foreign substance that binds the aggregate. There is little or none other than a mechanical affinity in concrete.

But for this difference concrete would be, in fact, a true natural stone. And taking this difference for granted it is more truly an artificial stone than it is anything else; the nature of the artifice enabling the artificer to enter at the time the mixture is in a state of flux, to give it whatever shape he may desire.

Yes, artificial stone it is that concrete usually becomes.

But the essential difference between stone and concrete is still unconsidered. And that essential difference is the plasticity of the material itself as distinguished from natural stone which has none at all.

I should say that in this plasticity of concrete lies its aesthetic value. As an artificial stone, concrete has no great, certainly no independent, aesthetic value whatsoever. As a plastic material—eventually becoming stone-like in character—there lives in it a great aesthetic property, as yet inadequately expressed.

Charles Ennis House,
Los Angeles, California. 1923.
FLLW Fdn# 2401.0012

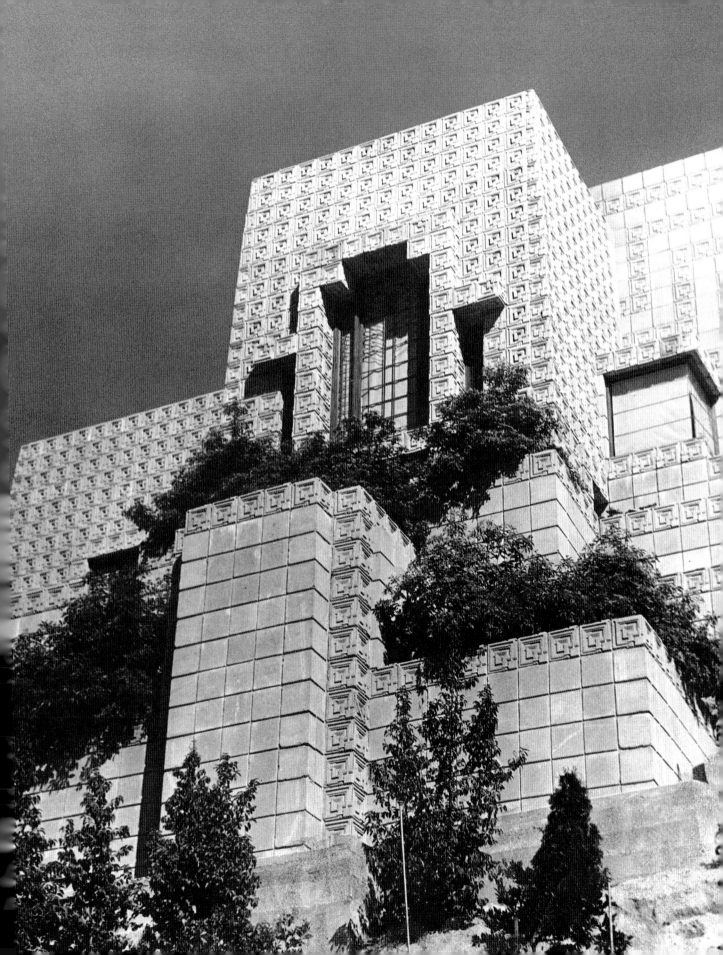

To design a concrete pattern for a casting that would feature this flow of the material might be possible and so allow its plastic nature to come through the process into artistic expression, thus distinguishing concrete from stone. I have seldom seen it done unless by accident. Of course, where the material is tamped relatively dry or beaten into molds there is no such problem.

There is another plastic possibility in treatment. The material *en masse* may be printed, "goffered," while fresh and wet, as the printer's die embosses his paper—and such effects had as may be seen in stone where fossil remains of foliage or other organic forms, either cameo or intaglio, are found in it. And this treatment would be nearer to its nature, aesthetically, than is any casting whatsoever.

The pre-cast slab, rolled to small thickness but large in size, is a means common to all materials that set hard from a flux and absorb reinforcement. But there is little or nothing in that treatment to distinguish concrete from sheet steel or glass or plaster.

The slab may be made smaller, be printed with design appropriate to the material, and be knit together with steel laid in wide grooved joints and the whole poured and locked together into a thin slab, and express the nature of the material itself no more than it would express terra-cotta or glass or metal, except as the feeling of the design and mass, as a whole, reflected it.

Most usefully then, probably, in this mechanical era, concrete is another passive or negative material depending for aesthetic life almost wholly upon the impress of human imagination. This element of pattern, however it may mechanically be made to occur, is therefore the salvation of concrete in the mechanical processes of this mechanical age, whenever it rises as a material above the mere mass into which it may naturally be thrown on the ground and where it serves as such better than any other material.

Of course, always there is the interior content or aggregate of the concrete to work up in various ways, giving texture and color to the block, slab, or mass. These treatments are too familiar to require much comment, and are all useful to qualify the material, but of no great significance in the broad question of finding the aesthetic interpretation that will best express the nature of concrete considered as a material.

These expedients all partake of the nature of stone and bring concrete still nearer as artificial stone, the sole advantage of the concrete being that it may be formed in place, in great size, by small means, by way of accretion—whereas stone must be got out, expensively cut, transported, and lifted to place in bulk.

Thus concrete becomes the ideal makeshift of this, the vainglorious Makeshift Era.

There never was a more "inferior" building material than was the old concrete block; unless it was ungalvanized sheet iron. The block was cheap imitation and abominable as material when not downright vicious. Every form it undertook it soon relegated to the backyard of aesthetic oblivion.

The illustration shows what that selfsame degraded block may become with a little sympathy and interpretation, if scientifically treated.

Herein the despised thing becomes at least a thoroughbred and a sound *mechanical* means to a rare and beautiful use as an architect's medium, as the "block" becomes a mere mechanical unit in a quiet, plastic whole. And this mechanical use of concrete as a *mechanical* material has only just begun. In it, alone, is a medium for an "Architecture"—humble as it is before Imagination enters.

And there remain to be developed those higher uses—non-mechanical, plastic in method, treatment, and mass—to which I have referred, working naturally with color into truly plastic beauty.

In the Cause of Architecture VIII: Sheet Metal and a Modern Instance

1928

Published with 5 illustrations in *The Architectural Record,* October 1928

The Machine is at its best when rolling, cutting, stamping, or folding whatever may be fed into it.

Mechanical movements are narrowly limited unless built up like the timer of a Corliss engine or like a linotype.

The movements easiest of all are rotary, next, the press or hammer, and the lift and slide works together with either or both. In these we have pretty much the powers of the "Brute." But infinite are the combinations and divisions of these powers until we have something very much like a brain in action—the Robot itself, a relevant, dramatic conception.

The consequences may well be terrifying when man's volition is added to these brute powers. This volition of man's, deprived of soul, may drive these powers to the limit of human endurance, yes—to the ultimate extinction of the humanity of the race.

Commerce, as we have reason to know, has no soul.

Commercial interests left to themselves would soon write their own doom in the exploitation of their own social life. They would soon cease to reproduce. They would fail to reproduce because the elements of commerce are those of the machine—they lack the divine spark necessary for giving life. The margin of profit, piling up into residue, is inert, inept, impotent.

The Machine itself represents this margin of profit in the physical body of our modern world: a profit, inept, inert, impotent.

The question propounded in these papers and the continual haunting reference in all of them— "What is this interpreter of life, the Architect, going to do about it?"—is again insistent here. For in sheet metal there is opportunity to give life to something the Architect seems to despise, while forced to use it because it is cheap. He avails himself of it as a degraded material. In the building trade, we find cornices, gutters, downspouts, watersheds, in lead, zinc, and tin, iron, and copper, everywhere. Imitations too in these materials, of every other material, are everywhere.

But where may sheet metal be seen used as a fine material for its own sake?

Oh yes, occasionally. But why not "everywhere." It is the one "best thing" in modern economy of materials brought by the Machine. Building trades aside, we now make anything at all of sheet metal— kitchen utensils, furniture, automobiles, and Pullman coaches. And in flashings and counter flashings or roofing it is keeping nearly all the citizens of America dry in their homes at the present moment.

Copper is easily king of this field, and what is true of copper will be true also of the other metals in some degree, with certain special aptitudes and properties added or subtracted in the case of each.

Back of this sheet-metal tribe, literally, we have the light-rolled steel section for stiffening any particular sheet-metal area in all particular cases whatsoever. All "spread" materials need reinforcement. Metal sheets no less than concrete slabs.

In the building trades we have had recourse to these metal fabrics in the cheapest and most insulting fashion, in buildings where the architect has either never been seen, or has been set aside. Sheet metal is prime makeshift to his highness the American jerry-builder.

Roofs seem to be the building problem naturally solved by sheet metal, as it may be stamped

into any desired form, lock seamed, and made into a light, decorative, and permanent watershed. It is possible to double the thicknesses in long panels or channels, sliding non-conducting material between them and lock-seaming together the continuous slabs thus made so that they lie together like planks on the roof framing, finished from below as from above. Each slab is a natural water channel.

The machinery at work in the sheet-metal trades easily crimps, folds, trims, and stamps sheets of metal as an ingenious child might his sheets of paper. The finished product may have the color brought up in surface treatment or be enameled with other durable substances as in enamel color glazing or plating or by galvanizing the finished work may be dipped and coated entire. But copper is the only sheet metal that has yet entered into architecture as a beautiful, permanent material. Its verdigris is always a great beauty in connection with stone or brick or wood, and copper is more nearly permanent than anything we have at hand as an architect's medium.

But now that all metals may be rolled into sheets and manipulated so cheaply—combinations of various metals may be made as any other combination of materials may be. And will be.

The Japanese sword guard shows how delightful these properties of metal become when contrasted and harmonized in the hands of a master-artist. A collection of these mighty little things in art and craft should be the *vade mecum* of every metal student or worker. In fact it seems that upon metals the Japanese, and before them the Chinese, have lavished much of their genius and have excelled from the making of a keen cutting-blade that would hold its edge against blows on steel to inventing subtle texture-treatments in iron for all decorative purposes.

Leaving the precious metals in a category by themselves, these sympathetic treatments of various humble metals are most significant for us who, as masters of metal production, are committed to it in our industries, though we have developed the beauty of it in use not at all.

In previous ages, beyond the roofer's use of lead in roofing and water-leads and the blacksmith's wrought iron as seen in gates and lanterns, there has been little use made of metal by architects, excepting such occasional use of bronze as Ghiberti made in his famous doors. But Ghiberti was a sculptor,

not an architect, or his doors would, probably, have been wood elaborately ironed in the mode.

I believe the time is ready for a building of sheet copper wherein the copper may be appropriate carriage for glass only. What would such a building be good for and what would it be like?

Why should we have such buildings? This architect will try to answer in his own fashion.

Since first meeting, thirty years ago, James A. Miller, a sheet-metal worker of Chicago, who had intelligent pride in his material and a sentiment concerning it (designing a house for himself at one time, he demanded a tin-floored balcony outside his bedroom window in order that he might hear the rain patter upon it), I have had respect for his sheet-metal medium.

At that time I designed some sheet-copper bowls, slender flower holders, and such things, for him, and fell in love with sheet copper as a building material. I had always liked lead, despised tin, wondered about zinc, and revolted against galvanized iron as it was then used in Chicago quite generally as a substitute for granite.

Miller Brothers in addition to other offices of that factory were then interested in sheet-metal window sash and frames—especially in skylights and metal doors.

We had contempt for them because they were made to imitate wooden sash. The doors too were made up in wood and covered with metal, the result being an imitation in metal of a wood-paneled door. It was usually "grained" to complete the ruse.

No one thought much about it one way or another. The city demanded these mongrels as fire-stops in certain places under certain conditions and that was that.

They were not cheap enough in those days—forcing the material as it was forced in this imitation work—to offer much incentive to bother with the problem.

But see how the matter has since grown up! We need no statistics to add to the evidence of our eyes wherever we go, which may see that what is left of the architectural framework of the modern world after concrete and steel have done with it will be in some form or other, sheet metal.

Twenty-seven years ago, under the auspices of Jane Addams, at Hull House, Chicago, an Arts and Crafts society was formed, and I then wanted to

make a study of the Machine as a tool at work in modern materials. I invited Mr. Miller, Mr. Bagley, Mr. Wagner to come to the tentative meeting to represent respectively sheet metal, machined marble work, and terra-cotta. I wanted them there with us to tell us what we as artists might do to help them. At that time, to put the matter before the proposed society, I wrote (and read) the "Art and Craft of the Machine," since translated into many languages.

It was useless. As I look back upon it I smile, because the society was made up of cultured, artistic people, encouraged by University of Chicago professors who were ardent disciples of Ruskin and Morris. What would they want to see, if they could see it in such a programme as mine?

It all came to nothing—then—although next day's *Tribune,* in an editorial, spoke of "the first word said, by an artist, for the machine." I suspect Miss Addams of writing it herself. Ever since my stand taken there, however, the matter has grown for me, and, if not for them, it is all about them now in nearly everything they use or touch or see, still needing interpretation today as much as it was needed then.

But to get back from this reflection to this sheet-copper and glass building which has eventually resulted from it.

I have designed such a building.

It is properly a tall building.

It is a practical solution of the skyscraper problem because the advantages offered by the material and method add up most heavily in their own favor where they can go farthest—either up or crosswise.

Standardization here may come completely into its own, for standardization is in the nature of both sheet-metal process and material. It may be again seen that the life of the imagination awakens its very limitations to life.

The exterior walls, as such, disappear—instead are suspended, standardized sheet-copper screens. The walls themselves cease to exist as either weight or thickness. Windows become in this fabrication a matter of a unit in the screen fabric, opening singly or in groups at the will of the occupant. All windows may be cleaned from the inside with neither bother nor risk. The vertical mullions (copper shells filled with non-conducting material) are large and strong enough only to carry from floor to floor and project much or little as shadow on the glass may or

may not be wanted. Much projection enriches the shadow. Less projection dispels the shadows and brightens the interior. These protecting blades of copper act in the sun like the blades of a blind.

The unit of two feet both ways is, in this instance, emphasized on every alternate vertical with additional emphasis on every fifth. There is no emphasis on the horizontal units. The edge of the various floors being beveled to the same section as is used between the windows, it appears in the screen as such horizontal division occurring naturally on the two-foot unit lines. The floors themselves, however, do appear, at intervals, in the recessions of the screen in order to bring the concrete structure itself into relief in relation to the screen as well as in connection with it.

Thus the outer building surfaces become opalescent, iridescent copper-bound glass. To avoid all interference with the fabrication of the light-giving exterior screen, the supporting pylons are set back from the lot line, the floors carried by them thus becoming cantilever slabs. The extent of the cantilever is determined by the use for which the building is designed. These pylons are continuous through all floors and in this instance exposed as pylons at the top. They are enlarged to carry electrical, plumbing, and heating conduits, which branch from the shafts, not in the floor slabs but into piping designed into visible fixtures extending beneath each ceiling to where the outlets are needed in the office arrangement. All electrical or plumbing appliances may thus be disconnected and relocated at short notice with no waste at all in time or material.

Being likewise fabricated on a perfect unit system, the interior partitions may all be made up in sections, complete with doors, ready to set in place and designed to match the general style of the outer wall screen.

These interior partition-units thus fabricated may be stored ready to use, and any changes to suit tenants can be made overnight with no waste of time and material.

The increase of glass area over the usual skyscraper fenestration is only about ten percent (the margin could be increased or diminished by expanding or contracting the copper members in which it is set), so the expense of heating is not materially increased. Inasmuch as the copper mullions are filled with insulating material and the window openings

are tight, being mechanical units in a mechanical screen, this excess of glass is compensated.

The radiators are cast as a railing set in front of the lower glass unit of this outer screen wall, free enough to make cleaning easy.

The walls of the first two stories, or more, may be unobstructed glass—the dreams of the shopkeeper in this connection fully realized.

The connecting stairways necessary between floors are here arranged as a practical fire escape forming the central feature, as may be seen at the front and rear of each section of the whole mass, and though cut off by fireproof doors at each floor, the continuous stairway thus made discharges upon the sidewalk below without obstruction.

The construction of such a building as this would be at least one-third lighter than anything in the way of a tall building yet built—and three times stronger in any disturbance, the construction being balanced as the body on legs, the walls hanging as the arms from the shoulders, the whole, heavy where weight insures stability.

But of chief value, as I see it, is the fact that the scheme as a whole would legitimately eliminate the matter of "architecture" that now vexes all such buildings, from field construction, all such elements of architecture "exterior" or interior becoming a complete shop-fabrication—assembled only in the field.

The shop in our mechanical era is ten to one, economically efficient over the field, and will always increase over the field in economy and craftsmanship.

The mere physical concrete construction of pylons and floors is here non-involved with any interior or exterior, is easily rendered indestructible, and is made entirely independent of anything hitherto mixed up with it in our country as "Architecture." In the skyscraper as practiced at present the "Architecture" is expensively involved but is entirely irrelevant. But here it is entirely relevant but uninvolved.

National Life Insurance Building,
Chicago, Illinois. 1925. Project.
FLLW Fdn# 2404.009

Also the piping and conduits of all appurtenance-systems may be cut in the shop, the labor in the field reduced to assembling only, "fitting" or screwing up the joints being all that is necessary.

Thus we have, literally, a shop-made building all but the interior, supporting posts and floors, which may be reinforced concrete or concrete-masked steel.

In this design, architecture has been frankly, profitably, and *artistically* taken from the field to the factory—standardized as might be any mechanical thing whatsoever, from a penny-whistle to a piano.

There is no unsalable floor space in this building created "for effect," as may be observed.

There are no "*features*" manufactured "for effect."

There is nothing added to the whole merely for this desired "effect."

To gratify the landlord, his lot area is now salable to the very lot-line and on every floor, where ordinances do not interfere and demand that they be reduced in area as the building soars.

What architecture there is in evidence here is a light, trim, practical commercial fabric—every inch and pound of which is "in service." There is every reason why it should be beautiful. But it is best to say nothing about that, as things are now.

The present design was worked out for a lot three hundred feet by one hundred feet, the courts being open to the south.

There is nothing of importance to mention in the general disposition of the other necessary parts of the plan. All may be quite as customary.

My aim in this fabrication employing the cantilever system of construction, which proved so effective in preserving the Imperial Hotel in Tokyo, was to achieve absolute scientific utility by means of the Machine—to accomplish—first of all—a true standardization which would not only serve as a basis for keeping the life of the building true as architecture, but enable me to project the whole, as an expression of a valuable principle involved, into a genuine living architecture of the present.

I began work upon this study in Los Angeles in the winter of 1923 having had the main features of it in mind for many years. I had the good fortune to explain it in detail to "lieber-meister," Louis H. Sullivan, some months before he died.

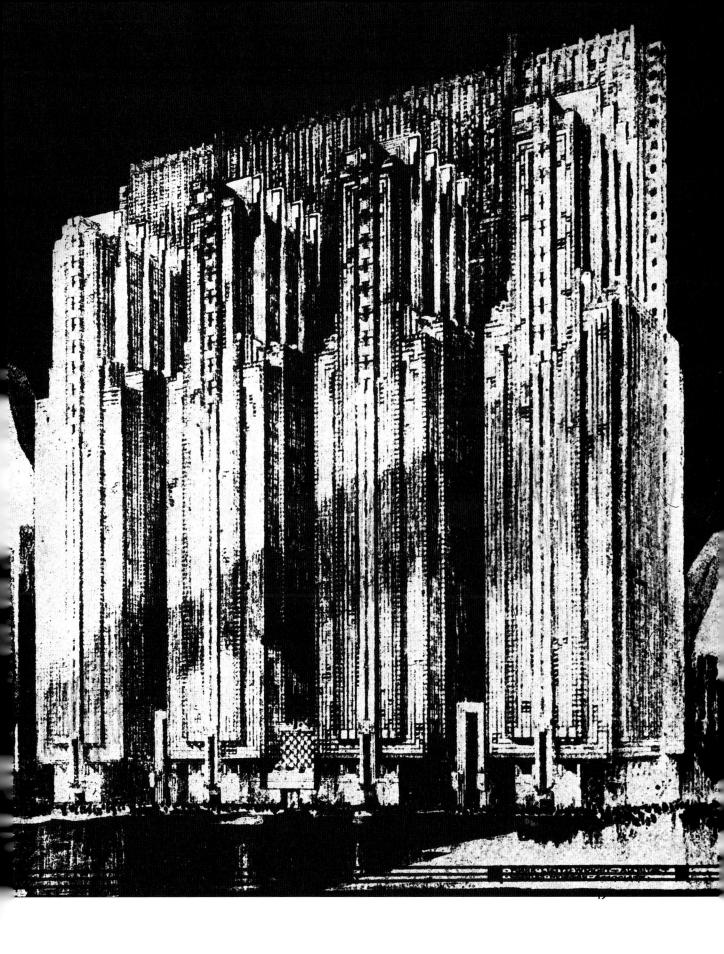

Gratefully, I remember—and proudly too—"I have had faith that it would come," he said. "This Architecture of Democracy—I see it in this building of yours, a genuine, beautiful thing. I knew what I was talking about all these years you see. I never could have done this building myself, but I believe that, but for me, you could never have done it."

I am sure I should never have reached it, but for what he was and what he did.

This design is dedicated to him.

In the Cause of Architecture IX: The Terms

1928

Published with 4 illustrations in *The Architectural Record*, December 1928

Enough, by now, has been said of materials to show direction and suggest how far the study of their natures may go. We have glanced at certain major aspects of the more obvious of building materials only, because these studies are not intended to do more than fire the imagination of the young architect and suggest to him a few uses and effects that have proved helpful in my own work. The subject has neither bottom, sides nor top, if one would try to exhaust "the nature of materials!" How little consideration the modern architect has yet really given them. Opportunity has languished in consequence and is waiting, still.

Perhaps these articles have been guilty of "poetic" interpretation now and then, turning these "materials" over and over in the hand. The imagination has caught the light on them, in them as well, and tried to fix a ray or two of their significance in the sympathetic mind.

Poetry, Poetic, Romantic, Ideal.

These words now indicate disease or crime because a past century failed with them and gave us the *language* of form—instead of the significant form itself.

So if we are not to fall into the category of "language" ourselves, I owe an explanation of the meaning of these words, for I shall continue to use them.

It has been common practice among artists to apply the terms qualifying one art to another art—say, those of Music to Architecture or vice versa. This may be done because certain qualities in each are common to all. It may be helpful to make comparisons between them to bring out particular significance, as our English vocabulary is poor at best in all the words we have with which to express shadings of qualities or of our feeling in dealing with qualities.

We can hack away at the thing with our body-terms and get the subject anywhere or nowhere except misunderstood.

Nor do we speak a common tongue in the use we have come to make of these main words. We may pack into each of them more or less, and differently than another would dream of doing, or could do. So it is well to clean them up—for now we are going to write about the uses and purposes of "materials" in creating this thing we name Architecture.

"Poetry of Form," for instance, is a phrase that will now make almost any sensible man sick.

The word "poetry" is a dangerous word to use, and for good reason. Carl Sandburg once said to me, "Why do you use the words 'poetry,' 'beauty,' 'truth,' or 'ideal' any more? Why don't you just get down to tacks and talk about boards and nails and barn doors?"

Good advice. And I think that is what I should do. But I won't, unless I can get an equivalent by doing so. That equivalent is exactly what I cannot get. Those words—romance, poetry, beauty, truth, ideal—are not precious words nor should they be *specious* words. They are elemental human symbols and we must be brought back again to respect for them by using them significantly if we use them at all, or go to jail.

Well, then—our lot being cast with a hod of mortar, some bricks, or stone or concrete and the Machine, we shall talk of the thing we are going to do with these things in the terms that are sensible enough, when we speak of the horsehair, catgut, fine wood, brass and keys, the "things" that make up the modern orchestra. By the way, that orchestra is New. Our possibilities in building with the Machine are New in just the same sense.

Although Architecture is a greater art than Music (if one art can be greater than another) this architect has always secretly envied Bach, Beethoven, and the great Masters of Music. They lifted their batons after great and painful concentration on creation and soared into the execution of their designs with a hundred willing minds—the orchestra—and that means a thousand fingers quick to perform every detail of the precise effect the Master wanted.

What a resource!

And what facility they were afforded by forms—they made them—moving according to mood from fugue to sonata, from sonata to concerto—and from them all to the melodic grandeur and completeness of the symphony.

I suppose it is well that no architect has anything like it nor can ever get it.

But as a small boy, long after I had been put to bed, I used to lie and listen to my father playing Beethoven—for whose music he had conceived a passion, playing far into the night. To my young mind it all spoke a language that stirred me strangely, and I've since learned it was the language, beyond all words, of the human heart.

To me, architecture is just as much an affair of the human heart.

And it is to architecture in this sense that we are addressing ourselves. We are pleading here in that cause.

What then, is "Poetry of Form"?

The term has become a red rag or a reproachful tag to architects at home and abroad. And, too, it is something that clients would rather not hear about. For all clients are, to some degree, infected by this contact with architects. And some of the best among them fall ill with Neo-Spanish that was itself Neo-Italian or some kind of Renaissance of the Renaissance, or linger along Quasi-Italian, or eventually die outright of Tudor or Colonial.

It is a new form of the plague—"this poison of good taste," as Lewis Mumford has precisely called it. This "poison" has cursed America for generations to come. And this happened to the good people who spoke the language of "Poetry of Form" and hopefully sought the "Romantic" when they became clients.

"Poetry of Form," in this romantic, popular sense, has not only cost wasted billions in money but has done spiritual harm beyond reckoning to the America of the future. But the fact remains that America wanted it and sought it. The failure is less significant than the fact.

So instead of speaking of "Poetry of Form" in buildings, perhaps, after all, we would do better to say simply the natural building, naturally built, native to the region.

Such a building would be sure to be all that "Poetry of Form" should imply, and would mean a building as beautiful on its site as the region itself.

And that word ROMANCE, Romantic or Romanza, got itself born in literature a century ago. Later Novalis and his kind chose the blue flower as its symbol. Their Romance was rather an escape from life than any realization of the idealization of it. As the word is popularly or commonly used today, it is still something fanciful, unlike life. At least it is something exotic. "Romance" is used as a word to indicate escape from the pressure of the facts of life into a realm of the beyond—a beyond each one fashions for himself or for others as he will—or may—dream.

But in music the Romanza is only a free form or freedom to make one's own form. A musician's sense of proportion is all that governs him in it. The mysterious remains just enough a haunting quality in a whole—so organic as to lose all tangible evidence of how it was made—and the organic whole lives in the harmonies of feeling expressed in sound. Translate "sounds and the ear" to "forms and the eye," and a Romanza, even, seems reasonable enough, too, in architecture.

And now that word IDEAL.

The IDEAL building? Why, only that building which is all one can imagine as desirable in every way.

And POETRY? Why, the poetry in anything is only the song at the heart of it—and in the nature of it.

Gather together the harmonies that inhere in the nature of something or anything whatsoever, and project those inner harmonies into some tangible "objective" or outward form of human use or understanding, and you will have Poetry. You will have something of the song that aches in the heart of all of us for release.

Any of these Arts called "Fine" are POETIC by nature. And to be poetic, truly, does not mean to escape from life but does mean *life raised to intense significance and higher power*.

POETRY, therefore, is the great potential need of human kind.

We hunger for POETRY naturally as we do for sunlight, fresh air, and fruits, if we are normal human beings.

To be potentially poetic in architecture, then, means—to create a building free in form (we are using the word Romanza), that takes what is harmonious in the nature of existing conditions inside the thing and outside it and with sentiment (beware of sentimentality)—bringing it all out into some visible form that expresses those inner harmonies perfectly, *outwardly*, whatever the shape it may take.

In this visible shape or form you will see not only what was harmonious in the existing conditions inside and outside and around about the building, but you will also see, in this sentiment of the architect, a quality added from the architect himself—because this ultimate form inevitably would be *his* sense of BEAUTY living now for you in these known and visible terms of his work.

These words—Poetry, Romance, Ideal—used in a proper sense—and I believe I have given them proper expression and interpretation here—are indispensable tools in getting understood when talking of creation.

At any rate, I shall use them, always in the sense I have just given them.

And there is need of another term to express a new sense of an eternal quality in creation.

Need, really, of a new dimension?

Either a new dimension to think with or a new sense of an old one.

We have heard of the fourth dimension frequently, of late, to meet this need. Why a fourth dimension, when we so little understand the possibilities of what we already use as the three dimensions?

If we make the first two (length and width) into one, as really they are both merely surface, and then add the third (thickness) as the second, thus getting mass, we will have an empty place as third in which to put this new sense as the missing dimension I shall describe. Thus comes in the third dimension about which I have talked a good deal and written somewhat.

Or suppose we arrive at it another way by simply giving spiritual interpretation to the three dimensions we already use. Say length (the first dimension) becomes continuity, width (the second dimension) becomes that breadth of which we speak when we refer to the measure of some great man's mind or a great prospect. Then thickness (the third dimension) becomes depth and we give to that word, "depth," the meaning we give to it when we speak of the "profound," the organic, the integral—again we have the third dimension.

We reach the missing dimension either way, but reach it we must.

For it is necessary to find some term that will make it easy to express this missing quality in discussing creation and reaching within for understanding.

But why say fourth dimension when, by properly interpreting the three we already have and by giving them the higher significance which is theirs by nature, we may be spared the confusion of more mere numbers?

This, then, is what I mean by the third dimension. Either an interpretation of the physical third, an interpretation that signifies this quality of "at-one-ness" or integral nature in anything or everything. Or, arrive at it by naming the three dimensions as now used as actually but two, adding the third as a new concept of organic-integrity, or more properly speaking, as that *quality* that makes anything *of* the thing and never on it.

Thus came the new conception of architecture as interior space finding utilization and enclosure as its "*members*"—as architecture. The *within* is thus made concrete realization in *form*.

This is the *integral* concept of building for which I have pleaded, am still pleading, and will continue to plead, instead of the earlier one—beautiful but less great—in which a block of building material was sculptured, punctured, and ornamented into architecture.

In this matter of supplying the needed term as the third dimension I may be found guilty of making a language of my own to fit my necessity.

Perhaps that is true—although it seems obvious enough to me that the quality lacking in the thought of our modern world where creation is concerned, is simply expressed in this way. I should be thankful for a better, more evident expression of this subjective element.

If I could find it, I should be among the first to use it.

Until then I can only write and speak of this es-

sence of all creative endeavor, objectively, as the third dimension. And here in this matter will be found the essential difference between what is only modern and what is truly new.

The pictorial age in which we live will no longer be satisfied to have the picture continue without this interior significance expressed in integral form. Two dimensions have characterized the work of the past centuries and two-dimensional thought and work is still modern, it seems. Is it too much to hope that the coming century will be one in which this element of the third dimension—this demand for organic significance—will characterize all the pictures that go to make up the main picture, which will be then tremendous with integrity and pregnant with new beauty?

Now, there are certain things as hard as nails, as pointed as tacks, as flat as a barn door that go to make up the technique of creation in this deepened, enlivened, more potential sense.

Since we now have materials in our hands to work with as elements, it is method that I now want to write about, believing that if I can make even the beginning of the matter of making true, significant buildings a little more clear, I shall have rendered real service. I would much rather build than write about building, but when I am not building, I will write about building—or the significance of those buildings I have already built.

The conception of the room *within,* the interior spaces of the building to be conserved, expressed, and made living as architecture—the architecture of the *within*—that is precisely what we are driving at, all along. And this new quality of thought in architecture, the third dimension, let us say, enters into every move that is made to make it—enters into the use of every material; enters the working of every method we shall use or can use. It will characterize every form that results naturally from this integral interpretation of architecture in its demand upon us for integrity of means to ends—for integrity of the each in all, and of the all in all in whatever we do—yes, from pig to proprietor, from a chicken-house to a cathedral.

One more word is indispensable to get the essence of this matter of creation visible on the surface.

That word is "PRINCIPLE."

In an earlier paper, there is an attempt to define character and to throw some light on the vexed matter of style!

Principle is the working scheme, or the scheme at work in character, style, integrity, truth, or beauty. It is not a motif but a means. We might say principle is the law that governs the production of any one or all of them.

The principle of anything is the law that works its being.

Natural law is principle, or the other way around, as you please. Our application of what we understand of principle is mostly expedient, seldom a genuine working of principle. That is all that is the matter with us. Principle is the tool with which the architect must consciously work to be a safe man or get great effects in his work.

He may be an artist—that is, he may be sentient to his fingertips and be merely artistic without this command of principle, or, let us say, without this noble submission to its command, never knowing the command when seen or heard or "sensed."

In command of principle or commanded by it, only so is the artist potential in creation.

This miserable assumption of virtues, though one has them not, may be expedient, but it is all the hell there is attached to this affair of getting spirit materialized in works that gratify supremely human desires—we might say, "getting the Beautiful born." And then have someone pop up and say with a sneer, "Yes, but what is beauty?" as though beauty were a commodity like soap, cheese or tobacco.

Well, yes. Here, in beauty, is another word to stumble over or mumble within this age of the pragmatic "expedient" which, after all, is only an experiment.

But, now we have them all in a row—Poetry, Romantic, Ideal, Beauty—faithful mistresses of principle which we may now name Truth. And "Integrity," "Character," "Style," are attributes, merely, of the working of the master—Principle.

What is Beauty? And Keats' "Ode to a Grecian Urn" answers—"Truth, Beauty—Beauty, Truth."[1]

Obviously, the gifted boy was right, but the nature of either is no nearer for his statement—in the case of the young architect who wants to build something that is both true and lovely. Before we get out of this, that word "love" and the word "joy" too, will get in, I feel sure. Here they are at this moment. Very well, let them in to the distinguished

company they know so well. And then let us ask them for help.

"Art is the evidence of man's joy in his work," man has said. And that love is the motivating power in creation we all know by experience.

We are talking about creating or about creations, and this motivation, "Love," is essential to any conception of it—to any beginning of it.

Conceive, then, in love, and work with principle, and what men call Beauty will be the evidence of your joy in your work. After the purity and intensity of your desire or love, then, according to the degree that you have got command of Principle or willingly obey its commands, that materialization of spirit will appear in your work in earthly form—and men will call it Beauty.

Look about you at earthly forms! Trees, flowers, the reactions to one another of the elements in sky, earth, and sea. All are merely effects of the working of definite principles with definite "materials"—which are really only elements in the creative hand.

The "design" of this in the altogether is too large in pattern to be yet comprehended by man, yet for our purposes in all or in each, we may find the evidence we seek of method in creation.

Method in creation?

It is there most certainly. Principle is at work continually in this school for architects—working there with simple materials and never-failing *ideas* of form. The form is a consequence of the principle at work. It would seem that no proper excuse for "making" anything ugly need ever be accepted from an architect—with all this prima facie evidence surrounding him, evident even in his own fingers as he writes or draws. He may study forms, "types" constructed by the infallible working of interior principles in this common school. What escapes us is the original idea or ultimate purpose.

This urge to create the beautiful for love of the beautiful is an inheritance. Enough for us that because of the inheritance we have carved out for ourselves with imagination, this higher realm of Beauty.

With imagination, then, let us try to learn the method of working principle with such simple elements as are everywhere put into our hands as materials. Love in our hearts—passion, yes, is essential to success, as our motif.

Now having done our best to light up these words and discuss the relationship existing between them, we will go on to talk of those matters, as hard as nails, as pointed as tacks, as flat as a barn door, that are involved in the method—of creation.

Love no one can give. Assuming that inspiration is in the heart, we can show facts and performances with materials according to Principle that will be helpful to others in relation to method in creation.

1. Wright has misquoted Keats. The line reads: "Beauty is Truth, Truth Beauty."

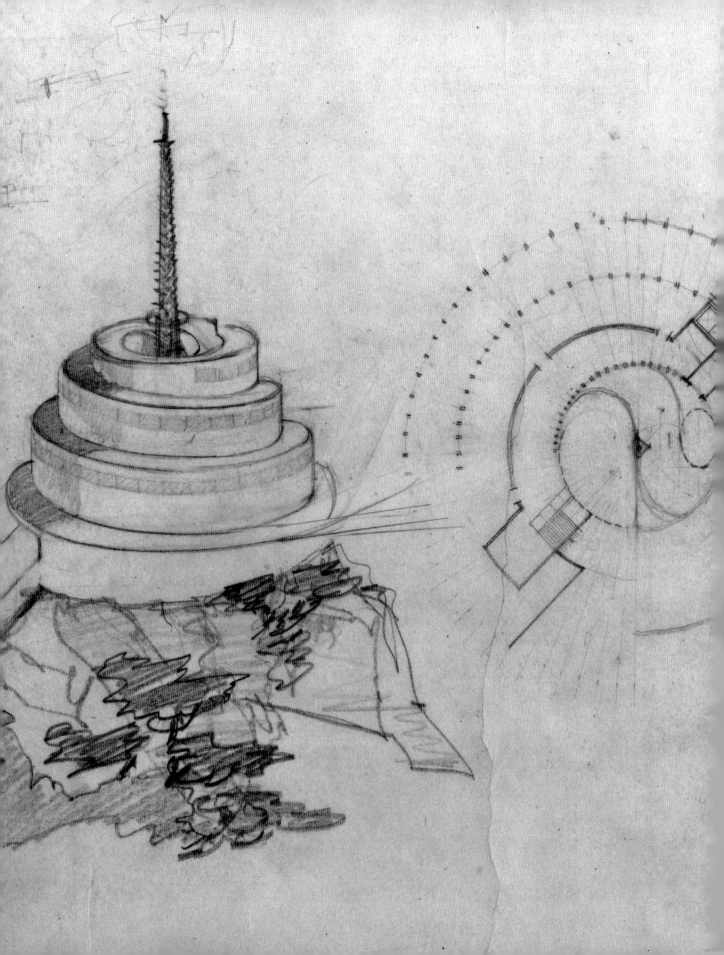

Gordon Strong Automobile Objective,
Sugarloaf Mountain, Maryland. 1925.
Project.
FLLW Fdn# 2505.058

Modern Architecture, Being the Kahn Lectures

1: Machinery, Materials, and Men

An architecture for these United States will be born "modern," as were all the architectures of the peoples of all the world. Perhaps this is the deep-seated reason why the young man in architecture grieves his parents, academic and familiar, by yielding to the fascination of creation, instead of persisting as the creature of ancient circumstance. This, his rational surrender to instinct, is known, I believe, as "rebellion."

I am here to aid and comfort rebellion insofar as rebellion has this honorable instinct—even though purpose may not yet be clearly defined—nor any fruits, but only ists, isms, or istics be in sight. Certainly we may now see the dawning of a deeper insight than has for the past thirty years characterized so-called American architecture. In that length of time, American architecture has been neither American nor architecture. We have had instead merely a bad form of surface-decoration.

This "dawn" is the essential concern of this moment and the occasion for this series of "lectures." We, here at Princeton, are to guard this dawning insight and help to guide its courage, passion, and patience into channels where depth and flow is adequate, instead of allowing youthful adventure to ground in shallows all there beneath the surface in the offing, ready to hinder and betray native progress.

In this effort I suppose I am to suffer disadvantage, being more accustomed to saying things with a hod of mortar and some bricks, or with a concrete mixer and a gang of workmen, than by speaking or writing. I like to write, but always dissatisfied, I, too, find myself often staring at the result with a kind of nausea . . . or is it nostalgia?

I dislike to lecture, feeling something like the rage of impotence. With a small audience hovering over my drawing board, there would be better feeling on my part and a better chance for the audience. But a lecturer may, in fact must, make his own diversion, indulge his "malice" as he goes along, or get no entertainment at all out of the matter.

So here at my hand I have some gently malicious pamphlets or leaflets issued, as myth has it, by that mythical group to which careless reference is sometimes made, by the thoughtless, as the "New School of the Middle West." From these rare, heretical pamphlets, from time to time as I may have occasion, I shall quote. Among them are such titles as: "Palladio Turns in His Grave and Speaks," another, "Groans from Phidias"; the author's original title—it would be beside our mark to mention it—was suppressed by the group as just that much too much. One solitary "New School" scholar, himself having, under painful economic pressure, degenerated to the practice of mere architectural surgery—blaming Vitruvius for his degradation—wrote bitterly and much under the title of "Vitruviolic Disorders."

A number of these leaflets are given over by several and sundry of the "New School" to the ravages of the "Vignola"—an academic epidemic showing itself as a creeping paralysis of the emotional nature—creeping by way of the optic nerve.

During the course of our afternoons, from among these modestly profane references, we may have occasion to hear from a rudely awakened Bramante, an indignant Sansovino, a gently aggrieved Brunelleschi, perhaps even from robustious "Duomo" Buonarroti himself, all, plucked even of their shrouds, frowning up from their graves on their pretentious despoilers . . . our own American classi-

1931

cists. These time-honored Italians in these wayward and flippant leaflets, are made to speak by way of a sort of motorcar Vasari. His name deserves to be lost—and as certainly will be.

Unfortunately and sad to say, because their names and individualities are unknown to us, so close were they, as men, to the soil or to man—we shall be unable to hear from the ancient builders of "Le Moyen-Age," those dreamers in cloisters, guild-masters, gardeners, worshipers of the tree, or the noble stone-craftsmen of still earlier Byzantium, who were much like the cathedral builders in spirit. No—we shall hear from them only as we, ourselves, are likewise dreamers, gardeners, or worshipers of the tree, and by sympathetic nature, therefore, well qualified to understand the silence of these white men. And those human nature-cultures of the red mall, lost in backward stretch of time, almost beyond our horizon, the Maya, the Indian, and of the black man, the African, we may learn from them. Last, but not least, come the men of bronze, the Chinese, the Japanese—profound builders of the Orient—imaginative demons, their art of earth winging its way to the skies: dragons with wings, their fitting symbol. Of their art—much. The ethnic eccentricity of their work makes it safe inspiration for the white man, who now needs, it seems, aesthetic fodder that he cannot copy or reproduce. I am not sure but there is more for us in our modern grapple with creation, in their sense of the living thing in art, than we can find in any other culture. Profundity of feeling the men of bronze could encourage. Their forms we should have to let alone.

In order that we may not foregather here in this dignified atmosphere of Princeton without due reference to authority, we will go far back for our text on this, our first afternoon together. Go so far back that we need fear no contradiction. Go without hesitation, to Rameses the Great, to find that: "All great architecture"—Rameses might have used the hieroglyph for art instead of the one for architecture—"*All great architecture is true to its architects' immediate present*," and seal it with the regal symbol. And in this connection comes the title of our discourse—the *Machinery, Materials, and Men* of our immediate present.

Long ago—yes, so long ago that the memory of it seems to join with recent echoes from Tutankha-

men's ancient tomb—I passionately swore that the machine was no less, rather more, an artist's tool than any he had ever had or heard of, if only he would do himself the honor to learn to use it. Twenty-seven years old now, the then offensive heresy has been translated and published, I am told, in seven or more foreign languages, English excepted, which means said in seven or more different ways. But just what the seven different ways each exactly mean, I can have no idea. At the time, I knew no better than to make the declaration—it seemed so sensibly obvious in the vast cinder field in which I then stood—our enormous industrial Middle West.

Today, twenty-seven years later, the heresy has become a truism, at least "truistic," therefore sufficiently trite to arouse no hostility even if said in several or even seven different ways. And yet, a Pompeian recently come back and struggling for nourishment on French soil has reiterated one-quarter of the matter, made more stark, with signs of success right here in our own country. The reiteration reaches us across the Atlantic, more machine-made than the erstwhile cry in the cinder field, but with several important omissions—most important, at least, to us. Or perhaps, who knows, they may not really be omissions but evasions. First among these probable evasions is the nature of materials; second is that characteristic architectural element, the third dimension; and third, there is integral ornament. This neglected trinity, it seems to me, constitutes the beating heart of the whole matter of architecture so far as art is concerned.

Surface and mass, relatively superficial, however machine-made or however much resembling machinery, are subordinate to this great trinity. Surface and mass are a by-product, or will be when architecture arises out of the matter. If proof is needed, we shall find it as we go along together. . . .

Machinery, materials, and men—yes—these are the stuffs by means of which the so-called American architect will get his architecture, if there is any such architect and America ever gets any architecture of her own. Only by the strength of his spirit's grasp upon all three—machinery, materials, and men—will the architect be able so to build that his work may be worthy the great name "architecture." A great architecture is greatest proof of human greatness.

The difference, to the architect and his fellow art-

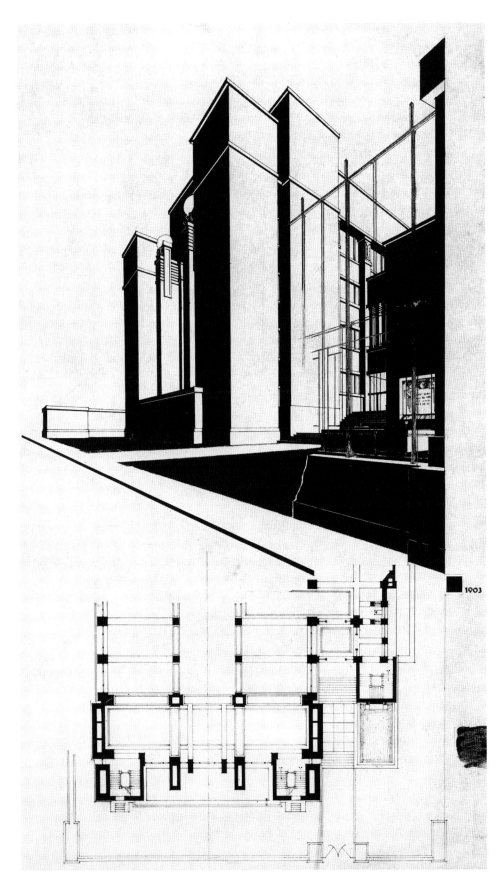

Larkin Company Office Building,
Buffalo, New York. 1903.
FLLW Fdn# 0403.002

1903

ists, between our era and others, lies simply enough in the substitution of automatic machinery for tools, and (more confusing), instead of hereditary aristocracy for patron the artist now relies upon automatic industrialism, conditioned upon the automatic acquiescence of men and conditioned not at all upon their individual handicraftsmanship.

At first blush an appalling difference, and the more it is studied, the more important the difference becomes. And were we now to be left without prophet—that is, without interpretation—and should we, among ourselves, be unable to arouse the leadership of supreme human imagination— yes, then we should be at the beginning of the end of all the great *qualities* we are foregathered here to cherish: namely, the arts which are those great qualities in any civilization. This republic has already gone far with very little of any single one of these great *saving* qualities, yet it goes further, faster, and safer; eats more, and eats more regularly; goes softer, safer, is more comfortable and egotistic in a more universal mediocrity than ever existed on earth before. But who knows where it is going? In this very connection, among the more flippant references referred to as at hand, there is also heavy matter and I have here serious original matter, saved several years ago from the flames by a miracle. The first pages were blackened and charred by fire, of this original manuscript, first read to a group of professors, artists, architects, and manufacturers at Hull House, Chicago. To show you how it all seemed to me, back there, twenty-seven years ago in Chicago, I shall read into the record, once more, from its pages. Should its clumsy earnestness bore you, remember that the young man who wrote, should, in that earlier day, as now, have confined himself to a hod of mortar and some bricks. But passionately he was trying to write—making ready to do battle for the life of the thing he loved. And I would remind you, too, that in consequence he has been engaged in eventually mortal combat ever since.

Here is the manuscript. We will begin, twenty-seven years later, again, at the beginning of—

The Art and Craft of the Machine

No one, I hope, has come here tonight for a sociological prescription for the cure of evils peculiar to this machine age. For I come to you as an architect to say my word for the right use upon such new materials as we have, of our great substitute for tools—machines. There is no thrift in any craft until the tools are mastered; nor will there be a worthy social order in America until the elements by which America does its work are mastered by American society. Nor can there be an art worth the man or the name until these elements are grasped and truthfully idealized in whatever we as a people try to make. Although these elemental truths should be commonplace enough by now, as a people we do not understand them nor do we see the way to apply them. We are probably richer in raw materials for our use as workmen, citizens, or artists than any other nation—but, outside mechanical genius for mere contrivance, we are not good workmen, nor, beyond adventitious or propitious respect for property, are we as good citizens as we should be, nor are we artists at all. We are one and all, consciously or unconsciously, mastered by our fascinating automatic "implements," using them as substitutes for tools. To make this assertion clear I offer you evidence I have found in the field of architecture. It is still a field in which the pulse of the age throbs beneath much shabby finery and one broad enough (God knows) to represent the errors and possibilities common to our time-serving time.

Architects in the past have embodied the spirit common to their own life and to the life of the society in which they lived in the most noble of all noble records—buildings. They wrought these valuable records with the primitive tools at their command and whatever these records have to say to us today would be utterly insignificant if not wholly illegible were tools suited to another and different condition stupidly forced to work upon them, blindly compelled to do work to which they were not fitted, work which they could only spoil.

In this age of steel and steam, the tools with which civilization's true record will be written are scientific thoughts made operative in iron and bronze and steel and in the plastic processes which characterize this age, all of which we call machines. The electric lamp is in this sense a machine. New materials in the man-machines have made the physical body of this age what it is as distinguished from former ages. They have made our era the machine age—wherein locomotive engines, engines of industry, engines of light or engines of war, or steamships take the place

works of art took in previous history. Today we have a scientist or an inventor in place of a Shakespeare or a Dante. Captains of industry are modern substitutes, not only for kings and potentates, but, I am afraid, for great artists as well. And yet, man-made environment is the truest, most characteristic of all human records. Let a man build and you have him. You may not have all he is, but certainly he is what you have. Usually you will have his outline. Though the elements may be in him to enable him to grow out of his present self-made characterization, few men are ever belied by self-made environment. Certainly no historical period was ever so misrepresented. Chicago in its ugliness today becomes as true an expression of the *life* lived here as is any center on earth where men come together closely to live it out or fight it out. Man is a selecting principle, gathering his like to him wherever he goes. The intensifying of his existence by close contact, too, flashes out the human record vividly in his background and his surroundings. But somewhere—somehow—in our age, although signs of the times are not wanting, beauty in this expression is forfeited—the record is illegible when not ignoble. We must walk blindfolded through the streets of this, or any great modern American city, to fail to see that all this magnificent resource of machine-power and superior material has brought to us, so far, is degradation. All of the art forms sacred to the art of old are, by us, prostitute.

On every side we see evidence of inglorious quarrel between things as they were and things as they must be and are. This shame a certain merciful ignorance on our part mistakes for glorious achievement. We believe in our greatness when we have tossed up a Pantheon to the god of money in a night or two, like the Illinois Trust Building or the Chicago National Bank. And it is our glory to get together a mammoth aggregation of Roman monuments, sarcophagi, and temples for a post office in a year or two. On Michigan Avenue, Montgomery Ward presents us with a nondescript Florentine palace with a grand campanile for a "farmer grocery," and it is as common with us as it is elsewhere to find the giant stone Palladian "orders" overhanging plate-glass shop fronts. Show windows beneath Gothic office buildings, the office-middle topped by Parthenons or models of any old sacrificial temple, are a common sight. Every commercial interest in any American town, in fact, is scurrying for respectability by seeking some advertising connection, at least, with the "classic." A commercial renaissance is here; the renaissance of "the ass in the lion's skin." This much, at least, we owe to the late Columbian Fair—that triumph of modern civilization in 1893 will go down in American architectural history, when it is properly recorded, as a mortgage upon posterity that posterity must repudiate not only as usurious but as forged.

In our so-called "skyscrapers" (latest and most famous business building triumph), good granite or Bedford stone is cut into the fashion of the Italian followers of Phidias and his Greek slaves. Blocks so cut are cunningly arranged about a structure of steel beams and shafts (whose structure secretly robs them of any real meaning), in order to make the finished building resemble the architecture depicted by Palladio and Vitruvius in the schoolbooks. It is quite as feasible to begin putting on this Italian trimming at the cornice and come on down to the base as it is to work, as the less fortunate Italians were forced to do, from the base upward. Yes, "from the top down" is often the actual method employed. The keystone of a Roman or Gothic arch may now be "set"—that is to say, "hung"—and the voussoirs stuck alongside or "hung" on downward to the haunches. Finally this mask, completed, takes on the features of the pure "classic," or any variety of "renaissance" or whatever catches the fancy or fixes the "convictions" of the designer. Most likely, an education in art has "fixed" both. Our Chicago University, "a seat of learning," is just as far removed from truth. If environment is significant and indicative, what does this highly reactionary, extensive, and expensive scene-painting by means of hybrid collegiate Gothic signify? Because of Oxford it seems to be generally accepted as "appropriate for scholastic purposes." Yet, why should an American university in a land of democratic ideals in a machine age be characterized by secondhand adaptation of Gothic forms, themselves adapted previously to our own adoption by a feudalistic age with tools to use and conditions to face totally different from anything we can call our own? The public library is again asinine renaissance, bones sticking through the flesh because the interior was planned by a shrewd library board, while an "art-architect" (the term is Chicago's, not mine) was "hired" to "put the architecture

on it." The "classical" aspect of the sham-front must be preserved at any cost to sense. Nine out of ten public buildings in almost any American city are the same.

On Michigan Avenue, too, we pass another pretentious structure, this time fashioned as inculcated by the Ecole des Beaux Arts after the ideals and methods of a Graeco-Roman, inartistic, grandly brutal civilization, a civilization that borrowed everything but its jurisprudence. Its essential tool was the slave. Here at the top of our culture is the Chicago Art Institute, and very like other art institutes. Between lions, realistic—Kemyss would have them so because Barye did—we come beneath some stone millinery into the grandly useless lobby. Here French's noble statue of the republic confronts us—she too, imperial. The grand introduction over, we go further on to find amid plaster casts of antiquity, earnest students patiently gleaning a half-acre or more of archaeological dry bones, arming here for industrial conquest, in other words to go out and try to make a living by making some valuable impression upon the machine age in which they live. Their fundamental tool in this business about which they will know just this much less than nothing, is—the machine. In this acre or more not one relic has any vital relation to things as they are for these students, except for the blessed circumstance that they are more or less beautiful things in themselves—bodying forth the beauty of "once upon a time." These students at best are to concoct from a study of the aspect of these blind reverences an extract of antiquity suited to modern needs, meanwhile knowing nothing of modern needs, permitted to care nothing for them, and knowing just as little of the needs of the ancients which made the objects they now study. The tyros are taught in the name of John Ruskin and William Morris to shun and despise the essential tool of their age as a matter commercial and antagonistic to art. So in time they go forth, each armed with his little academic extract, applying it as a sticking plaster from without, wherever it can be made to stick, many helplessly knowing in their hearts that it should be a development from within—but how? And this is an education in art in these United States. Climb now the grand monumental stairway to see the results of this cultural effort—we call it "education"—hanging over the walls of the exhibition galleries. You will find there the same empty reverences to the past at cost to the present and of doubtful value to the future, unless a curse is valuable. Here you may see fruits of the lust and pride of the patron-collector, but how shamefully little to show by way of encouraging patronage by the artist of his own day and generation. This is a temple of the fine arts. A sacred place! It should be the heart-center, the emotional inspiration of a great national industrial activity, but here we find tradition not as an *inspiring* spirit animating progress. No. Now more in the *past* than ever! No more now than an ancient mummy, a dead letter. A "precedent" is a "hangover" to copy, the copy to be copied for machine reproduction, to be shamelessly reproduced until demoralized utterly or unrecognizable.

More unfortunate, however, than all this fiasco, is the fiasco al fresco. The suburban house-parade is more servile still. Any popular avenue or suburb will show the polyglot encampment displaying, on the neatly kept little plots, a theatrical desire on the part of fairly respectable people to live in châteaux, manor houses, Venetian palaces, feudal castles, and Queen Anne cottages. Many with sufficient hardihood abide in abortions of the carpenter-architect, our very own General Grant Gothic perhaps, intended to beat all the "lovely periods" at their own game and succeeding. Look within all this typical monotony-in-variety and see there the machine-made copies of handicraft: originals; in fact, unless you, the householder, are fortunate indeed, possessed of extraordinary taste and opportunity, all you possess is in some degree a machine-made example of vitiated handicraft: imitation antique furniture made antique by the machine, itself of all abominations the most abominable. Everything must be curved and carved and carved and turned. The whole mass a tortured sprawl supposed artistic. And the floor-coverings? Probably machine-weavings of oriental rug patterns, pattern and texture mechanically perfect; or worse, your walls are papered with paper-imitations of old tapestry, imitation patterns, and imitation textures, stamped or printed by the machine; imitations under foot, imitations overhead, and imitations all round about you. You are sunk in "imitation." Your much-molded woodwork is stained "antique." Inevitably you have a white-and-gold "reception room" with a few gilded chairs, an overwrought piano, and withal, about you a gen-

eral cheap machine-made "profusion" of copies of copies of original imitations. To you, proud proprietors, do these things thus degraded mean anything aside from vogue and price? Aside from your sense of quantitative ownership, do you perceive in them some fine fitness in form, line, and color to the purposes which they serve? Are the chairs to sit in, the tables to use, the couch comfortable, and are all harmoniously related to each other and to your own life? Do many of the furnishings or any of the window millinery serve any purpose at all of which you can think? Do you enjoy in "things" the least appreciation of truth in beautiful guise? If not, you are a victim of habit, a habit evidence enough of the stagnation of an outgrown art. Here we have the curse of stupidity—a cheap substitute for ancient art and craft which has no vital meaning in your own life or our time. You line the box you live in as a magpie lines its nest. You need not be ashamed to confess your ignorance of the meaning of all this, because not only you, but everyone else, is hopelessly ignorant concerning it; it is "impossible." Imitations of imitations, copies of copies, cheap expedients, lack of integrity, some few blind gropings for simplicity to give hope to the picture. That is all.

Why wonder what has become of the grand spirit of art that made, in times past, man's reflection in his environment a godlike thing? *This* is what has become of it! Of all conditions, this one at home is most deplorable, for to the homes of this country we must look for any beginning of the awakening of an artistic conscience which will change this parasitic condition to independent growth. The homes of the people will change before public buildings can possibly change.

Glance now for a moment behind this adventitious scene-painting passing, at home, for art in the nineteenth century. Try to sense the true conditions underlying all, and which you betray and belie in the name of culture. Study with me for a moment the engine which produces this wreckage and builds you, thus cheapened and ridiculous, into an ignoble record.

Here is this thing we call the machine, contrary to the principle of organic growth, but imitating it, working irresistibly the will of man through the medium of men. All of us are drawn helplessly into its mesh as we tread our daily round. And its offices—call them "services"—have become the com-

monplace background of modern existence; yes, and sad to say, in too many lives the foreground, middle distance, and future. At best we ourselves have already become or are becoming some cooperative part in a vast machinery. It is, with us, as though we were controlled by some great crystallizing principle going on in nature all around us and going on, in spite of ourselves, even in our very own *natures*. If you would see how interwoven it is, this thing we call the machine, with the warp and the woof of civilization, if indeed it is not now the very basis of civilization itself, go at nightfall when all is simplified and made suggestive, to the top of our newest skyscraper, the Masonic temple. There you may see how in the image of material man, at once his glory and his menace, is this thing we call a city. Beneath you is the monster stretching out into the far distance. High overhead hangs a stagnant pall, its fetid breath reddened with light from myriad eyes endlessly, everywhere blinking. Thousands of acres of cellular tissue outspread, enmeshed by an intricate network of veins and arteries radiating into the gloom. Circulating there with muffled ominous roar is the ceaseless activity to whose necessities it all conforms. This wondrous tissue is knit and knit again and interknit with a nervous system, marvelously effective and complete, with delicate filaments for hearing and knowing the pulse of its own organism, acting intelligently upon the ligaments and tendons of motive impulse, and in it all is flowing the impelling electric fluid of man's own life. And the labored breathing, murmur, clangor, and the roar—how the voice of this monstrous force rises to proclaim the marvel of its structure! Near at hand, the ghastly warning boom from the deep throats of vessels heavily seeking inlet to the waterway below, answered by the echoing clangor of the bridge bells. A distant shriek grows nearer, more ominous, as the bells warn the living current from the swinging bridge and a vessel cuts for a moment the flow of the nearer artery. Closing then upon the great vessel's stately passage the double bridge is just in time to receive in a rush of steam the avalanche of blood and metal hurled across it; a streak of light gone roaring into the night on glittering bands of steel; an avalanche encircled in its flight by slender magic lines, clicking faithfully from station to station—its nervous herald, its warning, and its protection.

Nearer, in the building ablaze with midnight ac-

tivity, a spotless paper band is streaming into the marvel of the multiple-press, receiving indelibly the impression of human hopes and fears, throbbing in the pulse of this great activity, as infallibly as the gray matter of the human brain receives the impression of the senses. The impressions come forth as millions of neatly folded, perfected newssheets, teeming with vivid appeals to good and evil passions; weaving a web of intercommunication so far-reaching that distance becomes as nothing, the thought of one man in one corner of the earth on one day visible on the next to all men. The doings of all the world are reflected here as in a glass—so marvelously sensitive this simple band streaming endlessly from day to day becomes in the grasp of the multiple-press.

If the pulse of this great activity—automatons working night and day in every line of industry, to the power of which the tremor of the mammoth steel skeleton beneath your feet is but an awe-inspiring response—is thrilling, what of the prolific, silent obedience to man's will underlying it all? If this power must be uprooted that civilization may live, then civilization is already doomed. Remain to contemplate this wonder until the twinkling lights perish in groups, or follow one by one, leaving others to live through the gloom; fires are banked, tumult slowly dies to an echo here and there. Then the darkened pall is gradually lifted and moonlight outlines the shadowy, sullen masses of structure, structure deeply cut here and there by half-luminous channels. Huge patches of shadow in shade and darkness commingle mysteriously in the block-like plan with box-like skylines—contrasting strangely with the broad surface of the lake beside, placid and resplendent with a silver gleam. Remain, I say, to reflect that the texture of the city, this great machine, is the warp upon which will be woven the woof and pattern of the democracy we pray for. Realize that it has been deposited here, particle by particle, in blind obedience to law—law no less organic. That universe, too, in a sense, is but an obedient machine.

Magnificent power! And it confronts the young architect and his artist comrades now, with no other beauty—a lusty material giant without trace of ideality, absurdly disguised by garments long torn to tatters or contemptuously tossed aside, outgrown. Within our own recollection we have all been horrified at the bitter cost of this ruthless development, appalled to see this great power driven by greed over the innocent and defenseless—we have seen bread snatched from the mouths of sober and industrious men, honorable occupations going to the wall with a riot, a feeble strike, or a stifled moan, outclassed, outdone, outlived by the machine. The workman himself has come to regard this relentless force as his nemesis and combines against machinery in the trades with a wild despair that dashes itself to pieces, while the artist blissfully dreaming in the halls we have just visited or walking blindly abroad in the paths of the past, berates his own people for lackluster senses, rails against industrial conditions that neither afford him his opportunity, nor, he says, can appreciate him as he, panderer to ill-gotten luxury, folding his hands, starves to death. "Innocuous martyr upon the cross of art!" One by one, tens by tens, soon thousands by thousands, handicraftsmen and parasitic artists succumb to the inevitable as one man at a machine does the work of from five to fifty men in the same time, with all the art there is meanwhile prostituting to old methods and misunderstood ideals the far greater new possibilities due to this same machine, and doing this disgracefully in the name of the beautiful!

American society has the essential tool of its own age by the blade, as lacerated hands everywhere testify!

See the magnificent prowess of this unqualified power—strewing our surroundings with the mangled corpses of a happier time. We live amid ghostly relics whose pattern once stood for cultivated luxury and now stands for an ignorant matter of taste. With no regard for first principles of common sense, the letter of tradition is recklessly fed into rapacious maws of machines until the reproduction, reproduced *ad nauseam,* may be had for five, ten, or ninety-nine cents, although the worthy original cost ages of toil and patient culture. This might seem like progress, were it not for the fact that these butchered forms, the life entirely gone out of them, are now harmful parasites, belittling and falsifying any true perception of normal beauty the Creator may have seen fit to implant in us on our own account. Any idea whatever of fitness to purpose or of harmony between form and use is gone from us. It is lacking in these things one and all, because it is so sadly lacking in us. And as for making the best

of our own conditions or repudiating the terms on which this vulgar insult to tradition is produced, thereby insuring and rectifying the industrial fabric thus wasted or enslaved by base imitation—the mere idea is abnormal, as I myself have found to my sorrow.

And among the few, the favored chosen few who love art by nature and would devote their energies to it so that it may live and let them live—any training they can seek would still be a protest against the machine as the creator of all this iniquity, when (God knows) it is no more than the creature.

But, I say, usurped by greed and deserted by its natural interpreter, the artist, the machine is only the creature, not the creator of this iniquity! I say the machine has noble possibilities unwillingly forced to this degradation, degraded by the arts themselves. Insofar as the true capacity of the machine is concerned it is itself the crazed victim of artist-impotence. Why will the American artist not see that human thought in our age is stripping off its old form and donning another; why is the artist unable to see that this is his glorious opportunity to create and reap anew?

But let us be practical, let us go now afield for evident instances of machine abuse or abuse by the machine. I will show you typical abuses that should serve to suggest to any mind, capable of thought, that the machine is, to begin with, a marvellous simplifier in no merely negative sense. Come now, with me, and see examples which show that these craft-engines may be the modern emancipator of the creative mind. We may find them to be the regenerator of the creative conscience in our America, as well, so soon as a stultified "culture" will allow them to be so used.

First—as perhaps wood is most available of home-building materials, naturally then the most abused—let us now glance at wood. Elaborate machinery has been invented for no other purpose than to imitate the wood-carving of early handicraft patterns. Result? No good joinery. None salable without some horrible glued-on botchwork meaning nothing, unless it means that "art and craft" (by salesmanship) has fixed in the minds of the masses the elaborate old hand-carved chair as ultimate ideal. The miserable tribute to this perversion yielded by Grand Rapids alone would mar the face of art beyond repair, to say nothing of the weird

or fussy joinery of spindles and jigsawing, beamed, braced, and elaborated to outdo in sentimentality the sentiment of some erstwhile overwrought "antique." The beauty of wood lies in its qualities as wood, strange as this may seem. Why does it take so much imagination just to see that? Treatments that fail to bring out those qualities, foremost, are not *plastic*, therefore no longer appropriate. The inappropriate cannot be beautiful.

The machine at work on wood will itself teach us—and we seem so far to have left it to the machine to do so—that certain simple forms and handling serve to bring out the beauty of wood and to retain its character, and that certain other forms and handling do not bring out its beauty, but spoil it. All woodcarving is apt to be a forcing of this material likely to destroy the finer possibilities of wood as we may know those possibilities now. In itself wood has beauty of marking, exquisite texture, and delicate nuances of color that carving is likely to destroy. The machines used in woodwork will show that by unlimited power in cutting, shaping, smoothing, and by the tireless repeat, they have emancipated beauties of wood-nature, making possible, without waste, beautiful surface treatments and clean strong forms that veneers of Sheraton or Chippendale only hinted at with dire extravagance. Beauty unknown even to the Middle Ages. These machines have undoubtedly placed within reach of the designer a technique enabling him to realize the true nature of wood in his designs harmoniously with man's sense of beauty, satisfying his material needs with such extraordinary economy as to put this beauty of wood in use within the reach of everyone. But the advantages of the machines are wasted and we suffer from a riot of aesthetic murder and everywhere live with debased handicraft.

Then, at random, let us take, say, the worker in marbles—his gangsaws, planers, pneumatic chisels, and rubbing-beds have made it possible to reduce blocks ten feet long, six feet deep, and two feet thick to sheets or thin slabs an inch in thickness within a few hours, so it is now possible to use a precious material as ordinary wall covering. The slab may be turned and matched at the edges to develop exquisite pattern, emancipating hundreds of superficial feet of characteristic drawing in pure marble colors that formerly wasted in the heart of a great expensive block in the thickness of the wall. Here again

a distinctly new architectural use may bring out a beauty of marbles consistent with nature and impossible to handicraft. But what happens? The "artist" persists in taking dishonest advantage of this practice, building up imitations of solid piers with molded caps and bases, cunningly uniting the slabs at the edge until detection is difficult except to the trained eye. His method does not change to develop the beauty of a new technical possibility; no, the "artist" is simply enabled to "fake" more architecture, make more piers and column shafts because he can now make them hollow! His architecture becomes no more worthy in itself than the cheap faker that he himself is, for his classical forms not only falsify the method which used to be and belie the method that is, but they cheat progress of its due. For convincing evidence see any public library or art institute, the Congressional Library at Washington, or the Boston [Public] Library.

In the stonecutting trade the stone-planer has made it possible to cut upon stone any given molded surface, or to ingrain upon that surface any lovely texture the cunning brain may devise, and do it as it never was possible to do it by hand. What is it doing? Giving us as near an imitation of hand tooth-chiselling as possible, imitating moldings specially adapted to wood, making possible the lavish use of miles of meaningless molded string courses, cornices, base courses—the giant power meanwhile sneered at by the "artist" because it fails to render the wavering delicacy of "touch" resulting from the imperfections of handwork.

No architect, this man! No, or he would excel that "antique" quality by the design of the contour of his sections, making a telling point of the very perfection he dreads, and so sensibly designing, for the prolific dexterity of the machine, work which it can do so well that handwork would seem insufferably crude by comparison. The deadly facility this one machine has given "book architecture" is rivalled only by the facility given to it by galvanized iron itself. And if, incontinently, you will still have tracery in stone, you may arrive at acres of it now consistently with the economy of other features of this still fundamental "trade." You may try to imitate the hand-carving of the ancients in this matter, baffled by the craft and tenderness of the originals, or you may give the pneumatic chisel and power-plane suitable work to do which would mean a changed style, a shift in the

spiritual center of the ideal now controlling the use of stone in constructing modern stone buildings.

You will find in studying the group of ancient materials, wood and stone foremost among them, that they have all been rendered fit for *plastic* use by the machine! The machine itself steadily making available for economic use the very quality in these things now needed to satisfy its own art equation. Burned clay—we call it terra-cotta—is another conspicuous instance of the advantage of the "process." Modern machines (and a process is a machine) have rendered this material as sensitive to the creative brain as a dry plate is to the lens of the camera. A marvelous simplifier, this material, rightly used. The artist is enabled to clothe the steel structure, now becoming characteristic of this era, with modestly beautiful, plastic robes instead of five or more different kinds of material now aggregated in confused features and parts, "composed" and supposedly picturesque, but really a species of cheap millinery to be mocked and warped by the sun, eventually beaten by wind and rain into a variegated heap of trash. But when these great possibilities of simplicity, the gift of the machine, get to us by way of the architect, we have only a base imitation of the hand-tooled blocks, pilaster-cap and base, voussoirs, and carved spandrils of the laborious manhandled stonecrop of an ancient people's architecture!

The modern processes of casting in metal are modern machines too, approaching perfection, capable of perpetuating the imagery of the most vividly poetic mind without hindrance—putting permanence and grace within reach of every one, heretofore forced to sit supine with the Italians at their Belshazzar-feast of "renaissance." Yes, without exaggeration, multitudes of processes, many new, more coming, await sympathetic interpretation, such as the galvano-plastic and its electrical brethren—a prolific horde, now cheap makers imitating "real" bronzes and all manner of metallic antiques, secretly damning all of them in their vitals, if not openly giving them away. And there is electro-glazing, shunned because its straight lines in glasswork are too severely clean and delicate. Straight lines it seems are not so susceptible to the traditional designer's lack of touch. Stream lines and straight lines are to him severely unbeautiful. "Curved is the line of beauty," says he! As though nature would not know what to do with its own rectilinear!

The familiar lithograph, too, is the prince of an entire province of new reproductive but unproductive processes. Each and every one has its individualities and therefore has possibilities of its own. See what Whistler made and the Germans are making of the lithograph: one note sounded in the gamut of its possibilities. But that note rings true to process as the sheen of the butterfly's wing to that wing. Yet, having fallen into disrepute, the most this particular "machine" did for us, until Whistler picked it up, was to give us the cheap imitative effects of painting, mostly for advertising purposes. This is the use made of machinery in the abuse of materials by men. And still more important than all we have yet discussed here is the new element entering industry in this material we call steel. The structural necessity which once shaped Parthenons, Pantheons, cathedrals, is fast being reduced by the machine to a skeleton of steel or its equivalent, complete in itself without the artist-craftsman's touch. They are now building Gothic cathedrals in California upon a steel skeleton. Is it not easy to see that the myriad ways of satisfying ancient structural necessities known to us through the books as the art of building, vanish, become history? The mainspring of their physical existence now removed, their spiritual center has shifted and nothing remains but the impassive features of a dead face. Such is our "classic" architecture.

For centuries this insensate or insane abuse of great opportunity in the name of culture has made cleanly, strengthly, and true simplicity impossible in art or architecture, whereas now we might reach the heights of creative art. Rightly used the very curse machinery puts upon handicraft should emancipate the artist from temptation to petty structural deceit and end this wearisome struggle to make things seem what they are not and can never be. Then the machine itself, eventually, will satisfy the simple terms of its modern art equation as the ball of clay in the sculptor's hand yields to his desire—ending forever this nostalgic masquerade led by a stultified culture in the name of art.

Yes—though he does not know it, the artist is now free to work his rational will with freedom unknown to structural tradition. Units of construction have enlarged, rhythms have been simplified and etherealized, space is more spacious, and the sense of it may enter into every building, great or small.

The architect is no longer hampered by the stone arch of the Romans or by the stone beam of the Greeks. Why then does he cling to the grammatical phrases of those ancient methods of construction when such phrases are in his modern work empty lies, and himself an inevitable liar as well?

Already, as we stand today, the machine has weakened the artist to the point of destruction and antiquated the craftsman altogether. Earlier forms of art are by abuse all but destroyed. The whole matter has been reduced to mere pose. Instead of joyful creation we have all around about us poisonous tastes—foolish attitudes. With some little of the flame of the old love, and creditable but pitiful enthusiasm, the young artist still keeps on working, making miserable mischief with lofty motives: perhaps, because his heart has not kept in touch or in sympathy with his scientific brother's head, being out of step with the forward marching of his own time.

Now, let us remember in forming this new Arts and Crafts Society at Hull House that every people has done its work, therefore evolved its art as an expression of its own life, using the best tools; and that means the most economic and effective tools or contrivances it knew: the tools most successful in saving valuable human effort. The chattel slave was the essential tool of Greek civilization, therefore of its art. We have discarded this tool and would refuse the return of the art of the Greeks were slavery the terms of its restoration, and slavery, in some form, would be the terms.

But in Grecian art two flowers did find spiritual expression—the acanthus and the honeysuckle. In the art of Egypt—similarly we see the papyrus, the lotus. In Japan, the chrysanthemum and many other flowers. The art of the Occident has made no such sympathetic interpretation since that time, with due credit given to the English rose and the French fleur-de-lis, and as things are now the West may never make one. But to get from some native plant an expression of its native character in terms of imperishable stone to be fitted perfectly to its place in structure, and without loss of vital significance, is one great phase of great art. It means that Greek or Egyptian found a revelation of the inmost life and character of the lotus and acanthus in terms of lotus or acanthus life. That was what happened when the art of these people had done with the plants they most

loved. This imaginative process is known only to the creative artist. Conventionalization, it is called. Really it is the dramatizing of an object—truest "drama." To enlarge upon this simple figure, as an artist, it seems to me that this complex matter of civilization is itself at bottom some such conventionalizing process, or must be so to be successful and endure.

Just as any artist-craftsman, wishing to use a beloved flower for the stone capital of a column-shaft in his building must conventionalize the flower, that is, find the pattern of its life-principle in terms of stone as a material before he can rightly use it as a beautiful factor in his building, so education must take the natural man, to "civilize" him. And this great new power of the dangerous machine we must learn to understand and then learn to use as this valuable, "*conventionalizing*" agent. But in the construction of a society as in the construction of a great building, the elemental conventionalizing process is dangerous, for without the inspiration or inner light of the true artist—the quality of the flower—its very life—is lost, leaving a withered husk in the place of living expression.

Therefore, society, in this conventionalizing process or culture, has a task even more dangerous than has the architect in creating his building forms, because instead of having a plant leaf and a fixed material as ancient architecture had, we have a sentient man with a fluid soul. So without the inner light of a sound philosophy of art (the educator too, must now be artist), the life of the man will be sacrificed and society gain an automaton or a machine-made moron instead of a noble creative citizen!

If education is doomed to fail in this process, utterly—then the man slips back to rudimentary animalism or goes on into decay. Society degenerates or has a mere realistic creature instead of the idealistic creator needed. The world will have to record more great dead cities.

To keep the artist-figure of the flower *dramatized for human purposes*—the socialist would bow his neck in altruistic submission to the "harmonious" whole; his conventionalization or dramatization of the human being would be like a poor stone-craftsman's attempt to conventionalize the beloved plant with the living character of leaf and flower left out. The anarchist would pluck the flower as it grows and use it as it is for what it is—with essential reality left out.

The hereditary aristocrat has always justified his existence by his ability, owing to fortunate propinquity, to appropriate the flower to his own uses after the craftsman has given it life and character, and has kept the craftsman, too, by promising him his flower back if he behaves himself well. The plutocrat does virtually the same thing by means of "interests." But the true democrat will take the human plant as it grows and—in the spirit of using the means at hand to put life into his conventionalization—preserve the individuality of the plant to protect the flower, which is its very life, getting from both a living expression of essential man-character fitted perfectly to a place in society with no loss of vital significance. Fine art is this flower of the man. When education has become creative and art again prophetic of the natural means by which we are to grow—we call it "progress"—we will, by means of the creative artist, possess this monstrous tool of our civilization as it now possesses us.

Grasp and use the power of scientific automatons in this creative sense and their terrible forces are not antagonistic to any fine individualistic quality in man. He will find their collective mechanistic forces capable of bringing to the individual a more adequate life, and the outward expression of the inner man as seen in his environment will be genuine revelation of his inner life and higher purpose. Not until then will America be free!

This new American liberty is of the sort that declares man free only when he has found his work and effective means to achieve a life of his own. The means once found, he will find his due place. The man of our country will thus make his own way, and *grow* to the natural place thus due him, promised— yes, promised by our charter, the Declaration of Independence. But this place of his is not to be made over to fit him by reform, nor shall it be brought down to him by concession, but will become his by his own use of the means at hand. He must himself build a new world. The day of the individual is not over—instead, it is just about to begin. The machine does not write the doom of liberty, but is waiting at man's hand as a peerless tool, for him to use to put foundations beneath a genuine democracy. Then the machine may conquer human drudgery to some purpose, taking it upon itself to broaden, lengthen, strengthen, and deepen the life of the simplest man. What limits do we dare imagine to

an art that is organic fruit of an adequate life for the individual! Although this power is now murderous, chained to botchwork and bunglers' ambitions, the creative artist will take it surely into his hand and, in the name of liberty, swiftly undo the deadly mischief it has created.

▦ Here ends the early discourse on the art and craft of the machine.

You may find comfort in the reflection that truth and liberty have this invincible excellence, that all man does for them or does against them eventually serves them equally well. That fact has comforted me all the intervening years between the first reading of the foregoing discourse and this reading at Princeton . . . the last reading, for I shall never read it again. Tomorrow afternoon there will be—I am afraid—heavy matter also because the question of qualifying the "machine-made" in American industries by human elements of style will be, in detail, our subject. There may be matter more subjective and difficult but I do not know what it may be.

It will be necessary for us all to give close attention and considerable thought to the subject, "style in industry." We shall see that any hope of such style will mean a crusade against *the* styles.

2: Style in Industry

Where certain remarks I have made concern nature and romance on the one hand, and the machine upon the other, I am accused of inconsistency— also in several or seven different languages. But if the word "nature," and the word "romance" too, are understood in the sense that each is used we can find little to correct, although the last analysis is never to be made.

The machine is that mathematical automaton or automatic power contrived in brass and steel by men, not only to take the place of manpower, but to multiply manpower—the brainless craftsman of a new social order.

Primarily the word "nature" means the principle at work in everything that lives and gives to life its form and character. All lives, so we may refer to the nature of two plus two equals four, if we like, or to the nature of tin, or to the nature of a disease or of the chromatic seventh. The word has nothing to do with realistic or realism, but refers to the essential *reality* of all things, so far as we may perceive reality. We cannot conceive life, we do not know what it is, but we can perceive the nature of its consequences and effects and so enter into creation with some intelligence. If we have occasion to refer to the visible world we will use the term "external nature." The word "organic" too, if taken too biologically, is a stumbling block. The word applies to "living" structure—a structure or concept wherein features or parts are so organized in form and substance as to be, applied to purpose, *integral*. Everything that "lives" is therefore organic. The inorganic—the "unorganized"—cannot *live*.

While we are at the, perhaps unnecessary, pains of explaining, let us say also what we should understand by romance. True romanticism in art is after all only liberalism in art, and is so understood, I believe, by all great poets. Romance is the essential joy we have in living, as distinguished from mere pleasure; therefore we want no narrow inventions, as preventions, to rise up from small minds and selfish hands, no intolerant "modes" to grow up in the modern world; it is to be our privilege to build upon new fertile ground. Yes, we are to build in the arts upon this great ground fertilized *by* the *old* civilizations—a new liberty.

▦ We, so beset by educational advantages as are Americans, cannot say too often to ourselves or others that "toleration and liberty are the foundations of this great republic." We should keep it well in the foreground of our minds and as a hope in our hearts that liberty in art as well as liberty in society *should* be, and therefore *must* be, the offspring of political liberty.

Then to us all, so minded, let the artist come. He has a public. And as we have already seen in "Machinery, Materials, and Men," the artist now has both the making and the means. Let him arise in our industry. For a new people a new art!

Liberty, however, is no friend to license. So, for our text in connection with difficult "Style in Industry," for due reference to authority suppose we again go far back in history—again to avoid all contradiction—this time to the birth of old Japan—and there, to safeguard liberty, take for text, simply, "An artist's limitations are his best friends," and dedicate that text to Jimmu Tenno.

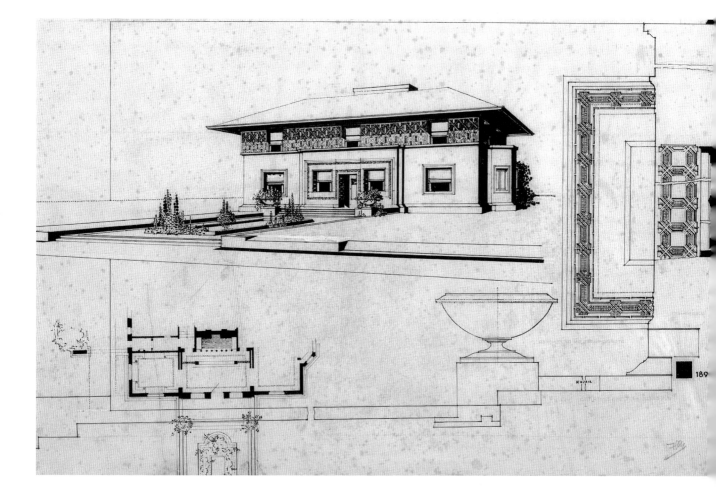

William Winslow House,
River Forest, Illinois. 1893.
FLLW Fdn# 9305.001

At least the ancient civilization of his slowly sinking stretch of pendulous island, arising from the sea in the snows of perpetual winter and reaching all the way south to perpetual summer, affords best proof of the text anywhere to be found. "Limitations," in this sense, were, I take it, those of materials, tools, and specific purpose.

In Jimmu's island perfect style in industry was supreme and native until Japan was discovered within range of our own Commodore Perry's guns. That Western contacts have destroyed this early style—if not the industry—only enhances the value of that early style. *Certainly,* the arts and crafts, as developed in Nippon during her many centuries of isolation in happy concentration, afford universal object lessons incomparable in style.

Industry and style there—before the "peaceful" commercial invasion by the West—were supremely natural. Nor in Jimmu Tenno's time was there anywhere to be found separate and contrasted existence between art and nature. Nowhere else in the world can we so clearly see this nor so well inform ourselves in considering this matter of style in our own native automatic industries. This notwithstanding the fact that our industries are conditioned upon automatic acquiescence of men instead of upon the craftsmanship of the man. By giving our attention to the ease and naturalness with which things Japanese originally achieved style, we may learn a valuable lesson.

Our industry must educate designers instead of making craftsmen—for our craftsmen are machines, craftsmen ready-made, efficient and obedient. So far as they go—mechanical power stripped clean. How to get these formidable craft-engines the work to do they may do well? Then, beyond mechanical skill, the cadences of form?

The first answer will seem generalization beyond any immediate mark, for that answer is—by means of imagination. Imagination superior and supreme. Supreme imagination is what makes the creative artist now just as it made one then. And imagination is what will make the needed designer for industry now—no less than then or ever before. But, strange to say, it is of the true quality of great imagination that it can see wood as wood, steel as steel, glass as glass, stone as stone, and make limitations its best friends. This is what Jimmu Tenno's busy people proved so thoroughly well and what may be so useful to us to realize. Our machine-age limitations are more severe and more cruelly enforced than limitations were in this severely disciplined island-empire of Japan. Nevertheless, though more difficult in important ways, in other more important directions, we have marvelously more opportunity than ever Japan had.

Principles which made the art and craft of old Japan a living thing—living, that is, for old Japan—will work as well now as then. The same principles in art and craft either of the East or the West, wherever similar truths of being went into effect with some force in the lives of their peoples, need no change now. Secrets of cause and effect in work and materials in relation to life as lived are the same for the coming designer for machines as they were for the bygone craftsman designers. But when a man becomes a part of the machine that he moves—the man is lost.

We Americans, too, *do live*—in a way—do we not? But we differ. We do live and, notwithstanding all differences, our souls yet have much in common with all souls. The principles, therefore, on which we must work our modern style for ourselves will not change the way our interpretation and applications will utterly change. Results in American industry will be simpler, broader, more a matter of texture and sublimated mathematics as music is sublimated mathematics; therefore our designs will be more subjective than before. Our applications will be more generalized but our derivations not more limited than in the days of ancient handicraft.

Provided the limitations of any given problem in the arts do not destroy each other by internal collision and so kill opportunity, limitations are no detriment to artist endeavor. It is largely the artist's business—all in his day's work—to see that the limitations do *not* destroy each other. That is to say, it is up to him to get proper tools, proper materials for proper work. Speaking for myself, it would be absurd if not impossible to take advantage of the so-called "free hand." To "idealize" in the fanciful sketch is a thing unknown to me. Except as I were given some well defined limitations or requirements—the more specific the better—there would be no problem, nothing to work with, nothing to work out; why then trouble the artist? Perhaps that is why "fairs" are so universally uncreative and harmful—the hand is too free, the quality of imagination, therefore, too insignificant.

No—not until American industrial designers have grown up to the point where they have known and made friends with the limitations characteristic of their job, will America have any style in industry. What are these limitations?

Automatic industrial fabrication is not the least of them. But—to reiterate from the matter of our first chapter, "Machinery, Materials, and Men"—the American designers' hope lies in the fact that as a consequence of the automaton, already machinery can do many desirable things, "by hand" prohibited or impossible. Now, mixed up with "Machinery, Materials, and Men," in our first chapter, was the word "plasticity" used as machine-aesthetic in modern designing for woodworking, stonework, metalcasting, and reproductive processes. Some practical

suggestions were made to indicate how and wherein this new "aesthetic" which the machine has given to us may enable the artist to make new use of old materials, and new use of new materials instead of making abuse of both.

"Plasticity" is of utmost importance. The word implies total absence of constructed effects as evident in the result. This important word, "plastic," means that the quality and nature of materials are seen "flowing or growing" into form instead of seen as built up out of cut and joined pieces. "Composed" is the academic term for this academic process in furniture. "Plastic" forms, however, are *not* "composed" nor set up. They, happily, inasmuch as they are produced by a *"growing"* process, must be developed . . . *created*. And to shorten this discourse we may as well admit that if we go far enough to find cause in any single industry like furniture for this matter of style, we will have the secret of origin and growth of style in any or in all industries. After getting so far, there would come only specialization in differences of materials and machinery in operation.

Repeatedly and freely too we are to use this word "style"—but if intelligently, what, then, is style? Be sure of one thing in any answer made to the question—style *has nothing to do with "the" styles!* "The great styles" we call them. "Styles" have been tattered, torn, and scattered to the four winds and all the breezes that blow between them as a form of mechanical corruption in industry, and yet, we have no style. The more "styles" in fact, the less style, unless by accident—nor anything very much resembling the stimulating quality. Our designers for various industries—still busy, unfortunately, trying to imitate "styles" instead of *studying the principles* of style intelligently—are at the moment jealously watching France as they see her products go from Wanamaker's on down the avenue and out along the highways of these United States as far as the Pacific Ocean. And yet, if you will take pains to compare the best of French products, say in textiles, with the products of the ancient Momoyama of Japan you will see the industrial ideas of old Japan at work in new French industry as direct inspiration. The French product is not Japanese and nearly all of the textiles are within the capacity of the machine; most of the product is good. But France, in all her moments of movement in art and craft, and no less at this "modern" moment in this "modernistic" particular, helps herself liberally if not literally from Japanese sources, and creditably. She it was who discovered the Japanese print by way of the de Goncourts. That discovery bore significant fruit in French painting. And there are more valuable brochures in the French language on the art of Japan in all its phases available for reference than in all other languages put together, the Japanese language included. France, the inveterate discoverer, must discover *l'esprit de l'art Japonais—à la Japon*, to her great honor be it said. Holland arrived at Nagasaki first, but France is probably further along today in profitable industrial results in present arts and crafts from the revelations she found when she got to Yedo by way of Yokohama than is any other country, Austria excepted—unless our own country should soon prove formidable exception.

This does not mean that France or Austria copies Japan or that America may do so. It does mean that France is, only now, beginning to do approximately well what Japan did supremely well four centuries ago in the great Momoyama period of her development—yes, about four hundred years ago!

Any principle is fertile, perhaps it is fertility itself! If its application is once understood in any branch of design, it will go on blooming indefinitely, coordinately, in as many different schools and schemes as there are insects, or in forms as varied as the flowers themselves, or for that matter be as prolific of pattern as the fishes or the flora of the sea.

We should, were we going into the matter at length, get to nature forms later on as the best of all references for the working of the principles we are here seeking, and I should have preferred to go to them at once as is my habit. But for the purposes of this hour I have preferred tradition because Japan has already done, in her own perfect way, what now lies for study before us. And I believe it well to know what humanity has accomplished in the direction we must take, if we are strong enough to profit by tradition—the spirit of principle—and leave traditions—the letter, or form—alone, as not our own. Even so, having finished with tradition, we will still have before us and forever, as an open book of creation, that natural appeal to the nature court of last resort.

Remember, however, that long before France rationalized and vitalized her industries, during the period when she was still sickened and helpless in

the serpentine coils of l'art nouveau (derived from her own deadly rococo), you may find in the "Secession" of Middle Europe an application earlier than the present application by France of the vital principles we are discussing on behalf of our subject.

I came upon the Secession during the winter of 1910. At that time Herr Professor Wagner, of Vienna, a great architect, the architect Olbrich, of Darmstadt, the remarkable painter Klimt, of Austria, and the sculptor Metzner, of Berlin—great artists all—were the soul of that movement. And there was the work of Louis Sullivan and of myself in America. Many Europeans accounted for this Secession—their own early contribution to modern art—as a "Mohammedan renaissance." (It was natural by that time to believe in nothing but some kind of renaissance.) But later, when the Secession—though frowned upon by the royal academies—was in full swing in the products of the Wiener Werkstätte, seen today similarly in the products of French art and craft, we find the ancient art and craft of Japan's great Momoyama often approximated in effect.

Nothing at this "modern" moment could be more ungracious nor arouse more contumacious "edge" than thus looking the "gift horse" or the "modernistic" in the teeth. Nevertheless, I believe it valuable to our future to raise this unpopular issue.

Artists, even great ones, are singularly ungrateful to sources of inspiration—among lesser artists ingratitude amounts to phobia. No sooner does the lesser artist receive a lesson or perceive an idea or even receive the objects of art from another source, than he soon becomes anxious to forget the suggestion, conceal the facts, or, if impossible to do this, to minimize, by detraction, the "gift." And as culture expands, we soon, too soon, deny outright the original sources of our inspiration as a suspected reproach to our own superiority. This you may quite generally find in the modern art world. At this moment in our development Japan particularly is thus the "great insulted." Cowardly evasion seems unworthy of great artists or great causes, and certainly is no manner in which to approach great matter for the future. Ignorance of origins is no virtue, nor to keep fresh thought ill-advised concerning them. So let us pursue still further this quest as to what is style by digging at the root of this ancient culture where I imagine there was more fertile ground and the workman had severer discipline than he ever had

anywhere else in the world. Thus we may interpret a ready-made record that is unique. Let us study for a moment the Japanese dwelling, this humble dwelling that is a veritable sermon on our subject, "style in industry."

It became what it is owing to a religious admonition. "Be clean!" "Be clean" was the soul of Shinto—Jimmu Tenno's own ancient form of worship. Shinto spoke not of a good man, nor spoke of a moral man, but spoke of a clean man. Shinto spoke not only of clean hands, but of a clean heart. "Be clean" was the simple cry from the austere soul of Shinto. Japanese art heard the cry, and therefore posterity has one primitive instance where a remarkably simple religious edict or ideal made architecture, art, and craftsmanship the cleanest, in every sense, of all clean workmanship the world over.

This simple ideal of cleanliness, held by a whole people, came to abhor waste as matter out of place, saw it as ugly—therefore as what we call "dirt."

Here you have a kind of spiritual ideal of natural, and hence organic, simplicity. Consequently all Japanese art with its imaginative exuberance and organic elegance (no fern frond freshly born ever had more) was a practical study in elimination of the insignificant. All phases of art expression in the Momoyama period were organic. There was no great and no small art. But there lived the profound Sotatsu, the incomparable Korin, the brilliant Kenzan, and their vital schools, as, later in the Ukiyoé, we find Kiyonobu, Toyonobu, Harunobu, Kiyonaga, Utamaro, Hokusai, and Hiroshige—a small student group gathered about each—all springing from the industrial soil thus fertilized by the school of the great Momoyama masters. Instinctive sense of organic quality qualified them as artists, *all*. Again, a kind of spiritual gift of significance. Here, as a saving grace in one civilization on earth, feeling for significance, simplicity in art was born, becoming soon an ideal naturally attained by organic means. Here, in this "plastic-ideal" *attained by organic means,* we touch the secret of great style. Wood they allowed to be wood, of course. Metal they allowed—even encouraged—to be metal. Stone was never asked to be less or more than stone. Nor did the designer of that day try to make any thing in materials or processes something other than itself. Here is a sound first principle that will go far to clear our encumbered ground for fresh growth in "art in industry."

Also the modern process of standardizing, as we now face it on every side, sterilized by it, prostrate to it, was in Japan known and practiced with artistic perfection by freedom of choice many centuries ago, in this dwelling we are considering. The removable (for cleaning) floor mats or *tatami* of Japanese buildings were all of one size, 3′ 0″ by 6′ 0″. The shape of all the houses was determined by the size and shape of assembled mats. The Japanese speak of a nine, eleven, sixteen, or thirty-four mat house. All the sliding interior partitions occur on the joint lines of the mats. The *odeau*—polished wood posts that carry ceilings and roof—all stand at intersections of the mats. The light sliding paper *shoji* or outside wall-screens are likewise removable, for cleaning. The plan for any Japanese dwelling was an effective study in sublimated mathematics. And the house itself was used by those who themselves made it for themselves with the same naturalness with which a turtle uses his shell. Consider too that, "be clean"—"the simplest way without waste"—was dignified as *ceremonial* in old Japan. The ceremonies of that ancient day were no more than the simple offices of daily life raised to the dignity of works of art. True culture, therefore. Ceremonials, too, it seems, may be organic, integral though symbolic. For instance, what is the important tea ceremony of the Japanese but the most graciously perfect way, all considered, of serving a cup of tea to respected or beloved guests? Grace and elegance, as we may see—*of* the thing itself—organic elegance. Not *on* it Greek-wise as the "elegant solution." It was in easy, simple, spontaneous expression of nature that the Japanese were so perfect—contenting themselves with humble obedience to nature-law.

Naturally enough, disorder, too, in this "clean" house built by Jimmu Tenno's people is in the same category as dirt. So everything large or little of everyday use, even the works of art for humble and profound admiration, have appropriate place when in use and are carefully put away into safekeeping when not in use.

All designed for kneeling on soft mats on the floor you say? Yes—but the same ideal, in principle, would work out just as well on one's feet.

With this Shinto ideal of "be clean" in mind the Japanese dwelling in every structural member and fiber of its being means something fine, has genuine significance, and straightway does that something

with beautiful effect. Art, for once, is seen to be supremely natural.

Yes—here is definite root of style in industry. Also in every other country and period where style developed as genuine consequence of natural or ethnic character, similar proofs may be found as to the origin of style.

Today, it seems to me, we hear this cry "be clean" from the depths of our own need. It is almost as though the machine itself had, by force, issued edict similar to Shinto—"be clean." Clean lines—clean surfaces—clean purposes. As swift as you like, but clean as the flight of an arrow. When this edict inspires organic results and not the mere picture-making that curses so-called "modernism," we will here find the basic elements of style in our own industry to be the same by machine as they were by hand back there in the beginning of the history of a unique civilization. To give this edict of the machine human significance, there is the command of the creative artist to keep a grip upon the earth in use of the architectural planes parallel to earth, and to make new materials qualify the new forms of the new methods, so that all is warmly and significantly human in the result. The human equation is the art equation in it all. "Clean," in human sense, does not mean "plain" but it does mean significant. Nor does it mean hard, nor mechanical, nor mechanistic, nor that a man or a house or a chair or a child is a machine, except in the same sense that our own hearts are suction pumps.

Style in our industries will come out of similar, natural, clean use of machines upon "clean" material, with similar, unaffected, *heart-felt* simplicity instead of *head-made* simplicity. The nature of both machine and material for human use must be understood and mastered so they may be likewise in our case plastic interpretations by great imagination. We will learn how to use both machinery and materials, and perhaps men as well, in the coming century. But we must learn how to use them all not only for qualities they possess in themselves, but to use each so that they may be beautifully, as well as scientifically related to human purpose in whatever form or function we humanly choose to put them. Then let us take all as much further along beyond the implications of "be clean," as our superior advantages in aesthetics permit.

To get nearer to the surface. We started to speak of textiles: having during the discourse of our first chapter touched upon woodworking, stonework, and metalworking, let us now go back for a moment to the Rodier fabrics for an example of present-day, successful design for the loom. Textures, infinite in variety, are the natural product of the loom. Pattern is related to, and is the natural consequence of, the mechanics of these varying textures. Large, flat patterns involved with textures, textures qualifying them or qualified by them, picturesque but with no thought of a picture, as in this product, are entirely modern in the best sense. And I would emphasize for you, in this connection, the fact that the ancient art we have just been interpreting was never, in any phase of its industries, ruined by childish love of the picture. The "picture" sense in art and craft came in with the Renaissance, as one consequence of the insubordination of the arts that disintegrated architecture as the great art. And before we can progress in our own machine products as art, we, too, will have to dispose of the insufferable insubordination of the picture. Summarily, if need be. I should like to strike the pictorial death blow in our art and craft. Of course I do not mean the picturesque.

Because of this insubordination of the picture few tapestries except the "Mille-fleurs" (and then very early ones) exist as good textile designs on account of the complex shading essential to the foolish picture as designed by the undisciplined painter. The insubordination of painting, setting up shop on its own account, divorced from architecture (architecture being the natural framework and background of all ancient, as it will be of any future, civilization), has cursed every form of art endeavor whatsoever with similar abuses of the *pictorial. Toujours la peinture, ad libitum, ad nauseam*—the *picture*. We live in the pictorial age. We do not have childlike imagery in simplicity but are "childish" in art, and whatever form our great art and craft in future may take, one thing it will not be, and that thing is "pictorial." Even a Japanese print, the popular form of imagery illustrating the popular life of Japan in all its phases, as the French well know, never degenerated to the mere picture. Let us be thankful that the machine by way of the camera today takes the pictorial upon itself as a form of literature. This gratifying feat has, already, made great progress in the cinematograph. Let the machine have it, I say, on those terms and keep it active there and serviceable in illustration as well, for what it may be worth—and it is worth much. But let us henceforth consider literature and the picture as one—eliminating both from the horizon of our art and craft—and for all time.

Let us now, in passing, glance at glassmaking: the Leerdam glass products for which artists are employed to make designs upon a royalty basis, similar to authors writing for publishers, then the special art of Lalique, and finally, the great, clear plates of our own commercial industry, the gift of the machine . . . great glass sheets to be cut up and used with no thought of beauty, valuable only because of their usefulness.

Here again let us insist that the same principle applies to glass as to wood, stone, metal, or the textiles just mentioned. But how far variety may go can be seen in the range of the Holland product from the simple glass-blown forms of De Basle, Copius, and Berlage at Leerdam to the virtuosity of French pieces by the genius Lalique. Certain characteristics of glass are properties of these designs: a piece by Lalique, being specialized handicraft, is useful as indicating the super-possibilities of glass as a beautiful material. Concerning our own "commercial" contribution (contributions so far are all "commercial") to glass—glass, once a precious substance, limited in quantity, costly in any size—the glass industry has grown so that a perfect clarity in any thickness, quality or dimension up to 250 square feet from $\frac{1}{8}''$ in thickness to $\frac{1}{2}''$ thick, is so cheap and desirable that our modern world is drifting towards structures of glass and steel.

The whole history of architecture would have been radically different had the ancients enjoyed any such grand privileges in this connection as are ours. The growing demands for sunshine and visibility make walls—even posts—something to get rid of at any cost. Glass did this. Glass alone, with no help from any of us, would eventually have destroyed classic architecture, root and branch.

Glass has now a perfect visibility, thin sheets of air crystallized to keep air currents outside or inside. Glass surfaces, too, may be modified to let the vision sweep through to any extent up to perfection. Tradition left no orders concerning this material as a means of perfect visibility; hence the sense of glass as crystal has not, as poetry, entered yet into architecture. All the dignity of color and material avail-

able in any other material may be discounted by glass in light, and discounted with permanence.

Shadows were the "brushwork" of the ancient architect. Let the "modern" now work with light, light diffused, light reflected, light refracted—light for its own sake, shadows gratuitous. It is the machine that makes *modern* these rare new opportunities in glass; new experience that architects so recent as the great Italian forebears, plucked even of their shrouds, frowning upon our "renaissance," would have considered magical. They would have thrown down their tools with the despair of the true artist. Then they would have transformed their cabinets into a realm, their halls into bewildering vistas and avenues of light—their modest units into unlimited wealth of color patterns and delicate forms, rivaling the frostwork upon the windowpanes, perhaps. They were creative enough to have found a world of illusion and brilliance, with jewels themselves only modest contributions to the splendor of their effects. And yet somehow Palladio, Vitruvius, Vignola, seem very dead, far away, and silent in this connection; Bramante and Brunelleschi not so far, nor Sansovino, though we must not forget that the great Italians were busy working over ancient forms. There was Buonarroti. Where should he be in all this, I wonder?

The prism has always fascinated man. We may now live in prismatic buildings, clean, beautiful, and new. Here is one clear "material" proof of modern advantage, for glass is uncompromisingly modern. Yes, architecture is soon to live anew because of glass and steel.

And so we might go on to speak truly of nearly all our typical modern industries at work upon materials with machinery. We could go on and on until we were all worn out and the subject would be still bright and new, there are so many industrial fields—so much machinery, so many processes, such riches in new materials.

We began this discussion of art in industry by saying, "toleration and liberty are the foundations of a great republic." Now let the artist come. Well, let him come into this boundless new realm so he be a liberal, hating only intolerance and especially his own. As said at the beginning of this discourse, true romanticism in art is after all only liberalism in art. This quality in the artist is the result of an inner experience and it is the essential poetry of the creative artist that his exploring brother, tabulating the sciences, seems never quite able to understand nor wholly respect. He distrusts that quality in life itself.

But the sense of romance cannot die out of human hearts. Science itself is bringing us to greater need of it and unconsciously giving greater assurance of it at every step. Romance is shifting its center now, as it has done before and will do constantly—but it is immortal. Industry will only itself become and remain a machine without it.

Our architecture itself would become a poor, flat-faced thing of steel-bones, box-outlines, gaspipe, and handrail fittings—as sun-receptive as a concrete sidewalk or a glass tank without this essential *heart* beating in it. Architecture, without it, could inspire nothing, and would degenerate to a box merely to *contain* "objets d'art"—objects it should itself create and *maintain*. So beware! The artist who condemns romance is only a foolish reactionary. Such good sense as the scientist or philosopher in the disguise of "artist" may have is not creative, although it may be corrective. Listen therefore and go back with what you may learn, to live and be true to romance.

Again—there is no good reason why objects of art in industry, because they are made by machines in the machine age, should resemble the machines that made them, or any other machinery whatever. There might be excellent reason why they should *not* resemble machinery.

There is no good reason why forms stripped clean of all considerations but function and utility should be admirable beyond that point: they may be abominable from the human standpoint, but there is no need for them to be so in the artist's hands.

The negation naturally made by the machine, gracefully accepted now, may, for a time, relieve us of sentimental abortion and abuse, but it cannot inspire and recreate humanity beyond that point. Inevitably the negation proceeds upon its own account to other abuses and abortions, even worse than sentimentality. Again, let us have no fears of liberalism in art in our industries, but encourage it with new understanding, knowing at last that the term romanticism never did apply to make-believe or falsifying, except as it degenerated to the artificiality that maintained the Renaissance.

The facts confronting us are sufficiently bare and

hard. The taste for mediocrity in our country grows by what it feeds on.

Therefore the public of this republic will, more than ever now, find its love of commonplace elegance gratified either by the sentimentality of the "ornamental" or the sterility of ornaphobia. The machine age, it seems, is either to be damned by senseless sentimentality or to be sterilized by a factory aesthetic. Nevertheless, I believe that romance—this quality of the *heart,* the essential joy we have in living—by human imagination of the right sort can be brought to life again in modern industry. Creative imagination may yet convert our prosaic problems to poetry while modern Rome howls and the eyebrows of the Pharisees rise.

And probably not more than one-fifth of the American public will know what is meant by the accusation, so frequently made in so many different languages, that the American is uncreative, four-fifths of the accused pointing to magnificent machinery and stupendous scientific accomplishment to refute the impeachment. So while we are digesting the nationalities speaking those same languages within our borders, such culture as we have in sight must assist itself with intelligence to materialize for Americans out of everyday common places—and transcend the commonplace.

▦ So finally, a practical suggestion as to ways and means to grow our own style in industry.

The machine, as it exists in every important trade, should without delay be put, by way of capable artist interpreters, into student hands, for them, at first, to play with and, later, with which to work. Reluctantly I admit that to put the machine, as the modern tool of a great civilization, to any extent into the hands of a body of young students, means some kind of school—and naturally such school would be called an art school, but one in which the fine arts would be not only allied to the industries they serve, but would stand there at the center of an industrial hive of characteristic industry as inspiration and influence in design problems. Sensitive, unspoiled students (and they may yet be found in this unqualified machine that America is becoming) should be put in touch with commercial industry in what we might call industrial style centers, workshops equipped with modern machinery, connected perhaps with our universities, but endowed by the industries themselves, where the students would remain domiciled, working part of the day in the shop itself.

Machinery-using crafts making useful things might through such experiment centers discover possibilities existing in the nature of their craft, which the present industries know nothing about and might never discover for themselves. In such a school it would be the turn of the fine arts to serve machinery in order that machinery might better serve them and all together better serve a beauty-loving and appreciative United States.

Let us say that seven branches of industrial arts be taken for a beginning (a number should be grouped together for the reason that they react upon one another to the advantage of each). Let us name glassmaking, textiles, pottery, sheet metals, woodworking, casting in metal, reproduction. Each industry so represented should be willing to donate machinery and supply a competent machinist and to a certain extent endow its own craft, provided such industries were certain of proper management under safe auspices, and assured of a share in results which would be directly theirs—sharing either in benefit of designs or presently in designers themselves, both adapted to their particular field.

Such experiment centers intelligently conducted could do more to nationalize and vitalize our industries than all else, and soon would make them independent of France, Austria, or any other country, except as instruction by international example from all countries would help work out our own forms. There is no reason why an experiment center of this character, each center confined to forty students or less, should not make its own living and produce valuable articles to help in "carrying-on." As compared with the less favorably circumstanced factories, and owing to the artists at the head of the group, each article would be of the quality of a work of art and so be a genuine missionary wherever it went.

Such a school should be in the country, on sufficient land so that three hours a day of physical work on the soil would insure the living of the students and the resident group of seven artist workers, themselves the head of the student group. There would remain, say, seven hours of each day for forty-seven individuals in which to unite in production. A well-directed force of this sort would very soon

have considerable producing power. Thus belonging to the school each month there would be beautifully useful or usefully beautiful things ready for market and influence—stuffs, tapestries, table linen, new cotton fabrics, table glassware, flower holders, lighting devices, window glass, mosaics, necklaces, screens, iron standards, fixtures, gates, fences, fire irons, enameled metals for house or garden purposes, cast metal sculpture for gardens, building hardware. All sorts of industrial art in aluminum, copper, lead, tin. Practical flower pots, architectural flower containers on large scale, water jars, pots, and sculpture. Paintings for decoration suitable for reproduction and designs for new media—for process-reproductions. Modern music, plays, rhythm, designs for farm buildings; the characteristic new problems like the gasoline station, the refreshment stand, food distribution, town and country cottages and objects for their furnishings, and factories, too, of various sorts.

The station might broadcast itself. Issue brochures, illustrated by itself, of pertinent phases of its work. Devote a branch to landscape studies on conservation and planting and town planning. In short, the station would be a hive of inspired industry. Architecture, without hesitation or equivocation, should be the broad essential background of the whole endeavor—again strong in modern life as it ever was in ancient times. It is logical to say that again it must be the background and framework of civilization. Such stations or centers could be alcoves in connection with standard university courses in the history of art, architecture, and archaeology. And it would not matter where the centers were located, were they sufficiently isolated in beautiful country. They should not be too easy of access.

No examinations, graduations, or diplomas. But so soon as a student worker showed special competence in any branch of industry, he would be available as teacher in the university or for a place in that industry, manufacturers who were contributors to the school having first right to use him or her. The body of inspirational talent and the trade machinists should be of such character that outside students would enjoy and seek points of contact with the work going on at the school—helpful to them and to the school as well.

I believe the time has come when art must take the lead in education because creative faculty is now, as ever, the birthright of man—the quality that has enabled him to distinguish himself from the brute. Through tricks played upon himself by what he proudly styles his intellect, turning all experience into arrogant abstractions and applying them as such by systems of education, he has all but sterilized himself. Science has been tried and found to be only a body. Science, and philosophy, too, have known but little of those inner experiences of the soul we call art and religion.

This creative faculty in man is that quality or faculty in him of getting himself born into whatever he does, and born again and again with fresh patterns as new problems arise. By means of this faculty he has the gods if not God. A false premium has been placed by education upon will and intellect. Imagination is the instrument by which the force in him works its miracles. Now—how to get back again to men and cultivate the creative quality in man is the concern of such centers as here suggested. What more valuable step looking toward the future could any great institution take than to initiate such little experiment stations in out of the way places, where the creative endeavor of the whole youth is coordinate with the machinery, and where the technique of his time is visible at work, so that youth may win back again the creative factor as the needed vitalizing force in modern life?

We know, now, that creative art cannot be taught. We know, too, that individual creative impulse is the salt and savor of the natural ego as well as the fruit and triumph of any struggle we call work. Civilization without it can only die a miserable death. To degrade and make hypocritical this quality of the individual by imposing mediocrity upon him in the name of misconceived and selfishly applied democracy is the modern social crime. Too plainly we already see the evil consequences of sentimentalized singing to Demos—foolishly ascribing to Demos the virtues of deity. Concentration and sympathetic inspiration should be isolated and concentrated in experimental work of this kind in order to hasten the time when art shall take the lead in education, and character be a natural consequence. Were this to be put into effect on even a small scale in various units scattered over the surface of these United States, this indispensable ego might be strengthened and restored to a sanity compared to which

"egotism," as we now know it in education, would only be a sickly disease of consciousness—highly improbable because manifestly absurd.

Thus given opportunity truly liberal, American youth might soon become the vital medium through which the spirit of man may so appear to men in their own work that they might again see and realize that great spirit as their own.

This liberal opportunity to work and study is a practical suggestion for the growth of that quality of style in industry we have been seeking this afternoon.

Behind personality tradition should stand—behind tradition stands the race.

We have put tradition before personality—and made tradition as a fatal hurdle for race.

3: The Passing of the Cornice

Instinctively, I think, I hated the empty, pretentious shapes of the Renaissance. When sixteen years old, I used to read the great "modern" of his day Victor Hugo. Reading his discursive novel, *Notre-Dame,* I came upon the chapter, *"Ceci Tuera Cela."* That story of the decline of architecture made a lasting impression upon me. I saw the Renaissance as that setting sun all Europe mistook for dawn; I believed Gutenberg's invention of the shifting types would kill the great edifice as architecture. In fact, as we all may now see, printing *was* the first great blow to art by the machine. I saw the lifeblood of beloved architecture slowly ebbing, inevitably to be taken entirely away from the building by the book, the book being a more liberal form of expression for human thought. This mechanical invention was to become the channel for thought—because more facile and more direct. In place of the art of architecture was to come literature made ubiquitous.

I saw that architecture, in its great antique form, was going to die. Ghastly tragedy—I could hardly bear the thought of the consequences.

About this time, too—catastrophe! As the new west wing of the old Wisconsin State Capitol at Madison fell, I happened to be passing in the shade of the trees that bordered the green park in which the building stood. Suddenly I heard the roar of collapse—saw the clouds of white lime-dust rise high in the air—heard the groans and fearful cries of those injured and not killed—some forty workmen dead or seriously hurt. I remember clinging to the iron palings of the park in full view of the scene, sick with horror as men plunged headlong from the basement openings—some seeming to be still madly fighting off falling bricks and timbers, only to fall dead in the grass outside, grass no longer green but whitened by the now falling clouds of lime. The outer stone walls were still standing. Stone basement-piers carrying the iron interior supporting columns had given way and the roof took all the floors, sixty men at work on them, clear down to the basement. A great "classic" cornice had been projecting boldly out from the top of the building, against the sky. Its moorings partly torn away, this cornice now hung down in places, great hollow boxes of galvanized iron, hanging up there suspended on end. One great section of cornice I saw hanging above an upper window. A workman hung, head downward, his foot caught, crushed on the sill of this window, by a falling beam. A red line streaked the stone wall below him and it seemed as though the hanging box of sheet-iron that a moment before had gloomed against the sky as the "classic" cornice, must tear loose by its own weight and cut him down before he could be rescued. The spectacle of that sham feature hanging there, deadly menace to the pitifully moaning, topsy-turvy figure of a man—a working man—went far to deepen the dismay planted in a boy's heart by Victor Hugo's prophetic tale. This terrifying picture persisting in imagination gave rise to subsequent reflections. "This empty sheet-iron thing . . . a little while ago it was pretending to be stone . . . and doing this, mind you, for the capitol of the great state of Wisconsin . . . what a shame!

"Somebody must have been imposed upon!

"Was it the state or perhaps the architect himself?

"Had the architect been cheated in that, too, as well as in the collapsed piers that had let the structure down? Or was it all deliberate and everybody knew about it, but did nothing about it—did not care? Wasn't this the very thing Victor Hugo meant?"

I believed it was what he meant and began to examine cornices critically. "Why was it necessary to make them 'imitation'? If it was necessary to do that, why have them at all? Were they really beautiful or useful anyway? I couldn't see that they were par-

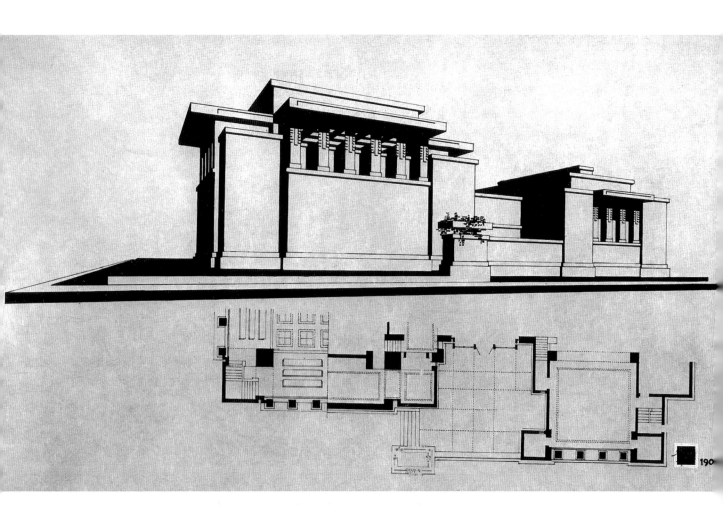

Unity Temple,
Oak Park, Illinois. 1905.
FLLW Fdn# 0611.007

ticularly beautiful—except that a building looked 'strange' without one. But it looked more strange when the roof fell in and this thing called the cornice hung down endwise and was 'thin.' But that was it. . . . No matter how thin it was, the great cornice put there regardless of reality, to make the building familiar. It had no other meaning. Well, then, Victor Hugo saw this coming, did he, so long ago? . . . He foresaw that architecture would become a sham? . . . Was it all now sham or was it just the cornice that was shamming? . . . And if they would lie about the cornice, or lie with it this way in matters of state, why wouldn't they lie about other parts of the building too . . . perhaps as a matter of taste?" And then came critical inquests held by the boy-coroner . . . the pilaster found to be another nauseating cheat. Others followed thick and fast, I remember.

It was early disillusionment and cruel, this vision of the lifeblood of idolized architecture ebbing slowly away, vividly pointed and finally driven home by the horror of the falling building, showing the sham architecture, a preposterous bulk, threatening to take the very life of the workman himself, his lifeblood already dripping away down the wall, just beneath. The poor workman became significant, himself a symbol. Both experiences, *"Ceci Tuera Cela"* and the wreck of the capitol by internal collapse, did something to me for which I have never ceased to be grateful. If the old order is to be preserved, regardless, it is not well for boys to read the great poets nor see classic buildings fall down.

Soon after this, Viollet-le-Duc's *Dictionnaire Raisonné de l'Architecture Française* fell into my hands by way of a beloved schoolteacher aunt of mine and the work was finished, ready for the master to whom I came some four years later, Louis H. Sullivan—Beaux-Arts rebel. I went to him, for one thing, because he did not believe in cornices.

Now if the "pseudo-classic" forms of the Renaissance had had more life in them they would have died sooner and long ago have been decently buried. Renaissance architecture, being but the dry bones of a life lived and dead, centuries before, the bones were left to bleach. For text, then, on this our third afternoon, our reference to authority is hereby inscribed to Moti, ancient Chinese sage.

This inscription: "In twilight, light of the lantern, or in darkness, worship no old images nor run after new. They may arise to bind you, or, being false, betray you into bondage wherein your own shall wither." (Twilight probably meaning partial understanding; lantern light, glamor; darkness, ignorance.) Or another translation—Chinese is far from English: "Except in full light of day bow down to no images, cast, graven, or builded by another, less they, being false, betray and bind you powerless to earth." Still another: "Without full knowledge worship no images, lest being false they bind thee powerless to make thine own true."

And finally we have reached the title of the discourse—"The Passing of the Cornice," the image of a dead culture.

There was a Graeco-Roman feature advocated by the American Institute of Architects to finish a building at the top. This authentic feature was called the cornice. Not so long ago no building, great or small, high or low, dignified and costly, or cheap and vile, was complete without a cornice of some sort. You may see accredited cornices still hanging on and well out over the busy streets in any American city for no good purpose whatsoever . . . really for no purpose at all. But to the elect, no building looked like a building unless it had the brackets, modillions, and "fancy" fixings of this ornamental and ornamented pseudo-classic "feature." Cornices were even more significantly insignificant than it is the habit of many of the main features of our buildings to be. The cornice was an attitude, the ornamental gesture that gave to the provincial American structure the element of hallowed "culture." That was all the significance cornices ever had—the worship of a hypocritical theocratic culture. Usually built up above the roof and projecting well out beyond it, hanging out from the top of the wall, they had nothing in reason to do with construction—but there the cornice had to be. It had, somehow, became "manner"—something like lifting our hat to the ladies, or, in extreme cases, like the leg an acrobat makes as he kisses his hand to the audience after doing his "turn." The cornice, in doing our "turn," became our commonplace concession to respectable "form," thanks again to the Italians thus beset—and disturbed in their well earned architectural slumber.

But, have you all noticed a change up there where the eye leaves our buildings for the sky—the "skyline," architects call it? Observe! More sky! The cornice has gone. Gone, we may hope, to join the procession of foolish concessions and vain professions that passed earlier. Gone to join the corner-tower, the hoop skirt, the bustle, and the cupola.

Like them—gone! This shady-shabby architectural feature of our middle distance, the seventies, eighties, and nineties, has been relegated to that mysterious scrap heap supposedly reposing in the backyard of oblivion. Look for a cornice in vain anywhere on America's new buildings high or low, cheap or costly, public or private. You will hardly find one unless you are looking at some government "monument." Government, it seems, is a commitment, a rendezvous with traditions that hang on.

But for a time no skyscraper—yes, it is all that recent—was complete without the cornice. The Belmont Hotel and the Flatiron Building in New York City perhaps said the last word, took the last

grand stand, and made the final grand gesture in behalf of our subject. For about that time the hidden anchors that tied the pretentious feature back on some high Chicago buildings began to rust off and let this assumption-of-virtue down into the city streets to kill a few people on the sidewalks below. The people killed, happened to be "leading citizens." But for "accident" what would modern American cities be looking like, by now? Cornices cost outrageous sums, cornices shut out the light below, but that didn't seem to hurt cornices, much, with us. Not until cornices became dangerous and pseudoclassic by way of the A.I.A. ("Arbitrary Institute of Appearances") and began to crash down to city streets—did the city fathers talk "ordinance" to the Institute. The learned architects listened, read the ordinances, and though indignant, had no choice but to quit. Observe the relief!

Nor dare we imagine they would have dared to quit the cornice on their own account!

▦ Shall we see the stagey, empty frown of the cornice glooming against the sky again? Has this cultured relic served its theatrical "turn" or are appearances for the moment *too* good to be true? Periodic "revivals" have enabled our aesthetic crimes to live so many lives that one may never be sure. But since we've learned to do without this particular "hangover" in this land of free progress and are getting used to bareheaded buildings, find the additional light agreeable, the money saved extremely useful, and as, especially, we are for "safety first," we are probably safe from the perennial renaissance for some years to come. At any rate for the moment "the glory that was Greece, the grandeur that was Rome," ours by way of Italy, may cease turning in ancient and honorable graves. Oh Palladio! Vitruvius! Vignola! be comforted—the twentieth century gives back to you your shrouds!

Ye Gods! And *that* was the American architecture of liberty! Yes, it was unwarranted liberty that American architecture took.

▦ We may well believe there is some subjective wave, that finally, perhaps blindly, gets buildings, costumes, and customs all together in effect as civilization marches on. At least it would so seem as we look about us, for in the umbrageous cornice-time immediately behind us, hats were extravagant cornices for human heads, just as the cornices were extravagant hats for buildings. And what about puffed sleeves, frizzes, furbelows, and flounces? Didn't they go remarkably well with pilasters, architraves, and rusticated walls? In fact, weren't they exactly the same thing? Even the skirts of the cornice-period were extravagant cornices upside down over feet. And there was the "train" trailing the floor on occasion, the last word in cornices. Nor was dinner in those days complete without its own peculiar "cornice." They called it "dessert." Many brave and agreeable men died of that less obvious "cornice," but "cornice" nevertheless.

And the manners of that period of grandomania! Were they not emulation of the "cornice" when really manner! And top-heavy too, with chivalry and other thinly disguised brutalities? Now? No hat brim at all. Just a close sheath for the head. Skirts? None. Instead, a pair of silken legs sheer from rigid stilted heel to flexing knees; something scant and informal hung round the middle from above. What would have barely served as underwear in the late cornice-days, now costume for the street. No "manner" in our best manners.

Study, by contrast, the flamboyant human and architectural silhouettes of the cornice-period just past with the silhouettes of today. After the comparison, be as grateful as it is in your nature to be—for escape, for even the *appearance* of simplicity.

Here comes "fashionable" penchant for the clean, significant lines of sculptural contours. Contrast these silhouettes in cars, buildings, clothing, hair dressing of today with those of the nineties. Even in the flower arrangements of the period of our "middle distance" and that of our immediate foreground you may see great difference. The "bokay" was what you remember it was. Now, a bouquet is a few long-stemmed flowers with artful carelessness slipped into a tall glass, or au naturel, a single species grouped in close sculptural mass over a low bowl. Consider, too, that modern music no longer needs the cornice. It, too, can stop without the crescendo or the grand finale, the flourish of our grandfathers, which was "classic." Yes, the cornice was "flourish" too. Curious! Jazz, all too consistently, belongs to this awakening period, to the youth that killed the cornice, awakening to see that nothing ever was quite so pretentious, empty, and finally demoralizing as that pompous gesture we were taught to re-

spect and to call the "cornice." It had much—much too much—foreign baggage in its train, ever to be allowed to come back to America.

Should we now clearly perceive what the cornice really meant in terms of human life, especially of our own life as dedicated to liberty, we *would* be rid of cornices forever. Turning instinctively from the cornice shows our native instincts healthy enough. But we require *knowledge* of its fatality, where freedom is concerned, to insure protection from the periodic "aesthetic revival" that is successfully put over every few years just because of enterprising salesmanship and our own aimlessness. We must have a standard that will give us protection. If we know *why* we hate the cornice now, it may never rise again to ride us or smite us some other day.

Suppose, for the sake of argument, once upon a time we *did* live in trees, lightly skipping from branch to branch, insured by our tails as we pelted each other with nuts. We dwelt sheltered from the sun and rain by the overhanging foliage of upper branches—grateful for both shelter and shade. Gratitude for that "overhead"—and the sense of it—has been with us all down the ages as the cornice, finally become an emblem—a symbol—showed. Instinctive gratitude is of course fainter now. But whenever the cornice, true to that primeval instinct, was *real shelter* or even the sense of it, and dropped roof-water free of the building walls—well, the cornice was not a cornice then but was an overhanging *roof.* Let the overhanging roof live as human shelter. It will never disappear from architecture. The sense of architecture as human shelter is a very fine sense— common sense, in fact.

But as soon as this good and innocent instinct became a habit, original meaning, as usual, lost by the time *usefulness* departed, the ancient and no less fashionable doctor-of-appearances took notice, adopted the "look" of the overhang, began to play with it, and soon the citizen began to view the overhang from the street, as *the* cornice. If ever "the doctor" knew or ever cared what meaning the overhang ever had, the doctor soon forgot. He became "cornice-conscious." The roof-water now ran back from the cornice on to the flat roof of the building and down inside down-spouts. But why should the doctor worry? Has the doctor of aesthetics ever worried about structural significances? No. So through him,

although all had been reversed, this now obsession of the "overhead," for mere aesthetic effect, an aesthetic that had got itself into Greek and, therefore, into Roman life as art for art's sake, this arbitrary convention, became our accepted academic pattern. It was all up with us then—until now.

The net result of it all is that no culture is recognizable to us as such without the cornice. But just eliminate the troublesome and expensive feature from Greek and Roman buildings and see what happens by way of consequence. Then when you know what it meant in their buildings, just take that same concession to the academic artificiality of tradition from their lives and see, as a consequence, what happens to culture. You will see by what is lost, as well as by what is left, that the cornice, as such, originally was Graeco-Roman culture, and to such an extent that—pasticcio-Italiano—it has been our own "American pseudo-classic" *ever since.* Inasmuch as nearly everything institutional in our much over-instituted lives is either Roman or Graeco-Roman, we couldn't have had our chosen institutions without this cherished symbol. No, we had to do the precious cornice too. So we did the cornice-lie with the best of them, to the limit and far and away beyond any sense of limit at all.

Amazing! Utter artificiality become a more or less gracefully refined symbolic *lie*, the culture we Americans patterned and tried our best to make our own classic, too, and adored for a long, long time. Thomas Jefferson himself was blameworthy in that. George Washington no less so.

But pragmatic as the Romans were in all other matters, we may comfort ourselves a little, if there is any comfort in the fact that these same Romans, great jurists and executives, too, when it came to "culture," denied their own splendid engineering invention of the arch for centuries in order to hang on to the same cornice—or more correctly speaking, to hang the cornice on.

Not until the Roman doctors-of-appearances (their names are lost to us, so we cannot chastely insult them) could conceal the arch no longer, did they let the arch live as the arch. Even then, in order to preserve "appearances," the doctors insisted on running a cornice—in miniature—around over the arch itself and called the little cornice on the curve an archivolt. They then let the matter go at that. Yes, the noble arches themselves now had to have the

cornices, and Renaissance arches have all had cornices on their curves for several centuries or more, in fact had them on until today. Roofs now have become flat or invisible. The roof-water ran back the other way. But here was the cornice, derived from and still symbolic of the overhanging roof, continuing to hang over just the same. Yes, it was now great "art." In other words, the cornice was secure as an academic aesthetic. No one dared go behind the thing to see how and what it *really* was. It no longer mattered what it was.

Another human instinct had left home and gone wrong, but civilization sentimentalized and made the degradation into prestige—irresistible. Professors taught the cornice now as "good school." Every building, more or less, had to defer to this corniced authority to be habitable or valuable. Only a radical or two in any generation dared fight such authority and usually the fight cost the radical his economic life.

But now you may look back, although the perspective is still insufficient, and see what a sham this undemocratic fetish really was, what an imposition it became, how pompously it lied to us about itself; realize how much social meanness of soul it hid and what poverty of invention on the part of the great architects it cleverly concealed for many centuries. And you may now observe as you go downtown that the worst is over. Only very sophisticated doctors-of-appearances dare use the cornice any more, and then the dead living dare use it only for monuments to honor the living dead; especially have they done so for a monument to Abraham Lincoln who would have said, with Emerson, "I love and honor Epaminondas—but I do not wish to be Epaminondas. I hold it more just to love the world of this hour, than the world of his hour."

Here the cornice, being by nature and derivation so inappropriate to the "great commoner," gave to the doctor his opportunity for final triumph. The doctor has now succeeded in using it where most awful—too insulting. When we see this, almost any of us—even the "best" of us—may fully realize why cornices had to die, for at least "let us desire not to disgrace the soul!"

Now, for some time to come, democratic governmental departments being what they are, it may be that America will continue to be-cornice her dead heroes, dishonor them by its impotence. But there is ample evidence at hand on every side that the "quick," at least, have shed the cornice. The sacred symbol is worn out—to be soon obliterated by free thought.

It is time man sealed this tradition under a final monument. I suggest as an admirable "project" for the students in architecture at Princeton a design for this monument, and by way of epitaph:

"Here lies the most cherished liar of all the ages—rest, that we may find peace."

For the first six thousand years of the world, from the pagodas of Hindustan to the Cathedral of Cologne, architecture was the great writing of mankind. Whoever then was born a poet became an architect. All the other arts were the workmen of the great work. The "symbol" unceasingly characterized, when it did not dogmatize, it all. Stability was an ideal—hence a great error of progress. What consecration there then was, was devoted to a conservation of previous primitive types.

According to the great modern poet, neglected now, quoted at the outset of this discourse—in the Hindu, Egyptian, and Roman edifices it was always the priest, . . . in the Phoenician, the merchant, . . . in the Greek, the aristocratic republican, . . . in the Gothic, the bourgeois. In the twentieth century—says our prophet—an architect of genius may happen, as the accident of Dante happened in the thirteenth, although architecture will no longer be the social art, the collective art, the dominant art. The great work of humanity it will be no longer.

But to Victor Hugo, when he spoke, architecture was the grand residue of the great buildings that wrote the record of a theocratic, feudalistic humanity, theologic, philosophic, aristocratic. Concerning that architecture his prophecy has come true. He foresaw democracy as a consequence, but did not foresee the consequences of its engine—the machine—except as that engine was symbolized by printing. He seems not to have foreseen that genius and imagination might find in the machine mightier means than ever with which to create anew a more significant background and framework for twentieth century civilization than was ever known before. Nor foreseen an architect who might create anew in genuine liberty—*for* great liberty—on soil enriched by the very carcasses of the ancient architectures. So let us take heart . . . we begin anew.

But instead of ourselves indulging in prophecy against prophecy, let us take hold of the cornice at the source from which it came to us, and take it apart—in order to see what the feature actually was. It may give us something useful in our own hard case. Perhaps we may find in it something valuable to the "modern"—in the sense that we ourselves are to be modern or die disgraced. Of course I visited Athens—held up my hand in the clean Mediterranean air against the sun and saw the skeleton of my hand through its covering of pink flesh—saw the same translucence in the marble pillars of the aged Parthenon, and realized what "color" must have been in such light. I saw the yellow-stained rocks of the barren terrain. I saw the ancient temples, barren, broken, yellow-stained too, standing now magnificent in their crumbling state, more a part of that background than ever they were when born—more stoic now than allowed to be when those whose record they were had built them—more heroic, as is the Venus of Melos, more beautiful without her arms. Like all who stand there, I tried to re-create the scene as it existed when pagan love of color made it come ablaze for the dark-skinned, kinky-haired, black-eyed Greeks to whom color must have been naturally the most becoming thing in life. I restored the arris of the moldings, sharpened and perfected the detail of the cornices, obliterated the desolate grandeur of the scene with color, sound, and movement. And gradually I saw the whole as a great painted, wooden temple. Though now crumbling to original shapes of stone, so far as intelligence went at that time there were no stone forms whatsoever. The forms were only derived from wood! I could not make them stone, hard as I might try. Nor had the Greeks cared for that stone quality in their buildings, for if traces found are to be trusted, and nature too, not only the forms but the marble surfaces themselves were all originally covered with decoration in gold and color. Marble sculpture was no less so covered, than was the architecture.

All sense of materials must have been lost or never have come alive to the Greeks. No such sympathy with environment as I now saw existed for them, nor had any other inspired them. No—not at all. These trabeated stone buildings harked back to what? A little study showed the horizontal lines of wooden beams, laid over vertical wooden posts, all delicately sculptured to refine and make elegant the resemblance. The pediments, especially the cornices, were the wooden projections of the timber roofs of earlier wooden temples, sculptured here in stone. Even the method of that ancient wood construction was preserved in more "modern" material, by way of the large, wooden beam ends that had originally rested on the wooden lintels, and by the smaller wooden beam ends that rested above those; even such details as the wooden pins that had fastened the beam structure together were here as sculptured stone ornament. Here then in all this fibrous trabeation was no organic stone building. Here was only a wooden temple as a "tradition" embalmed—in noble material. Embalmed, it is true, with grace and refinement. But beyond that, and considering it all as something to be taken for itself, in itself, all was false—arbitrarily to preserve for posterity a tradition. Thought, then, in this life of the Greeks, was not so free? The grand sculptured stone cornices of their greatest building had originally been but the timber edges and projections of an overhanging roof that was intended to drop roof-water free of the walls. Elegant refinements of proportion were not lost upon me, but there was small comfort to see recorded in them—for evermore—that liberty had not gone very far in thought in ancient Greece. Here at this remote day, architecture had been merely prostitution of the new as a servile concession to the high priest of the old order. In the hands of the impeccable Greeks here was noble, beautiful stone insulted and forced to do duty as an imitation enslaved to wood. Well, at any rate, the beautiful marble was itself again falling back from the shame of an artificial glory upon its own, once more. Here too, then, in this triumph was tragedy!

Was all this symbolic—a mere symptom of an artificial quality of thought, an imposition of authority that condemned this high civilization of the Greeks to die? Their "elegant solutions" and philosophic abstractions beneath the beautiful surface—were they as sinister? Were they too as false to nature as their architecture was false? Then why had it all to be born, reborn, and again, and yet again—confusing, corrupting, and destroying, more or less, all subsequent chance of true organic human culture? Here it seemed was subtle poison deadly to freedom. Form and idea or form and function had become separated for the Greeks, the real separation fixed upon a helpless, unthinking people, whose tool was

the chattel slave. By what power did such authority exist? In any case what could there be for democracy in this sophisticated abstraction, made by force, whether as intelligence or as power?

And then I thought of the beauty of Greek sculpture and the perfect vase of the Greeks. . . . Keats' "*Ode on a Grecian Urn*" came to mind. How different the sculpture and the vase were from their architecture—and yet the same. But Phidias fortunately had the living human body for his tradition. He was modern and his works eternal. The vase was sculpture too, pure and simple, so it could be perfected by them. It would live and represent them at their best. And their great stone architecture—it, too, was beautiful "sculpture"—but it had for its architectural *tradition* only a wooden temple!

It should die: here today in our new freedom, with the machine as liberator of the human mind, quickener of the artist-conscience—it is for us to bury Greek architecture deep. For us it is pagan poison. We have greater buildings to build upon a more substantial base—an ideal of organic architecture, complying with the ideal of true democracy.

Democracy is an expression of the dignity and worth of the individual; that ideal of democracy is essentially the thought of the man of Galilee, himself a humble architect, the architect in those days called carpenter. When this *unfolding* architecture as distinguished from *enfolding* architecture comes to America there will be truth of feature, to truth of being: individuality realized as a noble attribute of *being. That* is the character the architecture of democracy will take and probably that architecture will be an expression of the highest form of aristocracy the world has conceived, when we analyze it. Now what architecture? Clearly this new conception will realize architecture as no longer the sculptured block of some building material or as any *enfolding* imitation. Architecture must now *un*fold an inner content—express "life" from the "within." Only a development according to nature, intelligently aimed-at purpose, will materialize this ideal, so there is very little to help us in the old sculptural ideals of the architecture Victor Hugo wrote about, so splendidly prophetic. And what little there is, is confined within the carved and colored corners of the world where and when it was allowed to be itself—and is underneath the surface, in far out-of-the-way places, hard to find.

But I imagine the great romantic poet himself would be first to subscribe to this modern ideal of an organic architecture, a *creation* of industry wherein power unlimited lies ready for use by the *modern mind,* instead of the *creature* of chisel and hammer once held ready in the hands of the chattel slave. An architecture no longer composed or arranged or pieced together as symbolic, but living as upstanding expression of reality. This organic architecture, too, would be so intimately a *growth,* all the while, as to make barbarous the continual destruction of the old by the new. American architecture, though both little and young, therefore conceives something deeper and at the same time more vital than the great Parthenon or even the beautiful Greek vase: an architecture no longer symbolic sculpture but a true culture that will *grow* greater buildings and *grow* more beautiful belongings true to the nature of the thing and more at one with the nature of man. Radical, its roots where they belong—in the soil—this architecture would be likely to live where all else has had to die or is dying.

Being integral this art will not know contrasted and separate existence as art, but will be as much "nature" as we are ourselves natural. This should be the expression of any true democracy. Such an ideal is nowise pagan, more nearly of the Crusades maybe—but racial or national no longer except in superficial sense. It is only the method, the proper technique in which to use our resources with new sense of materials, that remains to be realized. This realization may truly be said to be modern: new in the thought of the coming world, in which the new and the old shall be as one.

▉ Now comes the usual feeling that this discourse has all been too free in idealization, not intimate enough realization of a very simple matter. The discourse simply means that make-believe is played out; that it has no longer nor ever had genuine significance as art; that we are in a hard but hopeful case where any pretense fails to satisfy us. Something has happened in this new ideal of freedom we call America that is contagious and goes around the world. I don't even know that it belongs to us as a nation particularly, because we, being the thing itself, seem to realize it least. It is often so. Of that which a man is most, he usually speaks least unless he has to speak, and then he will tell you less than someone

who is not so much the thing himself, but can see it a little apart, in perspective. We see then that in us is a deeper hunger—a hunger for integrity. For some such reason as this we are waking to see ourselves as the provincial dumping-ground for the cast-off regalia of civilization entire. We have been the village aristocracy of the great art world—"putting on" the style we took "by taste" from the pattern-books, or saw at the movies, or admired on postcards sent home by those who have "been abroad"—don't you know? It never occurred to us that we had greater and more coming to us *as our own* than any of the aristocracy of art we aped and imitated ever had. But now we are beginning to see that even Colonial was a "hangover," was a cornice, a nice, neat one, but the machine soon made it nasty-nice. *Ad libitum,* intoxicated by facility of "reproduction," we ran the gamut of all the "styles," the machine right after us to spoil the party. What, I ask you, in all history haven't we as a "free" people made free with in the name of art and architecture? We have acted like hungry orphans turned loose in a bakeshop.

And like the poor orphans, too, we have a bad case of indigestion now that would kill a less young and robust adventurer in that tasty, pasty, sugary realm we have known as art and decoration. The confectionery we have consumed—yes, but not digested, mind you—would have mussed up the sources from which it came beyond hope of any mortal recovery.

We are sick with it and we are sick of it. Some of us for that reason, and some of us because we are growing up. It was all bad for us—the machine made such "good taste" as we had, poisonous. Spanish was the latest acquired taste until "modernistic" got itself here by way of the Paris market with Madame. We will soon be no better satisfied eating that layer-cake than with the other cake-eating. It is all too modish, too thin, too soon empty—too illiberal, too mean. Our dyspeptic American souls hunger for realization, for a substantial "inner experience." Something more than a mere matter of taste, a taste for cake! All we've had has been predilection in this matter of taste, and we've tasted until we're so taste full that it is only a question of "where do we go from here?"

No wonder sensible Henry says "art is the bunk." He is right; all that *he* has known by that name is no more than what he says it is. And pretty much

all that all America knows, too, is likewise. The corruption of our own sources of power and inspiration shames or amuses us when we try to go deeper. But we are going deeper now, just the same. When we get the *meaning* of our shame we are disgusted—likely we turn from it all, but we come back to it again.

We have realized that life without beauty accomplished is no life; we grasp at anything that promises beauty and are somehow punished. We find that like the rose, it has thorns; like the thistle, it has defenses not to be grasped that way. The old canons have lost fire and force. They no longer apply. We are lost in the face of a great adversary whose lineaments we begin to see. Destruction of the old standards we see on every side. This new thing becomes hateful—but fascinates us. As we struggle, we begin to realize that we live on it, and with it, but still we despise and fear it—nevertheless and all the more because it fascinates us.

Well—we begin to glimpse this great adversary as the instrument of a new order. We are willing to believe there is a common sense. . . . A sense common to our time, directed toward specific purpose. We see an aeroplane clean and light-winged—the lines expressing power and purpose; we see the ocean liner, streamlined, clean, and swift—expressing power and purpose. The locomotive, too—power and purpose. Some automobiles begin to look the part. Why are not buildings, too, indicative of their special purpose? The forms of things that are perfectly adapted to their function, we now observe, seem to have a superior beauty of their own. We like to look at them. Then, as it begins to dawn on us that form follows function—why not so in architecture especially? We see that all features in a good building, too, should correspond to some necessity for being—the reason for them, as well as for other shapes, being found in their very purpose. Buildings are made of materials, too. Materials have a life of their own that may enter into the building to give it more life. Here certain principles show countenance. It is the countenance of organic simplicity. Order is coming out of chaos. The word organic now has a new meaning, a spiritual one! Here is hope.

With this principle in mind we see new value in freedom because we see new value in individuality. And there is no individuality without freedom.

The plane is a plane; the steamship is a steamship; the motorcar is a motorcar, and the more they are and *look* just that thing, the more beautiful we find them. Buildings too—why not? Men too? Why not? And now we see democracy itself in this fresh light from within as an ideal that is consistent with all these new expressions of this new power in freedom. We see this adversary to the old order, the machine, as—at last—a sword to cut old bonds and provide escape to freedom; we see it as the servant and savior of the new order—if only it be creatively used by man! Now, how to use it?

Then—what architecture?

4: The Cardboard House

"Inasmuch as the rivalry of intelligences is the life of the beautiful—O poet!—the first rank is ever free. Let us remove everything which may disconcert daring minds and break their wings! Art is a species of valor. To deny that men of genius to come may be the peers of the men of genius of the past would be to deny the ever-working power of God!"

Now what architecture for America?

▥ Any house is a far too complicated, clumsy, fussy, mechanical counterfeit of the human body. Electric wiring for nervous system, plumbing for bowels, heating system and fireplaces for arteries and heart, and windows for eyes, nose, and lungs generally. The structure of the house, too, is a kind of cellular tissue stuck full of bones, complex now, as the confusion of bedlam and all beside. The whole interior is a kind of stomach that attempts to digest objects—objects, "objets d'art" maybe, but objects always. There the affected affliction sits, ever hungry—for ever more objects—or plethoric with over plenty. The whole life of the average house, it seems, is a sort of indigestion. A body in ill repair, suffering indisposition—constant tinkering and doctoring to keep alive. It is a marvel we its infestors do not go insane in it and with it. Perhaps it is a form of insanity we have put into it. Lucky we are able to get something else out of it, though we do seldom get out of it alive ourselves.

But the passing of the cornice with its enormous "baggage" from foreign parts in its train clears the way for American homes that may be modern bi-ography and poems instead of slanderous liars and poetry-crushers.

A house, we like to believe, is *in status quo* a noble consort to man and the trees; therefore the house should have repose and such texture as will quiet the whole and make it graciously at one with external nature.

Human houses should not be like boxes, blazing in the sun, nor should we outrage the machine by trying to make dwelling-places too complementary to machinery. Any building for humane purposes should be an elemental, sympathetic feature of the ground, complementary to its nature-environment, belonging by kinship to the terrain. A house is not going anywhere, if we can help it. We hope it is going to stay right where it is for a long, long time. It is not yet anyway even a moving-van. Certain houses for Los Angeles may yet become vans and roll off most anywhere or everywhere, which is something else again and far from a bad idea for certain classes of our population.

But most new "modernistic" houses manage to look as though cut from cardboard with scissors, the sheets of cardboard folded or bent in rectangles with an occasional curved cardboard surface added to get relief. The cardboard forms thus made are glued together in box-like forms—in a childish attempt to make buildings resemble steamships, flying machines, or locomotives. By way of a new sense of the character and power of this machine age, this house strips and stoops to conquer by emulating, if not imitating, machinery. But so far, I see in most of the cardboard houses of the "modernistic" movement small evidence that their designers have mastered either the machinery or the mechanical processes that build the house. I can find no evidence of integral method in their making. Of late, they are the superficial, badly built product of this superficial, new "surface-and-mass" aesthetic falsely claiming French painting as a parent. And the houses themselves are not the new working of a fundamental architectural principle in any sense.

They are little less reactionary than was the cornice—unfortunately for Americans, looking forward, lest again they fall victim to the mode. There is, however, this much to be said for this house—by means of it imported art and decoration may, for a time, completely triumph over "architecture." And such architecture as it may triumph over—well,

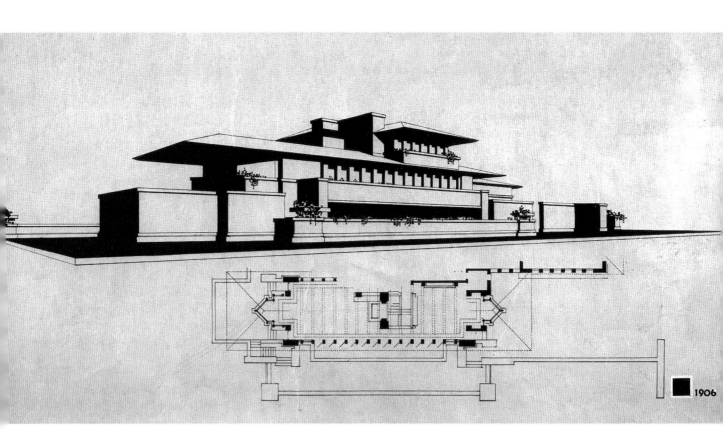

Frederick C. Robie House,
Chicago, Illinois. 1908.
FLLW Fdn# 0908.003

enough has already been said here, to show how infinitely the cardboard house is to be preferred to that form of bad surface-decoration. The simplicity of nature is not something which may easily be read—but is inexhaustible. Unfortunately the simplicity of these houses is too easily read—visibly an attitude, strained or forced. They are therefore decoration too. If we look into their construction we may see how construction itself has been complicated or confused, merely to arrive at exterior simplicity. Most of these houses at home and abroad are more or less badly built complements to the machine age, of whose principles or possibilities they show no understanding, or, if they do show such understanding to the degree of assimilating an aspect thereof, they utterly fail to make its virtues honorably or humanly effective in any final result. Forcing surface-effects upon mass-effects

which try hard to resemble running or steaming or flying or fighting machines, is no radical effort in any direction. It is only more scene-painting and just another picture to prove Victor Hugo's thesis of Renaissance architecture as the setting sun, eventually passing with the cornice.

The machine—we are now agreed, are we not—should build the building, if the building is such that the machine may build it naturally and therefore build it supremely well. But it is not necessary for that reason to build as though the building, too, were a machine, because, except in a very low sense, indeed, it is not a machine, nor at all like one. Nor in that sense of being a machine, could it be architecture at all! It would be difficult to make it even good decoration for any length of time. But I propose, for the purposes of popular negation of the cornice-days that are passed and as their final kick into

oblivion, we might now, for a time, make buildings resemble modern bathtubs and aluminum kitchen utensils, or copy pieces of well-designed machinery to live in, particularly the ocean liner, the aeroplane, the streetcar, and the motorbus. We could trim up the trees, too, shape them into boxes—cheese or cracker—cut them to cubes and triangles or tetrahedron them and so make all kinds alike suitable consorts for such houses. And we are afraid we are eventually going to have as citizens machine-made men, corollary to machines, if we don't look out? They might be face-masked, head-shaved, hypodermically rendered even less emotional than they are, with patent leather put over their hair and aluminum clothes cast on their bodies, and Madame herself altogether stripped and decoratively painted to suit. This delicate harmony, characteristic of machinery, ultimately achieved, however, could not be truly affirmative, except insofar as the negation, attempted to be performed therein, is itself affirmative. It seems to me that while the engaging cardboard houses may be appropriate gestures in connection with "Now What Architecture," they are merely a negation, so not yet truly conservative in the great cause which already runs well beyond them.

Organic simplicity is the only simplicity that can answer for us here in America that pressing, perplexing question, "Now What Architecture?" This I firmly believe. It is vitally necessary to make the countenance of simplicity the affirmation of reality, lest any affectation of simplicity, should it become a mode or fashion, may only leave this heady country refreshed for another foolish orgy in surface decoration of the sort lasting thirty years "by authority and by order," and by means of which democracy has already nearly ruined the look of itself for posterity, for a half-century to come, at least.

Well then and again, "what architecture?"

Let us take for text on this, our fourth afternoon, the greatest of all references to simplicity, the inspired admonition: "Consider the lilies of the field—they toil not; neither do they spin, yet verily I say unto thee—Solomon in all his glory was not arrayed like one of these." An inspired saying attributed to a humble architect in ancient times, called carpenter, who gave up architecture nearly two thousand years ago to go to work upon its source.

And if the text should seem to you too far away from our subject this afternoon—"The Cardboard House"—consider that for that very reason the text has been chosen. The cardboard house needs an antidote. The antidote is far more important than the house. As antidote—and as practical example, too, of the working out of an ideal of organic simplicity that has taken place here on American soil, step by step, under conditions that are your own—could I do better than to take apart for your benefit the buildings I have tried to build, to show you how they were, long ago, dedicated to the ideal of organic simplicity? It seems to me that while another might do better than that, I certainly could not, for that is, truest and best, what I know about the subject. What a man *does, that* he has.

When, "in the cause of architecture," in 1893, I first began to build the houses, sometimes referred to by the thoughtless as the "New School of the Middle West" (some advertiser's slogan comes along to label everything in this our busy woman's country), the only way to simplify the awful building in vogue at the time was to conceive a finer entity—a better building—and get it built. The buildings standing then were all tall and all tight. Chimneys were lean and taller still, sooty fingers threatening the sky. And beside them, sticking up by way of dormers through the cruelly sharp, sawtooth roofs, were the attics for "help" to swelter in. Dormers were elaborate devices, cunning little buildings complete in themselves, stuck to the main roof slopes to let "help" poke heads out of the attic for air.

Invariably the damp, sticky clay of the prairie was dug out for a basement under the whole house, and the rubble-stone walls of this dank basement always stuck up above the ground a foot or more and blinked, with half-windows. So the universal "cellar" showed itself as a bank of some kind of masonry running around the whole house, for the house to sit upon like a chair. The lean, upper house walls of the usual two floors above this stone or brick basement were wood, set on top of this masonry-chair, clapboarded and painted, or else shingled and stained, preferably shingled and mixed, up and down, all together with moldings crosswise. These overdressed wood house walls had, cut in them—or cut out of them, to be precise—big holes for the big cat and little holes for the little cat to get in and out or for ulterior purposes of light and air. The house walls were be-corniced or bracketed up

at the top into the tall, purposely profusely complicated roof, dormers plus. The whole roof, as well as the roof as a whole, was scalloped and ridged and tipped and swanked and gabled to madness before they would allow it to be either shingled or slated. The whole exterior was bedeviled—that is to say, mixed to puzzle-pieces, with corner-boards, panel-boards, window frames, corner-blocks, plinth-blocks, rosettes, fantails, ingenious and jigger work in general. This was the only way they seemed to have, then, of "putting on style." The scrollsaw and turning-lathe were at the moment the honest means of this fashionable mongering by the wood-butcher and to this entirely "moral" end. Unless the house-holder of the period were poor indeed, usually an ingenious corner-tower on his house eventuated into a candlesnuffer dome, a spire, an inverted rutabaga or radish or onion or—what is your favorite vegetable? Always elaborate bay windows and fancy porches played "ring around a rosy" on this "imaginative" corner feature. And all this the building of the period could do equally well in brick or stone. It was an impartial society. All material looked pretty much alike in that day.

Simplicity was as far from all this scrap pile as the pandemonium of the barnyard is far from music. But it was easy for the architect. All he had to do was to call: "Boy, take down No. 37, and put a bay window on it for the lady!"

So—the first thing to do was to get rid of the attic and, therefore, of the dormer and of the useless "heights" below it. And next, get rid of the unwholesome basement, entirely—yes, absolutely—in any house built on the prairie. Instead of lean, brick chimneys, bristling up from steep roofs to hint at "judgment" everywhere, I could see necessity for one only, a broad generous one, or at most, for two, these kept low down on gently sloping roofs or perhaps flat roofs. The big fireplace below, inside, became now a place for a real fire, justified the great size of this chimney outside. A real fireplace at that time was extraordinary. There were then "mantels" instead. A mantel was a marble frame for a few coals, or a piece of wooden furniture with tiles stuck in it and a "grate," the whole set slam up against the wall. The "mantel" was an insult to comfort, but the *integral* fireplace became an important part of the building itself in the houses I was allowed to build out there on the prairie. It refreshed me to see the fire burning deep in the masonry of the house itself.

Taking a human being for my scale, I brought the whole house down in height to fit a normal man; believing in no other scale, I broadened the mass out, all I possibly could, as I brought it down into spaciousness. It has been said that were I three inches taller (I am 5′ 8½″ tall), all my houses would have been quite different in proportion. Perhaps.

House walls were now to be started at the ground on a cement or stone water table that looked like a low platform under the building, which it usually was, but the house walls were stopped at the second-story windowsill level, to let the rooms above come through in a continuous window-series, under the broad eaves of a gently sloping, overhanging roof. This made enclosing screens out of the lower walls as well as light screens out of the second-story walls. Here was true *enclosure of interior space*. A new sense of building, it seems.

The climate, being what it was, a matter of violent extremes of heat and cold, damp and dry, dark and bright, I gave broad protecting roof shelter to the whole, getting back to the original purpose of the "cornice." The undersides of the roof projections were flat and light in color to create a glow of reflected light that made the upper rooms not dark, but delightful. The overhangs had double value, shelter and preservation for the walls of the house as well as diffusion of reflected light for the upper story, through the "light screens" that took the place of the walls and were the windows.

At this time, a house to me was obvious primarily as interior space under fine *shelter*. I liked the sense of shelter in the "look of the building." I achieved it, I believe. I then went after the variegate bands of material in the old walls to eliminate odds and ends in favor of one material and a single surface from grade to eaves, or grade to second-story sill-cope, treated as simple enclosing screens—or else made a plain screen band around the second story above the windowsills, turned up over on to the ceiling beneath the eaves. This screen band was of the same material as the underside of the eaves themselves, or what architects call the "soffit." The planes of the building parallel to the ground were all stressed, to grip the whole to earth. Sometimes it was possible to make the enclosing wall below this upper band of the second-story, from the second story window-

sill clear down to the ground, a heavy "wainscot" of fine masonry material resting on the cement or stone platform laid on the foundation. I liked that wainscot to be of masonry material when my clients felt they could afford it.

As a matter of form, too, I liked to see the projecting base, or water table, set out over the foundation walls themselves as a substantial preparation for the building. This was managed by setting the studs of the walls to the inside of the foundation walls, instead of to the outside. All door and window tops were now brought into line with each other with only comfortable head-clearance for the average human being. Eliminating the sufferers from the "attic" enabled the roofs to lie low. The house began to associate with the ground and become natural to its prairie site. And would the young man in architecture ever believe that this was all "new" then? Not only new, but destructive heresy, or ridiculous eccentricity. So new that what little prospect I had of ever earning a livelihood by making houses was nearly wrecked. At first, "they" called the houses "dress-reform" houses, because society was just then excited about that particular "reform." This simplification looked like some kind of "reform" to them. Oh, they called them all sorts of names that cannot be repeated, but "they" never found a better term for the work unless it was "horizontal Gothic," "temperance architecture" (with a sneer), etc., etc. I don't know how I escaped the accusation of another "renaissance."

What I have just described was all on the *outside* of the house and was there chiefly because of what had happened *inside*. Dwellings of that period were "cut up," advisedly and completely, with the grim determination that should go with any cutting process. The "interiors" consisted of boxes beside or inside other boxes, called *rooms*. All boxes inside a complicated boxing. Each domestic "function" was properly box to box. I could see little sense in this inhibition, this cellular sequestration that implied ancestors familiar with the cells of penal institutions, except for the privacy of bedrooms on the upper floor. They were perhaps all right as "sleeping boxes." So I declared the whole lower floor as one room, cutting off the kitchen as a laboratory, putting servants' sleeping and living quarters next to it, semi-detached, on the ground floor, screening various portions in the big room, for certain domestic purposes like dining

or reading, or receiving a formal caller. There were no plans like these in existence at the time and my clients were pushed toward these ideas as helpful to a solution of the vexed servant-problem. Scores of doors disappeared and no end of partition. They liked it, both clients and servants. The house became more free as "space" and more livable, too. Interior spaciousness began to dawn.

Having got what windows and doors there were left lined up and lowered to convenient human height, the ceilings of the rooms, too, could be brought over onto the walls, by way of the horizontal, broad bands of plaster on the walls above the windows, the plaster colored the same as the room ceilings. This would bring the ceiling-surface down to the very window tops. The ceilings thus expanded, by extending them downward as the wall band above the windows, gave a generous overhead to even small rooms. The sense of the whole was broadened and made plastic, too, by this expedient. The enclosing walls and ceilings were thus made to flow together.

Here entered the important element of plasticity—indispensable to successful use of the machine, the true expression of modernity. The outswinging windows were fought for because the casement window associated the house with out-of-doors—gave free openings, outward. In other words, the so-called "casement" was simple and more human. In use and effect more natural. If it had not existed I should have invented it. It was not used at that time in America, so I lost many clients because I insisted upon it when they wanted the "guillotine" or "double-hung" window then in use. The guillotine was not simple nor human. It was only expedient. I used it once in the Winslow House—my first house—and rejected it thereafter, forever. Nor at that time did I entirely eliminate the wooden trim. I did make it "plastic," that is, light and continuously flowing instead of the heavy "cut and butt" of the usual carpenter work. No longer did the "trim," so-called, look like carpenter work. The machine could do it perfectly well as I laid it out. It was all after quiet.

This plastic trim, too, with its running "backhand," enabled poor workmanship to be concealed. It was necessary with the field resources at hand at that time to conceal much. Machinery versus the union had already demoralized the workmen. The machine resources were so little understood that ex-

tensive drawings had to be made merely to show the "mill-man" what to leave off. But the "trim" finally became only a single, flat, narrow, horizontal wood band running around the room, one at the top of the windows and doors and another next to the floors, both connected with narrow, vertical, thin wood bands that were used to divide the wall surfaces of the whole room smoothly and flatly into folded color planes. The trim merely completed the window and door openings in this same plastic sense. When the interior had thus become wholly plastic, instead of structural, a new element, as I have said, had entered architecture. Strangely enough, an element that had not existed in architectural history before. Not alone in the trim, but in numerous ways too tedious to describe in words, this revolutionary sense of the plastic whole, an instinct with me at first, began to work more and more intelligently and have fascinating, unforeseen consequences. Here was something that began to organize itself. When several houses had been finished and compared with the house of the period, there was very little of that house left standing. Nearly every one had stood the house of the period as long as he could stand it, judging by appreciation of the change. Now all this probably tedious description is intended to indicate directly in bare outline how thus early there *was* an ideal of organic simplicity put to work, with historical consequences, here in your own country. The main motives and indications were (and I enjoyed them all):

First—To reduce the number of necessary parts of the house and the separate rooms to a minimum, and make all come together as enclosed space— so divided that light, air, and vista permeated the whole with a sense of unity.

Second—To associate the building as a whole with its site by extension and emphasis of the planes parallel to the ground, but keeping the floors off the best part of the site, thus leaving that better part for use in connection with the life of the house. Extended level planes were found useful in this connection.

Third—To eliminate the room as a box and the house as another by making all walls enclosing screens—the ceilings and floors and enclosing screens to flow into each other as one large enclosure of space, with minor subdivisions only.

Make all house proportions more liberally hu-

man, with less wasted space in structure, and structure more appropriate to material, and so the whole more livable. *Liberal* is the best word. Extended straight lines or streamlines were useful in this.

Fourth—To get the unwholesome basement up out of the ground, entirely above it, as a low pedestal for the living portion of the home, making the foundation itself visible as a low masonry platform on which the building should stand.

Fifth—To harmonize all necessary openings to "outside" or to "inside" with good human proportions and make them occur naturally—singly or as a series in the scheme of the whole building. Usually they appeared as "light-screens" instead of walls, because all the "architecture" of the house was chiefly the way these openings came in such walls as were grouped about the rooms as enclosing screens. The *room* as such was now the essential architectural expression, and there were to be no holes cut in walls as holes are cut in a box, because this was not in keeping with the ideal of "plastic." Cutting holes was violent.

Sixth—To eliminate combinations of different materials in favor of mono-material so far as possible; to use no ornament that did not come out of the nature of materials to make the whole building clearer and more expressive as a place to live in, and give the conception of the building appropriate revealing emphasis. Geometrical or straight lines were natural to the machinery at work in the building trades then, so the interiors took on this character naturally.

Seventh—To incorporate all heating, lighting, plumbing so that these systems became constituent parts of the building itself. These service features became architectural and in this attempt the ideal of an organic architecture was at work.

Eighth—To incorporate as organic architecture—so far as possible—furnishings, making them all one with the building and designing them in simple terms for machine work. Again straight lines and rectilinear forms.

Ninth—Eliminate the decorator. He was all curves and all efflorescence, if not all "period."

This was all rational enough so far as the thought of an organic architecture went. The particular forms this thought took in the feeling of it all could only be personal. There was nothing whatever at this time to help make them what they were. All

seemed to be the most natural thing in the world and grew up out of the circumstances of the moment. Whatever they may be worth in the long run is all they are worth.

Now *simplicity* being the point in question in this early constructive effort, organic simplicity I soon found to be a matter of true coordination. And beauty I soon felt to be a matter of the sympathy with which such coordination was effected. Plainness was not necessarily simplicity. Crude furniture of the Roycroft-Stickley-Mission Style, which came along later, was offensively plain, plain as a barn door—but never was simple in any true sense. Nor, I found, were merely machine-made things in themselves simple. To think "in simple," is to deal in simples, and that means with an eye single to the altogether. This, I believe, is the secret of simplicity. Perhaps we may truly regard nothing at all as simple in itself. I believe that no one thing in itself is ever so, but must achieve simplicity (as an artist should use the term) as a perfectly realized part of some organic whole. Only as a feature or any part becomes an harmonious element in the harmonious whole does it arrive at the estate of simplicity. Any wild flower is truly simple but double the same wild flower by cultivation, it ceases to be so. The *scheme* of the original is no longer clear. Clarity of design and perfect significance both are first essentials of the spontaneously born simplicity of the lilies of the field who neither toil nor spin, as contrasted with Solomon who had "toiled and spun"—that is to say, no doubt had put on himself and had put on his temple, properly "composed," everything in the category of good things but the cookstove.

Five lines where three are enough is stupidity. Nine pounds where three are sufficient is stupidity. But to eliminate expressive words that intensify or vivify meaning in speaking or writing is not simplicity; nor is similar elimination in architecture simplicity—it, too, may be stupidity. In architecture, expressive changes of surface, emphasis of line, and especially textures of material, may go to make facts eloquent, forms more significant. Elimination, therefore, may be just as meaningless as elaboration, perhaps more often is so. I offer any fool, for an example.

To know what to leave out and what to put in, just where and just how—ah, *that* is to have been educated in knowledge of simplicity.

As for objects of art in the house, even in that early day they were the *bête noir* of the new simplicity. If well chosen, well enough in the house, but only if each was properly digested by the whole. Antique or modern sculpture, paintings, pottery, might become objectives in the architectural scheme and I accepted them, aimed at them, and assimilated them. Such things may take their places as elements in the design of any house. They are then precious things, gracious and good to live with. But it is difficult to do this well. Better, if it may be done, to design all features together. At that time, too, I tried to make my clients see that furniture and furnishings, not built in as integral features of the building, should be designed as attributes of whatever furniture was built in and should be seen as minor parts of the building itself, even if detached or kept aside to be employed on occasion. But when the building itself was finished, the old furniture the clients already possessed went in with them to await the time when the interior might be completed. Very few of the houses were, therefore, anything but painful to me after the clients moved in and, helplessly, dragged the horrors of the old order along after them.

But I soon found it difficult, anyway, to make some of the furniture in the "abstract"; that is, to design it as architecture and make it "human" at the same time—fit for human use. I have been black and blue in some spot, somewhere, almost all my life from too intimate contacts with my own furniture. Human beings must group, sit, or recline—confound them—and they must dine, but dining is much easier to manage and always was a great artistic opportunity. Arrangements for the informality of sitting comfortably, singly or in groups, where it is desirable or natural to sit, and still to belong in disarray to the scheme as a whole—that is a matter difficult to accomplish. But it can be done now, and should be done, because only those attributes of human comfort and convenience, made to belong in this digested or integrated sense to the architecture of the home as a whole, should be there at all, in modern architecture. For that matter about four-fifths of the contents of nearly every home could be given away with good effect to that home. But the things given away might go on to poison some other home. So why not at once destroy undesirable things . . . make an end of them?

Here then, in foregoing outline, is the gist of America's contribution to modern American architecture as it was already under way in 1893. But the gospel of elimination is one never preached enough. No matter how much preached, simplicity is a spiritual ideal seldom organically reached. Nevertheless, by assuming the virtue by imitation—or by increasing structural makeshifts to get superficial simplicity—the effects may cultivate a taste that will demand the reality in course of time, but it may also destroy all hope of the real thing.

Standing here, with the perspective of long persistent effort in the direction of an organic architecture in view, I can again assure you out of this initial experience that repose is the reward of true simplicity and that organic simplicity is sure of repose. Repose is the highest quality in the art of architecture, next to integrity, and a reward for integrity. Simplicity may well be held to the fore as a spiritual ideal, but when actually achieved, as in the "lilies of the field," it is something that comes of itself, something spontaneously born out of the nature of the doing whatever it is that is to be done. Simplicity, too, is a reward for fine feeling and straight thinking in working a principle, well in hand, to a consistent end. Solomon knew nothing about it, for he was only wise. And this, I think, is what Jesus meant by the text we have chosen for this discourse: "Consider the lilies of the field," as contrasted, for beauty, with Solomon.

Now, a chair *is* a machine to sit in.

A home *is* a machine to live in.

The human body *is* a machine to be worked by will.

A tree *is* a machine to bear fruit.

A plant *is* a machine to bear flowers and seeds.

And, as I've admitted before somewhere, a heart *is* a suction pump. Does that idea thrill you?

Trite as it is, it may be as well to think it over because the *least* any of these things may be, *is* just that. All of them are that before they are anything else. And to violate that mechanical requirement in any of them is to finish before anything of higher purpose can happen. To ignore the fact is either sentimentality or the prevalent insanity. Let us acknowledge in this respect, that this matter of mechanics is just as true of the work of art as it is true of anything else. But, were we to stop with that trite acknowledgment, we should only be living in a low, rudimentary sense. This skeleton rudiment accepted, *understood*, is the first condition of any fruit or flower we may hope to get from ourselves. Let us continue to call this flower and fruit of ourselves, even in this machine age, art. Some architects, as we may see, now consciously acknowledge this "machine" rudiment. Some will eventually get to it by circuitous mental labor. Some *are* the thing itself without question and already in need of "treatment." But "Americans" (I prefer to be more specific and say "Usonians") have been educated "blind" to the higher human uses of it all—while actually in sight of this higher human use all the while.

Therefore, now let the declaration that "all is machinery" stand nobly forth for what it is worth. But why not more profoundly declare that "form follows function" and let it go at that? Saying "form follows function" is not only deeper, it is clearer, and it goes further in a more comprehensive way to say the thing to be said, because the implication of this saying includes the heart of the whole matter. It may be that function follows form, as, or if, you prefer, but it is easier thinking with the first proposition just as it is easier to stand on your feet and nod your head than it would be to stand on your head and nod your feet. Let us not forget that the simplicity of the universe is very different from the simplicity of a machine.

New significance in architecture implies new materials qualifying form and textures, requires fresh feeling, which will eventually qualify both as "ornament." But "decoration" must be sent on its way or now be given the meaning that it has lost, if it is to stay. Since "decoration" became acknowledged as such, and ambitiously set up for itself as decoration, it has been a makeshift, in the light of this ideal of organic architecture. Any house decoration, as such, is an architectural makeshift, however well it may be done, unless the decoration, so-called, is part of the architect's design in both concept and execution.

Since architecture in the old sense died and decoration has had to shift for itself more and more, all so-called decoration is become *ornamental,* therefore no longer *integral*. There can be no true simplicity in either architecture or decoration under any such condition. Let decoration, therefore, die for architecture, and the decorator become an architect, but not an "interior architect."

Ornament can never be applied to architecture any more than architecture should ever be applied

to decoration. All ornament, if not developed within the nature of architecture and as organic part of such expression, vitiates the whole fabric no matter how clever or beautiful it may be as something in itself.

Yes—for a century or more decoration has been setting up for itself, and in our prosperous country has come pretty near to doing very well, thank you. I think we may say that it is pretty much all we have now to show as domestic architecture, as domestic architecture still goes with us at the present time. But we may as well face it. The interior decorator thrives with us because we have no architecture. Any decorator is the natural enemy of organic simplicity in architecture. He, persuasive doctor-of-appearances that he *must* be when he becomes architectural substitute, will give you an imitation of anything, even an imitation of imitative simplicity. Just at the moment, he is expert in this imitation. France, the born decorator, is now engaged with Madame, owing to the good fortune of the French market, in selling us this ready-made or made-to-order simplicity. Yes, imitation simplicity is the latest addition to imported stock. The decorators of America are now equipped to furnish *especially* this. Observe. And how very charming the suggestions conveyed by these imitations sometimes are!

Would you have again the general principles of the spiritual ideal of organic simplicity at work in our culture? If so, then let us reiterate: first, simplicity is constitutional order. And it is worthy of note in this connection that 9 × 9 equals 81 is just as simple as 2 + 2 equals 4. Nor is the obvious more simple necessarily than the occult. The obvious is obvious simply because it falls within our special horizon, is therefore easier for us to *see,* that is all. Yet all simplicity near or far has a countenance, a visage, that is characteristic. But this countenance is visible only to those who can grasp the whole and enjoy the significance of the minor part, as such, in relation to the whole when in flower. This is for the critics.

This characteristic visage may be simulated—the real complication glossed over, the internal conflict hidden by surface and belied by mass. The internal complication may be and usually is increased to create the semblance of and get credit for simplicity. This is the simplicity-lie usually achieved by most of the "surface and mass" architects. This is for the young architect.

Truly ordered simplicity in the hands of the great artist may flower into a bewildering profusion, exquisitely exuberant, and render all more clear than ever. Good William Blake says exuberance is *beauty,* meaning that it is so in this very sense. This is for the modern artist with the machine in his hands. False simplicity—simplicity as an affectation, that is, simplicity constructed as a decorator's *outside* put upon a complicated, wasteful engineer's or carpenter's "structure," outside or inside—is not good enough simplicity. It cannot be simple at all. But that is what passes for simplicity, now that startling simplicity-effects are becoming the *fashion*. That kind of simplicity is *violent*. This is for "art and decoration."

Soon we shall want simplicity inviolate. There is one way to get that simplicity. My guess is, there is *only* one way really to get it. And that way is, on principle, by way of *construction* developed as architecture. That is for us, one and all.

5: The Tyranny of the Skyscraper

Michelangelo built the first skyscraper, I suppose, when he hurled the Pantheon on top of the Parthenon. The Pope named it St. Peter's and the world called it a day, celebrating the great act ever since in the sincerest form of human flattery possible. As is well known, that form is imitation.

Buonarroti, being a sculptor himself (he was painter also but, unluckily, painted pictures of sculpture), probably thought architecture, too, ought to be sculpture. So he made the grandest statue he could conceive out of Italian Renaissance architecture. The new church dome that was the consequence was empty of meaning or of any significance whatever except as the Pope's mitre has it. But, in fact, the great dome was just the sort of thing authority had been looking for as a symbol. The world saw it, accepted and adopted it as the great symbol of great authority. And so it has flourished as this symbol ever since, not only in the great capitals of the great countries of the world, but, alas, in every division of *this* country, in every state, in every county, in every municipality thereof.

From general to particular the imitation proceeds, from the dome of the national Capitol itself to the dome of the state capitol. From the state capitol to the dome of the county courthouse, and then

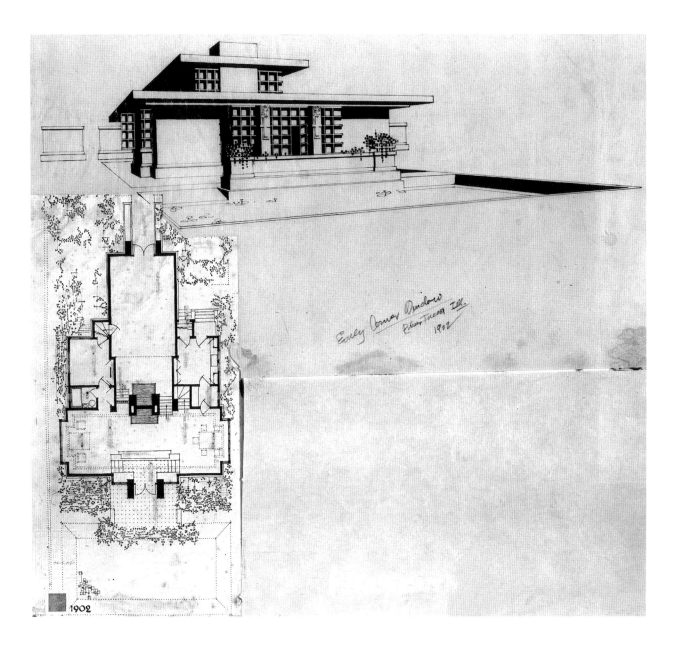

from the county courthouse on down to the dome of the city hall. Everywhere the symbol leaves us, for our authority, in debt to Michelangelo for life. Great success the world calls this and Arthur Brisbane called it great art. Many institutions of learning also adopted the dome. Universities themselves affected it until they preferred Gothic. Big business, I suspect, covets it and would like to take it. But to its honor be it said that it has not yet done so. Yes—this is success. Probably every other sculptor who ever

Richard Bock Home and Studio,
Maywood, Illinois. 1906.
Project.
FLLW Fdn# 0612.002

lived would like to have done or to do the thing that Michelangelo did.

Yet, as consequence of a great sculptor's sense of grandeur in an art that was not quite his own, we may see a tyranny that might well make the tyrannical skyscraper of the present day sway in its socket, sick with envy, although the tyrannical dome is by no means so cruel as the tyrannical skyscraper. But the tyrannical dome *is* more magniloquent waste. How tragic it all is! It is not only as though Buonarroti himself had never seen the Grand Canyon, which of course he never could have seen, but it is as though no one else had ever seen it either, and monumental buildings therefore kept right on being domeous, domicular, or domeistic—on stilts because they knew no better.

Domed or damned was and is the status of official buildings in all countries, especially in ours, as a consequence of the great Italian's impulsive indiscretion. But no other individual sculptor, painter, or architect, let us hope, may ever achieve such success again, or architecture at the end of its resources may pass out in favor of something else.

It would be interesting to me to know what Buonarroti would think of it now. But it is too late. We shall never know except as we imagine it for ourselves.

We should have to ignore the cradle-of-the-race, Persia, even Rome itself, to say that the sculptor did more than appropriate the dome. The earlier Romans had already made fat ones thrusting against the building walls, and the domes of Persia, relatively modest, though seated deep in the building, were tall and very beautiful. Stamboul and Hagia Sophia, of course, make St. Peter's look like the scrap pile of reborn posts, pilasters, and moldings of the Graeco-Roman sort that it is.

But Buonarroti got his dome up higher than all others—got it out of the building itself up onto stilts! Ah! That was better. History relates, however, that a hurry-up call had to be sent in at the last moment for the blacksmith. A grand chain was needed, and needed in a hurry, too, to keep this monumental grandeur, up there where it was, long enough for it to do its deadly work. While they were getting this grand chain fastened around the haunches of the grand dome, in jeopardy on its stilts, our hero, the truly great sculptor, deeply, or rather highly, in trouble with architecture, must have known some

hours of anguish such as only architects can ever know.

I can imagine the relief with which he crawled into bed when all was secure, and slept for thirty-six hours without turning over. This contribution "by the greatest artist who ever lived"—Arthur Brisbane said that is what he is—was our grandest heritage from the rebirth of architecture in Italy, called the Renaissance, and countless billions it has cost us to brag like that.

But all triumph, humanly speaking, is shortlived and we ourselves have found a new way to play hobbyhorse with the Renaissance—a way particularly our own—and now we, in our time, astonish the world similarly. We are not putting a dome up on stilts—no, but we are carrying the stilts themselves on up higher than the dome ever stood and hanging reborn architecture, or architecture-soon-to-be-born, all over the steel, chasing up and down between the steel-stilts in automatic machines at the rate of a mile a minute; until the world gasps, votes our innovation a success, and imitates. Another worldly success, but not this time empty in the name of grandeur. By no means; we are no longer like that. We are doing it for money, mind you, charging off whatever deficit may arise in connection therewith to advertising account. We are now, ourselves, running races up into the sky for advertising purposes, not necessarily advertising authority now but still nobly experimenting with human lives, meantime carrying the herd-instinct to its logical conclusion. Eventually, I fervently hope, carrying the aforesaid instinct to its destruction by giving it all that is coming to it so that it will have to get out into the country where it belongs—and stay there, for the city will be no more, having been "done to death."

Our peculiar invention, the skyscraper, began on our soil when Louis H. Sullivan came through the door that connected my little cubicle with his room in the Auditorium tower, pushed a drawing board with a stretch of manila paper upon it over onto my draughting table.

There it was, in delicately penciled elevation. I stared at it and sensed what had happened. It was the Wainwright Building—and there was the very first human expression of a tall steel office building as architecture. It was tall and consistently so—a unit, where all before had been one cornice building on top of another cornice building. This was a

greater achievement than the papal dome, I believe, because here was utility become beauty by sheer triumph of imaginative vision.

Here out of chaos came one harmonious thing in service of human need where artist-ingenuity had struggled with discord in vain. The vertical walls were vertical screens, the whole emphatically topped by a broad band of ornament fencing the top story, resting above the screens, and thrown into shade by an extension of the roof-slab that said, emphatically, "*finished.*" The extension of the slab had no business to say "finished," or anything else, so emphatically above the city streets, but that was a minor matter soon corrected. The skyscraper as a piece of architecture had arrived.

About the same time John Wellborn Root conceived a tall building that was a unit, the Monadnock. But it was a solid-walled brick building with openings cut out of the walls. The brick, however, was carried across openings on concealed steel angles and the flowing contours, or profile, unnatural to brickwork was got by forcing the material—hundreds of special molds for special bricks being made—to work out the curves and slopes. Both these buildings therefore had their faults. But the Wainwright Building has characterized all skyscrapers since, as St. Peter's characterized all domes, with this difference: there was synthetic architectural stuff in the Wainwright Building, it was in the line of organic architecture—St. Peter's was only grandiose sculpture.

A man in a congested downtown New York street, not long ago, pointed to a vacant city lot where steam shovels were excavating. "I own it," he said, in answer to a question from a man next to him (the man happened to be me), "and I own it clear all the way up," making an upward gesture with his hand. Yes, he did own it, "all the way up," and he might have added, too, "all the way down through to the other side of the world." But then he might have thoughtfully qualified it by, "at least through to the center of the earth." Yes, there stood His Majesty, legal ownership. Not only was he legally free to sell his lucky lot in the landlord lottery to increase this congestion of his neighbors "all the way up," but he was blindly encouraged by the great city itself to do so, in favor of super-concentration. The city, then, gets a thrill out of "going tall"? Architects, advertising as wholesale "manufacturers of space for rent," are advocating tall, taller, and tallest, in behalf of their hardy clients. Inventive genius, too, properly invited, aids and abets them all together, until this glorious patriotic enterprise, space-making for rent, is looked upon as bonafide proof of American progress and greatness. The space-makers-for-rent say skyscrapers solve the problem of congestion, and might honestly add, create congestion, in order to solve it some more some other day, until it will all probably dissolve out into the country, as inevitable reaction. Meantime, these machine-made solutions with an ancient architectural look about them all, like the Buonarroti dome, are foolishly imitated out on the western prairies and in the desolate mountain states. In large or even in smaller and perhaps even in very small towns, you may now see both together.

Our modern steel Goliath has strayed as far away from native moorings as Tokyo, Japan, where it is almost as appropriate to that country as the cornice is appropriate to Abraham Lincoln, in our own.

This apotheosis of the landlord may be seen now as another tyranny—the tyranny of the skyscraper. It is true, so it seems, that "it is only on extremes that the indolent popular mind can rest."

Having established an approximate form for these lectures—a preliminary amble in the direction of the subject, then a reference to authority as text, then the discourse, and a conclusion to lay it finally before you, all in the good old manner of my father's sermons—let us keep the form, choosing as text this time: "Do unto others as ye would that others should do unto you." The attribution is universally known. But not so well known perhaps is the command by Moti, the Chinese sage: "Do yourselves that which you would have others do themselves."

The Tyranny of the Skyscraper

It has only just begun, but we may observe that Father Knickerbocker's village, to choose our most conspicuous instance, is already gone so far out of drawing, beyond human scale, that—become the great metropolis—it is no good place in which to live, to do good work in, or wherein even to go to market. This, notwithstanding the stimulus or excitation of the herd-instinct that curses the whole performance.

Nonetheless—in fact just because of this—the price of ground that happens to be caught in the urban drift as it runs uptown in a narrow streak—no doubt to rush back again—soars just because the lucky areas may be multiplied by as many times as it is possible to sell over and over again the original ground area—thanks to the mechanical device of the skyscraper. The ground area used to be multiplied by ten, it was soon multiplied by fifty, and it may now be multiplied by one hundred or more. Meantime, we patiently pass over wide, relatively empty spaces in the city to get from one such congested area to another such congested area, waiting patiently, I suppose, until the very congestion, which is the source of inflated values, overreaches itself by solution and the very congestion it was built to serve severely interferes with and finally curses its own sacred sales privilege. New York, even at this very early stage of the high and narrow, speaks of the traffic problem, openly confessing such congestion—though guardedly. And as congestion must rapidly increase, metropolitan misery has merely begun. Yes—merely begun—for should every owner of a lot contiguous to or even already within the commercially exploited areas, not to mention those hopefully lying empty in between, actually take advantage of this opportunity to soar, all upward flights of ownership would soon become useless and worthless. This must be obvious to anyone. Moreover the occupants of the tall buildings are yet only about one-third the motorcar men that all will eventually emerge if their devotion to machine-made concentration means anything profitable to them.

So only those congestion-promoters with their space-manufacturers and congestion-solvers who came first, or who will now make haste, with their extended telescopes, uplifted elephant trunks, Bedford-stone rockets, Gothic toothpicks, modern fountain pens, shrieking verticality, selling perpendicularity to the earthworms in the village lane below, can ever be served. Nevertheless property owners lost between the luck, continue to capitalize their undeveloped ground on the same basis as the man lucky enough to have got up first into the air. So fictitious land values are created on paper. Owing to the vogue of the skyscraper, real estate values boom on a false basis, and to hold and handle these unreal values, now aggravated by the ma-

chine-made, standard solution, subways—sub-subways, are proposed, and super sidewalks, or super, super sidewalks, or double-decked or triple-decked streets. Proposals are made to set all the fair forest of buildings up out of reach of the traffic on their own fair stilts as a concession to the crowd. The human life flowing in and out of all this crowded perpendicularity is to accommodate itself to growth as of potato sprouts in a cellar. Yes—these super-most solutions are seriously proposed to hold and handle landlord *profits* in a dull craze for verticality and vertigo that concentrates the citizen in an exaggerated super-concentration that would have shocked Babylon and have made the tower of Babel itself fall down to the ground and worship.

"To have and to hold," that is now the dire problem of the skyscraper minded. Just why it should be unethical or a weakness to allow this terrific concentration to relieve itself by spreading out is quite clear. Anyone can see why. And to show to what lengths the landlord is willing and prepared to go to prevent it: as superior and philanthropic a landlord as Gordon Strong of Chicago recently argued—as the Germans originally suggested—the uselessness of the freedom of sun and air, claiming artificial ventilation and lighting now preferable, demanding that walls be built without windows, rooms be hermetically sealed, distribution and communication be had by artificially lighted and ventilated tunnels, subways, and super-ways. Here, on behalf of the landlord, by way of the time-serving space-maker-for-rent, we arrive at the "City of Night": Man at last and all so soon enslaved by, and his very life at the mercy of, his own appliances.

A logical conclusion, this one of Gordon Strong's, too, with its strong points—if the profits of exciting and encouraging the concentration of citizens are to be kept up to profitable pitch and the citizen be further educated and reconciled to such increased congestion as this would eventually put up to him. This patient citizen—*so much more valuable, it seems, if and when congested!* Must the patient animal be further congested or further trained to congest himself until he has utterly relinquished his birthright? Congested yet some more and taught—he can learn—to take his time (his *own* time especially, mind you), and watch his step more carefully than ever? Is he, the pickle in this brine, to be further reconciled or harder pushed to keep on

insanely crowding himself into vertical grooves in order that he may be stalled in horizontal ones?

Probably—but in the name of common sense and an organic architecture, why should the attempt be made to so reconcile him, by the architects themselves, at least architects are yet something more than hired men, I hope. Else why should they not quit and get an honest living by honest labor in the country, preparing for the eventual urban exodus?

May we rightfully assume architecture to be in the service of humanity?

Do we not know that if architecture is not reared and maintained in such service it will eventually be damned?

The city, too, for another century, may we not still believe, was intended to add to the happiness, security, and beauty of the life of the individual considered as a human being? Both assumptions, however, are denied by the un-American false premium put upon congestion by the skyscraper-minded: un-American, I say, because for many years past rapid mobilizing, flying, motoring, teletransmission, steadily proceeding, have given back to man the sense of space, free space, in the sense that a great, free, new country ought to know it—given it back again to a free people. Steam took it away. Electricity and the machine are giving it back again to man and have not only made super-concentration in a tight, narrow tallness unnecessary, but vicious, as the human motions of the city-habitant became daily more and more compact and violent. All appropriate sense of the space-values the American citizen is entitled to now in environment are gone in the great American city, as freedom is gone in a collision. Why are we as architects, as citizens, and as a nation, so slow to grasp the nature of this thing? Why do we continue to allow a blind instinct driven by greed to make the fashion and kill, for a free people in a new land, so many fine possibilities in spacious city planning? The human benefits of modern automobilization and teletransmission—where are they? Here we may see them all going by default, going by the board, betrayed—to preserve a stupid, selfish tradition of proprietorship. Is it because we are all, more or less, by nature and opportunity, proprietors? Are we proprietors first and free men afterward—if there is any afterward? At any rate, all these lately increased capacities of men for a wide range of lateral movement due to mechanicization

are becoming useless to the citizen, because we happen to be sympathetic to the cupidity of proprietorship and see it not only as commercially profitable but as sensational.

Now, as a matter of course and in common with all Usonian villages that grow up into great cities and then grow on into the great metropolis, Father Knickerbocker's village grew up to its present jammed estate; the great metropolis grew up on the original village gridiron. New York, even without skyscrapers and automobiles, would have been crucified long ago by the gridiron. Barely tolerable for a village, the grid becomes a dangerous crisscross check to all forward movements even in a large town where horses are motive power. But with the automobile and skyscraper that opposes and kills the automobile's contribution to the city, stop-and-go attempts to get across to somewhere or to anywhere, for that matter, in the great metropolis, are inevitable waste—dangerous and maddening to a degree where sacrificial loss, in every sense but one, is for everyone.

Erstwhile village streets become grinding pits of metropolitan misery. Frustration of all life, in the-village-that-became-a-city, is imminent in this, the great unforeseen metropolis; the machine that built it and furnishes it forth also was equally unforeseen. Therefore it may not be due, alone, to this ever-to-be-regretted but inherited animal tendency of his race to herd, that the citizen has landed in all this urban jam. But that animal tendency to herd is all that keeps him jammed now against his larger and more important interests as a thinking being. He is tragically, sometimes comically, jammed. True, properly fenced, he jams himself. Properly fenced he may continue to jam himself for another decade or so, and cheerfully take the consequences. Strangely helpless for long periods of time is this Usonian, human social unit! But let us try to believe that—as Lincoln observed—not all of him for all of the time.

Now what does the human unit, so far in contempt in all this commercial bedlam, receive as recompense for the pains of stricture and demoralizing loss of freedom, for the insulting degradation of his appropriate sense of space? What does he receive beside a foolish pride in the loss of himself to his time, increase in his taxes, and increase in the number of handsome policemen at crossings?

A little study shows that the skyscraper in the rank and file of the "big show" is becoming something more than the rank abuse of a commercial expedient. *I see it as really a mechanical conflict of machine resources. An internal collision!* Even the landlord must soon realize that, as profitable landlordism, the success of verticality is but temporary, both in kind and character, because the citizen of the near future preferring horizontality—the gift of his motorcar, and telephonic or telegraphic inventions—will turn and reject verticality as the body of any American city. The citizen himself will turn upon it in self-defense. He will gradually abandon the city. It is now quite easy and safe for him to do so. Already the better part of him can do better than remain.

The landlord knows to his dismay that to sell the first ten floors of New York City is his new problem. The city fathers, too, now see that, except on certain open spaces, and under changed conditions where beautiful tall buildings might well rise as high as the city liked, the haphazard skyscraper in the rank and file of city streets is doomed—doomed by its own competition. In certain strategic locations in every village, town, or city, tall buildings, and as tall as may be, should be permissible. But even in such locations very tall buildings should be restricted to only such area of the lot on which they stand as can be lighted from the outside and be directly reached from a single interior vertical groove of direct entrance to such space. Normal freedom of movement may thus be obtained below on the lot area that is proprietary to the building itself. Thus all tall building would be restricted to the central portion thus usable of each private lot area, adding the balance of that area, as park space, to the city streets. There would then be no longer interior courts in any building.

All real estate in the rank and file and upon which the tall buildings will cast their shadows, and from which they must partly borrow their light, should in building stay down to the point where the streets will be relieved of motorcar congestion, whether that point be three, five, seven, or nine stories, this to be determined according to the width of the streets on which the buildings stand.

As for the widening of streets, the present sidewalk and curb might be thrown into the street as transportation area, and the future sidewalks raised to headroom above the present street level, becoming in skillful hands well-designed architectural features of the city. And these elevated sidewalks should be connected across, each way, at the street intersections and down, by incline, to the streets below at the same four points of street intersections. This would make all pedestrian movement free of automobilization and, crossing in any direction above the traffic, safe. Motorcars might be temporarily parked just beneath these elevated sidewalks, the sidewalks, perhaps, cantilevered from the buildings.

Parking space in front of all present shop windows would thus be provided and protected overhead by the elevated sidewalks. Show windows would become double-decked by this scheme. Show windows above for the sidewalks and show windows below for the roadbed. This practical expedient, for of course it is no more than an expedient—only expedients are possible—would put a show-window emphasis on the second-story sidewalk level, which might become a mezzanine for entrances to the different shops also.

Entrances could be had to stores from the roadbed by recessions built in the lower store front or by loggias that might be cut back into them. Such restraint and ordered release for tall buildings as here proposed might enhance the aspect of picturesque tallness and not leave further chaotic unfinished masses jamming into the blue. Such well-designed separation of transportation and pedestrians as this might save the wear and tear of citizens doing daily the stations of the cross on their way to work.

Since in the metropolis the gridiron is organic disaster, and to modify it much is impossible, why not, therefore, accept and respect it as definite limitation and ease it by some such practical expedient? Working toward such modifications as suggested would vastly benefit all concerned:

First—By limiting construction.

Second—By taking pedestrians off the roadbed and so widening it.

The upper sidewalks might be made sightly architectural features of the city. While all this means millions expended, it might be done; whereas to abandon the old cities may be done but to build new ones will not be done.

Various other expedients are now practicable, too, if they were to be insisted upon, as they might well be, in the public welfare—such as allowing no

coal to be burned in the city, all being converted into electricity outside at the mines, and cutting down the now absurd automobile sizes of distinctly city carriers. All these things would palliate the evil of the skyscraper situation. But the danger of the city to humanity lies deeper, in the fact that human sensibilities naturally become callous or utterly damned by the constantly increasing futile sacrifices of time and space and patience, when condemned by stricture to their narrow grooves and crucified by their painful mechanical privileges. Condemned by their own senseless excess? Yes, and worse soon.

It seems that it has always been impossible to foresee the great city; not until it has grown up and won an individuality of its own is it aware of its needs. Its greatest asset is this individuality so hard won. The city begins as a village, is sometimes soon a town and then a city. Finally, perhaps, it becomes a metropolis; more often the city remains just another hamlet. But every village could start out with the plans and specifications for a metropolis, I suppose. Some few, Washington D.C. among them, did so and partially arrived after exciting misadventures.

But the necessity for the city wanes because of the larger human interest. That larger human interest? Is it not always on the side of *being,* considering the individual as related, even in his work—why not especially in his work?—to health and to the freedom in spacing, mobile in a free new country; living in and related to sun and air; living in and related to growing greenery about him as he moves and has his little being here in his brief sojourn on an earth that should be inexpressibly beautiful to him!

What is he here for anyway? *Life* is the one thing of value to him, is it not? But the machine-made in a machine age, here in the greatest of machines, a great city, conspires to take that freedom away from him before he can fairly start to civilize himself. We know why it does. And let us at this moment try to be honest with ourselves on another point, this "thrill"—the vaunted *beauty* of the skyscraper as an individual performance. At first, as we have seen, the skyscraper was a pile of cornice-buildings in reborn style, one cornice-building riding the top of another cornice-building. Then a great architect saw it as a unit, and as beautiful architecture. Pretty soon, certain other architects, so educated—probably by the Beaux-Arts—as to see that way, *saw it*

as a column, with base, shaft, and capital. Then other architects with other tastes seemed to see it as Gothic—commercial competitor to the cathedral. Now the wholesale manufacturers of space-for-rent are seeing it as a commercial tower-building with plain masonry surfaces and restrained ornament upon which New York's setback laws have forced a certain picturesque outline, an outline pretty much all alike. A picturesqueness at first welcome as a superficial relief, but already visible as the same monotony-in-variety that has been the fate of all such attempts to beautify our country. Standardization defeats these attempts—the machine triumphs over them all, because they are all false. Principle is not at work in them.

The skyscraper of today is only the prostitute semblance of the architecture it professes to be. The heavy brick and stone that falsely represents walls is, by the very setback laws, unnaturally forced onto the interior steel stilts to be carried down by them through twenty, fifty, or more stories to the ground. The picture is improved, but the picturesque element in it all is false work built over a hollow box. These new tops are shams, too—box-balloons. The usual service of the doctor-of-appearances has here again been rendered to modern society.

New York, so far as material wealth goes, piled high and piling higher into the air, is a commercial machine falsely qualified by a thin disguise. The disguise is a collection of brick and masonry façades, glaring signs, and staring dead walls, peak beside peak, rising from canyon cutting across canyon. Everything in the narrowing lanes below is "on the hard," groaning, rattling, shrieking! In reality the great machine-made machine is a forest of riveted steel posts, riveted girder-beams, riveted brackets, and concrete slabs, steel reinforced, closed in by heavy brick and stone walls, all carried by the steel framing itself, finally topped by water tanks, setbacks, and spires, dead walls decorated by exaggerated advertising or chastely painted in panels with colored brickwork.

What beauty the whole has is haphazard, notwithstanding the book-architecture which space-makers-for-rent have ingeniously tied onto the splendid steel sinews that strain from story to story beneath all this weight of make-believe. But the lintels, architraves, pilasters, and cornices of the pseudoclassicist are now giving way to the bet-

ter plainness of surface-and-mass effects. This is making, now, the picturesque external New York, while the steel, behind it all, still nobly stands up to its more serious responsibilities. Some of the more recent skyscraper decoration may be said to be very handsomely suggestive of an architecture to come. But how far away, yet, are appearances from reality!

The true nature of this thing is prostitute to the shallow picturesque, in attempt to render a wholly insignificant, therefore inconsequential, beauty. In any depth of human experience it is an ignoble sacrifice. No factitious sham like this should be accepted as "culture."

As seen in "The Passing of the Cornice," we are the modern Romans.

Reflect that the ancient Romans at the height of their prosperity lied likewise to themselves no less shamefully, when they pasted Greek architecture onto their magnificent engineering invention of the masonry arch to cover it decently. The Romans, too, were trying to make the kind of picture or the grand gesture demanded by culture. The Roman arch was, in that age, comparable to the greatest of all scientific or engineering inventions in our own machine age, comparable especially to our invention of steel. So likewise, what integrity any solution of the skyscraper problem might have in itself as good steel and glass construction has been stupidly thrown away. The native forests of steel, concrete, and glass, the new materials of our time, have great possibilities. But in the hands of the modern doctor-of-appearances they have been made to *seem* rather than allowed to *be*. Sophisticated polishing by the accredited doctor only puts a glare upon its shame. It cannot be possible that sham like this is really our own civilized choice?

But owing to the neglect of any noble standard such as that of an organic architecture, it is all going by default. All—sold.

Were it only strictly business there would be hope. But even that is not the case except as competitive advertising in any form is good business. Business ethics make a good platform for true aesthetics in this machine age or in any other.

No—what makes this pretentious ignorance so tragic is that there is a conscious yearn, a generosity, a prodigality in the name of taste and refinement in nearly all of it. Were only mummery dropped, tem-

porary expedient though it may be in itself, space-manufacturing-for-rent, so far as that goes in the skyscraper, might become genuine architecture and be beautiful as standardization in steel, metals, and glass.

We now have reasonably safe mechanical means to build buildings as tall as we want to see them, and there are many places and uses for them in any village, town, or city, but especially in the country. Were we to learn to limit such buildings to their proper places and give them the integrity as standardized steel and glass and copper they deserve, we would be justly entitled to a spiritual pride in them; our submission to them would not then be servile in any sense. We might take genuine pride in them with civic integrity. The skyscraper might find infinite expression in variety—as beauty.

But today the great city as an edifice mocks any such integrity. Artists idealize the edifice in graphic dreams of gigantic tombs into which all life has fled—or must flee—or in which humanity remains to perish. Uninhabitable monstrosities? An insanity we are invited to admire?

From any humane standpoint the super-concentration of the skyscraper is super-imposition not worth its human price.

It is impossible not to believe that, of necessity, horizontality and the freedom of new beauty will eventually take the place of opportune verticality and senseless stricture. And if these desiderata cannot be realized *in* the city, if they have no place there, they will take *the place of the city*. Breadth is now possible and preferable to verticality and vertigo, from any sensible human standpoint. Transportation and electrical transmission have made breadth of space more a human asset than ever, else what does our great machine-power mean to human beings? In all the history of human life upon earth, breadth, the consciousness of freedom, the sense of space appropriate to freedom, is more desirable than height to live with in the use and beauty that it yields mankind.

Why then, has commerce, the soul of this great, crude, and youthful nation, any pressing need further to capitalize and exploit the rudimentary animal instincts of the race it thrives on, or need to masquerade in the path picturesque, like the proverbial wolf in sheep's clothing, in New York City or anywhere else?

As for beauty—standardization and its cruel but honest tool, the machine, given understanding and accomplished technique, might make our own civilization beautiful in a new and noble sense. These inept, impotent, mechanistic elements, so cruel in themselves, have untold possibilities of beauty. In spite of prevalent and profitable abuses, standardization and the machine are here to serve humanity. However much they may be out of drawing, human imagination may use them as a means to more life, and greater life, for the commonwealth. So why should the architect as artist shirk or ignore humane possibilities to become anybody's hired man—for profit? Or if he is on his own why should he be willing to pay tribute to false gods merely to please the unsure taste of a transitory period, or even his own "superior" taste?

▦ Today all skyscrapers have been whittled to a point, and a smoking chimney is usually the point. They whistle, they steam, they moor dirigibles, they wave flags, or they merely aspire, and nevertheless very much resemble each other at all points. They compete—they pictorialize—and are all the same.

But they do not materialize as architecture. Empty of all other significance, seen from a distance something like paralysis seems to stultify them. They are monotonous. They no longer startle or amuse. Verticality is already stale; vertigo has given way to nausea; perpendicularity is changed by corrugation of various sorts, some wholly crosswise, some crosswise at the sides with perpendicularity at the center, yet all remaining envelopes. The types of envelope wearily reiterate the artificial set-back, or are forced back for effect, with only now and then a flight that has no meaning, like the Chrysler Building.

The light that shone in the Wainwright Building as a promise, flickered feebly and is fading away. Skyscraper architecture is a mere matter of a clumsy imitation masonry envelope for a steel skeleton. They have no life of their own—no life to give, receiving none from the nature of construction. No, none. And they have no relation to their surroundings. Utterly barbaric, they rise regardless of special consideration for environment or for each other, except to win the race or get the tenant. Space as a becoming psychic element of the American city is gone. Instead of this fine sense is come the tall and narrow stricture. The skyscraper envelope is not ethical, beautiful, or permanent. It is a commercial exploit or a mere expedient. It has no higher ideal of unity than commercial success.

6: The City

Is the city a natural triumph of the herd instinct over humanity, and therefore a temporal necessity as a hangover from the infancy of the race, to be outgrown as humanity grows?

Or is the city only a persistent form of social disease eventuating in the fate all cities have met?

Civilization always seemed to need the city. The city expressed, contained, and tried to conserve what the flower of the civilization that built it most cherished, although it was always infested with the worst elements of society as a wharf is infested with rats. So the city may be said to have served civilization. But the civilizations that built the city invariably died with it. Did the civilizations themselves die *of it?*

Acceleration invariably preceded such decay.

Acceleration in some form usually occurs just before decline and while this acceleration may not be the cause of death it is a dangerous symptom. A temperature of 104 in the veins and arteries of any human being would be regarded as acceleration dangerous to life.

In the streets and avenues of the city acceleration due to the skyscraper is similarly dangerous to any life the city may have left, even though we yet fail to see the danger.

I believe the city, as we know it today, is to die.

We are witnessing the acceleration that precedes dissolution.

Our modern civilization, however, may not only survive the city but may profit by it; probably the death of the city is to be the greatest service the machine will ultimately render the human being if, by means of it, man conquers. If the machine conquers, it is conceivable that man will again remain to perish with his city, because the city, like all minions of the machine, has grown up in man's image, minus only the living impetus that is man. The city is itself only man-the-machine—the deadly shadow of sentient man.

But now comes a shallow philosophy accepting machinery, in itself, as prophetic. Philosophers draw plans, picture, and prophesy a future city,

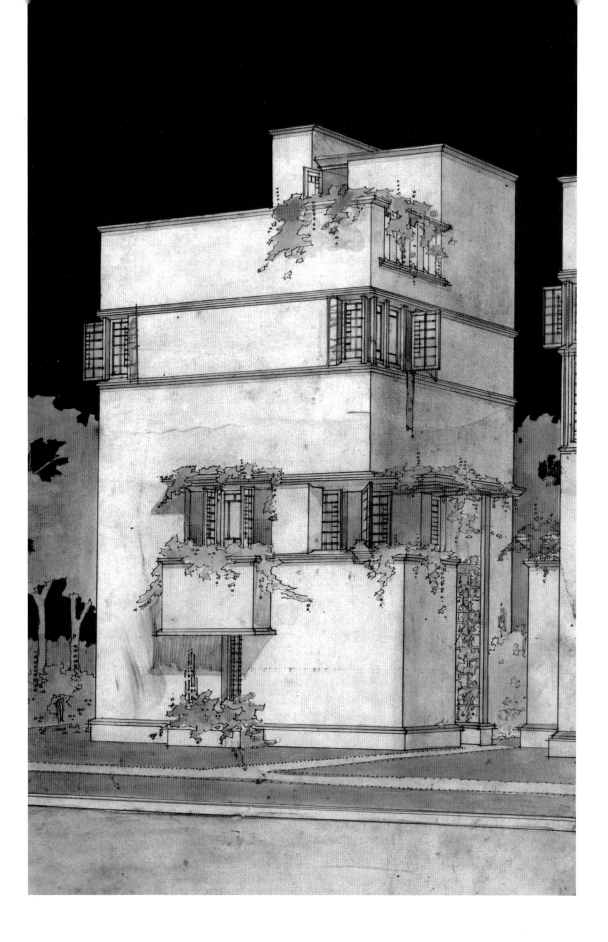

more desirable, they say, than the pig-pile now in travail, their pictures reducing everything to a mean height—geometrically spaced.

In order to preserve air and passage, this future city relegates the human individual as a unit or factor to pigeonhole 337611, block F, avenue A, street No. 127. And there is nothing at which to wink an eye that could distinguish No. 337611 from No. 337610 or 27643, bureau D, intersection 118 and 119.

Thus is the sentient individual factor—the citizen—appropriately disposed of in the cavernous recesses of a mechanistic system appropriate to man's ultimate extinction.

This future city may be valuable and utilitarian along a line of march toward the ultimate triumph of the machine over man and may be accomplished before the turn finally comes.

To me it is dire prophecy. Skull and crossbones symbolize a similar fate. Let us prefer to prophesy, finally, the triumph of man over the machine.

▦ For final text, then, for our final discourse:

> Except as you, sons-of-earth, honor your birthright, and cherish it well by human endeavor, you shall be cut down, and perish in darkness, or go up in high towers—a sacrifice to the most high God. Look you well, therefore, to yourselves in your posterity. Keep all close to earth, your feet upon the earth, your hands employed in the fruitfulness thereof be your vision never so far, and on high.
>
> —*Attributed to some unheeded Babylonian prophet.*

What built the cities that, invariably, have died? Necessity.

With that necessity gone, only dogged tradition that is another name for *habit* can keep the city alive, tradition that has the vitality of inertia and the power of the ball and chain.

Necessity built the city when we had no swift, universal means of transportation and had no means of communication except by various direct personal contacts. Then the city became naturally the great meeting place, the grand concourse, the immediate source of wealth and power in human intercourse. Only by congregating thus, the vaster the congregation the better, could the better fruits of human living then be had.

In that day the real life of the city lay in the stress of individual ties and the variety of contacts. The electric spark of curiosity and surprise was alive in the street, in public buildings, in the home.

Government the city had—fashions and fads. But the salt and savor of individual wit, taste, and character made the city a festival of life: a carnival as compared with any city today.

And architecture then reflected this livelier human condition as it now reflects the machine. Nor had the common denominator then arrived in the reckoning.

The common denominator has arrived with the machine in Usonia. Machine prophecy such as we have just referred to shows, if nothing else, that we are to deal with machinery considered as common-denominator salvation and in its most dangerous form here among us and deal with it soon, before it has finally to deal with our posterity as dominator. To deny virtue to the common denominator or to deny virtue to its eventual emancipator the machine would be absurd. But the eventual city the common denominator will build with its machines will not only be greatly different from the olden city or the city of today; it will be vastly different from the new machine-city of machine-prophecy as we see it outlined by Le Corbusier and his school.

What once made the city the great and powerful human interest that it was is now preparing the reaction that will drive the city somewhere, into something else. The human element in the civic equation may already be seen drifting or pushed—going in several different directions.

Congestion was no unmixed human evil until electricity, electrical intercommunication, motorcars, the telephone, and publicity came; add to these the airship when it lays away its wings and becomes a self-contained mechanical unit.

Accepting all these, everything changes.

Urban House.
1915.
Project.
FLLW Fdn# 1506.006

Organic consequences of these changes, unperceived at first, now appear. Freedom of human reach and movement, therefore the human *horizon* as a sphere of *action* is, in a single decade, immeasurably widened by new service rendered by the machine. Horizontality has received an impetus that widens human activities immeasurably.

Therefore such need for concentration as originally built the city is really nearing an end. But these new facilities of movement gifts to us of the machine, have, for a time, only intensified the old activity.

We are really witnessing an inevitable collision between mechanistic factors. The struggle is on. Additional human pressure, thus caused, thoughtlessly finds release by piling high into the air. The thoughtless human tendency in any emergency is to stand still, or to run away. We do—stay right there and pile up, or run away from the collision, to live to fight again some other day. To meet this human trait of staying right where we are, the skyscraper was born and, as we have seen, has become a tyranny. But the skyscraper will serve, equally well, those who are to run away, because probably the tall building has its real future in the country. But the skyscraper is now the landlord's ruse to hold the profits not only of concentration but of super-concentration: in the skyscraper itself we see the commercial expedient that enables the landlord to exploit the city to the limit, and exploit it by ordinance.

So greater freedom to spread out without inconvenience, the most valuable gift brought by these new servants, electrical intercommunication, the automobile, telephone, airship, and radio, has been perverted for the moment into the skyscraper, and the gifts of the machine diverted to profit lucky realty.

Let us admit popular thrill in the acceleration, the excitement, directly due to these *new* mechanistic facilities. Temperatures run high. No one seems to know whether the excess is healthy excitement of growth or the fever of disease; whether it means progress or is only some new form of exploitation.

Forces are themselves blind. In all history we may see that the human beings involved with elemental forces remain blind also for long periods of time. But—saving clause—along with the forces released by our new mechanistic servants, there comes in our day an *ubiquitous publicity,* a valuable publicity that often succeeds in getting done in a month what formerly may have drifted a decade. We have already cut elapsed time in all forms of human intercommunication a hundred to one. To be conservative, what took a century in human affairs now takes ten years.

Fifteen years, an epoch.

Thirty years, an age.

So the reactions to any human activity, idea, or movement may control this great agency, and even in one lifetime show the people the wisdom or folly of the nature of any particular activity and call for correction before the affair is too far gone. Thus the fate of earlier civilization may be avoided by the dissemination of knowledge in ours. Educational influences thus brought to bear may avert disaster.

The traffic problem, as we have already seen in "The Tyranny of the Skyscraper," forces attention to tyrannical verticality. The traffic problem is new but increasingly difficult—if not impossible—of solution.

Other problems will call soon and call louder.

As we have seen, the gridiron, originally laid out for the village now grown to the metropolis, already is cause for sufficient economic waste and human pain to wreck the structure of the city. High blood pressure, in the congested veins and arteries that were once the peaceful village gridiron, is becoming intolerable.

The pretended means of relief provided by space-makers-for-rent—the skyscraper itself—is now rendering distress more acute. The same means of relief carried somewhat further, and long before the solution reaches its logical conclusion, will have killed the patient—the overgrown city. Witness the splitting up of Los Angeles and Chicago into several centers, again to be split into many more.

And yet in new machine-prophecy, the tyranny of the skyscraper now finds a philosophy to fortify itself as an *ideal!*

We see, by the prophetic pictures of the city of the future, how the humanity involved therein is to be dealt with in order to render the human benefits of electricity, the automobile, the telephone, the airship, and radio into herd-exploitation instead of into individual human lives.

And alongside these specific skyscraper solutions-by-picture of downtown difficulties there usually goes the problem of the tenement, the

none-too-pretty picture of wholesale housing of the poor. The poor, it seems, are still to be with us and multiplied, in this grand new era of the machine. At any rate they are to be accepted, confirmed, and especially provided for therein as we may see in the plans. Catastrophe is to be made organic—built in.

That the poor will benefit by increased sanitation may be seen and granted at first glance. But not only are the living quarters of the poor to be made germ-proof, but life itself, wherever individual choice is concerned, is to be made just as antiseptic, if we trust our own eyes.

The poor man is to become just as is the rich man—No. 367222, block 19, shelf 17, entrance K.

But the surface-and-mass architecture that now proposes to extinguish the poor man as human, has already proposed to do the same for his landlord. Therefore why should the poor man complain? Has he not, still, his labor for his pains?

There he is, the poor man! No longer in a rubbish heap. No. He is a mechanized unit in a mechanical system, but, so far as he goes, he still is but two by twice. He has been cleaned up but toned down.

Nor can the poor in the modernistic picture choose anything aesthetically alive to live with, at least so far as neighbors or landlord can see it. Dirty rags have been covered with a clean cardboard smock.

The poor man is exhibit C—cog 309,761,128 in the machine, in this new model for the greater machine the city is to become.

Observe the simplified aspect!

This indeed, is the *ne plus ultra* of the *e pluribus unum* of machinery. This new scheme for the city is delightfully impartial, extinguishes everyone, distinguishes nothing except by way of the upper stories, unless it be certain routine economies sacred to a businessman's civilization, certain routine economies to be shared by the innovators with the ubiquitous numericals who are the "common denominator," shared with them by the nominators of the system as seen perfected in the picture. Shared fifty-fifty? Half to the initial nominator, half to the numericals? Fair enough—or—who can say?

The indistinguishable division of the benefits must in any case be left to the generosity of the initial nominators themselves, whoever they are. And who may say who they are?

But Humanity here is orderly. Human beings are again rank and file in the great war—this time in-dustrial—a peaceful war. The rank and file of the common denominator this time is gratuitously officered by architecture, standardized like any army, marched not only to-and-fro but up and down. Up and down—even more—much more and more to come. The common denominator on these up-and-down terms would be no more alive without the initial nominator than the machine will be without the human brain. The common denominator itself has become the machine, come into its very own at last before the war is fairly begun.

"The Noble Duke of York, he had ten thousand men"—he made them all go ten floors up and ten floors up again. And none may know just why they now go narrowly up, up, up, to come narrowly down, down, down—instead of freely going in and out and comfortably around about among the beautiful things to which their lives are related on this earth. Is this not to reduce everyone but the mechanistic devisors and those who may secure the privileges of the top stories, to the ranks of the poor?

Well, the poor?

Why are they the poor? Is there mechanical cure, then, for shiftlessness—machine-made? Or are the thriftless those whom the machine age is to herd beneficially in the mass and cover becomingly with a semblance of decency in a machine-made utopia? Or are the poor now to be the thrifty, themselves thus turned poor in all senses but one?

The lame, halt, blind, and the sick are the only poor. As for the other poor—the discouraged, the unhappy—fresh air, free space, green grass growing all around, fruits, flowers, vegetables in return for the little work on the ground they require, would do more to abolish their poverty than any benefice mechanistic devisors can ever confer.

At present the urban whirl *is* common-denominator recreation; the urban crowd *is* common-denominator consolation; the dark corners of movie halls *are* the common-denominator retreats for recreation when those retreats are not far worse.

And the herd instinct that moves in the crowd and curses it is only the more developed by the mechanistic conditions in which the crowd swarms and lives. Millions are already sunk so low as to know no other preferment, to desire none. The common denominator—so profitable when congested—being further educated to congest, *taught*

to be lost when not excited by the pressure and warmth of the crowd, turns Argus-eyed toward what—more whirl?

Yet many of the individuals composing the crowd, the best among them, know well that an ounce of independence and freedom in spacing under natural circumstances, is worth a ton of machine patronage, however disguised or distributed as sanitation or as "art."

A free America, democratic in the sense that our forefathers intended it to be, means just this *individual* freedom for all, rich or poor, or else this system of government we call democracy is only an expedient to enslave man to the machine and make him like it.

But democracy will, by means of the machine, demonstrate that the city is no place for the poor, because even the poor are human.

The machine, once our formidable adversary, is ready and competent to undertake the drudgeries of living on this earth. The margin of leisure even now widens as the machine succeeds. This margin of leisure should be spent with the fields, in the gardens, and in travel. The margin should be expanded and devoted to making beautiful the environment in which human beings are born to live, into which one brings the children who will be the Usonia of tomorrow.

And the machine, I believe—absurd as it may seem now, absurd even to those who are to be the first to leave—will enable all that was human in the city to go to the country and grow up with it: enable human life to be based squarely and fairly on the ground. The sense of freedom in space is an abiding human desire, because the horizontal line is the line of domesticity, the earthline of human life. The city has taken this freedom away.

A market, a countinghouse, and a factory is what the city has already become; the personal element in it all, the individual, withdrawing more and more as time goes on.

Only when the city becomes purely and simply utilitarian, will it have the order that is beauty, and the simplicity which the machine, in competent hands, may very well render as human benefit. That event may well be left to the machine.

This, *the only possible ideal machine* seen as a *city,* will be invaded at ten o'clock, abandoned at four, for three days of the week. The other four days of the week will be devoted to the more or less joyful matter of living elsewhere under conditions natural to man. The dividing lines between town and country are even now gradually disappearing as conditions are reversing themselves. The country absorbs the life of the city as the city shrinks to the utilitarian purpose that now alone justifies its existence. Even that concentration for utilitarian purposes we have just admitted may be first to go, as the result of impending decentralization of industry. It will soon become unnecessary to concentrate in masses for any purpose whatsoever. The individual unit, in more sympathetic grouping on the ground, will grow stronger in the hard-earned freedom gained at first by that element of the city not prostitute to the machine. Henry Ford stated this idea in his plan for the development of Muscle Shoals.

Even the small town is too large. It will gradually merge into the general non-urban development. Ruralism as distinguished from urbanism is American, and truly democratic.

The country already affords great road systems—splendid highways. They, too, leading toward the city at first, will eventually hasten reaction away from it. Natural parks in our country are becoming everywhere available. And millions of individual building sites, large and small, good for little else, are everywhere neglected. Why, where there is so much idle land, should it be parceled out by realtors to families, in strips 25′, 50′, or even 100′ wide? This imposition is a survival of feudal thinking, of the social economies practiced by and upon the serf. An acre to the family should be the democratic minimum if this machine of ours *is a success!*

What stands in the way?

It is only necessary to compact the standardized efficiency of the machine, confine the concentration of its operation to where it belongs and distribute the benefits at large. The benefits are human benefits or they are bitter fruit. Much bitter fruit already hangs on the city-tree beside the good, to rot the whole.

An important feature of the coming disintegration of the Usonian city may be seen in any and every service station along the highway. The service station is future city service in embryo. Each station that happens to be naturally located will as naturally grow into a neighborhood distribu-

tion center, meeting-place, restaurant, restroom, or whatever else is needed. A thousand centers as city equivalents to every town or city center we now have, will be the result of this advance agent of decentralization.

To many such traffic stations, destined to become neighborhood centers, will be added, perhaps, features for special entertainment not yet available by a man's own fireside. But soon there will be little not reaching him at his own fireside by broadcasting, television, and publication. In cultural means, the machine is improving rapidly and constantly.

Perfect distribution like ubiquitous publicity is a common capacity of the machine. This single capacity, when it really begins to operate, will revolutionize our present arrangement for concentration in cities. Stores, linked to decentralized chain service stations, will give more perfect machinery of distribution than could ever be had by centralization in cities.

Complete mobilization of the people is another result fast approaching. Therefore the opportunity will come soon for the individual to pick up by the wayside anything in the way of food and supplies he may require, as well as to find a satisfactory temporary lodging.

The great highways are in process of becoming the decentralized metropolis. Wayside interests of all kinds will be commonplace. The luxurious motorbus, traveling over magnificent road systems, will make intercommunication universal and interesting. The railway is already only for the "long haul" in many parts of the country.

A day's journey anywhere will soon be something to be enjoyed in itself, enlivened, serviced, and perfectly accommodated anywhere en route. No need to tangle up in spasmodic stop-and-go traffic in a trip to town or to any city at all.

Cities are great mouths. New York the greatest mouth in the world. With generally perfect distribution of food and supplies over the entire area of the countryside, one of the vital elements helping to build the city has left it forever, to spread out on the soil from which it came: local products finding a short haul direct, where an expensive long haul and then back again was once necessary.

Within easy distance of any man's dwelling will be everything needed in the category of foodstuffs or supplies which the city itself can now supply. The

"movies," through television, will soon be seen and heard better at home than in any hall. Symphony concerts, operas, and lectures will eventually be taken more easily to the home than the people there can be taken to the great halls in old style, and be heard more satisfactorily in congenial company. The home of the individual social unit will contain in itself in this respect all the city heretofore could afford, plus intimate comfort and free individual choice.

Schools will be made delightful, beautiful places, much smaller, and more specialized. Of various types, they will be enlivening, charming features along the byways of every *countryside*. Our popular games will be features in the school parks, which will be really sylvan parks available far and near to everyone.

To gratify what is natural and desirable in the get-together instinct of the community natural places of great beauty—in our mountains, seasides, prairies, and forests—will be developed as automobile objectives, and at such recreation grounds would center the planetarium, the racetrack, the great concert hall, the various units of the national theater, museums, and art galleries. Similar common interests of the many will be centered there naturally, ten such places to one we have now.

There will be no privately-owned theaters, although there will be places for them along the highways. But good plays and other entertainments might be seen at these automobile objectives from end to end of the country in various national circuits—wherever a play showed itself popular or desired.

Such objectives would naturally compete with each other in interest and beauty, stimulate travel, and make mobilization a pleasure, not a nuisance—affording somewhere worthwhile to go. The entire countryside would then be a well-developed park—buildings standing in it, tall or wide, with beauty and privacy for everyone.

There will soon remain the necessity for only shorter and shorter periods of concentration in the offices directly concerned with invention, standardization, and production. The *city of the near future* will be a depot for the factory—perhaps. Whatever it is, it will be only a degraded mechanistic servant of the machine, because man himself will have escaped to find all the city ever offered him, plus the

privacy the city never had and is trying to teach him that he does not want. Man will find the *manlike freedom* for himself and his that democracy must mean.

Very well—how to mitigate, meantime, the horror of human life caught helpless or unaware in the machinery that is the city? How easiest and soonest to assist the social unit in escaping the gradual paralysis of individual independence that is characteristic of the machine-made moron, a paralysis of the emotional nature necessary to the triumph of the machine over man, instead of the quickening of his humanity necessary to man's triumph over the machine?

That is the architect's immediate problem, as I see it.

Measured over great free areas, the living interest should be educated to lie in the contact of free individualities in the freedom of sun, light, and air, breadth of spacing—*with* the ground. Again we need the stress of encountering varieties on a scale and in circumstances worthy the ideal of democracy and more a part of external nature than ever before seen—more so because of internal harmony. We want the electric spark of popular curiosity and surprise to come to life again, along the highways and byways and over every acre of the land. In charming homes and schools and significant public gathering places . . . architectural beauty related to natural beauty. Art should be natural and be itself the joy of creating perfect harmony between ourselves and the birthright we have all but sold.

We may now dream of the time when there will be less government, yet more ordered freedom. More generous human spacing, we may be sure, will see to that.

When the salt and savor of individual wit, taste, and character in modern life will have come into its own and the countryside far and near will be a festival of life—great life—then only will man have succeeded with his machine. The machine will then have become the liberator of human life.

And our architecture will reflect this.

▦ Shirking this reality, vaunted "modernity" is still making another "picture," everywhere clinging to the pictorial—missing joy in merely seeking pleasure. "Modernistic" is attempting by fresh attitudinizing to improve the "picture." The "new movement" still seeks to recreate joy by making shift to improve the imitation, neglectful of all but appropriate gestures.

But even an improved imitation as a picture will soon be trampled down and out—because of the machine. No amount of picture making will ever save America now!

The artifex alone in search of beauty can give back the significance we have lost—and enable the republic to arrive at that great art, in the inevitably man-made concerns of life, which will be to the human spirit what clear springs of water, blue sky, green grass, and noble trees are to parched animal senses. For where the work of the artificer is a necessity, there the artist must be creatively at work on *significance* as a higher *form* of life, or the life of the human spirit will perish in this fresh endeavor that as yet is only a promise in this twentieth century.

The necessity for artistry that is laid upon us by the desire to be civilized, is not a matter only of appearances. Human *necessity,* however machine-made or mechanically met, carries within itself the secret of the beauty we must have to keep us fit to live or to live with. We need it to live in or to live on. That new beauty should be something to live *for.* The "picture," never fear, will take care of itself. In any organic architecture the picture will be a natural result, a significant consequence, not a perverse *cause* of pose and sham.

Eventually we must live for the beautiful whether we want to or not. Our industrial champion, Henry Ford, was forced to recognize this—probably not connecting the beautiful with art, "the bunk." Just as he did in his industry, so America will be compelled to allow necessity its own honest beauty, or die a death nowise different from those nations whose traditions we accepted and idolized.

Unless what we now miscall culture becomes natively fit and is no longer allowed to remain superficial, this picture, which America is so extravagantly busy "pictorializing," can only hasten the end. The buttons, stuffs, dictums, wheels, and things we are now using for the purpose of the picture will smother the essential—the life they were falsely made to falsely conceal instead of to express. And this experiment in civilization we call democracy will find its way to a scrap heap into which no subsequent race may paw with much success for proofs of quality.

Suppose some catastrophe suddenly wiped out what we have done to these United States at this moment. And suppose, ten centuries thereafter, antiquarians came to seek the significance of what *we* were in the veins of us; in the ruins that remained, what would they find? Just what would they find to be the nature of this picture-minded pictorialization of life and its contribution to the wisdom or the beauty of the ages past or to come?

Would the future find we were a jackdaw-people with a monkey-psychology given over to the vice of devices—looking to devices for salvation—and discovering this very salvation to be only another and final device?

No? Just the same, they *would* find broken bits of every civilization that ever took its place in the sun hoarded in all sorts of irrelevant places in ours.

They would dig up traces of sacred Greek monuments for banking houses. The papal dome in cast-iron fragments would litter the ancient site of every seat of authority, together with fragments in stone and terra-cotta of twelfth-century cathedrals where offices and shops were indicated by mangled machinery—relics of dwellings in fifty-seven varieties and fragments of stone in heaps, none genuine in character, all absurdly mixed. They would find the toilet appurtenances of former ages preserved as classic parlor ornaments in ours. They would find a wilderness of wiring, wheels, and complex devices of curious ingenuity, and—ye gods—what a collection of buttons! They might unearth traces of devices that enabled men to take to the air like birds or to go into the water like fishes, and they might find relics of our competent schemes of transportation, and a network or web of tangled wires stringing across the country, the relic of all our remarkable teletransmissions. But I think the most characteristic relic of all would be our plumbing. Everywhere a vast collection of enameled or porcelain waterclosets, baths and washbowls, white tiles and brass piping. Next would be the vast confusion of riveted steelwork in various states of collapse and disintegration where it had been imbedded in concrete. Where the steel was not so buried all would be gone, except here and there where whole machines—a loom, a Linotype, a cash register, a tractor, a dynamo, a passenger elevator—might be entombed in concrete chambers and so preserved to arouse speculation and curiosity, or to

cause amusement as they were taken for relics of a faith in devices—a faith that failed! Of the cherished *picture* we are making, nothing of any significance would remain. The ruin would defy restoration by the historian; it would represent a total loss in human culture, except as a possible warning. A few books might be preserved to assist restoration, although the chemicalized paper now in use would probably have destroyed most of them utterly. Such glass and pottery as we make could tell but little except curious falsehoods. Certain fragments of stone building on the city sites would remain to puzzle the savant, for they would be quite Greek or quite Roman or quite Medieval Gothic, unless they were Egyptian or Byzantine. But mainly they would find heaps of a pseudo-Renaissance—something that never told, nor ever could tell, anything at all. Only our industrial buildings could tell anything worth knowing about us. But few of these buildings would survive that long—electrolysis and rust would have eaten them utterly, excepting those where steel was buried in concrete. Glass fragments would be found in great quantity, but the frames, unless they happened to be bronze, and all else would be gone. They would have no skyscraper to gauge us by. Not one of those we have built would be there.

How and where, then, were it suddenly interrupted, would our progressive democratizing based upon picturizing the appliance, take its place in the procession of civilizations that rose and fell at appointed times and places? What architecture would appear in the ruins?

And yet—in all this attempt behind the significantly insignificant picture, may we not see culture itself becoming year by year more plastic? Are not some of our modern ideas less obviously constructed and more potent from within wherever we are beginning to emerge from the first intoxication of liberty? The eventual consequence of individual freedom is surely the elimination by free thought of the insignificant and false. Imprisoning forms and fascinating philosophic abstractions grow weaker as character grows stronger and more enlightened according to nature; this they will do in freedom such as we profess—*if only we will practice* that freedom. And, in spite of our small hypocrisy and adventitious reactions, let no one doubt that we really do yearn to practice genuine freedom to a

far greater extent than we do, all inhibitions and prohibitions notwithstanding. Yes, we may see a new sense of manlike freedom growing up to end all this cruel make-believe. Freedom, in reality, is already impatient of pseudoclassic posture and will soon be sick of all picturizing whatsoever.

A common sense is on the rise that will sweep our borrowed finery, and the scene-painting that always goes with it, to the museums, and encourage good life so to live that America may honorably pay her debt to manhood by keeping her promises to her own ideal.

Two Lectures on Architecture

1. In the Realm of Ideas

The idealist has always been under suspicion as performer, perhaps justly. The explorer Stanley wrote of a monkey caught and tied up overnight by a rope around his neck. The monkey gnawed the rope in two and departed, the knot still tied about his neck. Next morning found the monkey with the strange "necktie" trying to go home, but each approach to rejoin the tribe would bring wild cries from his fellows and such commotion—no doubt inspired by the Scribes—that the monkey "with something about him" now—would stop, dazed, pull at his "experience" a little, and think it over. Then he would move toward his fellows again, but such commotion would result that he would have to give it up. The Scribes had succeeded with the Pharisees. This kept up all day because the poor monkey kept on trying to come home, (to "tell the truth"?). Finally just before dark, the whole tribe, exasperated, rushed upon the suspected monkey . . . tore him limb from limb.

Monkey psychology? Of course, but our own tribe too, often destroys on similar suspicion the man who might impart something of tremendous importance and value to his tribe . . . such ideas as this poor suspect might have imparted, concerning how to avoid being caught and tied up, say, or if tied up, how to escape.

In our own tribe we have another tendency, the reverse side of this same shield, and that tendency, no doubt *inherited* too, hails the monkey with delight, puts on rope-ends likewise, makes them the fashion, soon ostracizing any monkey without the fashionable necktie.

And yet as similar experience ideas are not bad in their way, nor are ideas troublesome necessarily, unless they are great and useful ideas. Then, in earnest, the chattering, warning, prophesizing, and crucifying begin with the Scribes. Some form of murder is usually the result. In America we are now perfectly well used to ideas in the mechanical-industrial world. An inventor on that plane is practically immune and may safely come in with almost anything about him or on him and be acclaimed. We will try the thing though we are killed by thousands; we will scrap millions in the way of paper currency to put a shiny new dime in our pockets; as a result we get somewhere among commercial and mechanical lines.

But the absorbed idealist, egocentric inventor in the realm of the thought-built, has a hard time with us socially, financially, and, with peculiar force, morally. In addition to the instinctive fear for the safety of the tribe, in our form of social contract the man with an idea seems to have become an invidious reflection upon his many fellows who have none. And certain effects belonging naturally to the idealist, such as belief in himself as having caught sight of something deeper, wider, higher, or more important just beyond, mark him. He, all unsuspecting, will appear soon on the path as peculiar to his own individuality in ways the poor fool, less absorbed, would have realized as unimportant if true and have kept under cover. Ridicule from his many fellows, safely in the middle of the road, is always ready. And now it is only the incurably *young* person, in our country, who ever attempts to break through all down the line—and is laughed out of countenance, laughed out of a job, and eventually out of house and home.

But at the absorbed idealist the tribe has laughed wrong so many times that the prevailing middle-of-

the-road egotists are getting sensitive on the subject. They should realize, as Carlyle reminded us—himself a perfectly good specimen of the absorbed egocentric—"Great thoughts, great hearts once broke for, we breathe cheaply as the common air." History will continue to repeat itself: the middle-of-the-road egotist will keep on breathing cheaply, and egocentric hearts will keep on breaking in the cause of ideas.

But our middle-of-the-road egotist is not so safe as he imagines. He may as well face the fact that just as commerce has no soul, and therefore cannot produce as life, so no inventive genius on the commercial or the mechanical plane can preserve him now. In a flood of carbon monoxide he is hell-bound for somewhere and he does not know where. Ask him! He is trapped by the device, soon to be victimized, no doubt, by a *faith* in devices, now become a device in itself, and soon seen as a fool's faith that failed. Meantime, machine overproduction has made the statesman a propagandist for the poor, the banker a bulkhead, the salesman a divinity. Around each revolves a group of white-collar satellites as parasites while the workman himself continues to trip the lever or press the button of the automaton that is substitute for hundreds of workmen like him. Yes, for many reasons America, herself the great middle-of-the-road egotist, should be kind to her absorbed egocentrics. Russia killed off hers, and was compelled to import many before her tragic experiment could turn a wheel forward. America may also bankrupt herself, but America is likely to bankrupt life by commercial, political, and utensil machinery. No. No political device, no device of organization, no device of salesmanship, no mechanical device can help our country much further on beyond. Only ideas can help her now. Unhappily the word "ideas" and the word "egocentric" come naturally together in human affairs, and go together. Never mind; patience now with the "Nut"; toleration and a turn for the "Crank!"

Although egocentricity may develop egomania all too often and be only a folly, egotism, like other qualities of human nature, is bad only when it is poor and mean in quality, that is to say, pretentious, vain, and selfish; in a word, dishonest. We should realize, too, that *optimism* to the *idealist*, to the *realist pessimism*, are but the two sides of the same shield, both extremes of egotism.

But however all this by way of "setting the stage" may be, I am going to be direct and personal with you now in this matter of ideas.

What a man *does*, that he *has*; and I shall best show you respect by the self-respect that means hereafter talking out of my own experience. Nevertheless I shall try not to sing "but of myself," and so fail, and, like Pei-Woh, prince of Chinese harpists, I shall leave the harp to choose and, as he said, "know not whether the harp be I or I the harp. . . ."

An idea is a glimpse of the nature of the thing as more workable or "practical," as we say (we like that word "practical," but abuse it), than found in current practice or custom. An idea, therefore, is an act expressing in terms of human thought implicit faith in the character of nature, something for lesser men to build and improve upon.

A fancy or conceit trifles with appearances as they are. An idea searches the *sources* of appearances, comes out as a form of inner experiences, to give fresh proof of higher and better order in the life we live. Finally . . . AN IDEA IS SALVATION BY IMAGINATION.

Such ideas as I shall rehearse for you now belong to your immediate present, but instead of saying the "present," to be truthful, we should say, with Lao-tzu, your "infinite." Lao-tzu said two thousand five hundred years ago that the present was "the ever-moving *infinite* that divides Yesterday from Tomorrow. . . ."

Suppose something you always took for granted as made up of various things, "composed" as artists say, suddenly appeared to you as organic growth. Suppose you caught a glimpse of that "something" as a living entity and saw it as no creature of fallible expediency at all but really a creation living with integrity of its own in the realm of the mind. Suppose too you saw this something only awaiting necessary means to be born as living creation instead of existing as you saw it all about you as miserable makeshift or sentimental, false appliance.

Well, something like this is what happened to Louis Sullivan when he *saw* the first skyscraper, and something like that, in architecture, has been happening to me ever since in various forms of experience.

Thus a single glimpse of reality may change the *world* for any of us if, from the fancies and conceits of mere appearances, we get within the source of

appearances. By means of human imagination at work upon this source untold new life may find expression, for, with new force, ideas do actually fashion our visible world. A new order emerges to deepen life that we may become less wasted in anxious endeavor to go from here to somewhere else in order to hurry on somewhere from there. Any true conception as an idea, derived from any *original* source, has similar consequences in all the fields of our common endeavor to build a civilization.

As it worked with Louis Sullivan in designing the skyscraper, thus did going to the source work with me in building houses as the subsequent, consequent, flock of ideas that take flight from any constructive ideal put to work.

Here at hand was the typical American dwelling of 1893 standing about on the Chicago prairies. (I used to go home to Oak Park, a Chicago suburb, which denies Chicago.) That dwelling there became somehow typical, but, by any faith in nature implicit or explicit, it did not belong there. I longed for a chance to build a house and soon got the chance because I was not the only one then sick of hypocrisy and hungry for reality. And I will venture to say, at this moment ninety out of a hundred of you are similarly sick.

What was the matter with the house? Well, just for a beginning, it lied about everything. It had no sense of unity at all nor any such sense of space as should belong to a free people. It was stuck up in any fashion. It was stuck on wherever it happened to be. To take any one of those so-called homes away would have improved the landscape and cleared the atmosphere.

This *typical* had no sense of proportion where the human being was concerned. It began somewhere in the wet, and ended as high up as it could get in the blue. All materials looked alike to it or to anybody in it. Essentially this "house" was a bedeviled box with a fussy lid: a box that had to be cut full of holes to let in light and air, with an especially ugly hole to go in and come out of. The holes were all trimmed, the doors trimmed, the roofs trimmed, the walls trimmed. "Joinery," everywhere, reigned supreme. Floors were the only part of the house left plain. The housewife and her "decorator" covered those with a tangled rug collection, because otherwise the floors were "bare"—"bare" only because one could not very well walk on jigsawing or turned spindles or plaster ornament.

It is not too much to say that as architect my lot was cast with an inebriate lot of criminals, sinners hardened by habit against every human significance, except one. (Why mention "the one touch of nature that makes the whole world kin"?) And I will venture to say, too, that the aggregation was at the lowest aesthetic level in all history: steam heating, plumbing, and electric light its only redeeming features.

The first feeling therefore was for a new simplicity, a new idea of simplicity as organic. Organic simplicity might be seen producing significant character in the harmonious order we call nature: all around, beauty in growing things. None insignificant. I loved the prairie by instinct as a great simplicity, the trees and flowers, the sky itself, thrilling by contrast. I saw that a little of height on the prairie was enough to look like much more. Notice how every detail as to height becomes intensely significant and how breadths all fall short! Here was a tremendous spaciousness sacrificed needlessly, all cut up crosswise and lengthwise into fifty-foot lots, or would you have twenty-five feet? Salesmanship parceled it out and sold it without restrictions. In a great new free entry, everywhere, I could see only a mean tendency to tip up everything in the way of human habitation edgewise instead of letting it lie comfortably flatwise with the ground. Nor has this changed much today since automobilization made it a far less genuine economic issue and a social crime.

I had an idea that the planes parallel to earth in buildings identify themselves with the ground—make the building belong to the ground. At any rate I perceived it and put it to work. I had an idea that every house in that low region should begin *on* the ground—not *in* it, as they then began, with damp cellars. This idea put the house up on the "prairie basement" I devised, entirely above the ground. And an idea that the house should *look* as though it began there *at* the ground put a projecting basecourse as a visible edge to this foundation, where as a platform it was seen as evident preparation for the building itself.

An idea that shelter should be the essential look of any dwelling put the spreading roof with generously projecting eaves over the whole; I saw a building primarily not as a cave, but as shelter in the open.

But, before this had come the idea that the size of the human figure should fix every proportion of a dwelling—and, later, why not the proportions of all buildings whatsoever? What other scale could I use? So I accommodated heights in the new buildings to no exaggerated established order but to the human being. I knew the dweller could not afford too much freedom to move about in space at best; so, perceiving the horizontal line as the earthline of human life, I extended horizontal spacing by cutting out all the room partitions that did not serve the kitchen or give privacy for sleeping apartments or (it was the day of the parlor) prevent some formal intrusion into the family circle, like the small social office set aside as a necessary evil to receive callers. Even this concession soon disappeared as a relic of barbarism.

To get the house down in the horizontal to appropriate proportion with the prairie, the servants had to come down out of the complicated attic and go into a separate unit of their own, attached to the kitchen on the ground floor. Closets disappeared as unsanitary boxes wasteful of floor space: built-in wardrobes took their places.

Freedom of floor space and elimination of useless heights worked a miracle in the new dwelling place. A sense of appropriate freedom changed its whole aspect. The whole became more fit for human habitation and more natural to its site. An entirely new sense of space values in architecture came home. It now appears it came into the architecture of the modern world. It was due. A new sense of repose in quiet streamlining effects had then and there found its way into building, as we now see it in steamships, airplanes, and motorcars. The "age" came into its own.

But more important than all, rising to greater dignity as an idea, was the ideal of plasticity as now emphasized in the treatment of the whole building. (Plasticity may be seen in the expressive lines and surfaces of your hand as contrasted with the articulation of the skeleton itself.) This ideal in the form of continuity has appeared as a natural means to achieve truly organic architecture. Here was direct expression, the only true means I could see, or can now see to that end. Here, by instinct at first (all ideas germinate), principle had entered into building as continuity that has since gone abroad and come home again to go to work, as it will continue to work to revolutionize the use and custom of our Machine Age. This means an architecture that can live and let live.

The word "plastic" was a word Louis Sullivan himself was fond of using in reference to his scheme of ornamentation, as distinguished from all other or any applied ornament. But now, and not merely as form following function, why not a larger application of this element of plasticity considered as *continuity* in the building itself? Why any principle working in the part if not working in the whole? If form really followed function (it might be seen that it did by means of this concrete ideal of plasticity as continuity), why not throw away entirely the implications of post and beam? Have *no* beams, *no* columns, *no* cornices, nor any fixtures, nor pilasters or entablatures as such. Instead of two things, *one* thing. Let walls, ceilings, floors become part of each other, growing into one another, getting continuity out of it all or into it all, eliminating any constructed feature, such as any fixture or appliance whatsoever, as Louis Sullivan eliminated background in his ornament in favor of an integral sense of the whole. Conceive now that here the idea was a new sense of building that could *grow* forms not only true to function, but expressive beyond any architecture known. Yes, architectural forms by this means might now "grow up."

Grow up—in what image? Here was concentrated appeal to pure imagination. Gradually proceeding from generals to particulars, plasticity, now *continuity*, as a large means in architecture began to grip and work its own will. I would watch sequences fascinated, seeing other sequences in those consequences already in evidence. The old architecture, as far as its grammar went, began literally to disappear: as if by magic new effects came to life.

Vistas of a simplicity would open to me and harmonies so beautiful that I was not only delighted but often startled, sometimes amazed. I concentrated with all my energy on the principle of plasticity as continuity and a practical working principle within the building construction itself to accomplish the thing we call architecture.

Some years later I took continuity as a practical working principle of construction into the actual method of constructing the building. But to eliminate the post and beam, as such, I could get no help

from the engineer. By habit, engineers reduced everything in the field of calculation to the post and the girder before they could calculate anything and tell you where and just how much. Walls that were part of floors and ceilings all merging together and reacting upon each other the engineer had never met, and the engineer has not yet enough scientific formulae to enable him to calculate for such continuity. Slabs stiffened and used over supports as cantilevers to get planes parallel to the earth, such as were now necessary to develop emphasis of the third dimension, were new. But the engineer soon mastered this element of continuity in these floor slabs. The cantilever became a new feature in architecture. As used in the Imperial Hotel in Tokyo it was one of the features that insured the life of that building in the terrific temblor. After that demonstration not only a new aesthetic, but (proving the aesthetic as sound), a great new *economic stability* had entered building construction. And, as further sequence of this idea that plasticity should be at work as continuity in actual construction, from laboratory experiments made at Princeton by Professor Beggs it appears that the principle of continuity actually works in physical structure as specific proof of the soundness of the aesthetic ideal. So the ideal of continuity in designing architectural forms will soon be available as a structural formula. Thus continuity will become a new and invaluable economy in building construction itself. Welding instead of riveting steel is a new means to the same end, but that is ahead of the story.

An idea soon came from this stimulating, simplifying ideal that, to be consistent in practice, or, indeed, if it was at all to be put to work successfully, this new element of plasticity must have a new sense as well as a science of materials. It may interest you to know, as it astonished me, there is nothing in the literature of the civilized world on that subject.

I began to study the nature of materials. I learned to see brick as brick, learned to see wood as wood, and to see concrete or glass or metal each for itself and all as themselves. Strange to say, this required concentration of imagination; each required a different handling and each had possibilities of use peculiar to the nature of each. Appropriate designs for one material would not be appropriate at all for any other material in the light of this ideal of simplicity as organic.

Had our new materials—steel, concrete, and glass—existed in the ancient order, we would have had nothing at all like ponderous "classic" architecture. No, nothing. Nor can there now be an organic architecture where the nature of these materials is ignored or misunderstood. How can there be? Perfect correlation is the first principle of growth. Integration means that nothing is of any great value except as naturally related to the whole. Even my great old master designed for materials all alike; all were grist for his rich imagination with his sentient ornamentation. All materials were only one material to him in which to weave the stuff of his dreams. I still remember being ashamed of the delight I at first took in so plainly "seeing around" the beloved master. But acting upon this new train of ideas soon brought work sharply and immediately up against the tools that could be found to get these ideas put into form. What were the tools in use everywhere? *Machines!*—automatic many of them, stone or wood planers, stone or wood molding-shapers, various lathes, presses, and power saws—all in commercially organized mills: sheet-metal breakers, presses, shears, cutting-, molding-, and stamping-machines in foundries and rolling mills—commercialized in the "shops": concrete-mixers, clay-bakers, casters, glass-makers, and the trades union—all laborers, units in a more or less highly commercialized greater union in which craftsmanship only had place as survival for burial. Standardization was already inflexible necessity, either enemy or friend—you might choose. And as you chose you became either master and useful or a luxury—and eventually a parasite.

Already machine-standardization had taken the life of handicraft in all its expressions. But the outworn handicraft as seen in the forms of the old architecture never troubled me. The new forms as expression of the new order of the machine did trouble me. If I wanted to realize new forms I should have to make them not only appropriate to old and new materials, but so design them that the machines that would have to make them, could and would make them well. But now with this ideal of internal order as integral in architecture supreme in my mind, I would have done nothing less even if I could have commanded armies of craftsmen. By now had come the discipline of a great ideal. There is no discipline, architectural or otherwise, so severe, but there is

no discipline that yields such rich rewards in work, nor is there any discipline so safe and sure of results as this ideal of "internal order," the integration that is organic. Lesser ideas took flight, like birds, from this exacting, informing ideal, always in the same direction, but further on each occasion for flight until great goals were in sight. You may see the "signs and portents" gathered together in the exhibition gallery.

But, before trying to tell you about the goals in sight, popular reactions to this new endeavor might be interesting. After the first house was built (it was the Winslow house in 1893), my next client did not want a house so different that he would have to go down the back way to his morning train to avoid being laughed at. Bankers at first refused to loan money on the houses, and friends had to be found to finance the early buildings. Millmen would soon look for the name on the plans when they were presented for estimates, read the name, and roll the drawings up again, handing them back to the contractor, with the remark "they were not hunting for trouble." Contractors often failed to read the plans correctly—the plans were so radically different—so much had to be left off the building.

Clients usually stood by, often interested and excited beyond their means. So, when they moved in, quite frequently they had to take in their old furniture. The ideal of organic simplicity, seen as the countenance of perfect integration, abolished all fixtures, rejected all superficial decoration, made all electric lighting and heating fixtures an integral part of the architecture. So far as possible all furniture was to be designed in place as part of the architecture. Hangings, rugs, carpets—all came into the same category, so any failure of this particular feature of the original scheme often crippled results—made trouble in this plan of constructive elimination.

Nor was there any planting done about the house without cooperating with the architect. No sculpture, no painting unless cooperating with the architect. This made trouble. No decoration, as such, anywhere; decorators hunting a job would visit the owners, learn the name of the architect, lift their hats, and turning on their heels leave with a curt and sarcastic "Good day"—meaning really what the slang "Good night" meant, later. The owners of the houses were all subjected to curiosity, sometimes to admiration, but they submitted, most often, to the ridicule of the middle-of-the-road egotist. There was "something about them too," now, when they had a house like that—"the rope-tie?"

A different choice of materials would mean a different scheme altogether. Concrete was coming into use and Unity Temple became the first concrete monolith in the world—that is to say—the first building complete as monolithic architecture in the wooden forms in which it was cast.

Plastered houses were then new. Casement windows were new. So many things were new. Nearly everything was new but the law of gravitation and the idiosyncrasy of the client.

But, as reward for independent thinking in building, first plainly shown in the constitution and profiles of Unity Temple at Oak Park, more clearly emerging from previous practice, now came clear *an entirely new sense of architecture*, a higher conception of architecture: architecture not alone as form following function, but conceived as space enclosed. The enclosed space itself might now be seen as the reality of the building. This sense of the within or the room itself, or the rooms themselves, I now saw as the great thing to be expressed as *architecture*. This sense of interior space made exterior as architecture transcended all that had gone before, made all the previous ideas only useful now as means to the realization of a far greater ideal. Hitherto all classical or ancient buildings had been great masses or blocks of building material, sculptured into shape outside and hollowed out to live in. At least that was the sense of it all. But here coming to light was a sense of building as an organism that had new release for the opportunities of the Machine Age. This interior conception took architecture entirely away from sculpture, away from painting, and entirely away from architecture as it had been known in the antique. The building now became a creation of interior-space in light. And as this sense of the interior space as the reality of the building began to work walls as walls fell away. The vanishing wall joined the disappearing cave. Enclosing screens and protecting features of architectural character took the place of the solid wall.

More and more light began to become the beautifier of the building—the blessing of the occupants. Our arboreal ancestors in their trees are more likely precedent for us than the savage animals that holed

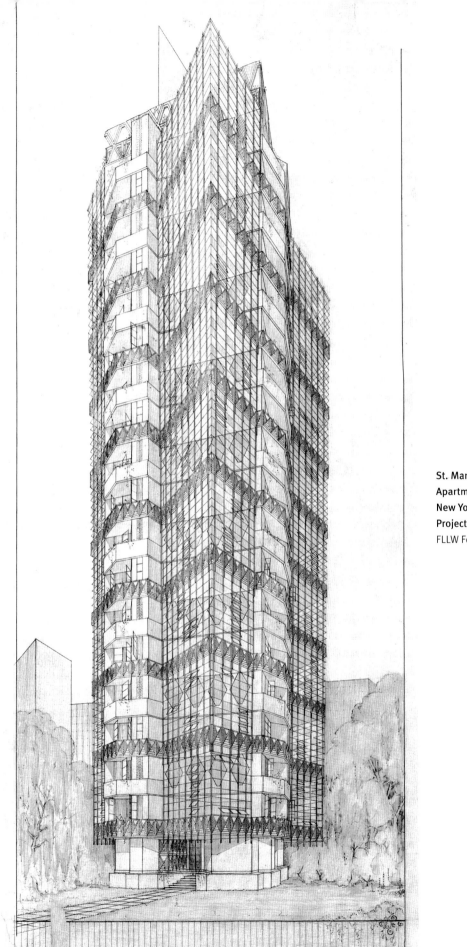

St. Mark's-in-the-Bouwerie
Apartment Towers,
New York, New York. 1928.
Project.
FLLW Fdn# 2905.002

in for protection. Yes, in a spiritual sense, a higher *order* is the sense of sunlit space and the lightness of the structure of the spider spinning as John Roebling saw it and realized it in his Brooklyn Bridge.

Inevitably, it seems to me, this sense of building is to construct the physical body of our Machine Age.

Our civilization is emerging from the cave. We are through with the fortification as a dwelling place. Feudal society, if not feudal thinking, is disappearing. With its disappearance will disappear the massive building that protected the might of its estate. With our new materials, steel, glass, and ferroconcrete with the steel always in tension, lightness and strength become more and more obvious as directly related to each other in modern building. The resources of the Machine Age confirm the new materials in this space-conception of architecture at every point. Steel-in-tension brings entirely new possibilities of spanning spaces and new aid in creating a more livable world.

Yes, already a sense of cleanliness directly related to living in sunlight is at work in us and working not only to emancipate us from the cavern but waking in us a desire for the substance of a new and more appropriate simplicity as the countenance of building construction: simplicity appearing now as a youthful clear countenance of truth. This reality is new. This sense of the reality as within, and with no exterior pretensions of architecture as something applied to construction, makes all the heavy pretentious masonry masses ornamented by brick or stone walls seem heavy, monstrous, and wrong, as in matter of fact they are utterly false in this age, as is, no less, the little-decorated cavern for a house.

Modern architecture is weary of academic make-believe. Architecture sees the airplane fly overhead, emancipated from make-believe, soon, when it lays its wings aside, free to be itself and true to itself. It sees the steamship ride the seas, triumphant as the thing it is, for what it is. It sees the motorcar becoming more the machine it should be, becoming daily less like a coach, more a freedom to be itself for what it is. In them all and in all utensils whatsoever, the Machine Age is seen more and more freely declaring for freedom to express the truths of being instead of remaining satisfied to be a false seeming. Modern architecture is profiting by what it sees and in five years' time you may look upon any sham-

boxes with holes or slots cut in them for light and air as senile, undesirable.

A new sense of beauty seen in the Machine Age, characteristic of direct simplicity of expression, is awakening in art to create a new world, or better said, to create the world anew. No mind that is a mind considers that world inferior to the antique. We may confidently see it as superior. And, within the vision of this conception of architecture, see the very city itself, as a *necessity*, dying. The acceleration we are witnessing in the tyranny of the skyscraper is no more than the hangover of a habit. The very acceleration we mistake for growth heralds and precedes decay.

Decentralization not only of industry, but of the city itself is desirable and imminent. Necessity built the city, but the great service rendered to man as a luxury by the machine as seen in automobilization and electrification will destroy that necessity. Already internal collision of the mechanistic device of the skyscraper and of these more beneficent automobilization and electrical factors may be seen winning in the struggle between the greedy skyscraper and the fleet automobile—the city splitting up in consequence. This is only one of the more obvious evidences of disintegration.

In the growth of the great highways, natural, state, and county, and in the gradually extending servicing of the ubiquitous gasoline station, we see in embryo other advance agents of decentralization! Such new avenues and spreading centers of distribution and servicing mean eventually the disintegration and subordination of the centralization now seen in the city. The greatest service sentient man is to receive from the machine he has built in his own image, if he conquers the machine and makes the machine serve him, will be the death of urbanism! Hectic urbanism will be submerged in natural ruralism. And we shall see soon that the natural place for the beautiful tall building, not in its present form but in this new sense, is in the country, not in the city.

If the machine conquers man, man will remain to perish with his city, as he has before perished in all the cities the great nations of the world have ever built.

Mankind is only now waking to visions of the machine as the true emancipator of the individual as an individual. Therefore we may yet see the Ma-

chine Age as the age of a true democracy, wherein human life is based squarely on and in the beauty and fruitfulness of the ground: life lived in the full enjoyment of the earthline of human life—the line of freedom for man, whereby man's horizon may be immeasurably extended by the machine, the creature of his brain in service of his heart and mind.

So, we may see, even now, taking shape in the realm of ideas in architecture to express all this, a new significance, or we might fairly enough say: *significance as new*. Significance as new because in architecture for five centuries at least "significance" has been lost, except as an outworn symbolism was feebly significant, or except as a tawdry sentimentality had specious significance. This new significance repudiates the sentimentality of any symbol; looks the philosophic abstraction full in the eye for the impostor it usually is; reads its lessons direct in the book of creation itself; and despises all that lives either ashamed or afraid to live as itself, for what it is or may become because of *its own nature*.

A new integrity then? Yes, integrity new to us in America—and yet so ancient! A new integrity, alive and working with new means—greater means than ever worked before. A new integrity working for freedom—yours and mine and our children's freedom—in this realm, we have called, for the purpose of this hour together, "the realm of ideas."

2. To the Young Man in Architecture

Today the young man I have in mind hears much too much about new and old. Sporadic critics of the new take their little camera minds about (snapshot emulation by the half-baked architect) and wail, or hail the dawn. If by chance the novice builds a building the cackling, if not the crowing, outdoes the egg. Propagandists, pro and con, classify old as new and new as old. Historians tabulate their own oblique inferences as fact. The "ites" of transient "ists" and "isms" proclaim the modern as new. And yet architecture was never old and will ever be new. From architecture the main current, little streams detach themselves, run a muddy course to be regathered and clarified by the great waters as though the little rills and rivulets had never been. All art in our time is like that and we witness only the prodigal waste Nature sponsors when she flings

away a million seeds to get a single plant, seeming in the meantime to enjoy her extravagance. Nature's real issue, no doubt, in the life of the mind is no less wasteful, and she may enjoy her extravagance in the million fancies for one idea, millions of celebrations for one thought, a million buildings for even one small piece of genuine architecture. Yes, she gives gladly a million for one now, because the species has declined five hundred years to the level of a commercially expedient *appliance*. The species itself, you see, is in danger. So be glad to see as evidence of life the babel of personal books, the dereliction of aesthetic movements—especially be glad to see the half-baked buildings by the novitiate.

But confusion of ideas is unnatural waste of purpose. Such confusion as we see means a scattering of aim nature herself would never tolerate. The confusion arises because there is doubt in some minds, fear in some minds, and hope in other minds, that architecture is shifting its circumference. As the hod of mortar and some bricks give way to sheet metal, the lockseam, and the breaker—as the workman gives way to the automatic machine—so the architect seems to be giving way either to the engineer, the salesman, or the propagandist.

I am here to assure you that the circumference of architecture *is* changing with astonishing rapidity, but that its *center* remains unchanged. Or am I here only to reassure you that architecture eternally returns upon itself to produce new forms that may live on forever? In the light of the new and with pain of loss, only now does America waken to see why and how art, conceived as a commercial expedient or degraded to the level of a sentimental appliance, has betrayed American life. Yes, that is one reason why the circumference of art, as a whole, is rapidly shifting. The circumference is shifting because hunger for reality is not yet dead, and because human vision widens with science as human nature deepens with inner experience.

The center of architecture remains unchanged because—though all unconfessed or ill-concealed—beauty is no less the true purpose of rational modern architectural endeavor than ever, just as beauty remains the essential characteristic of architecture itself. But today, because of scientific attainment, the modern more clearly perceives beauty as integral order; order divined as an image by human sensibility; order apprehended by reason, executed by

science. Yes, by means of a greater science, a more integral order may now be executed than any existing. With integral order once established you may perceive the rhythm of consequent harmony. To be harmonious is to be beautiful in a rudimentary sense: a good platform from which to spring toward the moving infinity that is the present. It is in architecture in this sense that "God meets with nature in the sphere of the relative." Therefore, the first great necessity of a modern architecture is this keen sense of order as integral. That is to say the *form* itself in orderly relationship with purpose or function: the *parts* themselves in order with the form: the materials and methods of work in order with both: a kind of natural integrity—the integrity of each in all and of all in each. This is the exacting new order.

Wherein, then, does the new order differ from the ancient? Merely in this—the ancient order had gone astray, betrayed by "culture," misled by the historian. But the organic simplicity to be thus achieved as new is the simplicity of the universe, which is quite different from the simplicity of any machine, just as the art of being in the world is not the same thing as making shift to get about in it.

Internal disorder is architectural disease if not the death of architecture. Needed then, young man, by you who would become an architect, and needed as a very beginning, is some intellectual grasp, the more direct the better, of this radical order of your universe. You will see your universe as architecture.

An inspired sense of order you may have received as a gift—certainly the schools cannot give it to you. Therefore, to the young man in architecture, the word *radical* should be a beautiful word. Radical means "of the root" or "to the root"—begins at the beginning and the word stands up straight. Any architect should be radical by nature because it is not enough for him to begin where others have left off.

Traditions in architecture have proved unsafe. The propaganda of the dead which you now see in a land strewn with the corpses of opportunity, is no more trustworthy than the propaganda of the living. Neither can have much to do with organic architecture. No, the working of principle in the direction of integral order is your only safe precedent. So the actual business of your architectural schools should be to assist you in the perception of such order in the study of the various architectures of the world—otherwise schools exist only to hinder and deform the young. Merely to enable you, young man, to make a living by making plans for buildings is not good enough work for any school. Thus you may see by this definition of order that the "orders" as such have less than nothing at all to do with modern, that is to say organic, architecture. And, too, you may see how little any of the great buildings of the ages can help you to become an architect *except as you look within them* for such working of principle as made them new in the order of their own day. As a matter of course, the particular forms and details appropriate to them become eccentricities to you—fatalities, should you attempt to copy them for yourselves when you attempt to build. This much at least, I say, is obvious to all minds as the Machine Age emerges into human view, with more severe limitations than have ever been imposed upon architecture in the past, but these very limitations are your great, fresh opportunity.

Now, even the scribes are forced by inexorable circumstances to see old materials give way to new materials, new industrial systems taking the place of old ones, just as all see the American concepts of social liberty replace the feudal systems, oligarchies, and hereditary aristocracies: and by force of circumstances, too, all are now inexorably compelled to see that we have nothing, or have very little, which expresses, as architecture, any of these great changes.

Due to the very principles at work as limitations in our mechanical or mechanized products, today, you may see coming into the best of them a new order of beauty that, in a sense, *is* negation of the old order. In a deeper sense, a little later, you may be able to see it, too, as scientific affirmation of ancient order. But you, young man, begin anew, limited, though I hope no less inspired, by this sense of the new order that has only just begun to have results. Only a horizon widened by science, only a human sensitivity quickened by the sense of the dignity and worth of the individual as an individual, only this new and finer sense of internal order, *inherent* as the spirit of architecture, can make you an architect now. Your buildings *must* be new because the law was old before the existence of heaven and earth.

You may see on every side of you that principle works in this spirit of cosmic change today just as it worked since the beginning. Lawless you cannot be in architecture, if you are for nature. And do not

be afraid, you may disregard the laws, but you are never lawless if you are for nature.

Would you be modern? Then it is the nature of the thing, which you now must intelligently approach and to which you must reverently appeal. Out of communion with nature, no less now than ever, you will perceive the order that is new and learn to understand that it is old because it was new in the old. Again, I say, be sure as sure may be that a clearer perception of principle has to be "on straight" in your mind today before any architectural ways or any technical means can accomplish anything for you at all.

As to these technical ways and means, there are as many paths as there are individuals with capacity for taking infinite pains, to use Carlyle's phrase. All are found in the field itself, the field where all that makes the America of today is active commercial issue. An architect's office may be a near corner of that field. A school in which modern machinery and processes were seen at actual work would be your true corner of that field. If only we had such schools, one such school would be worth all the others put together. But only a radical and rebellious spirit is safe in the schools we now have, and time spent there is time lost for such spirits. Feeling for the arts in our country, unfortunately for you, is generally a self-conscious attitude, an attitude similar to the attitude of the provincial in society. The provincial will not act upon innate kindness and good sense, and so tries to observe the other guests to do as they do. Fear of being found ridiculous is his waking nightmare. Innate good sense, in the same way, forsakes the provincial in the realm of ideas in art. By keeping in what seems to him good company, the company of the "higher-ups," he thinks himself safe. This self-conscious fear of being oneself, this cowardly capitulation to what is being done, yes, the architectural increment *servility* deserves—this is your inheritance, young man!—you inheritance from the time when the architect's lot was cast in between, neither old nor new, neither alive nor quite dead. Were this not so it would not be so hard for you to emerge, for you to be born alive. But as a consequence of the little modern architecture we already have, young architects, whatever their years, will emerge with less and less punishment, emerge with far less anguish, because the third generation is with us. That generation will

be less likely to advertise to posterity by its copied mannerisms or borrowed styles that it was neither scholar nor gentleman in the light of any ideal of spiritual integrity.

It would be unfair to let those architects in between who served as your attitudinized or commercialized progenitors go free of blame for your devastating architectural inheritance. Where they should have led they followed by the nose. Instead of being arbiters of principle as a blessed privilege, they became arbiters or victims of the taste that is usually a matter of ignorance. When leisure and money came, these progenitors of yours became connoisseurs of the antique, patrons and peddlers of the imitation. So, with few exceptions, it was with these sentimentalized or stylized architects: "Boy, take down Tudor no. 37 and put a bay window on it for the lady"; or, solicitous, "Madam, what style will you have?" A few held out, all honor to them. A tale told of Louis Sullivan has the lady come in and ask for a Colonial house: "Madam," said he, "you will take what we give you."

Except in a few instances (the result of some such attitude as this), the only buildings we have today approaching architecture are the industrial buildings built upon the basis of common sense: buildings built for the manufacturer who possessed common sense or buildings for residence built to meet actual needs without abject reference to the "higher-ups"—nor with foolish, feathered hat in hand to culture. These sensible works we possess and the world admires, envies, and emulates. This American common sense, is today the only way out for America. He is still the only architectural asset America ever had or has. Give him what he needs when he needs it.

To find out what he needs go whenever and wherever you can to the factories to study the processes in relation to the product and go to the markets to study the reactions. Study the machines that make the product what it is. To acquire technique study the materials of which the product is made, study the purpose for which it is produced, study the manhood *in* it, the manhood *of* it. Keep all this present in your mind in all you do, because ideas with bad technique are abortions.

In connection with this matter of "technique" you may be interested to know that the Beaux-Arts that made most of your American progenitors is it-

self confused, now likely to reinterpret its precepts, disown its previous progeny, and disinherit its favorite sons or be itself dethroned, since posterity is already declining the sons as inheritance: the sons who enabled the plan-factory to thrive, the "attitude" to survive in a sentimental attempt to revive the dead. Yes, it is becoming day by day more evident to the mind how shamefully the product of this culture betrayed America. It is beginning to show and it shames America. At our architecture, as "culture," quite good-naturedly the Old World laughs. Coming here expecting to see our ideals becomingly attired, they see us fashionably and officially ridiculous, by way of assumption of customs and manners belonging by force of nature and circumstances to something entirely different. They see us betraying not only ourselves but our country itself. But now by grace of freedom we have little otherwise to show to command dawning respect. No, young man, I do not refer to the skyscraper in the rank and file as that something nor does the world refer to it, except as a stupendous adventure in the business of space-making for rent—a monstrosity. I again refer you to those simple, sincere attempts to be ourselves and make the most of our own opportunities which are tucked away in out-of-the-way places or found in industrial life as homes or workshops. Our rich people do not own them. Great business on a large scale does not invest in them unless as straightforward business buildings where "culture" is no consideration and columns can give no credit.

American great wealth has yet given nothing to the future worth having as architecture or that the future will accept as such unless as an apology. In building for such uses as she had, America has made shift with frightful waste.

Though half the cost of her buildings was devoted to making them beautiful as architecture, not one thought-built structure synthetic in design has American great wealth, and even less American factotumized learning, yet succeeded in giving to the modern world. American wealth has been sold as it has, itself, bought and sold and been delivered over by professions, or the Scribes, to the Pharisees. So, young man, expect noting from the man of great wealth in the United States for another decade. Expect nothing from your government for another quarter of a century! Our government, too

(helpless instrument of a majority hapless in art), has been delivered over to architecture as the sterile hangover of feudal thought, or the thought that served the sophist with the slave. That is why the future of architecture in America really lies with the well-to-do man of business—the man of independent judgement and character of his own, unspoiled by great financial success—that is to say the man not persuaded, by winning his own game, that he knows all about everything else.

Opportunity to develop an architecture today lies with those sincere and direct people, who, loving America for its own sake, live their own lives quietly in touch with its manifold beauties—*blessed by comprehension of the ideal of freedom that founded this country*. In our great United States, notwithstanding alleged "rulers" or any "benign" imported cultural influences, these spontaneous sons and daughters are the soul of our country; they are fresh unspoiled life and, therefore, they are your opportunity in art, just as you, the artist, are their opportunity. You will be their means to emerge from the conglomerate "in between."

And this brings us to the American "ideal." This American ideal must be in architecture what it is in life. Why obscure the issue by any sophisticated aesthetics or involution with academic formulae? The arts are only such media as we have for the direct expression of life reacting in turn with joy-giving force upon that life itself—enriching all human experience to come. The arts in America are on free soil, and therefore all-imperatively call for the creative artist.

The soul of that new life we are fond of calling American is liberty: liberty tolerant and so sincere that it must see all free or itself suffer. This freedom is the highest American ideal. To attain it, then, is inner experience, because there is no "exterior" freedom. Freedom develops from within and is another expression of an integral order of the mind in high estate. Freedom is impossible where discord exists either within or without. So, perfect freedom no one has, though all may aspire. But, to the degree freedom is attained, the by-product called "happiness," meaning, I suppose, innocent life, will be the consequence.

Very well, take the American ideal of freedom from the realm of human consciousness to our specific expression of that consciousness we call archi-

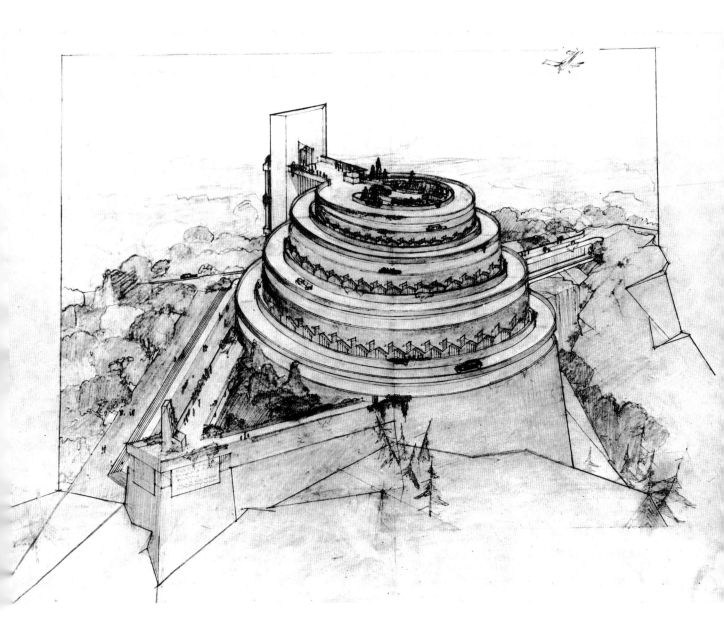

tecture. Could any decorator's shop, even if it were called a "studio," sell anything ready-made out of the world's stock of "styles" to do more than bedizen or bedevil this essential sentiment?—artificially dress it up for artificiality-making social occasion? No, it would be impossible to do more—architecture like freedom *cannot be put on,* it must be worked out from within.

Could any school of architecture inculcating the culture of Greece or Rome fit the case any better with current abstractions of ancient culture as dedicated to the sophist and the slave? No, ancient

Gordon Strong Automobile Objective, Sugarloaf Mountain, Maryland. 1925. Project.
FLLW Fdn# 2505.070

229

culture produced nothing to fit the case of an individual freedom evolved by the individual from within. And this is justification (is it?) for evolving nothing and going on with make-believe just because make-believe is organized and therefore the decorator has it in stock, the plan-factory sells it, and the schools provide it. The present tendency in architecture which we style modern says emphatically "No" to this betrayal.

If we are determining ourselves as a free people (and we are), by what you build you will now say proudly "No" to further menial treason of this academic type.

Are we a free people? Of course not. The question that is important, however, is: do we have it in our hearts as it is written in our constitutional charter to be free? Is it sincerely and passionately our ideal to be free? Notwithstanding so much cowardly popular evidence to the contrary, I say it is our ideal. Those highest in the realm of freedom should build suitable buildings and build them now, for that spirit first, and for America to ponder. There is no longer any doubt in the mind that eventually America will have a truly characteristic architecture—that much is already written for you on the vanishing wall and the disappearing cave.

Young man in architecture, wherever you are and whatever your age, or whatever your job, we—the youth of America—should be the psychological shock-troops thrown into action against corruption of this supreme American ideal. It will be for youth, in this sense, to win the day for freedom in architecture.

That American architecture cannot be imitative architecture is self-evident in spite of false standards. It is self-evident that neither architect who imitates nor architecture imitative can be free—the one is a slave, the other forever in bondage. It is as evident that free architecture must develop from within—an integral, or as we now say in architecture, an "organic" affair. For this reason if for no other reason, modern architecture can be no mode nor can it ever again be any "style." You must defend it against both or senility will again set in for another cycle of thirty years.

Specifically then, you may ask, what is truly modern in architecture? . . . The answer is *power*—that *is* to say material resources—*directly applied to purpose*. Yes, modern architecture is power directly applied to purpose in buildings in the same sense that we see it so applied in the airplane, ocean liner, or motorcar. Therefore, it is natural enough perhaps for newly awakened architects to make the error of assuming that, beyond accepting the consequences of directness and integral character, the building of itself must resemble utensil-machines or flying, fighting, or steaming-machines, or any other appliances. But here is this essential difference (it makes all the difference) between a machine and a building. A building is not an appliance nor a mobilization. The building as architecture is born out of the heart of man, permanent consort to the ground, comrade to the trees, true reflection of man in the realm of his own spirit. His building is therefore consecrated space wherein he seeks refuge, recreation, and repose for body but especially for mind. So our Machine Age building need no more look like machinery than machinery need look like buildings.

Certain qualities, humanly desirable qualities, I am sure you may obtain by means of machinery or by intelligent use of our mechanized systems without selling your souls to factotums by way of a factorialized aesthetic. There is rather more serious occasion for becoming ourselves in our environment, our architecture becoming more human, our dwelling-places becoming more imaginatively fresh and original in order to overcome not only the "cultured tag" but the deadly drag of mechanical monotony and the purely mechanical insignificance that otherwise characterizes us and that will eventually destroy us. But the "ites" of the "ism" and the "ist" give signs of being so engrossed in a new machine-aesthetic that they will be unable to rise above themselves—sunk, and so soon, in the struggle for machine technique. Already hectic architects' "modernistic" and the decorators' "modernism" obscure the simple issue. I would have you believe that to be genuinely new, the man must begin to win over the machine, and not the machine win over the man by way of the man.

We have already observed that whenever architecture was great it was modern, and whenever architecture was modern human values were the only values preserved. And I reiterate that modern architecture in this deeper sense is novelty only to novitiates, that the principles moving us to be modern now are those that moved the Frank and Goth, the Indian, the Maya, and the Moor. They are the same

principles that will move Atlantis recreated. If there is architecture on Mars or Venus, and there is, at least there is the architecture of Mars and Venus themselves, the same principles are at work there too.

Principles are universal.

If you approach principles from within you will see that many of the traditions we flattered to extinction by emulation never were even on speaking terms with principle, but were bound up with education by way of impotence or deadly force of habit, or what not? Modern architecture knows them now for impositions, and is gaining courage to cast them out, together with those who insist upon their use and administer them. This in itself you should gratefully recognize as no small value of the so-called "modern movement."

Goethe observed that death was nature's ruse in order that she might have more life. Therein you may see the reason why there must be a new, and why the new must ever be the death of the old, but this tragedy need occur only where "forms" are concerned, if you will stick to principle. It is because we have not relied on principle that the genius of the *genus homo* is now to be taxed anew to find an entirely new kind of building that will be a more direct application of power to purpose than ever before has existed in history. But again let us repeat that to secure beauty of the kind we perceive in external nature in the inflexible standardization that characterizes that power today, we must not dramatize the machine but dramatize the man. You must work, young man in architecture, to lift the curse of the appliance, either mechanical or sentimental, from the life of today.

But this modern constructive endeavor is being victimized at the start by a certain new aesthetic wherein appearance is made an aim instead of character made a purpose. The "new" aesthetic thus becomes at the very beginning old because it is only another "appliance." The French with all the delicacy and charm they seem to possess as substitute for soul, and with French flair for the appropriate gesture at the opportune moment, have contributed most to this affix or suffix of the appliance. Initiators of so many "art movements" that prove ephemeral, they recognize the opportunity for another "movement." The new world and the old world too had both already recognized a certain new order that

is beauty in the clean-stripped, hard look of machines—had admired an exterior simplicity due to the direct construction by which automatons were made to operate, move, and stop. But certain aesthetes—French by sympathy or association—are trying to persuade us that this exterior simplicity *as a new kind of decoration*, is the appropriate look of everything in our Machine Age. French painting foolishly claims to have seen it first—foolishly because we saw it first in ourselves. But French modernism proceeds to set it up flatwise in architecture in two dimensions—that is to say, to survey it in length and breadth. Although these effects of surface and mass were already well along in our own country (two dimensions, completed by surfaces parallel to the earth, as a third dimension to grip the whole building to the ground), Paris nevertheless ignores this, with characteristic desire for "movement," and sets up characteristic machine-appearance in two dimensions (that is to say, in the surface and mass effects with which Paris is familiar), and architecture thus becomes decoration. You may see it in the fashionable shops while France contemplates a fifty-four million dollar building to propagandize her arts and crafts in the American field while America is busy making enough motorcars to go around.

A certain inspiration characterized the first French recognition, but uninspired emulation has become reiteration, and in the end nothing will have happened unless another "mode," another aesthetic dictum goes forth to languish as superficial fashion. Another "istic," another "ism" comes to town to pass away—this time not in a hansom cab but in a flying machine!

Yes, America is young, so healthy it soon wearies of negation. The negation we have here is stranger to mysterious depths of feeling. It is protestant. The protestant is useful but seldom beautiful. When he ceases to protest and becomes constructive himself, some new protestant will arise to take his place and we may see this happening at the moment.

Yet for young America today a light too long diverted to base uses is shining again through all the propaganda and confusion. This light is the countenance of integral order, a more profound, consistent order than the world has fully realized before, wherein power is applied to purpose in construction just as mathematics is sublimated into music. By that light you may clearly see that, where there

is no integral order, there is no beauty, though the order be no more obvious than mathematics in music is obvious.

Not so strange then that the novitiate takes the machine itself as the prophet of this new order, though you must not forget that although music is sublimated mathematics the professor of mathematics cannot make music. Nor can the doctor of philosophy nor the master of construction nor the enthusiastic antiquarian make architecture.

No rationalizing of the machine or factorializing of aesthetics can obscure the fact that architecture is born, not made, and must consistently grow from within to whatever it becomes. Such forms as it takes must be spontaneous generation of materials, building methods, and purpose. The brain is a great tool with great craft; but in architecture you are concerned with our sense of the specific beauty of human lives as lived on earth in relation to each other. Organic architecture seeks superior sense of use and finer sense of comfort, expressed in organic simplicity. That is what you, young man, should call *architecture*. Use and comfort in order to become architecture must become *spiritual satisfactions* wherein the soul insures a more subtle use, achieves a more constant repose. So, architecture speaks as poetry to the soul. In this Machine Age to utter this poetry that is architecture, as in all other ages, you must learn the organic language of the natural, which is *ever the language of the new*. To know any language you must know the alphabet. The alphabet in architecture in our Machine Age is the nature of steel, glass, and concrete construction, the nature of the machines used as tools, and the nature of the new materials to be used.

Now what language?

Poverty in architecture—architecture the language of the human heart—has grown by unnatural appropriation of artificiality, has grown wretched and miserable by the fetish of the appliance, whether by the appliance as mechanical or sentimental. Prevailing historical sympathy administered as standardized learning has confused art with archaeology. In this academic confusion we have been unable to cultivate the principles that grow architecture as a flower of the mind out of our own nature as flowers grow out of earth.

To make architectural growth, you must now perceive that the essential power of our civilization can never be expressed or even capitalized for long in any shallow terms of any factorialized or merely mechanized art. If you would be true to the center of architecture wherever the circumference of architecture may be formed you will see the machine as a peerless tool but otherwise you will see any machine as sterility itself. Engrossed in the serious struggle for the new technique, you may not override your love of romance, except such foolish abuse of romance as is our present sentimentality or senility—our barren lot long since past.

I assure you that at least enough has appeared in my own experience to prove to me that the power of the man with the machine is really no bar at all to tremendously varied *imaginative* architecture.

Nor does any mind that is a mind doubt that the worthy product of our own industrialism should and would give us more digestible food for artistic enjoyment, than the early Italian, Italian pasticcio, or the medieval ever gave us. But such artistic enjoyment should not, could not, mean that the Machine Age commonplaces were accepted as worthy. It would mean these commonplaces transfigured and transformed by inner fire to take their places in the immense vista of the ages as human masterpieces. Such interpretation by inner fire as *character in the realm of nature* is the work of the young man in architecture.

Oh, America will have to go through a lot of amateurish experiments with you. We as Americans may have to submit to foolish experiments used in the American manner as quick-turnover propaganda. But we must be patient because architecture is profound.

Architecture is the very body of civilization itself. It takes time to grow—begins to be architecture only when it is thought-built, that is to say when it is a synthesis completed from a rational beginning and, naturally as breathing, genuinely *modern*.

America will factorialize and factotumize much more, and as many Americans will die of ornaphobia as of ornamentia by the wayside before any goal is reached. She will listen to much reasoning from all and sundry and will justly despise the poisonous fruits of most of the reasoning. She will see many little bands or cliques among you muddling about near-ideas, attempting to run with them and kick a goal for personal glory in what we already sufficiently know as modern movements. And you yourselves

will see exploitation of perfectly good ideals by every shade of every imported nationality on earth when the women's clubs of America wake to the great significance to the family of this rapidly changing order in which we live and which they are only now learning to call modern from the midst of antiques. And then in characteristic fashion America will be inclined to mistake abuse of the thing for the thing itself and kick the thing out. As a characteristic abuse we have already seen pseudo-classic architecture stripping off its enabling cornices, entablatures, and columns, and fundamentally unchanged, hung up to us on a grand scale as modern. We will soon see more of it on a grander scale. But washing pseudo-classic behind the ears cannot make architecture modern.

One abusive formula that enables the plan-factory to modernize overnight is that all architecture without ornament is modern. Another agonizing formula that gives the decorator a break is that sharp angles cutting flat surfaces are modern. Never mind, we will accept anything, just so recurrent senility does not again become a new aesthetic.

Yes, modern architecture is young architecture—the joy of youth must bring it. The love of youth, eternal youth must develop and keep it. You must see this architecture as wise, but not so much wise as sensible and wistful, nor any more scientific than sentient, nor so much resembling a flying machine as a masterpiece of the imagination.

Oh yes, young man, consider well that a house is a machine in which to live, but by the same token a heart is a suction pump. Sentient man begins where that concept of the heart ends.

Consider well that a house is a machine in which to live but architecture begins where that concept of the house ends. All life is machinery in a rudimentary sense, and yet machinery is the life of nothing. Machinery is machinery only because of life. It is better for you to proceed from the generals to the particulars. So do not rationalize from machinery to life. Why not think from life to machines? The utensil, the weapon, the automaton—all are *appliances*. The song, the masterpiece, the edifice are a warm outpouring of the heart of man—human delight in life triumphant: we glimpse the infinite.

That glimpse or vision is what makes art a matter of inner experience; therefore, sacred and no less, but rather more, individual in this age, I assure you, than ever before.

Architecture expresses human life, machines do not, nor does any appliance whatsoever. Appliances only serve life.

Lack of appreciation of the difference between the appliance and life is to blame for the choicest pseudoclassic horrors in America. And yet our more successful "modern" architects are still busy applying brick or stone envelopes to steel frames in the great American cities. Instead of fundamentally correcting this error, shall any superficial aesthetic disguised as new enable this same lack of appreciation of the principles of architecture to punish us again this time with a machinery abstract which will be used as an appliance of another cycle of thirty years? If so, as between architecture as sentimental appliance and architecture as mechanical appliance or even the aesthetic abstract itself as an architectural appliance, it would be better for America were you to choose architecture as the mechanical appliance. But, then, organic architecture would have to keep on in a little world of its own. In this world of its own the hard line and the bare upright plane in unimaginative contours of the box both have a place, just as the carpet has a place on the floor, but the creed of the naked stilt, as a stilt, has no place. The horizontal plane gripping all to earth comes into organic architecture to complete the sense of forms that do not box up contents but imaginatively express space. This is modern.

In organic architecture the hard straight line breaks to the dotted line where stark necessity ends and thus allows appropriate rhythm to enter in order to leave suggestion its proper values. This is modern.

In organic architecture, any conception of any building as a building begins at the beginning and goes *forward* to incidental expression as a picture and does not begin with some incidental expression as a picture and go groping *backward*. This is modern.

Eye-weary of reiterated bald commonplaces wherein light is rejected from blank surfaces or fallen dismally into holes cut in them, organic architecture brings the man once more face to face with nature's play of shade and depth of shadow seeing fresh vistas of native, creative human thought and native feeling presented to his imagination for consideration. This is modern.

The sense of interior space as reality in organic

architecture coordinates with the enlarged means of modern materials. The building is now found in this sense of interior space; the enclosure is no longer found in terms of mere roof or walls but as screened space. This reality is modern.

In true modern architecture, therefore, the sense of surface and mass disappears in light, or in fabrications that combine it with strength. And this fabrication is no less the expression of principle as power-directed-toward-purpose than may be seen in any modern appliance or utensil machine. But modern architecture affirms the higher human sensibility of the sunlit space. Organic buildings are the strength and lightness of the spiders' spinning, buildings qualified by light, bred by native character to environment, married to the ground. That is modern!

Meanwhile by way of parting moment with the young man in architecture—this he should keep—concerning ways and means:

1. Forget the architectures of the world except as something good in their way and in their time.
2. Do none of you go into architecture to get a living unless you love architecture as a principle at work, for its own sake—prepared to be as true to it as to your mother, your comrade, or yourself.
3. Beware of the architectural school except as the exponent of engineering.
4. Go into the field where you can see the machines and methods at work that make the modern buildings, or stay in construction directly and until you can work naturally into building-design from the nature of construction.
5. Immediately begin to form the habit of thinking "why" concerning any efforts that please or displease you.
6. Take nothing for granted as beautiful or ugly, but take every building to pieces, and challenge every feature. Learn to distinguish the curious from the beautiful.
7. Get in the habit of analysis—analysis will in time enable synthesis to become your habit of mind.
8. "Think in simples" as my old master used to say, meaning to reduce the whole to its parts in simplest terms, getting back to first principles. Do this in order to proceed from generals to particulars, and never confuse or confound them or yourself be confounded by them.

9. Abandon as poison the American idea of the quick turnover. To get into practice half-baked is to sell out your birthright as an architect for a mess of pottage, or to die pretending to be an architect.
10. Take time to prepare. Ten years' preparation for preliminaries to architectural practice is little enough for any architect who would rise above the belt in true architectural appreciation or practice.
11. Then go as far away as possible from home to build your first buildings. The physician can bury his mistakes, but the architect can only advise his client to plant vines.
12. Regard it as just as desirable to build a chicken-house as to build a cathedral. The size of the project means little in art, beyond the money matter. It is the quality of character that really counts. Character may be large in the little or little in the large.
13. Enter no architectural competition under any circumstances except as a novice. No competition ever gave to the world anything worth having in architecture. The jury itself is a picked average. The first thing done by jury is to go through all the designs and throw out the best and the worst ones so, as an average, it can average upon an average. The net result of any competition is an average by the average of averages.
14. Beware of the shopper for plans. The man who will not grubstake you in prospecting for ideas in his behalf will prove a faithless client.

It is undesirable to commercialize everything in life just because your lot happens to be cast in the Machine Age. For instance, architecture is walking the streets today; a prostitute because to get the job has become the first principle of architecture. In architecture the job should find the man and not the man the job. In art the job and the man are mates; neither can be bought or sold to the other. Meantime, since all we have been talking about is a higher and finer kind of integrity, keep your own ideal of honesty so high that your dearest ambition in life will be to call yourself an honest man, and look yourself square in the face. Keep your ideal of honesty so high that you will never be quite able to reach it. Respect the masterpiece—it is true reverence to man. There is no quality so great, none so much needed now.

The Disappearing City

On Earth

The value of this earth, as man's heritage, is pretty far gone from him now in the cities centralization has built. And centralization has over-built them all. Such urban happiness as the properly citified citizen knows consists in the warmth and pressure or the approbation of the crowd. Grown Argus-eyed and enamoured of "whirl" as a dervish, the surge and mechanical roar of the big city turns his head, fills his ears as the song of birds, the wind in the trees, animal cries and the voices and songs of his loved ones once filled his heart.

But as he stands, out of machines he can create nothing but machinery.

The properly citified citizen has become a broker dealing, chiefly, in human frailties or the ideas and inventions of others: a puller of levers, a presser of the buttons of a vicarious power, his by way of machine craft.

A parasite of the spirit is here, a whirling dervish in a whirling vortex.

Perpetual to and fro excites and robs the urban individual of the meditation, imaginative reflection and projection once his as he lived and walked under clean sky among the growing greenery to which he was born companion. The invigoration of the Book of Creation he has traded for the emasculation of a treatise on abstraction. Native pastimes with the native streams, woods and fields, this recreation he has traded for the taint of carbon-monoxide, a rented aggregate of rented cells up-ended on hard pavements, "Paramounts," "Roxies," and nightclubs, speakeasies. And for this he lives in a cubicle among cubicles under a landlord who lives above him, the apotheosis of rent, in some form, in some penthouse.

The citizen, properly citified, is a slave to herd instinct and vicarious power as the medieval laborer, not so long before him, was a slave to his pot of "heavy wet." A cultural weed of another kind.

The weed goes to seed. Children grow up, herded by thousands in schools built like factories, run like factories, systematically turning out herd-struck morons as machinery turns out shoes.

Men of genius, productive when unsuccessful, "succeed," become vicarious, and except those whose métier is the crowd, these men, who should be human salvage, sink in the city to produce, but create no more. Impotent.

Life itself is become the restless "tenant" in the big city. The citizen himself has lost sight of the true aim of human existence and accepts substitute aims as his life, unnaturally gregarious, tends more and more toward the promiscuous blind adventure of a crafty animal, some form of graft, a febrile pursuit of sex as "relief" from factual routine in the mechanical uproar of mechanical conflicts. Meantime, he is struggling to maintain, artificially, teeth, hair, muscles and sap; sight growing dim by work in artificial light, hearing now chiefly by telephone; going against or across the tide of traffic at the risk of damage or death. His time is regularly wasted by others because he, as regularly, wastes theirs as all go in different directions on scaffolding, or concrete or underground to get into another cubicle under some other landlord. The citizen's entire life is exaggerated but sterilized by machinery—and medicine: were motor oil and castor oil to dry up, the city would cease to function and promptly perish.

The city itself is become a form of anxious rent, the citizen's own life rented, he and his family evicted if he is in "arrears" or "the system" goes to smash.

Renting, rented and finally the man himself rent should his nervous pace slacken. Should this anxious lockstep of his fall out with the landlord, the moneylord, the machinelord, he is a total loss.

And over him, beside him and beneath him, even in his heart as he sleeps is the taximeter of rent, in some form, to goad this anxious consumer's unceasing struggle for or against more or less merciful or merciless money increment. To stay in lockstep. To pay up. He hopes for not much more now. He is paying his own life into bondage or he is managing to get the lives of others there, in order to keep up the three sacrosanct increments to which he has subscribed as the present great and beneficent lottery of private capital. Humanity preying upon humanity seems to be the only "economic system" he knows anything about.

But all the powerful modern resources naturally his by use of modern machinery are, by way of human progress, now involuntarily turning against the city. Although a system he, himself, helped to build,

capitalized centralization is no longer a system for the citizen nor one working for him. Having done its work for humanity, centralization is centripetal force beyond control, exaggerated by various vicarious powers. And it is exaggerating more and more in its victim his animal fear of being turned out of the hole into which he has been accustomed to crawl only to crawl out again tomorrow morning. Natural horizontality is gone and the citizen condemns himself to an unnatural, sterile verticality—upended by his own excess.

Notwithstanding, sporadic housing, slumming, and profit sharing to build him permanently into bondage as he stands, but for this involuntary war of mechanical factors he is all but helpless now, cursed by the primitive cave dwelling instinct: the shadow of the wall of the ancestral tribe.

Primitive Instincts

Time was when mankind was divided between cave dwellers and wandering tribes. And were we to go back far enough, we might find the wanderer swinging from branch to branch in the leafy bower of the trees insured by the curl of his tail while the more stolid lover of the wall lurked in such hidden holes and material cavities as he could find.

The cave dweller was the ancient conservative. But probably he was more brutal with his heavy club, if not more ferocious, than the wanderer with his spear.

The cave dweller became the cliff dweller and began to build cities. Establishment was his. His God was a statue more terrible than himself, a murderer, and hidden in a cave. This statue he erected into a covenant.

His swifter, more mobile brother devised a more adaptable and elusive dwelling place, the folding tent.

From place to place over the earth following the law of change, natural law to him, he went in changing seasons.

An adventurer.

His God was a spirit, a wind devastating or beneficent as himself.

These divisions of the human family, having the herd instinct in common with other animals, made God in their own image. Both set up an enmity, each of the other.

"The Disappearing City"
Frontispiece from book.
FLLW Fdn# 1019.009

The cave dwellers bred their young in the shadow of the wall. The mobile tribes bred their young under the stars in such safety as seclusion by distance from the enemy might afford.

So we may assume the cave dweller multiplied more swiftly than his brother. But more complete was his destruction, more terrible his waste when his defenses fell. His walls grew heavier as he grew more powerful. When he ceased to find a cave he made one. The fortification became his. Cities were originally fortifications.

The cave dweller's human counterpart cultivated mobility for his safety. Defenses, for him, lay in swiftness, stratagem, physical prowess and such arts as Nature taught.

As ingrained instinct of the human race now, in this far distance of time, are both these primitive instincts, though the wandering tribes seem, gradually, to have been overcome by the material defenses and the static forces of the material establishment of the cave dweller.

But I imagine that the ideal of freedom that keeps breaking through our establishments setting their features aside or obliterating them is due in some degree to the original instinct of the adventurer. He who lived by his freedom and his prowess beneath the stars rather than he who lived by his obedience and labor in the shadow of the wall.

However that may be here two human natures have married and brought forth other natures. A fusion of natures in some. A straining confusion in others. In some a survival, more or less instinct, of one or the other salient, archaic, characteristic instinct.

Gradually the body of mankind, both natures working together, has produced what the body of mankind calls civilization. Civilizations become conscious, insist upon, and strive to perfect culture. In this matter of civilization, the shadow of the wall has seemed to predominate, though the open sky of the adventurer is far from disappearing. As physical fear of brutal force and any need of fortification grow less, so the ingrained yearning for the freedom of the mobile hunter, surviving, finds more truth and reason for being than the stolid masonry or cave dwelling defenses erected and once necessary to protect human life and now slumbering in the manufacturer, the agrarian and the merchant. Those defenses, in any case, mod-

ern science and war have made useless and a man's value may again depend not so much on what he has as upon what he can do. So, by way of modern resources, a type is developing capable of changing environment to fit desires and offset losses to the type sinking permanently into the "shadow of the wall"—the big city.

It is already evident that life now must be more naturally conserved by more light, more freedom of movement and a more general spatial freedom in the ideal establishment of what we call civilization. A new space concept is needed. And it is evident, in this need, that it has come.

Modern mobilization, as a leading factor, is by way of modern means of transport, having its effect upon the nature of the cave dweller—this city brother who submitted obedience to man to be well saved by faith and not by works. But it is only a natural means of realization returning to his brother of the wandering tribe.

So, the "Machine" is at work moulding as well as destroying human character.

But survivals of human habit wait long for burial.

Man, mobile or static, is first a creature of habit. The habits bred by primitive instincts resist change, however reasonable the change, and will wear away as the dropping of water wears away stone.

All that any change in the conditions of life produces in the conglomerate man-mass at first is reaction toward the old order. Increased sentiment for the old, violence to the new.

But certain long subconscious desires rooted in these primitive instincts and never yet realized in the present dense order of centralization gradually find release and new means, in the new order of the machine age, to realization. As always, this new release and dawning realization acts positively in favor of the new and eventual destruction of the old life. Such is the order of change in the human habits bred by instinct.

A present instance: for generations the rural youth of Usonia[1] longed for the activity, the sophistication and prizes of the City. There he sought his "fortune." The great prizes were still to be had in accelerated human intercourse as well as in the human excitements to be found in the city. So when, by mobilization, he was made free to move he was by that aid moved cityward to gratify his longing.

The Uneconomic Basis of the City

Such human concentration upon the city has been abnormally intensified because, as hangover from traditions having their origin in other circumstances, three major economic artificialities have been grafted upon intrinsic production and grown into a legitimate economic system. Two of the three now uneconomic "economics" are forms of rent and are artificial because they are not intrinsic. Both are extrinsic forms of unearned increment. The third artificiality, unearned increment also, is so by way of traffic in machine-invention: another, less obvious, form of rent.

By the leverage of a mechanical acceleration never existing in the world before, the operation of these economic systems has been abnormally exaggerated and intensified.

The first and most important form of rent contributing most to poverty as a human institution and to the overgrowth of the cities is rent for land: land values, created by improvements or the growth of the community itself held by the fortuitous individual whose claim to a lucky piece of realty is good-fortune "by law." The profits of this adventitious good-fortune create a series of white-collar satellites all subsisting by the sale, distribution, operation and collection of the various unearned increments arising from traffic in more or less lucky land. The skyscraper is this adventitious fortune's modern monument. The city is its natural home.

The second artificiality is rent for money. By way of the ancient Mosaic invention of "interest," money, in itself, becoming alive to go on continuously working to make all work useless. The profits earned by money as a premium placed upon the accretions of labor, create another adventitious form of good-fortune. More armies of white-collar satellites are created busily engaged in the sale, distribution, operation and collection of this form of increment, unearned except as the gratuitous, mysterious premium placed upon earnings earned it.

The modern city is its stronghold.

The third artificiality is the unearned increment of the machine: the profits of this now great common invention of mankind, by way of traffic in invention, captained and placed where they do not belong except as capitalistic centralization itself is a proper objective. Inevitably by this means, the profits of imaginative ingenuity in doing the work of the world are almost all funneled into the pockets of fewer and fewer captains of industry. Only in a small measure—except by gift from the captains—are these profits yet where they belong—with the man whose life is modified, given or sacrificed by this new common agency for doing the work of the world.

Armies of high-powered salesmanship came into being to unload the senseless overvalues and overproduction, inevitable to this common machine-facility, upon the true owner of the machine; the man himself. In this third form of good-fortune another series of white-collar satellites arose, "selling." Selling by financing and collecting by threatening and foreclosure, or refinancing and "repossession." All, as a natural tendency, concentrating in fewer and fewer hands these various unearned increments, by the inevitable centripetal action of capitalistic centralization.

Now, to maintain in due force and legal effect all these various white-collar armies deriving from the three artificial "economic" factors and keep all dovetailing together smoothly, has inevitably exaggerated a simple natural human benefit. Government.

"That Government is best Government that is least Government" was the Jeffersonian ideal of these United States of America. But to keep peace and some show of equity between the lower passions busily engaged in getting money by these extraordinarily complicated forms of money-getting, legitimized by government, government ran away with government and itself became extraordinary. Another army of white-collarites to add to the other armies was the consequence. Major and minor courts, petty officials and their complex rulings themselves became this official army.

And now the multifarious laws enacted as complex expedients to make all function together bred, finally, still another white-collar army: the lawyers. It soon became impossible to hold, operate or distribute land, sell money or manufacture anything safely without the guide and counsel of these specialists in the extraordinary rules and regulations of this now involute game called machine-age civilization. No wonder the interpretations of these specialists, themselves, are often in conflict.

These satellites of rent in its several forms, too, are natural minions and mentors of cities.

This group of artificialities, naturally depending upon a strong-arm status-quo and, too, upon an expedient religion wherein men were to be saved by faith rather than by their own works, taken all together constitute the traditional but exaggerated and unsafe substitute for a sound economic basis of human society in the United States. They subsist as the substructure of the outmoded city; the inorganic basis of the inorganic city now battening and feeding upon all intrinsic sources of intrinsic production.

These intrinsic sources are the men who by manual toil or by concentration of superior ability upon actual production, physical, aesthetic, intellectual or moral—render "value received" to human life.

The Victim of the Battle of Increments

Meantime, what of the subject, or object or living man-unit upon whom, by his voluntary subordination this extraordinarily complicated economic superstructure, has been imposed, erected, and functions as government and "business"? What about the man himself? The man who labors out of the earth essential sustenance for all and the material riches for industry? Where, in all this, is the agrarian, the mechanic, the artist, the teacher, the inventor, the scientist, the artisan, hewers of wood and drawers of water?

All are pretty much in the same caste, no longer masters of fortune. Fortunes being engendered and controlled by schemers employing artificialities of a complex economic system resting upon no sound, broad basis in intrinsic production nor in the nature of man's relation to his earth. And these three false systems of false fortune place a false premium upon ignoble traits of character. Moreover, the three systems of good-fortune being thus necessarily maintained by the strong arm of a forced legitimacy, that arm—however strong—must tire and periodically come down for a rest while confusion and misery descend upon all or all become confused and in alarm, seek cover of some kind—somehow.

Where then is the genuine artifex in this tower of an economic Babel that finds its apex and ideal in exaggerated buildings and exaggerated enterprises in exaggerated cities?

Well, centralization has conferred certain human benefits upon him by stimulating machine development and expert mechanics while meantime, the essential rightmindedness and decency of humanity—the artifex—has gone on working with the machines trying to cultivate beauty, justice, generosity and pity: worshipping the one god, no longer a statue hidden in a cave but a great spirit ruling all by principle.

This god of the artifex is now a free spirit allowing man choice between what is good for him and what is bad for him, so that in free exercise of individual choice he may himself grow to be godlike.

The Experiment

Out of this confused life has come, gradually, the modern conception of God and man as growth—a concept called Democracy. And out of this concept, too, came the foundling: this nation conceived in liberty where all men were to have equal opportunity before the law; where vast territory, riches untouched, were inherited by all the breeds of the earth desiring freedom and courageous enough to come and take domain on the terms of the pioneer.

This new experiment in government soon became a great federation of states: these United States. A great nation harboring within its borders the adventuresome, the outcast, the cheated, the thwarted, the predatory worst and the courageous best, deserting previous nations.

With no corresponding revisions of traditional "property rights" the new country was founded upon this more just and therefore more complete freedom for the individual than any existing before in all the world: a government that should be "best government because least government." And a Thomas Jefferson crossing an Alexander Hamilton, a George Washington hand in hand with an Abraham Lincoln, a William Lloyd Garrison, a John Brown, an Emerson, a Whitman and a Thoreau, a Louis Sullivan, a Henry George—such were her sons. In them the original ideal was held, still clear. Then came, quickly, extreme private wealth by way of the three fortuitous money-getting systems, and soon commercial ascendancy and power outran culture. Unnatural reservoirs of capital made of little or no value such cultural understanding as the new country had. It was so easy to grow or gather or discover in the freshness and

the first spoils of a new ground, that fortunes piled up overnight in hands least fitted to administer either power or wealth, and both were willing to buy whatever they liked and what they should have grown. The suddenly rich needed a culture that could be bought or taken ready-made. The original idea grew more and more impractical. And such arts as had come to the new country with the decency of the early colonials naturally took ascendancy for a time. But, soon, with the advent of many nationalities came eclecticism in art and architecture. Ready-made art and architecture became a pressing need as the nation itself rapidly became the greatest eclecticism of all time. As culture, ready-made thus became a necessity, the expedient became a virtue.

Here for the first time in history a self-determining people subscribing to an ideal of new freedom sprang into being as a nation with a collection of ready-made cultures to piece together as best it could into a makeshift composite. The incongruities were enormous and begot abortions. Abortion became convenient, therefore desirable. Culture as a convenience consisted, at best, in a form of rebirth of rebirths until nothing was, or could be, born. All culture came to be selected, artificially adapted and soon was, by way of education, arbitrarily applied by academic advice to growing power and to developing resources. Inevitably such applied culture failed to qualify as impregnator of new life or as adequate interpreter of the new ideal on which the life of the country was originally founded.

So, as the new nation arose in might and riches, its crude natural resources, as culture, aborted strange, borrowed or "adapted" forms. Perversion or pretension became everywhere manifest. The new life itself outgrew the old forms, making them unnatural, but there seemed to be no imaginative power to impregnate life with new and natural forms because no constructive lessons could be learned by eclectic imitation. All was by way of personal likes or dislikes—a form of license in the name of the "classical."

Culture, impotent while power was enormous, itself became enormity, took refuge and committed enormities in the name of classic conformity. Names and styles had authority. Fashion ruled. Impotence became honorable. It was safe.

At length, parasiticism was raised to the level of an academic culture in the "new freedom" as the consequence of such utter confusion of choice by way of what selectious taste could buy. This was inevitable because the God of principle that was to rule the rulers of the country founded upon a more just expression of human liberty than men knew before did not inspire the people with a more sensible interpretation of life in the arts and crafts of that life. And now, into this vital department of the human mind, "Tradition" itself has entered as itself—an eclecticism. Art and architecture that had previously existed as parasite for five centuries imitated by parasites. Religion, too, sank to the level of eclecticism. This was necessary to maintain the general artificiality. The exploitation of the "formula" in all religion as well as in all art had the right-of-way.

Any nation, eclectic by nature, perhaps, could only, in matters of culture thus breed "tastes" that could only turn to "taste" as culture.

And the "academic" mistook a setting sun for dawn! The "pseudo," by official and academic order, ruled the mind. "American Culture" became a following after into the general darkness. What could it do except stumble or fall away where life insisted upon life?

There could be nothing in any such culture that could grow anything genuine out of the new soil if it would, except, as wealth and vicarious power increased, to overgrow centralized cities upon the ground upon which we were so newly founded. The Ideal was so quickly betrayed by sudden-riches.

The Jeffersonian democratic ideal, inspiring in the beginning, lacked nourishment in culture and so languished. Except as a mask might be imposed by the draper and haberdasher functioning as artists and architects, and high-powered salesmanship could sell both them and their product to the "successful," the facts of power and the surge of life of the new country were left to stand unqualified and ugly as mere necessity. But that naked necessity was better than their cultural mask.

Meantime Youth went to the professional eclecticism of the greatest colleges to be hopelessly confirmed as spiritual parasites.

▓ Thus has such culture as we have in the United States set itself up as something beautiful on life because we could not, or would not, learn how to be of life.

And life itself, as it is, goes on its subconscious and natural way in the channels of necessity performing the miracles to which culture itself now points with pride and wonderment . . . astonished that such things can be. Culture itself had to be rejected in order that the miracles might be and the scale of man-movement be utterly changed.

These miracles of technical machine invention with which culture has had nothing to do and that in spite of misuse and abuse are forces with which culture and life itself have now to reckon, working toward a new freedom, are the internal combustion engine working as various forms of mobilization; various forms of electric intercommunication; steel, glass and automatic machines; modern architecture.

Given electrification, distances are all but annihilated so far as communication goes. Given the automatons of machinery, and human labor, relatively, disappears.

Given mechanical mobilizations, the steamship, airship, automobile, and mechanical human sphere of movement immeasurably widens by way of comparative flight.

Given a modern architecture, and man is a noble feature of the ground as the trees and streams are such features. An architecture for the individual becomes reasonable and possible. The individual comes into his own.

The Case for the Individual

Buddha believed that only non-vicarious, that is to say individual, effort might reach the ultimate.

Jesus taught the dignity and worth of the individual developed from within as an individual, although Christianity perverted the teaching.

The Catholic Church discounting this ideal as every man for himself and the devil for the hindmost, emphasized the desirability of the utter disappearance of individuality which is more or less the politics of all agrarian peoples—but not their practice. The Protestants brought individuality, partially, back again. As a confused ideal. But some 500 years before Jesus the philosophy of the Chinese philosopher Laotze had a sense of individuality as achieved organic unity. Our own ideal social state, Democracy, was originally conceived as some

such organic unity—that is to say—the free growth of many individuals as units free in themselves, functioning together in a unity of their own making. This is the natural ideal of democracy we now need to emphasize and live up to in order to regain the ground we have lost to the big cities centralization has overbuilt.

The "rugged individualism" that now captains our enterprises and becomes the "capitalist" is entirely foreign to this ideal of individuality. The actual difference between such "ism" and true individuality is the difference between selfishness and selfhood; the difference between sentiment and sentimentality; the difference between liberty and license.

And such individual "ism," literally "every man for himself and the devil for the hindmost," aggravated by the misuse of vicarious power has got native individuality into bad repute. Like the abuse of any good thing it is likely to bring on reactionary consequences. Signs of this reaction are not wanting. No counteraction can come from such culture as we have assumed because in such art as we know the personal idiosyncrasy as personality is too easily and generally mistaken for individuality. Sterility is the natural consequence of the vicarious exercise of power that is our modern characteristic, where creative ability should be concerned as individuality.

As a matter of fact until Usonians recognize that individuality is a high attribute of character, seldom common, always radical, and so always truly conservative, a matter of the soul: we have no defense.

Personality run to seed is not individuality. The will and the intellect working together for desire cannot make individuality. They can only make a human monster.

True individuality is, above all, an interior quality of the spirit or let us say individuality is organic spirituality—to couple two words almost never joined in our conversation or philosophy.

But it is a popular weakness or error to speak of spirituality as apart from the body, instead of its essential significance. Any true significance can only be the spiritual indication of whatever is material. If such significance is lacking, then life itself must be lacking. Wherever there is life there is significance. The insignificant is without life.

Individuality then may be said to be the organic significance of any person or any soul as distin-

guished from mere personality. So the true man is, always, from first to last concerned with significance in this sense and recognizes its integrity. Individuality, then, is such integrity whether of persons or of things.

Without individuality in this fundamental sense as a human integrity what life may there be but vicarious life only? There can never be great Life, so there can never be great Art.

Therefore we should be careful how we turn upon individuality sickened by flagrant abuses in its name. Capitalism may be individualism run riot. But individuality is something else. Necessarily it has nothing to do with capitalism, or communism, or socialism. The "ism" in any form has no individuality. The Formula has already taken its place when the "ist," the "ism" or the "ite" may be applied. And that was why all the great religious teachers—Jesus, Abdul Bahai, and Laotze especially—wanted no institutionalizing, no officialdom, not even disciples except as "fishers of men."

But human nature, by way of the human head, is yet weak and can only function on civilized lines, it seems, by way of the groove or the rail. Or more probably the rut.

So the rut is respectable and advised as "safe." And the rut is too often called law and order, when it should be seen and recognized as only the rut. Individuality soon becomes a menace to any form of rut-life. So rut-life turns against Individuality.

The Broadacre City[2]

We are concerned here in the consideration of the future city as a future for individuality in this organic sense: individuality being a fine integrity of the human race. Without such integrity there can be no real culture whatever what we call civilization may be.

We are going to call this city for the individual the Broadacre City because it is based upon a minimum of an acre to the family.

And, we are concerned for fear systems, schemes, and "styles" have already become so expedient as civilization that they may try to go on in Usonia as imitation culture and so will indefinitely postpone all hope of any great life for a growing people in any such city the United States may yet have.

To date our capitalism as individualism, our eclecticism as personality has, by way of taste, got in the way of integrity as individuality in the popular understanding, and on account of that fundamental misunderstanding we, the prey of our culture-monger, stand in danger of losing our chance at this free life our charter of liberty originally held out to us.

I see that free life in the Broadacre City.

As for freedom; we have prohibition because a few fools can't carry their liquor; Russia has communism because a few fools couldn't carry their power; we have a swollen privatism because a few fools can't carry their "success" and money must go on making money.

If instead of an organic architecture we have a style formula in architecture in America, it will be because too many fools have neither imagination nor the integrity called individuality. And we have our present overgrown cities because the many capitalistic fools are contented to be dangerous fools.

A fool ordinarily lacks significance except as a cipher has it. The fool is neither positive nor negative. But by way of adventitious wealth and mechanical leverage he and his satellites—the neuters—are the overgrown city and the dam across the stream flowing toward freedom.

▚ It is only the individual developing in his own right (consciously or unconsciously) who will go, first, to the Broadacre City because it is the proper sense of the dignity and worth of the individual, as an individual, that is building that city. But after those with this sense the others will come trailing along into the communal-individuality that alone we can call Democracy.

But before anything of significance or consequence can happen in the culture of such a civilization as ours, no matter how that civilization came to be, individuality as a significance and integrity must be a healthy growth or at least growing healthy. And it must be a recognized quality of greatness.

In an organic modern architecture, all will gladly contribute this quality, as they may, in the spirit that built the majestic cathedrals of the Middle Ages. That medieval spirit was nearest the communal, democratic spirit of anything we know. The common-spirit of a people disciplined by means and methods and materials, in common, will have—and with no recognized formula—great unity.

Already the centripetal city is itself an "ism" for ists and ites. Individuality has no longer a place in it more important than a burrow. Individuality is driven into nooks and corners or thwarted or aborted: frustrated by the mass-life only competing with, never completing, life.

So no healthy human-soul may longer grow or long survive in the vicarious life of the machine-made city because life, there, must be a surrender of true correlation of the human faculties to the expedient in some form; expedients imposed senselessly upon every soul in it to no purpose at all—except as they may be found to be some form of rent.

Voluntary self-sacrifice may be constructive. But to be condemned to the servile sacrifice of a voluntary life-long use of petty expedients to get by to, eventually, nowhere, is quite another matter. The human soul grows by what it gives as well as by what it feeds on. But the soul does not grow by what is exacted from it. Urban life having served its term is become a life-sentence of vicarious acts and the petty exaction of the expedient. A life outmoded. The big city is no longer modern.

Change

Let us say that before the advent of universal and standardized mechanization, the city was more human. Its life as well as its proportion was more humane.

In planning the city, spacing was based, fairly enough, on the human being on his feet or sitting in some trap behind a horse, or two. Machinery had yet brought no swifter alternative. And a festival of wit, a show of pomp and a revel of circumstance rewarded life there in the original circumstances for which the city was planned. So, originally the city was a group life of powerful individualities true to life, conveniently enough spaced. This better life has already left the modern city, as it may, either for travel or the country estate. And such genius as the city has known for many a day is recruited from the country: the foolish celebrant of his "success," as such, seeking the city as a market, only to find an insatiable maw devouring quantity instead of protecting quality—eventually devouring himself as it is now devouring itself. "Fish for sale in the market-place" but none in the streams. Frequent escape is already essential to any life at all in the overgrown city which offers nothing to the individual in bondage he cannot better find on terms of freedom in the country.

What, then, is the overgrown city for? The necessity that chained the individual to city life is dead or dying away. It is only as life has been taken from him and he has accepted substitutes offered to him that the "citizen" now remains.

The fundamental unit of space-measurement has so radically changed that the man now bulks ten to one and in speed a thousand to one as he is seated in his motor car. This circumstance would render the city obsolete. Like some old building the city is inhabited only because we have it, feel we must use it and cannot yet afford to throw it away to build the new one we know we need. We will soon be willing to give all we have, to get this new freedom that is ours for our posterity, if not for ourselves.

Devouring human individuality invariably ends in desertion. Eventually, as history records, it invariably ends in the destruction of the devourer.

Instead of being modern in any phase the devourer is senile in every phase.

"Find the Citizen"
FLLW Fdn# 1019.009

The Whirling Vortex Built from the Top Down

The overgrown city of the United States stands, thus, enforced upon our undergrown social life as a false economy.

Like some tumor grown malignant, the city, like some cancerous growth, is become a menace to the future of humanity. Not only is the city already grown so far out of human scale by way of commercial exploitation of the herd instinct that the human being as a unit is utterly lost, but the soul, properly citified, is so far gone as to mistake exaggeration for greatness, mistake a vicarious power for his own power, finding in the uproar and verticality of the great city a proof of his own great quality. The properly citified citizen, reduced to a pleasing inferiority in the roar of congestion and terrific collision of forces, sees in this whirling exaggeration, his own greatness. He is satisfied to have greatness, too, vicarious.

But who, coming into New York, say, for the first time, could feel otherwise than that we were a "great" people to have raised the frame of such a relentless commercial engine so cruelly high, and hung so much book-architecture upon it regardless, at such cost?

Such energy, too, as has poured into a common center here to pile up material resources by way of riches in labor and materials and wasted attempts at "decoration," cramming the picturesque outlines of haphazard masses upon the bewildered eye peering from the black shadows down below? We see similar effects wherever irresistible force has broken and tilted up the earth's crust. Here is a volcanic crater of blind, confused, human forces pushing together and grinding upon each other, moved by greed in common exploitation, forcing anxiety upon all life. No noble expression of life, this. But, heedless of the meaning of it all, seen at night, the monster aggregation has myriad, haphazard beauties of silhouette and reflected or refracted light. The monster becomes rhythmical and does appeal to the love of romance and beauty. It is, then, mysterious and suggestive to the imaginative, inspiring to the ignorant. Fascinating entertainment this mysterious gloom upon which hang necklaces of light, through which shine clouds of substitutes for stars. The streets become rhythmical perspectives of glowing dotted lines, reflections hung upon them in the streets as the wisteria hangs its violet racemes on its trellis. The buildings are a shimmering verticality, a gossamer veil, a festive scene-drop hanging there against the black sky to dazzle, entertain and amaze.

The lighted interiors come through it all with a sense of life and well-being. At night the city not only seems to live. It does live—as illusion lives.

And then comes the light of day. Reality. Streams of beings again pouring into the ground, "holing in" to find their way to this or that part of it, densely packed into some roar and rush of speed to pour out somewhere else. The sordid reiteration of space for rent. The overpowering sense of the cell. The dreary emphasis of narrowness, slicing, edging, niching and crowding. Tier above tier the soulless shelf, the empty crevice, the winding ways of the windy, unhealthy canyon. The heartless grip of the selfish, grasping universal stricture. Box on box beside box. Black shadows below with artificial lights burning all day in the little caverns and squared cells. Prison cubicles. Above it all a false, cruel, ambition is painting haphazard, jagged, pretentious, feudal skylines trying to relieve it and make it more humane by lying about its purpose. Congestion, confusion and the anxious spasmodic to and fro—stop and go. At best the all too narrow lanes, were they available, are only fifty per cent effective owing to the gridiron. In them roars a bedlam of harsh sound and a dangerous, wasteful, spasmodic movement runs in these narrow village lanes in the deep shadows. Distortion.

This man-trap of gigantic dimensions, devouring manhood, denies in its affected riot of personality any individuality whatsoever. This Moloch knows no god but "More."

Nowhere is there a clear thought or a sane feeling for good life manifest. In all, even in the libraries, museums and institutes is parasitic make-believe or fantastic abortion. But, if the citizenry is parasitic, the overgrown city itself is barbaric in the true meaning of the word. As good an example of barbarism as exists.

How could it be otherwise?

Some thriving little village port driven insane by excess: excess of such success as current business ideals or principles knows as such. And it is nothing more than much more of much too much already.

The finer human sensibilities become numb.

And even the whole callous, commercial enterprise, pretentious as such, stalls its own engine!

Otherwise the interests that built the city and own it, and spend millions upon it and devote such prowess in the arts as we have to making its purpose—rent—acceptable to the millions, are in immediate danger of running each other down in the perennial race for bigger and better building bait for bewildered tenants, as the factual forces that built the city out of this competition for swarming tenantry in one form or another, built it only to tear it down.

The Forces That Are Tearing the City Down

Let us turn, now, to these forces that are thrusting at the city to see how they will, eventually, return such human nature as survives this festering acceleration, body and soul to the soil, and, in course of time, repair the damage cancerous overgrowth has wrought upon the life of the United States.

As one force working toward the destruction that is really emancipation, we have already mentioned the reawakening of the slumbering primitive-instinct of the wandering tribe that has come down the ages and intermingled with the instincts of the cave dweller.

The active physical forces that are now trained inevitably against the city are now on the side of this space loving primitive because modern force, by way of electrical, mechanical and chemical invention are volatilizing voice, vision and movement-in-distance in all its human forms until spaciousness is scientific. So the city is already become unscientific in its congested verticality and to the space-loving human being, intolerable. The unnatural stricture of verticality can not stand against natural horizontality.

As another force—a moving spiritual force—the fresh interpretation to which we have referred as a superb ideal of human freedom—Democracy comes to our aid. Our own new spiritual concept of life will find its natural consequences in the life we are about to live. We are going to move with that new spiritual concept the nation has been calling Democracy only half comprehending either ideal or form. This ideal is becoming the greatest subconscious spiritual moving force now moving against the city with new factual resources.

Surviving instincts of the freedom-loving primi-

tive; these new instruments of civilization we call the machines working on new and super materials, together with this great new ideal of human freedom, Democracy: these are three great organic agencies at work, as yet only partly conscious but working together to overthrow the impositions and indirection that have fostered and exaggerated the city as an exaggerated form of selfish concentration. No longer do human satisfactions depend upon density of population.

Let us glance at these new agencies at work as machines upon the super-materials that are forcing changes upon this "best of all possible worlds" and go, more in detail, into this new sense of freedom already at work as Modern Architecture.

The New Standard of Space Measurement

In previous times, too much legwork being objectionable, and as human intercommunication could only be had by personal contacts, integration, commercial or social, was difficult—if it was not wholly lacking except as the city was a close built mart, a general meeting place and a distributing center. So, cities originally grew that way to serve a human need. Human concentration was once upon a time, a necessity and not unmixed evil. Cities grew, as said before, as some organism within the organism that is our body grew, a non-malignant, fibrous tumor, say. The acceleration of circulation and activity characterizing the parasitic tumor characterized the centralized concentration called the city, as compared with the normal course of life in relation to natural environment and agrarian or industrial work over wide agrarian areas. The cities of ancient civilization so grew, originally, to relieve a lack of such integration as is now modern and they have all perished. European cities have resisted skyscraper exploitation and are, still, nearer to human scale. But now, owing to organic change, assuming malignant character, our skyscraper exploited cities must continue to grow as symptoms of disease that is relieved by fever and discharging matter. Or death.

But to take a less abhorrent view, cities were the centralization needed by the unorganized life of the country and on terms of concentration neces-

sary then, they served and, resisting exploitation, survived. But our American cities accepting such exaggeration with pride, have sucked the substance and the spirit of the very life they "centralized." The country once needed the city just as the city needed the country because of the physical inabilities of overcoming distance owing to the necessities of such primitive communications as were then at work. But more and more as those primitive limitations disappeared by way of developed invention, the new discoveries of science and the increasing use of laborsaving devices upon super-materials, these new devices and resources perverted the city, and enabled the city to absorb more and more from the country life what the city could never repay.

Finally, by force of thoughtless habit, the principal effect of all these powerful, fundamental, new physical resources which humanity itself has developed has been, in confusion, to exaggerate the no longer necessary city into a threat against life itself.

Owing to the pressure of these fundamental changes the fever and the excitation of the urban ganglia have not only grown phenomenal. They have grown deadly.

To look at the plan of any great city is to look at the cross section of some fibrous tumor. Seen in the light of present space needs there is unnatural concentration of tissue, an accelerated but painfully forced circulation.

Out of essential concentration centripetal centralization became the industrial economic force at work, unchecked. Unchecked. What force can check centralization?

Centralization, the social force that made kings, is the economic force that overbuilt cities. Centralization, by way of the leverage of the vicarious power of machinery, has now proved to be something that, winding up space tighter and tighter, is like a centripetal device revolving at increasing speed until, out of control entirely turning centrifugal, it is ended only by dissipation or destruction. Centralization as a centripetal force knows acceleration. What other control?

Government? No.

Only human intelligence grasping machine-power exaggeration and interference in behalf of human-ity in order to employ machines as organic agencies industrial, social, moral, of a new freedom: in this lies the only salvation from such urban centralization as the big city has become and the future of the machine age if the machine age has any future.

The Nature of Modern Resources

We have already mentioned these machine-age agencies of the new freedom which centralization itself has done much to bring to efficiency and that have immeasurably widened the areas of man-movement. But to reiterate:

Agency number one. Electrification: so far as communication is concerned, the city may now scatter. There is little advantage in a few blocks apart over ten miles apart or a thousand miles so far as communication went or goes. Human thought has long ago been rendered ubiquitous by printing. But now not only thought but speech and movement become volatile. First the telegraph, then the telephone, then mobilization, now the radio, soon television and safe flight.

Agency number two: Steam had congested and coupled as short as possible all human devices for living comforts. Enters, the internal combustion engine that might safely ride anywhere, smoothly working as it went. The motor-ship, the automobile, and the airplane came along; and so far as human movement by transport went, a few hundred feet had little advantage over a mile, and a mile not much advantage over ten. Hard roads began to be developed as avenues of swift, continuous motor communication.

Agency number three: Mechanical systems of refrigeration, heating and lighting make dependence upon the centralized service systems of the city unnecessary and of small account or economy.

Agency number four: The new materials, steel-in-tension and concrete, glass and broad, thin, cheap sheets of metal and similar sheets of insulation make a new type of building possible by way of machinery that may open to environment and broaden the life of the individual in relation to the ground.

Agency number five: The mass production of the machine, shop fabrications can now make expensive utilities and accommodations cheap for all

concerned instead of questionable luxuries for the few.

So, naturally enough, here come the means to take all the real advantages of the centralization known as the big city into the regional field we call the countryside and unite them with the features of the ground in that union we call modern architecture in that native creation we call the beauty of the country. The disadvantages of the city may all be left behind, for "finance" and prostitution until they too become regenerate.

▦ Modern architecture now comes with its new demand for a finer integrity to unite "modern-improvements" in the service of the individual. Integration as against centralization is the true corollary of the ideal "Democracy" and decentralization and integration come in as architecture to go to work over the whole land to create a better basis and re-create the framework and background of a modern life run too far out of human scale. Man must now be brought back to his inheritance that he may be a whole man. Nor is there longer excuse for him to be the parasite that centralization has been making of him.

But all these new forms of liberation are not yet working freely for mankind in this way. They are not yet owned by the man. They are owned by the forces of centralization that own the cities and mechanically so far as may be they are warped to triplex economic distortion instead of being devoted to the conservation of a growing human life.

Nevertheless, we may be sure that "all one does for or against the truth serves it equally well."

It is well within the internal nature and power of these forces, themselves organic, to destroy these systems that blindly usurp and warp them and deprive humanity, for the time being, of all but a small fragment of the benefits of new resources in machine power and super-materials.

The practical solution is a matter of social structure. But it is more a matter of what we call architecture. It is modern architecture that must lead the way out of this blind collision of forces and away from the perversions of our democratic ideal. End a waste of life not natural to our experiment in civilization.

Let us learn to see life as organic architecture and learn to see organic architecture as life. Be sure that great life will have a great architecture.

What the Traffic Problem Really Means to the Man in the Street

In art or architecture any imitative eclecticism, however sophisticated, is only some form of sentimentality. At best it can be no more than some exploitation of something ready-made. At worst it is a kind of thievery. The jackdaw, the magpie, the cuckoo. The monkey.

The "Experiment" has consciously known the artist only as a sophisticate sentimentalist. The sentimentalist, at the moment, be it said, is trying hard to see himself as a functionalist. But the sentimentalist's faith learns no such lessons and, to date, his effort is only another form of his usual expediency—imitative eclecticism.

Too long the artist has tried to pick and choose his "effects" ready-made and opportunely lead his life instead of letting life lead him, and teach him how to work and live honestly and effectively.

The artist's faith still lies, as it has since the birth of the republic, in expedients. So long as he remains "unnatural" how can he build for the future?

Only the radical faith that keeps faith with radical life itself is practical where any true building is to be done.

So, let us approach the traffic problem as a human problem—that is the essential problem the congested city now presents—not as mere tinker or as some garage-mechanic, nor childish, try to tear the out-moded city down to get the green pastures in and set the city up in them again on its old site—feudal towers only a little further apart.

Vested interests once invested cannot be divested except by agreement. They will not agree.

With an architect's vision, let us observe the natural law of organic growth at work upon the city as change: seeking the sequence to provide for inevitable consequences.

Enough blind-alley nonsense has been talked about congestion, by skyscraperites, obscuring the simple issue. Of what practical use is this expedient imagery of super-spacemakers for rent? To enable super-landlords to have and to hold the super-

millions in super-concentration to make super-millions of superfluous millions?

For organic reasons the "traffic-problem" as we call the more obvious problem of the city streets is insoluble for the future on any basis satisfactory to human life within any busy city we have.

The instincts of the amorphous human herd exploited by the city, swarm with the swarm in the erstwhile village streets, but the swarm is taking wing—or to wheels which is much the same thing because increased facilities of lateral movement are comparative flight. A fond human dream is about to be realized.

By means of the motor car and the collateral inventions that are here with it, the horizon of the individual has immeasurably widened. It is significant that not only have space values entirely changed with the new standard: It is more important that the new sense of spacing based upon the man in his motor car is now at work upon the man himself. Any ride high into the air in any elevator to-day only shows him how far he can soon go on the ground. And it is this view of the horizon that gives him the desire to go. If he has the means he goes. He has the means—his car—and his horizon widens as he goes.

This physical release is at work upon his character.

His selfish interests might easily multiply and pile him up senselessly in tiers of cells, ad infinitum when he got his release and may still do so. Still dazed by his new freedom, he is like some bird born in captivity to whom the door of his cage has been opened. Sometime, soon, he will learn that he can fly and when he learns that he is free, he is gone.

After all he is the city? So the city is going where and as he goes, and he will be gone where he may enjoy all that the centralized city ever really gave him plus the security, freedom and beauty of the ground that will be his.

That means that the citizen is going to the country with his machine by means of the machine, in larger sense, that is opening the way for him to be a better citizen in a better city in a better country.

▦ Considering this traffic-problem, reflect that the present city is yet only about one-tenth the motor car city it will be, if machine made promises to the man tied to the machine are ever kept. Any dutiful devotion to the machine on his part to-day should mean a motor car, comparative flight—or it means a moron for a citizen. Or a maniac. The citizen and his increase either have a car or dream of having one, envying the neighbor the one or two or three which he already has.

If grid-iron congestion is crucifixion now, what will the "grid-iron" be like when multiplied within a few years as many times by "success" as is inevitable?

Roughly calculate the mass of machines that machine-age "success" must mean to the overgrown city of one of several to six million people. More than one half the number of private cars; perhaps one twenty-fifth as many trucks and as many delivery machines, one fiftieth as many buses displacing street car tracks and unwholesome subways; thousands of taxi-cabs cruising about meantime. With room enough for each incidental transient, in his machine-bulk, to function at all lengthwise, the mass would fill the busy city channels above the tenth story.

Allowing for the criss-cross on the gridiron, making every street only half-time efficient and the mass would double and pile up over the skyscrapers themselves. Call this exaggeration and cut it in two—then cut it in two again, to be rash. There will be enough left, at the rate of increase "success" will bring, to put Manhattan and its kind out of commission with its own motors and those of inevitable transients in streets that can at best be but fifty per cent efficient owing to the crisscross of the grid-iron.

And reflect upon the fact that the motor car has just begun on the cities. Then why deck or double deck or triple deck city-streets at a cost of billions of dollars only to invite further increase and eventually meet inevitable defeat?

Why not allow citizenship to keep the billions it would have to pay for "decking" to buy more motor cars and get out and get more out of living in a more natural and fruitful life as freedom dawns on the citizen as for him? As the new freedom of our ideal dawns, the utility of the city vanishes by way of the machine that built it.

Yes, democracy means just that freedom for the citizen, by machine, if the machine is going to work for the citizen; and who can stop it now from going

to work for him voluntarily as it is working involuntarily?

Let us repeat: monarchy was the ideal of centralization . . . the unit—no emphasis upon individuality—compelled to revolve around about a common center, so democracy is the ideal of integration . . . many units free in themselves built up high in the quality of individuality, functioning together in freedom.

Consider that monarchy has fallen. It mortified democratic individuality. And our capitalistic system, if it persists as a form of centralization, stands to fall for the same reason. Electrified mechanical-forces employed in building our modern world are now, by nature, outmoding it and turning upon it to destroy it.

Centripetal centralization, whether as the city, the factory, the school or farm, now not only has the spiritual forces of democracy to work against, but by way of this traffic-problem has the enormous power of the machine-age setting in, dead against it because it is in the nature of universal or ubiquitous mobilization that the city spreads out far away and thin.

It is in the nature of flying that it disappears.

It is in the nature of universal electrification that the city is nowhere or everywhere.

Centralization, by way of the Usonian city, has had a big day but not a relatively long day. As a matter of course it is not dead yet. But it is easy, now, to see that it is no longer either a necessity or a luxury. Universal mobilization of the human animal, volatilization of his thought, voice and vision are making the city as troublesome an interference to human life as "static" is troublesome to radio.

Already the man may get more out of his new release, by way of increased facility for lateral movement, than ever came to him before in the history of his race. Imagine, then, what is coming to him in the next twenty-five years!

Democracy reintegrated as the systematized integration of small individual units built up high in quality of individuality is a practical and rational ideal of freedom: machine in hand. Division of the exaggerated commercial-enterprise into more effective smaller units and reintegration over the whole surface of the nation—this is now no less practical. Communal ownership by way of taxation of all communal resources is not necessarily communism, as Henry George pointed out with complete logic. It may be entirely democratic.

So the Broadacre City is not only the only democratic city. It is the only possible city looking toward the future. Exaggerated vertical lanes of transport impinging upon congested, narrow horizontal lanes; tall channels as "courts" ruinous to privacy, makeshifts for light and air in offices or habitations, towering concrete shelves and pigeonholes for human dwellings, these are landlord expedients to have done with. They are no human solution of any "traffic problem" because there is no life in them. There is only rent. As for the proposed improvement, "by modernism," securing privacy by hermetically sealed and blinded buildings, hot air circulating between two glass surfaces opaque or transparent, that proposed expedient means to heat the inside and the outside impartially—50-50—with no gratitude from the outside. And 1,000 people to the "hectare" (two and a half acres) is looking not so far ahead. That is, now, 990 too many.

The New Idea of Luxury

None may say how far man's liberation may go by proper use of the mechanical resources developed in the past century and by proper use of the new materials like steel and glass in the new spirit of an organic architecture.

Trained imagination of the same mind is needed to harness modern machines to higher uses, in order to get out of them what they have to give to expand human life.

A new idea of luxury and beauty is needed and must grow up, naturally here among us.

Power directly and simply applied to purpose is the clear basis of any such aesthetic expression now as is either utile or operative in this twentieth century. Machine-age luxury will consist more and more in the appropriate use and intelligent limitation of the machine at work in the making of the new patterns for the new life.

But why try to make buildings look as hard as machines? That means that life is as hard as machines, too. Why confound romance with sentimentality and so destroy both? Modern buildings should have the beauty that any well-balanced

machine has, but before all, that is only the basis for beauty, however novel at the moment, the assertion of the negation. Machine-power directly and simply applied to purpose is only the basis for buildings because it has been discovered that a single mechanical unit may be indefinitely repeated in construction or use, and yet infinite variety of form and scheme may be the given result in hands guided by creative imagination.

It has been discovered, too, that severe standardization is no bar at all to even greater freedom in self-expression than was ever known before, if by self-expression we mean genuine individuality and not personal idiosyncrasy. And these two discoveries are the Magna Charta of the new liberty into which the architect may now go by way of machinery and go in his own machine into a modern architecture. And the man himself may go to join the more natural group of the more natural buildings of the more natural Broadacre City of the Twentieth Century.

All unknown to the citizen, that city has already begun to be built on the ground where he belongs.

Only short-sighted interests can deny that the present-day city, in the light of our new opportunities, has become a stricture in distribution and transport; a handicap in production; an imposition upon family life. And the family holds within itself the seeds of the future! The traffic problem is not a symptom of urban success but evidence of urban failure. Make the ground available by modifying the terms of ownership to the man that can make good use of it, and the new city will grow fast. Otherwise it will grow but grow more slowly and by greater suffering. What then is the thought that is modern and working for the organic change that is growth?

What Thought—as Modern—Is Bringing Relief?

Well—certainly not the same old thought that made our American cities a landlord's triumph.

Certainly not the same old thought that has impoverished our agrarian areas . . . and offers—"relief"?

Certainly not the same old thought that turns America's youth into white-collar men, and sends them to the city in search of a job . . . a job where at least one hand may be kept in the pocket!

Certainly not the same old thought that has made of our economic system a legalized "strong arm" that must weaken periodically to come down for a "rest" while we all gravitate toward starvation in the midst of plenty.

Nor can we imagine it to be the same old thought that looked for freedom by way of arbitrary laws having no foundation in basic economic structure nor in the character of our ideal, resulting only in senseless reiterations by political cowardice, of falsehood: drifting again toward the same old impotence or cataclysm of centralization of which all civilizations, hitherto, have died.

That same old thought has made of this form of centralization we call the city a conspiracy against man-like freedom just as it made American architecture a bad form of surface-decoration; and just as, now—a typical if minor instance of impotence—it can offer for the fifth time only the same old Columbian Fair of 1893 with its face lifted, as progress, to mark our greatness in 1933.

That same old thought, as we may now see, places most of its premiums upon baser qualities and by way of privileges in property held out, always just ahead of him, tends to make the man a form of property himself.

The "same old thought" continues to standardize him as a piece of property in behalf of property, or breaks him.

That "same old thought" drives our universities to deprive the American youth of such correlation as he has, turning his mind into an empty tool box by throwing books at his head.

That "same old thought" makes the banker a wary professional acquisitive, by banking on Yesterday stalling or betraying Tomorrow.

That "same old thought" immures the man in the same old man-trap . . . the skyscraper Bedlam . . . where machine power emasculates him to the consistency of the machine-made moron, when machine power can have no meaning whatever except to help make him a man and set him free.

That "same old thought," simply stated, is this: the mistake that everything or anything at all worth any man's time can be made to happen by outside means or be the result of some external idea of form. And it is the confusing survival of such exterior ideal as characterized the pagan civilizations

upon which we have nurtured our youth and after which we have patterned our institutions. From this we have derived the pretentious Usonian culture we try to apply on the surface. All, inorganic.

What then is this idea we call modern?

Life as organic architecture and organic architecture as life.

The enlarged means of today employing super-materials and machine power, allowed to be today, not yesterday, is modern.

But more important still the new democratic conception of man-freedom where life or land or humanity itself is concerned, is modern.

The dignity and worth of the individual as an individual—not the mere personal idiosyncrasy—ancient as the ideal is, as basis for life or art is modern.

The sense of the within unfolding, by interior content to achieve genuine expression as individuality, ancient as Laotze at least, is modern . . . modern in manhood, modern in government: but especially modern in education and slowly and painfully becoming modern in art.

True simplicity seen as the countenance of organic-integrity in all man-made life-concerns: that, as it ever was—outward form, only, now changed—is modern.

Infinitely these new integrities have new possibilities in making a modern life for the machine-age.

And modern architecture, it must be, will grasp the integrity of this modern demand of modern life for a new and higher spiritual order of living: perceiving finer integrity in a more livable human simplicity than was the necessary basis for such architecture as we have had.

The new enlarged means of today used to increase spaciousness in human living and bring back appropriate sense of space in human life itself will give us the Broadacre City, complete. Modern.

If you can see the extended highway as the horizontal line of Usonian freedom, then you will see the modern Usonian city approaching.

And it is now modern to hate the waste of power and be suspicious of this opportunity to be vicarious that is forced upon the human being by the senseless reiteration of insignificance we call the city.

It is now modern no longer to build or consent to live in the prettified cavern or take pleasure in the glorified cave. Such vainglory is not only antique, but worse, it is now false. Improved conditions of life make it not merely an expedient but an impediment.

So it is modern to believe in, to see as new, and to seek for organic simplicity and see it as the fine countenance of this machine age in which we live.

Modern architecture sees this new simplicity working up out of the ground into the sunlight as no box, no boxment, nor any burrow in any overgrown city whatever. When the citizen himself sees this, the modern Broadacre City has come into being for him. He is "on his way" there.

Modern Architecture

Modern architecture sees all of life in terms of this future city although modernism can not do so.

Nevertheless, walls as solid-walls, everywhere building is sensible, are vanishing.

The heavy bulks of building material, hollowed out as caves to live in, are gradually disappearing with the fortifications that protected the might of feudal estate, just as shadows vanish.

No free man in a modern America needs to "box up" or "hole in" any longer for "protection" in any building or burrow in any city whatever. Our country, notwithstanding "vested interests," is gradually becoming as free as our own ideal must eventually and naturally make it. I see all the resources in power and material we have, working now to make our ideal of freedom come true in these United States. What need have we, longer, for master or slave however disguised? Or for lord and serf? Where is the need for more imitation of the exaggerated feudal-masonry defenses of a foregone, outlived human enmity by whatever name urban "interests" may choose to call them? Or for whatever purpose they may be thought to be appropriate decoration.

In a genuine democracy, in modern circumstances, no man needs longer to live as the savage animal as man was once compelled to live. Any man may now live as the free being the best of him has always dreamed of being and as our experiment declared he would have the opportunity to be.

Modern architecture then simply reinterprets

our own ideal of human freedom and naturally seeks the spaciousness, openness, lightness and strength that is so completely logical that it is bound, on its way, to scatter a diseased urbanism first into the regional field and then—as inadvertent disease is absorbed—into the circulation of the healthy body that is the whole country.

These modern gifts of glass; these modern gifts of steel-in-tension; these modern gifts of electromagnetic science—all these gifts begin for us a new era as soon as we begin to use them in the light of ancient principles but new ideals of form. So simple and fundamental are the natural agents of this new freedom for mankind that they are already all in the citizen's hands. If he will take them, as they are, they are his means to modern life.

Facility to roam the sky or ground and yet live with the perfect freedom of vision that will relate him to the ground and all that the ground should still mean to him, is already possible.

Architectural values are human values or they are not valuable. So any true modern building is born of organic integration and rises, as the modern city rises, enemy to centralization in whatever form. Both building and city are now true sun-growth and true sun-acceptance or not modern. The building itself may be a shaft of light flashing in the sun. And both building and city be no less true defense against time and against the elements than ever.

Modern architecture may be no less true shield for whatever privacy humanity desires or needs, but it may be indestructible machine-made fabric of light metals, woven in webs of turquoise, blue or green and gold and silver or the deep hues of bronze. Or the building may be visible as all together and as the integral patterns of a free life.

But organic architecture does demand the ground be made available on some fair basis to those who can use it as an intrinsic human value as are all the other elements. Once emancipated from the tyranny of the "lucky lot" area wherever it may lie, the building will stand free or lie long and lie low, flowing lazily on the mesa or upon the ledges of the hillsides. Any building public, private or industrial may now be a shaft or a streak of light, enmeshed in metal strands, as music is made of notes. But what is any building, as architecture, without intimate relation to the ground? No more than a man-trap or a landlord's ruse.

Organic architecture, as life itself, can no longer allow the man himself to crawl toward any dubious, impotent past, blind to the forces that ruined the past and to the new constructive forces that waken for us in our age of the machine.

Why should stupid faith—in the name of loyalty—in doctorial facts of sentimentalized academic culture result, for him, only in an afterglow of feudalism?

Why, still fearful, must he go along with the academic "interests" that have betrayed his own life in our own age by way of sentimentalized abuse of all noble traditions? Modern architecture, only, is true to tradition.

The Architect

America cannot afford to believe that great art, as her interpreter, is moribund. And the logical interpreter, perhaps the only one who can now show us the way is an organic modern architecture. The other arts are not yet awake, though they have lately shown signs of awakening.

We must believe in our country, and that means, we must believe that the ancient power that built great civilizations, to die, still lives to build a greater one, to live. We know that ancient cities are dead because of the exterior ideals of an external life that prevailed and withered away such life as they had.

But we know, too, the same human power that was theirs, multiplied infinitely now by the new leverage of mechanical forces may build a new city for us that will live indefinitely as the new architecture of a greater ideal belonging to the new ground of a fresh life.

This "new" ideal, having lived in the human heart two thousand five hundred years, finally founded this great Union of States. An experiment. If the "Experiment" is to succeed this union must now turn from centralization that was monarchic to the segregation and integration that is democratic. That means to turn toward the greater freedom of a life for the individual as individual, based squarely with the ground, some such life as life would be in the Broadacre City.

In the Broadacre City of modern architecture the individual home of the individual family group, more

directly related to transport, distribution and publicity than in the present city will enjoy in the country a freedom, a richness of life, no city ever yet gave, because it never had it to give.

So, the present city, feudal terms and feudal thinking now changed only to terms of commerce, has nothing to give the citizen, even commercialized, because centralization having no vital forces of regeneration, is grown old. This survival of the feudal type of city, the only one we have, seems only to conspire, as a hang-over of habit, to beguile the man from his birthright in freedom the high-priests of our culture singing false hymns to vicarious power in hypocritical language never understood and comprehended, least of all, by those who sang the hymns. Manifestly theme songs are now out of key, false in the singing and to the singers, as impotence slowly imprisons the citizen. Impotence is the price of his mistaking an artificial machine-power for his own. And impotence is the price of his artificial career and his habitual practice of an artifice without art.

The false atonement "big" centralization has asked of him in the name of "big-business" is inability to create. Impotence.

The True Atonement

When man shall build a building, a society, a life, as himself, inspired by nature in this modern interior sense, training his imagination to see life as the architect trains his imagination to see the nature of glass as glass, to see the nature of steel as steel, and see the nature of the time, the place, and the hour, eager to be himself, harmonious with nature, as the trees are native to the wood or the grass to the field, then the individual as a citizen, will rise high in the communal life of a civilization. And, supreme to all about him he can not fail to make the communal life the richer for his own riches. That faith is the faith of Democracy. Human values are life giving not life taking.

General View of the Broadacre City of the Future Based upon the New Scale of Spacing

In the City of Yesterday ground space was reckoned by the square foot. In the City of Tomorrow ground space will be reckoned by the acre: an acre to the family. This seems a modest minimum if we consider that if all the inhabitants of the world were to stand upright together they would scarcely occupy the island of Bermuda. And reflect that in these United States there is more than 57 acres of land, each, for every man, woman and child within its borders.

On this basis of an acre to the family architecture would come again into the service, not of the landlord, but of the man himself as an organic feature of his own ground. Architecture would no longer be merely adapted, commercialized space to be sold and resold by taximeter—no more standing room than competition demands.

Ground space is the essential basis of the new city of a new life.

The present form of the motor car is crude and imitative compared with the varied forms of fleet machines, beautiful as such, manufacturers will soon be inclined or be soon compelled to make.

The flying machine is yet a more or less extravagant, experimental form, unwieldy in scale, and with its exaggerated wings imitating a bird it is yet a hostage that gives itself to the mercy of the elements. No more than a primitive step in evolution.

Teletransmissions of sight and sound, too, are not only experimental they are in their infancy as is the intelligence to which their operation is entrusted.

We are justly proud of the great network of highways, the hardroad systems of the country. But they too are in their infancy. We are only just beginning to build them.

Young as the highway system is, however, it requires but little imagination to see in the great highway and see in the power of all these new resources of machines and materials a new physical release of human activity within reach of everyone . . . not only as adventure and romance with nature but a basis for safer, saner, less anxious life for a sane and dignified free people. A longer, happier life waits, naturally, upon this changed sense of a changed space relationship.

Any man once square with his own acre or so of ground is sure of a living for himself and his own and sure of some invigorating association with beauty. Not only is the city itself a stricture, a handicap in production: the contributing railroad itself is

too limited in movement, too expensively clumsy and too slow in operation. The end of the day of the long or short back and forth haul demanded by centralization is in sight. The end, too, of mass transport by iron rail.

Imagine spacious landscaped highways, grade crossings eliminated, "by-passing" living areas, devoid of the already archaic telegraph and telephone poles and wires and free of blaring bill boards and obsolete construction. Imagine these great highways, safe in width and grade, bright with wayside flowers, cool with shade trees, joined at intervals with fields from which the safe, noiseless transport planes take off and land. Giant roads, themselves great architecture, pass public service stations, no longer eyesores, expanded to include all kinds of service and comfort. They unite and separate—separate and unite the series of diversified units, the farm units, the factory units, the roadside markets, the garden schools, the dwelling places (each on its acre of individually adorned and cultivated ground), the places for pleasure and leisure. All of these units so arranged and so integrated that each citizen of the future will have all forms of production, distribution, self-improvement, enjoyment, within a radius of a hundred and fifty miles of his home now easily and speedily available by means of his car or his plane. This integral whole composes the great city that I see embracing all of this country—the Broadacre City of tomorrow.

It is because every man will own his acre of home ground, that architecture will be in the service of the man himself, creating appropriate new buildings in harmony not only with the ground but harmonious with the pattern of the personal life of the individual. No two homes, no two gardens, none of the three-to-ten-acre farm units, no two factory buildings need be alike. There need be no special "styles," but style everywhere.

Light, strong houses and workplaces will be solidly and sympathetically built out of the nature of the ground into sunlight. Factory workers will live on acre home units within walking distance or a short ride away from the future factories. Factories beautiful, smokeless and noiseless. No longer will the farmer envy the urban dweller his mechanical improvements while the latter in turn covets his "green pastures."

Each factory and farm would be within a ten mile radius of a vast and variegated wayside market, so that each can serve the other simply and effectively and both can serve that other portion of the population which lives and works in the neighborhood of that market. No longer will any need exist for futile racing to a common center and racing back again crucifying life just to keep things piled up and "big."

Without air, sunlight, land, human life cannot go on. Recognizing this principle, as we are all beginning to do, the home life of tomorrow will conform. It will eliminate no modern comforts, yet keep the age-less healthgiving comforts too. Steel and glass will be called in to fulfill their own—steel for strength, durability and lightness; translucent glass, enclosing interior space, would give privacy yet make of living in a house a delightful association with sun, with sky, with surrounding gardens. The home would be an indoor garden, the garden an outdoor house.

Tall buildings are not barred, but having no interior courts, they must stand free in natural parks. A "co-operative" apartment house might be eighteen stories, perhaps: tier on tier of immense glass screen-walls golden with sun, on shining steel or copper-sheathed frames, each tier with its flower and vine festooned balcony terrace, an iridescence of vivid color, the whole standing in generously parked and blossoming grounds.

The principles of architecture are simply the principles of life. Just as a house built on makeshift foundations cannot stand, so life set on makeshift character in a makeshift country cannot endure. Good and lasting architecture gives or concedes the right to all of us to live abundantly in the exuberance that is beauty—in the sense that William Blake defined exuberance. He did not mean excess. He meant according to nature, without stint. Thus, also, must good and lasting life yield up that right to all of us. And the only secure foundation for such life is enlightened human character which will understandingly accept, not merely ape the organic relation between the welfare of one and the welfare of the whole. Only that sort of character is fit for and able to create a permanent and universal well being.

And good architecture and the civilized architect of the future are necessarily modern, because life itself continually changes and new forms of building

are needed to contain and express it sincerely without waste, loving beauty.

To put it concretely again, architectural values are human values or they are not valuable. Human values are life-giving, not life-taking. When one is content to build for oneself alone taking the natural rights of life, breadth and light and space, away from one's neighbor, the result is some such monstrosity as the pretentious skyscraper. It stands for a while in the business slum formed by its own greed, selfishly casting its shadow on its neighbors, only to find that it, too, is dependent upon their success and must fail with their failure.

What life to give has the toll-gatherer the big city has become, to the worthwhile citizen now that the motor car stands at the door: the great, hard road systems of the country beckoning?

Voices and vision everywhere are penetrating solid walls to entertain and inform him wherever and as he goes, and when general and immediate distribution of everything he needs is becoming convenient to him wherever he may happen to be and or choose to live. I see his buildings modern, sanitary, living conveniences, his wherever he is or wants to be, and as economically as his motor car is his—by a few hours' devotion to machinery. I see the factory too, divided and operated in humane proportions not far away from him in the country; the time spent in any ceaseless to and fro from the office, senseless and waste time that may be well spent in the new individual centralization—the only one that is a real necessity, or a great luxury or a great human asset—his diversified modern Home. I see that home not so far away from the diversified farm units but that they may bring him, at the highway wayside markets, as he passes, food, fresh every hour.

I can see "going places" a luxury and a pleasure to him and to his; and beautiful places to which he can go. I see his children going to small and smaller individual garden schools in parks that are playgrounds as their parents live individual lives that enrich the communal life by the very quality of its individuality in a beauty of life that is appropriate luxury and superior common sense.

Transport, buildings, all life spaciously intimate with the ground, all appropriate to each other and life to each and every man according to his nature or his need and love of life. Woods, streams, mountains, ranges of hills, the great plains—all are shrines, beauty to be preserved. Architecture and acreage seen as landscape.

▦ Imagination is our human divinity. It alone may distinguish the human herd and save it from the fate that has overtaken all other herds, human or animal. All this leads the way to the realization of a new civilization with an architecture of its own which will make the machine its slave and create nobler longings for mankind.

Architecture and Acreage Seen as Landscape

The architectural features of the Broadacre City will arise naturally out of the nature and character of the ground on which it stands and of which it is a component if not an organic feature.

The individual architectural features themselves would naturally harmonize with the nature features; therefore no two could ever be precisely alike except as the city might be built on some featureless plain which again has a certain beauty of its own and might well bear repetition of pattern. But the Broadacre cities would seldom be so built, because a feeling for beauty of terrain, in the city builders, would be seeking for beauty of feature in the landscape. A great variety of architecture would be the natural result of a varied topography in the organic architecture which would be inevitable because natural to the thought building the new cities.

Twentieth-century architecture it is that is destined to comprise all the features of construction and design going to make up the framework, background and physical body of the machine age. Because it is the architecture of painting, of sculpture, of music, of life itself that is most vital, architecture is most vital because it is the essential structure of them all.

And as architecture was in ancient times, so it will be again if the organic correlation that is essentially a high ideal of beauty is to belong to twentieth-century life.

So the various features of the Broadacre City we are about to describe in more detail are primarily and essentially architecture. From the roads that are its veins and arteries to the buildings that are its cellular tissue, to the parks and gardens that are its

"epidermis" and "hirsute adornment," the new city will be architecture.

The time has come when the whole man must be reflected in the creative idea of his city, the city as free and organic in itself as man is in himself and as he will be in his thinking and his free institutions in this rendezvous he will make by way of nature-interior with nature-exterior.

So, in the Broadacre City the entire American scene becomes an organic architectural expression of the nature of man himself and of his life here upon the earth. This native expression of himself will be his in abundance, chiefly by intelligent use and restraint of his gigantic leverage, the machine.

Nevertheless, the ground will determine the shape and even the style of the buildings in the Broadacre City, so that to see where ground leaves off and the buildings begin would require careful attention. With this—the ground motive—variety in unity will be infinite. The architect himself, his ideal of organic unity held firmly in his mind, will become more equal to his opportunity with new materials and new machines. The ever-growing intelligence of the artifex itself, a desire for a whole life, will make the new city into which the old one disappears a great human work of art in every sense. Petty partitions and defacements of nature, everywhere irritating now, will no longer be excused or tolerated. No mechanical shrieks or smoke or grinding noises. No glaring abortions set up as super-salesmen to fight each other for the desired eye to sell anything. Not anything at all.

The Super-Highway and the Tributary Hard Road—the Lakes and Streams

The regenerate architect first enters upon the native scene as the master roadbuilder, the super-highway and the tributary hard road now architectural factors of fundamental if not greatest importance. In the new dispensation is a new sense of order, throughout.

Sweeping grades, banked turns, well considered cuts and fills healed by good planting of indigenous growth may have supreme beauty. Sympathetic moving lines that are the highways threading the hills and plains with safe grades will be, wherever they occur, elemental features of the landscape. So will be sightly road protection, well studied; well-designed culverts, bridges. Where concrete walls were prohibitive, there would be dotted lines along the banks of every turn. Evergreen masses would be lined up along the roads for snow protection, instead of unsightly snow fences. Masses of native growth would sweep over the banks of the cut or fill, not the usual collections of many different kinds of shrubs and trees called landscape architecture, but broad sweeps of a single species at one place with an eye to bloom and to color in the changing seasons.

No hard road in the new city would have less than three lanes. The super highway should have no less than six lanes. The fueling and servicing-station units would be developing in ample parks at appropriate points at desirable highway intersections. This road construction and planting, both as engineering and architecture, will be naturally under the control of the state, with the best supervising architects and landscape architects and structural engineers not only the state affords, but the country or perhaps the world affords. Each section receiving special attention by forces common to all.

An architect's trained sense of the harmonious "altogether" in the several matters of road construction, planting and bridge building, from beginning to end, would be indispensable to the integrity of the whole conception and so take place.

There is no more important function looking toward the city of the future than to get the best architects of the world interested in road building. They should see road building as great architecture.

The Romans built great roads that remain to this day. But with reinforced concrete as we now practice it and our modern machines, we could build better and more lasting roads and make them noble modern architecture. What greater, nobler agent has culture or civilization than the safe, open road made, in itself, beautiful?

Along these grand roads as through veins and arteries comes and goes the throng building and living in the Broadacre City of the Twentieth Century.

The lakes and streams too, now available by motorization, contribute no small element of transport or pleasure. The motor boat has done for bodies of water in relation to the land what it has done for the land itself.

The Great Traffic Station

The form of centralization that built the great rail-way station as the gateway of the old city will be gone. Exaggeration, conspicuous waste in any form will bore or insult society. There will be many minor stations instead of a few major ones because the great station will no longer be possible or desirable. Aeroplane depots, as flight develops, will be connected with the rights of way on which once lay the hard rails of the old, cumbersome railroads. And the new traffic "station" may occur as a minor feature, again ten for one, wherever one may be needed for purposes of general convenience. The big terminal and the storage capacities will disappear except at ports of entry or export. The major part of the business of gathering or distributing is, of course, from hand to hand or from factory and farm to family or from producer to exporter or from importer to distributing center by way of the universal traffic lanes to which all units of either production or consumption now have quick and easy access. The back and forth haul will no longer be necessary. It will be absurd. Distribution is direct.

There will always be a special concentration at ports and mines. A port-city will differ from an inland city as in fact every city will take on the character of its special environment and situation and differ from every other.

These differences would naturally be accentuated and developed as to their individuality except where uniformity of standardization and mass-production entered as substantial human benefit into the warp of the fabric. But the ultimate weaving need show no less imagination and individuality when the woof began to be stitched on to the warp. The finished whole should have an individuality now genuine, therefore, far greater than any the United States has ever known. It is this individual differentiation that would be interesting entertainment, no longer pretense or academic affectation as before, but genuine not only in cities but becoming so in people as well. And it is that human quality of individuality—strange to say—that the United States will find most difficult to preserve or to develop. As things are going with us we have all but lost it in the vicarious life of a vicarious means to live.

Power Units

In the Broadacre City it is inevitable that fuel be turned into electricity at the mines and wherever water power may be found, relayed from station to station to the consumer.

Electrification will easily become universal by this means; and current being produced at original centers of supply, like the mines or the dams or the oil wells and owned by the citizens, electricity will be able not only to compete but to abolish all but oil as a source of heat and power for the city. Oil itself might well be used at the source to produce electric power.

These great power units—they would be the same miracles of modern engineering as those we already have—would develop where natural resources were. Improved methods of conducting power would take the conduits underground, as the oil pipelines already are underground, with small loss of voltage.

A general sentiment for the beauty of the landscape would take advantage of developments in wireless telegraphy and telephone already available to make poles, trestles and wires a memory only of the disappearing city.

It is easy to realize how the complexity of crude utilitarian construction in the mechanical infancy of our growth, like the crude scaffolding for some noble building, did violence to the landscape. But this violence will disappear as power and traffic find avenues of distribution in more conservative and economical channels. The crude devices now called construction are already being swept away out of sight. Into the discard with poles and wires and rails will go track elevation, gas plants, coal burning power houses, train sheds, roundhouses, coal yards, lumberyards. There need be and there will be no unsightly structures in the Broadacre City of the future. The crude purpose of pioneering days has been accomplished. The scaffolding may now be taken down and the true work, the culture of a civilization, may appear.

The Organic Architecture of the Various New Buildings

We now have, in bare suggestive outline, the general topographical, traffic and power features of the new

city that integration has already begun to build and that begins to absorb the city built by centralization. The stem of the new city as we have seen will be the mobilization already well under way. A matter of "traffic."

We have already glanced at the changing ideals that will make the new city a finer, freer city by way of new ideals of what constitutes culture, according to our ideal of freedom—Democracy.

Let us now see how the buildings themselves as units of the plan in the construction of that city would be built into it as expressions of these new ideals: built into it as modern architecture by way of these new resources of industry and materials.

Let us now see how the new standard of spacing we have mentioned as necessary and at work will affect the arrangement or general plan of the city we call the Broadacre City and appear in every building feature of it. New forms for a finer concept of life. The new integrity of the individual as an individual must take effect in these constructions.

We might call this modern architecture an architecture for the individual as distinguished from the attempt at re-classification called an "international style," say, or any preconceived, impecunious or impertinent formula for appearances whatever.

In any conception of organic architecture, style is an expression of character. Character is an expression of principle at work. In this sense only will the new city have style. It will have style as something natural, not something exterior forced upon it by any outside discipline or academic attempt at classification whatsoever. Architecture and acreage will now again be seen together as landscape, as the best of architecture has ever been. If our principles are working and we are using our industrial means and new materials to good advantage with a sense of their fitness to purpose, we shall universally arrive at forms that are "good style" and perhaps—who knows?—though we need not bother much about this, a Twentieth-century Style.

The thing most important at the moment is the fact that a more livable life demands a more livable building under the circumstances of a more livable city. To make all more livable by our new means enters naturally, now. In all this conception of city plan and the plan of any buildings of whatever kind, enters this new sense of space. The old standards of spacing went out when the universal mobilization of

the individual came in. The individual has secured for himself comparative flight. By vicarious power he has secured this, it is true. But his power now if he seizes it and enlarges his life with it and develops his own power correspondingly, using this power as a tool and not ignorantly mistaking it for himself and passing out by its exaggeration and abuse.

To develop thus, he must appropriately use machine power to make for himself a new world of pure and noble form in which to live the new life that is inevitable, consistently with the new powers of motion that widen his physical horizon.

The New Scale

Several times the idea of a standard, necessarily new, of scale or measurement has already appeared in these pages: the man seated in his motor car with its powers being the unit of that standard rather than the man standing on his legs or his limitations in a trap hitched to a horse. His movement in a motor car is a far different thing from his movement on his legs or in any horse-drawn vehicle. This new standard of measurement is standard for all general plan-spacing in the planning of the new city. But, greatly important also, a new space concept now enters that directly applies to the buildings themselves: the sense of the lived-in space of the building itself as the real building. This is a new concept of architecture as new. But it is an essential implied by any true ideal of Democracy.

And along with steel and along with the use of a variety of indestructible thin insulated sheets of metal comes still another demand for the economical and appropriate use of these new materials. This demand is for lightly and widely spanned spaces closed to the elements but not closed, except at will, to human sight itself. Here enters the supermaterial, glass.

Here the old sense of architecture as heavy enclosure or the survival of the fortification disappears. A building appears as of the landscape. And the human life living in it is less separation from nature than ever before. The hard and fast lines between outside and inside disappear. The outside may come inside and the inside go outside, each seen as part of each other. This difference is a great difference, and the basis of a new world of effects.

The new building itself may now be as free in its

space relations as the new city itself is free, and free as the circumstances dawning in the man himself. The developing sense of individuality as communal organic expression of the man within has here something worthwhile to work with. Traditional forms can only interfere with this new freedom because all the traditional forms we know were mass-concepts for a mass-life under conditions where congestion was no unmixed evil. But it now becomes evil under present changed conditions, if not soon impossible. The fact is here that immense, significant freedom for the art of building serviceable beautiful buildings is now new economy. Economy may be beautiful. Economy and beauty are, at last, harmonious and primarily human.

Simplicity

Just as the present city is direct interference to the growth of modern life, so is the traditional form of a building not only interference in all building, but demoralizing. We have suffered from a surfeit of things not only within our buildings but from the buildings themselves. The same much too much of more as the city is itself. Our factory buildings alone are exempt from this criticism. And we suffer most of all from the results of property ideals too narrowly and meanly held and wrongly based. As the acquisitive jackdaw lines his nest, or monkey psychology glorifies the antique, so is this "to have and to hold" cult of things inorganic waste.

Not only was the fashionable house a heavy box-mass of some kind of building material punched with holes "à la" some pre-elected previous fashion, but the collector's mania for the antique made of it, inside, a bazaar or a junk shop gathering dust or disgrace in the shadow of the wall.

As the new era dawns in sunlight the fashionable American home appears as the graveyard of the impotent soul. Vicarious power by push-button or lever was here reflected in the vicarious expression of a taste for incompatible luxury. "Possession" may be seen here sunk to its lowest terms. For a sense of life that sank to mimicry there is ample punishment in this realization and confession of an inferiority that mistook itself for refinement.

Backward-looking, outworn styles were all the average householder possessed to inform him con-

cerning his own possibilities in his own age until regenerate, capable of consecutive thought, he takes hold of his modern problem in new light and thinks his way through to the beginning of an organic solution.

This beginning, for him, is found in the significance of the word "organic."

The architect and his client have tried all phases of affectation and pretense. They have tried in their better moments, in better homes, for a pictorial simplicity. Let them now try for an organic simplicity, or let's say, simplicity as organic. A sense of life as organic architecture or architecture as a form of organic life, that is the sense we need now.

The Negation That Is Affirmation

From where and how is this needed change in thought to come?

Probably the source nearest to our understanding: our machines. And, likely enough, turning to this source we will fall to imitating them in our buildings. Inspired by steamships, automobiles, aeroplanes, bathtubs, refrigerators and kitchen sinks, we will at first lay hold of simplicity as negation.

Not fatal, such negation? But not necessary either. And only pictorial simplicity, again, after all. We will eventually understand that organic simplicity is as far beyond that as the lilies of the field are far from a washtub or a clothes-wringer. But, as a beginning, it is enough, for it will serve to clear away the rubbish heap for us that encumbers our life now.

The citizen's bathtub is more nearly beautiful than his house dressed up as it now is.

The necessary act is his renunciation of the stuffy house à la mode for a new one with more sunlight and simplicity. His search for intimacy with the ground will result eventually in his search for principle. The realization of principle will result in competence in place of impotence. And with the song in him, not yet dead, he will begin to build as the song-masters wrote, out of the man.

No, not all of him, but such inevitable intelligent eclecticism as would follow him who could, would be nearer life in our own time than anything the eclectic had before by way of taste unless he should

fall into the same pretense of art, assume without the ability the prerogatives that belong only to creation and again stultify himself by stultifying others as himself. But the negation is good medicine and likely to do something to the culture fakir himself by way of awakened desire for true simplicity, if not on his part, then on the part of his attempted victim.

The passing order has left us with an inheritance of peddlers, brokers, "designing" partners, decorators and "esses" doing brokerage between the homeowner and the homebuilder for moderate fees, but exorbitant results. These will become the "modern" eclectics afresh. No matter. Instead of crying "aloud" for the exterior discipline that can only make more weaklings acceptable, let us put a premium upon the essentially organic quality in the human being that is individuality, not personality. Let us put this premium upon this quality in philosophy, in religion, in art and science. Let us demand that all be organic as all of life; and by such interior discipline as this would mean not only will we live in rubbish heaps no more, but the rubbish that builds them be swept away with them by a finer common sense encouraging the super-sense of the creative artist. The creative artist is one who is himself more society than society is itself. This means that he is, by nature, the naive interpreter of the best in the social order in which he lives, and society itself by way of the "next in line" must soon see him as a way-shower.

Society in this age at this period seems afraid of the radical mind of the creative artist because the values, economic and social, are so badly tipsy and twisted all down the line, too easily topsy-turvy if the strong arm relaxes. And were the true conception of the term organic applied, as a test, to the rubbish heap or the rubbishers themselves is all that is needed to set the United States on the road to a finer and higher order, social, economic, artistic. The word organic, if taken in too biological a sense, would be a stumbling block. As we are using the word here it applies to a concept of living structure. That would be a concept of structure wherein features and parts are so organized in form and substance as to be, applied to purpose, integral. Integration is used in this sense of the word integral, with this quality of thought in mind. Such is the quality "organic."

What, Then, in General Detail Will Broadacre Buildings Be Like?

Well, let us first take the poor.

That means the "housing-problem" receiving so much philanthropic attention at the moment which, beneficent though it is, can only result in putting off by mitigation the day of regeneration for the poor.

The Tenement

The poor are those damaged most by the progress of unearned increment as it piles up into vast fortunes by way of rent, or they are the lame, the halt and the blind.

Where is their place in the city built by triple rent?

See the salvage effected by the latest and best "housing" developments all over the world for your answer. Improved slums doubtless. But the slum quarter now changing to a region of the mind: standardization reaching for the soul. Poverty is being made a "decent" institution. The "row" is as inevitable to it as it is inevitable to any army.

Rows behind or beside rows of cubicles on shelves, hard, orderly and remote from nature as any coffin. Decent? Yes, but damnable straight jackets in which life is to be beneficiary but not blessed. Ingenious officering, this, of the army of the poor built in to stay "decently" poor. Institutionalized. The machine triumphant.

There is some dignity in freedom, even though "one's own way" may sink to license in filth. But what dignity in the cell of a soulless economic repetition of spiritual poverty, even though some posy be stuck in a flower box, gratuitous, for each?

Why not make more free to "the poor" the land they were born to inherit as they inherit air to breathe and daylight to see by and water to drink? I am aware of the academic economist's reaction to any land question. Nevertheless, Henry George clearly enough showed us the simple basis of poverty in human society. And some organic solution of this land problem is not only needed, it is imperative. What hope for stimulating a great architecture while land holds the improvements instead of the improvements holding the land? For an organic

economic structure this is wrong end around, and all architecture is only for the landlord.

By some form of exemption and subsequent sharing of increase in land values, make his acre available to each poor man, or more according to his ability to use the land, and what house for him? And where and how may he go to work to build it?

Well, mobilization is already his, too, by way of a fare in a bus or a secondhand Ford or more or less. Emancipated from the rent he must now pay the city in order to work at all the machine-worker goes back to his birthright in the ground, as his birthright in the air to breathe and water to drink, with his family and goes to work in the factory and for himself as he can, both factory and family now on their own ground. He goes to work for his manufacturing employer in some factory unit nearby. Ten miles is nearby now by any modern standard of spacing.

The poor man—the man at the machine—buys the modern, civilized, standardized privy (it is a bathroom) manufactured and delivered complete in a single unit, even as his car or bathtub is manufactured, ready to use when connected to a septic tank or a cesspool. He plants this first unit on his ground as a center unit to which a standardized complete kitchen unit similarly cheap and beneficial may be added. As the months go by, the rent saved may buy other standardized units, or as soon as he earns them by his work on the ground. The units would be suited in general scheme of assembly either to flat land or to hillside and designed to make a well planned whole. These various standardized units are the machine-workers' cheaply, by way of his labor in the factory unit nearby and as the automobile is his by the cheapening power of mass production in standardization. His ménage may grow as his devotion goes along with time, buying each unit in a group-scheme that has had the benefit of expert study, in design and production, by the world's best minds. Not only may this group of units be variegated and so harmonized to purpose as to do no outrage to the landscape, but be so cheap that his rent for three months, in the present city bondage, would buy him the first units.

In a year or two he would own a house scientifically modern and complete along any one of a variety of lines and plan-schemes and his establishment be good to look at, hooked up in his own way with such a garden as he could make and such outbuildings—also standardized units—as he would need. Fruit trees, shade trees, berry bushes, vegetables, flowers, hot and cold running water, a modern fireplace, cookstove and heat-unit all combined. With some proper aid in the way of tax exemption here is a home of his own that would be within reach of the man by way of his devotion to the machine. And the machine itself did this, say, five-hundred-dollar house for him as it did his automobile now standing in his fifty-dollar garage. Electricity for light, heat and power he might have cheaply by voluntary co-operation. And co-operation could simplify and bring life nearer to him in many ways.

There is nothing remarkable about this opportunity as a physical product. It is already accomplished. But what is remarkable is the fact that the whole establishment may have, the mass-product notwithstanding, the proportion that is order and the order that is beauty. The finished whole, as an expression of himself need not be lacking in individuality. Characteristic choice might be freely his in appropriate designs and devices where before he could exercise only a choice of abortive sentimentalities or be compelled to accept housing as an "institution."

Where is your "poor" man now? No longer poor. Because his soul again grows to be his own. It grows to be his own because opportunity has opened natural ways for him to be free to exercise his own faculties as well as the faculty of some machine. And the next erstwhile "poor" man is beside him a block away, or more, on his own also; but owing to the quality of mind in design and device, he is there differently in plan and scheme according to his individual needs and tastes. Birds sing, the grass grows for him, rain falls on his growing garden while the wheels of standardization and invention turn for him not against him where he lives. Because his devotion to the machine in these circumstances means increased life and opportunity for him, so it must mean increased life and opportunity for all concerned with him.

His children would be growing up making first-hand contact with all the freshness and sweetness of their birthright that any "rich" man's children can know, and not by grace of some municipal-minded landlord as a goldfish inhabits a glass globe, with a pebble and a reed.

He is planted square with his fellow-man to grow as he may grow on his own ground.

Individuality is his. So he, too, is aristocrat in the true democratic meaning of that word.

Now integrate his small garden production whatever it may be, and relate this factory service of his, so this aid by his family out of his ground, such as it may be, is related to the great, universal neighborhood markets opened by the great highway—perhaps as added features of the service stations. The family produce to be regularly called for each day in some such plan as that of the Walter V. Davidson[3] markets. Each day the family receives in cash one half the value of what their free time on the ground has raised and everyone in the new city may have "produce, fresh every hour," reinforcing the larger, more standardized farm units, not only affording still greater variety to the consumer but some additional money earned by the machine-worker's household.

Where, now, would be your city slums?

Integration by way of neighborhood schools, entertainments, hospitals for sickness, insurance for old age, all take from the machine-slave the anxieties that bore him down and out at an early age. Society would soon have an individual for a citizen instead of a herd-struck moron. Instead of another cultural weed gone to seed in good-style municipal barracks or filthy slums to raise more weeds, here would be a valuable human asset. Nonetheless a man because machine-man. No, much more—a man.

What would this establishment of his look like?

The Employee on His Acre

Well, so far as it went, it would look like a house to live in as his car looks like an automobile to ride in. The two would look well together—if you can imagine it. I can, and soon so can you and anyone although, now the automobile and the house are utterly out of feeling—incongruous in every case.

The various units of the house would be fabricated of sheet metal or composition slabs or both together, say, and permanently "finished" as is his car in any texture or color he preferred, but no "bad" color or unsuitable texture to be "preferred." Much glass he might have—but not to wither him—shaded above by thin, sheltering metal projections. The various units would be in one scheme rectangular, in another scheme hexagonal, in another circular in form. In other schemes, combinations could be made of these forms, infinite in variety. He might soon achieve the enclosure of a central court-garden and much greenery and flowers. Perhaps a pool. His establishment would grow as he grew, he would be earning it himself as he grew able.

The roofs he might leave flat and use as a roof-garden under an awning. Or he could slope the roof and use the ground to save expense. His furnishings become part of his house now, and are as good to look at inside as his house is good to look at outside because he got his furnishings as he got his house, designed for him by the best talent the world affords with perfect knowledge, not only of his problem, but of the capacities of production. And there is a range of choice wide enough in which he may find his own.

He works, now, on ground that cannot be taken away from him for it could not be his by way of debt, that is, mortgage but by way of improvement. There can be no landlord but society. A social unit will grow up independently on his own ground as he is able. The house is his own. He is no soulless unit, officered in the rank and file of the standardized army that is the "poor." No longer is the "poor" man a reproach to fortuitous good fortune in the form of rent unless enough rent is set aside to make him "look" decent.

No, here now may be a manly man, in Usonia, living in manlike freedom. On his own together with his own. Like the bravest and like the best.

In bare outline, of course, all this (essentials not all drawn). But here, in outline, is a sketch of the feasible "tenement" in the Broadacre City: the only possible city of the future.

**The Tiller of the Soil and
the Husband of the Animals**

What establishment would be the farmer's as a suburban citizen in the new city?

He is suffering from rent in its most oppressive form, any improvements he may make are only a gamble adding to his burden of rent. Should his labor be insufficient to pay rent for money, rent for his own improvements or rent for land and government goodbye to all his improvements. But at least so long as he can keep his ground under his feet and able to work he and his need have no fear of starving.

But farming is the hinterland of economics, if not the borderland of despair, because the farmer was not taken into the present scheme of increments except as a source. Let us take the farmer in the more thickly settled regions of the country where he is trying to compete against the grain and beef-raising of machine-farming on the almost endless and nearly free acreage of the great Western open spaces of the United States. Grain raising is against him. Nor in cattle and sheep raising can he compete with the ranges of the great ranches on western land with no improvements, taxed at fifty cents per acre, if at all, while the cost of his "improvements" only works dead against him on his land taxed at fifty dollars or more per acre.

Modern sanitation, the motor car and the radio have already brought the farmer's life a little nearer to the luxury of the sons and daughters he too has lost—voluntary deserters to the prevailing white-collarite army. But he is alone on the farm often. And sometimes an inmate of the poor house, or better off if he were, at the end of his labor on the ground, whatever may have been his energy and thrift.

This ground is so seldom his own ground, now, except by some slender show of equity. The farmer East, Middle West, or South, is no winner of the game of increment as the game is played for high stakes with the three false rules of the game. The dice are loaded against him by the very circumstances in which he is placed to "find" himself.

And it is amusing or exasperating, as you may happen to get the view, to see the empty political gestures his would-be saviors make to "relieve" him.

Not a statesman's voice nor a sensible legal move made to free him from the inequalities that grip him for no other purpose, it seems, than to give the white-collarite army a free ride on his back. That army rides to some extent on the farmer's back because the farmer's labor is intrinsic. A source.

His labor on the land contributes to the various vicarious powers—power by lever and push-button—of city life. But his labor contributes not much to his own life. Parasites are parasites because they batten down sources, live upon origins but never live by originating. So here in the tiller of the soil is good life, and genuine, in deep trouble.

Cities are great mouths. The farmer is essentially food for humanity. It is his job to feed the cities. And the raw material for clothing is his job also.

Without the farmer the cities would starve and go naked. Now the Broadacre City comes to him not only to be fed but also to take him in and share with him the luxury that the very nature of his service to the city has hitherto denied him. And his new establishment is a most welcome and perhaps the most attractive unit in all the structure of the city of the future.

Feeding the multitude being naturally his job, it is clear that the produce of intensive farming as varied as possible will be his advantage over the great grain- and beef-producing areas competing with him, and this produce is as direct to the consumer as possible. Dairying, fruit growing, truck gardening, raising the rarer meats and fowls, eggs, in all of which freshness is a first condition, though the tin-can has increasingly become the resource of our civilization—as life itself, became, more or less, canned.

The little-farmer who will take the place of the big-farmer by intensive methods needs a greenhouse and less than one tenth of the land he tries to farm now. And he needs an establishment that makes his life a more decent and bearable association with the animals he husbands, tending, breeding and feeding them, primarily, for the urban millions who have educated, therefore artificial, tastes as compared with his own more simple ones.

The farmer too, and most of all, needs the organic architecture that will end his wasteful to and fro about the inefficient group of crude, ill-adapted buildings now habitual to him, to turn all into a compact, efficient, correlated single unit for his purpose: considering his life as worthy of high conservation. The little-farmer needs his living comforts assured. He needs less in some ways than before when he was "big." He no longer needs a haymow, the thing that exaggerated his barn. He no longer needs machine sheds, but he needs a workshop and tools. He does not need many fences except those that are a part of his buildings.

His energy would be conserved by having, under sanitary conditions, his animals a step away, his car reached by opening a door, his crop proscribed and sold before he raises it by some such plan of integration, now of larger units, as the one referred to as being worked out by Walter V. Davidson in the plan for farm markets. This plan is of the type—integration of small units into great ones—that is destined, and

inevitably soon, to take the place of present over-grown centralizations.

Such a composite farm building as this one might be would be assembled of units consisting of a garage, a dwelling, a greenhouse, a packing and distributing house, a silo, a stable and a diversified animal shed. The whole would be practical architecture and as such could be delivered to the little-farmer at low cost by benefit of machine standardization. Again architecture would be his by way of the best brains in the world, to simplify, dignify and make his life effective as his own.

This composite farm building would be a group-building not of one type only, but of as many types in various materials as there are modifications of the farmer and his purpose.

In this modernization of the basis of farming is a true and important phase of farm relief.

Well-designed farm life grouped in units of three-, five-, or ten-acre farms, production pro-scribed and all related to highway traffic markets, produced fresh every hour, is radical farm relief. And the design of that great traffic market as an-other feature of this rural integration is another im-portant building among the service features along the highways of the Broadacre City.

A single community tractor could plow and har-row the soil for all. Community centers provide not only power and pooling of certain labors and inter-ests in sickness or in health but entertainment for all.

Again here is but a suggestive sketch, in outline, of "farm relief," and "relief" also for so many white-collarites who are still capable men and women but now unhappy as city parasites. They would by this division and reintegration of the smaller units, up-building living conditions on a better basis, find means to live well by their own labor on their own ground in an independent life. No longer rented but owners of themselves.

In every Broadacre City there would be plenty of room for many thousands of such integrated, yet independent farm units.

Factory Decentralization and Integration

The factory too is now to come to the countryside, the employees themselves small gardeners as out-lined in "The Tenement." Already the factory is so well organized and built and managed in our coun-try that it needs less re-designing than any institu-tion we have. Although its product is sadly in need of organic design, it needs only the ground available or comparatively free to its workers. The big factory already needs dividing up into smaller units, spaced in the countryside according to the new standards of space measurement. This ideal of re-integration, in this division of the big factory into smaller units, is now at work in many places. Instead of scheming for the greater and greater centralization that, as we may now see, defeats life and even defeats its own purpose by meaningless back and forth, the factory will be the first to end the expensive waste motion of to and fro. The factory, except for exaggeration of its size—due to over centralization—is in itself the one best thing America has done. The best thing we have ready to divide and reintegrate as sightly fea-tures of the country.

The Office in the New City

Financial, official, professional, distributive, admin-istrative: offices may now all go where they belong to function as units of whatever industry they rep-resent and be found there where actual production is taking place. Volatilized, instantaneous intercom-munication make this return to origins reasonable and practical. Once the movement is started, this correlation of offices and manufactures would be desirable and efficient conservation of time and energy. It will be easier to work forward from the plant than it is to work backward to it or to and fro from it.

The offices of public officialism, petty or major, should all center at the police and fire-stations at certain road junctions, and, owing to lack of conges-tion as a contributor cause of disturbance, might be cut to one of the ten needed now. The district court would be found at this point, and all functionaries be established there in appropriate quarters, not in the braggadocio buildings now customary. These functions are utilitarian. Not necessarily grandiose in a democracy. Appropriately, the reverse.

The offices of the "professional" man should develop for his especial work in connection with his own home-grounds as a shop, either a studio, a

clinic, a hospital, or a gallery suited to his purpose: "show-off" place, if he is like that. Such individualized units added to homes would enrich the architectural aspect of the whole, save human wear and tear in the "back and forth haul" and be more available under such conditions of modern transport as are fast approaching than they are under the present attempts to reach them in the positive traffic hindrances that do violence to the time and patience of the professional and his client, alike, in the present form of centralization. The professional man needs more time for service and study in a better atmosphere. Less of his energy consumed in the vain scramble in and scramble out would give it to him.

The bank is an "office," too, but as a quasi-public one it should be found with the public official-buildings at some important junction, in itself an integrated unit in various strong financial chain systems. It would no longer need to put on airs as a temple or place of worship to hold its importance or to get business.

A bank is a machine. A cold, calculating business institution. And it is a strongbox. So it might properly take on the air of a typewriter or a filing system in a steel box. Grandomania in the construction of banks, as in safes or locks, would no longer be direct invitation to thieves by useless glorification of money-power. The grand temple of the unearned increments might well shrink to the strongbox of intrinsic earnings.

The New Store: Or Distribution of Manufactured Merchandise

This integration of mercantile distribution as it will be natural to the Broadacre City would occur upon the great arteries of mobilization, or traffic. This feature of the future city is already appearing neglected and despised—but as the roadside service station the distributing centers, in embryo, of the future are appearing.

In the gasoline service station may be seen the beginning of an important advance agent of decentralization by way of distribution and also the beginning of the establishment of the Broadacre City.

Wherever the service station happens to be naturally located, these now crude and seemingly in-

significant units will grow and expand into various distributing centers for merchandise of all sorts. They are already doing so in the Southwest to a great extent. Each of these smaller units might be again integrated or systematically chained together over large areas, thus cutting down costs of buying and distribution to add to the economies of mass production and standardizing. They would become, in the little, distributors of all that Marshall Field, Sears-Roebuck, or Wanamaker now find to distribute in the large.

Fresh architectural opportunity is here: the most diversified single modern unit to be found in all the features of the Broadacre City. With the service-station would be found generous parking facilities and various schemes for automatic parking; beguiling entertainments; cabarets, cafés, and restaurants, and comfortable overnight accommodations for transients. There would be individual competition between the various centers and individuality would soon develop. From every stream of traffic one might turn aside and pick up, at these stations, in natural to and fro, anything needed or desired at home. To not too suddenly deprive the age of its characteristic art, advertising, the purchaser might be subjected to the same temptations by salesmanship and by means of effective display as is now the case in any of the highly specialized city stores. Proprietors, salesmen and managers all living nearby, within twenty-five miles say, and living in country places of their own, their children going to the Broadacre schools. Themselves now "landed gentry."

These are only slight changes for the better of an ideal that is already doing its work; and that ideal—reintegration of decentralization—must, to go on working, follow the law of change as Marshall Field followed when he established stores at outlying suburbs. And as Sears-Roebuck followed in establishing a chain of stores in small towns. And as Woolworth and his followers followed. So, ahead of their merchandising, now comes the next step in decentralization and the integration that is Democracy. This is for the inland towns. The port towns would naturally enough be subject to special concentrations.

Modern inventions and machine resources, now destructive interferences to city life, not only point in this direction but are compelling the merchant to take it.

The Maintenance of the Motor Car and the Plane

The garage will naturally be found as expansion of the roadside service stations.

Probably some of the stations will become "union-stations" merchandising all oils on some basis as drug and department stores now handle various brands of the same merchandise. Or they may subsist as individual units—co-related as now.

For Those Who Have Been Emasculated by the Present City

The tall apartment building will go to the country. It will be among the first steps toward rescue . . . this infirmary for the confirmed "citified." The Broadacre City unit here may be of the type proposed for the apartment tower in the small park of St. Mark's on the Bouwerie in New York City.[4]

An arrangement in quadruple of say, thirty-six indestructible duplex apartments built, furnished, complete. The buildings would stand in a small park of, say, thirty acres with its own garage beneath, and playgrounds and gardens for each tenant arranged as features of the park.

This type of structure would enable many to go to the country with their children who have grown so accustomed to apartment life under serviced conditions that they would be unable or unwilling (it is the same thing) to establish themselves in the country otherwise.

These prismatic metal and glass shafts rising from the greenery of the private parks in which they would stand would be acceptable units in the Broadacre City. Many of the advantages of the countryside could still go to them. And they might own the "apartment" in which they lived in the country on the economical terms of the age we live in.

The Hotel, the Mobile Hotel and the Predatory House

As a matter of course, there would be fewer hotels. Each would probably be a group of small cottages related to a general unit comprising the rooms for the use of all as seen in better planned establishments like the Arizona Biltmore,[5] or the San Marcos in the Desert at Chandler, Arizona.[6] And these would be found where Nature had "staged a show" with which they might harmonize and which they could well employ for recreation and recuperation by wise building.

But a new manifestation of hotel life would be the hotel on wheels. The mobilized hotel.

These commodious cars with sleeping accommodations and cuisine aboard would tour the country with parties. They would go from North to South and from East to West. With attendant trailers or lorries they would be found in the scenic marvels of the great plains and mountain ranges where no other hostelry could survive.

As the nature of transportation is developing, there is no reason why such mobile hotels should not be safe, comfortable and profitable in some such form as already developed by the McArthur brothers at Phoenix, Arizona, and intended as a feature for the Arizona Biltmore Hotel itself.

If the scheme is feasible for a hotel, it is certainly feasible for a house. And this mobilization applies to the lakes and streams by way of motorization.

Artists, pleasure-seekers, explorers, the modern gypsies, could all have road-traveling or floating houses of perfect convenience and, by way of superior design facilities, be presentable, as sightly as a plane or any car. More so, naturally, than most of them are now.

These motor houses could go about, at the householder's will, from place to place, from mountain to seashore or rivers or lakes as the nomad once drifted over the desert with his camel and tent.

The Bachelor

A new phase of domestic arrangements enters the picture here that might take the curse off domesticity for many who cannot tolerate it now, and so perhaps reclaim many a life dissolute because establishment means too great monotony.

And as a suggestion to this gregarious product, our heritage from the disappearing city, as the children came they could be accommodated in trailers, behind, nursery and all. Inasmuch as little trains will soon trickle along the highways anyway, why

not the domestic arrangements of the now unwilling husband?

The slogan of this element . . . "Give the children a ride."

The art of fashioning the trailer has already gone so far there would be no difficulty whatever in appropriately "trailing" any feature of life whatsoever, anywhere.

The Humane Hospital

Efficient and humane as it is, the present hospital is too large and too obviously an institution. The Broadacre hospital will be several sunlit clinics scattered in a spacious garden, to every large unit we have now. Homelike quarters where no disabled or sick person need ever see another disabled or sick person unless he so wills. The resources of modern therapeutics, surgery and medicine would be in their places as the plumbing, electric lighting and heating of the home are a part of the house, but not visible as fixtures.

In short, the emphasis should be on normality and not on the paraphernalia of abnormality. Death's head shows at once in the present hospital and grins incessantly at any and every unfortunate inmate. Why not a hospital as humane in effect as in its purpose?

The University: Universal

The present university, specialized, is the mass production of specialists in book knowledge. As the antenna of the insect is a feeler for the life of the insect, so a modern university should be the antenna of the life of a society and able to communicate its "findings."

Here in quiet retreats made beautiful and appropriate for reflection and concentration there should be rendezvous for groups of developed individuals in noble storehouses where all that mankind has produced in science, art and philosophy would be a matter of record, or model available for free study.

There need be no "professors," nor large groups. Only several father confessors and their recorders. One elected by the scientists, one by the artists, and one by the philosophers of each state, respectively, and, if one could be found, a statesman should be added to the group. The best chosen by the best.

All others would be privileged students accepted by the father confessors and employed in research concerning the correlation of these matters of the social soul. No privilege of the novice, this. Only those having given proof of inner human experience in some one of these qualities of human life would, of course, be accepted.

The old monastic institution, liberalized, made free and related to social progress by research work where contemporary life—modern materials, modern industrial circumstances and association with performances as well as ideas—would be inspiring. No preparation for teaching or practicing anything should be a feature of these "universities." This renunciation of vocational training would of course come along slowly, even in the Broadacre City. It is so much harder for us to de-limit the sacred institutions of "learning" than any of our institutions.

The Communal Center

Of course such centers would be features of every new city and each would be an automobile-objective situated near some major highway or in some nook of the countryside where views are inspiring and nature lovable.

Golf courses, racetrack, zoo, aquarium and planetarium will naturally be found at these places grouped in architectural ensemble with a botanical garden. Of clubs there would still be many, but the community center would be something else. It would be the great common club, but avoiding commonplace elegance. The community center would be an educational factor as well as an amusement center. The art gallery, the museum, would be there. And as all would be laid out in harmony with each other and the ground, each center would take on the individuality of its circumstances. Scattered over the states these centers would embody and express the best thought of which our democratic ideal is capable. There would be no commercial bustle or humdrum here. All common excitement could be reached, further on, at the service stations. But the various community centers should be quiet places for study, reflection and introspection, in comradeship.

The Theatre

Where nature has been raised by art to the level of greater nature, the new theatre, no longer a peep show but a circumstance, the building itself an automatic machine rivalling in plasticity the cinema, would be a sanctuary for emotion and aspiration, rivalling the church in the old city. Architecture in these civic centers would be worked out in native materials.

The cinema would, like the theatre, go direct from camera to the home. Sound and vision. But at the community center there would be special creative features maintained by the community not by big business as a sales agency.

The New Church

Assuming that religious sentiment has deepened by way of the ideal that builds the Broadacre City, and a false sentimentality as oppressive to enlightened democracy in religion as it would be in social economics or art, the surviving church would be likely to take on some non-sectarian devotional form. Here would be a great opportunity for a true symphony, as building. The church might, in the new city, be a church as a song without words is a song. The Broadacre church would be a rendezvous with beauty in the depths and breadths of the soul, a refuge no less individual because more profound and comprehensive, for the stained and worn and skeptic. Harmony complete might in this church again descend to refresh a mortal weariness. This skeptic ego of our more sophisticated age needs spiritual recreation. No theology, now, can ever be essential. The unhistorical cathedral as a feature of the Broadacre City would be erected by and for the spirit of man to evoke again in terms of our machine-age life an organic ideal of the organic social life and new faith in the nobility and beauty of which human nature itself is capable.

The Design Center

The machine as it exists in every important trade, by way of capable artist interpreters, should without delay be put into the hands of the young architects. Reluctantly I admit that to put the machine, as the modern tool of a great civilization, to any extent into the hands of a body of young students, means some kind of school; naturally such a school would be called an art school, but one in which competent interpreters of fine art would not only be allied to the industries they would now try to serve, but would stand there at the center of an industrial hive of characteristic industry as inspiration and influence to younger talent in the design problems of inevitable and desirable mass production.

Sensitive, unspoiled students (and they may yet be found in this unqualified machine that America is becoming) should be put in touch with commercial industry in what we might call industrial design or style centers. The centers would be workshops equipped with modern machinery, endowed by the industries themselves, where the students would remain domiciled and spend the better part of each day working in the shop itself.

Machinery-using crafts making useful things might through such experimental centers discover possibilities existing in the nature of their craft, which the present industries know nothing about and might never discover for themselves. In such a school it would be the turn of the fine arts to serve machinery in order that machinery might better serve them and all together better serve a beauty-loving and an appreciative United States.

Let us say that seven branches of industrial arts be taken for a beginning (a number should be grouped together for the reason that they react upon one another to the advantage of each).

Let us name glass-making, textiles, pottery, sheet-metals, woodworking, casting in metal, the "process reproduction." Each industry so represented should be willing to donate machinery and supply a competent machinist and to a certain extent endow its own craft, provided such industries were certain of proper management under proper auspices, and assured of a share in results which would be directly their own, sharing either the benefits of designs or presently in designers themselves, both adapted to their particular field.

Such experimental centers intelligently conducted could do more to rationalize and vitalize our industries than all else, and soon would make them independent of France, Germany, Austria or any other country, except as instruction by internation-

al example from all countries would help work out our own forms. There is no reason why an experiment center of this character, each center confined to one hundred students or less, should not make its own living and produce valuable articles to help in "carrying on the growth of style in our industries." As compared with the less favorably circumstanced factories, and owing to the artists at the head of the group, each article would be of the quality of a work of art and so be a genuine missionary wherever it went.

Such a school should be in the countryside on sufficient land so that three hours a day of physical work on the soil would help to insure the living of the students and the resident group of seven artist workers, themselves the head of the student group. There would remain, say, seven hours of each day for forty-seven individuals in which to unite in production.

A well-directed force of this sort would very soon have considerable producing power. Thus belonging to the school each month there would be beautifully useful or usefully beautiful things ready for market and influence: stuffs, tapestries, table linen, new cotton fabrics, table glassware, flower holders, lighting devices, window-glass mosaics, necklaces, screens, iron standards, fixtures, gates, fences, fire irons, enamelled metals for house or garden purposes, cast metal sculpture for gardens, building hardware. All sorts of industrial art in aluminum, copper, lead, tin. Practical flower pots, architectural flower containers on large scale, water jars, pots and sculpture. Paintings for decoration suitable for reproduction and designs for new media, for process reproductions. Modern music, plays, rhythm, designs for farm buildings, the characteristic new problems like the gasoline station, food distribution, town and country cottages and objects for their furnishings. And factories, too, of various sorts.

The station might broadcast itself. Issue brochures, illustrated by itself, of pertinent phases of its work. Devote a branch to landscape studies on conservation and planting and town-planning. In short, the station would be a hive of creative industry. Architecture, without hesitation or equivocation, should be the broad essential background of the whole endeavor, again strong in modern life as it ever was strong in ancient times. It is desirable to repeat that architecture again must be the logical background and framework of modern civilization.

Such style stations or culture centers could be alcoves in connection with standard college courses in the history of art, architecture and archaeology. And it would not matter where the centers were located, were they sufficiently isolated in beautiful country. They should not be too easy of access.

No examinations, graduations or diplomas. But so soon as a student worker showed special competence in any branch of industry he would be available as teacher in the Broadacre schools or for a place as designer in that industry. Manufacturers who were contributors to the school would, however, have first right to use him, or her. The body of inspirational talent and the trade machinists should be of such character that outside students would enjoy and seek points of contact with the work going on at the school, helpful to them and to the school as well.

These units, directly dedicated to practical style culture, would be essential to the organic growth of the organic Broadacre City.

The New School: The Teacher and His Flock

More teachers and smaller flocks would be the natural thing in the organic integration that challenges centralization.

The big knowledge-factory was always a self-defeating institution. How like a factory it looks and is, as one passes through the towns and villages. How unimaginative and impotent the vicarious product. How many prison houses for the mind are its abstractions. Armchair ethics, philosophy, science and art. Bookology is their science and their craft.

But any school in the Broadacre City would be, first, a park in the choicest part of the countryside, preferably by a stream or by a body of water. It is not only small as a whole, but that small could divide again into smaller so far as possible. Each school building is never more than one story high, fashioned of metals and glass for young life in sunlight. Divided into smaller buildings, each unit might contain not more than ten children. Say, forty children would be a large school. A gymnasium and a common hall, a

modelling and a drawing room, a kitchen and a dining room. The group in composition materials and glass, or perhaps metals, arranged about interior and exterior courts. Standardization could here, again, be used, but give way to more individual treatment. Enough ground for a flower and vegetable bed for each pupil would be alongside, with large play-spaces beyond that. Each pupil would learn of the soil by working on it and in it, and he would educate his hand to draw what his eye might see, and learn to model it equally well. Eye-minded is modern-minded. So the school building should be developed by artists and architects as, in itself, a free work of art.

To learn to draw well would civilize the faculties as a whole once more and more than any other means correlate the growing faculties.

Perfect correlation of all the faculties is the most important aim of the new education. The eye and the hand, the body and what we call the mind. And the just relation of this just correlation directly to the growth of the earth, as natural to the pupil. Thus getting a working sense and appreciation of the rhythm that is life itself.

In these sunlit buildings, beautiful in themselves, and in these garden courts, the child would be working, preparing food and learning how to eat it, learning to see accurately, by drawing what he sees, gradually taking the steps to learn how to make two blades of grass grow where one or none grew before. Physically and spiritually. Boys and girls here would become true co-efficients of a spiritually potent, therefore naturally creative humanity. Individuals, in communal individualship, becoming a certainty. An average of a teacher to a group of not more than ten would not be too much and the teachers themselves would be qualified as human beings to help develop or qualify an individual.

Here again is only a rough sketch of the smaller school buildings of the Broadacre City of which there would be ten such organic units for every inorganic one now attempting to function on hard pavements in overgrown, outdone centralization or new ones built on the model of the circus.

The New Home in the Broadacre City

We come, now, to the most important unit in the city, really the center and the only centralization allowable. The individual home. Integration here is voluntary and so far only as it is free individual choice.

Luxury may enter as gratification of developed sensibility. The home has grown in dignity and spiritual significance by this concept of the free city of Democracy. Not every man's home his castle, that was a feudal concept. No, every man's home his sunlit strand and no less, but more than ever, a refuge for the expanding spirit that is still his. And in his home the Broadacre citizen is, himself, true exponent and expression of his true place and relation to other men: his fellows. He inculcates high ideals in others by practicing them himself and insisting upon opportunities for others to do likewise.

The opportunity of men made equal before the law of the land as promised in the charter of Independence, and therefore the artificial economic structure dissolved or abolished, communal life may be based upon a sound economy of machine resources. Improvements of the ground are free to those who improve their ground. It is economic sense for the house owner to surround himself with such expression of himself as seems ideal to him, paying no penalty for so doing. Advantages have flowed in upon this house of his. He is becoming aware of these advantages. The significance of much he never realized before is coming clear to him. Physical changes in his situation have rendered obsolete most of his education and nearly all of his traditions. Then to what may he hold fast now, as he stands to go forward to new life on new ground with power never dreamed of until he began to dream?

Three Words

Let him learn their meaning well.
 The word "democracy."
 The word "integration."
 The word "organic."
They have never been interpreted and applied as ideals in this or, consciously, in any other culture up to now. The significance of these watchwords should be his guide. And as understanding opens to him the Old will naturally fall away. He will come face to face with the New.

The vicarious power that has left him and his home-making, too, spiritually stranded—aground

on sterility—will have a new meaning. In a new direction new forces will open to him that will make machine power no longer vicarious but a match for his own. He will build with that power the new house of a new world.

His Modern Home

In this modern home the hitherto painfully and expensively acquired utilitarian conveniences and sanitation may now be integrated in a single unit standardized for all. And ten for one in point of convenience and economy they may be his now to do for him what he could not ask of them ten years ago. Toilet convenience and sanitation and kitchen complete may be delivered to him as his car is delivered. In the standardized units composing his house, the new materials, glass and sheet metal, will let him out into the grounds and gardens around him as he lives within and open to him the vistas of the landscape.

The man himself has now a new ideal of living, in this new space concept of the machine age. Free space, in sunlight, ten feet or a thousand where one foot was his limit is now within his reach. His luxury consists, first, in that new sense of freedom, however simple the house may be otherwise. The homemaker will exercise this new sense of space freedom in the new space concept of his home. The reward and refuge of his life is this enlarged opportunity to build and live in a shelter of his own making.

This new standard of space measurement—the man seated in his automobile—affects him everywhere he goes, but most of all the new sense of space affects him here where he lives his family life. Vista, breadth, depth not only in his philosophy but in simple reaches of the building he calls home may now belong to him, not by way of mortgage or the "financing" that only leads to refinancing and eventually to "repossession."

Extended lightness, spacious openness, a firm cleanliness of line make satisfying appeal to his awakened imagination. And in the quality of surface, breadth of plane and length of line, he may see the simplicity of the flower. In all his home will be a feeling of free space to be lived in and enjoyed, even as the fields, the hill slopes, or the ravines and forests themselves. At home, he is lord of a free spacious

Frank Lloyd Wright, 1931
FLLW Fdn# 6004.0043A

interior life. Elemental spaciousness a reasonable possession. As a new significance physical and spiritual, this is in itself tremendous.

Let It Work

As a creative product of this sense of spaciousness, machine-age luxury will be more truly a concrete freedom than the Greek ever knew, the Goth ever felt or any man before except, perhaps, the Nomad. In sweep, simplicity and quality, no architecture ever rivalled what may now be the American home-unit: the only centralization in the new city in the American scene.

And characteristic also of this machine-age comes the increase of space by conservation of space. Such conservation makes all furniture either a part of or appropriate to the building. And takes all appurtenances for heat or light into invisible, but effective cooperation of the building itself.

A New and an Organic Simplicity

This sense of life as organic architecture and architecture as organic life reacts upon this man's sense of everything. He grows in breadth and health of mind. And his new freedom in his own home makes freedom dear to him, for others no less than for himself. He demands it as his right. Moreover, as the meaning of the word "organic" dawns upon him, he demands true significance in all about him. His awakened eye searches forms he once took for granted. Finding them false he rejects them. He will have truth of form or he will have none. And this goes out from him to establish itself in his relations with others in the communal life.

The communal life, too, must rest squarely and naturally with the basis for all human life, the ground for all.

Political science, too, he now sees as organic. Legitimatizing artificialities for crucifying life to feed ambition is no longer for him. Philosophy he has come to see as organic. The simplicities of Laotze and Jesus dawn afresh for him as he sees them, tangible, at work as modern art and religion. The interior discipline of a clean ideal of a simpler but more scientific and spacious life in true freedom of indi-

vidual expression is set up within him and grows tall against the very roof of his mind.

Potentialities undreamed of begin to work in him.

Soon he may walk abroad, a man among men.

When his power is no longer a vicarious power, he will be eager to share the work of the world, invigorated by the happiness and vitality of his life at home with the ground. The Usonian Citizen no longer growing impotent. Creatively he will be competent.

Typical Examples

Here set up in descriptive outline is the sketch of an ideal. The graphic arts must come in to show you what such a house would look like. And the different buildings described here already have graphic form. But the outline of an ideal is better than any specific plan for any house. . . . The ideal once fixed, the plan will come.

In Conclusion

These outlines of the appearing city—the disappearing city must really be the appearing city—may seem to the patient reader who has come with me so far, another Utopia to join the many, come and gone. I am not trying to prove a case. My interest lies in the nature of the elemental changes we have been discussing and there is plenty of evidence. Here, at least, is a study based upon an architect's experience in trying to get an organic architecture born for these United States.

I now realize that organic architecture is life, that life itself is organic architecture or both are in vain.

I see that the principles working in the one are at work in the other or must be. There can be no doubt that we are sacrificing the greater efficiency of humankind to put all into the lesser efficiency of the machine. I believe it is useless to go on working for the machine or the landlord on any general basis of any great future for a noble architecture because a noble architecture means a noble life. The landlord, as a hangover from feudal institutions, is not intrinsic, nor is the machine itself. What perversion to allow land to hold the improvements instead of

improvements holding the land and the machine to own the man instead of the man owning the machine!

We have reached the point where all is more or less makeshift where human life itself is concerned or at best more or less adventitious. It must be, so long as the basis upon which life as architecture and architecture as life must function together is not fundamentally strong and genuinely free. The valiant special case alone is free. Freedom is a dangerous adventure, as things are with us.

Out of my own sense of an organic architecture, observing the principles of that architecture at work as the law of natural change in the life of our country comes this tentative outline of the Broadacre City as I see it growing, as it must grow, from the ground up: a city to utilize for the human being the forces that built the present whirling vortex from the top down.

I confess that I have never been more than tolerant of reform. It is true form I am seeking. And no such form will ever be had by any alteration upon any old building or upon an old order. The new forms our modern life desperately needs will grow up from the ground, from within the nature of our common life. As Nature always grows her forms, so human nature must grow them, too; roots in the soil that is nature.

Cruelty, misfortune and poverty may be mitigated and should be, meantime. Honor to those so engaged in reform.

But I believe we have learned enough from the specialization that is centripetal centralization and have made enough ready, to go to the root for construction and do radical work with the law of natural, therefore of beneficent, change. The equalization, emphasizing individuality, that we call integration is that change. Why try to stand longer against it? "To have and to hold" is all very well when having and holding with nature. Both are disastrous when giving and taking against nature. And all that is written here is in line with that normal law of organic change as I have observed it beginning to work throughout our country.

The important new machine factors we have been discussing should be made no more than the scaffolding of our civilization. But we have been taking them for granted, high and low, as civilization itself. Therefore these factors are becoming

forces of destruction. As forces of construction they have had little intelligent recognition in our plan. In our culture—the elevation of the plan—none whatever. But adventitious increment derived from centralization as an incentive or premium has not been wholly wasted. These mechanical forces of our age having been more rapidly developed to a higher degree of efficiency than would ever have been the case otherwise these gains should now be utilized in the architecture of our states, economic, social, moral, aesthetic. The time has gone by when such development as centralization has brought with it can justify the immense cost of its "efficiencies."

▨ The time is here when something must be done with these new resources in a larger way for humanity in order to relieve the centripetal pressure inordinate centralization has become or we will leave a record of the shortest life of any civilization yet attempted. These new machine-and-material resources and humanity itself are fast growing apart as enemies to destroy each other although both are by way of each other, capable of new and true forms. Denied the new forms, degradation and misery will deepen.

Why not see the new forces openly thrusting at the old form or at the lack of any form, in all these agencies we have enumerated as beginning to decentralize the city? And see that we must subdivide the immense aggregates and build up individuality in order to re-integrate in larger scale and in the true individual freedom we desire, the life of our States.

Compelled by the organic force of these new resources the skeptical may see our big cities already splitting up into several centers; our big mercantile establishments already building distributing centers on the edges of the congestion. Our more advanced big manufacturers have already confessed the big establishment no longer necessary; the motorbus and motor truck have already cut the now senseless back and forth haul of the too many competing railways to the heart. The new centers of distribution serving mobilization—the roadside service station an important one among them—are everywhere rapidly growing in importance and range, especially Middle West and South, Southwest and West. Manhattan alone lost hundreds of thousands of citizens last year. Many other big cities lost heavily also. Density of population must decline.

So greatly has mobilization already changed human values, modified human character and needs and altered the circumstances, that most of our buildings and our cities, both in plan and in style, are obsolete when they are built. Almost all of our present architecture and structural equipment—outside certain industries—is obsolete. Too old. The machine-age has made the old arrangements of which the architecture of the city itself was perhaps the most important, already invalid.

It Is Time

Therefore it is time not to dream of the future but to realize that future as now and here. It is time to go to work with it, no longer foolishly trying to stand up against it for an eleventh-hour retrenchment.

Super-sense soon becomes common-sense. The Broadacre City is already super-sense, needing only to realize the forms that best express it in our daily life to make it valid. Those needed forms we already have. And they are all organic architecture. But we need organic economics and we need an organic social contract in order to make the new forms effective for all.

Our pioneer days are not over. Perhaps pioneer days are never over. But the frontier has shifted. Our American forebears took life in their hands and, efficient, went in their covered wagons to clear the ground for habitation. It seems they blazed the way for another efficiency that, by way of a rugged individualism that was only an exaggeration of their own great qualities, could only become exaggerated centralization. The strength of will and courage of our original pioneers was native forerunner to this type of domination we now see building its own mortal monuments, the skyscrapers in the cemetery that is the old city. They mark the end of an epoch.

Pioneering now lies along this new frontier: decentralization. Encumbrance and interference and danger again are there to be cleared away by the pioneers of a more humane because, at last, of an organic culture [sic]. Excess "success" must perish into promised opportunity for all to live as the bravest and best. Why, longer, should men be compelled to live according to the baser qualities of their natures would they live at all successfully? Why not a simpler natural basis for men to live according to their

better selves—and not only survive but, actually, thrive? As "pioneering" on this new frontier, then, is scraping off the too full bushel, while ignoring the complex impositions that overfill it, statesmanship? Then the tinker is the best maker, the imitator the best creator and vicarious power is the best power of which we are capable.

We now know that politicians are not statesmen. A statesman is an architect of an organic social order. The reforms proposed and effected by our political governing powers are no more than little shifts in the complex rules of the game. Makeshifts have been tried. But no interpretation in the changed circumstances of the ideal we have professed but have ignored has yet been tried. The by-products of any process whether of life or manufacture react and require constant modification. Are we thus stultified because we have really lost that ideal and so are unable to recognize or meet organic change?

There is no question whatever in the enlightened mind that includes a heart, as to the rightmindedness and humane instincts of humanity when humanity is free, but . . . in what does equitable human freedom actually consist in a modern society?

Let us discuss that and its underlying economics as intelligently and frankly as we discuss science—biology for instance—and this fundamental cause to which we have dedicated our lives may work more intelligently to allow these new forces we have raised to be released that we may come nearer our own Ideal.

What is the meaning of life in a democracy—developed machine power a factor—as distinguished from life in other forms of social contract? What is true human efficiency? What is true human economy?

Let our bravest and best seek the answer and although perhaps in other terms, whatever the terms may be, they will find the answer in life as organic architecture, as I have found it in organic architecture as life.

Evolution

We all know that the present basis of our life is inorganic—therefore unsound and dangerous just as such architecture as we have is two-fifths inorganic

waste. We should also know that the inorganic has sporadic increase but can not possibly reproduce as life because it lacks the correlation essential to organic growth. Centralization, as centripetal force has no interior, informing, expanding principle of life. Its efficiencies are all involved and narrow: involution not evolution.

So, because our economic system has been inorganic, inorganic our social system must be also and so our arts and our religion be uncreative. Our politics are absurd because our status quo is a strong arm. Our fortunes are largely false.

We have drifted into fatal exaggeration, and are being drawn inward toward impotence by way of a thoughtless use of vicarious power to make money as, itself, more vicarious power.

Let us have an intelligent interpretation of democracy—our own ideal. And then let us have an honest appraisal of our direction as we stand. And then?

With what we have accomplished let us go in the direction we intend.

1. Wright's acronym for the United States of America. He always asserted the word originated with Samuel Butler.
2. Broadacre City was Wright's solution to the problems of urban decentralization. The plan was first introduced here; a model, built by the Taliesin Fellowship, followed in 1934.
3. Roadside markets to be incorporated into the Broadacre City plan. Spaces were provided for fresh fruit and produce, a delicatessen, bakery, flower shop, and restaurant. See FLLW Fdn#3205.
4. A design commissioned by William Norman Guthrie, Rector of St. Marks in 1929.
5. Arizona Biltmore Resort (1927), Phoenix, Arizona.
6. San Marcos-in-the-Desert (project, 1929), Chandler, Arizona.

Architecture and Modern Life

**Some Aspects of the Past
and Present of Architecture**

Building upon the land is as natural to man as to other animals, birds or insects. In so far as he was more than an animal his buildings became what we call architecture.

In ancient times his limitations served to keep his buildings architecture. Splendid examples: Mayan, Egyptian, Greek, Byzantine, Persian, Gothic, Indian, Chinese, Japanese.

Looking back at these, what then is architecture?

It is man and more.

It is man in possession of his earth. It is the only true record of him where his possession of earth is concerned.

While he was true to earth his architecture was creative.

The time comes when he is no longer inspired by the nature of earth. His pagan philosophy is breaking down, owing to changing social conditions, to new science, new facilities, easy riches. The social world begins to turn upside down. Science takes the place of art. Things serve the man better than thoughts.

Nothing in his experience enables him to resist the disintegrating effect of money and machines. An enemy to his nature, likely to emasculate or destroy him, is embraced by him.

His creative faculties (art) are conditioned upon this earth. His possession of earth in this sense grows dim as his intellect (science and invention) discovers ways to beat work. Money shows him new ways to cheat life. Power becomes exterior instead of interior. His own acts—which are vicarious—are no longer inherent.

In these circumstances architecture becomes too difficult, building too easy. New facilities are here for which he has no corresponding forms. He seems for the moment powerless to make them. He is lost to the source of inspiration, the ground. He takes any substitute. Neither the pagan ideal nor its counterpart, Christianity, any longer lead him.

In the stress of circumstance a new ideal appears capable of leading him out of bondage into life again. Again the ground comes into the light as a brighter sense of reality dawns. It is the sense and nature of that which is within—integrity.

The room or space within the building is man's reality instead of his exterior circumstance. Though as old as philosophy, the new ideal takes on fresh significance in the ideal of architecture as organic. It must be integral to a life lived as organic.

New sense of the whole enters the life of man to bring order out of chaos. The old—"classic," eclecticism—is chaos, restlessness.

The new—"integral," organic—is order, repose.

All materials lie piled in masses or float as gases in the landscape of this planet much as the cataclysms of creation left them.

At the mercy of the cosmic elements, these materials have been disintegrated by temperatures, ground down by glaciers, eroded by wind and sea, sculptured by tireless forces qualifying each other. They are all externally modified by time as they modify this earth in a ceaseless procession of change.

Stone is the basic material of our planet. It is continually changed by cosmic forces, themselves

a form of change. Contrasted with these great mineral masses of earth structure—this titanic wreckage—are placid depths and planes of mutable water or the vast depth-plane of the immutable sky hung with evanescent clouds. And this creeping ground-cover of vegetable life, more inexorable than death, is rising from it all, over all, against all, texturing with pattern, infinite in resource, and inexhaustible in variety of effect. This is the earthly abode of the buildings man has built to work, dwell, worship, dance and breed in.

Change is the one immutable circumstance found in landscape. But the changes all speak or sing in unison of cosmic law, itself a nobler form of change. These cosmic laws are the physical laws of all man-built structures as well as the laws of landscape.

Man takes a positive hand in creation whenever he puts a building upon the earth beneath the sun. If he has birthright at all, it must consist in this: that he, too, is no less a feature of the landscape than the rocks, trees, bears or bees of that nature to which he owes his being.

Continuously nature shows him the science of her remarkable economy of structure in mineral and vegetable constructions to go with the unspoiled character everywhere apparent in her forms.

The long, low lines of colorful, windswept terrain, the ineffable dotted line, the richly textured plain, great striated, stratified masses lying noble and quiet or rising with majesty above the vegetation of the desert floor: nature-masonry is piled up into ranges upon ranges of mountains that seem to utter a form-language of their own.

Earth is prostrate, prostitute to the sun. All life we may know is sun life, dies sun death, as shadow, only to be born again. Evidence is everywhere.

Material forms are manifest in one phase today, to be found in another tomorrow. Everywhere around us creeps the eternally mysterious purpose of this inexorable ground-cover of growth. It is mysterious purpose, desperately determined, devouring or being devoured in due course upon this titanic battlefield. Growth seeks conquest by way of death.

To what end is all in pattern?

Always—eternally—pattern? Why?

Why this intrigue of eye-music to go with sensuous ear-music?

What is this inner realm of rhythm that dances in sentient beings and lies quiescent but no less sentient in pattern?

There seems to be no mortal escape, least of all in death, from this earth-principle which is again the sun-principle of growth. Earth becomes more and more the creative creature of the sun. It is a womb quickened by the passions of the master sun.

Nevertheless, every line and the substance of earth's rock-bound structure speak of violence. All is scarred by warring forces seeking reconciliation, still marred by conflict and conquest. But in our era violence has subsided, is giving way to comparative repose. Streamlines of the mountain ranges come down more gently to the plains. Geological cataclysm is subsiding or becoming subservient. Divine order creeps out and rises superior to chaos. Pattern asserts itself. Once more, triumph.

Ceaselessly, the rock masses are made by fire, are laid low by water, are sculptured by wind and stream. They take on the streamlines characteristic of the sweeping forces that change them.

Already matter lies quieted, and with it violence and discord. It is bathed in light that so far as man can see is eternal. Penetrating all, itself penetrated by itself, is mysterious eye-music: pattern.

Meantime in all this lesser building within greater building there is other animation, still another kind of building: these are creatures of creation patterned upon similar patterns until plant, animal creature and earth and man resemble each other for purpose malign or beneficent. Insect, reptile, fish, animal and bird are there in all the elements using gifts of life in this mysterious yet strangely familiar resemblance that we call our world. The seemingly senseless destruction goes on in each.

Some law of laws seems to keep in full effect the law of change in this world-workshop. The crevices and secret places of earth, shadows of the great underneath are swarming with fantastic insects, also singing, working, dancing and breeding.

But with this singular creature, man? Gaining dominion over all, what will he do to maintain his dominion? What will be his essential "pattern"? What does the vulnerable master of cause and effect know of instrumental cosmic law? What may he create?

Man by nature desired to build as the birds were meantime building their nests, as insects were building their cities, and as animals were seeking their dens, making their lairs, or burrowing into the ground. And architecture became by way of this desire the greatest proof on earth of man's greatness, his right to be born, to inherit the earth.

If the man was poor and mean by nature he built that way. If he was noble and richly endowed then he built grandly, like a noble man. But high or low it was his instinct to build on this earth.

By innate animal instinct he got his first lessons. He got ideas of form from those nature-forms about him, native to the place where he lived. Consciously or unconsciously he was taught by birds and animals. Inspired by the way rock ledges were massed up against sky on the hills, he was taught by the stratified masses of the rock itself. Trees must have awakened his sense of form. The pagodas of China and Japan definitely resemble the pines with which they were associated. The constructions of the Incas married earth itself.

Man's faithful companion, the tree, lived by light. The building, man's own tree, lived by shadows. Therefore, early building masses naturally belonged to the sunlit landscape in which they stood. The stone constructions of the Incas belonged there. Those of the African, of the sea-islanders and of the cliff-dwellers belonged there. The more developed buildings of Persia, China, and Japan belonged there. Later a building had become consciously no less a child of the sun than trees themselves always were.

Probably man first lived in stone caves, when he did not live in trees, using selected sticks and seeking appropriate stones for tools. Concerning this point it is perhaps better to say he first lived sometimes in trees and sometimes in stone caves. As he moved north or south his type of dwelling changed with the climate. The north always demanded most from him in the way of building, if he was to preserve himself. And the Esquimaux learned to build their igloos of blocks of snow cemented with ice.

Farther south the builder was satisfied with some grass and leaves raised up on a platform of sticks, or with some kind of tent that he might fold up and take with him on his horse as he rode away. While still dwelling in caves the man perhaps learned to make utensils out of wet clay. He burned them hard for use. These utensils he seems to have made with a higher faculty. His instinct became an aesthetic sense of environment. It taught him something of form. He learned from the animals, the serpents, the plants that he knew. Except for this faculty he was no more than another animal.

Still clinging to the cliffs, he made whole caves out of wet clay and let the sun bake the cave hard. He made them just as he had made the vessels that he had previously put into fire to bake and had used in the cave in the rocks. And so, once upon a time, man moved into his first earth-built house, of *earth*.

This large clay cave or pot of the cliff-dwellers, with a lid on it, was among the first man-made houses. The lid was troublesome to him then and has always been so to subsequent builders. But previously better forms of houses had come from the sticks that had been conferred upon him by his friendly companion, the tree. The lighter, more scientific house-shapes were at first conical, made so by leaning upright sticks together at the top. And the builder covered the sticks with skins of the animals he had eaten. But later man made more roomy houses by squaring the interior space and framing the walls upright. To make the walls he put sticks upright and crossed them at intervals with other horizontal sticks firmly lashed to the vertical sticks, finally covering all with various forms of mats woven of tall dried grasses or grasses lashed directly to the framework. Some forms of these earlier houses in certain parts of Africa and of the South Sea Islands are beautiful architecture to this day.

Then the builder had to contrive the lid—by now it may be called a roof—by framing much heavier sticks together, sloping the sticks across the interior spaces from wall to wall to carry overhead masses of tall dried grasses laid on smaller cross sticks in such a way as to run the water off. He covered this overhead wood framing in the manner of a thatch. The shape of this cover (or roof) was what most affected the general aspect of his building. Sometimes the roof stood up tall within the walls. Sometimes in shape it was a low protective mound. Sometimes it projected boldly. But it always showed its wood construction beneath the final covering.

Walls at first of earth, stone or wood stood up and out heavily as most important. The roof was seldom visible, especially where war was in man's

mind, as it usually was. Later the sense of roof as shelter overcame the sense of walls, and great roofs were to be seen with the walls standing back in under them. Man soon came to feel that, if he had no roof in this sense, he had no house.

Later he came to speak of his house as "his roof" and was fond of inviting strangers to come and sit or stay "under his roof." If other men displeased him he drove them "from beneath his roof." His roof was not only his shelter, it was his dignity, as well as his sense of home.

Civilization proceeded. Unless man had war in mind (as he usually did) the roof-shelter became the most important factor in the making of the house. It became the ultimate feature of his building. This remains true to this late day when changes of circumstances have made it the roof that he needs to fortify instead of the walls. The real menace of attack is now from the air.

The real science of structure entered into building with this sense of the roof and of wood, or "the stick," because every roof had to be framed strongly enough to span the interior space from wall to wall. Sometimes, as a confession of inability, perhaps, or a forced economy, the roof had to be supported on interior posts or partitions. Various picturesque roof forms arose as different materials were used to span the space below. More pains had to be taken with these spans than with anything else about the building. Although stone was used to imitate wood construction, the dome, the perfect masonry roof, soon arose among the myriad roofs of the world.

In all this work the principal tools in human hands were fire, the simple lever, and the wheel. But, in human hands, these soon grew into the might of the machine. Explosives soon came along to multiply the force of lever and wheel.

Early masonry buildings were mostly the work of men employing the simple leverage of inclined ways or using the bar as direct lever in human hands. The lever in some form (the wheel is the lever also) was used to make these early buildings.

Materials in primitive architecture were always most important. The character of all the earlier buildings was determined more by the materials available for construction than by any other one thing. Wood, brick, and stone always said "wood," "brick," or "stone," and acted it. Later the builder lost sight of nature in this integral sense. But these good limitations held until the so-called "Renaissance" or "Rebirth" of architecture.

Being craftsmen, because taught by experience with materials in actual construction, the early builders could find a right way to work whatever materials they found. They were ways that were best suited to the kind of buildings we can call architecture. Now the kind of building that we can call architecture today is the building wherein human thought and feeling enter to create a greater harmony and true significance in the whole structure. Shelter and utility in themselves were never enough. The edifice was the highest product of the human mind. Man always sought reflection in it of his sense of himself as God-like. Man's imagination made the gods, and so he made a God-like building. He dedicated it to the god he had made. His architecture was something out of his practical self to his ideal self.

The gods were various, but as the God he made was high or low, so the buildings he made were noble or relatively mean.

As we view the widely different kinds of buildings built by red, yellow, white, or black men, we see that all were clustered into various aggregations under many different conditions. These aggregations we call cities, towns, and villages. In primitive times these clusters of buildings were occasioned by animal fear and social need of daily human contacts, or by obedience to rule. So we see buildings in clusters great, and clusters small. No doubt the cluster once represented a certain social consensus. The village once satisfied a real human need.

The warlike tribe had its village. The peaceful tribe tilling the ground also went to its village for the night. It was necessary to go for protection on one hand, and offense or defense on the other. And always, for the convenience of the chieftain as well as of his subjects, all was closed in around him. Man, the animal, has always sought safety first. As a man, he continually seeks permanence. As an animal he wishes to endure his life long. As a man he has invented immortality. Nowhere is this yearning for continuity or permanence so evident as in his architecture. Perhaps architecture is man's most obvious realization of this persistent dream he calls immortality.

Animal instinct has reached upward and found a higher satisfaction.

These various clusters of buildings grew from tribal villages into towns, from towns to cities, and from lesser to greater cities until a few cities had something of the might and character of great individual building. Sometimes a city became as various in its parts as any building, and similar in greatness.

But usually the city was an accretion not planned beyond the placing of a few features. These features probably were not designedly placed. The city happened much as any crowd will gather about centers of interest wherever the centers of interest happen to be. Sometimes a circumstance of transport or historical consideration changed this center.

And, usually, there was a difference in degree only between the village, town, and great city. The one often grew into the other so that original spacing suitable to the village became a serious fault in the subsequent city. Populous crowding took what places it could find. It often took them by force of circumstance. Real freedom of human life in such circumstances soon became a farce.

In early times cities and towns were surrounded by fortified walls because cities and towns were forts. When might made right, the chieftain, the baron, the pirate and the bandit throve. Often the most successful robber became baron, sometimes monarch. The ruffian could rule in feudal times and often did rule, as he often rules in our own time.

The "divine right of kings" was a relatively modern improvement. It was an assumption that wore itself out by attrition. But meantime, by way of baron and monarch, we see architecture more and more undertaken as the great empires of the rich and powerful rather than a service to the genius of a whole people or as the expression of race. Architecture became self-conscious. It began to be pretentious, affected and petty. Oftentimes as the robber chieftain became the baron and baron became monarch, the desire to build became vainglorious. It far outran necessity. All the great buildings thus built—many palaces and tombs, even churches, baths, theaters, and stadiums—were built as monuments to the powerful individuals under whose patronage they were erected. But conquering races were always coming down from the north as potentate rose against potentate. While baron contended

with baron, neighboring cities were razed or enslaved by vandals, as they were called. This vandalism put new vandals into the places of weaker, older vandals. They called the weaker ones vassals. This is reflected in what remains of the architecture of periods when conquering mainly consisted in tearing down whatever the enemy might have built up. The more laborious and painstaking the building up had been, the more satisfactory was the pulling down.

In time, by way of the popular desperation caused by kingly discord and the baronial jealousies that employed men more for destruction than construction, government gradually became republican in form until in our day the people have subscribed to the idea of democratic government. This shows, at least, that the ultimate rise and progress of the whole people towards self-determination was proceeding, if slowly, through the human wreckage that we are viewing as ancient architecture. And however far away a satisfactory result may be, or however difficult it may be to imagine an indigenous architecture as its own expression, this struggle to rise does still go on among the peoples of the world. It is a seething in the mass. This, too, has affected the spirit that we call architecture. It is about to appear in new and more harmonious ways of building. Because they are more direct and natural, we are learning to call the new ways of building "organic." But to use the term in its biological sense only would be to miss its significance. The word organic should signify architecture as living "entity" and "entity" as individuality.

Let us now go nearer to the grand wreckage left by this tremendous energy poured forth by man in quest of his ideal, these various ruined cities and buildings built by the various races to survive the race. Let us go nearer to see how and why different races built the different buildings and what essential difference the buildings recorded.

Whether yellow, red, black, or white race took precedence in the buildings that followed down the ages is not known. We have many authorities ready in this respect to cancel each other. History, necessarily post mortem, must be some kind of internal evidence discerned within what remains of the building itself. Remains of each separate race have for the most part totally disappeared. Some subsist merely as cuneiform writing on stone or as porce-

lain tablets. So conjecture has wide limits within which to thrive. But architecture appears, more and more with every fresh discovery, to have had common origin in the civilizations of the past. It seems now to be on the way out rather than on the way in.

In the evolution of the kind of building that we may call architecture, such primitive civilizations as remain have a high place. We may not neglect the contributions from the South Sea Islanders, from far south to the north, or of the Pacific savages who already made their implements look and feel stronger as utensils through the decoration they put upon them. The old Persian, the Dorian, and Ionic, and the old Byzantine all are architectures of vast importance. Their origins are lost to view. And all are tributary in our view of architecture. They proceed from one common human stock. But we begin with those great architectures in view from about 1000 B.C. to 1300 A.D. This is a period of time in which the greatest buildings of the world, traces of which are still visible to us, arose out of the soul and the soil of civilization. Civilizations are original cultural impulses whether they converge on some downward road or not.

Uncertain scholarship places the Mayan civilization centuries later than the height of Egyptian civilization. It was, say, 600 B.C., Germans and others dissenting. However that may be, Mayan and Egyptian both have more in common where elemental greatness is concerned than other cultures, unless we include the great work of the To, Cho, and Han periods of Chinese culture. These we may also place from 600 B.C. to 600 A.D. And as we have seen, architecture was in point of style relative to all that was used in it or in relation to it, that is to say, utensils, clothes, ornaments, arts, literature, life itself. All, manifestly, were of a family. They served a common purpose converging to a common end.

The Egyptian of that period was already more sophisticated than either early Mayan or early Chinese, and so might well have arisen at an earlier period in human development than either. Or, if primitive character is the more ancient, then the Mayan might be the elder. In Maya we see a grand simplicity of concept and form. Probably it is greater elemental architecture than anything remaining on record anywhere else. Next would come the early Chinese, especially their stone and bronze sculptures. In both Mayan and Chinese there was an assertion of form that could only have proceeded from the purest kinship to elemental nature and from nature forms of the materials used by both. Egyptian architecture, pyramid and obelisk excepted (they probably belong to an earlier period), had a sensuous smoothness and comparative elegance inspired by the sensuous human figure. Egyptian architecture was a noble kind of stone *flesh*. In the Egyptian dance, as contrasted with the Greek form of the dance, you may see this verified. The background of the architecture, the Egyptian landscape, was the sweeping simplicity of deserts relieved by greenery of the oasis. By his industry in the agrarian arts the Egyptian grew. He was astrological. He was a God-maker through myth. Egyptian individuality seems rounded. Its reward seems completely recorded by architecture. It is the most sophisticated of survivals from ancient origins.

But the Mayan lived amidst rugged rock formations. He contended with a vast jungle-like growth in which the serpent was a formidable figure. The Mayan grew by war. He was a great ritualist. He was a God-maker through force. Flesh lives in his architecture only as gigantic power. Grasp the simple force of the level grandeur of the primal Mayan sense of form and the Mayan enrichment of it. Grasp the cruel power of his crude Gods (to objectify one, a sculptured granite boulder might suffice), then relate that to the extended plateaux his terraces made and to the mighty scale of his horizontal stone constructions. You will have in these trabeations the sense of might in stone. Even a Mayan "decoration" was mighty. It was mostly stone built.

Yet, both Egyptian and Mayan races seem children of a common motherland. With a broad grasp compare the might and repose of the Mayan outlines with the primitive Egyptian form in its almost human undulations; so rounded and plastic is the Egyptian architecture against the endless levels of the undulating sands surrounding it that it is the pagan song in an architecture of human profiles cut in stone. Though it is modeled in stone like the human nude, it finds great and similar repose in the ultimate mass.

Then compare both Mayan and Egyptian architecture with primal Chinese nature-worship as

seen in the outlines of early Chinese forms. They are influences, no doubt, coming in from the mysterious Pacific. A sense of materials is there. It is seeking qualities. It is form qualified always by the profound sense of depth in the chosen substance and in the working of it. You will then see that what the early Chinese made was not so much made to be looked at as it was made to be looked into. In whatever the Chinese made there was profundity of feeling that gave a perfect kinship to the beauty of the natural world as it lived about man, and that was China. It is an architecture wherein flesh as flesh lives not at all. The early art work of China is ethereal. And yet altogether these architectures seem to acknowledge kinship to each other, whether Mayan, Egyptian, Dorian or Chinese.

▦ Early stone buildings—perhaps earlier than Egyptian or Greek—in the hands of the Byzantines became buildings quite different from Incan, Egyptian, or Chinese stone buildings. The arch was Byzantine and is a sophisticated building act resulting in more sophisticated forms than the lintel of the Mayan, Egyptian or Greek. Yet it is essentially primitive masonry. Byzantine architecture lived anew by the arch. The arch sprung from the caps of stone posts and found its way into roofing by way of the low, heavy, stone dome. Its haunches were well down within heavy walls. It was a flat crown showing above the stone masses punctured below by arches. St. Sophia is a later example. The stone walls of Byzantium often became a heavy mosaic of colored stone. The interiors above, roundabout and below, were encrusted with mosaics of gold, glazed pottery and colored glass. The Byzantines carved stone much in exfoliate forms, but the forms preserved the sense of stone mass in whatever they carved. Heavy wooden beams, painted or carved, rested on carved bolsters of stone or were set into the walls. Roof surfaces were covered with crude tiles. The effect of the whole was robust nature. It was worship by way of heavy material, masterful construction and much color.

The Romanesque proceeded from the Byzantine. And among the many other influences today our own country—so long degenerate where architecture is concerned—in the work of one of its greater architects, Henry Hobson Richardson, shows Romanesque influence.

St. Sophia is probably the greatest remaining, but a late example, of the architecture of Byzantium. In point of scale, at least, it is so. The Byzantine sense of form seems neither East nor West but belongs to both. It is obviously traditional architecture, the origins of which are lost in antiquity. Eventually becoming Christian, the Byzantine building was more nobly stone than any Gothic architecture. It was no less truly stone, though less spiritually so, than Mayan architecture. Into Byzantine buildings went the riches of the East in metals, weaving, images and ritual. Byzantium grew most by merchandising. Notwithstanding the dominance of the merchant class, a robust spirit lived in Byzantine work. It still grappled earth forcefully with simple purpose and complete individuality.

In the domed buildings of Persia we see the Byzantine arch still at work. Their buildings were the work of an enlightened people. Their architecture was probably the pinnacle of the civilizations that proceeded to the valley of the Euphrates and the Tigris from the supposed cradle of the white race. Persian architecture lifted its arches and domes to full height, in full flower, when great medieval western architecture was beginning to point its arches in stone. The Persian loved masonry. By the most knowing use on record of clay and the kiln he achieved enormous building scale by way of bricks and mortar. He worked out his roof by way of the kiln as a great masonry shell domed and encrusted with extraordinary tile mosaics. He made his brick domes strong by placing their haunches well down into massive brick walls. His masonry dome was erected as an organic part of the whole structure. And lifting this sky-arch high, with gently sensuous, swelling sides, he humanized it completely. The Persian liked his dome so much that he turbaned his head, we may imagine, to match it, and robed himself from shoulders to the ground in keeping with the simple walls to carry the patterned enrichment. As ceramic efflorescence it flowed over his buildings, and as weaving and embroidery it overflowed upon his garments and carpets.

The Persian was born, or had become, a true mystic. And because he was a mystic, this particularly developed man of the white race naturally loved blue. He put blue within blue, blue to play again with blues in a delicate rhythmical pattern displaying divine color in all and all over his wall

surfaces. He kept his wall surfaces unbroken, extended, and plain, so that he might enrich them with these sunlit inlays of his spirit evident in glazed colored pottery tile. His jars, less elegant than the Greek, were shapely and large and blue as no blue—not even Ming blue—has ever been blue. His personal adornments and ornaments were blue and gold. Subtle in rhythm and color, indelible in all, were rhythms as varied as those of the flowers themselves. Under his thought, walls became sunlit gardens of poetic thought expressed as geometric forms loving pure color. So also were the woven carpets under his feet with which he covered the red and blue mosaics of his floors.

And then the Persian surrounded his buildings by avenues of cypress trees and acres of living flower gardens. He mirrored his domes and minarets in great, placid, rectangular adjacent pools of fresh water coming flush with the ground and rimmed from the gardens by a narrow rib of stone.

Yes, the Persian liked his domed buildings so well that he not only dressed his head likewise but was continually making out of brass or silver or gold or enamel, similar buildings, in miniature, and he domed them too. Filling their basements with oil he would hang these little buildings by hundreds inside his buildings as lamps to softly light the glowing spaciousness of his wonderfully dignified interiors. His sense of scale was lofty, and he preserved it by never exaggerating the scale of his exquisite details. So these edifices stood out upon the plains, blue-domed against the sky among the rank and file of Persian cities as complete in themselves as the cypress trees around them were complete.

No ruffian ever ruled the Persians, but one did conquer them. His name was Alexander.

In the works of this imaginative race, sensitive to inner rhythms, superlative craftsmanship by way of the greatest scientific masonry the world has ever seen is yet to be found in the remains of the period ending about the eleventh and thirteenth centuries. The workman was the potential artist. He was not yet the time-bound slave of a wage system. And the architect was grandly and usefully a poet.

The *quality* of a man's work was then still his honor. These noble buildings were made of and made for well-made bodies, tall of stature, fine minds. Black heads and deep dark eyes were the perfect complement for this poetic sense of build-

ing and the garden, and of blue. So the Persian of old made his God of Beauty and passionately dreamed his life away godward.

What a romantic of the race was this Persian, what mystic romance this Persia! Aladdin with the wonderful lamp? The wonderful lamp was Persian imagination.

In these creations of Persian life the upward growth of imaginative philosophic building had come far toward us, far beyond primitive walls and roofs of mankind. It came probably as far as it was ever to come with the exterior sense of form. Yet it was much more developed than the pagan sense of mass which preceded it.

The opulent Arabian wandered, striking his splendid, gorgeous tents to roam elsewhere. He learned much from the Persian; the Hindu, learning from the same origins, was himself seemingly more involved. He raised his complex but less spiritual temples to his God in the manifold tiers and terraces and domes of masonry or copper or gold. They even rivaled the Persian in exuberance but seemed to lack the pure and simple synthesis of form and clear pattern and color achieved by the Persian. This architecture traveled South and East, by way of its genius, Buddha. It influenced China, Java, Bhutan, and Thibet.

The Hindu carved and grooved, fluted his groovings with moldings. Then he loaded his architecture with images where the Persian held his surfaces true, as he inlaid them with precious materials to give them sun-glory as strong walls. But a Persian building sang in sunshine as the nightingale sings in shadow.

Perhaps Persian architecture was the end of a quality of the spirit, a feeling for the abstract as form in architecture. Probably it was gradually lost, never to be surpassed unless the ideal of architecture as organic now reaches logical but passionate expression in years to come. These simple masses of noble mind and the exquisite tracery of fine human sensibilities remain in our grand vista to remind us of this phase of human architecture, called Persian. It is the natural dome among the more self-conscious roofs of the world of architecture.

Somber, forest-abstract made in stone, the architecture we call Gothic is much nearer to us and has

taken to itself a long course of time in which to die. To the development of architecture in "Le Moyen Age" came stone embodying all earlier wood forms of architecture. The wood forms became more and more implicate and complicated as Gothic masonry perfected its science.

Stone craft as organic structure rose to its highest level. In the beautiful cathedral constructions of the Gothic builders, the "Gothic" of the Teuton, the Frank, the Gaul, the Anglo-Saxon, not only did the architect decorate construction but he constructed decoration. Some of this was not integral to structure. No stone arris was left unmolded. Stone itself had now blossomed into at least an affair of human skill, usually into a thing of the human spirit. The "Gothic" cathedral seems an expiring wave of creative impulse seizing humanity by way of stone. The noble material, becoming mutable as the sea, rose into lines of surge, peaks of foam that were all human symbols. In it images of organic life were caught and held in cosmic urge. It was the final movement in the great song of stone as in ages past we see man singing it in architecture. The human spirit, as organic or living entity, seems here to have triumphed over organic matter.

But this great architecture grew by feudal strength. The spirit called Gothic at this time pervaded the baron, the merchant, the guild, the peasant. In a religious age Mariolatry, the devil and hell became articulate in architecture, a dream of heaven. Flesh remained the rough, salty romance of the people. The merchant rapidly grew in power.

In all these great periods of human history the buildings themselves, in point of style, were related to everything put into them for human use or for beauty. They were related to anything else that was in any way related to them, even clothes and ornaments, the way of wearing them and of wearing the hair, the grooming of eyebrows, even making up the face. We may reasonably see these architectures altogether as having common origin, all flowing in the same direction. The features of all are truly the features of humankind. Human nature is their nature and human limitation their limitation. For, not only were ancient popular customs in perfect harmony with ancient buildings, utensils, and ornaments, but even human personal manners were affected likewise by environment and affected or reflected environment. Better to say that environ-ment and architecture were one with nature in the life of the people at the time, whenever and wherever it existed as architecture.

This is the great fact in this great human-scape called architecture: architecture is simply a higher type and expression of nature by way of human nature where human beings are concerned. The spirit of man enters into all, making of the whole a God-like reflection of himself as creator.

In all buildings that man has built out of earth and upon the earth, his spirit, the pattern of him, rose great or small. It lived in his buildings. It still shows there. But common to all these workman-like endeavors in buildings great or small, another spirit lived. Let us call this spirit, common to all buildings, the great spirit, architecture. Today we look back upon the endless succession of ruins that are no more than the geological deposits washed into shore formation by the sea, landscape formed by the cosmic elements. These ancient buildings were similarly formed by the human spirit. It is the spirit elemental of architecture. The buildings are now dead to uses of present-day activity. They were sculptured by the spirit of architecture in passing, as inert shapes of the shore were sculptured by cosmic forces. Any building is a by-product of eternal living force, a spiritual force taking forms in time and place appropriate to man. They constitute a record to be interpreted, no letter to be imitated.

We carelessly call these ancient aggregations "architecture." Looking back upon this enormous deposit to man's credit, and keeping in mind that just as man was in his own time and place so was his building in its time and place, we must remember that architecture is not these buildings in themselves but far greater. We must believe architecture to be the living spirit that made buildings what they were. It is a spirit by and for man, a spirit of time and place. And we must perceive architecture, if we are to understand it at all, to be a spirit of the spirit of man that will live as long as man lives. It begins always at the beginning. It continues to bestrew the years with forms destined to change and to be strange to men yet to come.

We are viewing this valid record of the inspired work of the red men, yellow men, black men or white men of the human race in perspective outline. What we see is a vast human expression having a common ground of origin. It is more a part

of man himself than the turtle's shell is part of the turtle. A great mass of matter has been eroded by man's spirit. These buildings were wrested by his tireless energy from the earth and erected in the eye of the sun. It was originally the conscious creation, out of man himself, of a higher self. His building, in order to be architecture, was the true spirit of himself made manifest (objective) whereas the turtle had no freedom of choice or any spirit at all in the making of his shell.

Considering this, we may now see wherein architecture is to be distinguished from mere building. Mere building may not know "spirit" at all. And it is well to say that the spirit of the thing is the essential life of that thing because it is truth. Such, in the retrospect, is the only life of architecture.

Architecture is abstract. Abstract form is the pattern of the essential. It is, we may see, spirit in objectified forms. Strictly speaking, abstraction has no reality except as it is embodied in materials. Realization of form is always geometrical. That is to say, it is mathematic. We call it pattern. Geometry is the obvious framework upon which nature works to keep her scale in "designing." She relates things to each other and to the whole, while meantime she gives to your eye most subtle, mysterious and apparently spontaneous irregularity in effects. So, it is through the embodied abstract that any true architect, or any true artist, must work to put his inspiration into ideas of form in the realm of created things. To arrive at expressive "form" he, too, must work from within, with the geometry of mathematic pattern. But he so works only as the rug maker weaves the pattern of his rug upon the warp. Music, too, is mathematic. But the mathematician cannot make music for the same reason that no mere builder can make architecture. Music is woven with art, upon this warp that is mathematics. So architecture is woven with a super-sense of building upon this warp that is the science of building. It also is mathematical. But no study of the mathematic can affect it greatly. In architecture, as in life, to separate spirit and matter is to destroy both.

Yet, all architecture must be some formulation of materials in some actually significant pattern. Building is itself only architecture when it is essential pattern significant of purpose.

We may look back now upon the character of the great works of man called architecture and see how, by way of instinctive abstraction, the hut of the African sometimes became in the sun very tree-like or flower-like or much like the more notable animal forms or hill-shapes round about it; how the cliff dwellers raised the clay up from under their feet into great square vessels for the sun to bake; and how they put smaller vessels into them, fire-baked into admirable shapes, for daily use or for fire-worship; how their vessels were marked by imaginative patterns, and how meanwhile they were making small human images to go into them or go along with them. We have seen how the Incas carried along earlier traditions, extending back to lost civilizations, and completed the rock strata of their region by noble structures of stone adorned by crude stone human images, and how they put stone and metal and pottery into them all and shaped them for use. Both buildings and their contents were enriched by adornment. They may be the record of greater, more ancient civilizations from which they were themselves only migrations.

We have seen how the Byzantines lifted stone up into the arch and then on up into the dome, asking their materials, even so, to be no better or worse than they were. We have seen how the Egyptians, another migration, worked stone ledges into buildings, and buildings into stone ledges; how they knew metals, pottery and weaving and adorned their buildings with the human image by way of painting and sculpture. Upon their walls, those pages of stone, were their hieroglyphics. But their buildings were in themselves hieroglyphs of truths coming to them from some ancient source of origin that seems common to all. This feeling seeps through all ancient architecture to us of the present day.

And we see how the later Greeks consciously evolved flower shapes in stone, but worked stone also as wood. After the Dorians and Ionians they seemed to have less sense of materials than other peoples. But the Greeks developed painting far and sculpture still further and put the building into the vase, as into the building they put the vase and the manuscript. The vase was the result of their search for the elegant solution, their supreme contribution to culture.

We have seen how the Persians came from similar distant origins, how they blue-domed their

buildings under the canopy of blue and emblazoned them with blue and purple ceramic flower gardens, making their buildings flower gardens within flower gardens, and put into them illuminated enamels, pottery and weaving. They omitted human images except when illustrating their books.

We have seen how, more recently, the cathedral builders put the somber uprising forest into stone, until stone triumphant could endure no more and began to fall. But meantime they had been weaving into their stone forest great glass paintings and wood carvings, and finishing them with pictured woolen and linen textiles, painted wood and stone images, great music, stately ritual and many books.

We have seen how the pagoda of the Orientals grew to resemble the fir trees, and how their shrines harmonized with the pines around them, and how within their buildings was a wealth of nature-worship in gold and painting and sculpture. Writing and myriad crafts were at home among them, and these buildings too were loaded with images.

And now, finally, we may see how all this was man's sense of himself: how it all came to be by the simple way of human use and purpose, but how also, in all ages and all races, it was man's greatest work wherein his five senses were all employed and enjoyed. By way of eye, ear, and finger, by tongue and even by nostril he was creating out of himself greater delights for a super-self, finding deep satisfactions far beyond those he could ever know were he merely a good animal.

But we are compelled to see, looking back upon this vast homogeneous human record, that the human race built most nobly when limitations were greatest and, therefore, when most was required of imagination in order to build at all. Limitations seem to have always been the best friends of architecture. The limitation in itself seems to be the artist's best friend in the sum of all the arts, even now. Later, we must see how subjugation, sophistication, easy affluence and increasing facility of intercourse began to get things all mixed up until nothing great in architecture lived any more. All architecture became bastardized. Finally the great arch of the Persian dome was fatuously invited by a "greatest artist" in the name of art to live up in the air. It was tossed against the sky to stand on top of round columns. Unnecessary columns were placed against

sturdy walls for mere appearance's sake. Roofs likewise became more ornamental than useful. Wood got to be used like stone, and stone like wood. Pottery began to be used like anything else but seldom used as itself. In short, mere appearance became enough. Integrity was given no thought. Also we are compelled to see how, when greater facilities of machinery came into use in the nineteenth century, the great art of building soon became utterly confused, degraded by mere facilities. The people began putting into their buildings so much piping and wiring, and so many sanitary appliances of every kind, that architecture of the earlier sort may be said to have died. Building had become so easy that architecture became too difficult.

No stream rises higher than its source. Whatever man might build could never express or reflect more than he was. It was not more than what he felt. He could record neither more nor less than he had learned of life when the buildings were built. His inmost thought lives in them. His philosophy, true or false, is there.

Inevitably, certain races were more developed than others. Some were more favorably situated. And we see that the influence in architecture of certain races profoundly or superficially affected other races. An instance: the artificial cornices and necessary columns of the Greeks still shape our public acts in the useless cornices and unnecessary columns of modern architecture "à la mode." Later work of the middle ages, called Gothic, still shapes our modern educational institutions and churches, and the modern homes of opulent tradesmen. They mark our public money-boxes called banks. It may be that the heights of architecture were reached so long ago that the various subsequent styles we now call "classic" and practice regardless, were already degenerate when they occurred.

▨ Throughout this authentic human record, inscribed in the countless buildings erected by man's labor, now fallen or falling back again upon the earth to become again earth, a definite character may be discerned determining man's true relationship to time and place. The sum of man's creative impulses, we find, took substance in architecture as his creative passion rose and fell within it. It always was creative. We have now reached the point in time when such original impulses subside

or cease. Inspiration is no more. Go back 500 years and nothing can be found in architecture worthy to be called creation, as architecture has been creative, except as folklore, folkways, folk building.

The last original impulse, called Gothic, has subsided and the "Renaissance," a period of rebirth of original forms that were also "rebirth" when first born, begins. Creative impulses grow dim, are all but lost. Only rebirth is possible to the culture of the period we are now to consider. It is probably an over-cultured period. Apparently, humanity had gone as far with its pagan ideal of architecture as it could go. The hitherto vast, uninspired merchant class has been gradually gaining the upper hand in society and will soon outbid the higher classes for power. It will then proceed to foreclose upon a decayed, uninspired higher class.

The handmaidens of architecture—music, painting, sculpture—during these 500 years are going on their way. Music, young, healthy, is growing up independently into Mozart, Bach and Beethoven. Painting based upon the work of Giotto and the early Italians begins to set up in this world of the "Reborn" as an art complete in itself. By way of many schools and phases it is to eventuate into the easel picture or the bogus mural. Sculpture begins the struggle for liberation from architecture that began with Buonarrotti. Undergoing many transforprimitive. At this period handicraft, still active and essential, is yet to die because men have found an easier way to accomplish the work of the world. Having found it, it is easier now for them to "immortalize" themselves.

From Italian sources, chiefly gathered together at Florence, where degeneration and regeneration of all arts were interlocked, Italian revivals of ancient Graeco-Roman architecture begin to reach the various European capitals as patterns. By importation or export these patterns are later to be exploited among the various western nations. Ancient Greek, itself a derivation, becomes the standard of a new "low" in western culture. The artificial cornice, the column and entablature, become the common refuge of a growing impotence.

Derivations of derivations, commercialized as Georgian "Colonial," or what not, are soon exports (or imports) to the new world, America. Later, all styles of all periods of "rebirth" were exported or imported by the Americans, as the Romans imported them and as the Japanese now import them, to be mingled, soon mangled, by the new machinery of endless reproduction. The saws, lathes, planers of modern mills are soon to strew the empty carcasses of these erstwhile styles far and wide until Queen Anne comes in and all sense goes out.

Where the primitive and splendid sense of structure or building construction was going on down the ages, the reality of all buildings for human occupation was found in the enclosing, supporting walls. But a deeper sense of architecture has come to light. This is due to a new philosophy, to the invention of new machines, and to the discovery of new materials. The new architecture finds reality in the space within the walls to be lived in. The new reality of the building is the interior space which roofs and walls only serve to enclose. This reality was not felt by primitive builders. Nor is it yet known to the pseudo-classic members of our academies today. Slowly dawning as the exterior or pagan sense of building dies, this interior ideal, or inner sense of the building as an organic whole, grows. It grows more consistent, carries more genuine culture with it as it develops: culture indigenous.

In modern building this ideal of structural cause as organic effect is destined to be the center line of man's modern culture. An organic architecture will be the consequence.

Ancient builders went to work "lavishly" upon the walls and roofs themselves as though they were the reality of the building, cutting holes in the walls for light and air. In the name of art they made such holes ornamental by putting molded caps over them, or by putting up unnecessary columns beside them, or by working needless moldings and insignificant ornament into or onto the walls. They built cornices. They surrounded all openings with more moldings to heal the breaches that had to be made in the walls to let in light and air, and to get in and out of. An architect worked with his building, then, much as a sculptor would work with his solid mass of clay. He strove to mold and enrich the mass. He tried to give to it some style that he had learned or happened to like. Exterior modeling and featuring thus became, by adoption, the so-called western academic concept of architecture. This academic—"classic"—concept was chiefly based upon Greek and Roman buildings. But meantime

the Chinese, Japanese, Persians and the Moors, Orientals all, developed a somewhat different sense of building. Their sense of the building was also the mass of solid matter sculptured from the outside, but the Oriental sense of the building was more plastic, therefore more a thing of the spirit.

Being "plastic," the building was treated more consistently as a unit or consistent whole. It was less an aggregation of many features and parts, all remaining separate features, by, and for, themselves. In organic building nothing is complete in itself but is only complete as the part is merged into the larger expression of the whole. Something of this had begun to find its way into many Oriental buildings.

During these later periods of various "renaissances," even the Pope's authority at Rome, the religious capital, has been rivaled by the authority of the Italian artist and workman, as the Italian Renaissance grew upon Europe. And so the remarkable Italian city of Florence grew to be the artist capital if not the cultural capital of a world.

But it became the artist capital of a western world that could only buy or sell. Already it was prostitute to imitation. It was a world prostitute to imitation because, with the exception of music and painting, and always excepting the newly born literature, society was unable to distinguish between birth and rebirth. It was unable to create anything much above the level of technique, scientific process or mechanical invention. The new world was learning to buy and sell its way to whatever it wanted in this matter of culture. By way of commercial reproductions of the styles affected by these European cultures society gratified such creative aspiration as remained.

Upon this prevalent rising tide that is called "commerce" comes the printed page, "letters," the book. Society becomes consciously literate as the printed book absorbs ever more of the cultural energies of mankind. Upon any large scale this scientific art of printing was the first application of the machine to human affairs. It is the machine that brings the book to humanity. And men, by means of the book, grew more literal. Life itself became and continues to grow more and more vicarious.

Human nature always seeks an easier way to do its work, or seeks a substitute. Human effort finds this "easiest way," or a substitute. The nineteenth century, especially, found both in machine development. As a consequence of this easy release all life, therefore all architecture, became less and less from within until society became content that art be something purchasable, something to be applied. The tendency of art in such circumstances is to become uncreative. It appears as some perverted form of literature or at least as no more than something literal. Realistic is the word. Machine power increased the deluge of literature and ready-made European "*objets d'art.*" A newly literalized humanity becomes obvious to commerce as the new facility for exploitation. Yes, "realistic" is the proper word for the art work of the period. It was really no great art at all. Photography could take over the popular "art interest" of the period. It proceeded to do so.

Yet, the machine is to make opportunity new. The science of printing is to make the book a medium for human expression more facile than building and the book is to become a means of recording life perhaps more enduring than the great edifice ever was.

But, meantime, the printed word accelerates. An increasingly vicarious life and servile art is becoming universal in the western world. Foregathering to listen, to stand, to watch, or to ride is now sufficient. Fifty thousand people watch a football game. Ninety thousand watch a prize fight. A remittance man sits at the steering wheel of a hundred and twenty-five horse-power car, with the airs, and sensation, too, that the power is his own—is, in fact, him. Connection with the soil is giving way to machinery. Contacts between men are increasingly had by electrical devices. Intercommunication becomes instantaneous and far reaching, but actual human contacts become fewer and more feeble. Superficial release is provided by literature, now ubiquitous, and new ways and means to beat work are found. Culture as architecture and architecture as culture is on the way down and out. Structure no longer finds beauty by way of integral evolution. Nor does society think to ask for such.

The place where this great integrity was wont to be is fast becoming an empty place.

The machine can exploit externality. But as we have set it up the machine can do nothing nor let much be done from within. The machine reduces and reproduces such forms of old-fashioned rep-

resentation in art as are most salable. Those most salable are naturally those most realistic or superficially elegant. Grandomania flourishes in consequence. Architecture as something ready-made is in the hand of the highly specialized and speculative salesman. Characteristic of this show-window period, architecture can only be a thing of mixed origins and haphazard applications. We may see it around us everywhere. Styles now abound. But nowhere is there genuine style. These are the days of the General Grant Gothic and the Pseudo-Classic. When Michelangelo piled the Pantheon upon the Parthenon and called it St. Peter's, he, a painter, had committed architectural adultery. It was destined to bring forth a characteristic monstrosity, namely, an arch set up into plain air on posts to shift for itself. It is an imitative anachronism that characterizes our public acts, as illustrated by our capitols, court houses, and town halls. A noble thing, the Persian dome has become ignoble. Now it is base. The same depravity sees a Greek temple as fitting memorial to Abraham Lincoln. He is the Greek antithesis. Nothing is Greek about his life or work or thought. A Gothicized French Château, incongruous pattern, is the unsuitable stall for some urban fire engine. Any Roman bath or sarcophagus will do to lend prestige to the sacrosanct bank on any town sidewalk anywhere. A Gothicized cathedral is set up at Yale to throw a glamour over college athletics. Another may serve to memorialize the grandmother of a successful speculator. All serve, unchallenged, this commercialized assumption or provincial gesture that the period calls culture.

In short, in this present time only the bastard survives even as a temple for the work of the Supreme Court of the United States. Stale survivals of every sort are "modern." Business turns to help itself liberally to "the classic." The "classic" goes to market as diamonds go.

Art and religion, in this inversion of human circumstances, lose prestige. Both these resources of the human spirit become purchasable and, as a natural consequence, life itself becomes purchasable. Meantime, science, far more useful to trade than either art or religion, grows in dominion. Neither art nor religion is longer a necessity to the people. The people have sought a replica. They have found and bought a substitute. The merchant has become the ruler for the time being of man's singing, dancing, dwelling and breeding. And the creative individual in the arts must become pauper, at this time when a Joseph Duveen is a knight, Andy Mellon a prince, and a Rockefeller, king.

In the preceding era, men of Florence were the guiding spirits and the light on the horizon, such as that light was. So, now in the twentieth century, social, economic, and artistic forms are determined by outward rather than by inner factors. Today the "civilized" world has come to the consequences of "renaissance." It has tried to live on a decadent precedent. Architecture and its kindred, as a matter of course, are divorced from nature in order to make of art the merchantable thing of texts, classroom armchairs and, above all, of speculative "price," that it now is. It is a speculative commodity.

The artist, now no more than the designing partner, the official streamliner, the interior decorator, the industrial designer, is entirely outside. Nothing could be more external than an interior decorator. Nothing could be more irrelevant than the exterior architect. Nothing could be more remote from life at the moment than citizens content to live in what either of them produces. Perspective is in reverse. The cart is before the horse.

A new type of patron of the arts has grown up out of this perversity. He is a Frick, a Widener, a Morgan, a Henry Ford, or a Bendix. Perhaps he is a Hart, Shaffner and Marx or Metro-Goldwyn-Mayer. He is, and he must be, some success in speculation upon some grand scale. Not for nothing was Joseph Duveen a knight.

By money power democracy has been perverted to inverted aristocracy. The new world has made social parasitism and vulgarity academic. What by nature can only be grown, may by such modern improvements be mere artifice freely bought to change hands at a price. Life itself must now be standardized because it is to be prefabricated, show-windowed, and eventually sold. Yes, and sold even now.

Trade and machine production are having their way and their say in the standardizations of our day. How can the young escape? As for the architect, who consents to buy and sell indulgences for his people, indulgences unwittingly provided by the traffic in foreign cultures to which he himself helped educate them: with him standardization has had its way too. Unwittingly, the Cass Gilberts, Ray

Hoods, Corbetts and Walkers, the McGonigles and Popes carry on the work of the McKim, Mead and Whites, the D. H. Burnhams, Richard M. Hunts and the Henry Hardenbergs. They are merely useful tools of this devastating power.

The great and liberal arts that man nourished because they nourished him have gone. They have gone by this same route to the mill which is this remorseless standardization for profit. And the tide of literal representation by way of the press, radio and cinema, all rapacious maws for more fodder of the sort, rises unsteadily to new monopolies.

At this moment, 1937 A.D., any ideal at all organic in character becomes impractical if not slightly absurd: shopkeepers all. All in all are ruled by the expedient.

Only petty specialists in architecture and the sister arts are needed on the job made by our order of "business." Its wholly artificial power must be maintained upon an artificial basis. It is engendered and kept by indiscriminate use of indiscriminate increment. The whole man can no longer be used. He too is a "job."

Let us frankly admit it:

The universal modern "art" is really salesmanship.

Showmanship is perihelion. Everywhere, it is at a premium.

The show-window is the most important form of all artistry in these United States. Let it stand for the symbol of this era.

The mother of the arts, architecture, in such circumstances could have little or no issue. Neither impregnation nor conception upon any social scale is possible. And a restless movement begins the world over. Action is inevitable. It has now begun because, long ago, it was time.

In this human restlessness the new order of culture, structure to emerge as "organic," lies concealed as the child in the womb. Meanwhile, cultural decay of the individual proceeds by way of the commercialized mass-education we have learned to call academic.

Has this modern restlessness anything to turn to? Has it recourse? Yes. Organic architecture with its sense of structure, the sense of the whole, is one great recourse. Religion might be another. These two, now as always.

We have been describing what has happened to art. What, then, has happened to religion so far as it relates to art?

Religion, in its present form, is become "Christianity," the church. The church was the last great client of architecture. The last great urge of human creative energy, upward thrust of human creative power, flowered into stone as it built the great cathedrals. The church was Christianity. What of Christianity, now, as it passes for religion in this general confusion and debauchery of the creative powers of man-kind? Neither the teaching nor character of Christianity was such as to inspire the nature-worship of the creative mind.

Christianity took the church to man as a substitute for that law and order of the universe which should have been worked out by him from within himself, law and order made his own by way of the arts. But, as Christianity had it, the man was to be saved by his beliefs, not saved by his works. So, the church substituted beatitudes for beauty. Spiritually the man was invited to become a parasite upon the Lord. That quality in the man that stood tall inside him up against the roof of his mind, which must ever be his true self, can no longer be much encouraged even by the church.

And the ideals of Jesus, the gentle anarchist, remain generally feared because generally misunderstood or yet unknown.

This failure to see God and man as one has disaffected all art for it has betrayed architecture. There is no longer general realization of matter and spirit as the same thing. This is a fatal division of the house against itself. A great wave of ugliness has followed in the wake of this error. Bogus sanctuaries to God stand propped against the sky by steel, as though it were necessary to prove to some court of last resort that the final period of creative impulse on earth is dying of imitation or already dead by mutilation.

With Christianity for tenant today, architecture is a parasite, content with an imitation of an imitation like the spurious St. John the Divine in New York City. To go along with the imported cathedral are such inversions as the Lincoln Memorial, such aberrations as our capitols, such morgues as our museums, monuments, and such grandomania as our city halls. Abortions of sentiment, like the

"Great White Whale" at Princeton, a Rockefeller cathedral on Riverside Drive are proof enough that the spirit of architecture has fled from a social era. Corpses encumber the ground. As for religion or art, a pig may live in a palace: any cat can scratch the face of a king.

Upon this, the American scene, emerges the new ideal-structure as organic architecture becomes interpretation of life itself. From within outward is no longer remote ideal. It is everywhere becoming action. With new integrity action insists upon indigenous culture. The new reality.

"The Architectural Forum"

To take this matter of an organic architecture a little deeper into the place where it belongs—the human heart—the design matter in this issue falls readily into the following sensuous expressions of principle at work. It is a sense of the whole that is lacking in the "modern" buildings I have seen, and we are here concerned with that sense of the whole which alone is radical.

1. The sense of the ground. (Topography, organic features. Growth.)
2. The sense of shelter.
3. The sense of materials. (Illustrated by characteristic early plans—showing interior living space becoming exterior architecture. Characteristic plans—early and late—abolishing walls, interior partitions, etc., and grouping or placing utilitarian features in such a manner as to allow space to be either magnified or uninterrupted so far as possible.)
4. The sense of space.
5. The sense of proportion. (With this you must be born. An instinct.)
6. The sense of order. (Related by cultivation to the sense of proportion.)
7. Ways and means, that is to say, technique. Last and least. Each man his own.

Characterizing these expressions in various forms—each an actual experience—plot-plans, plans, perspectives and photographs, some reminders of early buildings alongside later buildings. I have always considered plans most essential in the presentation or consideration of any building. There is more beauty in a fine ground plan itself than in almost any of its consequences. So plot-plans and structural plans have been given due place in this issue as of first importance. Furniture and planting are indicated on them. Next—the perspective study of the original concept. Then, photographs of finished structures and those in course of construction. Finally—certain details of these Usonian buildings.

TALIESIN, a house of the north, is best seen under its blanket of snow, long icicles pendent from the eaves.

Twice destroyed by fire, it now stands on its 200 acres as rebuilt in 1925–26. The native product is the work of farmer masons, farmer carpenters, and farmer plasterers—and a farmer architect. Apprentices have added many features, completing and extending it to house—temporarily—in addition to the architect and family, some twenty-five young people, working alongside in architecture. Taliesin is a natural building, in love with the ground, built of native limestone quarried nearby. Sand from the river below was the body of its plastered surfaces, plain wood slabs and marking strips of red cypress finish the edges, mark the ceilings, and make the doors and sash.

Located four miles from the nearest village, forty from the nearest city, Taliesin must have its own water, sewer, heat, light and power systems and its own transportation system. What life and entertainment it knows are found pretty much within itself.

Such remnants (twice escaped destruction when the building burned) of the considerable collection of ancient works of art acquired during the building of the Imperial Hotel in Tokyo still stand on the piers and walls. Some of those that fell in the fire of '25 are built into its stone walls. In the vault is a fine collection, still, of Japanese prints.

Any modern building really out of the ground is timeless (fashion cannot harm it in the long run).

Frank Lloyd Wright House,
Taliesin III,
Spring Green, Wisconsin. 1925
FLLW Fdn# 2501.0239

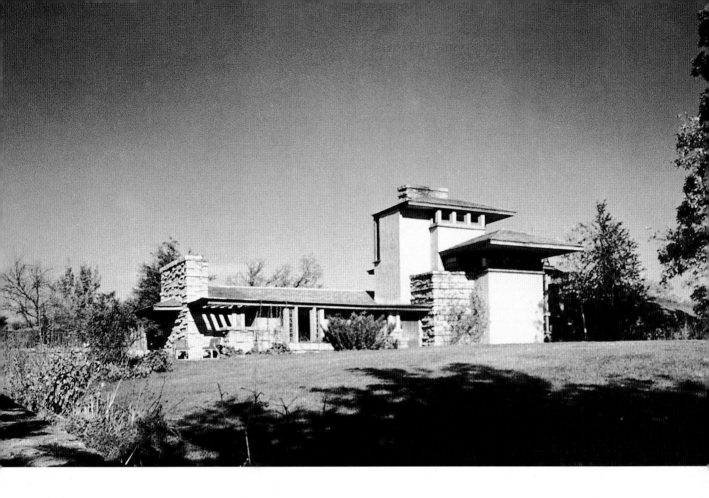

The mother art—Architecture—may well associate with the timeless in sculpture, painting, and music wherever found without loss of significance or beauty to itself or to those arts. That is as far as "creed" at Taliesin goes.

The blacksmith's horses, the shoemaker's children, the architect's home all know a certain habitual "lag." Taliesin knows it, too. But its architect has here taken his own medicine in doses all but fatal.

The buildings of the Taliesin Fellowship, old and new, are a quarter of a mile away, just over the hill to the south.

Perhaps this house should stand as a proper example of the sense of the ground in the category of sensitiveness mentioned in the foreword.

It is also a good example of the use of materials and the play of space relations, the long stretches of low ceilings extending outside over and beyond the windows, related in direction to some feature of the landscape.

These low stretches are frequently relieved by high ceilings following the roof pitches—marked by wood strip: to emphasize contrasting planes with an eye to the repose of the whole. Landscape seen through the openings of the building thus placed and proportioned has greater charm than when seen independent of the architecture. Architecture properly studied in relation to the natural features surrounding it is a great clarifier and developer of the beauty of landscape. . . .

"Hillside," home and workshop of the Taliesin Fellowship is a reconditioning and extension of the Hillside Home School built for the Lloyd Jones sisters in 1902.

The original buildings, "Romeo and Juliet" one of them, were built of native brick sandstone quarried a mile away and of oak timbers felled and sawed on the timber lands of surrounding farms. The labor of digging, quarrying, and hauling was done by "the family." The then "assembly room" (now the living room of the Taliesin Fellowship) was intended as memorial to grandfather and grandmother. These Welsh pioneers settled on the site of the school some eighty years ago. Quotations from Isaiah

Frank Lloyd Wright House,
Taliesin III,
Spring Green, Wisconsin. 1925.
FLLW Fdn# 2501.0235
and FLLW Fdn# 2501.0241

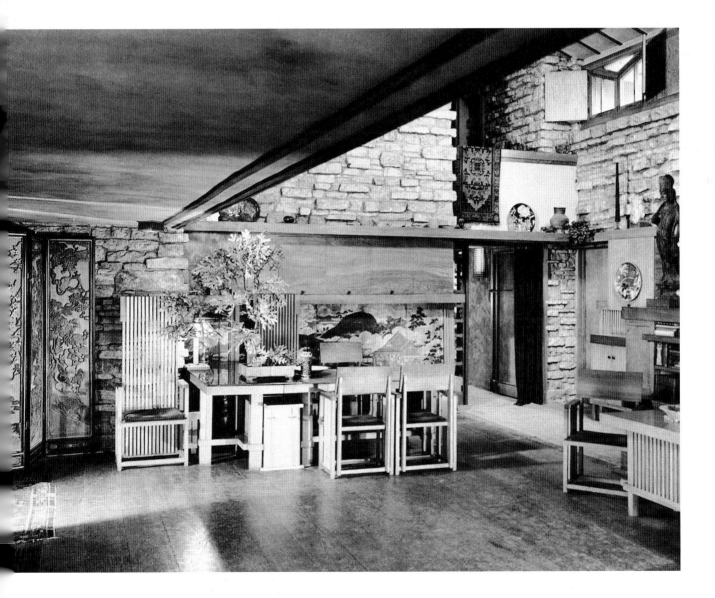

(grandfather insisted on his sons and daughters learning the chapter from which they were taken) are carved in the oak beams of the room. The pioneer verses from Gray's "Elegy" are carved in the sandstone slabs over the fireplace.[1] The andirons "straight-line" pattern were made because they resembled Welsh hats, from cones the village blacksmith used in making iron rings. But there was a better reason. The old gymnasium the apprentices converted into the Taliesin Playhouse. A new drafting room 85′ × 100′ is ready to work in all but the finished floors. The other buildings are commenced or roofed over but the shops and guest inn are not yet begun. The original buildings were salvaged and extended when, as fate would have it (early in 1932), I had recourse only to the materials and in similar circumstances to those in which the early buildings were originally built.

We bought trees standing—logged them to the site, and from the sawn trunks dripping sap made the abstract forest we now call the drafting room, a photograph of which you see here. Forced to postpone construction when "relief" came in for our workmen in 1934, we have begun again to carry out the plan for the whole as a meanwhile steady job for the Fellowship itself—going ahead as materials are available. Within two years we hope to have the whole as you see it herewith.

The type of Architecture—Usonian type—is suited to the modeling of the surrounding hills, bespeaks the materials and methods under which and by way of which the buildings themselves were necessarily born. That they are not "modern" as use of steel, concrete, and glass would have made them is—I think—beside the mark.

"THE GARDEN WALL." House built for Dean Malcolm Willey—Nancy Willey, Superintendent. Cost $10,000. A well-protected brick house built upon a brick-paved three-inch concrete mat laid down over well drained bed of cinders and sand—the concrete mat jointed at partitions. To develop the nature of the materials a sand mold brick course alternates with a course of paving brick, the exterior cypress is left to weather and the interior cypress is only waxed.

Malcolm Willey House scheme #1,
Minneapolis, Minnesota. 1932. Project.
FLLW Fdn# 3204.001

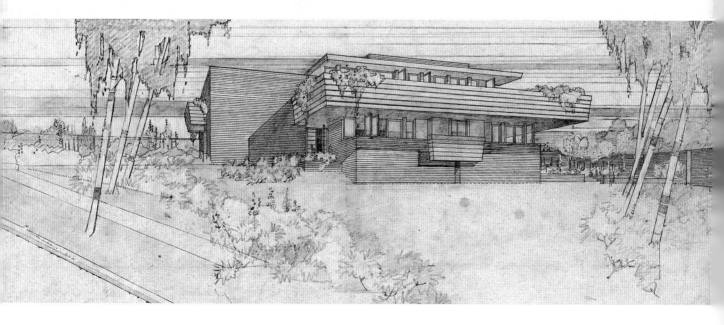

Malcolm Willey House scheme #2,
Minneapolis, Minnesota. 1933.
FLLW Fdn# 3401.0012

The house wraps around the northwest corner of a lot sloping to the south—a fine vista in that direction. The plan protects the Willeys from the neighbors, sequesters a small garden and realizes the view to the utmost under good substantial shelter. Notwithstanding the protests of the builder and unusually many kind friends, the fireplace draws perfectly and the mat is perfectly comfortable in 30° below-zero weather. Nor does the frost show upon the inside of the outside walls. The house emphasizes the modern sense of space by vista inside and outside, without getting at all "modernistic." There is a well-balanced interpenetration (that is to say sense of proportion) of the sense of shelter with this sense of space, the sense of materials and the purpose of the whole structure in this dwelling. It is well-constructed for a life of several centuries if the shingle roof is renewed in twenty-five years or tile is substituted. Perhaps this northern house comes as near to being permanent human shelter as any family of this transitory period is entitled to expect. The furniture is of a like substantial character, missing items still being built and moved in from time to time as designs arrive and ways and means appear.

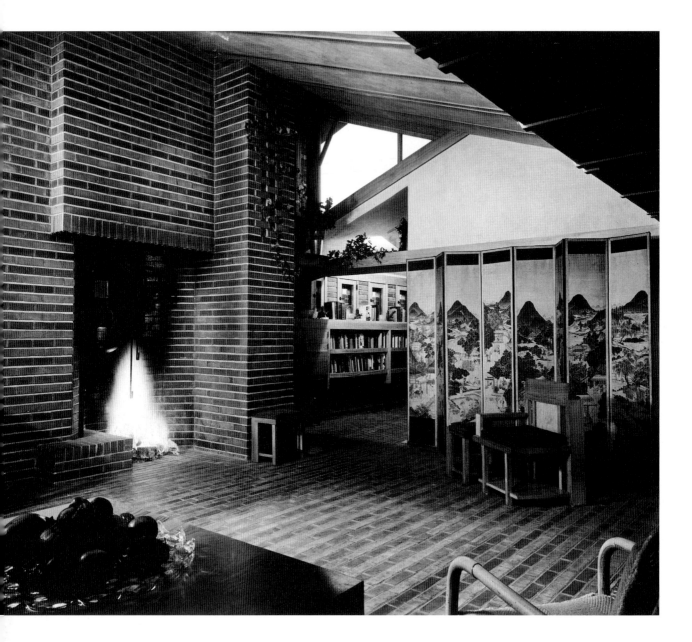

Malcolm Willey House scheme #2,
Minneapolis, Minnesota. 1933.
FLLW Fdn# 3401.0018

Memorial to the Soil,
Cooksville, Wisconsin. 1934.
Project.
FLLW Fdn#3710.001

*"Sculptors and painters ask me: 'What place has sculpture
and painting in your building?' I reply: 'My buildings are
painting and sculpture. But painting and sculpture that
is architecture could enter where I am compelled to leave
off for want of more highly specialized technique.' . . . To
carry the building higher in its own realm is the rightful
place of painting and sculpture wherever architecture is
concerned. Within this Memorial Chapel they are that and
are so employed. Colored bas-relief heightens the memorial
theme."* (Text from the 1938 *Architectural Forum*)

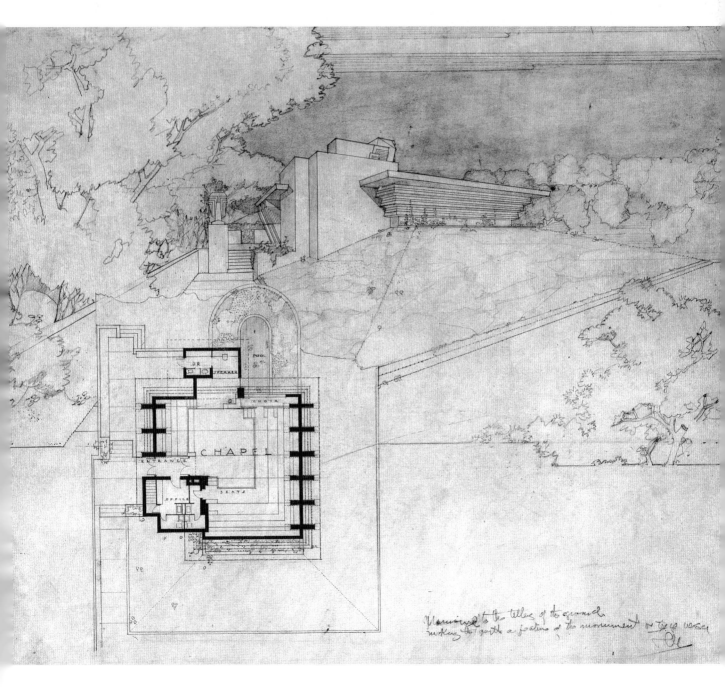

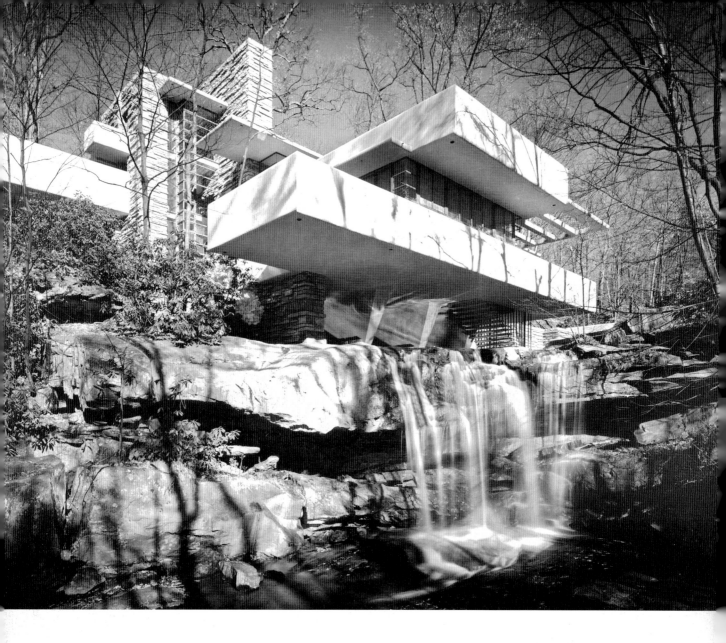

Edgar J. Kaufmann House,
"Fallingwater,"
Mill Run, Pennsylvania. 1935.
FLLW Fdn# 3602.0041
and FLLW Fdn# 3602.0050

FALLINGWATER. The country lodge of Edgar Kaufmann built at Bear Run, Pennsylvania, is pretty clearly what it is shown to be in the photographs herewith. For the first time in my practice, where residence work is concerned in recent years, reinforced concrete was actually needed to construct the cantilever system of this extension of the cliff beside a mountain stream, making living space over and above the stream upon several terraces upon which a man who loved the place sincerely, one who liked to listen to the waterfall, might well live. Steel sash came within reach also for the first time. In this design for living down in a glen in a deep

forest, shelter took on definite masonry form while still preserving protection overhead for extensive glass surface. These deep overhangs provide the interior, as usual, with the softened diffused lighting for which the indweller is invariably grateful, I have found.

The interiors would tell this story better than words but though they soon will be, they were not furnished at the time these pictures were made. Inasmuch as this furnishing is intimately part of the building, the interiors will appear at some later time.

This building is a late example of the inspiration of a site, the cooperation of an intelligent, appreciative client and the use of entirely masonry materials except for an interlining of redwood and asphalt beneath all flooring. Again, by way of steel in tension this building takes its place and achieves its form. The grammar of the slabs at their eaves is best shown by a detail. But the roof water is caught by a lead strip built into the concrete above near the beginning of the curve so what water dripping by gravity at the bottom of the curve—as it does—does not very much stain the curves. It is not the deluge of water in a storm that hurts any building: it is ooze and drip of dirty water in thawing and freezing, increased by slight showers. The cantilever slabs here carry parapets and the beams. They may be seen clutching big boulders. But next time, I believe, parapets will carry the floors—or better still we will know enough to make the two work together as one, as I originally intended.

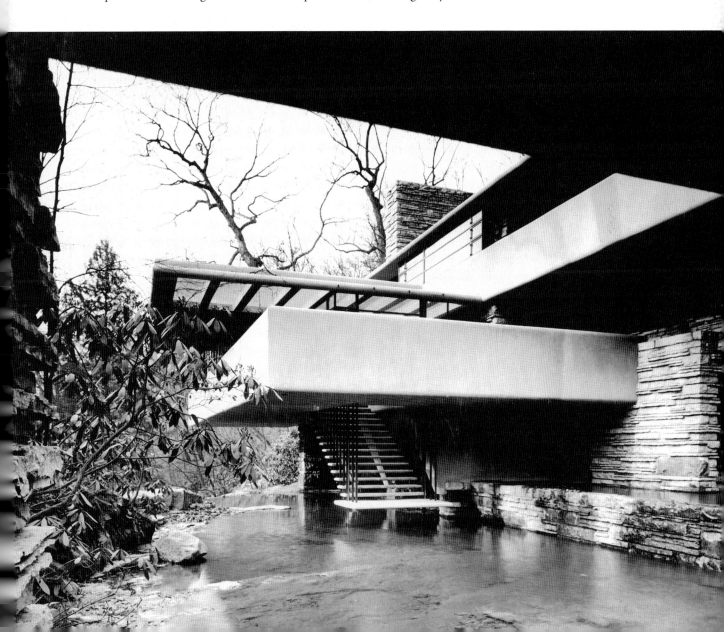

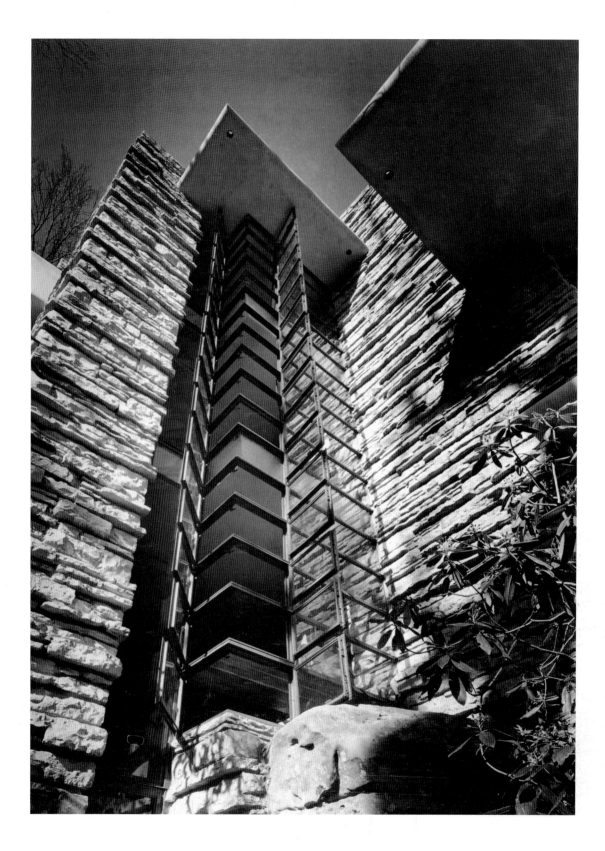

Edgar J. Kaufmann House,
"Fallingwater,"
Mill Run, Pennsylvania. 1935.
FLLW Fdn# 3602.0043

Edgar J. Kaufmann Office,
Pittsburgh, Pennsylvania. 1935.
FLLW Fdn# 3704.0001

*"Plywood mural in private office of
Kaufmann Senior . . . Floor, walls and
ceiling of cypress slabs . . . temporary
rugs and upholstery."*

This structure might serve to indicate that the
sense of shelter—the sense of space where used
with sound structural sense—has no limitations as
to form except the materials used and the methods
by which they are employed for what purpose. The
ideas involved here are in no ways changed from
those of early work. The materials and methods of
construction come through them, here, as they may
and will always come through everywhere. That is
all. The effects you see in this house are not super-
ficial effects.

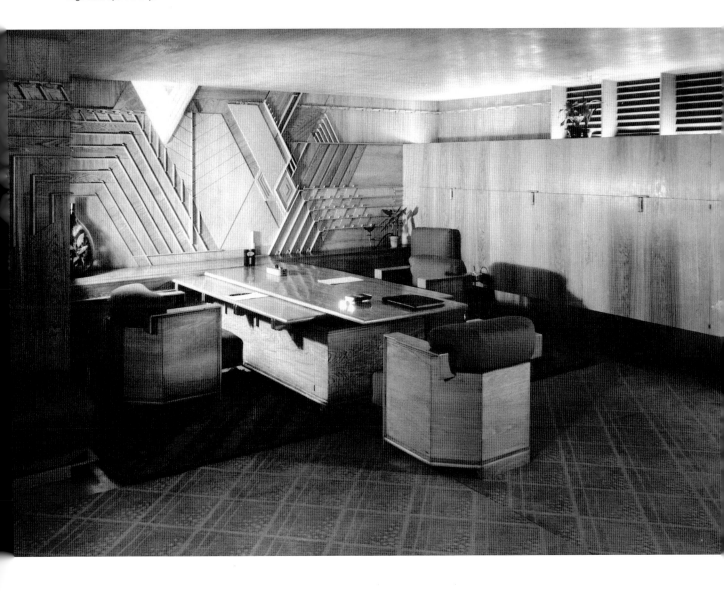

Texas rolling prairie needs a house—a house with modern sense and idea of space—above all airy, naturally air conditioned. The breadths of vista down there are inspiring.

This house is so inspired. An extended central chimney stack exhausts hot air from all the rooms, especially the sleeping rooms. Except for these upper rooms the roof over the house is a screened-in deck like that of a ship. The floor areas below, exterior and interior, are unbroken except for gratings inserted at the wall lines under the door screens to intercept the sweeping water of sudden downpours.

When the house is open it may be wide open. When it is closed it may be completely closed except the roof deck. All top surfaces are insulated against a merciless sun and the roof deck is screened against it by shutters rolling back and forth on extended cantilever arms which also carry insect screens, the screening extending downward to include the lower terrace area in front of the living room.

The walls are of slender flesh-colored roman bricks—coped with copper to match the copper roofs.

All glass surfaces are continuous under wide thin projecting eaves—glass used more for vista than for light. These sheltering planes not only marry the house to the ground but afford a pleasant diffusion of light in the interiors. The copper itself is turquoise blue.

If Texas ever realizes that it needs a Texas house it will have a sheltering wing-spread over the ground similar to this one; an openness to rolling prairie vistas—like this one; a house protected from stagnation of summer air and sudden cold as this one— as clean and swift of line. Texas is yet young and architecturally Texas is yet untouched. But perhaps construction as permanent as contemplated here is unnecessary for the climate.

I believe—making provision against violent winds—a lighter more transient construction would serve well enough, something between Ocatilla, the architect's camp in the desert, and the San Marcos block building itself. The experiment would be worth making, local architects to the contrary notwithstanding.

Estimates on this house ran between 30 and 35 thousand dollars. Inasmuch as 20 to 25 thousand dollars was the cost limit fixed we reluctantly laid the plans aside and the job went local.

ST. MARKS-IN-THE-BOUWERIE. This plan for a skyscraper standing park-free in the city, the only urban skyscraper fit for human occupancy, is as nearly organic as steel in tension can make it, here doing for a tall building what Lidgerwood made it do for the long ship. The ship had its keel. This building has its concrete core. A shaft of concrete rises through the floors engaging each floor slab as one passes through the shaft at eighteen levels. Each floor proceeds outward as a cantilever slab extended from the shaft. The slab, thick at the shaft, grows thinner by way of an overlapping scale pattern as it goes outward until at the final leap to the rectangle it is no more than three inches thick. The outer enclosing shell of glass and copper is pendent from these cantilever slabs. The inner partitions nest upon the slab.

Quadruple in plan (four double-decked apartments to each floor, each apartment unaware of the other as all are looking outward), the structure eliminates entirely the weight and waste space of masonry walls. The central shaft, standing inside away from lighted space, carries the elevators and entrance hallway well within itself. Two of the exterior walls of every apartment are entirely of glass set into sheet copper framing. But the building is so placed that the sun shines on only one wall at a time and the narrow upright blades, or mullions, project

Herbert H. Johnson House,
"Wingspread,"
Racine, Wisconsin. 1937.
FLLW Fdn# 3703.002

nine inches so that as the sun moves, shadows fall on the glass surfaces.

The building increases substantially in area from floor to floor as the structure rises—in order that the glass frontage of each story may drip clear of the one below, the building, thus, cleaning itself, and, also, because areas become more valuable the higher (within limits) the structure goes. The central shaft extending well into the ground may carry with safety a greatly extended top mass. This building, earthquake, fire and sound proof from within by structural economics inherent in its nature, weighs less than one-half the usual structure besides increasing available area for living purposes more than twenty percent.

It is a logical development of the idea of a tall building in the age of glass and steel—as logical engineering as the Brooklyn Bridge or the ocean liner. But the benefits of modernity such as this are not merely economic. There is greater privacy, safety, and beauty for human lives within it than is possible in any other type of apartment building.

Again the 1-2 triangle is employed—this time because in itself it has a flexibility in arrangement for human movement not afforded by the rectangle. The apparently irregular shapes of the rooms would not appear as "irregular" in reality—all would have great repose because all are not only properly in proportion to the human figure but to the figure made by the whole.

The building is a complete standardization for prefabrication. Only the concrete core and slabs need be made in the field. Our shop fabricating industrial system could here function at its best with substantial benefits to humanity. Owing to the unusual conformations the metal (copper) furniture would have to be a part of the building, as the furniture is designed to be.

Here again is the poise, balance, lightness and strength that may characterize the creations of this age instead of masonry mass which is an unsuitable, extravagant and unsafe hangover from feudal times.

"WINGSPREAD," the Herbert Johnson prairie house, now being built, is another experiment in the articulation which began with the Coonley House at Riverside, built 1909, wherein Living Room, Dining Room, Kitchen, Family sleeping rooms, Guest Rooms were each separate units grouped together and connected by corridor.

Notwithstanding the unprepossessing state of the building and the weather, several construction photographs are included here. The plan is oriented

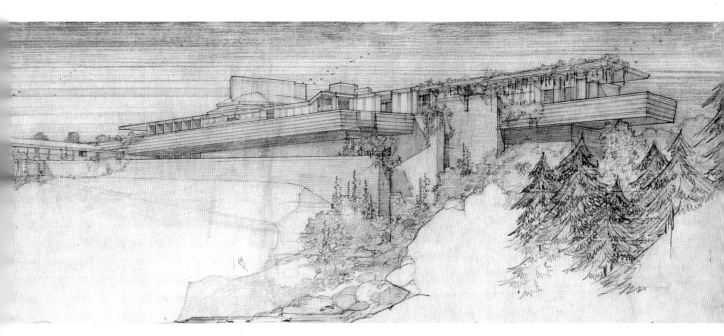

so that sunlight falls in all of the rooms and shows a logical expression of the zoned house.[2] (The first design for such a house was printed in the Taliesin monograph 1936).

At the center of the four zones the spacious Living Room stands. A tall central chimneystack with five fireplaces divides this vertical space into spaces for the various domestic functions: Entrance Hall, Family Living Room, Library Living Room, and Dining Room. Extending from this lofty central room are four wings—three low and one with mezzanine. The one with mezzanine floor and galleries is for the master, mistress and young daughter. Another wing extends from the central space for their several boys; a playroom at the end, a graduated deep-pool in conjunction—another wing for service and utilities—another for guests and five motor cars. Each wing has independent views on two sides, each has perfect privacy—the whole being united by a complete house telephone system. Lighting is integral. Heating is integral, in the floor slab as in the S. C. Johnson Co. Administration Building and the Jacobs house at Madison.

This extended wing plan lies, very much at home, integral with the prairie landscape which is, through it, made more significant and beautiful. In this case, especially, growth will claim its own; wild grapevines pendent from trellises; extensive collateral gardens in bloom; a great mass of evergreens in the entrance court; single tall associate of the building. Lake Michigan lies off to the middle distance seen over a wild-fowl pool stretching away in that direction from just below the main terrace of the house.

The farm unit is just opposite and in view. A gate lodge mounted on a street wall at the main highway is not in view. This structure is of the common type, proving itself to be a good one for a home in the climate around the Great Lakes. It is popularly known as brick veneer. Outside members are cypress plank, roofs tiled, floors of concrete, four-inch-square concrete-slab-tiles.

This house, while resembling the Coonley house, is much more bold, masculine and direct in form and treatment—executed in more permanent materials. The house has a heavy footing course of Kaso-

ta sandstone, the best brickwork I have seen in my life—and the materials of construction throughout are everywhere substantial. The house will be architecturally furnished in keeping with the character established by the building.

Construction is under a cost-plus system, in the architect's hands like the Administration Building for the S. C. Johnson Co. Construction being managed by Ben Wiltscheck, supervised by the Taliesin Fellowship.

Another prairie house in 1938 here joins the early ones of 1901–1910.

Since our favorite depression rendered the complete plans, specifications, and estimates for this winter resort a project merely—although the contract was ready for signature—the economical sum for completion was $480,000. I record it here so that ideas involved in that work may not be wholly lost.

I wanted to experience living in the desert so I might better make the plans. With my family and nine draftsmen I went into camp nearby the site to prepare the plans for this structure. The camp was actually built there by ourselves but as soon as we left, it was carried away by the Indians—so herewith also photographs of Ocatilla—the architect's camp.

San Marcos-in-the-Desert was worked out upon a unit system adapted to the 1–2 or 60–30 triangle because, as you may have noticed, mountain ranges are all 60–30 triangles unless your eye is arrested by an effect produced by one that is equilateral. A cross-section of the talus at the base of the mountains is the hypotenuse of a 30–60 triangle. The camp itself first took the 60–30 form. Compounded, boarded up waist high, canvased on wood framing above that level and overhead, the openings were canvas on wood frames rigged with ship cord to open and shut. Open in the sunlight the camp resembled a fleet of ships sailing down the bay.

San Marcos-in-the-Desert,
Chandler, Arizona. 1928.
Project.
FLLW Fdn# 2704.047

Paul and Jean Hanna House,
Palo Alto, California. 1936.
FLLW Fdn# 3701.001

Concrete block construction was on my mind at the time having just seen it through with Albert McArthur in the Arizona Biltmore. I used the surrounding giant growth, Sahuaro, as motive for the building (see texture model erected in the compound of the camp) thus getting dotted lines throughout the construction. Here is another secret—the dotted line is outline in all desert creations. The building was laid out as a system of sunlit terraces conforming to the terrain and the Sahuaro entered into architecture. Dr. Alexander Chandler wanted echo-organ concerts as a feature.[3] This accounts for the tower seen beside the center of the whole: really a cluster of great organ pipes. Echo organs were planted on adjoining hills.

Sunlight poured into every room, bathroom, corridor and closet in the building. For once space concepts became a revel. The building was economical nevertheless—but too good to be true. I have found

that when a scheme develops beyond a normal pitch of excellence the hand of fate strikes it down. The Japanese made a superstition of the circumstance. Purposely they leave some imperfection somewhere to appease the jealousy of the gods. I neglected the precaution. San Marcos was not built.

In the vault at Taliesin is this completely developed set of plans, every block scheduled as to quantity and place. These plans are one of our prize possessions.

Dr. Paul Hanna of Stanford University has just moved into this house. We shall be able to complete the design only with the furniture and growth of the planting. Here the thesis changes, not in content—but in expression. Again we have a preliminary study for prefabrication—also made in humble native materials—principally redwood board-partitions erected on a concrete mat cut into hexagonal tiles. Another experiment because I am convinced

that a cross-section of honeycomb has more fertility and flexibility where human movement is concerned than the square. The obtuse angle is more suited to human "to and fro" than the right angle. That flow and movement is, in this design, a characteristic lending itself admirably to life, as life is to be lived in it. The hexagon has been conservatively treated—however, it is allowed to appear in plan only and in the furniture which literally rises from and befits the floor pattern of the concrete slab upon which the whole stands. Heating being no serious matter on the Coast, we have allowed it to go "as is." This model for prefabrication was built by hand, not employing shop methods for which the work was primarily designed. The result is necessarily more expensive than need be were construction to have that advantage.

But the thesis goes far enough to demonstrate the folly of imagining that a true and beautiful house must employ synthetics or steel to be "modern," or go to the factory to be economical. Glass? Yes, the modern house must use glass liberally. Otherwise this house is a simple wood house under a sheet of copper—thin as paper, enough material in the whole construction only to make it substantial. Not a pound to waste. It might be said of this building that it is a plywood house, plywood furnished. To me here is a new lead into a fascinating realm of form, although somewhat repressed on the side of dignity and repose, in this first expression of the idea. I find it easy to take a definite unit of any simple geometric pattern and by modern technologies suited to the purpose, adjusted to human scale, evolve not only fresh appearances but vital contributions to a livelier domesticity. This house goes very far in conservation of space. I hope to demonstrate that no factory can take the house to itself but may itself go to the house. In the hands of one well-versed in the design of patterns for living it may come out continually refreshed by imagination—from within. You prefer what character, what atmosphere, Mrs. Gablemore, Mrs. Plasterbuilt, Miss Flattop? Very well, you shall have it. Only make up your mind as to qualities and character—forgetting that you have "been abroad"—asking only that you get desired character in the qualities you specify. Then you shall have all, with greater convenience and comfort than in the escapist architecture of your escapist lives, today. And have it so much better with so much less

waste of money. I am speaking of modern architecture, Usonian, instead of Florentine Mission or Colonial. Or even the Museum style to which the "modern" seems converting the "classics." The new Reality of which I bespeak is in this house, with certain reservations needful at the moment. Appreciative clients not afraid they were going to be made ridiculous were essential to this experiment. Without such help as Paul Hanna and his wife Jean gave to this experiment with their lives, nothing could ever have really happened in that direction. University City would have had just another one of those things—nice things but nevertheless just "things." And we should mention Harold Turner the builder who "took" to these ideas and did well with them considering the difficulties of this new venture into space-concepts erected in slight materials by new methods entirely.

▒ The house of moderate cost is not only America's major architectural problem but the problem most difficult for her major architects. As for me, I would rather solve it with satisfaction to myself and Usonia, than build anything I can think of at the moment except the modern theater now needed by the legitimate drama unless "the stage" is to be done to death by "the movies."

In our country the chief obstacle to any real solution of the moderate-cost house problem is the fact that our people do not really know how to live, imagining their idiosyncrasies to be their "tastes," their prejudices to be their predilections and their ignorance to be virtue where any beauty of living is concerned.

To be more specific, a small house on the side street might have charm if it didn't ape the big house on the avenue, just as the Usonian village itself might have great charm if it didn't ape the big town. Likewise, Marybud on the old farm might be charming in clothes befitting her state and her work, but is only silly in the Sears-Roebuck finery that imitates the clothes of her city sisters who imitate Hollywood stars with their lipstick, rouge, high heels, silk stockings, bell skirt and cock-eyed hat. Exactly that sort of "monkeyfied" business is the obstacle to architectural achievement in our U.S.A. This provincial "culture-lag" does not allow the person, thing or thought to be simply and naturally itself: the true basis of genuine culture.

I am certain that any approach to the new house needed by indigenous culture—why worry about the house wanted by provincial ignorance—is fundamentally different. That house must be a pattern for more simple and, at the same time, more gracious living: new, but suitable to living conditions as they might so well be in the country we live in today.

This needed house of moderate cost must sometime face reality. Why not now? The houses built by the million, which journals propagate, do no such thing. To me such houses are "escapist" houses, putting on some style or other, really having none. Style *is* important. *A* style is not. There is all the difference when we work *with* style and not for *a* style. But so little honest thought has been allowed to penetrate to living conditions among us that to write about them and even to build for them seems foolish enough although seen to be necessary.

A pressing, needy, hungry, confused issue is the American "small house" problem. But where is a better thing to come from while government housing itself is only perpetuating the old stupidities? I do not believe the needed house can come from current education, from big business, or by way of smart advertising experts. I do not think it will be a matter of expert salesmanship at all unless common sense has dropped to that level in America. It is, first, common sense that might take us along the road to the better thing.

What would be really sensible in this matter? Let's see how far the Herbert Jacobs house at Madison, Wisconsin, is a sensible house. This house for a young journalist, his wife, and small daughter, is now under roof: cost $5,500, including architect's fee of $450. Contract let to Bert Groves.

To give the little Jacobs family the benefit of industrial advantages of the era in which they live, something else must be done for them than to plant another little imitation of a mansion. Simplifications must take place. Mr. and Mrs. Jacobs must themselves see life in somewhat simplified terms. What are essentials in their case, a typical case? It is necessary to get rid of all unnecessary materials in construction, necessary to use the mill to good advantage, necessary to eliminate, so far as possible, field labor which is always expensive. It is necessary to consolidate and simplify the three appurtenance systems—heating, lighting, and sanitation. At least

this must be done if we are to achieve the sense of spaciousness and vista already necessary.

And it would be ideal to complete the building in one operation as it goes along, inside and outside. One operation and the house is finished inside as it is completed outside. There should be no complicated roofs. Every time a hip or valley or a dormer window is allowed to ruffle a roof the life of the building is threatened. The way windows are used is naturally the most useful resource to achieve the new characteristic sense of space. All of this fenestration can be made ready at the factory and set up as the walls. But there is no longer any sense in speaking of doors and windows. These walls are largely a system of fenestration having its own part in the building scheme—the system being as much a part of the design as eyes are a part of the face.

Now what can be eliminated?

1. Visible roofs are expensive and unnecessary.
2. A garage is no longer necessary as cars are made. A carport will do, with liberal overhead shelter and walls on two sides.
3. The old-fashioned basement, except for a fuel and heater space was always a plague spot. A steam-warmed concrete mat four inches thick laid directly on the ground over gravel filling, the walls set upon that, is better.
4. Interior "trim" is no longer necessary.
5. We need no radiators, no light fixtures. We will heat the house the Roman way—that is to say—in or beneath the floors, and make the wiring system itself be the light fixtures, throwing light upon the ceiling. Light will thus be indirect except for a few outlets for floor lamps.
6. Furniture, pictures and bric-a-brac are unnecessary except as the walls can be made to include them or be them.
7. No painting at all. Wood best preserves itself. Only the floor mat need be waxed.
8. No plastering in the building.
9. No gutters, no down spouts.

Now to assist in general planning, what must or may we use in our new construction? In this case five materials: wood, brick, cement, paper, glass. To simplify fabrication we must use the horizontal unit system in construction. (See lines crossing plans both ways making rectangles 2 × 4 feet.) We must also use a vertical unit system which will be

the boards and batten-bands themselves, interlocking with the brick courses.

The walls will be wood board-walls the same inside as outside—three thicknesses of boards with paper placed between them, the boards fastened together with screws. These slab-walls of boards will be high in insulating value, be vermin proof, and practically fireproof. These walls like the fenestration may be prefabricated on the floor and raised up into place, or they may be made at the mill.

The appurtenance systems to avoid cutting and complications, must be an organic part of construction. Yes, we must have polished plate glass. It is one of the things we have at hand to gratify the designer of the truly modern house and bless its occupants.

Herbert Jacobs House,
Madison, Wisconsin. 1936.
FLLW Fdn# 3702.002
FLLW Fdn# 3702.003

The roof framing in this instance is laminated of 2 × 4's making the three offsets seen outside in the eaves of the roof and enabling the roof to be sufficiently pitched without the expense of "building up" the pitches. The middle offset may be used to ventilate the roof spaces in summer. These 2 × 4's sheathed and covered with a good asphalt roof are the top of the house, its shelter gratifying to the sense of shelter.

All this is in hand—no, it is in mind—as we will plan the disposition of the rooms.

What must we consider essential now? We have our corner lot—an acre—with a south and west exposure. We have a garden. The house is wrapped about two sides of this garden.

1. We must have as big a living room with as much garden coming into it as we can afford, with a fireplace in it, and book shelves, dining table, benches, and living room tables built in.

2. Convenient cooking and dining space adjacent to if not a part of the living room. This space may be set away from outside walls within the living area to make work easy. This is a new thought concerning a kitchen—taking it away from outside walls and letting it run up into overhead space with the chimney, thus connection to dining space is made immediate without unpleasant features and no outside wall space lost to the principal rooms. There are steps leading down from this space to a small cellar below for heater, fuel, and laundry. The bathroom is next so that plumbing features of both kitchen and bath may be combined.

3. Two bedrooms and, in this case, a workshop which may be a future bedroom. The single bathroom is not immediately connected to any single bedroom, for the sake of privacy. Bathrooms opening directly into a bedroom occupied by more than one person or two bedrooms opening into a single bathroom have been badly overdone. We will have as much garden and space in all these space appropriations as our money allows after we have simplified our construction as proposed by way of modern technique.

These drawings represent a modest house that has no feeling at all for the "grand" except as the house extends itself parallel to the ground, companion to the horizon. That kind of extension can hardly go too far for comfort or beauty of proportion. As a matter of course a home like this is an architect's creation. It is not a builder's nor an amateur's effort and there is considerable risk in exposing the scheme to that sort of imitation or emulation. This is true because it could not be built except as the architect oversees the building and the building would fail of proper effect unless the furnishing and planting were done by the architect.

Showing it to you thus briefly may help to indicate how stifling the little colonial hot-boxes, hallowed by government or not, really are where Usonian family life is concerned. You might easily put two of them, each costing more, into the living space of this one and not go much outside the walls. Here is a moderate cost brick and wood house that by new technology of a lifetime has been greatly extended in scale and comfort. A single house. Imagine how the cost would come down were the technique familiar or if many were executed at one time—probably down to $3,500, according to number built and location. There is freedom of movement, and privacy too, afforded by the general arrangement here, unknown to the current boxment. Let us say nothing about beauty. It is an ambiguous term in the provinces of which our big cities are the largest. But I think a cultured American housewife will look well in it. The now inevitable car will seem part of it. Where does the garden leave off and the house begin? Where the garden begins and the house leaves off. Withal, it seems a thing loving the ground with the new sense of space—light—and freedom to which our U.S.A. is entitled.

Architectural interpretation of modern business at its best, this building is designed to be as inspiring a place to work in as any cathedral ever was in which to worship. The building is laid out upon a horizontal unit system twenty feet on center both ways and a vertical unit of one brick course, three and a half inches. Glass is not used as bricks in this structure; the building becomes by way of long glass tubing crystal where crystal, either transparent or translucent, is most appropriate. In order to make the structure monolithic as possible, the exterior enclosing wall-material appears inside wherever it is sensible for it to do so. Main feature of construction is the simple repetition of hollow slender monolithic dendriform shafts or stems—stems standing on metal tips bedded at the floor level. The structure is light and plastic—reinforcing being mostly steel mesh—welded. The structure is earthquake proof

and fireproof, cold and sound proof. Weight, here by way of steel in tension, appears to float in light and air, the "column" taking on integral character as a plastic unit of a plastic building-construction instead of being a mere insert for support. Clerical work is correlated in one vast room, 128 × 228 feet. The great room, air conditioned, is day-lit by rifts in the walls. The heating system of the main building is entirely in the floor slab. This building stands in unimpressive surroundings bounded by three streets, so main entrance is made interior to the lot; the motor car provided for as a modern indispensable. Ample parking facilities are under cover of

S. C. Johnson & Son Company
Administration Building,
Racine, Wisconsin. 1936.
FLLW Fdn# 3601.002

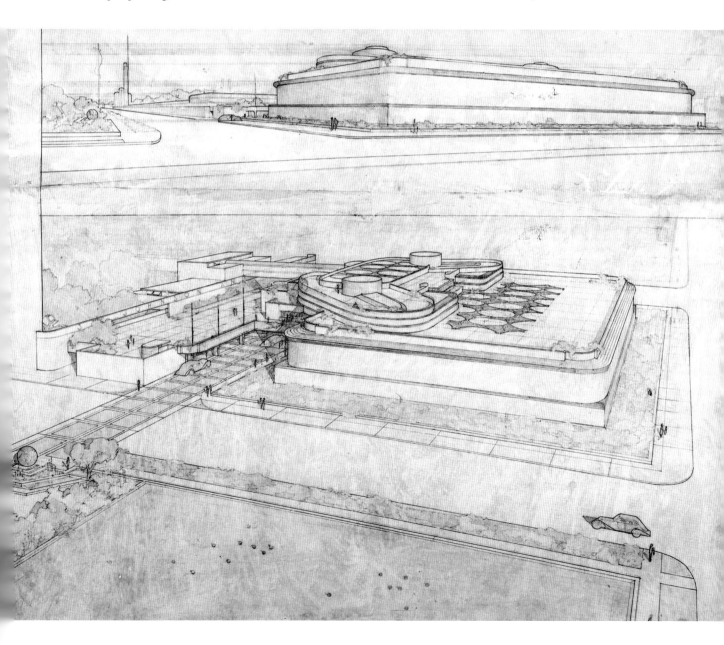

this carport. The main building is set back from the streets on three sides; a colorful band of growth divides the main walls from the sidewalks, enlivening a dreary environment. Above, the carport becomes a playground for workers. A cinema seating 250 for daytime lectures or entertainment is placed at mezzanine level in the middle of the arrangement. An enclosed bridge connects the officers' quarters in the pent-house with a squash court rising above the garage. Herbert Johnson's office, stenographer and laboratory are at the apex of the pent-house; the other officers are in the wings extending from it. Below this arrangement of officers are the several hundred office workers. Subheads of various departments there function in a low gallery, mezzanine to the big room, where direct vision and prompt connection with the workers in the big room is had directly at convenient points by spiral iron stairways. The few enclosures within the big workroom are low glass walls, screened by Aeroshades. Thus the sense of the whole most stimulating to various parts is preserved. The officers' house at the center is wide open to this big workroom below. The entire building construction, generally by way of cost-plus arrangements, is in the architect's hands—ably managed by Ben Wiltscheck, supervised by the Taliesin Fellowship.

Foreword Concluded

Coming back from numerous meetings with young people in the colleges of most of our States, it seems to me that some kind of snubbing post for Usonian youth is urgently needed, where reality is concerned in this functionalistic drift toward realism and realistic. Neither realism nor realistic is the stuff of which the universal is made. As a matter of fact, the universal is made of intense and lively personal matter asking only that the matter have individuality. For a moment, risking offense, let me be personal, as an individual.

Already the architectural matter of this issue of the *Forum* will look out upon a modern-fashioning more in the likeness of the buildings, their interiors, building, and ways of furnishing them—originally designed by myself as early as 1895, getting into their modern stride by 1901 and continuing to this hour.

The ideas taking fresh form then have gone into a twentieth-century designer's world, worldwide.

With a change of labels from a bewildering variety of sources, the forms and features of these original designs are now—with certain sterilizations to make them safe for academic consumption—become modern architecture, modern industrial design, "streamlining" in general: mostly administered by minions "joined up" with our great American advertising order. It never sleeps.

At least enough success is prematurely result to make it apparent that the new simplicity unpretentiously making appearance as early as 1896 may be *the* fashionable eclecticisms of 1938–40. Then God help us all. We shall have sunk beneath the surface of an eclectic's world. Perhaps it is the only possible world.

But to this possibility the matter of this issue still says NO.

What disconcerts me is simply this: the early ideas and ways of planning buildings and building-ways of furnishing them do not seem so much changed for the better. "Effects" have been slenderized and hardened; they have been cleaned up a little, now and then, by unwisely leaving off protective copings, abolishing the sense of shelter by concealing it behind parapets; interiors and exteriors have changed superficially (they should have changed fundamentally) with the use of steel, glass, and synthetics; surfaces in general are smoothed out a little by omission of the articulation of materials and their logical protection from the elements. A severe negation of ornament is evident, not a bad negation when ignorance of the nature of ornament generally prevails, as it does. Reaction against that negation, however, is already visible. Sterilized, then, as the order that clings to standardization for life deems suitable, the work, internationally, has been counted sufficient for "new schools." Nothing radical has been done to carry it further afield.

Thus history repeats itself?

▦ Negation is easy. Affirmation difficult.

The negation dubbed—by the Museum of Modern Art—"International Architecture" could make no headway unless there were truth in my accusation: "more reflection of surface than substance." How pernicious the notion of "functionalism" as a style! Why turn superficially to a style? The words

"integral," "organic," "principle"—basic words concerning our ideal seem never to have occurred as necessary to such language as I have read trademarking that device. Yes, "device"—academic device at that—seeking to make a style when only style is needed. "No ornament?" That collateral fetish is the bastard begotten by intellectualists out of the dogma "Form follows function"; begotten because the abuse of a noble thing was mistaken for the thing itself.

"Form follows function" is but a statement of fact. When we say "Form and function are one"—only then do we take mere fact into the realm of creative thought. I should say that in that difference of statement lies the real difference between organic work, and that of the professed functionalists.

Melodic structure is absent in modern music for the same reason that genuine ornament is absent in "functionalism." True ornament is the inherent melody of structure and functionalism to date is a bad builder.

Russia trying out "functionalismus" proceeded to kick it out. That she should have mistaken it for modern architecture was tragedy for the Soviets.

I have at least ten years more (unless I get a Ford up my back, or something) in which to practice the basic principles of an organic architecture. Slowly but surely, often through closed doors, these principles are making way against baldly ballyhooed, badly oversold practices of the unfunctional "functionalist" wing of our cause. For you who sympathize with this ideal of an organic architecture there is not only urgent need for real thought on our part to account for the deeper feeling behind it, but need also for the kind of technical knowledge in hand which only the application of actual principles by way of experience can give. Neither academic formulae nor sloganized dicta can really serve the cause at this time.

Organic architecture is profound architecture. Premature publicizing in this circus-era has some passing value but the fact appears that the deeper the matter, the more undesirable is premature publicity. Notwithstanding rescripts of university education every future architect must develop, in his own grasp, a technology of his own, his hands in work, however limited (the limitations will be his best friends) if technologies he employs are not to defeat the main purpose—a living architecture for our country as a free country.

We speak of genius as though it were the extrusion of some specialty or other. No, the quality is not there. Find genius, and you will find a poet. What is a poet?

If he is a poet he bestows on every object or
quality its fit proportion—neither more nor
less.
He is the arbiter of the diverse—the equalizer
of his age and land.
He judges not as a judge judges, but as the sun
falling round a helpless thing.

How America needs poets! God knows—she has enough profit takers, enough garage mechanics, enough journalists, enough teachers of only what has been taught, enough wage slaves. Without the poet—man of vision wherever he stands—the Soul of this people is a dead Soul. One must be insensible not to feel the chill creeping over ours.

We have technology and technologies to throw away, technicians to burn, but still have no architecture. To show, for them all, we have only a multiplicity of buildings imitating many insignificant countenances or making caricature of the countenance of principle. We need an architecture so rich in the life of today that just because of it life will be better worth living—even though a reeling capitalistic "system" fall flat of its own idiotic excess. Antiseptics are not enough to grow an architecture. Profit-taking as a motive for a civilization does not seem to be the ennobling basis for one.

But I believe, were the "system" aware of it, the capitalists especially would fortify themselves in Architecture that is Organic Architecture.

Having myself had the best and the worst of everything as preliminary to the ten years next to come, I hope none of the years will be wasted or thwarted where architecture, in what remains to us all of life, is concerned.

1. The lines above the fireplace read: "Oft did the harvest to their sickle yeild [*sic*], Their furrow oft the stubborn glebe has broke; How jocund did they drive their team afield! How bow'd the woods beneath their sturdy stroke!"
2. "The Two-Zone House," published in *Taliesin*, vol. 1, no. 1, 1936.
3. Dr. Chandler commissioned San Marcos-in-the-Desert (1927).

Monument to Haroun Al Rashid,
Baghdad, Iraq. 1957.
Project.
FLLW Fdn# 5751.003

The Natural House

BOOK ONE: 1936–1953
Organic Architecture

The typical American dwelling of 1893 was crowding in upon itself all over the Chicago prairies as I used to go home from my work with Adler and Sullivan in Chicago to Oak Park, a Chicago suburb. That dwelling had somehow become typical American architecture but by any faith in nature implicit or explicit it did not belong anywhere. I was in my sixth year with Adler and Sullivan then, and they had completed the Wainwright Building in St. Louis, the first expression of the skyscraper as a *tall* building. But after building the great Auditorium the firm did not build residences because they got in the way of larger, more important work. I had taken over dwellings, Mr. Sullivan's own house among them, whenever a client came to them for a house. The Charnley house was done in this way.[1] I longed for a chance to build a sensible house, and (1893), soon free to build one, I furnished an office in the Schiller Building and began my own practice of architecture. The first real chance came by way of Herman Winslow for client.[2] I was not the only one then sick of hypocrisy and hungry for reality. Winslow was something of an artist himself, sick of it all.

What was the matter with the typical American house? Well, just for an honest beginning, it lied about everything. It had no sense of unity at all nor any such sense of space as should belong to a free people. It was stuck up in thoughtless fashion. It had no more sense of earth than a "modernistic" house. And it was stuck up on wherever it happened to be. To take any one of these so-called "homes" away would have improved the landscape and helped to clear the atmosphere. The thing was more a hive than a home just as "modernistic" houses are more boxes than houses. But these "homes" were very like the homes Americans were making for themselves elsewhere, all over their new country.

Nor, where the human being was concerned, had this *typical* dwelling any appropriate sense of proportion whatever. It began somewhere way down in the wet and ended as high up as it could get in the high and narrow. All materials looked alike to it or to anything or anybody in it. Essentially, whether of brick or wood or stone, this "house" was a bedeviled box with a fussy lid; a complex box that had to be cut up by all kinds of holes made in it to let in light and air, with an especially ugly hole to go in and come out of. The holes were all "trimmed"; the doors and windows themselves trimmed; the roofs trimmed; the walls trimmed. Architecture seemed to consist in what was done to these holes. "Joinery" everywhere reigned supreme in the pattern and as the soul of it all. Floors were the only part of the house left plain after "Queen Anne" had swept past. The "joiner" recommended "parquetry" but usually the housewife and the fashionable decorator covered these surfaces down underfoot with a tangled rug collection because otherwise the floors would be "bare." They were "bare" only because one could not very well walk on jigsawing or turned spindles or plaster ornament. This last limitation must have seemed somehow unkind.

It is not too much to say that as a young architect, by inheritance and training a radical, my lot was cast with an inebriate lot of criminals called builders; sinners hardened by habit against every human significance except one, vulgarity. The one touch of nature that makes the whole world kin. And I will venture to say, too, that the aggregation

was at the lowest aesthetic level in all history. Steam heat, plumbing, and electric light were the only redeeming features and these new features were hard put to it to function in the circumstances. Bowels, circulation, and nerves were new in buildings. But they had come to stay and a building could not longer remain a mere shell in which life was somehow to make shift as it might.

When I was 11 years old I was sent to a Wisconsin farm to learn how to really work. So all this I saw around me seemed affectation, nonsense, or profane. The first feeling was hunger for reality, for sincerity. A desire for simplicity that would yield a broader, deeper comfort was natural, too, to this first feeling. A growing idea of simplicity as organic, as I had been born into it and trained in it, was new as a quality of thought, able to strengthen and refresh the spirit in any circumstances. Organic simplicity might everywhere be seen producing significant character in the ruthless but harmonious order I was taught to call nature. I was more than familiar with it on the farm. All around me, I, or anyone for that matter, might see beauty in growing things and, by a little painstaking, learn how they grew to be "beautiful." None was ever insignificant. I loved the prairie by instinct as itself a great simplicity; the trees, flowers, and sky were thrilling by contrast. And I saw that a little of height on the prairie was enough to look like much more. Notice how every detail as to height becomes intensely significant and how breadths all fall short. Here was a tremendous spaciousness needlessly sacrificed, all cut up crosswise or lengthwise into 50-foot lots, or would you have 25 feet? Reduced to a money-matter, salesmanship kept on parceling out the ground, selling it with no restrictions. Everywhere, in a great new, free country, I could see only this mean tendency to tip everything in the way of human occupation or habitation up edgewise instead of letting it lie comfortably flatwise with the ground where spaciousness was a virtue. Nor has this changed much since automobilization has made it no genuine economic issue at all but has made it a social crime to crowd in upon one another.

By now I had committed the indiscretion that was eventually to leave me no peace and keep me from ever finding satisfaction in anything superficial. That indiscretion was a determination to search for the *qualities* in all things.

I had an idea (it still seems to be my own) that the planes parallel to the earth in buildings identify themselves with the ground, do most to make the buildings belong to the ground. (Unluckily they defy the photographer.) At any rate, independently I perceived this fact and put it to work. I had an idea that every house in that low region should begin *on* the ground, not *in* it as they then began, with damp cellars. This feeling became an idea also; eliminated the "basement." I devised one at ground level. And the feeling that the house should *look* as though it began there *at* the ground put a projecting base course as a visible edge to this foundation where, as a platform, it was evident preparation for the building itself and welded the structure to the ground.

An idea (probably rooted deep in racial instinct) that *shelter* should be the essential look of any dwelling, put the low spreading roof, flat or hipped or low gabled, with generously projecting eaves over the whole. I began to see a building primarily not as a cave but as broad shelter in the open, related to vista; vista without and vista within. You may see in these various feelings all taking the same direction that I was born an American child of the ground and of space, welcoming spaciousness as a modern human need as well as learning to see it as the natural human opportunity. The farm had no negligible share in developing this sense of things in me, I am sure.

Before this, by way of innate sense of comfort, had come the idea that the size of the human figure should fix every proportion of a dwelling or of anything in it. Human scale was true building scale. Why not, then, the scale fixing the proportions of all buildings whatsoever? What other scale could I use? This was not a canon taught me by anyone. So I accommodated heights in the new buildings to no exaggerated established order nor to impress the beholder (I hated grandomania then as much as I hate it now) but only to comfort the human being. I knew the house dweller could seldom afford enough freedom to move about in built-in or built-over space, so, perceiving the horizontal line as the earth line of human life (the line of repose), this, as an individual sense of the thing, began to bear fruit. I first extended horizontal spacing without enlarging the building by cutting out all the room partitions that did not serve the kitchen or give needed privacy for sleeping apartments or (as in the day of

the parlor) serve to prevent some formal intrusion into the intimacy of the family circle. The small social office I set aside as a necessary evil to receive "callers," for instance. Even this one concession soon disappeared as a relic of the barbarism called "fashion"; the "parlor."

To get the house down to the horizontal in appropriate proportion and into quiet relationship with the ground and as a more humane consideration anyway, the servants had to come down out of the complicated attic and go into a separate unit of their own attached to the kitchen on the ground floor. They liked this compulsion, though the housewife worried. Closets disappeared as unsanitary boxes wasteful of room and airy wardrobes in the rooms served instead.

Freedom of floor space and elimination of useless heights worked a miracle in the new dwelling place. A sense of appropriate freedom had changed its whole aspect. The dwelling became more fit for human habitation on modern terms and far more natural to its site. An entirely new sense of space values in architecture began to come home. It now appears that, self-conscious of architectural implications, they first came into the architecture of the modern world. This was about 1893. Certainly something of the kind was due.

A new sense of repose in flat planes and quiet "streamline" effects had thereby and then found its way into building, as we can now see it admirably in steamships, airplanes and motorcars. The age came into its own and the "age" did not know its own. There had been nothing at all from overseas to help in getting this new architecture planted on American soil. From 1893 to 1910 these prairie houses had planted it there. No, my dear "Mrs. Gablemore," "Mrs. Plasterbilt," and especially, no, "Miss Flattop," nothing from "Japan" had helped at all, except the marvel of Japanese color prints. They were a lesson in elimination of the insignificant and in the beauty of the natural use of materials.

But more important than all, rising to greater dignity as idea, the ideal of plasticity was now to be developed and emphasized in the treatment of the building as a whole. Plasticity was a familiar term but something I had seen in no buildings whatsoever. I had seen it in Lieber Meister's ornament only.[3] It had not found its way into his buildings otherwise. It might now be seen creeping into the expressive lines and surfaces of the *buildings* I was building. You may see the appearance of the thing in the surface of your hand as contrasted with the articulation of the bony skeleton itself. This ideal, profound in its architectural implications, soon took another conscious stride forward in the form of a new aesthetic. I called it *continuity*. (It is easy to see it in the "folded plane.") Continuity in this aesthetic sense appeared to me as the natural means to achieve truly organic architecture by machine technique or by any other natural technique. Here was direct means, the only means I could then see or can now see to express, objectify and again bring natural form to architecture. Here by instinct at first (all ideas germinate) principle had entered into building as the new aesthetic, "continuity." It went abroad as "plasticity." They began to call it, as I myself often did then, "the third dimension." It was only a single phase of "continuity" but a phase that has come back home again to go to work on the surface and upon the novice. It will do him no harm as it is. But were the full import of continuity in architecture to be grasped, aesthetic and structure become completely one, it would continue to revolutionize the use and wont of our machine age architecture, making it superior in harmony and beauty to any architecture, Gothic or Greek. This ideal at work upon materials by nature of the process or tools used means a living architecture in a new age, organic architecture, the only architecture that can live and let live because it never can become a mere style. Nor can it ever become a formula for the tyro. Where principle is put to work, not as recipe or as formula, there will always be *style* and no need to bury it as "a style."

▨ Although the wrap-around window, originally a minor outward expression of the interior folded plane in my own buildings, and various other minor features of the work of this period intended to simplify and eliminate "parts" are now scattered around the world and have become the rather senseless features of various attempts at formula, such as the sporadic "international" and other attempts characterized by plain surfaces cut into patterns by simple large openings, nevertheless the ideas behind these earlier appearances, the fundamental ideas that made them genuine expressions of architecture, have been altogether missed. The nature of materials is ignored in these imitations to get block mass

outlines. The reverse of the period wherein mass material outlines tried to ignore the materials. But it is the same mistake.

The word "plastic" was a word Louis Sullivan himself was fond of using in reference to his scheme of ornamentation as distinguished from all other or any *applied* ornament. But now, and not merely as "form following function," came a larger application of the element called plasticity. "Form follows function" is mere dogma until you realize the higher truth that form and function are one.

Why any principle working in the part if not working in the whole?

I promoted plasticity as conceived by Lieber Meister to *continuity* in the concept of the building as a whole. If the dictum, "form follows function," had any bearing at all on building it could take form in architecture only by means of plasticity when seen at work as complete *continuity*. So why not throw away entirely all implications of post and beam construction? Have no posts, no columns, no pilasters, cornices or moldings or ornament; no divisions of the sort nor allow any fixtures whatever to enter as something added to the structure. Any building should be complete, including all within itself. Instead of many things, *one* thing.

The folded plane enters here with the merging lines, walls and ceilings made one. Let walls, ceilings, floors now become not only party to each other but *part of each other,* reacting upon and within one another; continuity in all, eliminating any merely constructed features as such, or any fixture or appliance whatsoever as such.

When Louis Sullivan had eliminated background in his system of ornament in favor of an integral sense of the whole he had implied this larger sense of the thing. I now began to achieve it.

Conceive that here came a new sense of building on American soil that could *grow* building forms not only true to function but expressive far beyond mere function in the realm of the human spirit. Our new country might now have a true architecture hitherto unknown. Yes, architectural forms by this interior means might now grow up to express a deeper sense of human life values than any existing before. Architecture might extend the bounds of human individuality indefinitely by way of safe interior discipline. Not only had space come upon a new technique of its own but every material and

every method might now speak for itself in objective terms of human life. Architects were no longer tied to Greek space but were free to enter into the space of Einstein.

▦ Architectural forms might *grow* up? Yes, but grow up in what image? Here came concentrated appeal to pure imagination. Gradually proceeding from generals to particulars in the field of work with materials and machines, "plasticity" (become "continuity") began to grip me and work its own will in architecture. I would watch sequences fascinated, seeing other sequences in those consequences already in evidence. I occasionally look through such early studies as I made at this period (a number of them still remain), fascinated by implications. They seem, even now, generic. The old architecture, always dead for me so far as its grammar went, began literally to disappear. As if by magic new effects came to life as though by themselves and I could draw inspiration from nature herself. I was beholden to no man for the look of anything. Textbook for me? "The book of creation." No longer need any more to be a wanderer among the objects and traditions of the past, picking and choosing his way by the personal idiosyncrasy of taste, guided only by personal predilection. From this hell I had been saved. The world lost an eclectic and gained an interpreter. If I did not like the Gods now I could make better ones.

Visions of simplicities so broad and far reaching would open to me and such building harmonies appear that I was tireless in search of new ones. In various form researches, with all my energy I concentrated upon the principle of plasticity working as continuity. Soon a practical working technique evolved and a new scale within the buildings I was building in the endeavor to more sensibly and sensitively accomplish this thing we call architecture. Here at work was something that would change and deepen the thinking and culture of the modern world. So I believed. . . .

From some laboratory experiments at Princeton by Professor Beggs which I saw while there delivering the Kahn Lectures in 1930,[4] it appears that aesthetic "continuity" at work in the practice of physical structure is concrete proof of the practical usefulness of the aesthetic ideal in designing architectural forms and, I hope, may soon be available as

structural formula in some handbook. Welding instead of riveting steel is one new means to this new end and other plastic methods are constantly coming into use. But that and other possibilities (they will, I hope and believe, never need) are ahead of our story.

There were then no symbols at all for these ideas. But I have already objectified most of them. Were architecture bricks, my hands were in the mud of which bricks were made.

An idea soon came from this stimulating simplifying ideal (ideas breed, especially in actually making them work) that in order to be consistent, or indeed if all were to be put to work as architecture successfully, this new element of plasticity should have a new *sense* as well as a new *science* of materials.

It may interest you to know (it surprised me) that there is nothing in the literature of the civilized world upon that subject. Nothing I could find as *interpretation* in this sense of the nature of materials. Here was another great field for concrete endeavor, neglected. So I began, in my fashion, to study the nature of materials. Life is short. Lieber Meister had not reached this study. All materials alike were to receive the impress of his imagination. I began to learn to see brick as brick. I learned to see wood as wood and learned to see concrete or glass or metal each for itself and all as themselves. Strange to say this required uncommon sustained concentration of uncommon imagination (we call it vision), demanded not only a new conscious approach to building but opened a new world of thought that would certainly tear down the old world completely. Each different material required a different handling, and each different handling as well as the material itself had new possibilities of use peculiar to the nature of each. Appropriate designs for one material would not be at all appropriate for any other material. In the light of this ideal of building form as an organic simplicity almost all architecture fell to the ground. That is to say, ancient buildings were obsolete in the light of the idea of space determining form from within, all materials modifying if indeed they did not create the "form" when used with understanding according to the limitations of process and purpose.

Architecture might, and did, begin life anew.

Had steel, concrete, and glass existed in the ancient order we could have had nothing like our ponderous, senseless "classic" architecture. No, nothing even at Washington. Such betrayal of new life and new opportunities as ours has been would have been impossible to the ancients, the Greeks excepted, and we should have had a practice of architecture by the eclectic wherein tradition was not a parasite nor an enemy but a friend because the ancestors would have done the necessary work for us that we seem unable to do for ourselves. We would then have been able to copy the antique with sense and safety. Myself with the others.

Now there can be no organic architecture where the nature of synthetic materials or the nature of nature materials either is ignored or misunderstood. How can there be? Perfect correlation, integration, is life. It is the first principle of any growth that the thing grown be no mere aggregation. Integration as entity is first essential. And integration means that no part of anything is of any great value in itself except as it be integrate part of the harmonious whole. Even my great old master designed for materials all alike. All were grist for his rich imagination and he lived completely as artist, all to the contrary notwithstanding, only with his sentient ornament. Contrary to the ideas formed of him by wordwise but superficial critics, in this he created out of himself a world of his own, not yet appreciated at its true worth. How could it be yet? In this expression he went beyond the capacities of any individual before him. But all materials were only one material to him in which to weave the stuff of his dreams. Terra cotta was that one material. Terra cotta was *his* material, the one he loved most and served best. There he was master. But I honored him when I carried his work and thought further along by acting upon this new train of ideas, and the acts soon brought work sharply and immediately up against the tools that could be found to get these ideas put into new forms of building.

What a man does—*that* he has. You may find other things on him but they are not his.

What were the tools in use in the building trades everywhere? *Machines* and the automatic process, all too many of them. Stone or wood planers, stone and wood molding shapers, various lathes, presses, and power saws, the casting of metals and glass; all in commercially organized mills. The kiln; sheet-

metal breakers; presses; shears; cutting, molding, and stamping machines in foundries and rolling mills; commercialized machine "shops"; concrete mixers; clay breakers; casters; glassmakers themselves; and the trade-unions versus capital; all laborers' or employers' units in a more or less highly commercialized greater union in which craftsmanship had no place except as survival for burial by standardization. Quantity production or standardization was already inflexible necessity either as enemy or friend. You might choose. And as you chose you became master and useful, or a luxury and eventually the more or less elegant parasite we call an "eclectic"; a man guided only by instinct of choice called "taste."

By now I did not choose by instinct. I felt, yes, but I *knew* now what it was I felt concerning architecture.

▦ Already, when I began to build, commercial machine standardization had taken the life of handicraft. But outworn handicraft had never troubled me. To make the new forms living expression of the new order of the machine and continue what was noble in tradition did trouble me. I wanted to realize genuine new forms true to the spirit of great tradition and found I should have to make them; not only make forms appropriate to the old (natural) and to new (synthetic) materials, but I should have to so design them that the machine (or process) that must make them could and would make them better than anything could possibly be made by hand. But now with this sense of integral order in architecture supreme in my mind I could have done nothing less unless I could have commanded armies of craftsmen as later I did command them in the building of the Imperial Hotel: a building in no sense a product of machine method. By now, safe inner discipline had come to me: the interior discipline of a great ideal. There is none so severe. But no other discipline yields such rich rewards in work, nor is there any man so safe and sure of results as the man disciplined from within by this ideal of the integration that is organic. Experience is this man's "school." It is yet his only school.

As I put these ideas to work in materials, lesser ideas took flight from this exacting ideal. But always in the same direction. They went farther on each occasion for flight, which was each new building I built, until great goals were in sight. Some few of the goals have been partially realized. You may see the "signs and portents" gathered together in various exhibition galleries if you can read drawings and models. The photographs are poor because the depth planes cannot be rendered by photography. But a number of the buildings are scattered or mutilated and unfortunately most of the best drawings are gone. The best buildings, too, were never built and may only be studied by the record. But later designs and models all exemplify in some material or grouping of materials, or idea of arrangement, these early objectives. Lieber Meister had been searching for "the rule so broad as to admit of no exception." For the life of me I could not help being most interested in the exception that proved the rule. This may explain "inconsistency" in performance and apparent departure from original objectives.

A group of young Chicago architects were gathered about me as disciples and friends in the early days, about 1893. They were my contemporaries and all learned from me to speak the new language. I wrote a little and later I tried to stem the tide of imitation. An instance was the paper read at Hull House in 1904 on "The Art and Craft of the Machine."[5] Occasionally, then an indifferent lecturer, I lectured. But talking isn't building, as I soon saw where any "school" as they called it (and later had names for the branches) had actually *to build*. Among these contemporaries the more ambitious began to call the new dwellings that appeared upon the prairies from 1893 to 1910 "the prairie school." I suppose this was modern architecture's first gallery. None knew much of Louis Sullivan, then, except by such work as he had done. And to a certain extent they imitated him too; imitating his individual ornamentation as the feature most in view. Some years later C. R. Ashbee came over to the United States and Kuno Francke of Harvard came to Oak Park. Both, in turn, saw the new work on the prairies and carried the tale of it to Europe in 1908. Some 15 or 20 years later a Swiss (in France) was to rediscover a familiar preliminary aesthetic; the affirmative negation declared by the Larkin Building, widely published at the time when it was built and recorded by an article in the *Architectural Record,* March 1908. But already (1910) in my own work the ideal of an organic architecture as affirmation had gone far beyond that belated negation that was at work in Europe itself.

Before trying to put down more in detail concerning goals now in sight, popular reaction to this new endeavor might be interesting. After the first "prairie house" was built, the Winslow house in 1893, which only in the matter of ornamentation bore resemblance in respect to the master (in the Charnley house I had stated, for the first time so far as I know, the thesis of the plain wall given the nature of decoration by a well-placed single opening which is also a feature of the Winslow house), my next client said he did not want a house "so different that he would have to go down the back way to his morning train to avoid being laughed at." That was one popular consequence. There were many others; bankers at first refused to loan money on the "queer" houses, so friends had to be found to finance the early buildings. Millmen would soon look for the name on the plans when the plans were presented for estimates, read the name of the architect and roll up the drawings again, handing them back with the remark that "they were not hunting for trouble"; contractors more often than not failed to read the plans correctly, so much had to be left off the buildings. The buildings were already off the main track. The clients themselves usually stood by interested and excited, often way beyond their means. So, when they moved into their new house, quite frequently they had no money left, had borrowed all they could and had to drag their old furniture into their new world. Seldom could I complete an interior because the ideal of "organic simplicity" seen as the countenance of perfect integration (as you have already read) naturally abolished all fixtures, rejected the old furniture, all carpets and most hangings, declaring them to be irrelevant or superficial decoration. The new practice made all furnishings so far as possible (certainly the electric lighting and heating systems) integral parts of the architecture. So far as possible all furniture was to be designed in place as part of the building. Hangings, rugs, carpets, were they to be used (as they might be if properly designed), all came into the same category. But the money matter generally crippled this particular feature of the original scheme, as I have said, and made trouble in this process of elimination and integration.

Nor, theoretically, was any planting to be done about the houses without cooperating with the architect. But, of course, it was done more often than not. But no sculpture, no painting was let in unless cooperating with the architect, although more often than not pictures were "hung." This made trouble. For no decoration, as such, was to be seen anywhere. Sculpture and painting were to be likewise *of* the building itself. In the Midway Gardens built in Chicago in 1913 I tried to complete the synthesis: planting, furnishings, music, painting, and sculpture, all to be one. But I found musicians, painters, and sculptors were unable to rise at that time to any such synthesis. Only in a grudging and dim way did most of them even understand it as an idea. So I made the designs for all to harmonize with the architecture; crude as any sketch is crude, incomplete as to execution, but in effect sufficiently complete to show the immense importance of any such attempt on any architect's part and show, indeed, that only so does architecture completely live. A new ideal of ornamentation had by now arrived that wiped out all ornament unless it, too, was an integral feature of the whole. True ornament became more desirable than ever but it had to "mean something"; in other words *be* something organic in character. Decorators hunting a job would visit the owners and, learning the name of the architect, lift their hats, turn on their heels, leaving with the curt and sarcastic "good day!" meaning really what the slang "good night!" of the period meant. This matter of integral ornament is the rock upon which a later generation of young architects splits and wisely decides to let it alone for the time being.

The owners of the early houses were, of course, all subjected to curiosity, sometimes to admiration, but were submitted most often to the ridicule of the "middle of the road egotist." To that ubiquitous egotist there was something about the owner too, now, when he had a house like that, "the rope tie around the monkey's neck."

Well, I soon had to face the fact that a different choice of materials would mean a different building altogether. Concrete was just coming into use and Unity Temple became the first concrete monolith in the world, that is to say, the first building complete as monolithic architecture when the wooden forms in which it was cast were taken away. No critic has yet seen it as it is for what it is except to realize that here, at least, was *something*. They might not like the temple but they were "impressed" by it. Meanwhile, the Larkin Building at Buffalo had just been built,

a consciously important challenge to the empty ornamentality of the old order. The phrases I myself used concerning it in the issue of the *Architectural Record* in 1908 devoted to my work, put it on record as such. "Here again most of the critic's architecture has been left out. Therefore, the work may have the same claim to consideration as a work of art, as an ocean liner, a locomotive, or a battleship." The words may have escaped the Swiss "discoverer"; he was young at the time.

Plastered houses were then new. Casement windows were new. So many things were new. Nearly everything was new but the law of gravity and the idiosyncrasy of the client.

And simple as the buildings seemed and seem to be to this day because all had character and the countenance of principle, only the outward countenance of their simplicity has ever taken effect and that countenance is now being variously exaggerated by confirmed eclectics for the sake of the effect of a style. The innate simplicity that enabled them and enables them to multiply in infinite variety has not been practiced. I had built 187 buildings, planned and detailed about 37 more that had not been built, and all together they did not classify as a style. Nevertheless, all had "style."

As reward for independent thinking put into action as building and first plainly shown in the constitution and profiles of the prairie houses of Oak Park, Riverside, and other suburbs and Chicago and other cities, Unity Temple at Oak Park and the Larkin Administration Building in Buffalo, an entirely new sense of architecture for anyone who could read architecture had emerged. A higher concept of architecture. Architecture not alone as "form following function" in Lieber Meister's sense but architecture for the spirit of man, for life as life must be lived today; architecture spiritually (virtually) conceived as appropriate enclosure of interior space to be lived in. Form and function made one. The enclosed space within them is the *reality* of the building. The enclosed space comes through as architecture and may be seen in these exteriors I have built as the *reality* of the building I wanted to build and did build and am still building in spite of all opposition and the supreme obstacle, pretentious ignorance. This sense of the "within" or the room itself (or the rooms themselves) I see as the

great thing to be realized and that may take the new forms we need as architecture. Such a source would never stultify itself as a mere style. This sense of interior space made *exterior* as architecture, working out by way of the nature of materials and tools, transcends, as a fertilizing motive, all that has ever gone before in architecture. This clarifying motive of the whole makes previous ideas useful only as a means to the realization of this far greater concept of architecture. But if the buildings I have conceived upon this basis still seem enigmatical, most of all they must seem so to those who profess the "modernistic." A chasm exists between the usual profession and performance, because growth, where the quality we now call organic is concerned, must be slow growth. Eclecticism may take place overnight but organic architecture must come from the ground up into the light by gradual growth. It will itself be the ground of a better way of life; it is not only the beautifier of the building; it is, as a circumstance in itself, becoming the blessing of the occupants. All building construction naturally becomes lighter and stronger as fibrous "integument" takes the place of "solid mass." Our arboreal ancestors in their trees seem more likely precedent for us at the present time than savage animals who "hole in" for protection. But to properly put it on a human level, a higher *order* of the spirit has dawned for modern life in this interior concept of lived-in space playing with light, taking organic form as the reality of building; a building now an entity by way of native materials and natural methods of structure; forms becoming more naturally significant of ideal and purpose, ultimate in economy and strength. We have, now coming clear, an ideal the core of which must soon pervade the whole realm of creative man and one that, I know now, dates back to Laotse 500 B.C., and, later, to Jesus himself. The building era that Louis Sullivan ushered in is developing beyond the limitations that marked it, aside from his splendid elemental fluorescence, into the higher realm where as a human creative ideal throughout all culture it will make all form and function one.

Not much yet exists in our country—no, nor in any country outside plans and models—to exemplify steel and glass at its best in the light of this new sense of building. But a new countenance—it is the countenance of principle—has already appeared

around the world. A new architectural language is being brokenly, variously, and often falsely spoken by youths, with perspicacity and some breadth of view but with too little depth of knowledge that can only come from continued experience. Unfortunately, academic training and current criticism have no penetration to this inner world. The old academic order is bulging with its own important impotence. Society is cracking under the strain of a sterility education imposes far beyond capacity; exaggerated capitalism has left all this as academic heritage to its own youth. General cultural sterility, the cause of the unrest of this uncreative moment that now stalls the world, might be saved and fructified by this ideal of an organic architecture: led from shallow troubled muddy water into deeper clearer pools of thought. Life needs these deeper fresher pools into which youth may plunge to come out refreshed.

More and more, so it seems to me, light is the beautifier of the building. Light always was the beautifier of the building in the matter of shadows but now especially needs these deeper satisfactions; needs a more worthy human ego for that tomorrow that is always today because of yesterday.

Inevitably this deeper sense of building as integral produce of the spirit of man is to construct the physical body of our machine age. But that in itself will not be enough. Unless this construction were to enable a broader, finer sense of life as something to be lived in to the full, all resources of time, place, and man in place to give us an architecture that is inspiring environment at the same time that it is a true expression of that life itself, the ideal will again have failed.

These gestures being lightly called "modernistic," what then is this new lip service, in shops, studios and schoolrooms? What are these pretentious gestures, this superficial association of ideas or this attempted academic rationalizing of this new work of mine? Why is the true content or motivating inner thought of this new architecture as organic architecture so confused in their hypocritical manifestations? Why is there so little modest, earnest effort to profit honestly by cooperation in these researches and, understanding such proofs as we have, honestly use them, such as they are? Why not go ahead

with them for growth instead of continuing to exploit them for a living or for a passing name? This self-seeking of some transient fame? "Publicity" is the only fame such shallow ambition may know, and like all such ambitions only the "advertising" that will be dead with yesterday's newspaper.

Building the New House

First thing in building the new house, get rid of the attic, therefore the dormer. Get rid of the useless false heights below it. Next, get rid of the unwholesome basement, yes absolutely—in any house built on the prairie. Instead of lean, brick chimneys bristling up everywhere to hint at Judgment, I could see necessity for one chimney only. A broad generous one, or at most two. These kept low down on gently sloping roofs or perhaps flat roofs. The big fireplace in the house below became now a place for a real fire. A real fireplace at that time was extraordinary. There were mantels instead. A mantel was a marble frame for a few coals in a grate. Or it was a piece of wooden furniture with tile stuck in it around the grate, the whole set slam up against the plastered, papered wall. Insult to comfort. So the *integral* fireplace became an important part of the building itself in the houses I was allowed to build out there on the prairie.

It comforted me to see the fire burning deep in the solid masonry of the house itself. A feeling that came to stay.

Taking a human being for my scale, I brought the whole house down in height to fit a normal one—ergo, 5′ 8½″ tall, say. This is my own height. Believing in no other scale than the human being I broadened the mass out all I possibly could to bring it down into spaciousness. It has been said that were I three inches taller than 5′ 8½″ all my houses would have been quite different in proportion. Probably.

House walls were now started at the ground on a cement or stone water table that looked like a low platform under the building, and usually was. But the house walls were stopped at the second-story windowsill level to let the bedrooms come through above in a continuous window series below the broad eaves of a gently sloping, overhanging roof. In this new house the wall was beginning to go as an impediment to outside light and air and beau-

ty. Walls had been the great fact about the box in which holes had to be punched. It was still this conception of a wall-building which was with me when I designed the Winslow house. But after that my conception began to change.

My sense of "wall" was no longer the side of a box. It was enclosure of space affording protection against storm or heat only when needed. But it was also to bring the outside world into the house and let the inside of the house go outside. In this sense I was working away at the wall as a wall and bringing it towards the function of a screen, a means of opening up space which, as control of building-materials improved, would finally permit the free use of the whole space without affecting the soundness of the structure.

The climate being what it was, violent in extremes of heat and cold, damp and dry, dark and bright, I gave broad protecting roof-shelter to the whole, getting back to the purpose for which the cornice was originally designed. The underside of roof-projections was flat and usually light in color to create a glow of reflected light that softly brightened the upper rooms. Overhangs had double value: shelter and preservation for the walls of the house, as well as this diffusion of reflected light for the upper story through the "light screens" that took the place of the walls and were now often the windows in long series.

And at this time I saw a house, primarily, as livable interior space under ample shelter. I liked the *sense of shelter* in the look of the building. I still like it.

The house began to associate with the ground and become natural to its prairie site.

And would the young man in Architecture believe that this was all "new" then? Yes—not only new, but destructive heresy—ridiculous eccentricity. All somewhat so today. Stranger still, but then it was *all* so *new* that what prospect I had of ever earning a livelihood by making houses was nearly wrecked. At first, "they" called the houses "dress reform" houses because Society was just then excited about that particular reform. This simplification looked like some kind of reform to the provincials.

What I have just described was on the *outside* of the house. But it was all there, chiefly because of what had happened *inside*.

Dwellings of that period were cut up, advisedly and completely, with the grim determination that should go with any cutting process. The interiors consisted of boxes beside boxes or inside boxes, called *rooms*. All boxes were inside a complicated outside boxing. Each domestic function was properly box to box.

I could see little sense in this inhibition, this cellular sequestration that implied ancestors familiar with penal institutions, except for the privacy of bedrooms on the upper floor. They were perhaps all right as sleeping boxes. So I declared the whole lower floor as one room, cutting off the kitchen as a laboratory, putting the servants' sleeping and living quarters next to the kitchen but semidetached, on the ground floor. Then I screened various portions of the big room for certain domestic purposes like dining and reading.

There were no plans in existence like these at the time. But my clients were all pushed toward these ideas as helpful to a solution of the vexed servant problem. Scores of unnecessary doors disappeared and no end of partition. Both clients and servants liked the new freedom. The house became more free as space and more livable too. Interior spaciousness began to dawn.

Thus came an end to the cluttered house. Fewer doors; fewer window holes though much greater window area; windows and doors lowered to convenient human heights. These changes once made, the ceilings of the rooms could be brought down over on to the walls by way of the horizontal broad bands of plaster on the walls themselves above the windows and colored the same as the room-ceilings. This would bring ceiling-surface and color down to the very window tops. Ceilings thus expanded by way of the wall band above the windows gave generous overhead even to small rooms. The sense of the whole broadened, made plastic by this means.

Here entered the important new element of plasticity—as I saw it. And I saw it as indispensable element to the successful use of the machine. The windows would sometimes be wrapped around the building corners as inside emphasis of plasticity and to increase the sense of interior space. I fought for outswinging windows because the casement window associated house with the out-of-doors, gave free openings outward. In other words, the so-called casement was not only simple but more

human in use and effect. So more natural. If it had not existed I should have invented it. But it was not used at that time in the United States so I lost many clients because I insisted upon it. The client usually wanted the double-hung (the guillotine window) in use then, although it was neither simple nor human. It was only expedient. I used it once, in the Winslow house, and rejected it forever thereafter. Nor at that time did I entirely eliminate the wooden trim. I did make the "trim" plastic, that is to say, light and continuously flowing instead of the prevailing heavy "cut and butt" carpenter work. No longer did trim, so-called, look like carpenter work. The machine could do it all perfectly well as I laid it out, in this search for quiet. This plastic trim enabled poor workmanship to be concealed. There was need of that much trim then to conceal much in the way of craftsmanship because the battle between the machines and the union had already begun to demoralize workmen.

Machine resources of this period were so little understood that extensive drawings had to be made merely to show the mill-man what to leave off. Not alone in the trim but in numerous ways too tedious to describe in words, this revolutionary sense of the *plastic* whole began to work more and more intelligently and have fascinating unforeseen consequences. Nearly everyone had endured the house of the period as long as possible, judging by the appreciation of the change. Here was an ideal of organic simplicity put to work, with historical consequences not only in this country but especially in the thought of the civilized world.

Simplicity

Organic Simplicity—in this early constructive effort—I soon found depended upon the sympathy with which such co-ordination as I have described might be effected. Plainness was not necessarily simplicity. That was evident. Crude furniture of the Roycroft-Stickley-Mission style, which came along later, was offensively plain, plain as a barn door—but was never simple in any true sense. Nor, I found, were merely machine-made things in themselves necessarily simple. "To think," as the Master used to say, "is to deal in simples." And that means with an eye single to the altogether.

This is, I believe, the single secret of simplicity: that we may truly regard nothing at all as simple in itself. I believe that no one thing in itself is ever so, but must achieve simplicity—as an artist should use the term—as a perfectly realized part of some organic whole. Only as a feature or any part becomes harmonious element in the harmonious whole does it arrive at the state of simplicity. Any wild flower is truly simple but double the same wild flower by cultivation and it ceases to be so. The scheme of the original is no longer clear. Clarity of design and perfect significance both are first essentials of the spontaneous born simplicity of the lilies of the field. "They toil not, neither do they spin." Jesus wrote the supreme essay on simplicity in this, "Consider the lilies of the field."

Five lines where three are enough is always stupidity. Nine pounds where three are sufficient is obesity. But to eliminate expressive words in speaking or writing—words that intensify or vivify meaning—is not simplicity. Nor is similar elimination in architecture simplicity. It may be, and usually is, stupidity.

In architecture, expressive changes of surface, emphasis of line and especially textures of material or imaginative pattern, may go to make facts more eloquent—forms more significant. Elimination, therefore, may be just as meaningless as elaboration, perhaps more often is so. To know what to leave out and what to put in; just where and just how, ah, *that* is to have been educated in knowledge of simplicity—toward ultimate freedom of expression.

As for objects of art in the house, even in that early day they were bêtes noires of the new simplicity. If well chosen, all right. But only if each were properly digested by the whole. Antique or modern sculpture, paintings, pottery, might well enough become objectives in the architectural scheme. And I accepted them, aimed at them often but assimilated them. Such precious things may often take their places as elements in the design of any house, be gracious and good to live with. But such assimilation is extraordinarily difficult. Better in general to design all as integral features.

I tried to make my clients see that furniture and furnishings that were not built in as integral features of the building should be designed as attributes of whatever furniture *was* built in and should be seen as a minor part of the building itself even

if detached or kept aside to be employed only on occasion.

But when the building itself was finished the old furniture they already possessed usually went in with the clients to await the time when the interior might be completed in this sense. Very few of the houses, therefore, were anything but painful to me after the clients brought in their belongings.

Soon I found it difficult, anyway, to make some of the furniture in the abstract. That is, to design it as architecture and make it human at the same time—fit for human use. I have been black and blue in some spot, somewhere, almost all my life from too intimate contact with my own early furniture.

Human beings must group, sit or recline, confound them, and they must dine—but dining is much easier to manage and always a great artistic opportunity. Arrangements for the informality of sitting in comfort singly or in groups still belonging in disarray to the scheme as a whole: *that* is a matter difficult to accomplish. But it can be done now and should be done, because only those attributes of human comfort and convenience should be in order which belong to the whole in this modern integrated sense.

Human use and comfort should not be taxed to pay dividends on any designer's idiosyncrasy. Human use and comfort should have intimate possession of every interior—should be felt in every exterior. Decoration is intended to make use more charming and comfort more appropriate, or else a privilege has been abused.

As these ideals worked away from house to house, finally freedom of floor space and elimination of useless heights worked a miracle in the new dwelling place. A sense of appropriate freedom had changed its whole aspect. The whole became different but more fit for human habitation and more natural on its site. It was impossible to imagine a house once built on these principles somewhere else. An entirely new sense of space-values in architecture came home. It now appears these new values came into the architecture of the world. New sense of repose in quiet streamline effects had arrived. The streamline and the plain surface seen as the flat plane had then and there, some thirty-seven years ago, found their way into buildings as we see them in steamships, aeroplanes and motorcars, although they were intimately related to building materials, environment and the human being.

But, more important than all beside, still rising to greater dignity as an idea as it goes on working, was the ideal of plasticity. That ideal now began to emerge as a means to achieve an organic architecture.

Plasticity

Plasticity may be seen in the expressive flesh-covering of the skeleton as contrasted with the articulation of the skeleton itself. If form really "followed function"—as the Master declared—here was the direct means of expression of the more spiritual idea that form and function are one: the only true means I could see then or can see now to eliminate the separation and complication of cut-and-butt joinery in favor of the expressive flow of continuous surface. Here, by instinct at first—all ideas germinate—a principle entered into building that has since gone on developing. In my work the idea of plasticity may now be seen as the element of continuity.

▦ In architecture, plasticity is only the modern expression of an ancient thought. But the thought taken into structure and throughout human affairs will recreate in a badly "disjointed," distracted world the entire fabric of human society. This magic word "plastic" was a word Louis Sullivan himself was fond of using in reference to his idea of ornamentation as distinguished from all other or applied ornament. But now, why not the larger application in the structure of the building itself in this sense?

Why a principle working in the part if not living in the whole?

If form really followed function—it did in a material sense by means of this ideal of plasticity, the spiritual concept of *form and function as one*—why not throw away the implications of post or upright and beam or horizontal entirely? Have no beams or columns piling up as "joinery." Nor any cornices. Nor any "features" as *fixtures*. No. Have no appliances of any kind at all, such as pilasters, entablatures and cornices. Nor put into the building any fixtures whatsoever as "fixtures." Eliminate the separations and separate joints. Classic architecture was all fixation-of-the-fixture. Yes, entirely so. Now why not let walls, ceilings, floors become *seen* as component

parts of each other, their surfaces flowing into each other. To get continuity in the whole, eliminating all constructed features just as Louis Sullivan had eliminated background in his ornament in favor of an integral sense of the whole. Here the promotion of an idea from the material to the spiritual plane began to have consequences. Conceive now that an entire building might grow up out of conditions as a plant grows up out of soil and yet be free to be itself, to "live its own life according to Man's Nature." Dignified as a tree in the midst of nature but a child of the spirit of man.

I now propose an ideal for the architecture of the machine age, for the ideal American building. Let it grow up in that image. The tree.

But I do not mean to suggest the imitation of the tree.

Proceeding, then, step by step from generals to particulars, plasticity as a large means in architecture began to grip me and to work its own will. Fascinated I would watch its sequences, seeing other sequences in those consequences already in evidence: as in the Heurtley, Martin, Heath, Thomas, Tomek, Coonley and dozens of other houses.

The old architecture, so far as its grammar went, for me began, literally, to disappear. As if by magic new architectural effects came to life—effects genuinely new in the whole cycle of architecture owing simply to the working of this spiritual principle. Vistas of inevitable simplicity and ineffable harmonies would open, so beautiful to me that I was not only delighted, but often startled. Yes, sometimes amazed.

I have since concentrated on plasticity as physical continuity, using it as a practical working principle within the very nature of the building itself in the effort to accomplish this great thing called architecture. Every true esthetic is an implication of nature, so it was inevitable that this esthetic ideal should be found to enter into the actual building of the building itself as a principle of construction.

But later on I found that in the effort to actually eliminate the post and beam in favor of structural continuity, that is to say, making the two things one thing instead of two separate things, I could get no help at all from regular engineers. By habit, the engineer reduced everything in the field of calculation to the post and the beam resting upon it before

he could calculate and tell you where and just how much for either. He had no other data. Walls made one with floors and ceilings, merging together yet reacting upon each other, the engineer had never met. And the engineer has not yet enough scientific formulae to enable him to calculate for continuity. Floor slabs stiffened and extended as cantilevers over centered supports, as a waiter's tray rests upon his upturned fingers, such as I now began to use in order to get planes parallel to the earth to emphasize the third dimension, were new, as I used them, especially in the Imperial Hotel. But the engineer soon mastered the element of continuity in floor slabs, with such formulae as he had. The cantilever thus became a new feature of design in architecture. As used in the Imperial Hotel at Tokyo it was the most important of the features of construction that insured the life of that building in the terrific temblor of 1922. So, not only a new esthetic but proving the esthetic as scientifically sound, a great new economic "stability," derived from steel in tension, was able now to enter into building construction.

In the Nature of Materials: A Philosophy

Our vast resources are yet new; new only because architecture as "rebirth" (perennial Renaissance) has, after five centuries of decline, culminated in the imitation of imitations, seen in our Mrs. Plaster-built, Mrs. Gablemore, and Miss Flat-top American architecture. In general, and especially officially, our architecture is at long last completely significant of insignificance only. We do not longer have architecture. At least no buildings with integrity. We have only economic crimes in its name. No, our greatest buildings are not qualified as great art, my dear Mrs. Davies, although you do admire Washington.

If you will yet be patient for a little while—a scientist, Einstein, asked for three days to explain the far less pressing and practical matter of "Relativity"—we will take each of the five new resources in order, as with the five fingers of the hand. All are new integrities to be used if we will to make living easier and better today.

The first great integrity is a deeper, more intimate sense of reality in building than was ever pagan—that is to say, than was ever "Classic." More human than was any building ever realized in the Christian

Middle Ages. This is true although the thought that may ennoble it now has been living in civilization for more than twenty centuries back. Later it was innate in the simplicities of Jesus as it was organic 500 years earlier in the natural philosophy, Tao (The Way), of the Chinese philosopher Laotse. But not only is the new architecture sound philosophy. It is poetry.

Said Ong Giao Ki, Chinese sage, "Poetry is the sound of the heart."

Well, like poetry, this sense of architecture is the sound of the "within." We might call that "within," the heart.

Architecture now becomes integral, the expression of a new-old reality: the livable interior space of the room itself. In integral architecture the *room-space itself must come through*. The *room* must be seen as architecture, or we have no architecture. We have no longer an outside as outside. We have no longer an outside and an inside as two separate things. Now the outside may come inside, and the inside may and does go outside. They are *of* each other. Form and function thus become one in design and execution if the nature of materials and method and purpose are all in unison.

This interior-space concept, the first broad integrity, is the first great resource. It is also true basis for general significance of form. Add to this for the sake of clarity that (although the general integration is implied in the first integrity) it is in the nature of any organic building to grow from its site, come out of the ground into the light—the ground itself held always as a component basic part of the building itself. And then we have primarily the new ideal of building as organic. A building dignified as a tree in the midst of nature.

This new ideal for architecture is, as well, an adequate ideal for our general culture. In any final result there can be no separation between our architecture and our culture. Nor any separation of either from our happiness. Nor any separation from our work.

Thus in this rise of organic integration you see the means to end the petty agglomerations miscalled civilization. By way of this old yet new and deeper sense of reality we may have a civilization. In this sense we now recognize and may declare by way of plan and building—the *natural*. Faith in the *natural* is the faith we now need to grow up on in this coming age of our culturally confused, backward twentieth century. But instead of "organic" we might well say "natural" building. Or we might say integral building.

So let us now consider the second of the five new resources: glass. This second resource is new and a "super-material" only because it holds such amazing means in modern life for awakened sensibilities. It amounts to a new qualification of life in itself. If known in ancient times glass would then and there have abolished the ancient architecture we know, and completely. This super-material GLASS as we now use it is a miracle. Air in air to keep air out or keep it in. Light itself in light, to diffuse or reflect, or refract light itself.

By means of glass, then, the first great integrity may find prime means of realization. Open reaches of the ground may enter as the building and the building interior may reach out and associate with these vistas of the ground. Ground and building will thus become more and more obvious as directly related to each other in openness and intimacy; not only as environment but also as a good pattern for the good life lived in the building. Realizing the benefits to human life of the far-reaching implications and effects of the first great integrity, let us call it the interior-space concept. This interior-space realization is possible and it is desirable in all the vast variety of characteristic buildings needed by civilized life in our complex age.

By means of glass something of the freedom of our arboreal ancestors living in their trees becomes a more likely precedent for freedom in twentieth-century life, than the cave.

Savage animals "holing in" for protection were more characteristic of life based upon the might of feudal times or based upon the so-called "classical" in architecture, which were in turn based upon the labor of the chattel slave. In a free country, were we ourselves free by way of organic thought, buildings might come out into the light without more animal fear; come entirely away from the pagan ideals of form we dote upon as "Classic." Or what Freedom have we?

Perhaps more important than all beside, it is by way of glass that the sunlit space as a reality becomes the most useful servant of a higher order of the human spirit. It is first aid to the sense of cleanliness of form and idea when directly related to free

living in air and sunlight. It is this that is coming in the new architecture. And with the integral character of extended vistas gained by marrying buildings with ground levels, or blending them with slopes and gardens; yes, it is in this new sense of earth as a great human *good* that we will move forward in the building of our new homes and great public buildings.

I am certain we will desire the sun, spaciousness and integrity of means-to-ends more year by year as we become aware of the possibilities I have outlined. The more we desire the sun, the more we will desire the freedom of the good ground and the sooner we will learn to understand it. The more we value integrity, the more securely we will find and keep a worthwhile civilization to set against prevalent abuse and ruin.

Congestion will no longer encourage the "space-makers for rent." The "space-maker for rent" will himself be "for rent" or let us hope "vacant." Give him ten years.

These new space values are entering into our ideas of life. All are appropriate to the ideal that is our own, the ideal we call Democracy.

A New Reality: Glass

A resource to liberate this new sense of interior space as reality is this new qualification called glass: a super-material qualified to qualify us; qualify us not only to escape from the prettified cavern of our present domestic life as also from the cave of our past, but competent actually to awaken in us the desire for such far-reaching simplicities of life as we may see in the clear countenance of nature. Good building must ever be seen as in the nature of good construction, but a higher development of this "seeing" will be construction seen as nature-pattern. *That* seeing, only, is inspired architecture.

This dawning sense of the *Within* as *reality* when it is clearly seen as *Nature* will by way of glass make the garden be the building as much as the building will be the garden: the sky as treasured a feature of daily indoor life as the ground itself.

You may see that walls are vanishing. The cave for human dwelling purposes is at last disappearing.

Walls themselves because of glass will become windows and windows as we used to know them as holes in walls will be seen no more. Ceilings will often become as window-walls, too. The textile may soon be used as a beautiful overhead for space, the textile an attribute of genuine architecture instead of decoration by way of hangings and upholstery. The usual camouflage of the old order. Modern integral floor heating will follow integral lighting and standardized unitary sanitation. All this makes it reasonable and good economy to abolish building as either a hyper-boxment or a super-borough.

Haven't senseless elaboration and false mass become sufficiently insulting and oppressive to our intelligence as a people? And yet, senseless elaboration and false mass were tyrannical as "conspicuous waste" in all of our nineteenth-century architecture either public or private! Wherever the American architect, as scholar, went he "succeeded" to that extent.

Another Reality: Continuity

But now, as third resource, the resource essential to modern architecture destined to cut down this outrageous mass-waste and mass-lying, is the principle of continuity. I have called it tenuity. Steel is its prophet and master. You must come with me for a moment into "engineering" so called. This is to be an unavoidable strain upon your kind attention. Because, unfortunately, gentle reader, you cannot understand architecture as *modern* unless you do come, and—paradox—you can't come if you are too well educated as an engineer or as an architect either. So your common sense is needed more than your erudition.

However, to begin this argument for steel: classic architecture knew only the post as an *upright*. Call it a column. The classics knew only the beam as a *horizontal*. Call it a beam. The beam resting upon the upright, or column, was structure throughout, to them. Two things, you see, one thing set on top of another thing in various materials and put there in various ways. Ancient, and nineteenth-century building science too, even building *à la mode*, consisted simply in reducing the various stresses of all materials and their uses to these two things: post and beam. Really, construction used to be just sticking up something in wood or stone and putting something else in wood or stone (maybe iron)

on top of it: simple super-imposition, you see? You should know that all "Classic" architecture was and still is some such form of direct super-imposition. The arch is a little less so, but even that must be so "figured" by the structural engineer if you ask him to "figure" it.

Now the Greeks developed this simple act of super-imposition pretty far by way of innate tasteful refinement. The Greeks were true estheticians. Roman builders too, when they forgot the Greeks and brought the beam over as a curve by way of the arch, did something somewhat new but with consequences still of the same sort. But observe, all architectural features made by such "Classic" agglomeration were killed for us by cold steel. And though millions of classic corpses yet encumber American ground unburied, they are ready now for burial.

Of course this primitive post-and-beam construction will always be valid, but both support and supported may now by means of inserted and welded steel strands or especially woven filaments of steel and modern concrete casting be plaited and united as one physical body: ceilings and walls made one with floors and reinforcing each other by making them continue into one another. This Continuity is made possible by the tenuity of steel.

So the new order wherever steel or plastics enter construction says: weld these two things, post and beam (wall and ceiling) together by means of steel strands buried and stressed within the mass material itself, the steel strands electric-welded where steel meets steel within the mass. In other words the upright and horizontal may now be made to work together as one. A new world of form opens inevitably.

Where the beam leaves off and the post begins is no longer important nor need it be seen at all because it no longer actually *is*. Steel in tension enables the support to slide into the supported, or the supported to grow into the support somewhat as a tree branch glides out of its tree trunk. Therefrom arises the new series of interior physical reactions I am calling "Continuity." As natural consequence the new esthetic or appearance we call *Plasticity* (and plasticity is peculiarly "modern") is no longer a mere appearance. Plasticity actually becomes the normal *countenance,* the *true esthetic* of genuine structural reality. These interwoven steel strands may so lie in so many directions in any extended member that the

extensions may all be economical of material and though much lighter, be safer construction than ever before. There as in the branch of the tree you may see the cantilever. The cantilever is the simplest one of the important phases of this third new structural resource now demanding new significance. It has yet had little attention in architecture. It can do remarkable things to liberate space.

But plasticity was modest new countenance in our American architecture at least thirty-five years ago in my own work, but then denied such simple means as welding and the mesh. It had already eliminated all the separate identities of post and beam in architecture. Steel in tension enters now by way of mesh and welding to arrive at actual, total plasticity if and when desired by the architect. And to prove the philosophy of organic architecture, form and function are one, it now enters architecture as the *esthetic* countenance of *physical reality*.

To further illustrate this magic simplifier we call "plasticity": see it as *flexibility* similar to that of your own hand. What makes your hand expressive? Flowing continuous line and continuous surfaces seen continually mobile of the articulate articulated structure of the hand as a whole. The line is seen as "hand" line. The varying planes seen as "hand" surface. Strip the hand to the separate structural identities of joined bones (post and beam) and plasticity as an expression of the hand would disappear. We would be then getting back to the joinings, breaks, jolts, and joints of ancient, or "Classic," architecture: thing to thing; feature to feature. But plasticity is the reverse of that ancient agglomeration and is the ideal means behind these simplified free new effects of straight line and flat plane.

I have just said that plasticity in this sense for thirty-five years or more has been the recognized esthetic ideal for such simplification as was required by the machine to do organic work. And it is true of my own work.

As significant outline and expressive surface, this new esthetic of plasticity (physical continuity) is now a useful means to form the supreme physical body of an organic, or integral, American Architecture.

Of course, it is just as easy to cheat by simplicity as it is to cheat with "classical" structure. So, unluckily, here again is the "modernistic" architectural picture-maker's deadly facility for imitation at ease

and again too happy with fresh opportunity to "fake effects." Probably another Renaissance is here imminent.

Architecture is now integral architecture only when Plasticity is a genuine expression of actual construction just as the articulate line and surface of the hand is articulate of the structure of the hand. Arriving at steel, I first used Continuity as actual stabilizing principle in concrete slabs, and in the concrete ferro-block system I devised in Los Angeles.

In the form of the cantilever or as horizontal continuity this new economy by means of tenuity is what saved the Imperial Hotel from destruction, but it did not appear in the grammar of the building for various reasons, chiefly because the building was to look somewhat as though it belonged to Tokyo.

Later, in the new design for St. Mark's Tower, New York City, this new working principle economized material, labor, and liberated or liberalized space in a more developed sense. It gave to the structure the significant outlines of remarkable stability and instead of false masonry-mass significant outlines came out. The abstract pattern of the structure as a complete structural-integrity of Form and Idea may be seen fused as in any tree but with nothing imitating a tree.

Continuity invariably realized remarkable economy of labor and building materials as well as space. Unfortunately there is yet little or no data to use as tabulation. Tests will have to be made continually for many years to make the record available to slide-rule engineers.

In the ancient order there was little thought of economy of materials. The more massive the whole structure looked, the better it looked to the ancients. But seen in the light of these new economic interior forces conserved by the tensile strength of a sheet of plastic or any interweaving of strands of steel in this machine age, the old order was as sick with weight as the Buonarotti dome. Weak . . . because there could be no co-interrelation between the two elements of support and supported to reinforce each other as a whole under stress or elemental disturbance.

So this tremendous new resource of *tenuity*—a quality of steel—this quality of *pull* in a building (you may see it ushering in a new era in John Roebling's Brooklyn Bridge) was definitely lacking in all ancient architecture because steel had not been born into building.

The tenuous strand or slab as a common means of strength had yet to come. Here today this element of continuity may cut structural substance nearly in two. It may cut the one half in two again by elimination of needless features, such elimination being entirely due to the simplification I have been calling "plasticity."

It is by utilizing mass production in the factory in this connection that some idea of the remarkable new economics possible to modern architecture may be seen approaching those realized in any well-built machine. If standardization can be humanized and made flexible in design and the economics brought to the home owner, the greatest service will be rendered to our modern way of life. It may be really born—this democracy, I mean.

Involved as a matter of design in this mass production, however, are the involute, all but involuntary reactions to which I have just referred: the ipso facto building code and the fact that the building engineer as now trained knows so little about them. However, the engineer is learning to calculate by model-making in some instances—notably Professor Beggs at Princeton.

The codes so far as I can see will have to die on the vine with the men who made them.

Materials for Their Own Sake

As the first integrity and the two first new resources appeared out of the interior nature of the kind of building, called Architecture—so now, naturally, interior to the true nature of any good building, comes the fourth new resource. This is found by recognizing the nature of the materials used in construction.

Just as many fascinating different properties as there are different materials that may be used to build a building will continually and naturally qualify, modify and utterly change all architectural form whatsoever.

A stone building will no more *be* nor will it *look* like a steel building. A pottery, or terra cotta building, will not be nor should it look like a stone building. A wood building will look like none other, for it will glorify the stick. A steel and glass building could not possibly look like anything but itself. It will glorify steel and glass. And so on all the way

down the long list of available riches in materials: Stone, Wood, Concrete, Metals, Glass, Textiles, Pulp and Plastics; riches so great to our hand today that no comparison with Ancient Architecture is at all sensible or anything but obstruction to our Modern Architecture.

In this particular, as you may see, architecture is going back to learn from the natural source of all natural things.

In order to get Organic Architecture born, intelligent architects will be forced to turn their backs on antique rubbish heaps with which Classic eclecticism has encumbered our new ground. So far as architecture has gone in my own thought it is first of all a character and quality of *mind* that may enter also into human conduct with social implications that might, at first, confound or astound you. But the only basis for any fear of them lies in the fact that they are all sanely and thoroughly *constructive*.

▥ Instinctively all forms of pretense fear and hate reality. THE HYPOCRITE MUST ALWAYS HATE THE RADICAL.

▥ This potent fourth new resource—the Nature of Materials—gets at the common center of every material in relation to the work it is required to do. This means that the architect must again begin at the very beginning. Proceeding according to Nature now he must sensibly go through with whatever material may be in hand for his purpose according to the methods and sensibilities of a man in this age. And when I say Nature, I mean inherent *structure* seen always by the architect as a matter of complete design. It is in itself, always, *nature-pattern*. It is this profound internal sense of materials that enters in as Architecture now. It is this, the fifth new resource, that must captivate and hold the mind of the modern architect to creative work. The fifth will give new life to his imagination if it has not been already killed at school.

And, inevitable implication! New machine-age resources require that all buildings do *not* resemble each other. The new ideal does *not* require that all buildings be of steel, concrete or glass. Often that might be idiotic waste.

Nor do the resources even *imply* that mass is no longer a beautiful attribute of masonry materials when they are genuinely used. We are entitled to a vast variety of form in our complex age so long as the form be genuine—serves Architecture and Architecture serves life.

But in this land of ours, richest on earth of all in old and new materials, architects must exercise well-trained imagination to see in each material, either natural or compounded plastics, their own *inherent style*. All materials may be beautiful, their beauty much or entirely depending upon how well they are used by the Architect.

In our modern building we have the Stick. Stone. Steel. Pottery. Concrete. Glass. Yes, Pulp, too, as well as plastics. And since this dawning sense of the "within" is the new reality, these will all give the main *motif* for any real building made from them. The materials of which the building is built will go far to determine its appropriate mass, its outline and, especially, proportion. *Character* is criterion in the form of any and every building or industrial product we can call Architecture in the light of this new ideal of the new order.

The New Integrity

Strange! At this late date, it is modern architecture that wants life to learn to see life as life, because architecture must learn to see brick as brick, learn to see steel as steel, see glass as glass. So modern thought urges all of life to demand that a bank look like a bank (bad thought though a bank might become) and not depend upon false columns for credit. The new architecture urges all of life to demand that an office building look like an office building, even if it should resemble the cross section of a beehive. Life itself should sensibly insist in self-defense that a hotel look and conduct itself like a hotel and not like some office building. Life should declare, too, that the railroad station look like a railroad station and not try so hard to look like an ancient temple or some monarchic palazzo. And while we are on this subject, why not a place for opera that would look something like a place for opera—if we must have opera, and not look so much like a gilded, crimsoned bagnio. Life declares that a filling station should stick to its work as a filling station: look the part becomingly. Why try to look like some Colonial diminutive or remain just a pump on the street. Although "just a pump" on the

street is better than the Colonial imitation. The good Life itself demands that the school be as generously spaced and a thought-built good-time place for happy children: a building no more than one story high—with some light overhead, the school building should regard the children as a garden in sun. Life itself demands of Modern Architecture that the house of a man who knows what home is should have his own home his own way if we have any man left in that connection after F.H.A. is done trying to put them, all of them it can, into the case of a man who builds a home only to sell it. Our Government forces the home-maker into the real-estate business if he wants a home at all.

Well, after all, this line of thought was all new-type common sense in architecture in Chicago only thirty years ago. It began to grow up in my own work as it is continuing to grow up more and more widely in the work of all the world. But, insulting as it may seem to say so, nor is it merely arrogant to say that the actual thinking in that connection is still a novelty, only a little less strange today than it was then, although the appearances do rapidly increase.

Integral Ornament At Last!

At last, is this fifth resource, so old yet now demanding fresh significance. We have arrived at integral ornament—the nature-pattern of actual construction. Here, confessed as the spiritual demand for true significance, comes this subjective element in modern architecture. An element so hard to understand that modern architects themselves seem to understand it least well of all and most of them have turned against it with such fury as is born only of impotence.

And it *is* true that this vast, intensely human significance is really no matter at all for any but the most imaginative mind not without some development in artistry and the *gift* of a sense of proportion. Certainly we must go higher in the realm of imagination when we presume to enter here, because we go into Poetry.

Now, very many write good prose who cannot write poetry at all. And although staccato specification is the present fashion, just as "functionalist" happens to be the present style in writing—poetic prose will never be undesirable. But who condones prosaic poetry? None. Not even those fatuously condemned to write it.

So, I say this fourth new resource and the fifth demand for new significance and integrity is ornament *integral to building as itself poetry*. Rash use of a dangerous word. The word "Poetry" *is* a dangerous word.

Heretofore, I have used the word "pattern" instead of the word ornament to avoid confusion or to escape the passing prejudice. But here now ornament is in its place. Ornament meaning not only *surface qualified by human imagination* but imagination giving *natural pattern* to structure. Perhaps this phrase says it all without further explanation. This resource—integral ornament—is new in the architecture of the world, at least insofar not only as imagination qualifying a surface—a valuable resource—but as a greater means than that: *imagination giving natural pattern to structure itself.* Here we have new significance, indeed! Long ago this significance was lost to the scholarly architect. A man of taste. He, too soon, became content with symbols.

Evidently then, this expression of structure as a pattern true to the nature of the materials out of which it was made, may be taken much further along than physical need alone would dictate? "If you have a loaf of bread break the loaf in two and give the half of it for some flowers of the Narcissus, for the bread feeds the body indeed but the flowers feed the soul."

Into these higher realms of imagination associated in the popular mind as sculpture and painting, buildings may be as fully taken by modern means today as they ever were by craftsmen of the antique order.

It is by this last and poetic resource that we may give greater structural entity and greater human significance to the whole building than could ever be done otherwise. This statement is heresy at this left-wing moment, so—we ask, "taken how and when taken?" I confess you may well ask by whom? The answer is, taken by the true *poet*. And where is this Poet today? Time will answer.

Yet again in this connection let us remember Ong's Chinese observation, "Poetry is the sound of the heart." So, in the same uncommon sense inte-

gral ornament is the developed sense of the building as a whole, or the manifest *abstract pattern of structure itself*. Interpreted. Integral ornament is simply *structure-pattern made visibly articulate* and seen in the building as it is seen articulate in the structure of the trees or a lily of the fields. It is the expression of inner rhythm of Form. Are we talking about Style? Pretty nearly. At any rate, we are talking about the qualities that make *essential architecture* as distinguished from any mere act of building whatsoever.

What I am here calling integral ornament is founded upon the same organic simplicities as Beethoven's Fifth Symphony, that amazing revolution in tumult and splendor of sound built on four tones based upon a rhythm a child could play on the piano with one finger. Supreme imagination reared the four repeated tones, simple rhythms, into a great symphonic poem that is probably the noblest thought-built edifice in our world. And Architecture is like Music in this capacity for the symphony.

▦ But concerning higher development of building to more completely express its life principle as significant and beautiful, let us say at once by way of warning: it is better to die by the wayside of left-wing Ornaphobia than it is to build any more merely ornamented buildings, as such; or to see right-wing architects die any more ignoble deaths of *Ornamentia*. All period and pseudo-classic buildings whatever, and (although their authors do not seem to know it) most protestant buildings, they call themselves internationalist, are really ornamental in definitely objectionable sense. A plain flat surface cut to shape for its own sake, however large or plain the shape, is, the moment it is sophisticatedly so cut, no less ornamental than egg-and-dart. All such buildings are objectionably "ornamental," because like any buildings of the old classical order both wholly ignore the *nature* of the *first* integrity. Both also ignore the four resources and both neglect the nature of machines at work on materials. Incidentally and as a matter of course both misjudge the nature of time, place and the modern life of man.

Here in this new leftish emulation as we now have it, is only the "istic," ignoring principle merely to get the "look" of the machine or something that looks "new." The province of the "ite."

In most so-called "internationalist" or "modernistic" building therefore we have no true approach to organic architecture: we have again merely a new, superficial esthetic trading upon that architecture because such education as most of our architects possess qualifies them for only some kind of eclecticism past, passing, or to pass.

Nevertheless I say, if we can't have buildings with integrity we would better have more imitation machines for buildings until we can have truly sentient architecture. "The machine for living in" is sterile, but therefore it is safer, I believe, than the festering mass of ancient styles.

Great Power

A far greater power than slavery, even the intellectual slavery as in the school of the Greeks, is back of these five demands for machine-age significance and integrity. Stupendous and stupefying power. That power is the leverage of the machine itself. As now set up in all its powers the machine will confirm these new implicities and complicities in architecture at every point, but will destroy them soon if not checked by a new simplicity.

The proper use of these new resources demands that we use them all together with integrity for mankind if we are to realize the finer significances of life. The finer significance, prophesied if not realized by organic architecture. It *is* reasonable to believe that life in our country will be lived in full enjoyment of this new freedom of the extended horizontal line because the horizontal line now becomes the great architectural highway. The flat plane now becomes the regional field. And integral-pattern becomes "the sound of the Usonian heart."[6]

I see this extended horizontal line as the true earth-line of human life, indicative of freedom. Always.

The broad expanded plane is the horizontal plane infinitely extended. In that lies such freedom for man on this earth as he may call his.

▦ This new sense of Architecture as integral-pattern of that type and kind may awaken these United States to fresh beauty, and the Usonian horizon of the individual will be immeasurably extended by enlightened use of this great lever, the

machine. But only if it gets into creative hands loyal to humanity.

The Usonian House I

The house of moderate cost is not only America's major architectural problem but the problem most difficult for her major architects. As for me, I would rather solve it with satisfaction to myself and Usonia, than build anything I can think of at the moment except the modern theater now needed by the legitimate drama unless the stage is to be done to death by "the movies." In our country the chief obstacle to any real solution of the moderate-cost house problem is the fact that our people do not really know how to live. They imagine their idiosyncrasies to be their "tastes," their prejudices to be their predilections, and their ignorance to be virtue—where any beauty of living is concerned.

To be more specific, a small house on the side street might have charm if it didn't ape the big house on the Avenue, just as the Usonian village itself might have a great charm if it didn't ape the big town. Likewise, Marybud on the old farm, a jewel hanging from the tip of her pretty nose on a cold, cold day, might be charming in clothes befitting her state and her work, but is only silly in the Sears-Roebuck finery that imitates the clothes of her city sisters who imitate Hollywood stars: lipstick, rouge, high heels, silk stockings, bell skirt, cockeyed hat, and all. Exactly that kind of "monkey-fied" business is the obstacle to architectural achievement in our U.S.A. This provincial "culture-lag" in favor of the lag which does not allow the person, thing, or thought to be simple and naturally itself. It is the real obstacle to a genuine Usonian culture.

I am certain that any approach to the new house needed by indigenous culture—why worry about the house wanted by provincial "tasteful" ignorance!—is fundamentally different. That house must be a pattern for more simplified and, at the same time, more gracious living: necessarily new, but suitable to living conditions as they might so well be in this country we live in today.

This need of a house of moderate cost must sometime face not only expedients but Reality. Why not face it now? The expedient houses built by the million, which journals propagate, and government builds, do no such thing.

To me such houses are stupid makeshifts, putting on some style or other, really having no integrity. Style *is* important. *A* style is not. There is all the difference when we work *with* style and not for *a* style.

I have insisted on that point for forty-five years.

▓ Notwithstanding all efforts to improve the product, the American "small house" problem is still a pressing, needy, hungry, confused issue. But where is a better thing to come from while Authority has pitched into perpetuating the old stupidities? I do not believe the needed house can come from current education, or from big business. It isn't coming by way of smart advertising experts either. Or professional streamliners. It is only super-common-sense that can take us along the road to the better thing in building.

What would be really sensible in this matter of the modest dwelling for our time and place? Let's see how far the first Herbert Jacobs house at Madison, Wisconsin, is a sensible house. This house for a young journalist, his wife, and small daughter, was built in 1937. Cost: Fifty-five hundred dollars, including architect's fee of four hundred and fifty. Contract let to P. B. Grove.

To give the small Jacobs family the benefit of the advantages of the era in which they live, many simplifications must take place. Mr. and Mrs. Jacobs must themselves see life in somewhat simplified terms. What are essentials in their case, a typical case? It is not only necessary to get rid of all unnecessary complications in construction, necessary to use work in the mill to good advantage, necessary to eliminate, so far as possible, field labor which is always expensive: it is necessary to consolidate and simplify the three appurtenance systems—heating, lighting, and sanitation. At least this must be our economy if we are to achieve the sense of spaciousness and vista we desire in order to liberate the people living in the house. And it would be ideal to complete the building in one operation as it goes along. Inside and outside should be complete in one operation. The house finished inside as it is completed outside. There should be no complicated roofs.

Every time a hip or a valley or a dormer window

is allowed to ruffle a roof the life of the building is threatened.

The way the windows are used is naturally a most useful resource to achieve the new characteristic sense of space. All this fenestration can be made ready at the factory and set up as the walls. But there is no longer sense in speaking of doors and windows. These walls are largely a system of fenestration having its own part in the building scheme—the system being as much a part of the design as eyes are part of the face.

░ Now what can be eliminated? These:

1. Visible roofs are expensive and unnecessary.

2. A garage is no longer necessary as cars are made. A carport will do, with liberal over-head shelter and walls on two sides. Detroit still has the livery-stable mind. It believes that the car is a horse and must be stabled.

3. The old-fashioned basement, except for a fuel and heater space, was always a plague spot. A steam-warmed concrete mat four inches thick laid directly on the ground over gravel filling, the walls set upon that, is better.

4. Interior "trim" is no longer necessary.

5. We need no radiators, no light fixtures. We will heat the house the "hypocaust" way—in or between the floors. We can make the wiring system itself be the light fixture, throwing light upon and down the ceiling. Light will thus be indirect, except for a few outlets for floor lamps.

6. Furniture, pictures and bric-a-brac are unnecessary because the walls can be made to include them or *be* them.

7. No painting at all. Wood best preserves itself. A coating of clear resinous oil would be enough. Only the floor mat of concrete squares needs waxing.

8. No plastering in the building.

9. No gutters, no downspouts.

To assist in general planning, what must or may we use in our new construction? In this case five materials: wood, brick, cement, paper, glass. To simplify fabrication we must use our horizontal-unit system in construction. We must also use a vertical-unit system which will be the widths of the boards and batten-bands themselves, interlocking with the brick courses. Although it is getting to be a luxury material, the walls will be wood board-walls the same inside as outside—three thicknesses of boards with paper placed between them, the boards fastened together with screws. These slab-walls of boards—a kind of plywood construction on a large scale can be high in insulating value, vermin-proof, and practically fireproof. These walls like the fenestration may be prefabricated on the floor, with any degree of insulation we can afford, and raised into place, or they may be made at the mill and shipped to the site in sections. The roof can be built first on props and these walls shoved into place under them.

The appurtenance systems, to avoid cutting and complications, must be an organic part of construction but independent of the walls. Yes, we must have polished plate glass. It is one of the things we have at hand to gratify the designer of the truly modern house and bless its occupants.

The roof framing in this instance is laminated of three 2 × 4's in depth easily making the three offsets seen outside in the eaves of the roof, and enabling the roof span of 2 × 12″ to be sufficiently pitched without the expense of "building up" the pitches. The middle offset may be left open at the eaves and fitted with flaps used to ventilate the roof spaces in summer. These 2 × 4's sheathed and insulated, then covered with a good asphalt roof, are the top of the house, shelter gratifying to the sense of shelter because of the generous eaves.

All this is in hand—no, it is in mind, as we plan the disposition of the rooms.

░ What must we consider essential now? We have a corner lot—say, an acre or two—with a south and west exposure? We will have a good garden. The house is planned to wrap around two sides of this garden.

1. We must have as big a living room with as much vista and garden coming in as we can afford, with a fireplace in it, and open bookshelves, a dining table in the alcove, benches, and living-room tables built in; a quiet rug on the floor.

2. Convenient cooking and dining space adjacent to if not a part of the living room. This space may be set away from the outside walls within the living area to make work easy. This is the new thought concerning a kitchen—to take it away from outside walls and let it turn up into overhead space within the chimney; thus connection to dining space is made imme-

Herbert Jacobs House,
Madison, Wisconsin. 1936.
FLLW Fdn# 3702.0025

George Sturges House,
Brentwood Heights, California. 1939.
FLLW Fdn# 3905.0008
Dining table arrangement between
workspace and living room fireplace.

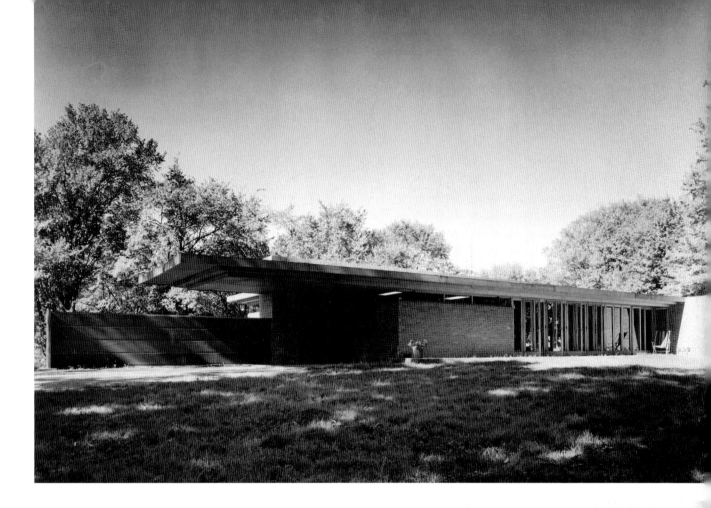

diate without unpleasant features and no outside wall space lost to the principal rooms. A natural current of air is thus set up toward the kitchen as toward a chimney, no cooking odors escaping back into the house. There are steps leading down from this space to a small cellar below for heater, fuel, and laundry, although no basement at all is necessary if the plan should be so made. The bathroom is usually next so that plumbing features of heating kitchen and bath may be economically combined.

3. In this case (two bedrooms and a workshop which may become a future bedroom) the single bathroom for the sake of privacy is not immediately connected to any single bedroom. Bathrooms opening directly into a bedroom occupied by more than one person or two bedrooms opening into a single bathroom have been badly overdone. We will have as much garden and space in all these space appropriations as our money allows after we have simplified construction by way of the technique we have tried out.

A modest house, this Usonian house, a dwelling place that has no feeling at all for the "grand" except as the house extends itself in the flat parallel to the ground. It will be a companion to the horizon. With floor-heating that kind of extension on the ground can hardly go too far for comfort or beauty of proportion, provided it does not cost too much in upkeep. As a matter of course a home like this is an architect's creation. It is not a builder's nor an amateur's effort. There is considerable risk in exposing the scheme to imitation or emulation.

This is true because a house of this type could not be well built and achieve its design except as an architect oversees the building.

And the building would fail of proper effect unless the furnishing and planting were all done by advice of the architect.

Thus briefly these few descriptive paragraphs together with the plan may help to indicate how stuffy and stifling the little colonial hot-boxes, hallowed by

THE NATURAL HOUSE

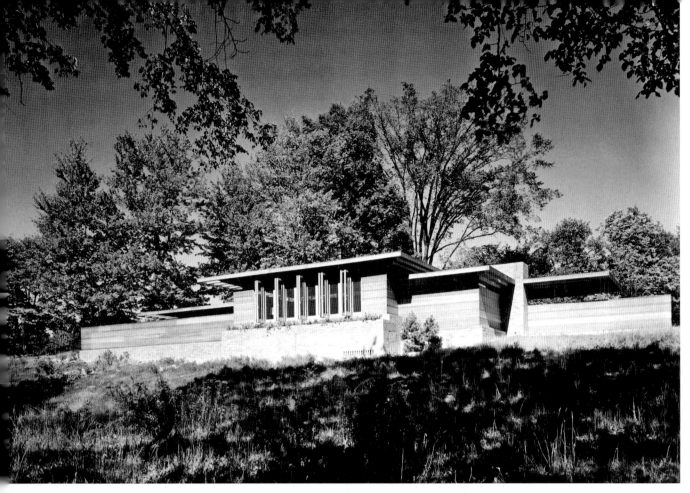

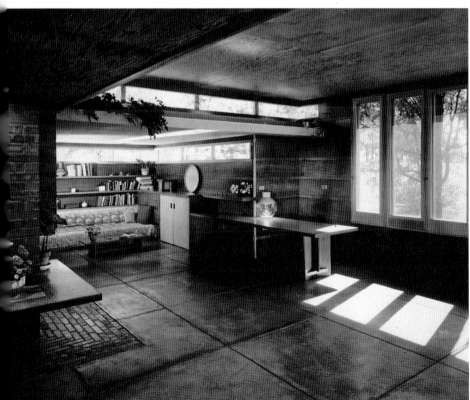

Alma Goetsch and
Kathrine Winckler House,
Okemos, Michigan. 1937.
FLLW Fdn# 3907.0010, 3907.0012,
and 3907.0013

government or not, really are where Usonian family life is concerned. You might easily put two of them, each costing more, into the living space of this one and not go much outside the walls. Here is a moderate-cost brick-and-wood house that by our new technology has been greatly extended both in scale and comfort: a single house suited to prefabrication because the factory can go to the house.

Imagine how the costs would come down were the technique a familiar matter or if many houses were to be executed at one time—probably down to forty-five hundred dollars, according to number built and location.

There is a freedom of movement, and a privacy too, afforded by the general arrangement here that is unknown to the current "boxment." Let us say nothing about beauty. Beauty is an ambiguous term concerning an affair of taste in the provinces of which our big cities are the largest.

But I think a cultured American, we say Usonian, housewife will look well in it. The now inevitable car will seem a part of it.

Where does the garden leave off and the house begin? Where the garden begins and the house leaves off.

Withal, this Usonian dwelling seems a thing loving the ground with the new sense of space, light, and freedom—to which our U.S.A. is entitled.

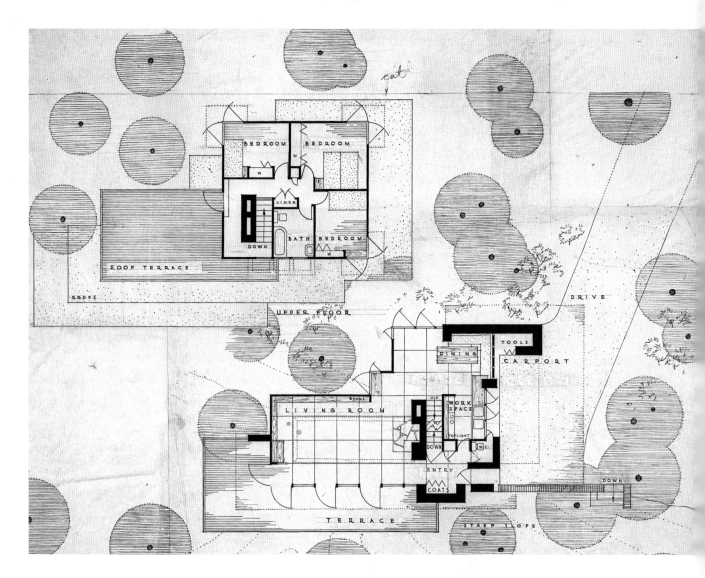

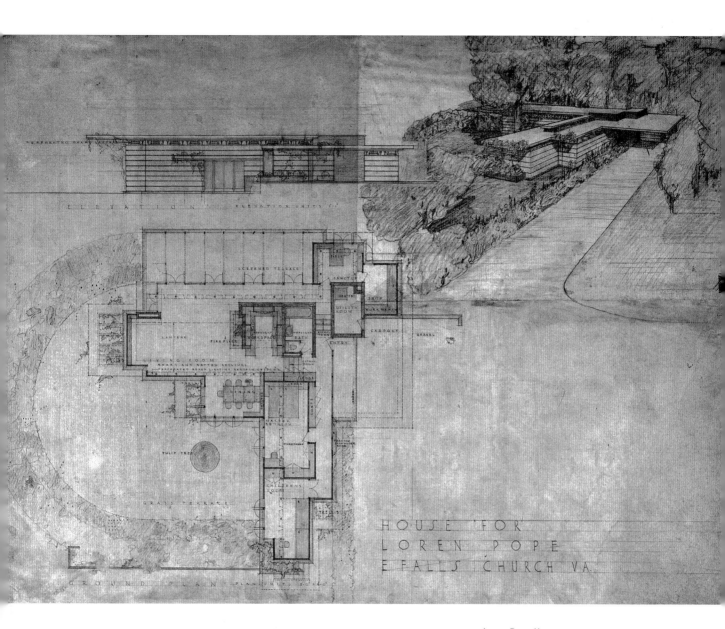

House for Loren Pope E Falls Church Va.

Loren Pope House,
Alexandria, Virginia. 1939.
FLLW Fdn# 4013.001

John Pew House,
Shorewood Hills, Wisconsin. 1938.
FLLW Fdn# 4012.010

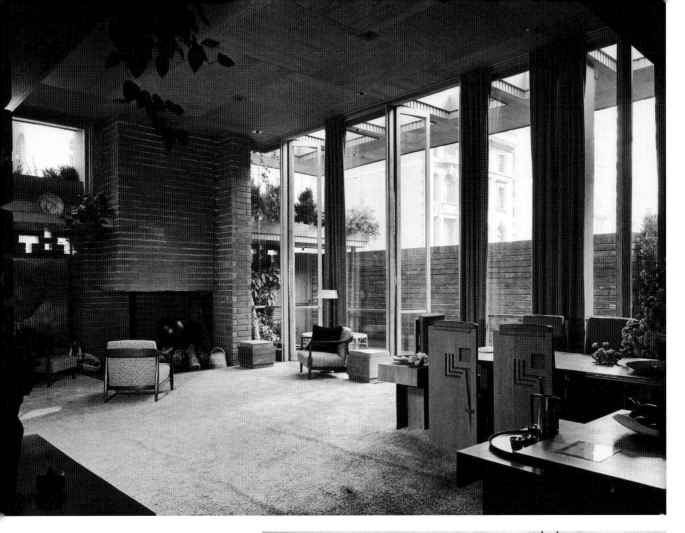

Exhibition House for
"Sixty Years of Living Architecture"
New York, New York, 1953.
FLLW Fdn# 5314.0022

Usonian Automatic Block
Construction.
FLLW Fdn# 5612.114

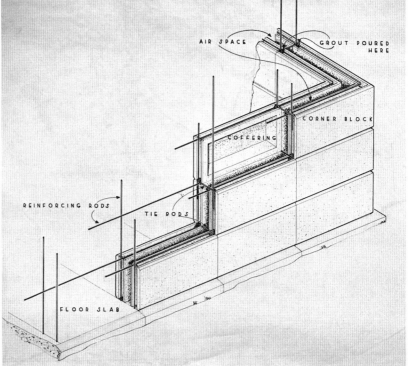

The Usonian House II

We have built over a hundred of them now in nearly all our states. Building costs in general in the U.S.A. were rising and are rising still.[7] We find that twenty thousand dollars is about the sum needed to do what the Jacobs bought for fifty-five hundred. The Usonian house would have cost from twelve, and in some certain extensive programs, on up to seventy-five thousand dollars. We have built several extended in every way that cost more than one hundred thousand.

The houses cost a good deal more to build now than when we started to build them in 1938. But this holds true—any comparison with the "regular" houses around them shows that they are more for the money physically for the sums they cost than the "regulars" around about them. Their freedom, distinction, and individuality are not a feature of that cost except as it does, by elimination, put the expenditure where it liberates the occupant in a new spaciousness. A new freedom.

It is true however that no man can have the liberation one of these houses affords with liberal outside views on three sides becoming a part of the interior, without incurring extra fuel—say twenty per cent more. Double windows cut this down—but also cost money.

Gravity Heat

Concerning floor heating. Heated air naturally rises. We call it gravity heat because the pipes filled with steam or hot water are all in a rock ballast bed beneath the concrete floor—we call the ballast with concrete top, the floor mat. If the floor is above the ground it is made of two-inch-square wood strips spaced 3′ 8″ apart. The heating pipes are in that case set between the floor joists.

▦ It came to me in this way: In Japan to commence building the new Imperial Hotel, winter of 1914, we were invited to dine with Baron Okura, one of my patrons. It is desperately cold in Tokyo in winter—a damp clammy cold that almost never amounts to freezing or frost, but it is harder to keep warm there than anywhere else I have been, unless in Italy. The universal heater is the *hibachi*—a round

vessel sitting on the floor filled with white ashes, several sticks of charcoal thrust down into the ashes all but a few inches. This projecting charcoal is lighted and glows—incandescent. Everyone sits around the *hibachi,* every now and then stretching out the hand over it for a moment—closing the hand as though grasping at something. The result is very unsatisfactory. To us. I marveled at Japanese fortitude until I caught sight of the typical underwear—heavy woolens, long sleeves, long legs, which they wear beneath the series of padded flowing kimono. But as they are acclimated and toughened to this native condition they suffer far less than we do.

Well, although we knew we should shiver, we accepted the invitation to dine at Baron Okura's Tokyo house—he had a number of houses scattered around the Empire. As expected, the dining room was so cold that I couldn't eat—pretending to eat only and for some nineteen courses. After dinner the Baron led the way below to the "Korean room," as it was called. This room was about eleven by fifteen, ceiling seven feet, I should say. A red-felt drugget covered the floor mats. The walls were severely plain, a soft pale yellow in color. We knelt there for conversation and Turkish coffee.

The climate seemed to have changed. No, it wasn't the coffee; it was Spring. We were soon warm and happy again—kneeling there on the floor, an indescribable warmth. No heating was visible nor was it felt directly as such. It was really a matter *not of heating at all* but an affair of *climate.*

The Harvard graduate who interpreted for the Baron explained: the Korean room meant a room heated under the floor. The heat of a fire outside at one corner of the floor drawn back and forth underneath the floor in and between tile ducts, the floor forming the top of the flues (or ducts) made by the partitions, the smoke and heat going up and out of a tall chimney at the corner opposite the corner where the fire was burning.

The indescribable comfort of being warmed from below was a discovery.

I immediately arranged for electric heating elements beneath the bathrooms in the Imperial Hotel—dropping the ceiling of the bathrooms to create a space beneath each in which to generate the heat. The tile floor and built-in tile baths were thus always warm. It was pleasant to go in one's bare feet into

the bath. This experiment was a success. All ugly electric heat fixtures (dangerous too in a bathroom) were eliminated. I've always hated fixtures—radiators especially. Here was the complete opportunity to digest all that paraphernalia in the building—creating not a heated interior but creating climate—healthful, dustless, serene. And also, the presence of heat thus integral and beneath makes lower temperatures desirable. Sixty-five degrees seems for normal human beings sufficient. But neighbors coming in from super-heated houses would feel the cold at first. It is true that a natural climate is generated instead of an artificial forced condition—the natural condition much more healthful, as a matter of course.

▦ I determined to try it out at home at the first opportunity. That opportunity seemed to be the Nakoma Country Club but that Indianesque affair stayed in the form of a beautiful plan.[8]

Then came the Johnson Administration Building. Just the thing for that and we proceeded with the installation, but all the professional heating contractors except one (Westerlin and Campbell) scoffed, refusing to have anything to do with the idea. But as chance had it, the little Jacobs house turned up meantime and was completed before that greater venture got into operation.

So the Jacobs house was the first installation to go into effect.[9] There was great excitement and curiosity on the part of the "profession." Crane Company officials came in, dove beneath the rugs, put their hands on the concrete in places remote from the heater, got up and looked at one another as though they had seen a ghost. My God! It works. Where were radiators now?

As usual.

Articles on "radiant heat" began to appear in testimonial journals. But it was in no sense "radiant heat" or panel heating or any of the things they called it that I was now interested in. It was simply *gravity heat*—heat coming up from beneath as naturally as heat rises.

Many of the Usonian buildings now have floor heating. We have had to learn to proportion the heat correctly for varying climates and conditions. We have accumulated some data that is useful.

There is no other "ideal" heat. Not even the heat of the sun.

Concerning the Usonian House

To say the house planted by myself on the good earth of the Chicago prairie as early as 1900, or earlier, was the first truly democratic expression of our democracy in Architecture would start a controversy with professional addicts who believe Architecture has no political (therefore no social) significance. So, let's say that the spirit of democracy—freedom of the individual as an individual—took hold of the house as it then was, took off the attic and the porch, pulled out the basement, and made a single spacious, harmonious unit of living room, dining room and kitchen, with appropriate entry conveniences. The sleeping rooms were convenient to baths approached in a segregated, separate extended wing and the whole place was flooded with sunlight from floor to ceiling with glass.

The materials of the outside walls came inside just as appropriately and freely as those of the inside walls went outside. Intimate harmony was thus established not only in the house but with its site. *Came the "Open Plan."* The housewife herself thus planned for became the central figure in her menage and her housewifery a more charming feature (according to her ability) of her domestic establishment.

She was now more hostess "officio," operating in gracious relation to her own home, instead of being a kitchen-mechanic behind closed doors.

Nobody need care now how this thing happened. It may not be important. But if not—what is?

In addition to this new freedom with its implication of fresh responsibility for the individual homester came a technical recognition of the new materials and means by which the house was to be built. Materials were now so used as to bring out their natural beauty of character. The construction was made suitable to the appropriate use of machinery—because the machine had already become the appropriate tool of our civilization. (See essays written by myself at that time.)

To use our new materials—concrete, steel and glass, and the old ones—stone and wood—in ways that were not only expedient but beautiful was Culture now. So many new forms of treating them were devised out of the working of a new principle of building. I called it "organic."

Moreover, the house itself was so proportioned that people looked well in it as a part of them and

their friends looked better in it than when they were outside it.

Thus a basic change came about in this affair of a culture for the civilization of these United States. What then took place has since floundered, flourished and faded under different names by different architects in an endless procession of expedients.

Here the original comes back to say hello to you afresh and to see if you recognize it for what it was and still is—a home for our people in the spirit in which our Democracy was conceived: the individual integrate and free in an environment of his own, appropriate to his circumstances—a life beautiful as he can make it—with her, of course.

BOOK TWO: 1954
Integrity: In a House as in an Individual

What is needed most in architecture today is the very thing that is most needed in life—Integrity. Just as it is in a human being, so integrity is the deepest quality in a building; but it is a quality not much demanded of any building since very ancient times when it was natural. It is no longer the first demand for a human being either, because "Success" is now so immediately necessary. If you are a success, people will not want to "look the gift horse in the mouth." No. But then if "success" should happen today something precious has been lost from life.

Somebody has described a man of this period as one through the memory of whom you could too easily pass your hand. Had there been true *quality* in the man the hand could not so easily pass. That quality in the memory of him would probably have been "Integrity."

In speaking of integrity in architecture, I mean much the same thing that you would mean were you speaking of an individual. Integrity is not something to be put on and taken off like a garment. Integrity is a quality *within* and *of* the man himself. So it is in a building. It cannot be changed by any other person either nor by the exterior pressures of any outward circumstances; integrity cannot change except from within because it is that in you which *is you*—and due to which you will try to live your life (as you would build your building) in the best possible way. To build a man or building from within is always difficult to do because deeper is not so easy as shallow.

Naturally should you want to really live in a way and in a place which is true to this deeper thing in you, which you honor, the house you build to live in as a home should be (so far as it is possible to make it so) integral in every sense. Integral to site, to purpose, and to you. The house would then be a home in the best sense of that word. This we seem to have forgotten if ever we learned it. Houses have become a series of anonymous boxes that go into a row on row upon row of bigger boxes either merely negative or a mass nuisance. But now the house in this interior or deeper organic sense may come alive as organic architecture.

We are now trying to bring *integrity* into building. If we succeed, we will have done a great service to our moral nature—the psyche—of our democratic society. Integrity would become more natural. Stand up for *integrity* in your building and you stand for integrity not only in the life of those who did the building but socially a reciprocal relationship is inevitable. An irresponsible, flashy, pretentious or dishonest individual would never be happy in such a house as we now call organic because of this quality of integrity. The one who will live in it will be he who will grow with living in it. So it is the "job" of any true architect to envision and make this human relationship—so far as lies in his power—a reality.

Living within a house wherein everything is genuine and harmonious, a new sense of freedom gives one a new sense of life—as contrasted with the usual existence in the house indiscriminately planned and where Life is *contained* within a series of confining boxes, all put within the general box. Such life is bound to be inferior to life lived in this new integrity—the Usonian Home.

In designing the Usonian house, as I have said, I have always proportioned it to the human figure in point of scale; that is, to the scale of the human figure to occupy it. The old idea in most buildings was to make the human being feel rather insignificant—developing an inferiority complex in him if possible. The higher the ceilings were then the greater the building was. This empty grandeur was considered to be human luxury. Of course, great, high ceilings had a certain utility in those days, because of bad planning and awkward construction. (The volume of contained air was about all the air to be had without violence.)

The Usonian house, then, aims to be a *natural*

performance, one that is integral to site; integral to environment; integral to the life of the inhabitants. A house integral with the nature of materials—wherein glass is used as glass, stone as stone, wood as wood—and all the elements of environment go into and throughout the house. Into this new integrity, once there, those who live in it will take root and grow. And most of all belonging by nature to the nature of its being.

Whether people are fully conscious of this or not, they actually derive countenance and sustenance from the "atmosphere" of the things they live in or with. They are rooted in them just as a plant is in the soil in which it is planted. For instance, we receive many letters from people who sing praises for what has happened to them as a consequence; telling us how their house has affected their lives. They now have a certain dignity and pride in their environment; they see it has a meaning or purpose which they share as a family or feel as individuals.

We all know the feeling we have when we are well-dressed and like the consciousness that results from it. It affects our conduct and you should have the same feeling regarding the home you live in. It has a salutary effect morally, to put it on a lower plane than it deserves, but there are higher results above that sure one. If you feel yourself becomingly housed, know that you are living according to the higher demands of good society, and of your own conscience, then you are free from embarrassment and not poor in spirit but rich—in the right way. I have always believed in being careful about my clothes; getting well-dressed because I could then forget all about them. That is what should happen to you with a good house that is a *home*. When you are conscious that the house is right and is honestly becoming to you, and feel you are living in it beautifully, you need no longer be concerned about it. It is no tax upon your conduct, nor a nag upon your self-respect, because it is featuring you as you like to see yourself.

From the Ground Up
Where to Build

When selecting a site for your house, there is always the question of how close to the city you should be and that depends on what kind of slave you are. The best thing to do is go as far out as you can get. Avoid the suburbs—dormitory towns—by all means. Go way out into the country—what you regard as "too far"—and when others follow, as they will (if procreation keeps up), move on.

Of course it all depends on how much time you have to get there and how much time you can afford to lose, going and coming. But Decentralization is under way. You may see it everywhere. Los Angeles is a conspicuous example of it. There the powers that be are trying to hold it downtown. Robert Moses is struggling to release New York to the country. He thinks he is doing the opposite. But he isn't. New York's Moses is another kind of Moses leading his people *out* from the congestion rather than into it—leading the people from the city.

So go out with these big ferry-boats gnashing their chromium teeth at you as they come around the corner. But don't buy the huge American car with protruding corners but buy the smaller one, such as Nash has produced, and go thirty or forty miles to the gallon. A gallon of gas is not so expensive that you cannot afford to pay for the gas it takes to get pretty far from the city. The cost of transportation has been greatly decreased by way of the smaller car. In this way, decentralization has found aid, and the easier the means of egress gets to be, the further you can go out from the city.

I tried to get a congregation out of the city when we built the Unitarian Church in Wisconsin, but before it was finished, a half dozen buildings had sprung up around it. Now it is merely suburban instead of in the country. In Arizona we went twenty-six miles from the center of town to build Taliesin West; and are now there where we will soon be suburban, too. Clients have asked me: "How far should we go out, Mr. Wright?" I say: "Just ten times as far as you think you ought to go." So my suggestion would be to go just as far as you can go—and go soon and go fast.

There is only one solution, one principle, one proceeding which can rid the city of its congestion—decentralization. Go out, un-divide the division, un-subdivide the division, and then subdivide the un-subdivision. The only answer to life today is to get back to the good ground, or rather I should say, to get forward to it, because now instead of going back, we can go forward to the ground: not the city going to the country but the country and city becoming one. We have the means to go, a means that is entirely adequate to human purposes where

life is now most concerned. Because we have the automobile, we can go far and fast and when we get there, we have other machines to use—the tractor or whatever else you may want to use.

We have all the means to live free and independent, far apart—as we choose—still retaining all the social relationships and advantages we ever had, even to have them greatly multiplied. No matter if we do have houses a quarter of a mile apart. You would enjoy all that you used to enjoy when you were ten to a block, and think of the immense advantages for your children and for yourself: freedom to *use* the ground, relationship with all kinds of living growth.

There is no sense in herding any more. It went out when we got cheap and quick transportation. When we got a kind of building, too, that requires more space. The old building was a box—a fortification more or less. It was a box which could be put close to other boxes so that you could live as close together as possible—and you did. You lived so close together in houses of the Middle Ages because you had to walk to communicate. You were concentrated for safety also. So there was ground only for you to get into a huddle upon. Also, one town was liable to be attacked by townsfolk coming in from the North or from somewhere else to conquer you and take your ground away. You were forced to live compactly. Every little village in the old days was a fortress.

Today there is no such condition, nor is there ever going to be such again in our country or in any other country as far as I know. Today the threat is from the sky in the form of an atom bomb (or an even more destructive bomb), and the more you are divided and scattered, the less temptation to the bomb—the less harm the bomb could do. The more you herd now the more damage to you, as conditions now are.

Looking at it from any standpoint, decentralization is the order of this day. So go far from the city, much farther than you think you can afford. You will soon find you never can go quite far enough.

What Kind of Land

With a small budget the best kind of land to build on is flat land. Of course, if you can get a gentle slope, the building will be more interesting, more

satisfactory. But changes of ground surface make building much more expensive.

It is also cheaper to build in the South where no deep foundations or insulation are necessary, rather than in the North where summers are short and you have to prepare for them in air-conditioning a house, and for the long winters: piling up firewood, putting away food, etc., etc., etc.

But it is because of this need for resourcefulness that the man of the North has traditionally and actually conquered the man softened by the South; and then, these comforts thus won, the Northern man has himself grown soft only to be re-conquered. So it seems to go on ceaselessly.

A Suitable Foundation

The sort of foundation that should be used for a house depends upon the place where you are going to build the house. If you are building in the desert, the best foundation is right *on* the desert. Don't dig into it and break it.

One of the best foundations I know of, suitable to many places (particularly to frost regions), was devised by the old Welsh stone-mason who put the foundations in for buildings now used by Taliesin North. Instead of digging down three and a half feet or four feet below the frost line, as was standard practice in Wisconsin, not only terribly expensive but rendering capillary attraction a threat to the upper wall, he dug shallow trenches about sixteen inches deep and slightly pitched them to a drain. These trenches he filled with broken stone about the size of your fist. Broken stone does not clog up, and provides the drainage beneath the wall that saves it from being lifted by the frost.

I have called it the "dry wall footing," because if the wall stayed dry the frost could not affect it. In a region of deep cold to keep a building from moving it is necessary to get all water (or moisture) from underneath it. If there is no water there to freeze, the foundation cannot be lifted.

All those footings at Taliesin have been perfectly static. Ever since I discovered the dry wall footing—about 1902—I have been building houses that way. Occasionally there has been trouble getting the system authorized by building commissions. A recent encounter was with the Lake Forest Building

Department of Illinois. It refused to allow the building to be so built. The Madison, Wisconsin, experts also refused to let me use the system on the hillsides above the lake. When the experts do not accept it, they will not accept the idea of saving the builders of the house many thousands of dollars. But we have in all but eight or ten cases put it through now, thereby saving the client excess waste of money below ground for no good purpose.

That type of footing, however, is not applicable to treacherous sub-soils where the problem is entirely different. For example, the Imperial Hotel was built on soil about the consistency of cheese, some eight feet thick, and a foundation for that particular soil had to be devised to bear the load of any building we wanted to build. I remembered I had bored holes with an auger on the Oak Park prairie. So I had driven into the soil a tapered pile eight feet long which punched a hole. I made tests to determine how far apart each of these piles would have to be to carry the necessary load and found that centers, two feet apart, were far enough—had they been further apart, not all of the ground would have been utilized. We punched these holes and filled them with concrete. We had to do it quickly, because, since we were almost down to water level, the water might come right up. On these tapered concrete piles we spread a thin plate of concrete slab, or beam, which gathered all these little pins in the pin cushion together and added up to enough resistance to carry the walls.

No one foundation, then, is suitable for all soils; the type of foundation used must be applicable to the particular site.

Advantages of the Berm-Type

The berm-type house, with walls of earth, is practical—a nice form of building anywhere: north, south, east or west—depending upon the soil and climate as well as the nature of the site. If your site contains a lot of boulders or rock ledges it is impossible. In the berm-type house the bulldozer comes along, pushes the dirt up against the outsides of the building as high as you want it to go and you may carry the earth banking as far around the structure as you please. Here you have good insulation—great protection from the elements; a possible economy,

too, because you do not have to finish any outside below the window level. You do not have to finish the inside walls either if not so inclined. I think it an excellent form for certain regions and conditions. An actual economy and preservation of the landscape.

How to Light the House

The best way to light a house is God's way—the natural way, as nearly as possible in the daytime and at night as nearly like the day as may be, or better.

Cities are commonly laid out north, south, east and west. This was just to save the surveyor trouble, I imagine. Anyway that happened without much thought for the human beings compelled to build homes on those lines. This inevitably results in every house having a "dark side."

Surveyors do not seem to have learned that the south is the comforter of life, the south side of the house the "living" side. Ordinarily the house should be set 30–60 to the south, well back on its site so that every room in the house might have sunlight some time in the day. If, however, owing to the surveyor the house must face square north, we always place the clerestory (which serves as a lantern) to the south so that no house need lack sunlight. It is a somewhat expensive way to overcome the surveyor's ruse.

The Great Luminary

Proper orientation of the house, then, is the first condition of the lighting of that house; and artificial lighting is nearly as important as daylight. Day lighting can be beautifully managed by the architect if he has a feeling for the course of the sun as it goes from east to west and at the inevitable angle to the south. The sun is the great luminary of all life. It should serve as such in the building of any house. There is, however, the danger of taking "light" too far and leaving you, "the inmate," defenseless in a glass cage—which is somewhat silly. You must control light in the planning of your home so that light most naturally serves your needs without too much artificial production and consequent control—putting light in only to block it out.

As for all artificial lighting, it too should be integral part of the house—be as near daylighting as possible. In 1893, I began to get rid of the bare lightbulb and have ever since been concealing it on interior decks or placing it in recesses in such a way that it comes from the building itself; the effect should be that it comes from the same source as natural light. Sometimes we light the grounds about the house putting outside light so that it lights the interior of the rooms.

Wiring for lights, as piping for plumbing and heating, should not show all over the house unless by special design—any more than you would have organs of your body on the outside of your skin. Lighting fixtures should (as should all others) be absorbed *in* the structure, so that their office is *of* the structure. All this after the building has been properly orientated.

Steel and Glass

There is much new good in houses being built today and chiefly on account of the new freedoms afforded organic architecture by the uses of steel and glass; miraculous materials. As a result of these space is now freer, wider spans are easier; therefore more open spaces, made possible owing to steel in tension, and a closer relation to nature (environment) owing to the use of glass. These materials, everywhere to be seen now, are enabling building to go in varied directions with more ease; to go beyond the traditional constraint of the box with economy.

The Basement

A house should—ordinarily—not have a basement. In spite of everything you may do, a basement is a noisome, gaseous damp place. From it come damp atmospheres and unhealthful conditions. Because people rarely go there—and certainly not to live there—it is almost always sure to be an ugly place. The family tendency is to throw things into it, leave them there and forget them. It usually becomes—as it became when I began to build—a great, furtive underground for the house in order to enable the occupants to live in it disreputably. Also, so many good housewives, even their lords and masters,

used to tumble downstairs into the basement and go on insurance for some time, if not make it all immediately collectible.

Another objection to the basement is that it is relatively expensive. It has to be some six to eight feet below grade and so you have to get big digging going. It is a great inhibition in any building because you must construct a floor over it and the space it provides you with is, as I have said, usually disreputably occupied.

Of course, a basement often is a certain convenience, but these conveniences can now be supplied otherwise. Mechanical equipment is now so compact and good-looking. So we decided to eliminate it wherever possible and provide for its equivalent up on the ground level with modern equipment.

Insulation and Heating

In either a very cold or a very hot climate, the overhead is where insulation should occur in any building. There you can spend money for insulation with very good effect, whereas the insulation of the walls and the air space within the walls becomes less and less important. With modern systems of air conditioning and heating you can manage almost any condition.

But the best insulation for a roof and walls in a hot climate is nearly the same as the best insulation for a roof and walls in a cold region. Resistance to heat in a building is much the same as resistance to cold, although of course the exact specifications should vary according to circumstances. In a warm region it is important that the overhead not get overheated. You have to use a very tough cover for roof insulation or the sun will take the life out of it quickly. We have never found a roofing that lasts as long as we would like in a hot climate like the desert—but a white-top is economical partly because white, of course, reflects heat rather than absorbs it.

But in a cold climate like southern Wisconsin the real basis for purposeful insulation is floor heating. When you have the floor warm—heat by gravity—insulation of the walls becomes comparatively insignificant. You may open the windows in cold weather and still be comfortable, because, if your feet are warm and you sit warm, you are warm. In this case overhead insulation is extremely important:

heat rises and if it finds a place overhead where it can be cooled off and dropped, you have to continuously supply a lot of heat. If, however, the overhead is reasonably defensive against cold, you can heat your house very economically, more so than by any other system.

On the other hand, snow is the best kind of insulation. You do not have to buy it. In northern climates you can see how well a house is insulated by noticing how quickly the snow melts off the roof. If the snow stays for some time, the roof is pretty well insulated. If you get insulation up to a certain point, snow will come and give you more. To hold snow on the roof is always a good, wise provision and a good argument for a flat roof. I have seen people shovelling snow off the roof and I never could understand why—unless the snow was creating a load that the roof could not bear or the roof was steep and the snow load might slide down and injure someone or something.

The Kind of Roof

Now the *shape* of roof—whether a shed roof, a hip roof or a flat roof—depends in part on expediency and in part on your personal taste or knowledge as to what is appropriate in the circumstances.

One of the advantages of the sloping roof is that it gives you a sense of spaciousness inside, a sense of overhead uplift which I often feel to be very good. The flat roof also has advantages in construction. It is easy to do, of course. But with the flat roof, you must devise ways and means of getting rid of the water. One way to do this is to build, on top of the flat, a slight pitch to the eaves. This may be done by "furring." There are various ways of getting water off a flat roof. But it must be done.

The cheapest roof, however, is the shed roof—the roof sloping one way, more or less. There you get more for your money than you can get from any other form of roof. There is no water problem with a shed roof because the water goes down to the lower side and drops away. With a hip roof the water runs two ways into a natural valley, so there is not much problem there either.

Suitable to flat roof construction in many locations is the flat roof covered with a body of good earth—what I call the "berm type" roof. On top of the building there will be—say—about sixteen inches of good fertile earth in which may be planted grass or whatever you please to plant. There is the most natural insulation that can be devised. Probably the cheapest. Always I like the feeling you have when beneath it. The house I will build for my son, Llewellyn, in Virginia has a flat roof with earth to be placed on top.

I have also sometimes pitched roofs from high on the sides to low in the center. You can do with a roof almost anything you like. But the type of roof you choose must not only deal with the elements in your region but be appropriate to the circumstances, according to your personal preference—perhaps.

The Attic

Why waste good livable space with an attic any more than with a basement? And never plan waste space in a house with the idea of eventually converting it into rooms. A house that is planned for a lot of problematical space or space unused to be used some other day is not likely to be a well-planned house. In fact, if you deliberately planned waste space, the architect would be wasted, the people in the house would be wasted. Everything would probably go to waste.

If, however, in future you are going to need more room for more children and you wish to provide that room it need not be waste space if properly conceived. But the attic, now, should always come *into* the house to beautify it. Sunlight otherwise impossible may be got into the house through the attic by way of what we call a lantern or clerestory. And that should also give you the sense of lift and beauty that comes in so many of our plans at this time.

We *use* all "waste" space: make it part of the house; make it so beautiful that as waste space it is inconceivable. It is something like the little boy eating an apple, and another little boy ranges up alongside and wants to know if he can have the core, but the apple-eater says—"Sorry, there ain't gonna be no core."

Size of Kitchen

In the Usonian house the size of the kitchen depends largely on the home-maker's personal preference.

Some homesters like to get a lot of exercise in the homestead—walking from place to place. Some women want things on ball bearings. Some don't want to bend over; they like to stand up when they work: for them we put everything high: ovens up in the wall, etc. Women who do not mind bending over like things more compact; they do not want to waste their substance going to and fro. For them we put things on ball bearings as you may easily do now that modern gadgetry is so well designed.

So we like to make kitchens small, and put things on ball bearings. We have more money to spend on spaciousness for the rest of the house. Sometimes we are caught making a kitchen too small, and then the woman of the house comes in and asks us to make it bigger; sometimes they get this but sometimes they do not—it depends on the good proportions of the design as a whole.

But I believe in having a kitchen featured as the work space in the Usonian house and a becoming part of the living room—a welcome feature. Back in farm days there was but one big living room, a stove in it, and Ma was there cooking—looking after the children and talking to Pa—dogs and cats and tobacco smoke too—all gemütlich if all was orderly, but it seldom was; and the children were there playing around. It created a certain atmosphere of a domestic nature which had charm and which is not, I think, a good thing to lose altogether. Consequently, in the Usonian plan the kitchen was called "workspace" and identified largely with the living room. As a matter of fact, it became an alcove of the living room but higher for good ventilation and spaciousness.

The kitchen being one of the places where smells originated, we made that the ventilating flue of the whole house by carrying it up higher than the living room. All the air from the surrounding house was thus drawn up through the kitchen itself. You might have liver and onions for dinner and never know it in the living room, until it was served to you at the table. The same is true of other smells and conditions in the way the bathrooms were made. We were never by this means able to eliminate noise. So in a Usonian house a needlessly noisy kitchen is a bad thing.

Everything in the Usonian kitchen should be (as it may so easily be) modern and attractive as such. Because it is incorporated into the living room, the kitchen (workspace) should be just as charming to be in or look at as the living room—perhaps more so. When we built the Usonian house in the New York Exhibition (fall of 1953) the kitchen was a delightful little place to look at, no less so as a "work place."

The Client and the House

The needs and demands of the average client should affect every feature of a house but only insofar as the clients do manifest intelligence instead of exert mere personal idiosyncrasy. This manifestation of intelligence is not so rare. Yet when a man has "made his money"—is therefore a "success"—he then thinks, because of this "success," that he can tell you, or anybody else, all about things of which he really knows nothing at all—a house in particular. His success as a maker-of-money makes him a universal expert. So he begins to exercise his idiosyncrasies as this universal expert.

But I've really had little enough trouble with good businessmen or their wives. They *do* have what we call "common sense." A man does have to have common sense to make any sort of fortune in this country dedicated to ruthless competition—and you can usually explain the subtle inner nature of things to a man of good sense who has never thought about them—but must now go in for them.

But, the wife? Well, too often she is quite another matter, having made him what he is today. Although the wives we encounter are so often far wiser in this affair of home making than their husbands. The peripatetic marriage is the enemy of good architecture—as a matter of course.

Expanding for Growing Family

A Usonian house if built for a young couple, can, without deformity, be expanded, later, for the needs of a growing family. As you see from the plans, Usonian houses are shaped like polliwogs—a house with a shorter or longer tail. The body of the polliwog is the living room and the adjoining kitchen—or work space—and the whole Usonian concentration of conveniences. From there it starts out, with a tail: in the proper direction, say, one bedroom,

two bedrooms, three, four, five, six bedrooms long; provision between each two rooms for a convenient bathroom. We sometimes separate this tail from the living room wing with a loggia—for quiet, etc.; especially grace.

The size of the polliwog's tail depends on the number of children and the size of the family budget. If the tail gets too long, it may curve like a centipede. Or you might break it, make it angular. The wing can go on for as many children as you can afford to put in it. A good Usonian house seems to be no less but more adapted to be an ideal breeding stable than the box.

Children's Rooms

People who have many children want to build a house usually, but do not have enough money to do justice to the children. As a rule, they do not have *any* on account of the children. But they keep on having children just the same no matter what else they may do or not do. So you see their architect has to tuck the extra children in somehow; and the idea seems to be to give them the smallest possible sleeping space with double deckers but to try also to give them a playroom. If possible this should be apart from sleeping quarters. Or build a separate section entirely for progeny.

For the children's bedrooms, then, we introduced the double-decker bed. We put two children in a small room next to a bath—two children high is the limit in most of our houses. But you could put in a third. The boys and girls still have to be separated, for some mysterious reason. So the compact three-bedroom house is about the minimum now.

The playroom is planned as part outdoors and part indoors and so gives children a little liberty for play, etc. Usually, of course, they now play in the living room and the house is a bedlam. Everything loose is likely to be turned inside out or upside down, and there is not much use trying to do anything about them at that. Building a house for the average family (children and their adults) is a pretty rough extravaganza. Either the children get left or must get spanked into place, else they have the whole house and the grown-ups do what they can do to make themselves as comfortable as they may be able.

It is more important for the child to live in an appropriate, well-considered home development than it is for the grown-ups, because the grown-ups are halfway through and consequently do not have so much to lose or gain from the home atmosphere. The child, however, is a beginning; he has the whole way to go and he may go a lot further in the course of time than Pa and Ma ever had a chance to go. But after forty—even thirty-five—the home is not so important for the parents as for the child, as the case may be, although they leave soon for homes of their own. The Catholics say, "Give me a child up to the age of seven, and who cares who takes the child after that." This is because it is in childhood that impressions become most indelible.

For these and many unmentioned reasons it is peculiarly important that a child should grow up in building conditions that are harmonious, live in an atmosphere that contributes to serenity and well-being and to the consciousness of those things which are more excellent, in childhood. What a pity that parents have children so fast, so inconsiderately, that their architect must put them into little cells, double-decker them, and shove them off into the tail of the house where life becomes one certain round of washing diapers.

Furnishings

Rugs, draperies and furnishings that are suitable for a Usonian house are those, too, that are organic in character; that is, textures and patterns that sympathize in their own design and construction with the design and construction of the particular house they occupy and embellish (or befoul). A mobile, for instance, should be composed of the design elements of the room it hangs in.

Out of the nature of the materials used in building a house come these new effects. The "effect" is not all that the artist-architect gives you. He not only sees more or less clearly the nature of the materials but, in his own trained imagination and by virtue of his own feeling, he qualifies it all as a whole. You can only choose the result that is sympathetic to you.

The range of choice is growing wider now. But it is extraordinary still to see how the manufacturer is trying to burn the candle at both ends, still hanging on to the old William Morris era and old rococo

fabrics. You may—at your own peril—get L'art Nouveaux, rococo, Morris, ancient and modern in the same store for the same purpose for the same price.

Chairs

My early approach to the chair was something between contempt and a desperation. Because I believe sitting to be in itself an unfortunate necessity not quite elegant yet, I do not yet believe in any such thing as a "natural" chair for an unnatural posture. The only attractive posture of relaxation is that of reclining. So I think the ideal chair is one which would allow the would-be "sitter" to gracefully recline. Even the newest market chairs are the usual machines-for-sitting. Now I do not know if whatever God may be ever intended you or me to fold up on one of these—but, if so, let's say that fold-up or double-up ought to make you look more graceful. It ought to look as though it were intended for you to look and be just that.

We now build well-upholstered benches and seats in our houses, trying to make them all part of the building. But still you must bring in and pull up the casual chair. There are many kinds of "pull-up" chairs to perch upon—lightly. They're more easy. They're light. But the big chair wherein you may fold up and go to sleep reading a newspaper (all that kind of thing) is still difficult. I have done the best I could with this "living room chair" but, of course, you have to call for somebody to help you move it. All my life my legs have been banged up somewhere by the chairs I have designed. But we are accomplishing it now. Someday it will be well done. But it will not have metal spider-legs nor look the way most of the steel furniture these days looks to me. No—it will not be a case of "Little Miss Muffet sat on her tuffet, eating of curds and whey, when up beside her came a great black spider and frightened Miss Muffet away." I am for "Little Miss Muffet" frightened by the spider—away.

Yet every chair must eventually be designed for the building it is to be used in. Organic architecture calls for this chair which will not look like an apparatus but instead be seen as a gracious feature of its environment which can only be the building itself. So the stuffed-box-for-sitting-in is not much better than the machine-for-setting-it-in.

No doubt most practical sitters are troubled by these chairs, too. Finding a good comfortable chair in which to place one's trunk is never quite easy and so most sitting to date still lacks dignity and repose. But it is possible now to design a chair in which any sitter is compelled to look comfortable whether he is so or not. And there is no reason why he, or she, should not be comfortable in mind as well as body folded up or down.

When the house-interior absorbs the chair as in perfect harmony, then we will have achieved not so minor a symptom of a culture of our own.

Paint

In organic architecture there is little or no room for appliqué of any kind. I have never been fond of paints or of wallpaper or anything which must be applied *to* other things as a surface. If you can put something by skill *on* the thing that becomes part *of* it and still have that thing retain its *original character* that may be good. But when you gloss it over, lose its nature—enamel it, and so change the character of its natural expression, you have committed a violation according to the ideals of organic architecture. We use nothing applied which tends to eliminate the true character of what is beneath, or which may become a substitute for whatever that may be. Wood is wood, concrete is concrete, stone is stone. We like to have whatever we choose to use demonstrate the beauty of its own character, as itself.

The only treatment we aim to give to any material is to preserve it pretty much as it *is*. A strange fallacy has developed that to paint wood preserves it. The reverse is true. Wood must breathe just as you must breathe. When you seal wood off from this innate need to breathe, you have not lengthened its life at all, you have done just the opposite. Merely staining wood is one thing; painting is quite another. When you coat anything in the way of a natural material you are likely to shorten its life, not preserve it.

Air Conditioning?

To me air conditioning is a dangerous circumstance. The extreme changes in temperature that tear down a building also tear down the human body. Build-

ing is difficult in a temperate zone, where you have extreme heat and extreme cold. For instance—the boards in the ceiling over my bedroom at Taliesin West, overheated during the day, begin to pull and crack and miniature explosions occur at about three o'clock in the cool of the morning. Owing to changes of temperature nothing in construction is ever completely still.

The human body, although more flexible, is framed and constructed upon much the same principles as a building. I can sit in my shirt sleeves at eighty degrees, or seventy-five, and be cool; then go outside to 118 degrees, take a guarded breath or two around and soon get accustomed to the change. The human body is able continually to adjust itself—to and fro. But if you carry these contrasts too far too often, when you are cooled the heat becomes more unendurable; it becomes hotter and hotter outside as you get cooler and cooler inside. Finally, Nature will give up. She will just say for you, "Well, what's the use?" Even Nature can't please everybody all the time.

So air conditioning has to be done with a good deal of intelligent care. The less the degree of temperature difference you live in, the better for your constitutional welfare. If one may have air and feel the current of air moving in on one's face and hands and feet one can take almost any degree of heat. But as for myself if I feel close *and* hot, I cannot well take it. Neither can anybody else, I believe.

So, in a very hot climate, the way to deal with air conditioning best would be to have a thorough protection overhead and the rest of the building as open to the breezes as it possibly can be made. On the desert slopes at Taliesin West there is always a breeze. But when we first went there, and spent a summer in town, I had to wrap myself in wet sheets to get to sleep. Being a man from the North, I was unaccustomed to such heat as came from living in a bake-oven. But if I lived there all year round—and could get air by breezes—I would soon get accustomed to it.

Another way of dealing with air conditioning in a humid, hot climate is the "fireplace" as I devised it for a house in tropical Acapulco, Mexico. In this "fireplace" the air came down the flue instead of going out, and the hearth was a pool of cool water as artificial rain poured down the chimney and the pool was cooled by one of the devices designed for air conditioning. You could sit around the "fireplace" and be especially cool but the rooms were each cooled. The chimney now did not stick up much above the roof—it was just rounded up to keep the water from running in—just a low little exuberance on the roof.

Even in cold climates air conditioning has now caught on because the aim now is to maintain the degree of humidity for comfort within, no matter what is going on outside. I do not much believe in that. I think it far better to go *with* the natural climate than try to fix a special artificial climate of your own. Climate means something to man. It means something in relation to one's life in it. Nature makes the body flexible and so the life of the individual invariably becomes adapted to environment and circumstance. The color and texture of the human skin, for an example—dark or bright—is a climatic adaptation—nothing else. Climate makes the human skin. The further north you go, the more bleached the hair and the whiter the skin, even the eyes; everything becomes pallid. The further south, the darker everything gets. It is climatic condition that does the protective coloring. I doubt that you can ignore climate completely, by reversal make a climate of your own and get away with it without harm to yourself.

The Contractor

In choosing a contractor, the only way to judge him is to look carefully into his previous work. You should be able to tell fairly well from what he has done what he may do.

Dankmar Adler—the old Chief—used to say that he would rather give work to a crook who does know how to build than to an honest man who does not know how to build. He had this to say about that: "I can police a crook, but if a man doesn't know good work, how am I to get it out of him?" Remember also what Shakespeare said about one's not being able to make a silk purse out of a sow's ear ?

Grammar: The House as a Work of Art

Every house worth considering as a work of art must have a grammar of its own. "Grammar," in

this sense, means the same thing in any construction—whether it be of words or of stone or wood. It is the shape-relationship between the various elements that enter into the constitution of the thing. The "grammar" of the house is its manifest articulation of all its parts. This will be the "speech" it uses. To be achieved, construction must be grammatical.

Your limitations of feeling about what you are doing, your choice of materials for the doing (and your budget of course) determine largely what grammar your building will use. It is largely inhibited (or expanded) by the amount of money you have to spend, a feature only of the latitude you have. When the chosen grammar is finally adopted (you go almost indefinitely with it into everything you do) walls, ceilings, furniture, etc., become inspired by it. Everything has a related articulation in relation to the whole and all belongs together; looks well together because all together are speaking the same language. If one part of your house spoke Choctaw, another French, another English, and another some sort of gibberish, you would have what you mostly have now—not a very beautiful result. Thus, when you do adopt the "grammar" of your house—it will be the way the house is to be "spoken," "uttered." You must be consistently grammatical for it to be understood as a work of Art.

Consistency in grammar is therefore the property—solely—of a well-developed artist-architect. Without that property of the artist-architect not much can be done about your abode as a work of Art. Grammar is no property for the usual owner or the occupant of the house. But the man who designs the house must, inevitably, speak a consistent thought-language in his design. It properly may be and should be a language of his own if appropriate. If he has no language, so no grammar, of his own, he must adopt one; he will speak some language or other whether he so chooses or not. It will usually be some kind of argot.

The Architect of the Future

The first thing to do to get a Usonian house is to go to a Usonian architect! That is to say, go to some architect who has been trained from the ground up in consistent organic construction and has lived in it as a natural circumstance. He may have absorbed it only intellectually. But through the pores of his skin, his soul becomes awakened and aware of it (he will say instinctively) by his own experience.

I doubt that this affair can be *taught* to anyone. It does not come from a university with some degree or other. You cannot get it from books alone and certainly no conditioned Harvard man would be likely to have it. Harvard seems degraded to believe in the work of the committee-meeting instead of the inspired individual. But I know you can never get it through any form of collectivism. A true work of art must be induced as inspiration and cannot be induced or inspired through "teamwork." So it will not come through communism or fascism or any ism—only as slow growth by way of Democracy.

I doubt if there is much hope for the present generation's ever learning to discriminate surely between what makes a building good or what it is that makes a bad one. Hope lies within the next generation now in high school.

It is necessary for the child to grow up in an atmosphere conducive to the absorption of true esthetic values. It is necessary to study building as a kind of doing called Architecture. Not merely is Architecture made at the drafting board, but Architecture in all of its aspects is to be studied as environment, as the nature of materials to be used, as the forms and proportions of Nature itself in all her forms—sequences and consequences. Nature is the great teacher—man can only receive and respond to her teaching.

It Is Valiant to Be Simple

One of the essential characteristics of organic architecture is a natural simplicity. I don't mean the side of a barn door. Plainness, although simple, is not what I mean by simplicity. Simplicity is a clean, direct expression of that essential quality of the thing which is in the nature of the thing itself. The innate or organic pattern of the form of anything is that form which is thus truly *simple*. Cultivation seems to go against simplicity in the flower, as it does much the same thing in human life with the human being.

As we live and as we are, Simplicity—with a capital "S"—is difficult to comprehend nowadays. We are no longer truly simple. We no longer live

in simple terms, in simple times or places. Life is a more complex struggle now. It is now valiant to be simple; a courageous thing to even want to be simple. It is a spiritual thing to comprehend what simplicity means.

In attempting to arrive at definitions of these matters, we invariably get into the spirit. The head alone cannot do enough. We have overrated what the head can do, consequently we now are confused and in a dangerous situation where our future is concerned. We have given up those things that are leading lights to the spirit of man; they are unfortunately no longer sufficiently important to us for us to pay for them what they cost.

This architecture we call organic is an architecture upon which true American society will eventually be based if we survive at all. An architecture upon and within which the common man is given freedom to realize his potentialities as an individual—himself unique, creative, free.

The "Usonian Automatic"

We are often asked how a young couple, with a limited budget, can afford to build a house designed on these basic principles of organic architecture. What couple does not have a limited budget? It is within limitations that we have to work in designing houses for the upper middle third of the democratic strata in our country. Our clients come from that strata. We are often asked: "Will you build a house for us for $15,000"; or "Will you build us a house for $25,000"; sometimes for $75,000 or even $200,000.

The other day someone came with $250,000. He embarrassed me. Very wealthy people usually go to some fashionable architect, not to a known radical who is never fashionable if he can help it.

Reducing the Costs

How then, you may ask, can people with even more limited means experience the liberation, the sense of freedom that comes with true architecture? This problem will probably always exist in one direction or another. But we have gone far in solving this generic problem by the natural concrete block house we call the "Usonian Automatic." This Usonian house incorporates innovations which reduce most of the heavier building costs, labor in particular. The earlier versions of these concrete block houses built in Los Angeles about 1921–24 may also be seen in the Arizona-Biltmore cottages.[10] The Millard house in Pasadena was first; then the Storer and Freeman and last—the Ennis house in Los Angeles. Among recent examples are the Adelman cottage and Pieper cottage in Phoenix, Arizona.

With the limited budget of a G. I. you cannot pay a plasterer, mason, bricklayer, carpenter, etc., twenty-nine dollars a day (and at that never be sure whether the work is done well). To build a low cost house you must eliminate, so far as possible, the use of skilled labor, now so expensive. The Usonian Automatic house therefore is built of shells made up of pre-cast concrete blocks about 1′ 0″ × 2′ 0″ or larger and so designed that, grooved as they are on their edges, they can be made and also set up with small steel horizontal and vertical reinforcing rods in the joints, by the owners themselves, each course being grouted (poured) as it is laid upon the one beneath; the rods meantime projecting above for the next course.

How the "Usonian Automatic" Is Built

The Usonian Automatic system is capable of infinite modifications of form, pattern and application, and to any extent. The original blocks are made on the site by ramming concrete into wood or metal wrap-around forms, with one outside face (which may be patterned), and one rear or inside face, generally coffered, for lightness.

All edges of the blocks, having a semi-circular groove (vertically and horizontally), admit the steel rods. When blocks are placed, edges closely adjoining, cylindrical hollow spaces are formed between them in which the light steel "pencil" rods are set and into which semi-liquid Portland cement grout is poured.

Walls may be either *single* (one layer of blocks), the coffered back-face forming the interior wall surface, or *double* with two layers of blocks, with an interior insulating air space between.

Ordinarily the procedure of erection of walls is as follows:

a) Vertical reinforcing bars or dowels are set on unit intervals in slab or in footing which is to receive the block wall-construction.

b) The blocks are set between these rods so that one vertical rod falls in the round cylindrical groove between each two blocks.

c) Grout, formed of one part cement and two parts sand, is then poured into the vertical groove at joints, running into the horizontal groove at joints locking all into a solid mass.

d) Horizontal rods are laid in horizontal grooves as the courses are laid up.

e) If double walls are planned, galvanized U-shaped wall tie-rods are set at each joint to anchor outer and inner block-walls to each other.

f) Another course of blocks is set upon the one now already poured.

g) As each course is added, grout is again poured into vertical joints, automatically filling the previous horizontal joint at the same time. Etc. Etc.

The pattern, design and size of the blocks may vary greatly. In some cases blocks have been made with patterned holes into which glass (sometimes colored) is set. When these glazed perforated units are assembled they form a translucent grille or screen of concrete, glass and steel.

At corners special monolithic corner blocks are used; in the case of double walls inside and outside corner blocks are required. About nine various types of block are needed to complete the house, most of them made from the same mold. For ceilings the same block units have been employed to cast horizontal ceiling and roof slabs, the same reinforcing rods forming a reinforced slab on which to put built up roofing above.

In this "Usonian Automatic" we have eliminated the need for skilled labor by prefabricating all plumbing, heating and wiring, so each appurtenance system may come into the building in a factory-made package, easily installed by making several simple connections provided during block-construction.

Here then, within moderate means for the free man of our democracy, with some intelligence and by his own energy, comes a natural house designed in accordance with the principles of organic architecture. A house that may be put to work in our society and give us an architecture for "housing" which is becoming to a free society because, though standardized fully, it yet establishes the democratic ideal of variety—the sovereignty of the individual. A true architecture may evolve. As a consequence conformation does not mean stultification but with it imagination may devise and build freely for residential purposes an immensely flexible varied building in groups never lacking in grace or desirable distinction.

Organic Architecture and the Orient

When I built the Imperial Hotel in Tokyo, Japan, I tried to make a coherent link between what the Japanese then were on their knees and what they now wanted to be on their feet. Every civilization that had gone to Japan had looted their culture. Because it was the only such genuine culture, coming from their own ground as it did, I was determined as an American to take off my hat to that extraordinary culture. At the same time I was now faced with the problem of how to build a modern building earthquake-proof.

This was mainly the Mikado's building. So I had also to consider the Mikado's needs for a social clearing house for the official life that would inevitably now come to Japan. So the Impeho would have to be comfortable enough for foreigners, although primarily it would need to serve the needs of the Japanese.

That became quite a problem—in addition to the earthquake which we never lost sight of day or night. The seismograph in Japan is never still. At night you have the feeling that the bed is going down under you and you are lost. You never get rid of that nice feeling.

But across the moat just beyond, there was the Emperor's Palace, and since I was the Emperor's "Kenchikukaho" (High Builder) and he was really my client, I felt impelled to devise ways and means not too far removed from what would be becoming to that palace of his across the moat. I think I succeeded. It is all there so far as it could be done at the time.

Of course, when I wanted to use native materials for the building—the common stone that was underfoot in Tokyo, called *oya*, which is something like travertine with big, burned, brown spots in it—there

was a terrific objection by the building committee. Too common. But I liked the material and finally won. We built with "oya." We could use it by the acre—which we proceeded to do. We bought whole quarries far up at Nikko, so we quarried it there and floated it down to the site—in great barges.

The problem was how to help the Japanese people up from their knees and onto their feet. That problem still remained. When the Japanese had selected foreign things to live with, they had taken our most obvious forms which are our worst. They were uncomfortable at awkward high tables, and when sitting on the high chairs suitable to us their short legs would dangle. The first thing to do then was to get everything down to their own humanscale so that they could sit on a chair with their feet on the floor, eat at tables that did not require them to sit with food just under their chins. Sleep in beds up off the floor. Thus, to start with, the whole scale of the building became Japanese.

The next problem was how to devise things that were in reasonable accord with their high state of civilization. Instead of making so many things that would simply stand around, the way we have them, everything began to have its own place in its own way—to be put away out of sight when not wanted—the living areas kept clear. For example, the dressing table became just a mirror against the wall with a little movable cabinet against the wall beside it. It could be moved around and a chair belonging to the room could be brought up to sit there beside it. All such things I simplified in accordance with Japanese culture so far as possible, making them easy and natural for Japanese use. At the same time, everything must have true esthetic effect and be not too impractical for the foreigner.

The Japanese had never had interior bathrooms or toilets. They had what they called the "benjo," and the benjo had to be kept out of the "devil's corner." What was the devil's corner? It was only that corner from which the prevailing winds blew, bringing the scent from the benjo. But now in the Imperial Hotel these little detached toilet rooms became organic features of the building. And in these little bathrooms, floor heat was born. The tub was of tiles and sunk in the floor; the tile was a small vitreous mosaic and you would come out of the tub with a print of the mosaic designs on your backside. But that didn't matter.

Anyhow, it was all becoming one thing—the things within it in relation to each other—organic. The heating pipes ran across the wall above the tubs and so became a gleaming hot towel rack on which the towel would naturally dry very quickly. It was a very pretty thing to look at too, one of those bathrooms, modern but also quite in the Japanese way of doing things.

Their way of doing things was always more or less organic. The Japanese house is the closest thing to our organic house of anything ever built. They already had the instinct of adapting and *incorporating* everything, so that is one reason why I brought into the Imperial Hotel this incorporation of everything in it. The heating was in the center of the room in a little hand-wrought filigree copper tower, on top of which was a light fixture that spread light over the ceiling—indirect lighting. The beds were one this way and one that way, at right angles, and to one side in their center was a nest of small tables that could be decentralized and spread around the room—all more or less organic in itself, again like their own arrangements at home.

Finally we used to go around to determine the impact of the building on "the foreign guest." We would see these fellows come in with their trunks and bags—accompanied by the timid little Japanese house-boy—the boy apologetic and bowing them in, trying to show them everything (how this should be, how they should do that). The "guest" would come up and perhaps kick the table nest in the center and say, "What the hell do you call this?" and "Where is the telephone?" and "Where do these things go?"

Well, the utility all went into appropriate closets provided for them. Everything was there but everything was absorbed, and so puzzled them. The little Japanese boy would be very kindly and apologetic for everything that existed. But the whole attitude of the American tourist was: "Well, what do you know? Now, what the hell do you call this?" Etc., etc., etc.

The Philosophy and the Deed

Many people have wondered about an Oriental quality they see in my work. I suppose it is true that when we speak of organic architecture, we are speaking of something that is more Oriental than Western. The answer is: my work *is,* in that deeper

philosophic sense, Oriental. These ideals have not been common to the whole people of the Orient; but there was Laotse, for instance. Our society has never known the deeper Taoist mind. The Orientals must have had the sense of it, whatever may have been their consideration for it, and they instinctively built that way. Their instinct was right. So this gospel of organic architecture still has more in sympathy and in common with Oriental thought than it has with any other thing the West has ever confessed.

The West as "the West" had never known or cared to know much about it. Ancient Greece came nearest—perhaps—but not very close, and since the later Western civilizations in Italy, France, England and the United States went heavily—stupidly—Greek in their architecture, the West could not easily have seen an indigenous organic architecture. The civilizations of India, Persia, China and Japan are all based on the same central source of cultural inspiration, chiefly Buddhist, stemming from the original inspiration of his faith. But it is not so much the principles of this faith which underlie organic architecture, as the faith of Laotse—the Chinese philosopher—his annals preserved in Tibet. But I became conscious of these only after I had found and built it for myself.

And yet the West cannot hope to have anything original unless by individual inspiration. Our culture is so far junior and so far outclassed in time by all that we call Oriental. You will surely find that nearly everything we stand for today, everything we think of as originated by us, is thus old. To make matters in our new nation worse, America has always assumed that culture, to be culture, had to come from European sources—be imported. The idea of an organic architecture, therefore, coming from the tall grass of the Midwestern American prairie, was regarded at home as unacceptable. So it went around the world to find recognition and then to be "imported" to its own home as a thing to be imitated everywhere, though the understanding of its principles has never yet really caught up with the penetration of the original deed at home.

It cannot truthfully be said, however, that organic architecture was derived from the Orient. We have our own way of putting these elemental (so ancient) ideals into practical effect. Although Laotse, as far as we know, first enunciated the philosophy, it prob-ably preceded him but was never built by him or any Oriental. The idea of organic architecture that the reality of the building lies in the space within to be lived in, the feeling that we must not enclose ourselves in an envelope which is the building, is not alone Oriental. Democracy, proclaiming the integrity of the individual *per se,* had the feeling if not the words. Nothing else Western except the act of an organic architecture had ever happened to declare that Laotsian philosophic principle which was declared by him 500 years before our Jesus. It is true that the wiser, older civilizations of the world had a quiescent sense of this long before we of the West came to it.

For a long time, I thought I had "discovered" it, only to find after all that this idea of the interior space being the reality of the building was ancient and Oriental. It came to me quite naturally from my Unitarian ancestry and the Froebelian kindergarten training in the deeper primal sense of the form of the interior or heart of the appearance of "things." I was entitled to it by the way I happened to come up along the line—perhaps. I don't really know. Chesty with all this, I was in danger of thinking of myself as, more or less, a prophet. When building Unity Temple at Oak Park and the Larkin Building in Buffalo, I was making the first great protest I knew anything about against the building coming up on you from the outside as enclosure.[11] I reversed that old idiom in idea and in fact.

When pretty well puffed up by this I received a little book by Okakura Kakuzo, entitled *The Book of Tea*, sent to me by the ambassador from Japan to the United States. Reading it, I came across this sentence: "The reality of a room was to be found in the space enclosed by the roof and walls, not in the roof and walls themselves."

Well, there was I. Instead of being the cake I was not even dough. Closing the little book I went out to break stone on the road, trying to get my interior self together. I was like a sail coming down; I had thought of myself as an original, but was not. It took me days to swell up again. But I began to swell up again when I thought, "After all, who built it? Who put that thought into buildings? Laotse nor anyone had consciously *built* it." When I thought of that, naturally enough I thought, "Well then, everything is all right, we can still go along with head up." I have been going along—head up—ever since.

1. The James Charnley residence, Chicago, Illinois, 1891.
2. William Herman Winslow residence, River Forest, Illinois, 1893.
3. FLLW footnote from original text: Louis Sullivan.
4. "Modern Architecture, Being the Kahn Lectures, 1930." Reprinted in this volume.
5. Wright delivered the paper "The Art and Craft of the Machine" at Hull House in 1901.
6. FLLW footnote from original text: Usonia was Samuel Butler's name for the United States.
7. Brought up to date by Frank Lloyd Wright, 1954.
8. Nakoma Country Club, golf course clubhouse, Madison Wisconsin, 1923. Unbuilt project.
9. Herbert Jacobs house, Madison, Wisconsin, 1936–1937.
10. Cottage apartments at the Arizona Biltmore Hotel, Phoenix, Arizona, 1929.
11. Unity Temple, 1905. The Larkin Company Administration Building, 1903.

A Testament

BOOK ONE: Autobiographical

Part One

Philosophy is to the mind of the architect as eyesight to his steps. The term "genius" when applied to him simply means a man who understands what others only know about. A poet, artist or architect, necessarily "understands" in this sense and is likely, if not careful, to have the term "genius" applied to him; in which case he will no longer be thought human, trustworthy or companionable.

Whatever may be his medium of expression he utters truth with manifest beauty of thought. If he is an architect, his buildings are natural. In him, philosophy and genius live by each other, but the combination is subject to popular suspicion and the appellation "genius" likely to settle him—so far as the public is concerned.

Everyone engaged in creative work is subject to persecution by the odious comparison. Odious comparisons dog the footsteps of all creation wherever the poetic principle is involved because the inferior mind learns only by comparisons; comparisons, usually equivocal, made by selfish interests each for the other. But the superior mind learns by analyses: the study of Nature.

The collected evidence of my own active worktime is for my guidance, pride and pleasure as much as for any other reason half so good. Romanticist by nature—self-confessed—I am pleased by the thread of structural consistency I see inspiring the complete texture of the work revealed in my designs and plans, varied building for my American people over a long period of time: from the beginning—

1893—to this time, 1957. This architecture is often called "engineering-architecture." I plead guilty to the tough impeachment.

So the poet in the engineer and the engineer in the poet and both in the architect may be seen here working together, lifelong. William Blake—poet—has said "exuberance is Beauty." It took me sometime to know just what the great Blake meant when he wrote that. For one thing, this lesson, now valuable to the creative architect, I would finally illustrate here; in this poetry-crushing, transitory era of the Machine wherein development of a national culture or even a personal culture of one's own has long been so recreant. Blake meant that Beauty always is the consequence of utter fullness of nature in expression: expression intrinsic. Excess never to be mistaken for exuberance; excess being always vulgar. He who knows the difference between excess and exuberance is aware of the nature of the poetic principle, and not likely to impoverish, or be impoverished, by his work. The more a horse is Horse, a bird Bird, the more a man is Man, a woman Woman, the better? The more a design is creative revelation of intrinsic nature, whatever the medium or form of expression, the better.

"Creative," then, implies exuberance. It is not only true expression but true interpretation, as a whole, of the significance, truth and force of Nature, raised to the fullest power by the poet. That design revealing truth of inner being most abundantly is best design. Design that lasts longest; remembered by mankind with greatest profit and pride.

Art formalized, empty of this innate significance, is the cliché: cut and dried content no longer humanely significant. The so-called modern "classic"

has become cliché and does not live under this definition of exuberance. Only the mind of one who has left the region of the soul and inhabits the region of the nervous system in our time mistakes florid or senseless elaboration for exuberance. The "efficient" mind that would put Pegasus to the plough never knows the difference between the Curious and the Beautiful or the difference between the prosaic and the poetic.

Architecture Is Always Here and Now

Victor Hugo, in the most illuminating essay on architecture yet written, declared European Renaissance "the setting sun all Europe mistook for dawn." During 500 years of elaborate reiteration of restatements by classic column, entablature and pediment—all finally became moribund. Victor Hugo, greatest modern of his time, went on to prophesy: the great mother-art, architecture, so long formalized, pictorialized by way of man's intellect could and would come spiritually alive again. In the latter days of the nineteenth or early in the twentieth century man would see architecture revive. The soul of man would by then, due to the changes wrought upon him, be awakened by his own critical necessity.

The Seed

I was fourteen years old when this usually expurgated chapter in *Notre Dame* profoundly affected my sense of the art I was born to live with—lifelong; architecture. His story of the tragic decline of the great mother-art never left my mind.

The University of Wisconsin had no course in architecture. As civil-engineer, therefore, several months before I was to receive a degree, I ran away from school (1888) to go to work in some real architect's office in Chicago. I did not want to be an engineer. A visit to the pawnbroker's—"old man Perry"—made exodus possible. My father's Gibbon's *Rome* and Plutarch's *Lives* (see Alcibiades) and the mink cape collar my mother had sewed to my overcoat financed the enterprise.

There, in Chicago, so many years after Victor Hugo's remarkable prophecy, I found Naissance had already begun. The sun—architecture—was rising!

As premonition, then, the pre-Raphaelites had appeared in England but they seemed sentimentalist reformers. Beside the mark. Good William Morris and John Ruskin were much in evidence in Chicago intellectual circles at the time. The Mackintoshes of Scotland; restless European protestants also—Van de Velde of Belgium, Berlage of Holland, Adolph Loos and Otto Wagner of Vienna: all were genuine protestants, but then seen and heard only in Europe. Came Van de Velde with *Art Nouveau*, himself predecessor of the subsequent Bauhaus. Later, in 1910 when I went to Germany by instigation of Professor Kuno Francke, there I found only the rebellious "Secession" in full swing. I met no architects.

But more important than all, a great protestant, grey army engineer, Dankmar Adler, builder and philosopher, together with his young partner, a genius, rebel from the Beaux-Arts of Paris, Louis H. Sullivan, were practising architecture there in Chicago, about 1887.

After tramping the Chicago streets for some days I got in with Cecil Corwin, foreman for J. L. Silsbee, then Chicago's foremost resident architect. He was a minister's son—as I was—and so were Cecil and the other four draughtsmen there at the time. One year later I was accepted by Mr. Sullivan and went to work for "Adler and Sullivan" then the only moderns in architecture, and with whom, for that reason, I wanted to work. Adler and Sullivan were then building the Chicago Civic Auditorium, still the greatest room for opera in the world.

The tragedy befallen beloved architecture was still with me, Victor Hugo's prophecy often in mind. My sense of the tragedy had already bred in me hatred of the pilaster, the column for its own sake, the entablature, the cornice; in short all the architectural paraphernalia of the Renaissance. Only later did I come to know that Victor Hugo in the sweeping arc of his great thought had simply affirmed the truth: *Art can be no restatement.*

Frank Lloyd Wright, 1945
FLLW Fdn# 6006.0075

The great poet had foreseen that new uses of new materials by new inventions of new machine-methods would be devised and therefore great social changes become inevitable in the life of mankind. The poet saw that inherited styles and customs would undergo fundamental change in life and so in architecture: to make man ready to face reality anew in accord with "the great becoming." The inexorable Law of Change, by way of which the very flow of human life provides fresh inspiration, would compel new architecture, based upon Principle, to come alive.

The poet's message at heart, I wanted to go to work for the great moderns, Adler and Sullivan; and finally I went, warned by the prophecy and equipped, in fact armed, with the Froebel-kindergarten education I had received as a child from my mother. Early training which happened to be perfectly suited to the T-square and triangle technique now to become a characteristic, natural to the machine-age. Mother's intense interest in the Froebel system was awakened at the Philadelphia Centennial, 1876. In the Friedrich Froebel Kindergarten exhibit there, mother found the "Gifts." And "gifts" they were. Along with the gifts was the system, as a basis for design and the elementary geometry behind all natural birth of Form.

Mother was a teacher who loved teaching; Father a preacher who loved and taught music. He taught me to see great symphony as a master's *edifice of sound*. Mother learned that Friedrich Froebel taught that children should not be allowed to draw from casual appearances of Nature until they had first mastered the basic forms lying hidden behind appearances. Cosmic, geometric elements were what should first be made visible to the child-mind.

Taken East at the age of three to my father's pastorate near Boston, for several years I sat at the little kindergarten table-top ruled by lines about four inches apart each way making four-inch squares; and, among other things, played upon these "unit-lines" with the square (cube), the circle (sphere) and the triangle (tetrahedron or tripod)—these were smooth maple-wood blocks. Scarlet cardboard triangle (60°–30°) two inches on the short side, and one side white, were smooth triangular

sections with which to come by pattern—design—by my own imagination. Eventually I was to construct designs in other mediums. But the smooth cardboard triangles and maple-wood blocks were most important. All are in my fingers to this day.

In outline the square was significant of integrity; the circle—infinity; the triangle—aspiration; all with which to "design" significant new forms. In the third dimension, the smooth maple blocks became the cube, the sphere and the tetrahedron; all mine to "play" with.

To reveal further subordinate, or encourage composite, forms these simple elemental blocks were suspended from a small gibbet by little wire inserts at the corners and whirled. On this simple unit-system ruled on the low table-top all these forms were combined by the child into imaginative pattern. Design was recreation!

Also German papers, glazed and matte, beautiful soft color qualities, were another one of the "gifts"—cut into sheets about twelve inches each way, these squares were slitted to be woven into gay colorful checkerings as fancy might dictate. Thus color sense awakened. There were also ingenious "constructions" to be made with straight, slender, pointed sticks like toothpicks or jack-straws, dried peas for the joinings, etc., etc. The virtue of all this lay in the awakening of the child-mind to rhythmic structure in Nature—giving the child a sense of innate cause-and-effect otherwise far beyond child-comprehension. I soon became susceptible to constructive pattern *evolving in everything I saw*. I learned to "see" this way and when I did, I did not care to draw casual incidentals of Nature. I wanted to *design*.

Later, when I was put to work as a teen-ager on my Uncle James' farm in the valley where I now live, this early habit of *seeing into and seeing from within* outward went on and on way beyond until at the age of nineteen when I presented myself as a novice to Mr. Sullivan I was already, and naturally, a potential designer with a T-square and triangle technique on a unit-system; the technique that could grow intimate with and master the rapacious characteristics of the Machine in consistent straight-line, flat-plane effects natural to machine technology, which then, as now, confronted all who were to build anything for modern life in America.

The Confusion

Among most of the architects I soon saw the great mother-art, architecture, completely confused when not demoralized. I saw their work as hackneyed or sentimentalized travesty of some kind; some old or limited eclecticism or the so-called "classic" of Beaux-Arts training encouraged by too many influential American Beaux-Arts graduates. The pilaster again!

But of the *Naissance* needed to replace moribund Renaissance I saw little or nothing outside the offices of Adler and Sullivan to take the place of the futility of restatement at least. Awakening was to come. Whoever then acknowledged the importance of art did not seem to know so well as we now know that art cannot be restatement. Against all this face-down servile perversion by education, encouraged by my early training at the kindergarten table and subsequent work on the farm in the valley, I came to feel that in the nature of Nature—if from within outward—I would come upon nothing not sacred. Nature had become my Bible.

Man the spiritual being, I now saw continually defeating himself—confusing his spiritual power with his mentality; his own beauty lost by his own stupidity or cupidity simply because he could not see from inside by his intellect alone: could not see the nature of his own intrinsic values: see his own genius, therefore. So during those days of early apprenticeship to Adler and Sullivan I found that when I talked about Nature I was not talking about the same thing those around me meant when they used the term. I could not fail to see (nearby was the Chicago Art Institute) each noble branch of the fine-arts family driven to filch what might be from the great wreck of architecture—the head of the regal family of art—and trying to make a go of it.

To survive, our American art was cheating itself of life. This consequent spread of the tragic Renaissance, I saw largely due to outworn but desperate reliance upon a dated formal professionalism: the Classic. This not alone in architecture but in all the arts; partly, perhaps mostly, due to the fearfully efficient tools, invented by Science, so abusing artists and abused by them. These new tools I saw wrecking the "classic" imitation of ancient formalism, called modern art but founded upon a philosophy completely false to modern life.

Human life itself was being cheated.

All was the same dire artificiality. Nature thus denied was more than ever revenging itself upon human life! The very soul of man was endangered. The Machine thus uncontrolled enlarged, and was living upon, these abuses. Already machine systems had done deadly harm—and more harm, as things were then. Modern machine-masters were ruling man's fate in his manufactures as in his architecture and arts. His way of life was being sterilized by marvelous power-tools and even more powerful machine-systems, all replacing hand labor by multiplying—senselessly—his activity and infecting his spirit. Everywhere these inventions of science by ignorant misuse of a new technique were wiping out the artist. He was himself now becoming a slave. The new chattel. I saw in these new "masters" no great motive above the excess of necessity-for-profit; all likely themselves by way of their own assembly lines to become machines. The kind of slavery that now loomed was even more monstrous and more devastating to our culture now dedicated to senseless excess, so it seemed to me, than ever before. Slavery more deadly to human felicity than any yet devised. Unless in the competent artist's hand.

The pole-and-wire men in the name of social necessity had already forged a mortgage on the landscape of our beautiful American countryside while all our buildings, public and private, even churches, were senseless commitments to some kind of expediency instead of the new significances of freedom we so much needed. In the name of necessity, false fancy fronts hung with glaring signs as one trod along the miles of every urban sidewalk—instead of freedom, license—inextricable confusion. Trimmings and embellishments of trimmings pressed on the eye everywhere, made rampant by the casual taste of any ignoramus. These were all social liabilities forced upon American life by the misconception, or no conception at all, of the mother-art—architecture. Man, thus caricatured by himself—nature thus violated—invaded even the national forest-parks by a clumsy rusticity false to nature and so to architecture. The environment of civilized mankind was everywhere insulted by such willful stupidity.

▚ But soon this saving virtue appeared to me in our disgraceful dilemma: Realization that any true cul-

tural significance our American free society could know lay in the proper use of *the machine as a tool and used only as a tool*. But the creative-artist's use of mechanical systems, most beneficial miracles, was yet wholly missing.

Awakening

Steel and glass themselves seemed to have come to use only to be misunderstood and misused, put to shame by such abuses as might be seen anywhere because they were everywhere.

In the plans and designs here presented in much detail may be seen the appropriate uses of the properties of steel in tension in relation to concrete (concrete the new-old plastic). With glass and the growing sheet-metal industries, these were, it seemed to me, only awaiting creative interpretation to become the body of our new democratic world: the same being true of new uses of the old materials—wood, brick and stone.

Often I sat down to write about this as well as continue to design new forms for these new methods and materials. Occasionally, when invited, I went out to speak on the subject of the proper use of all these—always to say "we must know better the here and now of *our own* life in its Time and Place. In all we must learn to see ourselves as we are, as *modern* man—and this be our true culture." As architects young and old we owed this to ourselves, and certainly to our people. In this country of ours we were free now to abandon outdated idiosyncrasy in the name of taste, or arbitrary academic formalisms without thought or feeling—and learn to show, by our own work, our love and consequent understanding of the principles of Nature.

Windmill Tower "Romeo and Juliet,"
Spring Green, Wisconsin. 1897.
FLLW Fdn# 9607.0012

Life *indigenous* was now to be embodied in new forms and more significant uses; new forms of materials by the inevitable new machine-methods yet missing or misunderstood. A natural heretic, I declared these materials and methods to be in themselves a new potential needed in the culture of modern life. Because of the machine itself, architecture was now bound by its own nature to be prophetic. The architect's interpretations would show the way to the right use of these great new organic resources. Our new facilities were already capable of inspiring and enriching human life if provided with true forms, instead of perpetually inciting American life to folly and betrayal of its own nature by ignorant or silly eclecticism or any of the 57 fashionable Varieties of the day. Despite artificial limitations, a new beauty would be ours. Thus awakening to action, we architects had to become effective soon—or our civilization would destroy its chances for its own culture. Instead of by the handle, man had taken this dangerous new tool by the blade!

Realization

In this sense I saw the architect as savior of the culture of modern American society; his services the mainspring of any future cultural life in America—savior now as for all civilizations heretofore. Architecture being inevitably the basis of an indigenous culture, American architects must become emancipators of senselessly conforming human beings imposed upon by mediocrity and imposing mediocrity upon others in this sanitary but soulless machine-age. Architecture, I believed, was bound to become more humanely significant because of these vast new facilities. Therefore not only special but social knowledge of the nature of architecture as presenting man himself, must be greatly expanded. Architecture was to be liberated from all formalistic stylizing by any elite, especially from that perpetuated by scholastic architects or by the criteria of insolent criticism. Architecture of the machine-age should become not only fundamental to our culture but natural to the happiness of our lives in it as well. All this was rank heresy at the time. We have made some progress since because it does not seem so heretical now.

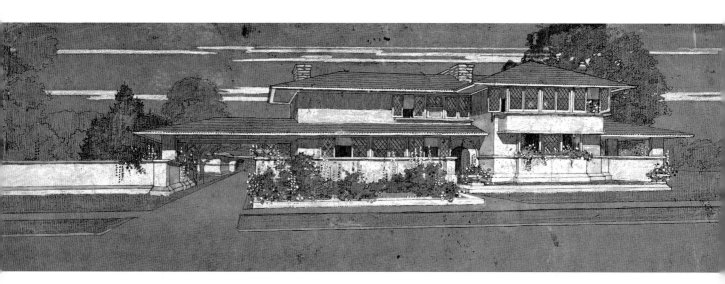

Ladies' Home Journal,
"A Home in a Prairie Town." 1900.
Project.
FLLW Fdn# 0007.001

Young heretic, then, I freely spoke but steadily planned all the time: hope of realization firmly at heart—pretty well in mind now, as poetry. I loved architecture as romantic and prophetic of a true way of life; life again coming beautifully alive today as before in the greatest ancient civilizations. We were free men now? The architect among us then should qualify as so inspired; be free leader of free human beings in our new free country. All buildings built should serve the liberation of mankind, liberating the lives of *individuals*. What amazing beauty would be ours if man's spirit, thus organic, should learn to characterize this new free life of ours in America as natural!

Retrogression

But soon I saw the new resources not only shamefully wasted by machinesters but most shamefully wasted by our influential architects themselves; those with the best educations were most deadly. Our resources were being used to ruin the significance of any true architecture of the life of our own day by ancient ideas imposed upon modern building or ancient building ruined by so-called "modern" ideas. Thus played upon, some better architects, then called modern, were themselves desperately trying to reorganize American building and themselves as well. The A.I.A., then composed of architects who came down the hard way, was inclined to be sincere, but the plan-factory was already appearing as public enemy number one.

I had just opened my own office in the Schiller Building, 1893, when came disaster—Chicago's first World's Fair. The fair soon appeared to me more than ever tragic travesty: florid countenance of theoretical Beaux-Arts formalisms; perversion of what modern building we then had achieved by negation; already a blight upon our progress. A senseless reversion. Nevertheless at that time—now more than sixty years ago—I was myself certain that awakening in our own architecture was just around the turn of the corner of the next year. That year I wrote *The Art and Craft of the Machine*, delivering the essay at Hull House by Jane Addams' invitation. Next day a *Chicago Tribune* editorial announced that an American artist had said the first word for the appropriate use of the machine as an artist's tool. I suspect that Jane Addams wrote the editorial herself.

By this time the American people had become sentimentally enamored of the old-lace, nervous

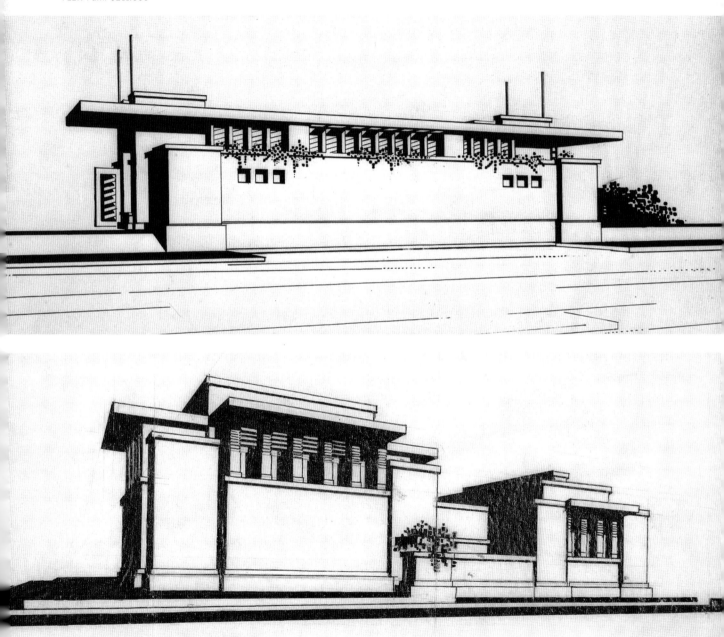

Yahara Boathouse,
Madison, Wisconsin. 1905.
Project.
FLLW Fdn# 0211.006

Unity Temple,
Oak Park, Illinois. 1905.
FLLW Fdn# 0611.056

Study for Brick and Concrete.
1904. Project.
FLLW Fdn# 0414.001

William R. Heath House,
Buffalo, New York. 1903.
FLLW Fdn# 0507.0002

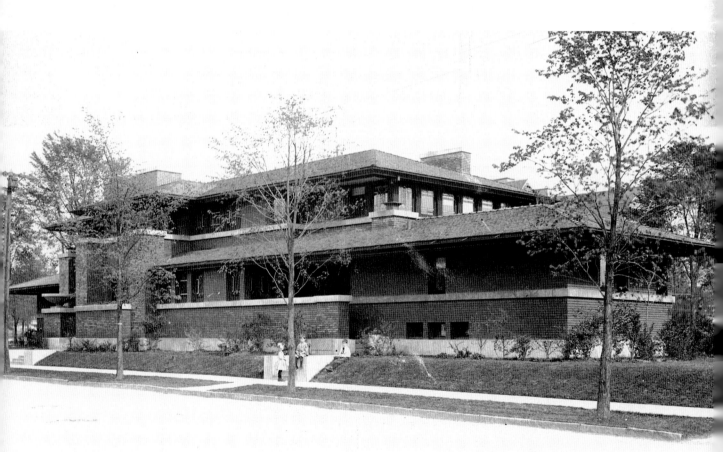

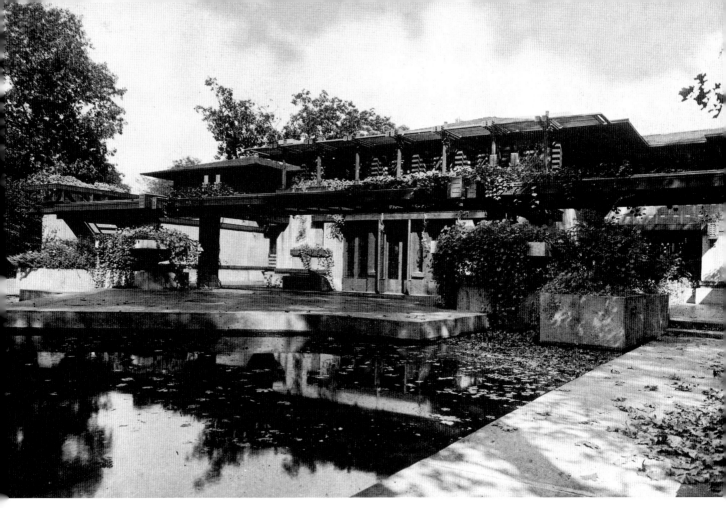

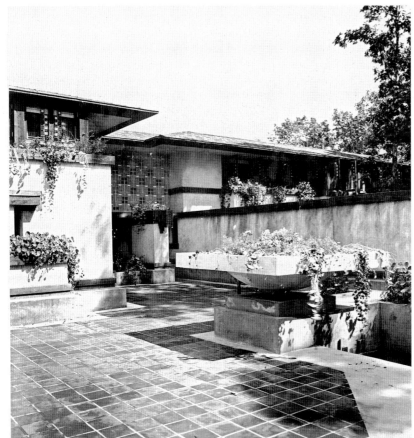

Avery Coonley House,
Riverside, Illinois. 1907.
FLLW Fdn# 0803.0002 and
FLLW Fdn# 0803.0010

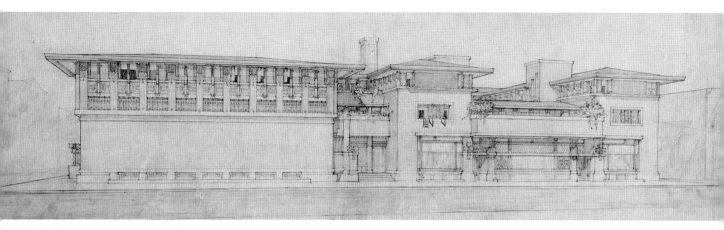

City National Bank and Hotel,
Mason City, Iowa. 1909.
FLLW Fdn# 0902.001

artificiality of the "classic" grandomania endorsed by the A.I.A. at the fair. It was everywhere in evidence: excess—as usual—mistaken for exuberance. Owing to this first World's Fair, recognition of organic American architecture would have to wait at least another half-century.

"The Chicago School"

No school exists without something to teach; and until the phrase "Chicago School" appeared so many years later, I was not aware that anything like a "school" had existed. At the time, there was a small group composed of my own adherents and of contemporary dissenters by nature. The work of Adler and Sullivan was in constant contrast to the work of Richardson and Root; later, Shepley, Rutan and Coolidge (heirs of Richardson), but few of the architects, young or old, then admitted the Adler and Sullivan influence.

Because I was, so far as they were concerned, Sullivan's "alter ego," a small clique soon formed about me, myself naturally enough the leader. Friendships were formed in those early days, especially after the gold letters ARCHITECT were put upon the plate glass door of my office in the Schiller Building. The "followers" were not many: first among them Cecil Corwin and Robert C. Spencer, Jr. (Bob)—first converts to the new architecture. Bob was regarded by his "classic" comrades as apostate because his em-

ployers—Shepley, Rutan and Coolidge—had gone "classic" soon after the romantic Richardson's death. Bob and I were often seen together; later he took the office next mine in the Schiller. Chicago conformists working in other offices, seeing us arm in arm down the street, would say in derision, "There goes God-almighty with his Jesus Christ." Bob didn't mind. He stuck. Some others began to "come around": George Dean, Hugh Garden, Myron Hunt, Dwight Perkins, Dick Schmidt and Howard Shaw; all were friendly but not willing to cut their umbilical cord to the Colonial or the French château, the English manor house or the grandomania of Beaux-Arts days.

Before long a little luncheon club formed, comprised of myself, Bob Spencer, Gamble Rogers, Handy and Cady, Dick Schmidt, Hugh Garden, Dean, Perkins and Shaw, several others; eighteen in all. We called the group the "Eighteen."

The "Eighteen" often wanted to know how I convinced my clients that the new architecture was the right thing. "Do you hypnotize them?" was a common question. The idea of an American architecture fascinated them to a certain degree according to the nature of their understanding. Almost all admired what I was doing though they were not yet willing to say it was the right thing.

Gamble Rogers never left the Gothic; Howard Shaw never dared leave colonial English. But most of the others fell in with the idea of some sort of modern architecture. I became original advisory exemplar to the group.

The little luncheon round-table broke up after a year or two. I with those nearest me rented a vacant loft in Steinway Hall: a building Dwight Perkins had built. But Spencer, Perkins, Hunt and Birch Long (clever boy renderer) moved in with me. Together we subdivided the big attic into studio-like draughting rooms. We felt the big attic especially appropriate for our purpose. We each had a share in a receptionist and stenographer in common as "office force" on the floor below, trying to please us all. The entrance door panel was a single sheet of clear plate glass, the second one in existence, like the entrance door to the Schiller offices, with all our names thereon in the same kind of gold letters.

By this time an increasing number of young draughtsmen, like Max Dunning et al, began to come around. I got Lieber Meister to address the Chicago Architectural Sketch-Club, which he did with great effect. Dankmar Adler was dean of the A.I.A. at the time, and he also wrote valuable papers on the subject of skyscraper construction, and the effect of steel on modern life. Meantime, buildings were going up under "the Adler and Sullivan influence." A little of the new was worked in by others here and there. But all in all, from my impatient standpoint, weak if not impotent or cowardly. On occasion, I did say so, but patiently worked on their plans when I could be helpful. My most enthusiastic advocate, young Myron Hunt, was first among them to set up in Evanston, Illinois, as a "modern," with the building of the "White" house. That was a characteristic instance. I believed myself helpful to them all.

I remember an ebullient Italian, Boari by name, who won the competition to build the National Grand Opera House in Mexico City. He came into our attic space, temporarily, to make plans for that edifice. He was far from all of us but observing, curious and humorous. He would look at something I was doing and say with a good natured grunt, "Huh, temperance-architecture!" turn on his heel with another grunt and go back to his Italian Renaissance "gorge" as I called it in retaliation. What he was then doing is now there in Mexico City but badly affected by the universal settlements going on because of the lowering of the water-level beneath the city.

Other work went on in our studio-loft for several more years. But when I had left Adler and Sulli-van to settle down in Oak Park, Bob had moved out to River Forest, the next suburb to the west. I—the amateur still with Adler and Sullivan—was able to build a little house on Chicago Avenue; and, on my own, built a studio adjoining my home, where the work I had then to do enabled me to take in several draughtsmen and a faithful secretary, Isabel Roberts, for whom I later built a dwelling in River Forest, now owned by and revised for the Scotts.

But by that time at Oak Park I had lost touch with most of the original group. Into the now flourishing Oak Park studio had come Walter Griffin, Marion Mahoney (later married to Walter), William Drummond, George Willis, Andrew Willatzen, Frank Byrne, Albert McArthur. Others came and went as time went along.

By that time, 1894–5, architecture so-called "modern" had made sporadic appearances here and there around Chicago; reminiscent of Lieber Meister's ornament or something I had myself done or was doing as a dwelling.

George Elmslie—I had brought George from Silsbee's as my understudy (lasting the seven years I remained with Adler and Sullivan and staying on for many more years)—would sometimes come out to lend us a hand in the Oak Park studio, putting in overtime when pressure of work would keep us all up all night, and the dawn would find the boys asleep on their draughting boards.

But, now independent, I didn't use the fascinating ornament, had struck out a new line in a field of my own—the American dwelling: the nature of materials and steel in tension. Of what was going on abroad at this time I had no knowledge nor any interest in. Nor was there any Japanese architectural influence, as may be seen in these illustrations.

Disaster

Schools of thought, to and fro, soon arose in America—one of them misled by the dictum "Art is art precisely in that it is not nature"; misunderstanding the word "nature." This was really art for art's sake? "Form follows function" came along now also to become the new slogan (also misunderstood). But art was not as yet transferred to the region of the mere nervous system; the nervous system had not yet been mistaken for the soul. But little men were

using little brains and little-finger sensibility to confect semblances that "tasted" to them like inspiration, confections mistaken for architecture. All but several architects seemed to be trying to annul the idea of architecture as noble organic expression of nature; the Form-Follows-Function group seeing it as a physical raw-materialism instead of the spiritual thing it really is: the idea of life itself—bodily and spiritually—intrinsic *organism*. Form and function as one.

Well—Daniel H. Burnham was right. The Chicago World's Fair became the occasion of modern architecture's grand relapse. The nature of man was there reduced to the level of a clever trained animal: Architecture contrived as a hackneyed ruse to cheat modern life of its divine due instead of serving to glorify it. Beaux-Arts intellectualism was the aesthetic that could only eventuate as some kind of menial to the monumental. Therefore "classic" misuse of the "Classic" slandered the noble idea of art as organic, and I was compelled to see that it would go on so long as man had no true sense of his own dignity as a free man. Only if his intellect, which had been stimulated but pauperized by education, again became subject to the inner laws of his own being, could he be a valid force in Architecture, Art or in Religion: only so could he ever rise creative above our inventive sciences in the grasp of the Expedient. Otherwise his life in America would remain helplessly afloat upon a sea of corrupted taste; no realization would be possible.

Contribution

When man's pride in his own intellect was set up as an anti-nature-formalism in art, he became responsible for the dictum: "where every prospect pleases and only man is vile."

▥ Different were the Orientals and different were Jesus, Shakespeare, Milton, Blake, Wordsworth, Coleridge, Keats, Shelley, Beethoven, Bach, Brunelleschi, Goethe, Rembrandt, Dante, Cervantes, Giotto, Mantegna, Leonardo, Bramante, Angelo. Different were the prophets of the human soul. All masters of the Nature of Man and the hosts they have inspired. No longer trying to lift himself by his boot-straps or busy cutting out the head of

his drum to see whence comes the sound, man by nature still creative may grow.

Man and the Machine

As Victor Hugo wrote also in *Notre Dame*, Gutenberg's invention of shifting-type was the beginning of the great triumph of the machine over all the fine-arts and crafts of architecture. By way of the machine came the soulless monstrosities now so far out of human scale as to be out of hand. Death came to handicraft and to any corresponding culture in the world, blindly inherited by us. As for America, cultural confusion had already come upon us in our new "house," almost before we were born. Buildings, business, education—all were becoming great enterprises stimulated by infatuations with science and sentimentality concerning the past. The inventive engineering of mechanization lacked the insight—creative poetic imagination, let's say—to recognize the power of interpretation by architecture of these vast new facilities. As they came fresh from science, they but stimulated the cupidity of commerce. As for the architects, they were either silent or huddled in the lap of overpowering change. Our capitalism was a kind of piracy, our profit-system tended to encourage low forms of avaricious expansion. American culture, such as it was, wore a false face, a hideous masquerade. Success was misunderstood as essential to progress. Really success was worse than failure. Wanton denials of humanity were made by machine-power, abetted by the impotence of artists and architects, themselves blind to the fresh opportunities, really their duties. Such failures as they were making of life, then as now, were a standardized slander upon the liberated individual rather than any true reflection of his innate power. Thus doomed to spiritual sterility, art and architecture were facing extinction in all the hell there was.

▥ Well, nevertheless—rather more—I kept on planning, preaching, presenting the real social need for the creative artist-architect—the competent, conscientious interpreter of his kind and time! But where were such architects? Was the A.I.A. alive to the new ideals? The story by now might have been different if the A.I.A. had not been more interested in architects than in architecture. In such circum-

stances how could the architect's vision become effective action? Could action come to grips with selfish forces to humanize their excesses by rejecting their power, to evolve the new forms modern man needed to sustain the freedom he had declared, 1776? This was up to the greater architect we had neither inherited nor cultivated. Because of this default I kept trying to gather together the dangling, loose ends, so twisted by this confusion; gather them little by little into organic synthesis of means to ends, thus showing with all my might the idea and purpose of organic character and proportions in building, if made appropriate to life under American Democracy.

New architecture was fundamental necessity. But it seemed impossible for architecture to rise without deeper knowledge of the poetic principle involved. The slide-rule of the engineer could not diminish, but only cherish and confirm, all this damnation—and did so.

The needed interpretation had arrived in my own mind as organic and, being true to nature would naturally, so I thought, be visible to my fellow architects. In spite of myself, because becoming more and more articulate, I became a kind of troublesome reminder—a reproach to my fellows. Naturally enough I would not join the profession to help make a harbor of refuge for the incompetent? So, deemed arrogant even by those who might have been expected to go a little deeper and go to work themselves, I had to go it pretty much alone—Lieber Meister gone.

The Field

Among the architects practising in America when I entered Adler and Sullivan's offices, Richardson had the high honor of the field; Beaux-Arts graduate, Bostonian well-connected with the better elements of society, the Adamses, etc. But Richardson had robust appetite for romance. His Romanesque soon overthrew prevailing preferences for Renaissance. Eventually he became the most productive and successful of those men, the great eclectics of their time. Many of them fell in love with his love of the Romanesque. Yes, his Romanesque soon amounted to something wherever his fellow architects were concerned with a style.

Louis Sullivan himself kept an eye upon Richardson's superb use of stone in the arch. H. H. Richardson's use of the arch in early days, "but not his ornament," had a visible effect upon Lieber Meister. Richardson disciples were legion; his success was tremendous. Henry Hobson Richardson, though an artist and giving signs of emerging as modern, was just what America deserved most but should have had least—a powerful romantic eclectic. Gone now.

McKim, Mead and White, Richardson's elite running competition, were also Beaux-Arts men. Their eclecticism was of another more elegant order, faithful to the more choice effects of early Italian (moyen-age or better-day) Renaissance. In their affected cultivated stride they took the ancient buildings verbatim. Whenever they found the buildings they admired, they copied them, enlarging the details by lantern slide. Used them straight. Their following was, of course, automatically more socially elite than Richardson's but extensive. Gone now.

Richard M. Hunt, darling of New York's four hundred, head of their procession on Fifth and other American avenues, was a good technician with a finished preference for the French-Gothic ensemble. He was fashionable, too, his eclecticisms immensely popular and profitable to him. But not to America. Gone now.

There was another much less idolized group, to which Adler and Sullivan, Major Jenney, John Root, Cass Gilbert, Van Brunt and Howe and several others, belonged. Of them the only men indicating genius above engineering ability and the capabilities of front-men were Louis Sullivan and John Root. Of Root it might be said that Sullivan was slightly envious because the two firms, Adler and Sullivan and Burnham and Root, were in direct competition, the latter firm having the best of it. Then Root's office building, the Monadnock of Chicago, might be put against Louis Sullivan's Wainwright of St. Louis. Although the Monadnock arose later, it was vital too, but an unsuitable forcing of the material: brick. See the unbricklike molded corners.

The strain of genius in Root was far less than the miracle of genius in Sullivan. Unfortunately Root barely survived the Chicago World's Fair, in the planning of which he had a major hand, supported as he was by the great master-manager, his partner Daniel H. Burnham, head architect of the Fair. He,

"Uncle Dan" ("make no little plans") would have been equally great in the hat, cap or shoe business.

Of young aspirants at the time there were many, mostly head-draughtsmen like myself. There were also independents like S. S. Beman, J. L. Silsbee and many other talented men in the offices of the Middle West and of the East, such men as the Beaux-Arts Carrère and Hastings, etc., etc.

The Chicago World's Fair was a procession of this talent that brought these leaders of their profession out into the open. Their merits and defects might be there seen and appraised. Due largely to "Uncle Dan" Burnham's ("Frank, the Fair shows our people the beauty of the Classic—they will never go back")[1] ability to promote ideas of Charles McKim et al, the Fair reopened wide the case for European Renaissance, and America had a memorable field day à la Paris Beaux-Arts. The "Classic" easily won and the more pertinacious and influential among the more successful architects of the A.I.A. were for the time being almost totally in command. "The eye of the vox-populi" (as a popular Fourth of July orator once put it) opened wide in dreamy-eyed wonder at the Chicago World's Fair. The ambitious ignoramus in the architectural profession throughout America was captivated. The old, old story! By this overwhelming rise of grandomania I was confirmed in my fear that a native architecture would be set back at least fifty years.

▥ But Louis Sullivan's Transportation Building was the only picture building at the Fair presented by the Paris Beaux-Arts itself with its distinguished gold medal; which must have astonished the Beaux-Arts society of America. A society of which the original French Beaux-Arts seemed not to think highly, as I learned long years later, 1940.

▥ Such in broad outline was the rough contour of the A.I.A. during my apprenticeship with Adler and Sullivan. There in the Adler and Sullivan offices high in the Chicago Auditorium Tower I worked for nearly seven years—George Elmslie alongside—occasionally looking out through the romantic Richardsonian Romanesque arches over Lake Michigan or often, after dark, watching the glow of giant Bessemer Steel converters reddening the night sky down towards South Chicago. I looked from those high-up arches down upon the great, growing city of Chicago as the Illinois Central trains puffed along the lake front.

Civilization as Abstraction

This abstraction we are calling Civilization—how was it made and how is it misused or being lost now? By "abstraction" I mean taking the essence of a thing—anything—*the pattern of it,* as the substance of reality. Incidental effects aside, the *heart* of the matter would lie in the abstraction if well made, and nature truly interpreted—expressed in pattern by the true artist: Linear and spatial significance of the reality *within*—this is what is patterned forth. If thus intrinsic, this is the artist's contribution to his society: truly the *creative* artist's affair. Our customs, costumes, habits, habitations and manners, all are, or should be, such abstractions; and made, as such, true to the great abstraction we call civilization. That, genuine, would be our culture. If the abstraction is truly made well above the animal nature in man—his gregarious nature—it will keep the ancient rituals of his higher nature as long as possible. Human abstractions if true usually become rituals. Once made, although the ritual may become "obsolete," the original abstraction will be cherished by man because the rituals recorded what his kind once considered beautiful to see, to feel, to hear or to know. Sometimes all together.

This retention of the abstract as beautiful goes to the extent that few now living can distinguish in those abstractions (civilizations now dead) what differs essentially from those still alive. "Taste" still meanders about among them all—confused as it is in this vast forest of the ancient abstract. "Taste," waif or prostitute, lost in the interminable stretches of the abstract. We therefore need the prophet always to make new abstractions for life more in accord with the eternal Law of Change. This is largely the service the creative architect renders to his society, now no less than ever. The service he alone may render with conscience, justice and lustre.

What means more to the life of the individual in our own place in Time than this study of the nature of human nature, the search to discover pertinent traces of hidden impulses of life, to form continually new abstractions uplifting the life he lives? From such intensive introversion issues inestimable

treasure for extroversion in interpreting his civilization. This, alone, justifies the trust that society must repose in the architect if creative. The true architect is a poet who will someday discover in himself the presence of the tomorrow in our today.

Poet — "Unacknowledged Legislator of the World"

Then, as now, I knew that he alone could have the inspiring insight needed to give human society true answers—answers always related to philosophy continually new. Yes, I knew, even then, that the revelations American society needed to go with our new declaration of faith in man could not possibly come from science. Except for Louis Sullivan among the many poets I knew and have named, there were then none among all the architects of this world. The poet had been too long absent from architecture. So long indeed, architecture was no longer considered as a great creative art. But where might the soul of any humane culture we might ever know be found unless in architecture?

Thoreau, Emerson, were ours. Yes. And then, too, Walt Whitman came to view to give needed religious inspiration in the great change: our new Place for the new Man in our Time. Walt Whitman, seer of our Democracy! He uttered primitive truths lying at the base of our new life, the inspirations we needed to go on spiritually with the brave "sovereignty of the individual." Might not the *spirit* of creative art, desperately needed by man, lie in the proper use of the radical new technologies of our times, and so arise? Not from, nor by, any established authority whatsoever, nor any religious sectarianisms. This kind of inspiration was nothing to expect from the committee-mind or from any officialdom. I well knew it was not there. Sixty years ago I knew that until the needed inspiration could be found forthcoming in architecture—enlightened instead of conditioned in this realm we have been calling Education—we would probably look in vain for coherent interpretation of our time and our place in time.

Consider that the United States of America appeared 160 years ago with this unique, inspiring message that started a world revolution in government. Freedom for the human being to be his better self! Reflect that man thus became the unit of a civilization itself *individual*. See how inspired and brave were our founders. What courage then to declare *officially a nation* of people free! Consider too: Were American freemen conscious of being newborn to the mundane society of this world, how inevitable to America, then, was great art and so as its basis a genuine architecture. *Organic* to go with the nature of that Declaration! Organic architecture based upon this new faith, not only faith in mankind's manhood but faith in the man as himself *creative;* man always greater than any system he might ever devise! Therein fresh opportunity came to us. Modern man enabled to conceive and achieve a new harmony with life. New hope now for a man to improve himself—*as himself:* to serve with good conscience the new idea of State according to his ability. Men were now bound to *grow;* to become useful leaders in their own time, in their own country, because they were now free to use and be used by their fellows each to each preserving the integrity and beauty of life for each and so for all. This was what our new democracy, as a form of government, meant? Heresy when it was declared. A quandary even now?

Conformity

Unfortunately conformity reaches far and wide into American life: to distort our democracy? This drift toward quantity instead of quality is largely distortion. Conformity is always too convenient? Quality means *individuality,* is therefore difficult. But unless we go deeper now, quantity at expense to quality will be our national tragedy—the rise of mediocrity into high places.

Servility increases—already a seemingly unguarded danger to democracy not only in art and architecture and religion but in all phases of life. Between the radical and the conformist lies all the difference between a lithe tendon and a length of gas-pipe.

Because of this all the more, it was for illustrious *sovereignty of the individual* that I wanted to build. Too little of the beautiful had ever been built for man's personal life on earth and nothing whatever by government with the depth of understanding essential to this new ideal of manhood. So, 1921,

I wrote (badly) *The Disappearing City,* followed this later by *When Democracy Builds,* prophesying and promoting the inevitable American City of tomorrow—ours if democracy is to survive.[2] At least I did succeed in outlining what I thought would be the center-line in building democratic man into his environment according to his new ideals of government, by means of his amazing new scientific leverage: the machine. Planning the new city now became organic: organic building design and construction. This new city belonging to America also to accord with our political Declaration. Accordingly, Taliesin (1932) modeled Broadacre City. I saw it coming as an irresistible current to vindicate new uses of science and bring closer to reality the new vision of man's social integrity as an individual. I had learned to see the right use of machine-craft as a living element in the organism of our society—and therefore bound to come right side up in the American City. I saw this new city denying all enforced formalisms in any style whatsoever. I saw our big cities as the overgrown villages they are—over-invested, under-engineered, unclassified, the outmembered, over-numbered, over-gadgeted cliché of antiquity. European civilizations of the Middle Ages had left us our city and we had done nothing with it but cram it with gadgetry. We, the last word in progress, were still back there with Sodom and Gomorrah. See the chapter in Genesis where Cain, the murderer of his brother, went forth with his sons to found the city. The City still murdering his brother.

New Thought

Other than the declaration of the master-poet of our world: "The Kingdom of God is within *you,*" it seemed to me that organic architecture was the only visible evidence of this in modern art. Old definitions were sadly lacking perspective anywhere; new definitions were now imperative all down the line: definitions long past due in religion as well as art. This new-old philosophy, too—and therefore—had to appear if we were ever to experience inspiring creation and—soon enough—find a basis for the free culture we might honestly call our own. We the American people would learn to develop a true humane joy in the environment of our daily life, and achieve beauty of life—the home as a work of art part of this vision. This, despite all confusions, I saw wrought by and for the self-hood of the individual. But confusions of the public "taste" were only increased by self-made, self-willed, self-styled critics, also an affliction by "taste." I then believed critics were by nature no less confused than confusing.

Were I as an architect to work thus for the Beautiful—I loved the idea of "romantic"—in the everyday American city and the country by myself, my first thought must be a valid social science, a conscious point of view in society: philosophic thought basic to democracy, organic planning no less basic to a new architecture fit for the machine-age. What necessarily then, would such organic planning be? Naturally true to our Declaration: thought free. Not only the artist's motive free but also the *political* basis of the democracy we love as an ideal made valid and try to believe we still desire, free.

Romance—The Free Philosophy

Comes to our American view, then, the highest form of aristocracy yet known—the highest because *innate:* Aristocracy natural as the quality of the man himself, no longer *on* him but *of* him: aristocracy his, not by way of privilege nor inheritance, but truly his: a quality developed from within himself. Unique.

The ancient American architectures of the Inca, the Mayan and the Toltec are lying centuries deep buried in the earth where ages ago instead of the free soul of man, the cosmic-order of sun, moon and stars inspired primitive man to level mountains and erect great temples to his material power.

Again in America we erect temples but this time not so much to the mystery of great terrestrial or cosmic forces as to the interior or spirit-power of manhood as released by American democracy and its sciences. How much greater is this new expression of the soul of man! A new light may shine from every edifice built by the human mind.

Jefferson's Aristoi

Thomas Jefferson prophesied the democratic Aristoi. We his people must now not only meet the radical changes in our political and social systems but

face no less these changes in the basis of our culture. If integrity of spirit inheres in man, its natural countenance will be found in his architecture: the countenance of principle. Because architecture presents man as he is, he will live anew in the free spirit of organic architecture of our own time.

New, but still natural, interpretations of man in a living architecture thus become our privilege. A new abstraction, as civilization, arises to express the new life-of-man as free. He is yet a changeling of tide and time. This I believed long ago even as I became an architect, trained at the kindergarten table. So nearly everything I saw standing outside myself—man-made—had to be *new*. How could buildings any longer be of past or future "schools" so-called? There could now never be schools! Schools could only be remade and so be makeshifts: old cultures that were originally in themselves eclecticisms.

But now for us must come an America neither modern cliché nor ancient classic. Nor any habitual repetitions, restatements, restorations, under which the spirit of man has so long languished to disintegrate. For 500 years at least, these pressures of temporal authority have prevailed. The old manipulations of mankind by authority, politics, fashions, academic pressures, prevailed but were not really authentic.

Fresh cultural life, now to issue from the "reality within," begins a new world!

Integrity

Meantime many contumacious substitutes have arisen and more will arise. A natural or organic architecture, as modern, has already been misused. Much perversity has been extolled, admired as expedient. Worthless architectural façades in novel materials are now commercial posters—hailed by the "avant garde" as modern. Abuses are disastrously imposed as proper uses upon sincere but ill-advised efforts and the clever apostate is here and there front-paged and lionized, as usual in our country. The widely accepted prophet is rarely prophetic. Seen as heroic he is too often only the blind leading the blind. Thus the plausible expedient has become gospel and continues to be generally foisted upon those who seek better things; the conformities proclaimed by authority, however specious,

temporarily mistaken for Godhead. But if they were seen for what they are worth in the realm of art as they would be seen in other realms, I am sure that the world of architecture would rise above the current abuse of the thing-mistaken-for-the-thing, to rebuke and reject these traces of simian ancestry now appearing as modern.

In every new expression of a fundamental Idea there will always be the substitutes, the imitations, dangling from it, as the soiled fringe from a good garment. It takes long years to learn that superficial commotion is habitually mistaken by our provincial society for emotion, and that motion itself—action—is dangerous: the danger ever precedent to the practice of any new essential truth. This weakness in our provincial society I have seen during the more than sixty years of my own practice of architecture: see it now none the less, perhaps exaggerated by television, radio and press. So any deeper desire for indigenous culture thus is impeded.

How, then, can it be eagerly sought by our people? A deeper hunger is needed spiritually than we seem to know. The popular desire for entertainment is exploited by the commodity merchant all down the line. In upper social brackets, as in lower, there does not seem to exist enough desire to fight exploitation by mediocrity for a more enlightened life in art but rather a disposition to succumb. Therefore beauty of thought and grace of entertainment as well as beauty of environment suffer. The culture of the spirit we so desperately need we will discover with a *new integrity*—the integrity actually necessary to preserve our civil liberties! We will learn to see what is consistent with the poetic principle in the way of daily living. If our lives are to be sacrificed let it be for a humane, more beauty-loving tomorrow: make this new age more lasting and beneficent than any lying back there in ruins ever was. We should not be looked back upon tomorrow as merely the Scientific or the Sanitary Age. This means that America must be wholeheartedly involved in the arts of town-planning and living in homes that are true works of art. This new integrity is now possible to us: as a free people we must know how to use the new sciences for genuine culture; the only genuine culture is indigenous culture.

Beautiful buildings are more than scientific. They are true organisms, spiritually conceived; works of art, using the best technology by inspiration rather

than the idiosyncracies of mere taste or any averaging by the committee mind.

New or Old

Almost all our so-called "modern" is not yet new. It is merely novel by imitation or indirection; or pretense by imported picture. Our fresh architecture will be based upon nature, reinforced by the genuine democratic sentiment already existing among us as a people—a people conscious of it as the proper basis of survival as a democracy. Whether we yet know it well or not, we of this Machine-Age are growing inevitably toward organic unity not only in our architecture but in every feature of our national as well as of our private life: no *re-birth* in philosophy, art or religion for us now in any form. Birth itself.

All this as *new* is not clear enough yet, not naturally enough our social purpose. Did it so seem to our forefathers?

Why is this not more widely recognized as *natural* in the realm of education? Is it because civilization itself proceeds only by the authority of intellect and so soon becomes non-integral? Is false abstraction always the consequence of spiritual degeneration? Is decline of the spirit toward utter materialism the reason why it is so difficult for any ideal to survive? Is only the gas-pipe (materiality) safe and the lithe tendon (spirit) so difficult? Is the human nervous system now being groomed by the slaves of the expedient as a substitute for soul? If so, vital abstraction is unlikely now.

Creation is not only rare but always hazardous. Always was. But why is it growing so much more hazardous now? Is it owing to our "systems," educational and otherwise, that we seem to be capable always of less and less rather than more—less *vision* and less love essential to the understanding of exuberance? Comes to mind a triad from the old Welsh *Mabinogion* defining genius: A man who sees nature. Has a heart for nature. The courage to follow nature.

Naissance

Renaissance no longer. Comes *Naissance:* Nature. Just as Naissance has always come to the brother-hood of man at the critical moment so it came to us as a nation in the brave Declaration of principle. 1776. It has come to our architecture as the dawn of a natural free American spirit in building ourselves "into" our country, and really began about 1890. This in but one American century of civilization is dawn indeed. Thus inspired, there can be no prolonged discouragement hereafter. Many new buildings, characteristic of our own place in Time and of modern Man, have already appeared East, West, North and South. First appearing on American prairie, Midwest, they aimed to be organic and appropriate and so refused to accept, accent, or in any way serve the old forms of either European or Oriental architecture. From the start, confident, seminal, inspired by the love of architecture as well as the nature of man, notwithstanding the prevailing confusion, waste and slip by the abuse of machine-powers, the new architecture came gradually into view—in focus by 1893. A prophecy sustained.

Reversion

Unhappily for this early development, old-world ideas of architecture revived at the Chicago World's Fair by the professional A.I.A. had already been so firmly fixed by official and educational America that reaction was reprompted and spread country-wide over the surface of our nation. The prophecy of "Uncle Dan" already quoted, "Frank, the American people are going 'classic'" came true. European or Beaux-Arts training—old ways in architecture—were indeed "going"! Became more than ever a stumbling block. The "classic" more than ever hindered organic architecture. Even now it is confirming the robbery of our proper use of scientific invention.

The View

Most critics of the time, as we then knew, were masters of or mastered by the odious comparison; or were inexperienced, teaching architecture by book. All were well-meaning enough but mostly made by academic armchair or managed publicity of some kind. Naturally all these agencies, though

willing enough, were helpless, when deeper independent thought was urgent, especially in discriminating where architecture concerned the culture of our own society as distinguished from other societies. It has remained the blind spot of our nation. Architectural magazines were naturally more interested in architects than architecture. Architecture was not a subscriber. To them, as to the plan-factory magnate, the cliché proved a godsend. If they abandoned the one it was only to take up another. Whatever the likely cliché happened to be or wherever it came from, it was quickly salvaged by publicity and accepted, promoted and fed to the American people as the proper thing. To "the improper press" the cliché most useful in advertising and standardizing the vast fabric of our industrial and educational system was always the latest one; the names changing with stunning rapidity. But although organic architecture had already met the crushing blows of machine-age science with the right technique, not for another half-century was it to become at all operative in education. The struggle to and fro on the part of our own robust new thought, or any action based upon it, did not prevail then against the firmly established standard that "culture had to come from abroad." Suspicious always of change, established order was as usual hostile to enlightenment. So the art of building as an organism remained unfamiliar except to the more discerning, courageous, and already sentient American individual.

Betrayal

As one consequence (even as a cause) architects of that period did not love architecture enough to have it on their consciences—nor did their successors. Our so-called "modern architect" lived, then as now, a curious hybrid. Gadget-lover and servile auctioneer of novelty, he was prime merchant of the commonplace; speedster in all ways; quick to arrive first along the beaten path. Were he a shellfish he would not hesitate to eat holes in his own shell. Could anything be made of *his* "housing" or *his* government's? But he has happened to us, to our country, and thrives under enormous bureaucratic expansion. Look at the seashell—and listen to the indictment of this hybrid.

Faith in Man

Again: mainspring of any true architecture is sound philosophy of Nature. Wherever it appears unhampered, it is the basis of the only indigenous culture yet to appear in our modern American life. The new architecture is not yet "officially" understood at home because not imported. So if not imported, as culture, not "safe"? No. No matter how sane. As for our political esthetes if they had only a glimpse of the significance of the philosophy of the new architecture, they would know it to be native. But therefore inutile or controversial. Being controversial, government would shun it. To sponsor it would not be safe for a politician because there is always "the next election." Besides since "culture has always come from abroad anyhow—why not forget the whole native thing?"

Nevertheless original organic architecture, widely recognized abroad, is now being accepted here at home although the principles upon which it stands have had little comprehension. In government, good or bad, and in education, too little of it is yet established. Gradually growing, but still puzzling or offending "arty" or routine architects and critics educated far beyond their capacity. Only among the better citizens, able to function independently of the popular effects of managed publicity or mannered art do we find the practicing architect not servile to fashion nor influenced by academic authority. Is he rare because architects have to live or because they are not sufficiently alive—and so not fit to live as architects?

The Trojan Horse—Confidential

Germany, 1910. After Kuno Francke's admonition at Oak Park, "Your life will be wasted here, do come to Germany," I remember Herr Dorn, majordomo of the world-famous Wasmuth Publishing House of Berlin once introduced me, when I first arrived, as "the Olbrich of America." Curiosity aroused, I went to Darmstadt to see Olbrich, only to find that the famous German architect had just passed away.

About fourteen years later, when several German architects of whom I had then not heard— Mies of the Barcelona Pavilion, Gropius of the Bauhaus, Curt Behrendt of Prussia and, later, Erich

Mendelsohn of the Einstein Turm—came over to America—I welcomed them all as sincere advocates of the battle for freedom in the dynamics of a new architecture. They knew in 1910 that I was waging a one-man war. Some twenty years or more later, it appeared that Mies (owing to Hitler's closing of the Bauhaus) was available for the post of leader at Armour Institute. The motion was seconded by me with what influence I had. Mies first arrived at Taliesin, before taking up his post in Chicago. He stayed with us there for a fortnight, speaking no English. Soon to be inducted at Armour; a banquet was given in his honor by the A.I.A. in the ballroom of the Palmer House. Mies, feeling himself a stranger, did not want to go unless I went with him.

The banquet was standard as those things go but a fulsome affair, functioning chiefly through the A.I.A. M.I.T. President Emerson read an unctuous falsification of modern architecture. Speakers of welcome, all face down to modern architecture from abroad, followed suit. All this seemed false to me and false to Mies as well. But, Mies, of course, understood nothing, sat ready to read the twenty-minute paper he had written in German at Taliesin. I was sitting next to Emerson on the raised platform where the principal speakers were gathered to honor modern architecture from abroad. Next to me sat Mies. By this time I was wondering: why not let Mies speak for himself and be properly translated? But when finally his turn came I put my arm around his shoulders, led him to the podium and said, "Ladies and Gentlemen—Mies van der Rohe! Treat him well. He will reward you. He will now himself address you. He is worthy of any support you can give him. Ladies and gentlemen, I give you Mies van der Rohe." Accent on the *I*. Then, displeased, turning the podium over to Mies, I left the room, not because I did not understand German but because the whole affair had made me feel the attitude toward both Mies and myself was false; just as false to itself; another proof that modern architecture for the A.I.A. had to come from abroad. A.I.A., in one way or another, was itself from abroad—mostly Beaux-Arts à la Paris. The fact that modern architecture had been originated by a contemporary in Chicago was simply not to be borne.

Well, the twenty-minute paper Mies had prepared in his own language he proceeded to read in full, all expecting a proper translation. My friend,

Ferdinand Schevill (Chair of History at Chicago University) was present. He said that Mies' paper was to be translated by A.I.A. president Woltersdorf. Woltersdorf appeared, shuffled his feet, cleared his throat several times, looked toward President Emerson for help. Finally he said, "Ladies and gentlemen, Mr. van der Rohe says he is so sorry that Mr. Frank Lloyd Wright left so early." And that was all the assembly ever heard or will ever know of the van der Rohe acceptance speech on his American debut—unless they understood German or have since read a copy that may exist, somewhere.

Said Dr. Schevill later, "Frank, Mies van der Rohe's speech throughout was a splendid tribute to you. Obviously this was not what these A.I.A. sponsors wanted or expected. Thus—clumsily—when it appeared, they cut it out."

Consequences

Nevertheless the straight-line, flat-plane effects, the new shapes of shelter I had published in Germany (1910) and France (1911) have, by stimulating worldwide imitation and some true emulation, scattered far. As one consequence, temporal novelty often appears upon our urban streets; and façades more quiet than usual. They not only loom upon our urban streets, but ride our housing in countless subdivisions. But as yet, *no deep satisfaction*. This "modern-architecture" we see as a negation in two dimensions. An improvement? Yes, but with too little evidence of the depths of the architecture conceived according to Principle, built from inside outward as organism. The essence of construction itself is yet haphazard or old-fashioned steel-framing of the box. Natural elegance, the true serenity (due to indigenous character) of an organic original seems likely to be lost: sterilized by studied stylizing or by careful elimination of all ornament and pretty much all but the box-frame with a flat lid. The tranquil emphasis on space as the reality of the building is mostly missing. Parasitic practices appear everywhere, credit given to this or that new name. Always new names. But no matter how many, such derivations from the outside in all run dry. Then there are the novelty-façades that have appeared in our big cities, usually façades glassified as steel-framed boxes, often great mirrors acting as commercial posters. Fair enough! But why call this

manifest advertising in the abuse of new materials, architecture? Is it possible that the City is entitled only to such negation?

Nevertheless a conscientious architect learns to understand the nature of human nature so well that the character of his structural ability may eventually justify calling organic architecture man's love of life presenting man to Man. Democracy needs this inspiration to keep democracy alive and the American people free.

■ Meantime pseudo-scientific minds, like those of the scientist or the painter in love with the pictorial, both teaching as they were taught to become architects, practice a kind of building which is inevitably the result of *conditioning* of the mind instead of *enlightenment*. By this standard means also, the old conformities are appearing as new but only in another guise, more insidious because they are especially convenient to the standardizations of the modernist plan-factory and wholly ignorant of anything but public expediency. So in our big cities architecture like religion is helpless under the blows of science and the crushing weight of conformity—caused to gravitate to the masquerade in our streets in the name of "modernity." Fearfully concealing lack of initial courage or fundamental preparation or present merit: reactionary. Institutional public influences calling themselves conservative are really no more than the usual political stand-patters or social lid-sitters. As a feature of our cultural life architecture takes a backward direction, becomes less truly radical as our life itself grows more sterile, more conformist. All this in order to be safe?

How soon will "we the people" awake to the fact that the philosophy of natural or intrinsic building we are here calling organic is at one with our freedom—as declared, 1776?

The Expedient

Circumstances I have been describing indicate lack of spiritual insight inspired by love of our own nation.

The old-time "committee-mind" is the devil's advocate in education, being justified there by the teaching of "teamwork" as safer substitute for inspiration. This justification is admission of spiritual failure. As a people we remain comparative strangers to our own life in our own time in our own home: native culture waiting in vain on our door step. Our foreign relations—nationalities abroad—seem to have inherited better perspective. Having once enjoyed a culture of their own is it easier for them to recognize indigenous culture when they see it? The peripatetic cliché, shallow by nature, is their expedient too but it cannot, there as here, wake up the average business mind in commerce; although there too, whenever this mind says *practical,* only *expedient* is meant. They say that substitutes are everywhere preferred to originals in America because originals, having more character-value and strength, are not so easily controlled and exploited as the substitute. Nor can imitation ever do more than insult original inspiration. Imitation is always insult—not flattery.

The Substitute

The national recourse is the substitute, freely distributed in mutual byplay between the kind of journalese-architect, popular educator and museum-director—purveyors of the fashion—all more or less in the business of themselves—therefore all "busy" with such activity as I have described. For this, if for no other reason, degeneration of creative ability in America has had ample support, and what nobility our society might still have is in danger of being submerged in overwhelming tides of rising conformity. The artist-teacher too becomes only a conformist trader when he should by no means be either. Knowledge of principle as creative is still behind us or under foot, the uncommon slandered on suspicion and left to be revived by the youth of the future.

Meantime the multitudinous substitutes for indigenous culture cannot grow. Having no roots, they can only age and decay. Studious, sincere youth retires, defeated. American youth, capable of becoming serious competent artists, under such pressure as this on every side, confused, try not to give up—or "fall in line." This is the nature of about all that can be called American education in the arts and architecture at this time. As for religion true to the teaching of the great redeemer who said "The Kingdom of God is within *you*"—that religion is yet to come: the concept true not only for the new real-

ity of building but for the faith we call democracy. Nevertheless and notwithstanding, I have wanted to *build* this faith—life-long.

"The Common Man"

Our schools today, busy turning out "the common man," seem to be making conformity a law of his nature. The study of architecture is often relegated to the abandoned military shed or the basement of our educational institutions, and the old adage— "those who can, *do*, those who can't, *teach*"—was never more truly descriptive of purveyors of "the higher education" in architecture. Life-long I have been shocked by the human deficiency capitalized by American education.

▨ Many of our young men are eager, groping; hopeful that our civilization, now over a century and a half old, may still wholeheartedly desire indigenous culture and enable the fundamental distinctions between art creative, science inventive and taste intuitive to be learned by schooling. But they are fed prejudicial comparisons instead of the results of patient intelligent analyses or performance based upon nature-study encouraged. Forced to choose this or that personality, they must give up trying to find their direction within themselves, their powers of interior analysis weakened and confused by stock comparisons. Comparisons made by whom? By those who themselves have been bred upon similar comparisons—all odious. No wonder that persistent analysis based upon actual experience is so rare.

Also, "Truth told with bad intent beats all the lies man can invent."[3] Truth faces this travesty today.

▨ This is no exaggerated indictment of our nationwide neglect of basic experience and principle as a qualification. Regents, curators, professors and critics, with too few exceptions seem paid to honor by comparison—still unable to go deeper into the vital nature of art. Should our life be either ready-made or made to the measure of this conformity, by casual journalese or the prophets of the profit system? Why should it be essentially influenced by such personal opinion as our critics and museums seek to inflict? The answer seems to be that education has not learned to draw with firm, courageous hand the dividing line between the merely Curious and the truly Beautiful; and knows culture only by rote or hearsay or taste. Science may easily mistake the curious for the beautiful and often does, instinctively preferring the curious. For evidence we need only go

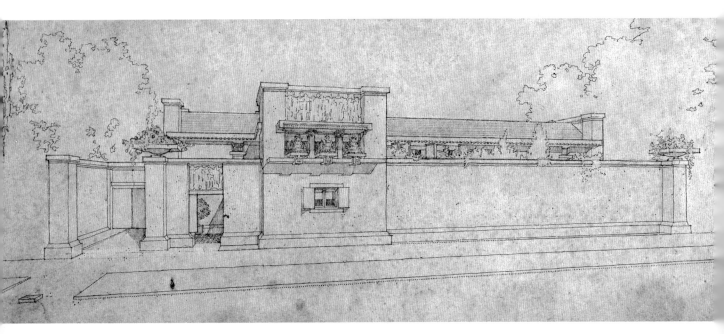

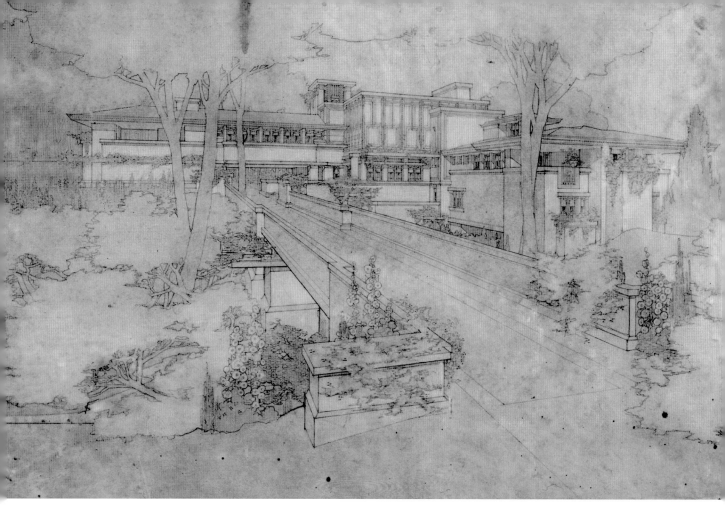

Sherman Booth House,
Glencoe, Illinois. 1911. Project.
FLLW Fdn# 1118.001

to the buildings in which scientific education unwittingly administers paralysis of the sense of beauty to the optic nerve. This fatal defect in "the higher learning" is tragic and can only beget servility to our "catch-as-catch-can" culture. Reform only means more conformity. It is form first that is needed. And it is not to be found in sporadic endeavors to remodel our lives by imported aesthetics—even if we import our own export. We will not be able to maintain faith in democracy merely by profit-system equipment, nor help it grow by the conditioning our youngsters receive in the name of education.

Frank Lloyd Wright Home and Studio,
Fiesole, Italy. 1910. Project.
FLLW Fdn# 1005.001

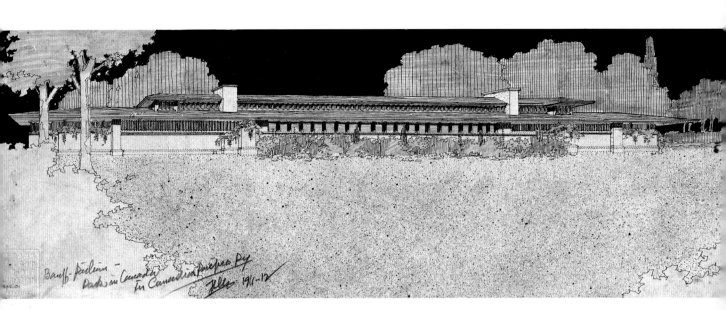

Banff Pavilion – Park in Canada In Canadian purposes 4 FLLW 1911-12

The Need for the New American

New enlightenment and courage is needed to help resist such influences. The soul of any civilization on earth has ever been and still is Art and Religion, but neither has ever been found in commerce, in government or the police. We cannot long console ourselves with the thought that we are at the mercy of a numerical materialism. Votes are counted. Yes—but vision can neither be counted nor discounted.

▥ Our good hope lies in the hearts of men and women of vision rather than in the minds habituated by such education as we now provide. Democracy's best hope for survival lies in, let's say, the upper middle third of our American families—the better units of our present society. In the communications we at Taliesin receive daily from students in the high schools of the nation, I see teenage interest in architecture already evident there: Dynamic spiritual force, parallel to the spirit of our democracy itself—when not pushed too far scienceward or arrested by conformity; or when not too sentimentally inclined by parental sense of tradition or confused by the categorical-imperative in art—is now organic and therefore poetic. Art expression is by nature romantic; and this awakening interest cannot long survive without

a sound philosophy to give it direction and true religion to give it emotion. Both Art and Religion are on the way. Both must go hand in hand as ever before. Both together illuminating our sciences will constitute the soul of this civilization.

Man above Law or Law above Man

By attempts to keep man-made law alive when by nature it is dead, the spirit in which law was made is betrayed and so is law. My father taught me that a law is originally made to prevent or cure some timely, manifest evil; the law usually made by "experts." (An expert? Generally, a man who has stopped thinking because he knows!) So whenever court judgments continue to be based upon "the letter of the law," long after the good intended by the letter goes out of it, judges defy its sense and betray justice. The law, whenever (too often) put above man, ceases to shed the light of reason. Justice then becomes, not true servant of the humanities, but mere routine; and so we fail of democracy, robbed of our title to manhood. Again, the calamitous drift toward conformity. Again, fear instead of reverence for life as hoped by our forefathers. Again, "bigness" legally engendered—by standardizing human beings into "the common man."

Banff National Park
Recreation Building,
Banff, Alberta,
British Columbia, Canada.
1911.
FLLW Fdn# 1302.001

Midway Gardens,
Chicago, Illinois. 1913.
FLLW Fdn# 1401.0032

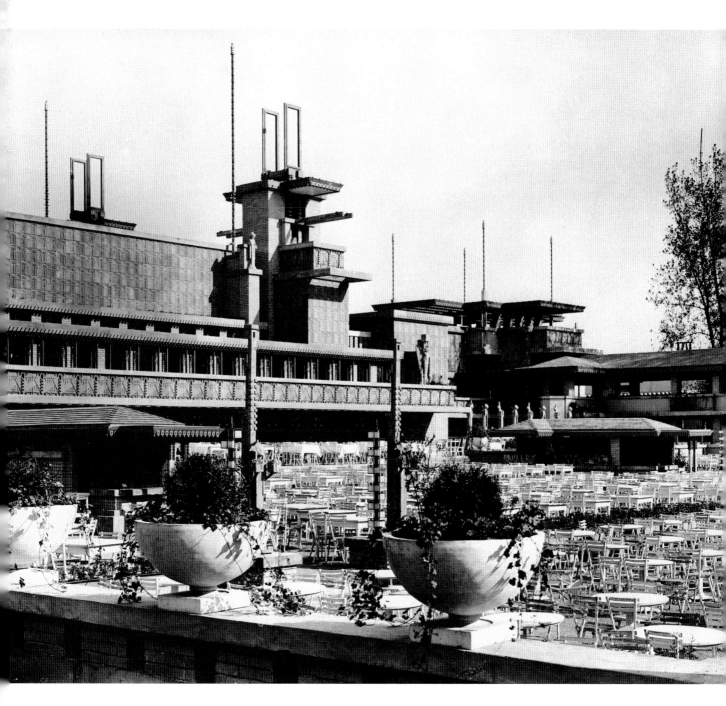

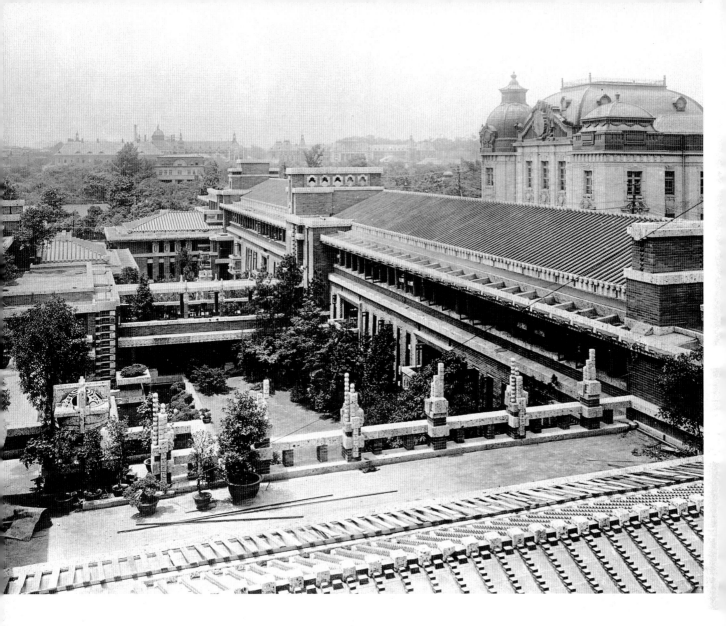

Imperial Hotel scheme #2,
Tokyo, Japan. 1917–22.
FLLW Fdn# 1509.0095
and 1509.0098

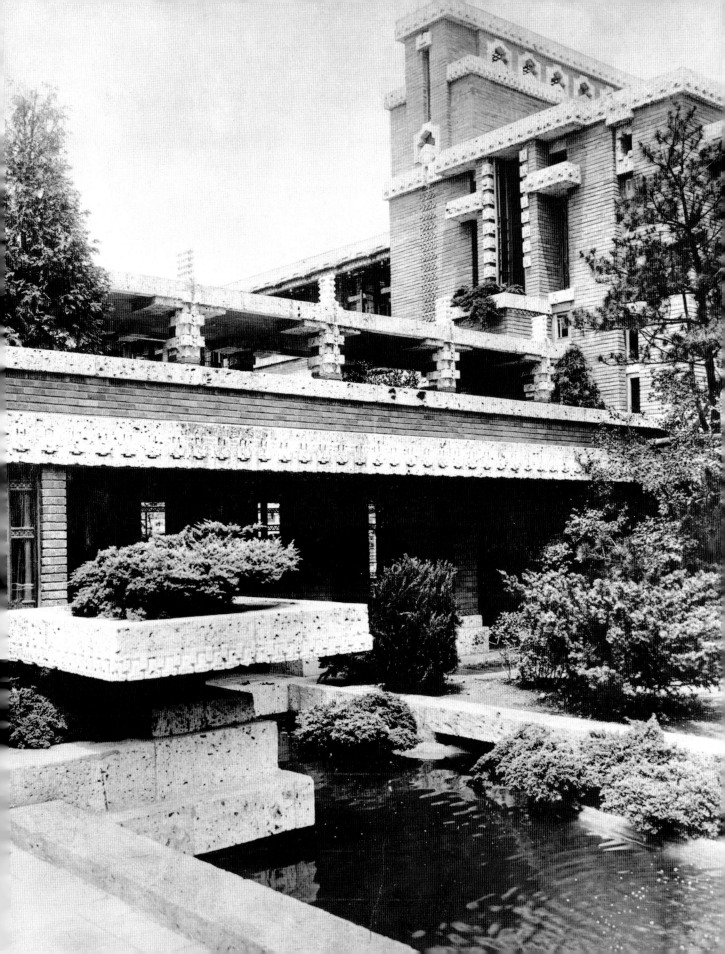

Yes, and because the "common" man is a man who believes only in what he sees and sees only what he can put his hand on, he—the hero of "all men are created equal but some are more equal than others"—is by lack of vision made to become a caricature of himself.

Do not call this exploitation of massology—Democracy. Mobocracy is the more proper term: When any man is compelled to sign away his sovereignty as an individual to some form of legalized pressure by government or society or to some kind of authorized gangsterism democracy is in danger of sinking to communism. This shall not be our fate.

Walt Whitman—Seer of Democracy

When Walt Whitman, asked for the cure for evils of Democracy, replied, "more Democracy," for us he touched a great truth. But patriotism can eventually become "the last refuge of the scoundrel." What did our poet of democracy mean by *democracy*?

The terms of democratic salvation may only be found deep within man himself by his comprehension of the basic principles of nature and of his own human nature. Then—without popular prejudice, sentimentality or fear—we will achieve the native culture we can *honestly call our own*. We will reach the expressions of our own democratic nature by probing the depths to discover our one-ness. More important than war or "segregation" is this original idea of "integration"? Integration that lies implicit in life as in art, architecture and natural religion.

Beginning

Back to the Froebel kindergarten-table. Presented by my teacher-mother with the Froebel "gifts," then actually as a child I began to be an architect; unless long before, when I chose my ancestors with the greatest care. So this son of a teacher-mother and a musician preacher-father grew up blissfully unaware of worldly conflicts in our brave experiment in human liberation, as here presented. Many years later when I had grown up and began to practice architecture it was in time to become keenly aware, perhaps too zealous, where the social situation I have been trying to describe was a concern; thus earning the epithet "arrogant."

Looking backward now: When I put the gold letters "Frank Lloyd Wright Architect" on the plate-glass panel of my office door in "The Schiller," 1893, the causes of the cultural lag I encountered lay in the social bias created by growing eclecticisms in the practices of the A.I.A. Dead-sea fruit of inadequate architectural education. The true character of American life was being submerged.

Nevertheless—rather more—owing to this social confusion of ethics in our ways and means, there was growing up native strength enough to keep faith with this vision of the new birth in art and architecture, the awakening prophesied by the great French poet: first made imperative by the American Declaration and Constitution. We have come thus far to see the end, forever, of "restatement" as creative art. We know that the beginning of all true significance in great art must be not only appropriate but parallel in philosophy to our faith in man. The fundamental new freedom in architecture was on record about 1893; the new philosophy in architecture came to parallel in art what had been so bravely asserted by the original statesmanship of 1776. American architecture confirmed the prophecy of Victor Hugo by becoming action; beginning to feel sinews anew, take on vital flesh, lift its head high for new vision. New forms were born—forms natural to freedom! Shapes in building, unfamiliar but peculiar to the modern circumstances of machine-technique, were then evolving. Engineering advances by adventure in new machine-age materials and techniques began to be natural and many of these are to be seen in the illustrations herewith. For the first time, then, new straight-line, flat-plane, "streamlined" designs, adapted to machine uses, became more or less familiar as technique to architects (imitations of these effects you may buy today as a cliché from the plan factories). These new effects were born with a new sense of integrity. They were not unbecoming nor devoid of human grace. Call that grace: ornament. Even though a disgrace, machine-made, ornament stayed and still thrives.

But no sincere help for "the new reality" was found in any authoritarian body, either Beaux-Arts or A.I.A. No jealousy is comparable to professional jealousy, so this trait was to be expected by the new architecture to say nothing of a new architect. So

the New by sheer force of character was compelled to break through neglect and barriers continually arising and due to private and public indifference, animosity or fear—the dominant characteristics of "culturists," promoted and patronized by machine-masters, themselves becoming merchandisers of "the Past." Our tradition was the inexorable Past. As regents and leaders, these would-be bulwarks of tradition had and still have ownership in the realm of education. Worthless traditions were "safe." Ideas not utterly archaic but traditional were alone respectable. This graft upon the future still called conservatism. As a matter of fact our social register itself was then not much above a market record. Family and especially official society, if unconsciously, made merchandise of itself. All purblind cultures were thus on sale, our "57 varieties" were made available by the A.I.A. itself to the elite who kept on buying by taste—and regardless.

░ Thus culture at the time I was entering the practice of architecture seemed to be hopelessly involved with making a living. It was this mongrelized affair which had never learned the values of native beauty or even realized the virtues of original beauty. The meretricious substitute everywhere: the elite, enthusiastically all looting "from abroad," were scavengers in the name of "refinement." William Randolph Hearst was perhaps ideal exemplar in this class though he had powerful competition. American wealth quite generally founded "modern" museums, and art institutes were dedicated as educational enterprises to this or that; town libraries all over the country were thrown in. An amazing mass of perfectly good material was to be found there, all wrong in the right places or right in the wrong places. Too many of these public benefactors were simply buying tickets for a preferred or at least a respectable place as a reward for these virtues to be conferred in the hereafter?

░ Reading here like merely a sordid old-wives' tale, this dreary addiction to excess by American success was really a teeming hive characterized by will, speed, ruthless competition, contradiction and fury but always action, getting the unintended insult to the fore with amazing hindsight. For my part, by this time on my own, the master (L.H.S.) gone—I faced this tantalizing and threatening chal-lenge to what I stood for: the end of which is not yet seen—if ever? Can co-existence be effected between body and soul by science? No. By art and religion? Yes, together with science. I am bound to think that we in America have the answer in the principles of building called organic architecture.

Inside Out—Outside In

In order to become national reality, this intrinsic philosophy (new and yet so ancient) now interior to the competent architect as man or creative artist, must, so I see, destroy any cultural or educational fetish whatsoever; especially destroy the fetish of "a style," a cliché.

Yet to come to modern architecture, as official, in this world is *Style* as style for its own sake. But never—now—should we in America be caught in the fetters or the talons of *a* style. Certainly not, when natural building is free to live from within outward with our magnificent new equipment. Already the Idea is again vital and fascinating. The triumph of spirit over circumstance is evident nation-wide. This expression of idea if genuine has always had style and so always sure of popular appeal. "Style" is becoming an American "natural."

Part Two: Form—A Birth

Again to architecture comes the serenity of the right idea; human integrity is in action. True significance of line, color and form is now the very method of construction. Principle itself is looking out from our American habit of thinking about planning not only buildings but planning the new city; developing this beauty in our villages by appropriate uses of ground: learning now how to build and dwell in a building as a work of art: dwell harmonious with our own Time, Place and Man. We need be apostate no longer. Now we are apotheosis, able to master our vast facilities of machine power and the sciences.

░ New methods and new means continue to arrive. Well-adapted forms may be seen based upon Principle instead of Precedent! Instead of the incongruous selecticisms, ambiguous forms of a dated aristocracy, forged by illegitimate taste upon the legitimate

patterns of machine craft, here come the concepts of genuine forms to rescue character from ruin by false leadership or any hangover from the Renaissance: perhaps rescue America itself from recession? Our era is still young, yet more or less nostalgic, so Victorian in spite of our progress. The motorcar is yet a wagon trying to digest four wheels when ruts no longer exist. Etc. But Ruskin and Morris are now "once upon a time." Going and gone also are the ites and all isms of the modernistic. The rational is no longer inimical to art and architecture or the reverse. The spirit may live anew.

New Philosophy

This philosophy of organic character develops new strength; timely apprehensions going deeper (and wider); penetration into the heart of "matter"; the true nature of a new building-construction is now indigenous. When understood as a principle it applies to architecture anywhere on earth. The great mother-art, Architecture, is still living. Never in history has timely philosophy asserted itself in action more quietly or simply. Witness, here, Unity Temple, the Taliesins, the Hillside Home School and the Larkin Building. Amidst turbulent changes a way of building has brought to our society a new integrity. Principle recognized despite our hectic superficiality. Integrity has been proved feasible in actual practice. These simple buildings themselves show architecture to be *organism,* based upon: "part is to part as part is to whole." Only such entity can live. Inevitably this nature-concept was individual in architecture as it was individual in the Declaration of Independence and characteristic of the nature of man himself. Wholeness of humane expression in architecture is now assured. Never again could successful building be otherwise. "Such as the life is, such is the form."[4]

Poets, Jesus and Laotze leading them, have so declared from time to time. Poets the "unacknowledged legislators of the world"; preservers of the human race. Laotze expressed this truth, now achieved in architecture, when he declared the "reality of the building does not consist in the roof and walls but in the space within to be lived in." I have built it. When Unity Temple was built this sense of interior space began to "come through": 1906.

New Integrity

To Americans thus came natural, free building. For mankind *the ideal* of man free, therefore his own building humanistic. Both these freedoms I understood then as now to be basic to all our modern art, parallel to the *idea* by which we live and have our being as a people. This is the meaning of democracy. Architecture will never long be satisfied by the shell itself nor by anything done to it in the name of Architecture. It will now be conceived only as integral feature of Interior Space. Because of this more humane sense of cultural integrity by this new way of building, entity is born to put an end to mere machine-age depravity in our culture. This new ideal to shape appropriate environment for life—free—is now true determinant of technology and no less of style!

Principle before Precedent

Here then is new "school." Principle-before-Precedent. Negation of the national current of haphazard, standby, knockdown taste: new basis for all kinds of aesthetic or ethical achievement. A new "school" able to turn right side up almost all perversions by modern*ism,* enabling the architect forever to prevent the return of classicism. Struggle for natural performance in American architecture begun all over again. To continue . . . how long?

In any case liberal in thought means liberal in art. The nineteenth century has given birth to new achievement: comes in time to be in tune with the awakening prophesied "late in the nineteenth century or early in the twentieth . . ." Now comes a twentieth-century architecture. The mother-art of civilization should be able to live no longer tied down by formalistic fashioning nor be put into harness or into uniform either by academic education or political authority; be further stultified by science or vulgarized by commercial success. Our human environment may now be conceived and executed *according to nature:* the nature of Time, Place and Man: native as was always natural to cultures wherever life in the past was strongest, richest and best. The level always highest when *native.*

This upshoot of indigenous art is already dedi-

cated to our democracy: alive none too soon, organic expression of modern life square with our forefathers' faith in man as Man. Sovereignty of the individual now stems true as the core of indigenous culture in the arts and architecture. Yet to come to us as a free people is the organic *religion* natural to this new era of organic faith in man. Organic economy would naturally follow. Sovereignty in this sense of a new religion is needed to go hand in hand with man truly free. Human sensibilities, little by little, are opening to vistas of the new America.

"Normalcy"

The more any building as Idea is true to the Idea itself the better I like the building. The more it is likely to be in itself a free wholeness of expression of the Idea. It stands then for the ideal building that would be wholesome as a work of art. And the more the home is a work of art in our society now the better even for the selfish property instincts of the owner.

What is called "efficiency" among us is to be regarded with suspicion, or impatience, because it has too little sympathy with the deficiency that now goes with it. The alcoholic, the chain-smoker or habituate in any form has, for me, a claim upon pity too strong to be borne. I have always regarded him with wonder or suspicion. So to be a doctor was not an ambition of mine. I believed that all was possible if in full accord with nature. I believed that less than this was the result of either poverty or sin.

So I have grown up intolerant of any "falling short" by way of pretense, artificiality, limitations or scholasticism or of any form of brainwashing. Insufficiency of any sort becomes increasingly the mortgage on freedom. Mercy is a divine quality, and always somewhere as a quality of my soul, but too often severely "strained." If mercy was spontaneous (genuine) I loved the quality of mercy, perhaps most of all, divine. But I have always hated "efficiency" *per se,* as I see it standardized in American life in big or little business. No less hate it in daily life as the "E Pluribus Unum" of success. Life thus overorganized is always deficient, soon becomes a form of imposition.

What I am trying to say is that life is fullness of love when *normal to the human being* and it is so either in the realm of ideas or in the nature of building—or conduct. Body, if used as and when *guided by spirit,* constitutes man's true virtue and the quality that distinguishes him from the brute. Exuberance has always seemed to me constituent good health. Poverty of any kind I view with deep dread as a kind of punishment flourishing upon deprivation. Exuberance to me early meant ecstasy of love, the poetic principle of life. Therefore, Beauty, as the poet Blake said it was. In this sense I have loved life with pertinacity and delight in ever new phases of idealization—in which love itself is realization. These eternal springs of inspiration never run dry for the human spirit in love with Nature's exuberance. Through lack of this life-given exuberance, love from within, the fountain-head of Art goes dry.

The "classic" was excess negation by rote: dry. The Renaissance became a dry tree. The "tree dry" was William Morris' withering symbol for jealousy or hatred. To this day it is so to me. Nature's own inexhaustible fertility is manifest exuberance, and never less than the elemental poetry of all her structure. So it will be in the structure of all our native culture when we do arrive at a culture of our own. The love we know as beauty and the beauty we know as love will be natural to our civilization and no longer will every prospect please while man alone is vile. I propose as the symbol of this love—the tree.

The Nature of Nature

I would here again eliminate confusion too often caused by my use of the word "nature." So many years ago when I began to write and speak upon the subject of architecture I used the word to mean "the interior essence of all cause and effect." My sense of "native" thus took the inner nature of the poetic principle to be right in whatever it might consist or make manifest. *Truth,* this was, of any object or condition: this was to me the innate sense of *origin.* The original.

According to my training at my mother's kindergarten table this was the activating *cause* of all visible effects. Nor, later, was it necessarily moral, but always ethical. For instance, the essence of a brick,

of course, lies in its brickness. In a machine it lies in its dependable mechanism. The same of a human heart, a sinew or a screw or any interior activating impulse or synthesis; parts whether of a pump, a brook, a stone; sex, a scoundrel or a poem. All this became inexorable thesis of man as a whole. Innate sense of scale then was proportion. Really investiture of life in our present time—not to be distinguished from all time? I have continually asked myself this question. What is the great or small difference between "then and now"?

What is this life of ours today; is man in his new place in Time? What kind of Man is this man of today? What of his civilization? Nature is how now? What is Man as he is? Where does this activation of life-force apply to old or new form, and what is substance as he represents it to be God or Devil? What lies ahead of us all now as we wander confused in the capacious lap of Change? Are we really helpless as we seem? What would be the nature of the abstraction that could be intelligently made to clarify and defend us in what we are calling "civilization"? In short, in what does man really consist as he exists in our native civilization?

▦ The answer to all such questions lies implicit in human Nature. I have always wanted to build for the man of today, build his tomorrow in, organic to his own Time and his Place as modern Man. Therefore come these questions about *him*. And what is Art, now? What countenance would his life on earth really wear if not spurious or on masquerade? Of course it should be expression of his spirit and natural to his circumstances. Is it? Now, what Architecture would be *natural* to him? Can any man maintain this prevalent divorce from nature under the new freedom? But is man yet capable to live as the world's "free man"? Would he be capable of *anything* natural as things are with him? For so long has his excitable nervous system been his substitute for soul—how much is left of his soul now? Has modern man, by his taste for sensation and desire for security, become prone to mere expediency? Can his education, too long fashioned upon his expediency, be more than a false moment in history? Has false environment already made him a mere numerical factor, trampling with the herd? Is this atmosphere of ugliness he now endures actually created by him without his knowing it to be the

result of his own confusion of mind? Or his impotence? He has lived so long subject to conformity or conflict that his judgment is atrophied? Has his habit of servility to custom and circumstance become servitude to mediocrity? Or is it that he fears his taste for the "unusual" might shut him in or shuttle him back again to insecurity? (There is nothing so timid as a million dollars.) Why does my brother live as a mendicant in this servility he thus puts upon himself or is put upon him because he puts it upon others? What is this modern man's true nature? Is something deadly put upon him by his false sense of himself extended to others? By being so far educated beyond his capacity is he unable to learn within himself from Nature? Divorced as he is from her, who and what can now be his? Does the so-called free man of democracy merely exploit his sovereignty?

▦ Let us look back. I remember how as a boy, primitive American architecture—Toltec, Aztec, Mayan, Inca—stirred my wonder, excited my wishful admiration. I wished I might someday have money enough to go to Mexico, Guatemala and Peru to join in excavating those long slumbering remains of lost cultures; mighty, primitive abstractions of man's nature—ancient arts of the Mayan, the Inca, the Toltec. Those great American abstractions were all earth-architectures: gigantic masses of masonry raised up on great stone-paved terrain, all planned as one mountain, one vast plateau lying there or made into the great mountain ranges themselves; those vast areas of paved earth walled in by stone construction. These were human creations, cosmic as sun, moon, and stars! Nature? Yes, but the nature of the human being as he was, then. *Entity even more cosmic* had not yet been born. The machine then was but a simple lever in the hand of the slave: man himself a menial, subject to the cruel despotisms of high authority; priests imposing "divine" mysteries upon his lack of a better sense of himself. This he called "divinity" by equally mysterious authority. By the will of despots his hands were thus tied behind his back. He was himself but an obedient tool. His magnificent masonry was architecture beyond conceivable human need; truly monumental. Monuments to the gods of temporal power were laid out and built upon the great man-made stone-paved earth-levels of South American plateau. Architectural grandeur

was thus made one with the surrounding features of mountainous land; made by wasting away the mountains; mountains moved at will by the simple persistent might of the human being multiplied, a man's own strength multiplied by the strength of multitudes of his kind. By such direct and simple multiplication of strength his buildings grew to be man-mountains. All were built as and for grandiloquent religious rituals to stand forever in the eye of the sun as the earthly embodiment of the mystery of human majesty, honoring deity. Thus man was made into, built into, living harmony with surrounding mountains by the physical might of primitive man. Reverence for authority was thus made manifest and mighty by the nature of manpower thus animated. All this great, manbuilding took place with a splendid human sense of primitive resources and the majesty of what was then apprehended as Man's place in Nature. All was exponent of great nature and, as we have called civilization, an abstraction. There was architecture by powerful primitive manpower. Basic it was, but based upon glorified abnegation of man to authority because of what he himself did not know. Such was his worship. His sense of beauty as a mighty son of Earth! Man's God involved with the worship of means to ends then—as now? A grandeur arose in the scale of total building never since excelled, seldom equalled by man either in truth of plan or simple primitive integrity of form. Architecture intrinsic to Time, Place and Man.

Now—Freedom Is from Within

But now the man, potent lever of primitive authority in architecture, has been given even more powerful means with which to build. The science of the Machine. Already a power grown to dominant world-power. Worship of this power has grown by means of the man of science. But science in true human civilization is but a tool. Science is inventive but creative never.

So many centuries later, American man begins to build again. Something has happened to his buildings. Notwithstanding his new sciences, nor due to them, a more powerful vision has come to him, the higher sense of his own soul. This is his own sovereignty—his freedom as native American. Interior vision far greater now even in grandeur of construction, himself therefore more deeply creative as an individual, there comes to him this concept of "might" as spiritual. The dignity and worth to himself of the soul of individual man—a man no longer a tool of power or of a monarch or of any exterior authority, a man not bowed down to sacrificial mysticism but man free. Kingship now of his own soul ruled by conscience and increasingly cultured intelligence. This man has risen: himself gradually coming awake to power even greater than man's primitive power because it is power of the spirit. A new ideal of civilization arises based upon freedom of man's mind guided by his conscience. In view of this new abstraction the past subsides. Ever higher come new interpretations of old power by man's new might. Spirit is man's new power if he is to be truly mighty in his civilization. Only Art and Religion can bring this new vision as reality to a nation. Only the free man brings freedom. This new sense of life comes to his own nation and to the modern world as well. So Art and Architecture, soon his Religion too, must be new. The spiritual dignity of this new humane life for mankind, is the Spirit of Man himself sacrosanct. America has made this commitment. How are we to live up to the promise of that commitment? Where find the true sacrifices by and for this new man in this new world we call the United States of America?

▓ This new release of the spirit of man comes to pass in our own good turn of time. Therefore to architecture comes a new sense of scale; the scale of the human being, man himself. Greater freedom all along the line of habitation becomes not only his desire but his privilege. A great simplicity is now his; the simplicity of perfect organism may be his in what he does. Human dignity based upon union of man's physical nature with his spiritual sensibilities.

His philosophy henceforward will cherish this freedom he has accepted and is endeavoring to establish for himself. But he has not yet wrought this new philosophy into terms of his modern life as the old philosophy of the ancient primitives was wrought into theirs. When he has done this, his dangerous new tools instead of the practiced human hand will be used by him to make his liberation not only wishful theory but actual life—incomparable. But if they are not so used by him, a greater enslavement than ever now looms for him. Man either learns to use for

humanity his new facilities or he perishes by them. A true sense of this new power in building-construction is basic to his civilization now. In architecture he will still find the basis of his new culture. At last this realization is dawning upon him.

In the realm of his own imagination come forms found only in freedom of spirit. Space outflowing instead of static containment. Liberation a fulfillment. Architecture no longer any kind of fortification but generously spacious and plastic. Thus expression of the new freedom no longer aggrandizes exterior forms of power but truly liberates man's sense of himself as Man. Instead of fortifying life by extraneous means and remaining subservient to ancient earthly gods—now comes our revelation that man conceives nothing higher than the soul of man himself and when he interprets himself from within, his outward expression will be all the heaven he could imagine and so desire. We call him thus, in himself, great Architecture. Trusting the great "becoming" as always he is in himself the omnipotent Idea. Forever becoming, always on his way to life eternal.

Thus comes to us the new sense of the true building: free in design, poetic but no less, even more, invulnerable shelter from the elements. Space free—space *flowing outward* by way of forms appropriate to life and circumstance. Appropriate *in human scale,* significance comes alive and works for mankind more at one with the character of man's spiritual nature.

For instance, here see the third dimension becoming a fourth; the architect's sensibilities throughout as creative artist becoming aware of democracy in a medium appropriate to his new life. Daily needs are no longer met by the old inappropriate architecture. Sound and practical these poetic liberations are when seen. The straight-line, stream-lined, flat-plane effects appropriate to proper use of his new advantages in this age of the machine are quiet but in the quick. Architecture is of elemental beauty again and of increased service to mankind.

The European Contradiction

This concept of architecture as organic, as expression from within outward, is twentieth century—a new sense of building entirely. The concept a "natural." Out of this concept comes interpretation of the third as a fourth dimension: the third seen not as thickness but as depth. Independent of any European influences whatsoever this twentieth century contribution, as a negation of previous concepts of architecture went to Germany, 1910 or earlier. And this—although originally an *affirmative* negation—became, in the European nineteenth century contribution, a negative affirmation, still applying to the old bridge engineer's concept of steel framing—structure from the outside in—the brittle box emphasized as brittle. Unless much mistaken in what I see at the core of the effort I am afraid it has too long remained so. Now past the middle of the twentieth century, European architecture is still nineteenth century in concept. Louis Sullivan's buildings were nineteenth century prophetic; the European contribution is nineteenth century reminiscent.

Yet almost all of our architecture here in America still speaks with foreign accent. First the accent was British, then the accent was French, then German.

▥ Simple truths of the nature of the originating idea of modern architecture from the outside in and the space concept—are just beginning to be recognized by our critics. The new architecture was never so much "functional" as it was dynamic humanism. Solidly based upon the new humanities and modern sciences as the cornerstone of our genuine American culture, it has lacked penetrating criticism. Dynamic forms true to democratic sentiment would become more expanded and extended had such interpretation been forthcoming: life would have become by now more humane, imaginative and colorful. All this has passed unrecognized by current "criticism." In the practice of the dated cliché, our modern riches have gone by default into a sterile classicism: the steel framing of the box. (Don't go near the window!) The crack in the picture-window is widening.

Discovery

From the prophetic nineteenth century work of Louis H. Sullivan, twentieth century architecture issued by way of the Hillside Home School, the Larkin Building, Unity Temple, the Coonley and Robie houses, the Imperial Hotel and the block houses (The Millard, etc.) of 1921 on.

In this connection, I remember Kuno Francke, German exchange-professor of aesthetics at Harvard (one of Theodore Roosevelt's exchange-professors), came from Harvard to Oak Park (1909) with his charming wife. Herr Professor came to see the work I had done of which he had heard at Harvard. Astonished and pleased by what he saw already accomplished when he came: the Coonley, Robie, Winslow and Cheney houses; Unity Temple; designs for other buildings; he urged me to come to Germany. Said Kuno Francke, "My people are groping, only superficially, for what I see you doing organically: your people are not ready for you. Your life here will be wasted. But my people are ready for you. They will reward you. Fifty years, at least, will pass before your people will be ready for you."

I did not want to go to Germany. I could not speak German. Fascinated by what I was already doing, I declined this invitation. Professor Francke soon returned to Germany. Several months later came the proposition from Wasmuth (well-known publisher in Berlin of art works) proposing to publish the work Kuno Francke had seen (all of it) if I would come to Germany to supervise preparation. A few months later, cancelling obligations of every nature in the field of architecture and at home, I went; risking the worm's-eye view of society I felt must follow. There in Germany and Italy I lived and worked for a year. In the little Villino Belvedere of Fiesole, massive door of the villino opening directly upon the steep, narrow little Via Verdi of the ancient old Roman town on the hill above Florence—I found sanctuary. Just below the little villino spread downward to ancient Firenze the slope where so many distinguished refugees from foreign lands had found sanctuary and were still finding harbor. Most of that year—1910—I worked preparing the forthcoming publication in German, *Ausgefuehrte Bauten und Entwürfe*.[5] Accordingly published in Berlin 1910–11. German edition promptly absorbed. Unfortunately the part of the edition bought for American distribution by two of my good clients, Francis W. Little and Darwin D. Martin, was temporarily stored below ground-level at Taliesin, previous to arrangements for distribution.[6] The entire portion of the edition meant for America was consumed in the fire destroying the first Taliesin—1914. (First of three destructive fires at Taliesin.) Smoke rose from the smouldering mass below grade for several days. So America saw little of this original publication in German unless imported. But one whole copy only and about one-half of another now stays at Taliesin with me. The entire work was more cheaply reprinted (smaller in size) in Germany later—also reprinted, in still smaller format, by Japan. *Cahiers d'Art,* France, published a resume in 1911. These publications have all but disappeared.

Incidental

Unfortunately, most of the original drawings made for this publication I took with me to Japan when commissioned to build the Emperor's "Teikoku Hotel" in Tokyo. Disappeared—perhaps because the Japanese covet, and cherish, the work of their masters; therefore of other masters.

For instance, a famous Japanese poet himself wrote a sign "Please keep off the grass"; set it up on the freshly seeded lawn in front of his new house. Every morning the sign was gone. But he kept on for several more days, posting a new sign each morning which he had himself written. Each morning the sign was gone. In despair the poet asked advice of a friend: Said the friend, "Employ a sign-writer to make the sign." The poet did. The sign stayed.

Ornament

Plasticity, a *quality* new to architecture, is directly related to elasticity. What plasticity is to architecture, as I have been using that term, may need explanation. Somehow, as a boy of fourteen—probably deduced from my memory of Victor Hugo's prophecy, read in *Notre Dame*—I had come to regard the pilaster with aversion because it was applied to the face of a wall as pretended construction. So the pilaster became a symbol of falsity to me, or mere applied decoration. By then I was seeing the buildings of European Renaissance themselves as a kind of *pilaster,* as later I learned to see the Greek entablature and cornice as carpenter-work in stone. The Parthenon was really a copy in stone of an Etruscan wooden temple. So soon I throw all that in with pilaster! Both were the kind of arty-pretense I had already learned to call "constructed decoration"—that is to say, ornament found out of place in violation of the organic nature

of materials and construction. Ornament if organic was never *on* the thing but *of* it; therefore little of the ornamentation of the Greek orders seemed more than merely pictorial. Charming but appliqué. This thought had appeared and remained with me: any true plasticity would be a quality *of* the thing itself, never be on it (applied to it). This meant positive negation of most classic ornament of the many "classic" styles. Plasticity therefore dictated ornament as one with structural or interior quality; its place was intrinsic. Yes. In architecture ornament should be organic in character: See nature! Building constructions embodying these ideals were built by myself in the Midwest, 1893, and seen in Germany by the Wasmuth publication just mentioned. At least as early as 1910, these were explained by myself as organic plasticity; the term I first applied to more humble buildings—dwellings. But "plastic" might apply with truth to all ornament in construction. Architecture by nature was susceptible to ornament. If old forms were denied, new ones should be capable of great affirmation. Humanity in the great mother-art would be seen in buildings for America's new place in time. Architecture might, but not by way of plasticity alone, become new and fit for a culture natural to us.

Integration Intrinsic

When these new integers are able to cultivate and enrich the technical uses of art in organic architecture, new significance will have come to the citizen. The vital changes in his life could be interpreted to him and affirmed by his modern art. Were architects to become more interested in Architecture than in architects, architecture might not only tell posterity how man was in our time but *present* him for what he aimed to be. In the spiritual fibre of new ideas, his architecture yet does not tell! To be thus richer in culture he must be alive, more wide awake than man ever was before. This should be because he is better equipped, commands extraordinary facilities now. His responsibility widens with his own stature. All is now fresh opportunity for him; if still beyond his reach—as his lack of vision now would seem to indicate—in his humanity a quality "always sings" and is the virtuous life ever so "beautiful as the morning"?

The young American has yet to learn that freedom is earned "from within": a persistent vision that never for long leaves the man who is in love with the sense of democratic life. Freedom is promised to him by the nature of his government. But government, the policeman, can only guard not bestow freedom. Culture and government dislike each other by nature. In architecture, eventually, ideal freedom is up to the individual.

Exuberant and serene as this new architecture is it should no longer shy at the term "romantic" because organic free-thinking and building *are* by nature romantic; rich in romance of the human heart as ever. "Romantic?" Yes. This romance already stirs in young America because in the young the essence of character is always the originating idea of form. Character is no less fate in architecture today than ever in the life of the man of past ages.

Wherever they are found, organic buildings will belong, solidly based upon the *human* nature of elemental Nature. This nature-wise philosophy of architecture can never resort to the expedient cliché. The petty bias of personal taste can no longer hide either excrescence or spiritual poverty in the name of style. As natural building proceeds, the individual will see building as he is learning to see life. Idea to idea, idea to form and form to function, buildings designed to liberate and expand, not contain and confine, the richer, deeper elements of nature.

The Idea

The idea? In philosophy, the idea is ancient as Laotze but—in building for the occupation of modern man—as modern as the future. Poetic is prophetic insight. The genius of highly cultivated emigrés first gave birth to our nation. Now must come those who make the nation a worthy reality! Such truth of being will characterize those who will eventually bear this fruit, however long neglected—or worse, distorted—either by success or by fear.

So "classic" now is far worse for the cause of freedom than ever classic was before because fresh light has now dawned from fruitful sources within upon man's imperishable soul. If it is neglected, we lose our American birthright.

The social influences of all that science can do, if not interpreted by the creative artist, may be more sterilizing than fructifying. Intellectual is not necessarily intelligent either. At the Chicago World's Fair,

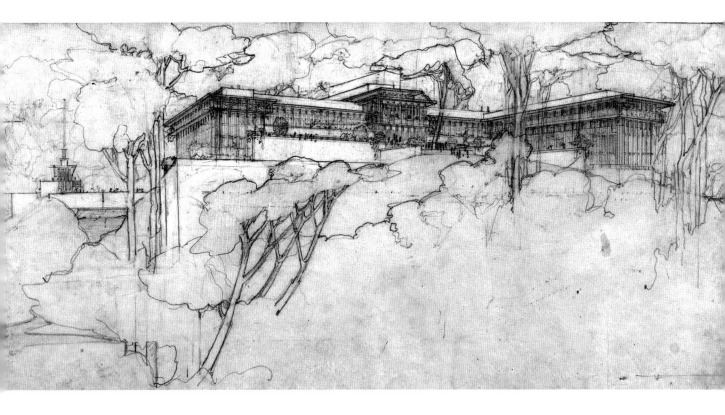

Odawara Hotel,
Odawara, Japan. 1922.
FLLW Fdn# 1706.003

American architecture sadly learned that popular sentimentality has nothing in common with true sentiment and unless, in the architecture of today, the new tools of this era of the machine come in for interpretation and human use in artists' hands a heavy liability will result.

Standardized

Man in his upended street must know he is becoming a mere numerical item of convenience; on the way to being a thing. His inherent instinct for love and beauty is not only becoming suspect but, in spite of all intent, useless to society. He sees the human creature atrophy as he sees poverty of imagination in much "modern art," so-called. But it was Walt Whitman himself who raised the perpendicular hand to declare: "It is provided in the essence of things that from any fruition of success no matter what, shall come forth something to make a greater struggle necessary." This is what is now coming forth in our architecture as in our life.

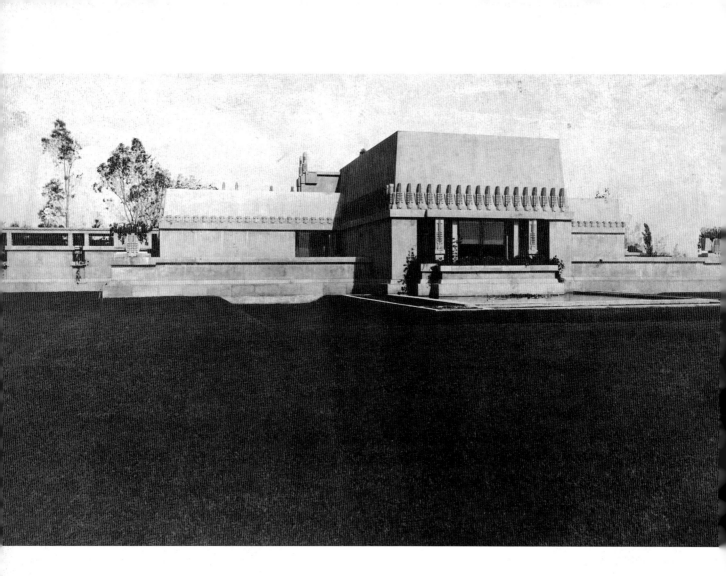

Aline Barnsdall "Hollyhock House,"
Los Angeles, California. 1920.
FLLW Fdn# 1705.0007

Alice Millard House
"La Miniatura,"
Pasadena, California.1923.
FLLW Fdn# 2302.0006

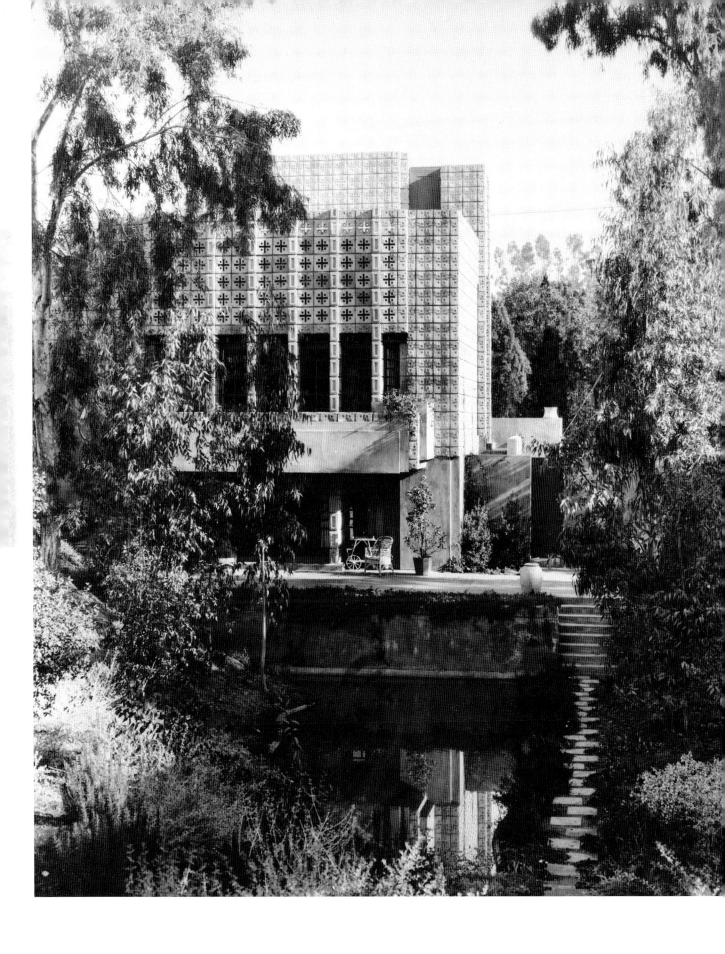

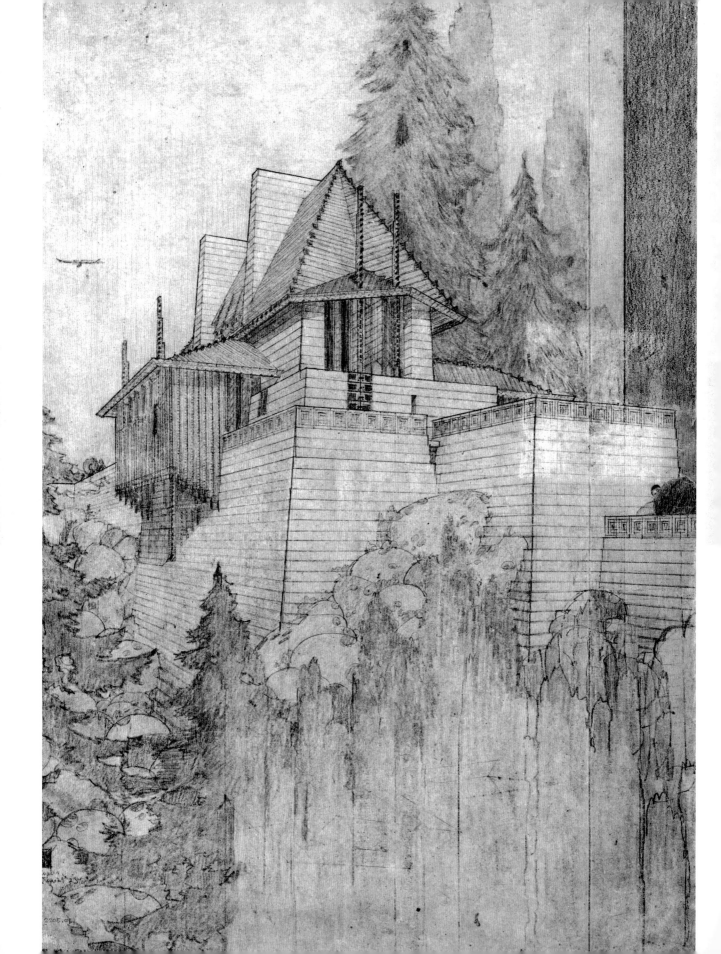

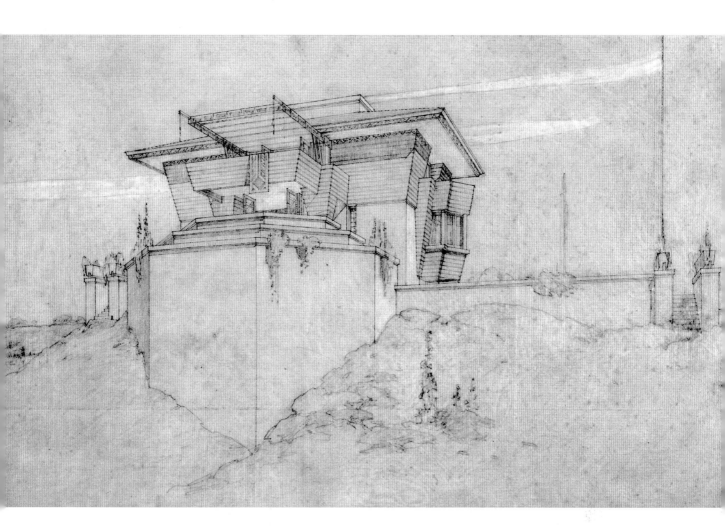

Mrs. Samuel Gladney House,
Fort Worth, Texas. 1925. Project.
FLLW Fdn# 2502.001

Lake Tahoe Summer Colony,
Lake Tahoe, California. 1923. Project.
FLLW Fdn# 2205.001

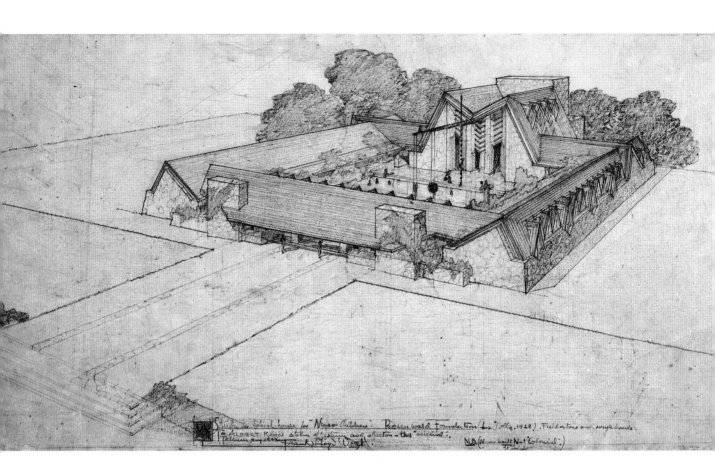

Rosenwald School,
Hampton, Virginia. 1928. Project.
FLLW Fdn# 2904.001

Part Three: Concerning the Third Dimension

Error I

Today, around the circumference of architectural thought, basic error still exists concerning the new concept I have stated of the good old third dimension—usually seen as thickness, weight, a solid. Sublimated by organic architecture, it is interpreted as *depth*. The "*depth*-dimension"—really a fourth now—the sense of space. Perhaps the fourth as sought by the European cubist? The element we call *space* given a new concept. Listen to Laotze again: "The reality of the building consists not in the walls and roof but in the space within to be lived in." Witness organic architecture.

Error II

Concerns our universal power-tool, the Machine. The machine is accepted by organic architecture

only as a tool to a greater freedom: new power to manipulate new materials by new strategy. But the machine has already been so far misused, taken aside from culture, as to become deadly facility, mostly in the wrong direction. By too many architects it is used as a motif or an excuse for one. Or else they are used by it.

Even now, sixty years later, its true significance is rarely grasped and used for what it really is. Promoted now by too many "moderns" in architecture, it is reduced to the status of a ritual, or at least to an end in itself; exaggerating quantity at expense to the quality of human significance.

The appeal of this mechanical facility appears to be to the "pictorial" in art and architecture—an evasion of the nature of construction: the two-dimensional poverty of design seen in the façades of current steel-framing of the box added to this purely negative cliché. Now, we have too many stale derivatives of the straight-line, flat-plane effects originally contributed by organic architecture to Europeans in the early days when it was the great negation. The effects then were seminal but the depth-language of that early time is badly translated when it is separated from its original concept of the depth-dimension. So misunderstood, this dimension again appears as thickness instead of depth. What made these early effects—wholly new to architecture then—possible some fifty years ago and enables them to continue, seems yet to be obscure. Therefore various phases of this original straight-line, flat-plane architecture are still mistaken for negation as, in a sense, they originally were—especially their grammar as it appeared until about 1908. But then came another beginning, revolutionary in character—amazing the consequences—still revelation: A further concept of plan and form to go on with the cantilever and continuity—suitable to new materials and as genuine machine-age technique—but grown richer in human content. No longer confined to the earlier "affirmative negation" the new effects of affirmation, earlier only implied, were now directly involved; and misunderstood by hatchet-men following "the moderns." Having been attracted by the original negation they remain, more or less (if unconsciously) negative.

Commercialized as these latter-day two-dimensional façades appear: empty mirrors or emaciated steel-framed cages criss-crossed, they seem to have no more vitality as architecture of the depth-dimension than the radiator front of a motor car, a bird-cage, a glass box at the zoo or a goldfish globe. These box façades are topped with a flat invisible lid in order to emphasize this box effect. The steel box-frame buildings of modern architecture now make a church, a house, a factory, or a hotel, all appear much alike—creating an impression somewhat similar to that made by a horse with his ears laid back. So-called "modern" architecture has therefore gone as ambiguous as it has gone "styleward" (soon to call itself the new "classic") instead of toward a richer expression of the liberation of human beings made possible by the new facilities of our time. But, though the early ideas of organic design have been exploited blindly, or wilfully, their fundamentals are actually not much damaged except in point of time-lapse. Again unreasonable delay on the part of education and government.

▨ Notwithstanding any abortion, organic architecture is for our own country still on an upward way to richer expressions of our freedom and superior technology, growing out of love of human nature. I still believe that architects are all that is the matter with architecture. I have therefore not yet joined the A.I.A. Instead of the American Institute of *Architects,* as I have said, they should make the letters A.I.A. stand for the American Institute of *Architecture*—and mean just that.

Organic Ornament

"Such as the life is, so is the form." Can the Ethiopian change his skin or the leopard change his spots? Or the turtle be without the pattern of his shell? Expression of the constitution of nature is emphasized, unified, clarified, *identified* by what we call Ornament? True architectural form has innate significance of character expressed and enhanced by the creative architect's organic uses of organic ornament. As melody is in music ornament is in architecture *revelation* of the poetic-principle, with character and significance. Ornament is as natural to architecture of the genus Man as the turtle's shell is to the genus Turtle. Inevitable as plumage to the bird: natural as the

form of any seashell; appropriate as scales of the fish or leaves of the tree or the blossom of a blooming plant.

▨ So every living thing bears innate witness to the need for love, expressing the poetic principle by what we call "pattern": visible in all organism. Creation as eye-music is no less expressive than ear-music because it too is heart-music, appealing too, to human life at the very core. Both melody and ornament reach us by way of the soul of all Creation and as we are made we respond.

▨ By human faculties man is able to produce natural melody of a permanent kind to give more pregnant significance to his habitation. Humanly speaking ornament is true attribute of all human culture. To say, ornament is genuine—is to say it is indigenous. Ornament is intrinsic to the being human of the human being.

▨ No! is always easier to say than Yes. In this matter of integrity of architecture a sense of honor in the human individual has its counterpart. Sympathy and kindness, fine sentiment in the realm of the human heart are in human conduct as the grace and beauty of ornament are to organic architecture. This beautiful quality of thought in the organic constitution of building-construction is fundamentally affirmative. Never can it be negative except as a preliminary preparation for some such affirmation.

Romance

The eternal Law of Change proceeds. Development has wrought and multiplies as growth among us—or subtracts the past. We are increased or diminished—perhaps destroyed. Evasion, imposition, supposition, suppression, distortion, foolish misinformation all notwithstanding, change proceeds, inexorable, and nature her custom holds. The philosophic center-line of future action in the realm of art is thus daily becoming more evident as the changing current of humane thought in human beings. This old-fashioned term "romantic," too, so long and still so often meaning mere affectation or sentimentality is become liberated and liberating. Architecture is truly romantic. There should

lie in the very science and poetry of structure the inspired love of Nature. This is what we should and we do now call Romantic.

The ceaseless overtones and intones of space, when developed as the new reality in architecture, go on, tone upon tone, as they do in the music of Beethoven or Bach, Vivaldi or Palestrina. Like music-totality every good building has this poise, floats, at home on its site as a swan on its lake. Much of the "modern," devoid of this innate sense of music, makes factories of our studios, churches and schools. Education, our greatest busyness, is our greatest deficiency in this matter because it lacks courage as well as enlightenment. It still calls ornament a form of embellishment and, regardless of its poetry, regards it as an impractical luxury. Wherever the question of an *indigenous* American culture comes up to be either appraised or acted upon, the question of its expediency arises, and the expedient is the "pay-off" in terms of money. The cart thus inevitably put before the horse.

But if you listen! You will sometimes hear the language of the poetic principle spoken. And nevertheless, an infinite variety of indigenous art-expressions still come and go in spite of us, especially in architecture. To me, the principles of affirmation were alive and operative even within the original negation, say that of the Larkin Building in Buffalo, New York, as early as 1904, or, about the same time, Unity Temple, Oak Park, or the Hillside Home School I built for my aunts, 1902. These buildings show the principles and should by this time have "come into school." "From inside out" had there been firmly established as a better basis for any criticism directed against, or for, the life of such architecture as lived in our midst.

This is largely the fault of such criticism as reaches us in so many mediums: none of them deep enough or wide enough to see architecture as the cornerstone of our culture, no less than it has been the cornerstone of culture from time immemorial.

The Critic

How is he made? Oftentimes bitter, sometimes sweet, seldom even wide-awake, architectural criticism of "the modern" wholly lacks inspiration or any qualification because it lacks the appreciation

that is love: the flame essential to profound understanding. Only as criticism is the fruit of such experience will it ever be able truly to appraise anything. Else the spirit of true criteria is lacking. That spirit is love and love alone can understand. So art criticism is usually sour and superficial today because it would seem to know all about everything but understand nothing. Usually the public prints afford no more than a kind of irresponsible journalese wholly dependent upon some form of comparison, commercialization or pseudo-personal opinion made public. Critics may have minds of their own, but what chance have they to use them when experience in creating the art they write about is rarely theirs? So whatever they may happen to learn, and you learn from them, is very likely put over *on* both of you as it was put over on them. Truth is seldom *in* the critic; and either good or bad, what comes from him is seldom his. Current criticism is something to take always on suspicion, if taken at all.

Usonia

Samuel Butler, author of *The Way of All Flesh,* originator of the modern realistic novel, in his *Erewhon* ("nowhere" spelled backwards) pitied us for having no name of our own. "The United States" did not appear to him a good title for us as a nation and the word "American" belonged to us only in common with a dozen or more countries. So he suggested USONIAN—roots of the word in the word unity or in *union*. This to me seemed appropriate. So I have often used this word when needing reference to our own country or style.

Imagine for a moment what fertile Usonian manifestations of well-disciplined human imagination our environment might be today if, instead of the panders to European dead-ends, creative thought and feeling had been encouraged, the creative sense of space in architecture properly recognized—and now become intrinsic! If teachers had become *enriched by such experience,* and cultivated it as basic element of their own education, they would have been free to cultivate our democratic vision, might have buttressed our American spirit against the confusion and conformity that beset us now. With their help we might now be able to see spiritual entity as beauty—beauty as ethical—and ethics as more important than morals, or money, or laws. If the meaning of the word Usonian had only thus become truly characteristic of the unity of our national life we would have earned this title, and Usonia would be ours.

Science and the Scientist

The scientist: he who takes life apart but is unable to put it back together again to live. Scientists practice invention, addition and subtraction—but in the teaching of architecture they should not continue to be mistaken as creative themselves. They are one reason why the huge business of education is not on speaking terms with culture and such culture as we now have is not on speaking terms with reality. So long as the scientific, pictorial or business interest comes first in order to make a living, culture—divorced from life as it is lived—will be helpless or false.

The Substitute

The substitute for art and religion has been science.

Indigenous poetry has been leeched from our common life by the "practical" materialistic ideals of industry, education and government. War—ultimate substitute provided by science. Yet the poet is not yet dead and, as a consequence, we are not.

Would you worship life amid this confusion of today, remember again the prophecy by the ideal Man, "The Kingdom of God is within *you.*" By Nature-worship, by way of revelation of your own nature alone, can your God be reached. By this fresh sentiment of individuality that gave America freedom, organic building has come along. If its principles had been comprehended by the hordes of those impressed by its appearance; if its imitators, so quickly attracted by its aspects, had grasped its intrinsic virtue, we would now be well ahead of any controversy now confusing the issue. We might not be called "the only great nation to have proceeded directly from barbarism to degeneracy with no culture of our own in between." The truth is: we are a great experiment still: and all the same a great civilization. But the truth is also we are an amazing ten-

tative culture, in possession of more than we have digested or are able yet to understand. So far as a culture of our *own* is concerned we still thrive on substitutes provided by science in spite of the fact that we *do* now have something to export besides dollars.

It is all too easy for derivatives of culture to thrive in our midst at expense to the original. Society always a coward afraid to acknowledge any debt to origins. How can any substitute ever be good in our nation for the creative artist? Our culture depends on him.

The Monumental

The monumental should now be not so monumental as memorial. Owing to our sovereignty it is high time the scale of the human figure and its elemental, natural rhythms be put into the culture of our architects and by way of characteristic machine-age technique by T-square and triangle made to take the place of the unsightly grandomania of our early days as a nation. Witness our national capital and its progeny, our tributes to greatness. Ironical that a nation devoted to the upholding of law should have become so devoted to illegitimate architecture. But "the monument" is still seen in the mere bigness or tallness that is not in itself natural but tries to match the chronic old syndrome of column, pilaster and cornice. Whereas the modern should have something more noble and appropriate to say. Architecture has no need for monumentality unless as a natural beauty. On any other terms, either public or private, size or tallness is not the point at issue. The question is, has it the significance of beauty natural to *now*.

▥ The wall standing stark is essential monumentality but empty. Such architectural features and proportions as are designed to put the inferiority complex to the soul of man are no longer valid or vital. It was picturesque in the days of empire, kingship and great temporal authority; and may be thrilling and picturesque again when serving a purpose well and we inherit from nature its grandeur. But, such pictorialization as we see in reckless posterism, this sterile negation of the individual, these fixations of his fate rattling the bones of construction in boxlike

frames, the strident steel criss-cross of these boxes trying to look tall when they can only look big—are all eventually unsatisfactory to the spirit of man. In the nature of life, tall should mean not merely high, but a beautiful expression of aspiration. The soul of modern man has more depth than such architectural masquerade, expression of mere quantity, would indicate. Desire for more imaginative humane expression with deeper feeling still grows outside as well as in our cities due to the sense of the individual's sovereignty in his America. The essential suppression of his spiritual faith will be his curse, if freedom ceases to be beautiful as expression of the American spirit.

▥ In any sincere practice of this fundamental philosophy of building we will find the great means to put the best of man, *living as himself,* into what he builds to live in, live up to and be judged by. If better architects could thus find themselves they would eventually be found by their people. They might see themselves ennobled and built into the hearts of their people by their knowledge of the straight way to serve life as it can be lived today.

Self-Possession

Americans need the serenity of spiritual strength in what they build even more than in what they do. Tranquility and repose as a people would be great reward and assurance—always an indispensable quality of freedom. Modern mechanical skills are cheap enough though technical skill is cheated, because it is expected to be only mechanical, not inspired. Architects are wasting skills both ways and so their clients are cheated of what they really have a right to expect: integrity of spirit. Integrity? I believe I see it awakening here and there as a new American civic conscience. The great mother-art of architecture will not fail to envision and ennoble the American life of our future. True to this emancipation the common man standing there beyond will be bravest and best of us and where he belongs.

▥ We—the people—must retrieve this environment of ours already so heavily mortgaged. Both the life of town and country now waste each other.

Accelerated by the exaggerated motor car, these interchanges and mortgages are forged by the rail men, the pole-and-wire men, advertising men; the realtor, the so-called "developer"—all defacing life. Call these *conservative?* Conservative should mean faithful maintenance at all costs of the free ideals for the sake of which our forefathers gave to every man in the country a stake in himself, as most glorious of all his privileges. Men truly "conservative" would not tolerate overwhelming violations of life, moving us toward the danger of mediocrity in high places. We should be less likely to allow an expedient conformity to frustrate our growth. Nor should we be willing to settle, by weight of mass opinion, for a bureaucratic economy on a low socialistic scale that will not take long to sink American policies to the level of or beneath communism.

Democracy

Our forefathers were not only brave. I believe they were right. I believe that what they meant was that every man born had equal right to grow from scratch by way of his own power unhindered to the highest expression of himself possible to him. This of course not antagonistic but sympathetic to the growth of all men as brothers. Free emulation not imitation of the "bravest and the best" is to be expected of him. Uncommon he may and will and should become as inspiration to his fellows, not a reflection upon them, not to be resented but accepted—and in this lies the only condition of the common man's survival. So only is he intrinsic to democracy.

Persistently holding quality above quantity only as he attempts to live a superior life of his own, and to whatsoever degree in whatever case he finds it; this is his virtue in a democracy such as ours was designed to be.

Only this sense of proportion affords tranquility of spirit, in itself beauty, in either character or action. Nature is never other than serene even in a thunderstorm. The assumption of the "firm countenance, lips compressed" in denial or resentment is not known to her as it is known to civilization. Such negation by human countenance may be moral (civilization is inclined to morality) but even so not nature. Again exuberance is repose but never excess.

The Appeal

Truth.

Who then is "conservative" in democracy? Would he not be the man with a sense of himself as at one with truth, seeing truth as his own love of the beautiful? "Conservative" then as he looks into nature from this inner self of his and his aims to be true to his own spirit—this is the conservative, normal to America. In this spirit beauty will ever be dear to him. Truth in every form becomes *necessary* to his spirit and the quest of appropriate form is vital to his happiness. The conservative man looking for Truth as the Beautiful, and the Beautiful as Truth. Wittingly or not, the word *beautiful* therefore is to him indissolubly associated with the word *truth*.

Freedom

Liberty may be granted but freedom cannot be conferred. Freedom is from within. Notwithstanding all the abuses to which freedom is now subject—marking man down as a commercial item and cutting him off from his birthright by senseless excess and the demoralization of the profit-system—yet man may still be in love with life and find life less and less abundant for this very reason. Truth is of freedom, always safe and affirmative, therefore conservative. Truth proclaims rejection of dated minor traditions, doomed by the great Tradition. The Law of Change is truth's great "eternal." Freedom is this "great becoming."

Tradition

Thus to break with many of the commonly accepted ways of life is imperative to freedom. By the natural working of his own sensibility, the free mind of man in democracy is always open to the truth. Together mind and heart constitute his soul and their unity is the true protection—perhaps the only one—of his freedom.

Democratic man thus free may by his own acts enlist in the struggle for a national culture but he must himself be none the less the very hub of virtue

in the circumstances. The commercializations of his era are not for him. They are not his friends. If this era is to be known as "The Sanitary Age" only, then our freedom is doomed. Democracy must die. To cultivate beauty in his society, the citizen must again see life as poetic, study the poetic principle as guide, as counselor and friend.

From within this philosophy of fundamental freedom any disorder is made manifest. Force, as Napoleon confessed, can never organize anything. Force soon renders useless our discoveries of new facilities such as those of this our Machine-age. Force reduces "progress" to affairs of mere invention, to such subsciences as the mere taking of things apart. Life may only be redeemed, rendered more noble, by great thought and feeling in all our art and in concise opposition to unwholesome manifestations devoid of spirit which we have long been calling tradition. "Style" taste-built is about all our evidence of culture. Unsafe because "taste" (whether old or new) is basically a matter of ignorance, seldom unless by accident on good terms with knowledge of the poetic-principle. It is necessary to know, not to taste.

Part Four: The City

By neglect of prophetic apprehension of the nature of the future as practical, an expedient form of centralization (no more than habituation) stands. It is now seen, at last, as foremost among American social evils, the ancient city as inheritance; not planned for modern man or his uses. Modern man has only crammed the city of his ancient brother with gadgetry and is now being demoralized by it. Scientific modern "advantages" have been his confusion and may be his defeat.

The Medieval city is still all the city he has and his gigantic financial investment in it is encouraged regardless of fate or fact. Persistently this abuse is not only by investors knowing no better but by academic authority that should know better. Enormous static, thus inherited, is perpetuated by gregarious human habit so manipulated. This giant investment in the city is an appeal to the gregarious nature of the human animal; eventually, too, to be dead-sea fruit. The urban realtor now looms as future America's most obstinate enemy, manipulating the huge barricade of urban habit in his behalf against the future of the race. Quantity is entrenched by him to put an end to quality. Life is overwhelmed, becomes an undercurrent beneath the unsafe success of mass- or quantity-production. The insolence of authority is endeavoring to substitute money for ideas.

This ominous trampling of the herd is now the traffic-problem in big-city streets. Perpetual pig-piling of enormous increasing masses of humanity, steering to and fro, rolling out to dormitory town, rolling bumper to bumper morning and evening, back and forth again and yet again, crowds packed into cubicles to work or be entertained in crowds, always invoking artificial light, crowds crowding into schools and crowds crowding university campuses, crowds crowded into brick citadels themselves the sanitary slums a grade above the old slums by sanitation; and we hear the vain boasts of science as well as of government remorselessly promoting the Crowd, more investment in crowds, always more, never less, congestion; building more roads into and out of the cities, increasing the need for parking facilities.

Meantime we boast the highest standard of living in the world, when it is only the biggest. Society finds itself helplessly committed to these excesses and pressures. Ugliness is inevitable to this inorganic, therefore senseless, waste motion of the precious life of our time become a form of involuntary homicide. So mesmerized are we by the "payoff" that any public participation in culture becomes likewise wasted. So little are we enlisted in the potential new life that belongs to America.

Thus cheated by ourselves of general culture we have little genuine architecture. Official authority being by nature more and more merely numerical is already helpless even to recognize this fact, basic as it is. However I like to believe I see continuing signs of worldwide unrest pointing to the long desired awakening, to the needed integrity of an organic architecture—the very awakening, late in the nineteenth or early in the twentieth century, foreseen by the poet Victor Hugo.

Ideas and Ideals

Our United States of America—itself a radical statement of ethical philosophy—a prophetic faith.

A civic conscience is necessary to protect the new civilian freedom, promising more humanity than any promised before.

There is no individual without a point of view. It is the condition of individuality. Ideas are fountainheads! An idea is an achievement in itself; originality of thought most desirable of human qualities.

It is on this quality that the life of democracy truly depends, and on the protection it affords *its own genius*. Nor can "teamwork"—the committee-mind—ever safely be substituted for the inspirations of genius.

Any enterprise depreciating American idealism to an abject level no higher than the concept of "the common man" is either communistic or some low form of socialism that our brave progenitors feared and our friends abroad sometimes prophesy. For when the free man our forefathers conceived falls under the regime of the committee-mind, individuality is lost in the average of averages. I have never believed there is a "common man," nor does any man, not in his *own* estimation at least.

No man will ever live happily with himself or with other men under democracy unless he takes the opportunity afforded him by our nation to rise above average (the common) by his own virtue. By playing down to the idea of the common man, dogmatic political authority exploits him; and has gone far to destroy for everyone reverence for distinction and individual achievement by personal virtue and sacrifice.

So the ideal of innate aristocracy of which our forefathers dreamed is betrayed for votes in the name of democracy. But the Declaration was originally made the thesis of a solid new faith in man as individual. This man could only mean the rise from within the nation of a genuine American aristocracy of sympathy and character, a new kind of aristocracy—as I have said—*of* the man, not *on* him. Again: his not by privilege, or birth, but by virtue *earned*: aristocracy, therefore, of man's own nature: an earned benefit to his kind.

▦ New definitions as well as new dimensions are therefore needed all down the line, including that of the now threadbare term "gentleman." Definitions now imperative in America, because danger to this nation among its neighbor-nations lies in the inferiority complexes of mediocrity exalted by the impact upon it of politics, its numerical aspects, the ubiquity of its character.

Youth and Architecture

Our present discouragement and distortion of architecture as individual expression is alarming. Our best young men too rarely seek to be interpreters of the poetic principle, which is what an architect should be by nature. Maybe because they are no longer so born or perhaps because they are so conditioned by education; they are no longer deeply enough desired by our society to be properly rewarded.

Consider the overwhelming toll taken by the premium placed upon more "successful" professions or upon captains of industry or the persuasive salesmen of anything at all. It is "men-of-affairs" and men-of-science that are in demand; the politician rates high. All ride the tide to take what each may take of his share in society. Superior reward for inferior performance taxes heavily the young man's choice of a "career." The novice sees far greater financial chances for "security" and social standing afforded him almost anywhere else than in architecture and the arts. The true rewards in the practice of art, architecture or religious devotion are becoming dubious intangibles. Students must go into practice of architecture too cheaply—go ready-made either by rule or rote by way of some preferred educational institution and a license after spending too many years in service to a (perhaps mediocre) professional. Only then is he "licensed" to build. His experience is here reduced by inorganic regulations and rules to servitude—a requirement of his services as architect.

Therefore most of the novitiate thus "licensed" are not builders because of ability, good background or depth of character; they have no proved capacity for the long, patient experience in work which should be theirs when they start to practice. Unfortunately, it can come only later. True dedication to adequate preparation is not there; and it is not to be had "by license." Qualification is rendered not only unlikely but virtually impossible, so architects today usually lack both inspiration and integrity. A protection to which society is entitled has thus become only elimination of superior human material, an exploitation of the profession which can only

be explained by their need for a continuing supply of draughtsmen. Only devotion to nature-study in the light of guiding experience under competent leadership by a qualified master can reveal to the right kind of apprentice the necessary knowledge to safeguard America from unripe or demoralizing building-performance. Instead, the young man in architecture must try every shortcut provided by the available systems of education today in order to become a tastemaker according to this name or that name as may be recommended by their "followers." But a creative artist is not to come to us by the same educational process or the same means we employ to produce a scientist, a businessman or a politician. So the story of our current architecture in any true retrospect is likely to be a sad one: architecture declining in significance and power until the tragedy of "restatement" or no statement at all worth considering becomes again "classic."

Retrospect

Serious architects coming here from abroad found our culture around the beginning of the century almost completely ignorant of our own architecture or, for that matter, of any architecture except that taught by the Paris Beaux-Arts or in evidence as old "Colonial." Old Colonial derived by the English from France and by France from Medieval Italy. Italy was indebted to Greece. Greece to Egypt and Egypt to—? (As a consequence of all this procession, see how the beam that bore the poet-builder's message to humanity down the ages has been short circuited by modern science. But only for the time being—until the true significance of the mother-art comes again clear. Every so often in history the fate of a civilization depends upon a single ray or hangs by a thread—but it has thus never yet been lost.)

The same was then true in the "liberal" arts: American society, worldly-rich, was utterly poor in art and afraid to live as itself. Fearful of being ridiculed for lacking knowledge of art, we felt much safer in buying "culture" ready-made from abroad. That is where our culture had always come from?

So, from Europe, rather than the Orient, came most of what art our people knew, and there, at top-heavy financial levels, it could, and did, buy what it wanted. America, meantime, was getting noisier,

faster and uglier (the exceptions being the Louis Sullivan skyscraper and the dwellings I built on the Midwest prairie around Chicago) under the prodigious success of machine-masters. As we were, then (and not very different now), if a substitute was presented as an original—who would know? This obviously meant a consequent atrophy of our spiritual arteries.

Already educated far beyond capacity, our over-privileged society tended more and more toward some kind of servile conformity. The old box forms, stripped of ornament, were encouraged by expedient social standardizations now grown so useful. Any cliché would do. So American life was left to be quickened above the belt by any phase of art provided it was imported—Old English, Beaux-Arts or Bauhaus—or what have you? All to be subjected eventually to mass-production. Due to our skill in scientific invention, our life became more and more subject by the professional tastemakers of the country (never artists, merely artistic) to the exploitation of commonplaces.

The compulsory machinery of public education plus the real-estate "developer" (and we have now government housing not to mention the public "service" corporation) all contributed to the degradation of the beauty America promised.

Add a vast and growing bureaucracy to this, and the natural result of machine politics was the man more and more a machine. Our biggest machine became not the corporations of big industry, but incorporated government, and biggest of all, the machinery of education.

In general (of necessity) machinery feeds and thrives on quantity production. So our society became subject to the influence of profit-minded industries (and what other kind of industry have we?).

"Profit-minded" meant, first and foremost, *quantity*-minded. Owing to endless machine invention and production, the reproduction of the substitute was easily accepted.

Even in 1893 art was servile to "big business." It is now easy to see how architecture, art (and religion, too) become subservient to business in order to survive. The university not much above the level of a trade school or business college (business has now made a college degree a virtual requirement); and higher education is largely a cultural liability backed by big American executives themselves.

Though often sensitive, sensible (occasionally mature), these money-magnates seldom allowed themselves any show of feeling for the cultivation of beauty. To give to beauty more than a casual look or gesture, to give any extensive (or expensive) consideration to the "beautification" of even their own business world—though it is now at last increasing—would have seemed, to most of them, weak—if not waste motion.

The machine thus magnified became Moloch, dominant as quantity factor. So, instead of raising the quality, it increased only the *size,* of the standard of living of our society, inevitably reducing the value of the man himself.

Any honest, intelligent analysis of our situation will show that, with rare exceptions, money must talk, take over, and decide even these matters of the soul. Success breeds success, but where success breeds excess maintained by some form of advertising, the end is unpleasant to see. Advertising, subsidized by government—at public expense—is really our most distinguished form of art, and grows rank and noxious as any weed.

Technology Again

Why did the manpower and technology of the haphazard uprisings of building that characterize our big cities almost entirely escape the essential hand of the creative artist-architect? Wherever and how did he ever manage to survive? His apparent contribution to American life is still small and continually ignored by the business-administration of art by "efficient" plan factories.

Novelty seems always to be a good form of advertising a substitute. And superficial architecture is based upon just such a temporary novel appeal, and thus upon "taste." Organic architecture cannot have the automatic advantage attaching to the substitute. So it has not been able to qualify much this appalling drift toward expedient conformity. It is hard to realize that until recently organic architecture was comparatively unknown to our people.

To what extent is the bureaucrat to determine the culture of our civilization? The "insolence of office" thrives upon conformity. See now the distortion of our intrinsic social purpose by experts and specialists and the encouragement of mediocrity

by mass-education. With the inspiration of great art unheeded, where is the check to deterioration? Are architecture and art simply to fade out with religion?

Still to be discovered as a devoted son of culture is the inspired architect, the public servant who, if appreciated and used, could express the quality of depth and validity in the human values of our society, enabling us to qualify this ruthless imposition of quantity over quality. The artist-architect will be a man inspired by love of the nature of Nature, knowing that man is not made for architecture; architecture is made for man. He will see the practice of architecture never as a business but always religiously as basic to the welfare and culture of humanity as, at its best, it ever has been. And we must recognize the creative architect as poet and interpreter of life. We have only to consider what he has done and where he has been in every true culture of all time to see how important this son of culture is to our own future as a nation. By way of a growing art chiefly comes the culture that fertilizes society, by fructifying the individual and enabling men to call their lives their own. This enrichment of life is the cause of Architecture, as I see it.

Both abroad and at home I find that good minds still doubt the consequences of such all-out commercialism as characterizes our life and threatens human interest here in America. Yet, wholesale mechanization now seems a matter of course; technology and science menace the exuberance, the richness, of life expression and help to fashion it into a monotonous Style without human scale or significance.

The machine as a tool now is inevitable to human joy and comfort, and originals must have, in themselves, properties essential to the proper use of our machine-powers. But, machined-shapes are no *substitute* for architectural form, nor is the machine itself a form-giver or interpreter.

Salvation

If our American engineers had had more sense of organic architecture in their systems and the architects more sense of organic engineering, the fate of

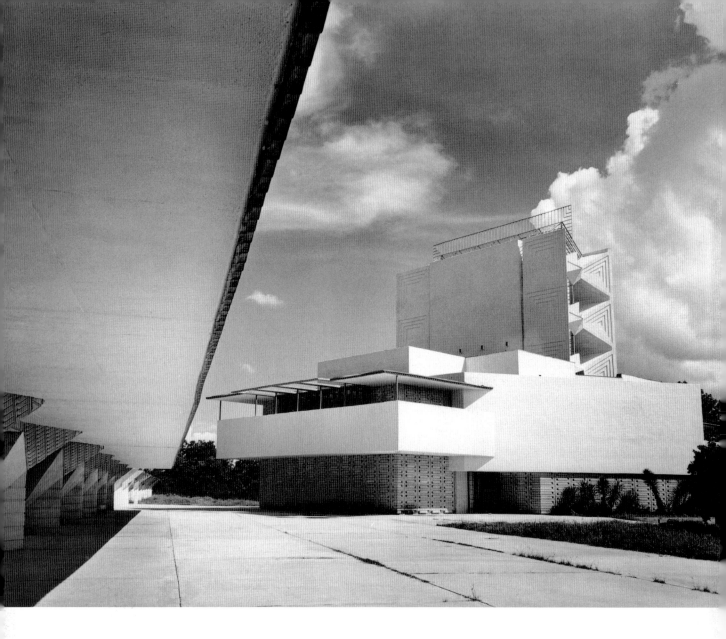

our modernization of medievality would not be so tragic. Full-scale planning, afresh, might have saved city life for another half-century, or more.

The primitive ideals of centralization are now largely self-defeating. Human crucifixion by verticality on the now static checkerboard of the old city is pattern already in agony; yet for lack of any organic planning it is going on and on—not living, but rather hanging by its eyebrows from its nervous system.

Well-meaning ignorance and greed habitual add story to story, congestion to congestion, in order for the landlord to "pay off." Landlordism, now a disease of our profit-system, fights skyscraper with skyscraper. The frantic attempt to salvage urban investment destroys all human values and tries to make the human creature like it. The upended street is the invention that made possible this attempt to cage human beings.

Our oversized mobiles with non-mobile shapes— sheer excess—squared off, squared up platforms, swallowing four wheels, barge between trucks scaled more to the railroads than to city streets; all making menace constant and driving a hazard.

Florida Southern College
Anne Pfeiffer Chapel,
Lakeland, Florida. 1938.
FLLW Fdn# 3816.0061

Research Tower for the
S. C. Johnson & Son Co.,
Racine, Wisconsin. 1943.
FLLW Fdn# 4401.0122

Unitarian Meeting House,
Shorewood Hills, Wisconsin. 1947.
FLLW Fdn# 5031.0061

Solomon R. Guggenheim Museum,
New York, New York. 1943–59.
FLLW Fdn# 4305.017

A TESTAMENT

Add to this the mortgage on our American landscape forged and foreclosed by the pole-and-wire men—and the citizen himself is condemned; on the road but headed for bankruptcy.

Owing to demolition of human values, saturation is not far away. Life itself is now distorted out of proportion, out of perspective. Everywhere in the city the citizen is treated by service itself as a servant. Subject to this universal backfiring of modern "advantages," now featured and practiced like a tax levied upon him, he is becoming a piece of machinery himself, his city a vast urban garage.

Fission of the atom might eventually prove the logical conclusion to his insoluble traffic problem created by human cupidity plus stupidity. Elimination of our badly overgrown cities, if only to release man from this growing universal bondage, would be merciful? Organic planning by way of organic architecture would be liberation. By decentralization. The forces that will eventually secure this planning are meantime at work. Why do we not work with them? The architect as more engineer and the engineer as more architect could by now have had man's liberation well under way.

First principles of organic architecture bring much light upon a new type of agrarian-urban planning. But even without benefit of such planning, the building of the new city is going on. Inevitable undercurrents beneath the old city life are taking both city and country apart. To bring them back together again in *humane* proportion is not the work of science or commerce; it requires the vision of the architect in love with architecture.

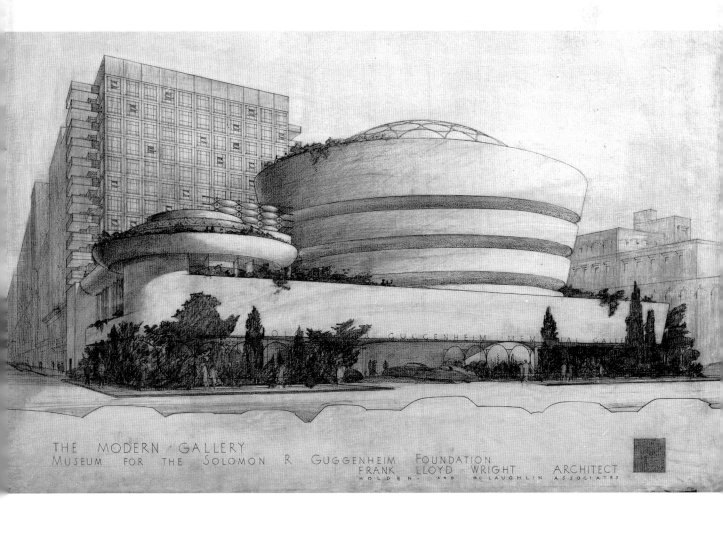

THE MODERN GALLERY
MUSEUM FOR THE SOLOMON R GUGGENHEIM FOUNDATION
FRANK LLOYD WRIGHT ARCHITECT
HOLDEN AND McLAUGHLIN ASSOCIATES

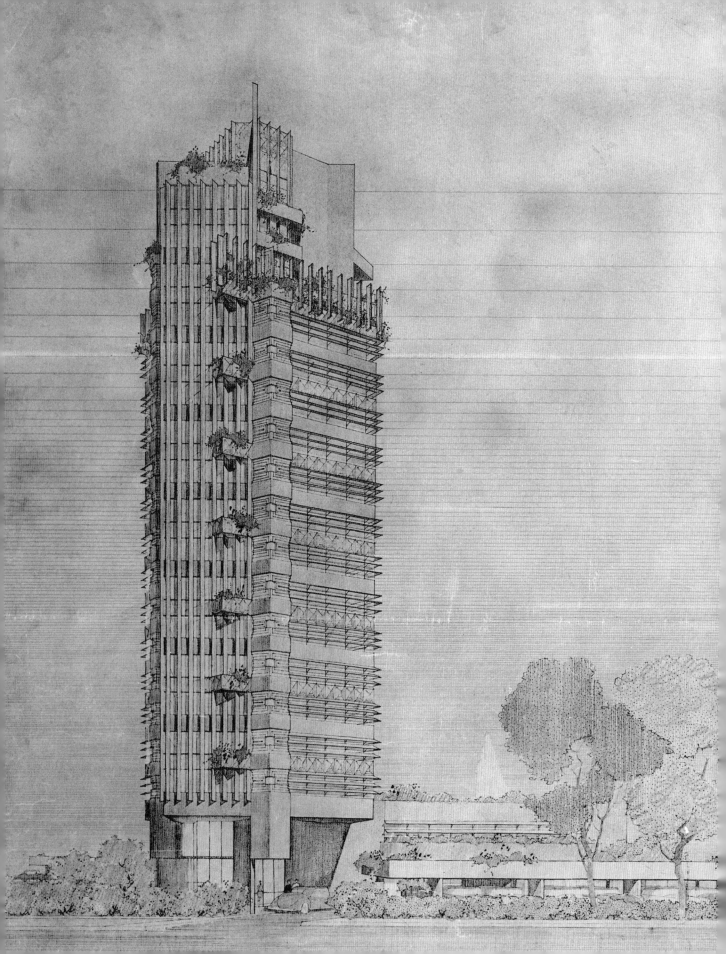

Everywhere pushed to extremes, the abuses of machine-power, the gigantic property interests cast ominous shadows upon defenseless *human* interests.

The character of "modern" citizenship is more a hangover from the animal than ever—and yet "humanity begins where the animal leaves off"? Yes. But the urbanite seems willing not only to go in to be pig-piled flat, but now to be pig-piled up on end. The realtor-landlord and the landlord-realtor, prime movers of present urban centralization, take him up and take him down; in and out, to and fro goes the hapless victim, until he is finally "taken over." By what? And how?

His coming emancipation is what should matter most to him now, notwithstanding his habituate embrace of deadly factual routine. His essential dignity remains only in his intelligent sense of himself. Fortunately for him he is learning to see Architecture as basic element of his civilization, and to understand that his birthright lies in that higher nature to which, for the sake not merely of his survival but of his happiness, he aspires. Decentralization and organic reintegration of his city is chiefly an affair of architecture.

Organic Characteristics

Quiet mass-outlines extended upon the ground levels in becoming human proportions throughout: an appropriate new use of materials old and new: these characterized the early straight-line, flat-plane dwellings built by myself—happily and with great hope—on the midwest prairie I loved, beginning 1893. Buildings creating a free, new phase of horizontality were also characteristic of the capacity of our new tool, the machine; and a new sense of human scale.

New-old philosophy had come to the rescue, soon afforded new freedoms in design. The plan grew more beneficial to human life. Eventually to do so universally. These initial buildings were made to declare and express the affinity not only of man's life to his ground, but of the ground to the nature of the man who lived upon it. They showed how the inevitable order of the machine was better fitted as a tool to build these new buildings than any means ever known. But this revelation could not have been made under the old codes, nor could it have come alive under the rules of the old classic or medieval order.

Box-frame architecture, being set up on every hand as the urban ideal, also constituting the respectability of our "more educated" villagers. These standard lines of dreary human cages, with flat lids or none visible, that stretched for miles and miles were indistinguishably serving to live in, to live by; to learn in, to play in. The steeple marked the box to pray in, the dome the box to rule in.

The New Cliché

Now, latest in the succession of habituated boxation is the open box with glassified poster-facade standing on urban streets from Chicago to New York—representing contagion? Box to box, boxes within the box, framed by steel from the outside in, has long been the traditional form of building; but if this boxation is to continue, why call it modern architecture? We know better. What we now need is not more nineteenth century architecture of this type. Past the middle of the twentieth century, we are at last ready for twentieth century architecture.

As for novelty, everybody is learning to know that almost all sensationalism is good advertising and may be made to serve commerce. But there is neither architecture nor artistry in any of it; only a low level of invention, at best. Prolixity bred to propinquity, these mantraps seem to express the herd ideal spread by way of advertising, and accepted by man's own default. We see here the breakdown, owing to man's lack of faith in himself, of our national ideal: the sovereignty of the individual. We see here the triumph of conformity, man the individual now man as termite.

▨ Integrity of *principle is* lacking in all this, but perhaps the self-immolating confusion called "modern architecture" is only a preliminary skirmish on the way to true modernity. Probably as old style, restyled; novel, not new, but on the whole better than the usual collection of older eclecticisms known as "the classic."

<div style="text-align: right">

H. C. Price Tower,
Bartlesville, Oklahoma. 1952.
FLLW Fdn# 5215.004

</div>

Knowledge that could retrieve from imitation the original effects of organic architecture is not forthcoming from contemporary graduates of our colleges. With no principle or ethical performance, these mere effects are taken as a new style, one to be copied, so the cliché.

Managed publicity in newsprint, in magazines and on the air is for architects instead of architecture, and the standardized architectural schooling in our universities, their curriculum a mere run-around, seems designed to go along with formulas now being substituted for performance. Much of the criticism we know aids, if indeed it is not inspired by, this expediency. Here is one reason why our "modern architecture" grows in platitude and volume while decreasing in sensitive, imaginative significance. The art of building steadily diminishes in spiritual character by the brainwashing architects receive as education. "Practice makes perfect," only if practice be right. But if the practice be wrong?

▓ Genuine expressions as essence of the great art itself cannot be taught or imitated. Nor can they in any way be forced. If the quality of vision we call inspiration is lacking, all is lacking; and inspiration comes in its own good time in its own way, from within—comes only when all is ready, and usually must wait.

Great art has always, at first, been controversial. Now that our means of communication have multiplied, how much more so today? Any moot point soon becomes every man's controversy. Specialists in controversy, numerous and vociferous, sprout on every branch. And the pressure toward conformity leaves young minds weak with the uncertainty that cleaves, for reassurance, to the static in some form.

▓ Resemblances are mistaken for influences. Comparisons have been made odious where comparison should, except as insult, hardly exist. Minds imbued by the necessity of truth, uttering truths independently of each other and capable of learning by analysis instead of comparison are still few. Scholarly appraisals? Only rarely are they much above the level of gossip. So, up comes comparison, to compare organic architecture to the Crystal Palace of London, for instance—Horatio Greenough, *Art Nouveau,* Emerson, Whitman, Sullivan, Coleridge, Thoreau, etc.

Those adversaries of truth who claim its discovery are invariably traitorous. Contemporary criticism is mostly posture, at the back door or at best side entrance, therefore a mere guess as to what the affair really looked like from the front. Every now and then one of the so-dedicated writes a book about a book written by a man who did the same, to win the "take away" prize in this game; never actually to be won because it was lost before it started.

Influences and Inferences

To cut ambiguity short: there never was exterior influence upon my work, either foreign or native, other than that of Lieber Meister, Dankmar Adler and John Roebling, Whitman and Emerson, and the great poets worldwide. My work is original not only in fact but in spiritual fiber. No practice by any European architect to this day has influenced mine in the least.

As for the Incas, the Mayans, even the Japanese— all were to me but splendid confirmation. Some of our own critics could be appreciated—Lewis Mumford (*Sticks and Stones*), early Russell Hitchcock, Montgomery Schuyler and a few others.

While admiring Henry Hobson Richardson, I instinctively disliked his patron Henry Adams as our most accomplished (therefore most dangerous) promoter of eclecticism. I believed Adams, Boston Brahmin, would dislike Louis Sullivan and Walt Whitman. His frame of reference was never theirs, or mine. My enthusiasm for "sermons in stones and books in running brooks" was not "fascination frantic for ruins romantic—when sufficiently decayed."

At that early day I was thrilled by Mayan, Inca and Egyptian remains, loved the Byzantine. The Persian fire-domed, fire-backed structures were beautiful to me. But never anything Greek except the sculpture and the Greek vase—the reward of their persistence in search of the elegant solution. My search was more for the exception that went to prove the rule, than for the rule itself.

As for inspiration from human nature, there were Laotze, Jesus, Dante, Beethoven, Bach, Vivaldi, Palestrina, Mozart. Shakespeare was in my pocket for the many years I rode the morning train to Chicago. I learned, too, from William Blake (all of his work I read), Goethe, Wordsworth, Dr. Johnson, Carlyle

(*Sartor Resartus* at the age of fourteen), George Meredith, Victor Hugo, Voltaire, Rousseau, Cervantes, Nietzsche, Unamuno, Heraclitus, Aristotle, Aristophanes.

I loved the Byzantine of San Sophia—a true dome in contrast to Michelangelo's bastard. I loved the great Momoyama period in Japanese painting and the later Ukiyoe as I found it in the woodblock prints of the periods. These prints I collected with extravagant devotion and shameful avidity, and sat long at the inspiring series of Hokusai and Hiroshige; learned much from Korin, Kenzan, Sotatsu and always the primitives. The Ukiyoe and the Momoyama, Japanese architecture and gardening, confirmed my own feeling for my work and delighted me, as did Japanese civilization which seemed so freshly and completely of the soil, organic.

Monona Terrace Civic Center, scheme #2
Madison, Wisconsin. 1959. Project.
FLLW Fdn# 5632.002

425

MUSIC BUILDING FOR FLORIDA SOUTHERN COLLEGE
LAKELAND, FLORIDA
FRANK LLOYD WRIGHT ARCHITECT

Florida Southern College
Music Building #3,
Lakeland, Florida. 1957.
Project.
FLLW Fdn# 5320.003

Gothic soared for me, too; but seldom if ever the Renaissance in architecture, outside the original contributions of the Italians. I read, being a minister's son, much of the Bible; and inhabited, now and then, all the great museums of the world, from America to London, across the globe to Tokyo.

I read and respected many of our own poets and philosophers, among them: Emerson, Thoreau, Melville, William James, Charles Beard, John Dewey, Mark Twain, our supreme humorist-story-teller; especially the giver of the new religion of democracy, Walt Whitman. I cared little for the great pragmatists in philosophy and less for the Greek sophists. Historicism always seemed equivocal to me; the best of the histories Gibbon's *Rome;* my respect for Friedrich Froebel always high owing to my mother's kindergarten table. Soon I turned away from the Greek abstraction via Oxford or elsewhere. Of all the fine arts, music it was that I could not live without, and—as taught by my father (the symphony an edifice of sound)—found in it sympathetic parallel to architecture. Beethoven, and Bach too, were princely architects in my spiritual realm.

I liked Beethoven's great disciple, Brahms. Italy was to me and is still so ever the beating heart of art creative, manifest in Vivaldi, the Italian troubadours and Palestrina. They came along with Giotto, Mantegna, Leonardo, etc.

My mother taught me, in my childhood as described, the kindergarten "gifts" of Friedrich Froebel—a true philosopher. At the age of eleven I was confided by my mother to her brother, my uncle James, on the farm in "the Valley" to practice both edifice and gifts as I might, and did. Never a thought in politics as other than profane until I was past fifty-five.

Wisdom

Again: I found repeatedly confirmed that the inferior mind not only learns by comparison, but loosely confers its superlatives, while the superior mind which learns by analysis refrains from superlatives. I have learned about architecture by root, by worldwide travel and by incessant experiment and experience in the study of nature. In the midst of sensible experiment based always upon preliminary experiments, I never had the courage to lie. Meantime I lived with all the expressions of beauty I could see. And all those that I could acquire and use for study and enjoyment I acquired as my library, but living with them all as I might. I never had much respect for the collector's mind.

Part One: Principles

I. The Earth Line

At last we come to the analysis of the principles that became so solidly basic to my sense and practice of architecture. How do these principles, now beginning to be recognized as the centerline of American democracy, work?

Principle One: Kinship of Building to Ground. This basic inevitability in organic architecture entails an entirely new sense of proportion. The human figure appeared to me, about 1893 or earlier, as the true *human* scale of architecture. Buildings I myself then designed and built—Midwest—seemed, by means of this new scale, to belong to man and at the moment especially as he lived on rolling Western prairie. Soon I had occasion to observe that every inch of height there on the prairie was exaggerated. All breadths fell short. So in breadth, length, height and weight, these buildings belonged to the prairie just as the human being himself belonged to it with his gift of speed. The term "streamlined" as my own expression was then and there born.

As result, the new buildings were rational: low, swift and clean, and were studiously adapted to machine methods. The quiet, intuitional, horizontal line (it will always be the line of human tenure on this earth) was thus humanly interpreted and suited to modern machine-performance. Machine-methods and these new streamlined, flat-plane effects first appeared together in our American architecture as expression of new ways to reach true objectives in building. The main objective was gracious appropriation of the art of architecture itself to the Time, the Place, and Modern Man.

What now is organic "design"? Design appropriate to modern tools, the machine, and this new human scale. Thus, design was opportune, and well within the architect's creative hand if his mind was receptive to these relatively new values: moving perception at this time with reverential spirit toward the understanding of the "nature of nature." The nature of the machine, studied by experiment and basically used in structural design, was still to be limited to a tool, and proved to be a powerful new medium of expression. Buildings before long were evidencing beautiful simplicity, a fresh exuberance of countenance. Originality.

Never did I allow the machine to become "motif"—always machine for man and never man for the machine. Ever since, in organic architecture I have used the machine and evolved a system of building from the inside out, always according to the nature of both man and machine—as I could see it—avoiding the passing aspects now characteristic of urban architecture. The machine I found a better means to broaden the humane interest in modern architecture. Nor, in point of style, have I once looked upon the machine as in itself an end, either in planning or building or style. Quantity has never superseded quality.

The Modular of the Kindergarten Table

Kindergarten training, as I have shown, proved an unforeseen asset: for one thing, because later all my planning was devised on a properly proportional unit system. I found this would keep all to scale, ensure consistent proportion throughout the edifice, large or small, which thus became—like tapestry—a consistent fabric woven of interdependent, related units, however various.

So from the very first this system of "fabrication" was applied to planning even in minor buildings. Later, I found technological advantages when this system was applied to heights. In elevation, therefore, soon came the vertical module as experience might dictate. All this was very much like laying warp on the loom. The woof (substance) was practically the same as if stretched upon this predetermined warp. This basic practice has proved indispensable and good machine technique must yield its advantages. Invariably it appears in organic architecture as visible feature in the fabric of the design—insuring unity of proportion. The harmony of texture is thus, with the scale of all parts, within the complete ensemble.

II. Impulse to Grow

Principle Two: Decentralization. The time for more individual spaciousness was long past due. 1893. I saw urban-decentralization as inevitable because a

Christian Science Church, scheme #2,
Bolinas, California. 1956.
Project.
FLLW Fdn# 5527.009

growing necessity, seeking more space everywhere, by whatever steps or stages it was obtainable. Space, short of breath, was suffocating in an airless situation, a shameful imposition upon free American life. Then, as now, the popular realtor with his "lot" was enemy of space; he was usually busy adding limitation to limitation, rounding up the herd and exploiting the ground for quick profit.

Indigestible competition, thus added to the big city, despoiled the villages. Over-extended verticality then congested to hold the profits of congestion was added to the congestion already fashioned on the ground.

To offset the senselessness of this inhuman act, I prepared the Broadacre City models at Taliesin in 1934.[7] The models proposed a new space concept in social usage for individual and community building. But the whole establishment was laid out in accordance with the conditions of land tenure already in effect. Though the centers were kept, a new system of subdivision was proposed.

Later, this model of the broader use of ground for a new idea of a new city was carefully studied in detail in a series of smaller tributary models, all as described in *When Democracy Builds,* a book I later wrote on the suggestion of Robert Hutchins. Buildings, roads, planting, habitation, cultivation, decoration, all became as architectural as they were in Umbria in Italy in the Middle Ages; qualities of ancient sort in modern form for modern times, considered in terms of modern humane utility. Thus broadened, the view of architecture as basic now in service to society came as relief and gave a preview of primary form facing the law of the changes inevitable.

Therefore quantity—the machine source—was in no way, nor anywhere, at any time, to be used to hinder the quality of new resources for human profit and delight in living. Living was to be a quality of man's own spirit.

Science, the great practical resource, had proceeded to date itself and magnify the potential sacrifice of man as menial, now wholesale destruction of democracy. Congested in cities by continually bigger mechanical means to avoid labor, man was to be

given a new freedom. The ground plan of Broadacre City was bound together in advantageous, interactive relationship to the new resources of human life under protected freedom, our own if only we would reach out and take it.

Convenient, inspiring continuity appeared in this plan for a new community (still called a city), inevitable to the survival of human individuality. But I have learned that a new pattern can never be made out of the old one: only palliation is possible—and is soon inefficient. These initial Broadacre City models, still to be seen at Taliesin, were exhibited at Rockefeller Center, New York, 1934, and many times since, elsewhere in our country and abroad. Notwithstanding the A.I.A. and the critics, this complete group-model, new in concept and pattern, showing the new life of agrarian-urbanism and urbanized-agrarianism, virtually the wedding of city and country, reappeared to travel around the world in the exhibition "Sixty Years of Living Architecture." After being shown in Philadelphia, Florence, Paris Beaux-Arts (where I was told this was the only one-man exhibition since the one accorded to James McNeill Whistler), Zurich Art Institute, Munich Art Palace, Rotterdam Civic Center, University of Mexico, it returned to a special exhibition building in New York City, and later to a special extension of Olive Hill in Los Angeles by the Municipal Art Society.

III. Character Is a Natural

Three: Appropriate "character" is inevitable to all architecture if organic. Significance of any building would clearly express its objective, its purpose—whether store, apartment building, bank, church, hotel or pie-club, factory, circus or school. Fundamental requirement, this should apply to all building, in ground-planning and, especially, relative to human life and its site. This means sane appropriation of imaginative design to specific human purposes, by the natural use of nature-materials or synthetics, and appropriate methods of construction. Our new resources already evolved by science, especially glass and steel wrought by the machine, are bound continually to develop new forms. Continually new ways and shapes of building will continue to give fresh character and true significance to all modern structure.

Poetic tranquility instead of a more deadly "efficiency," should be the consequence in the art of Building: concordant, sane, exuberant, and appropriate to purpose. Durable, serviceable, economical. Beautiful. In the ever-changing circumstances of complex modern existence all this is not too easy to accomplish and the extent of these evolving changes may not yet be fully seen but as architects we may thus reconstitute architecture in our hearts and minds and act to re-write our dated "codes" and refrain from disfiguring our American landscape by buildings or "service" systems.

IV. Tenuity Plus Continuity

Four: Completely new character by these simple means came to architecture; came to view, not by haphazard use, but by organic interpretation, of steel and glass. Steel gave rise to a new property: I call it *tenuity*. Tenuity is simply a matter of tension (pull), something never before known in the architecture of this world. No building could withstand a pull. Push it you might and it would stay together but pull on it and it would fall apart. With tensile strength of steel, this pull permits free use of the cantilever, a projectile and tensile at the same time, in building-design. The outstretched arm with its hand (with its drooping fingers for walls) is a cantilever. So is the branch of a tree.

The cantilever is essentially steel at its most economical level of use. The principle of the cantilever in architecture develops tenuity as a wholly new human expression, a means, too, of placing all loads over central supports, thereby balancing extended load against opposite extended load. This brought into architecture for the first time another principle in construction—I call it *continuity*—a property which may be seen as a new, elastic, cohesive *stability*. The creative architect finds here a marvelous new inspiration in design. A new freedom involving far wider spacings of more slender supports. Thus architecture arrived at construction from within outward rather than from outside inward; much heightening and lightening of proportions throughout all building is now economical and natural, space extended and utilized in a more liberal planning than the ancients could ever have dreamed of. This is now prime characteristic of the new architecture called organic.

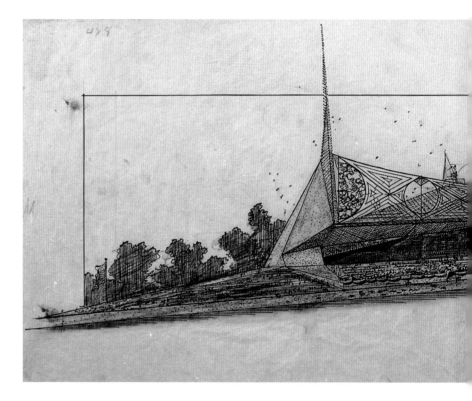

New Sports Pavilion,
Belmont Park, New York. 1956.
Project.
FLLW Fdn# 5616.014

Rigid box shapes, outsides steel-framed, belong strictly to the nineteenth century. They cannot be twentieth century architecture. Support at rigid corners becomes mere obstruction: corners themselves now insignificant become extravagant waste, mere accents of enclosure. Construction lightened by means of cantilevered steel in tension, makes continuity a most valuable characteristic of architectural enlightenment. Our new architectural freedom now lies within this province. In the character of this new circumstance buildings now may proceed *from within outward:* Because push or pull may be integral to building design.

V. The Third Dimension: Interpretation

Five: To sum up, organic architecture sees the third dimension never as weight or mere thickness but always as *depth*. Depth an element of space; the third (or thickness) dimension transformed to a *space* dimension. A penetration of the inner depths of space in spaciousness becomes architectural and valid

motif in design. With this concept of depth interpenetrating depths comes flowering a freedom in design which architects have never known before but which they may now employ in their designs as a true liberation of life and light within walls; a new structural integrity; outside coming in; and the space within, to be lived in, going out. Space outside becomes a natural part of space *within* the building. All building design thus actually becomes four-dimensional and renders more static than ever the two-dimensional effects of the old static post and girder, beam and box frame type of construction, however novel they seem to be made. Walls are now apparent more as humanized screens. They do define and differentiate, but never confine or obliterate space. A new sense of reality in building construction has arrived.

Now a new liberation may be the natural consequence in every building exterior. The first conscious expression of which I know in modern architecture of this *new reality*—the "space within to be lived in"—was Unity Temple in Oak Park. True harmony and economic elements of beauty were consciously planned and belong to this new sense of space-with-

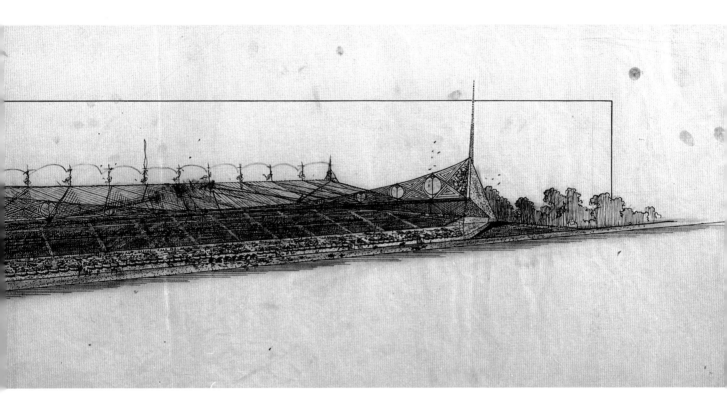

in. The age-old philosophy of Laotze is alive in architecture. In every part of the building freedom is active. Space the basic element in architectural design.

This affirmation, due to the new sense of "the space within" as reality, came from the original affirmative negation (the great protestant) 1904, the Larkin Building of Buffalo—now demolished. Here came the poetic principle of freedom itself as a new revelation in architecture. This new freedom that was first consciously demonstrated in Unity Temple, Oak Park (1906) as written in 1927 for AN AUTOBIOGRAPHY. With this new principle at work in our American architecture came a new sense of style as innate. A quality natural to the act and art of modern habitation: no longer applied by "taste." (Again: "Such as the life is, such is the form"—Coleridge gives us perhaps a better slogan than Form Follows Function.) For Americans as for all shades and shapes of human beings everywhere "style" becomes generic: poetic expression of character. Style is intrinsic—or it is false. As a characteristic of "the space within to be lived in"—the life of style is perpetually fresh.

VI. Space

Six: Space, elemental to architecture, has now found architectural expression. Glass: air in air, to keep air out or keep it in. Steel, a strand slight and strong as the thread of the spider spinning, is able now to span extraordinary spaces. By new products of technology and increased inventive ingenuity in applying them to building-construction many superlative new space-forms have already come alive: and, because of them, more continually in sight. Some as a matter of course will be novel but insignificant; some will be significant and really new. But more important, modern building becomes the solid creative art which the poetic principle can release and develop. Noble, vital, exuberant forms are already here. Democracy awakes to a more spiritual expression. Indigenous culture will now awaken. Properly focused upon needs of twentieth century life, new uses of livable space will continually evolve, improved; more exuberant and serene. A new security and a new tranquility. Enlightened enjoyment of fresh beauty is here or due. As for the future:

encouraging to me are the many letters, coming continually, country-wide, from teen-agers now in high school, asking for help with the term theses they have chosen to write upon organic architecture. This widening of the awareness of the coming generation's interest in architecture can only mean a new American architecture. When these young-sters become fathers and mothers, say a generation hence, they are going to demand appropriate space-homes on these modern terms. We will soon see the house as a work of art and because of its intrinsic beauty more a home than ever.

VII. Form

Seven: Anyone anything of an architect will never be content to design a building merely (or chiefly) for the picture it makes—any more than a man would buy a horse merely by its color. What kind of intellect must the critic have who seeing a building judges it by "the look of it," ignorant of the nature of its construction?

▥ For the first time in 500 years a sense of architectural form appears as a new spiritual integrity.

Heavy walls, senseless overheads and overloads of every sort, vanish—let us be glad. Light and thin walls may now depend from cantilever slabs supported from the interior on shallow, dry-wall footings, walls themselves becoming slender screens, entirely independent of use as support. Centralized supports may stand isolated, balancing load against load—seen not as walls at all, but as integral pattern; walls may be slender suspension from point to point, in fascinating pendant forms. In general, structure now becomes an affair from the inside outward instead of

Mile High, "The Illinois,"
Chicago, Illinois. 1956.
Project.
FLLW Fdn# 5617.005

from the outside inward. Various geometrical forms (circular especially) in planning structure become more economical than the square of the box. Building loads may be suspended, suspension supported by slender, isolated uprights. Glass or light plastics may be used to fill in and make the whole habitable. Sheet metal and light metal castings afford a permanent material for the exteriors of such structures. Enclosures extremely light in weight combined with such structural elements relieve all modern building of surplus static; structure no longer an obesity or likely to fall of its own weight. Walls require little or no floor space. Spaces hitherto concealed or wasted or made impossible by heavy walls are revealed and made useful. Arrangements for human occupation in comfort may be so well aimed that spaciousness becomes economical as well as beautiful, appearing where it was never before thought to exist. Space now gives not only charm and character to practical occupation but beauty to the countenance and form of a valid new kind of habitation for mankind. Buildings, at long last—like their occupants—may be themselves free and wear the shining countenance of principle and directly say honestly, by free expression, yet becomingly, what they really are, what they really mean. The new sense of interior space as reality may characterize modern building. Style will be the consequence of integral character. Intellect thus reinforces and makes Spirit effective. An art as flexible, as various, as infinite in its possibilities as the spirit of man.

Organic Unit

Thus environment and building are one: Planting the grounds around the building on the site as well as adorning the building take on new importance as they become features harmonious with the space-within-to-be-lived-in. Site, structure, furnishing—decoration too, planting as well—all these become as one in organic architecture. What was once called "decorating"—landscaping, lighting, etc.—and modern gadgetry (mechanical fixtures like air-conditioning) all are within the building structure as features of the building itself. Therefore all are elements of this synthesis of features of habitation and harmonious with environment. This is what *posterity* will call "modern architecture."

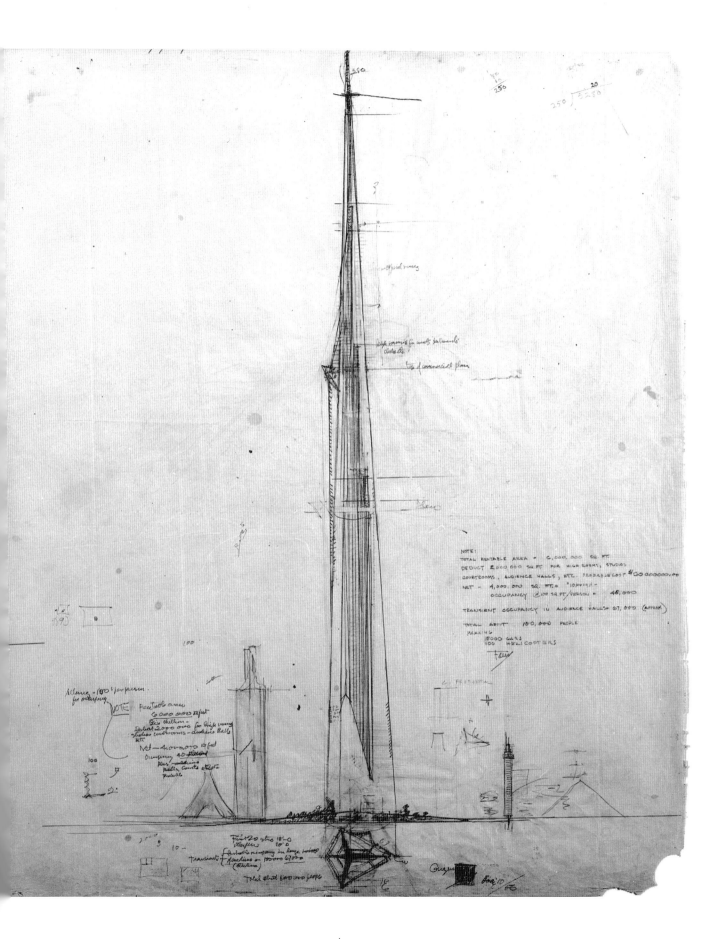

NOTE:
TOTAL RENTABLE AREA = 6,000,000 SQ FT
DEDUCT 2,000,000 SQ FT FOR HIGH ROOMS, STUDIOS
COURTROOMS, AUDIENCE HALLS, ETC. PROBABLE COST $400,000,000.00
NET = 4,000,000 SQ FT = "10/room"
OCCUPANCY @ 100 SQ FT/PERSON = 45,000

TRANSIENT OCCUPANCY IN AUDIENCE HALLS= 67,000 (APPROX)

TOTAL ABOUT 100,000 PEOPLE
PARKING
5000 CARS
100 HELICOPTERS

VIII. Shelter: Inherent Human Factor

Eight: As interior space to be lived in becomes the reality of building so shelter thus emphasized becomes more than ever significant in character and important as a feature. Shelter is still a strange disorder when reduced to a flat lid—though a common desire on account of economy. *To qualify this common-sense desire for shelter* as most significant feature of architecture is now in organic architecture of greatly increased importance. Witness, for instance: The new sense of spaciousness requires, as inherent human factor, significant cover as well as shade. Cover therefore now becomes in itself a feature more important as architectural form: Solidity of walls vanishing to reappear as imaginative screens involving light, and as inevitable consequence leaving more responsibility to the shapes and shaping of the whole building "overhead" with direct reference to the elements. Radical structural changes too now make the overhead lighter, less an imposition, more graceful, more harmonious feature of environment. Organic architecture sees shelter not only as a quality of space but of spirit, and the prime factor in any concept of building man into his environment as a legitimate feature of it. Weather is omnipresent and buildings must be left out in the rain. Shelter is dedicated to these elements. So much so that almost all other features of design tend to lead by one another to this important feature, shelter, and its component shade. In order to complete the building, protecting all within it from every changing circumstance of light, of cold and heat, of wear and tear and usage, we require shelter. The occupants of a building readily discover greater opportunity for comfort and more gracious, expanded living wherever shelter is becoming shade. By shade, charm has been added to character; style to comfort; significance to form.

The Client

Thus modern architecture implies far more intelligent cooperation on the part of the client than ever before. New rewards being so much greater in a work of art than by any "good taste" of the usual client, the wisdom of human investment now lies in "the home as a work of art." Correspondingly, the architect becomes more important than ever.

The dwelling "as-a-work-of-art" is a better place in which to be alive, to live with, and live for and by in every sense. Therefore, why not a better "investment"? The interests of architect and owner are thus mutual and binding upon both.

IX. Materials

Nine: I told my story of the nature of materials in building-construction in a series of articles written for Dr. Mikkelsen when he was editor of *The Architectural Record* of New York—about 1928. The good Doctor saved my economic life while I was getting a worm's eye view of society by calling me in to commission me to do a series of articles on "any subject I liked." I chose "The Nature of Materials," astonished to learn when starting research on the subject that nothing in any language had ever been written upon the subject.

All the materials usable in building-construction are more than ever important. They are all significant: each according to its own peculiar nature.

Old or new materials have their own lively contributions to make to the form, character and quality of any building. Each material may become a happy determinant of style; to use any one material wrongly is to abuse the integrity of the whole design.

Style

There is no such thing as true style not indigenous. Let us now try to evaluate style. "Style *is* the man." Yes, style is, as should be, largely a matter of innate *character*. But style only becomes significant and impressive in architecture when it is thus integral or organic. Because it is innate it is style genuine— or not at all. Style is now a quality natural to the building itself. Style develops from *within*. Great repose—serenity, a new tranquility—is the reward for proper use of each or any material in the true forms of which each is naturally most capable.

Ownership

In the hands of any prophetic architect the building is far more the owner's building than ever it was

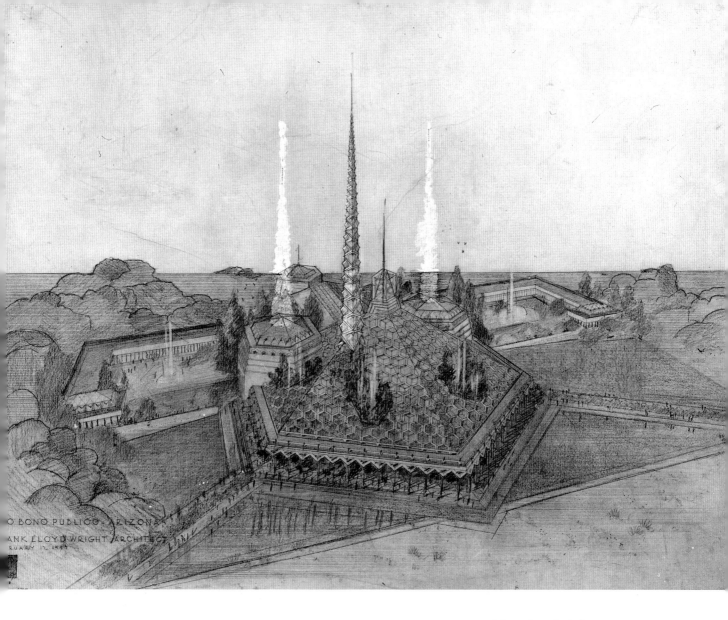

O BONO PUBLICO ARIZONA
ANK LLOYD WRIGHT ARCHITECT
RUARY 17, 195

Arizona State Capitol,
Phoenix, Arizona. 1957.
Project.
FLLW Fdn# 5732.001

when built for him only by way of his, or her, own taste or whim. His building is the owner's now by his knowledge of the knowledge involved. So it is in the nature of architecture organic, that there can no longer be reason to deny any man his own way with his house if he really knows what he wants. The house may be designed to suit his preferences or his situation in his own way of life: but there is a difference between his preferences and his taste. If by his preferences, he reveals awareness of the principles involved and here touched upon, that will make his building genuinely his. If he seeks to understand *how* they involve, and evolve, his freedom *as individual* in this, his own, particular case

his new home will declare his sovereignty as an enlightened individual. Homes of the new American *aristoi* may be as they must eventually become: one's own, not chiefly nor even ever "for sale." But this individual supremacy will come to the owner only with the knowledge of what it is that establishes this work of art as his own. "Taste" will now amount only to a certain discrimination in his approval of means to ends and appear once and for all in his choice of an architect. New light on both sides is indispensable to this new relationship, owner and architect.

▦ Again, the *style* of each house may be much more than ever individual. Therefore the necessity for a new *cultural integrity* enters: individual sensitivity and personal responsibility are now essential. So comes a man-sized chance to choose a place not only in which to be alive, but in which to live as a distinguished entity, each individual owner genuinely a contributor to the indigenous culture of his time. Within the spirit of this wider range of individual choice, it becomes the home-owner's responsibility to be well aware of the nature of his choice of an architect. What he does now will not only surround him and represent him for life; it will probably be there for several hundred years. Integrity should appear in his life by his own choice. In our democracy the individual should rise to the higher level of aristocracy *only by his own perception of virtue.*

What Is Natural

As the consequence of these basic principles of design, wood and plaster will be content to be and will look as well as wood and plaster, will not aspire to be treated to resemble marble. Nor will concrete buildings, reinforced with steel, aim to resemble cut-stone or marble. Each will have a grammar of its own, true to materials, as in the new grammar of "Fallingwater," my first dwelling in reinforced concrete. Were this simple knowledge of the grammar, the syntax, of organic design to become actual performance, each building would show its nature with such honest distinction of form as a sentient architect might afford to the awakened, appreciative owner. Building is an organism only if in accord outside with inside and both with the character and nature of its purpose, process, place and time. It will then incorporate the nature of the site, of the methods by which it is constructed, and finally the whole—from grade to coping, ground to skyline—will be becoming to its purpose.

A lady does not wear diamonds to market nor appear in shorts in the hotel lobby. Why then should she live with disregard for parallel good sense in the conduct of her own home environment? Building as organism is now entitled to become a cultural asset.

This is all merely the common-sense of organic architecture.

Addendum I

New materials in construction and methods of good building slowly remake the aspect of the world. A new grammar of design in the use of materials, all capable of characteristic effects, should enrich the building of the world without overemphasis or ignorant abuse, should never become a cliché. However, not many such buildings are in evidence as thoroughbred.

Furniture

Furnishings should be consistent in design and construction, and used with style as an extension in the sense of the building which they "furnish." Wherever possible all should be natural. The sure reward for maintaining these simple features of architectural integrity is great serenity. What makes this whole affair of house-building, furnishing and environment so difficult to come by is the fact that though a good sense of proportion, which is the breadth and essence of organic design, may find adequate response from good "taste," good taste is not a substitute for knowledge. A sense of proportion cannot be taught; a sense of proportion is born. Only so gifted can it be trusted as an affair of culture. Knowledge not only of the philosophy of building but its constitution is necessary. But there is no true understanding of any art without some knowledge of its philosophy. Only then does its meaning come clear.

The Camera Eye

If one would get the essential character of an organic building, it could not be by camera, inasmuch as it is wholly a matter of experience. One must be *in* the building before he can understand what makes it what it is. To write about it otherwise is false. Its pictorial aspects are purely incidental—but integral. Pictures of the buildings of the old two-dimensional school (nineteenth century) are most meaningful because they were seen as pictorial when conceived. But the building living before us now as an organism (twentieth century) may only be seen by *experience within* the actual structure. Since the depth-planes so characteristic of these structures are inevitable to their effects and are, chiefly, edgewise to the camera, any true sense of the whole edifice is seldom if ever found in a photograph. The depth-plane defies the flat camera-eye. Profoundly natural, these buildings are never dull or monotonous because this subtle quality of integrity due to "the each in each and the each in all" is continually there although not tangible to any superficial view. The essence of organic building is space, space flowing outward, space flowing inward (not necessarily by the use of the picture-window). Both plan and construction are seen to be inspired from within. For this important reason also, photographic views of these buildings are seldom satisfactory on the record. Only when the buildings are comprehended from within and each in its place a feature of its own special environment—serving its own appropriate purpose with integrity—are they really seen. If trees or mountains are round about, they will come to join and enrich the building by their natural sympathy. Architecture will become more charming because of this affinity. *The people in it gain the same distinction they would gain by being well-dressed.*

The character of the site is always fundamental to organic design. But fortified enclosure is no longer needed nor is it now often desirable. The old sense of fortification may still be with us as a more or less "monumental" weakness, as is any mere wall left standing alone. But ponderous though monumentality usually is, a monument often has its place: still serves some human purpose, as an emphasis of some chronic egotism or as true respect for the memorable, but usually abused as the dressiness of some exaggerated sentimentality.

The Profession

Architects today seem to have left but this one thing in common—something to sell: to be exact, themselves. Eventually, as a matter of course what *is* sold is chiefly themselves. Architecture is not on their minds.

But is degradation to the level of salesmanship and its profits a criterion to be tolerated by American society, either coming or going, in architecture? To take as earnest of our American future any cliché or endeavor to be international, this monotonous range of the commonplace which much of the architectural profession is now busy making of our present, is too fantastic, pessimistic egotism. Is there to be no true vision of whatever superior possibilities may exist for us in our new world besides these abortive boxes endeavoring to look tall?

Can it be that the ultimate chapter of this new era of democratic freedom is going to be deformed by this growing drift toward conformity encouraged by politics and sentimental education? If so then by what name shall our national American character be justly called? Doomed to beget only curiosities or monstrosities in art, architecture and religion by artists predominant chiefly by compliance with commercial expediency?

Machine standardization is apparently growing to mean little that is inspiring to the human spirit. We see the American workman himself becoming the prey of gangsterism made official. Everything as now professionalized, in time dies spiritually. Must the innate beauty of American life succumb or be destroyed? Can we save truth as beauty and beauty as truth in our country only if truth becomes the chief concern of our serious citizens and their artists, architects and men of religion, independent of established authority?

They Also Serve

Nevertheless I realize that if all false or unfriendly forces (due to ignorance or so conditioned as here described) inimical to culture, were to become less and less, many long years would still be needed to overcome the deep habituations that have been built into the American scene by inroads upon the American character; wholly against natural grain

and against our glorious original aim. If this twentieth century architecture, true to the principles of construction and more in line with our democratic faith, were to be more widely acknowledged by established authority; even if it were to be proclaimed from the housetops by cinema, television, press, politics, government and society as "the right thing" to be studied and practiced—there would still be controversy. Controversy would, even then, continue for the coming half-century at least, would perhaps never cease. Democracy knows only too well the senseless weight and conflicts of irresponsible public opinion, the chronic oralism, the dead weight of ignorance, the prejudices of conditioned minds siding right or left with selfish interests of hearts hardened—instead of the deep faith in Man necessary to inspire enlightenment by generosity of motive, which democracy meant to our forefathers and must yet mean to us. The common sense of the simple truth in this new-old philosophy, *from within outward,* if awakened in our society as now in our architecture, would ensure the true uses of technology for human shelter and reverential harmonious environment, both socially and politically. It would soon get into politics.

▨ Meanwhile we continue to hope that the Comic Spirit in which we as a people do excel may survive long enough to salt and savor life among us long enough for our civilization to present us to the world as a culture, not merely as an amazing civilization. The basic distinction between the curious and the beautiful, in which culture really consists, will make all the difference between a society with a creative soul and a society with none.

Part Two: Humanity—The Light of the World

Constantly I have referred to a more "humane" architecture, so I will try to explain what *humane* means to me, an architect. Like organic architecture, the quality of humanity is *interior* to man. As the solar system is reckoned in terms of light-years, so may the inner light be what we are calling humanity. This element, Man as light, is beyond all reckoning. Buddha was known as the light of Asia; Jesus as the light of the world. Sunlight is

to nature as this interior *light* is to man's spirit: Manlight.

▨ Manlight is above instinct. Human imagination by way of this interior light is born, conceives, creates: dies but to continue the light of existence only as this light lived in the man. The spirit is illumined by it and to the extent that his life *is* this light and it proceeds from him, it in turn illumines his kind. Affirmations of this light in human life and work are man's true happiness.

There is nothing higher in human consciousness than beams of this interior light. We call them beauty. Beauty is but the shining of man's light—radiance the high romance of his manhood as we know Architecture, the Arts, Philosophy, Religion, to be romantic. All come to nourish or be nourished by this inextinguishable light within the soul of man. He can give no intellectual consideration above or beyond this inspiration. From the cradle to the grave his true being craves this reality to assure the continuation of his life as Light thereafter.

As sunlight falls around a helpless thing, revealing form and countenance, so a corresponding light, of which the sun is a symbol, shines from the inspired work of mankind. This inner light is assurance that man's Architecture, Art and Religion, are as one—its symbolic emblems. Then we may call *humanity* itself the light that never fails. Baser elements in man are subject to this miracle of his own light. Sunrise and sunset are appropriate symbols of man's existence on earth.

▨ There is no more precious element of immortality than mankind as thus humane. Heaven may be the symbol of this light of lights only insofar as heaven is thus a haven.

▨ Mankind has various names for this interior light, "the soul" for instance. To be truly *humane* is divinity in the only sense conceivable. There can be no such thing as absolute death or utter evil—all being from light in some form. In any last analysis there is no evil because shadow itself is of the light.

And so when Jesus said "the kingdom of God is within you," I believe this is what he meant. But his disciples betrayed his meaning when they removed

the Father, supreme light, from the human heart to inhabit a realm of his own, because it was too difficult for human beings to find faith in man. So Christianity, itself misled, put out the interior light in order to organize worship of life as exterior light. Man is now too subject to his intellect instead of true to his own spirit. Whenever this inner light of the man has been submerged in the darkness of discord and failure he has invented "Satan" to explain the shadow. Insofar as light becomes thus inorganic, humanity will never discover the unity of mankind. Only by interior light is this possible. Science seems to be going toward the physical discovery that light is the essence of human being so far as life itself can be known.

Genesis: "Let there be light and there was light."

"More light," said the dying Goethe and he, no doubt, found it.

Then let this rediscovery of Architecture as Man and Man as Architecture illumine the edifice in every feature and shine forth as the countenance of truth. The freedom of his art will thus find consecration in the soul of man.

American Genius

So the genius of our democracy still lies hidden in the eternal law of change: Growth, our best hope, consists in understanding at last what other civilizations have only known about and left to us—ourselves comforted meantime by the realization that all one does either for or against Truth serves it equally well.

1. FLLW footnote to original text: Daniel H. Burnham to Frank Lloyd Wright.
2. The 1945 *When Democracy Builds* was a minor reworking of the 1932 book *The Disappearing City*, reprinted in this volume. Wright would greatly revise it again in 1958, this time publishing it under the title *The Living City*.
3. FLLW footnote to original text: William Blake.
4. FLLW footnote to original text: Samuel Coleridge.
5. The introduction to this monograph is reprinted in this volume.
6. Francis W. Little house, "Northome," Deephaven, Minnesota, 1912. Demolished 1972. Darwin D. Martin house, Buffalo, New York, 1904.
7. The model was exhibited at Rockefeller Center in 1935.

Note: Page numbers in italic type indicate illustrations.

cave dwellers, 236–37

ceilings, 193, 194, 328

centralization, urban, 235–41, 246–47, 249, 253, 273

ceramics, 131–36; artist's relation to, 131–32; brick, 136; characteristics of, 6; mosaics, 136; pottery, 136; terra-cotta, 132–33, 135; tiles, 136; Wright's response to, 120

Cervantes, Miguel de, 17, 378, 425

chairs, 357

Chandler, Alexander, 308

character, of architecture, 18, 118–19, 429

Charnley House (Wright), 319, 325

Cheney House (Wright), *48*, 401

Chicago, Illinois, 210

Chicago Architectural Sketch-Club, 377

Chicago Art Institute, 164, 369

Chicago Auditorium (Adler and Sullivan), 75, 120, 140, 319, 367

Chicago School, 51n2, 376–77

Chicago Tribune (newspaper), 147, 372

Chicago World's Fair. *See* World's Columbian Exposition (Chicago, 1893)

children's rooms, 356

chimneys, 192–93, 327

China: ceramics in, 131; early art and architecture of, 281–82, 286; love of stone in, 122, 125; metalwork in, 146

Christianity, 290, 439

Christian Science Church (Wright), *428*

Chrysler Building (Van Alen), 207

church: as architectural client, 290; in Broadacre City, 268

cities, 207–16, 235–75; abandonment of, 204, 206; centralization of, 235–41, 246–47, 249, 253, 273; and civilization, 207; compared to living beings, 32, 165–66; congestion in, 201–4, 210–11, 243, 414; critique of, 235–36, 243–45, 253, 414, 417–18, 421, 423; disintegration of, 207, 210, 212–13, 224, 245, 273; economics and, 238–39; electrification in, 246; growth of, 245–46, 280; humans' relation to, 9–10, 32, 165–66, 203–7, 209–11, 214, 235–36, 244, 256; ideas fundamental to, 250; individuality thwarted in, 243; machine and, 207, 209, 212; modern, 32, 165–66; nature of, 207, 212, 243; origins and development of, 280; pedestrians in, 204; proposals for improved living conditions in, 204–5; reasons for, 209; social problems of, 210–11; transportation in, 204–5, 247–49, 414. *See also* Broadacre City

City National Bank and Hotel, Mason City, Iowa (Wright), *376*

civilization: as abstraction, 380; architecture and, 232; art and, 73–74; and cities, 207; conventionalization and, 73–74, 170; developments in, 237; machine age and, 81, 165; standardization and, 95

classical architecture: criticism of, 42, 75, 91, 107, 159; modern reproduction of, 26, 28, 78, 84, 163–64, 169, 185, 228–30, 286, 289, 369, 378, 384; structure of, 24, 100; World's

Columbian Exposition and, 4. *See also* Greek architecture; Roman architecture; traditional architecture

cleanliness, 175, 176

clients, 46, 51, 116, 309, 355, 434–36

cliff-dwellings, 278

climate, 63, 193, 357–58

Coleridge, Samuel Taylor, 378, 424, 431

color: appropriate, 35, 49; in Japanese art, 70; of wood stains, 129–30; Wright's response to, 120, 368

commerce, 145

"common man," 388, 392, 394, 415

common sense, 58, 227, 355

communication, speed and extent of modern, 210, 246

community centers, 267

competitions, architectural, 234

composition, versus plasticity, 174

concrete, 141–44; aggregate of, 141, 142, 144; as artificial stone, 141, 142, 144; characteristics of, 6–7, 102, 141–42; fabrication of, 102–4; and imagination, 144; misuse of, 142; and ornament, 103; and plasticity, 103, 142, 144; steel and, 99–100; and terra-cotta, 142. *See also* concrete blocks; reinforced concrete

concrete blocks, 15–16, 144, *346*, 360–61

conformity, 381–82, 387–88, 423

conservatism, 34, 141, 413

Constitution, U.S., 394

construction methods: plans affected by, 113–14; for steel, 99–100; for Usonian Automatic houses, 15–16, 360–61

continuity, in architecture, 15, 18, 220–21, 279, 321–22, 331, 333–35, 429–30

contractors, 358

conventionalization: architecture as model of, 49; art and, 53, 73–74, 169–70; civilization as, 73–74, 170; of color, 35; in Japanese art, 36, 68–73; knowledge and, 74; life-principle and, 74; in organic architecture, 62; of ornament, 46; style and, 43. *See also* standardization

Coonley House (Wright), 12, 42, 64, *86*, 86, 110, 113, 114, 140, 305, 331, *375*, 400, 401

copper, 7, 145–48, 150

cornices, 117–18, 181–90

Corwin, Cecil, 367, 376

country: living in, 200, 201, 212, 248, 350–51; skyscrapers in, 206, 210, 224, 254, 266. *See also* Broadacre City

craft. *See* handicraft

creation, concepts connected with, 151–55

creativity, 31, 102, 180, 365. *See also* ideas

critics, 410–11

Croker, Richard, 27, 33n4

Crystal Palace, London, 424

crystals, 120

culture: obstacles to true, 411; spiritual expressed through, 55–56, 71–72, 89, 169. *See also* American culture; civilization; spirit

Dana House (Wright), *41*, *59*, 140

Danjuro. *See* Ichikawa Danjuro (Kabuki actor)

Dante Alighieri, 17, 378, 424

Davidson, Walter V., 262, 263

Dean, George, 35, 376

decentralization, urban, 18, 212–13, 224, 273–74, 350, 427–29

Declaration of Independence, 170, 381, 384, 394, 396, 415

decoration: architecture as, 231; Japanese art and, 70. *See also* ornament; pattern

decorative arts, modern reproduction of, 27–28

democracy: American experiment in, 239–40, 252; architecture and, 16, 118, 150, 188, 348–49, 359, 381–82; characteristics of, 413; and freedom, 56; and humanity, 107; individuality and, 38, 56, 188, 212, 241, 242, 415; machines and, 24, 26, 27, 32, 49, 91, 96; mobocracy versus, 394; origins of, 280; ruralism and, 212; Usonian houses and, 348–49

design center, 268–69

Dewey, John, 426

Dictionnaire Raisonné de l'Architecture Française (Viollet-le-Duc), 183

Disappearing City, The (Wright), 9, 235–75, 382, 439n2; frontispiece, *236*

distribution of goods and services, 213, 265

domes, 198–200, 282–83

dress reform houses, 42, 194, 328

Drummond, William, 50, 377

dry wall footing, 351–52

Dunning, Max, 377

Duveen, Joseph, 289

Early Renaissance architecture, 3, 52

earth, human significance of, 276–77

economic factors: architects and, 40; cities and, 238–39; government and, 238; human effects of, 239; skyscrapers and, 201–3, 210. *See also* poverty; wealth

education: American, 388–89, 415; in architecture schools, 61–62, 84, 225, 387, 415–16; in art schools, 62, 164, 170, 268–69, 387; in Broadacre City, 267–70; and corruption of taste, 53–54; critique of, 107; Froebel pedagogy, 16–17, 368, 394; in machine's possibilities, 30–31, 80, 93, 179–81; philosophy of, 269–70

efficiency, 397

egocentrics, 217–18

Egypt: architecture in, 281, 285, 424; ceramics in, 131; expression of plant forms in, 169; glass use in, 138; stone use in, 122

"Eighteen," the, 376

Einstein Tower (Mendelsohn), 113

electricity: in Broadacre City, 257; and communication, 246, 253

electro-glazing, 29, 97, 168

Elmslie, George, 377, 380

Emerson, Ralph Waldo, 17, 186, 239, 381, 424, 426

Emerson, William, 386

engineering-architecture, 365

engineers, 82, 99, 221, 331, 333, 335

Ennis House (Wright), 113, 114, *143*, 360

European architecture, twentieth-century, 400

Exhibition House for "Sixty Years of Living Architecture" (Wright), *346*

expediency, 55, 94, 116, 369, 383, 387, 410

experiment centers, industrial, 179–81

exteriors, of organic architecture, 49

fabrication, 102–5, 168

Faerie Queene (Spenser), 70

Fallingwater (Wright), 11–12, 300–1, *300–2*, 303

family, Usonian houses and, 355–56

farmers, 262–64

fashion, in architecture, 36, 84, 107, 116

fenestration. *See* windows

Field, Marshall, 26, 33n3, 265

fireplaces, 193, 327

fixtures, 35, 63, 140, 222, 330, 348

Flatiron Building, New York City, 183

Florida Southern College (Wright), *418*, *426*

folded plane, 321, 322

Ford, Henry, 212, 214, 289

forests, destruction of, 127

form and function: in architecture, 34, 189, 225, 322, 330; beauty and, 53; Coleridge and, 431; Greek architecture and, 187; misunderstanding of, 377–78; in nature, 73; significance of, 197, 315; Sullivan and, 135

formulas, versus principles, 105

foundations, building, 351–52

fourth dimension, 153

France: and decoration, 231; Japanese art influential in, 174; textile production in, 174

Francis Apartments (Wright), 42, 51n4

Francke, Kuno, 324, 367, 385, 401

freedom: in American society, 170, 171, 228–30, 251, 381, 399; architecture and, 400; Broadacre City and, 242; consequences of, 215–16; democracy and, 56; early humans and, 237; Greek architecture and, 187–88; and individuality, 189; machine influence on, 26–27, 100, 104, 169–71; in residential interiors, 220; source of, 413; space and, 203, 206, 210, 212, 214

Freeman House (Wright), *139*, 360

Froebel, Friedrich, 16, 363, 368, 394, 426

function. *See* form and function

functionalism, 315

furnishings, 356–57, 436

furniture: chairs, 357; critique of typical, 165; human use of, 196, 330; integration of, into architecture, 35, 63, 196, 222, 329–30; plain, 196; wood, 128

Future of Architecture, The (Wright), 8

pioneering, 274

Pisano, 52

plans, 109–14; articulation in, 114; building methods and, 113; factors in, 109–10; formulation of, 109; in organic architecture, 42; scale of, 110; significance of, 11, 109, 292; standardization in, 110, 115

plants, artistic expression of, 169

plasticity: concrete and, 103, 142, 144; and continuity, 220–21; machine and, 25, 27–29, 80, 97, 100, 168, 173–74; organic architecture and, 334–35; Sullivan and, 75, 220, 322, 330; and third dimension, 85–87, 321; wood and, 128, 130; in Wright's architecture, 194, 220, 321–23, 328, 330–31; Wright's concept of, 4–5, 401–2

Plato, 67

plumbing systems, 195, 215, 361

poetry, 152–53, 315, 332, 337, 365, 381, 409–11, 414

poetry of form, 151–52

politics, 274

Pope House (Wright), *345*

post-and-beam construction, 15, 220–21, 322, 331, 333–34

post office architecture, 163

pottery, 136

poverty, 211–12, 238, 260–62

prairie, architecture appropriate to, 35, 64, 192–94, 219–20, 320–21, 427

Prairie School, 324

Prairie Style, 51n2

Pre-Raphaelites, 70, 367

Price Tower (Wright), *422*

primitive instincts, 236–37, 278

Princeton University, 7

principles: creation and, 155; definition of, 154; fertility of, 174; formulas versus, 105; importance of, 396; universality of, 173, 231

printing, 24–25, 32, 95, 165–66, 181, 186, 288, 378

prisms, 178

processes, architectural, 102–5, 168

production, machine, 93, 246–47

progress, 116, 170

proportion: importance of, 110; in organic architecture, 17–18. *See also* human scale

Protestantism, 241

provincialism, 78, 227

public library architecture, 163

Puvis de Chavannes, Pierre, 71

Queen Anne style, 127, 287, 319

Rabelais, François, 77

race, and architecture, 280–81, 286

radicalism, in architecture, 225

Raphael, 71

realism, 69, 288, 314

reality, architecture and, 14, 34

regionalism, 152

reinforced concrete, 11, 85, 86, 99, 100

religion, 268, 290, 390

Rembrandt van Rijn, 378

Renaissance art and architecture, critical remarks about, 25, 42, 53–55, 58, 84, 116–17, 181, 183, 279, 287, 367, 380, 397, 426. *See also* Early Renaissance architecture

rent, 201–2, 205–6, 235–36, 238, 245

repose, as architectural quality, 197

Research Tower for S. C. Johnson & Son Co. (Wright), *419*

residential architecture: American, 190–98; berm-type, 352; in Broadacre City, 252–53, 270–71; "cardboard house" type of, 190–92; cost of, 309–12, 339–40, 342, 344, 347, 360; critique of, 164–65, 192–93, 219, 259, 319–20; of the future, 254; grammar of, 358–59; human body compared to, 190; materials of, 252; modern, 8, 271, 309–12, 327–29; for the poor, 261–62; principles of, 190; small house problem, 310, 339; suburban, 164; tall apartment buildings, 266; unnecessary elements in modern, 310, 340; Wright and, 34–35, 192–95, 219–22, 292–312, 319–63

resources of architecture, 14–15, 331–38

Richardson, Henry Hobson, 33n3, 34, 51n1, 78, 282, 376, 379, 424

roads, 212–13, 224, 253–54, 256

Roberts, Isabel, 50, 377

Robie House (Wright), *61*, *191*, 400, 401

Robinson, Harry, 50

Rococo art and architecture, 54, 175

Roebling, John, 17, 224, 335, 424

Rogers, Gamble, 376

Rogers Groups (sculptures), 73

Roman architecture: arch in, 91, 98; criticism of, 91, 206; domes in, 200; stone in, 122. *See also* classical architecture

Roman culture, 107

romance, 152, 171, 178–79, 382, 402, 410

Romanesque architecture, 282

roofs: berm-type, 354; for climate control, 353; origins of, 278–79; overhanging, 185, 193, 219, 320, 328; shapes of, 354; sheet metal for, 145–46

room, as genesis of architectural form, 118, 154, 195, 326, 328, 332, 363

Roosevelt, Theodore, 401

Root, John Wellborn, 34, 51n1, 201, 376, 379

Rosenwald School (Wright), *408*

Rossetti, Dante Gabriel, 70

Rousseau, Jean-Jacques, 17, 425

Roycroft furniture, 196, 329

"rugged individualism," versus true individuality, 241

ruralism, 212

Ruskin, John, 23, 28, 30, 58, 80, 95, 147, 164, 367, 396

Russia, 315